Mordecai Naor

The Twentieth Century in Eretz Israel

A pictorial history

KÖNEMANN

Copyright © 1996
Am Oved Publishers Ltd., Tel-Aviv
M.O.D. Publishing House, Israel

Design: Dorit Sharfstein
Production Managers: Ya'akov Brumstein, Arik Ben-Shalom

Copyright © 1998 for the English language edition
Könemann Verlagsgesellschaft mbH
Bonner Str. 126, D-50968 Cologne

Translation from Hebrew: Judith Krausz
Managing Editor: Aggi Becker
Editor: Mona Yahia
Copy Editor, and translation of excerpts by S.Y. Agnon and Natan Alterman: Naomi Z. Sofer
Editorial Assistant: Alex Morkramer
Typesetting and text composition: Thomas Heider; PageProduction GmbH
Production Manager: Detlev Schaper
Assembly and Reproduction: Reproservice Pees
Printing and Binding: Kossuth Nyomda Printing House
Printed in Hungary
ISBN 3-89508-595-2

10 9 8 7 6 5 4 3 2 1

Cover Photographs:
(clockwise from top center right)

Hashomer guards; paratroopers at the Western Wall - 1967; a Black Panther; children in a bomb shelter in the Jordan Valley during the War of Attrition - 1970; newly Ottomanized subjects: Meir Dizengoff, Hayim Bograshov and Ben-Zion Mossinson - 1915; the Gulf War - 1991; Itzhak Sadeh, Moshe Dayan and Yigal Allon in Hanita; Golda Meir and Moshe Sharett; a wounded soldier is being treated during a retaliatory raid at Nuqeib - 1962; Hanna Rovina in the film *Tzabar* - 1932; the Western Wall; soldier instructing the use of gas masks - 1990; Hasidic Yeshiva students in confrontation with the police - 1995; *Yedi'ot Aharonot* headlines: "The U.S. Bomb the Missiles in Iraq." Gulf War - 1991; rescue at Ma'alot - 1974; the Pagoda House, Tel-Aviv; flooded immigrant transit camp - 1951; the Israel-Jordan peace agreement - 1994; grandfather and grandson studying the Torah in the Old City of Jerusalem.

CONTENTS

Foreword by Dr. Mordecai Naor

FOREWORD

The 20th century witnessed far-reaching changes throughout the world, experienced in Eretz Israel both as part of broader processes and independently of them. Massive upheavals occurred during the century which affected the country and which, to some extent, were generated within the country itself. Rulers came and left. During the early part of the century, the Ottomans controlled the country (until 1917-18), to be followed by the British for the next 30 years, in form of the Mandate the League of Nations had granted them. Close to mid-century, during 1947-49, a war erupted that involved the Jews in Palestine, the Arabs of the country (the Palestinians) and five Arab states. Rising out of the turmoil of this war, the State of Israel was established, while the Palestinians, for their part, continued to reject the United Nations plan of 1947 to establish a Palestinian state in part of the country, side by side with Israel. In the end, part of the territory that had been allocated to the Arabs was divided up between Jordan and Egypt. Thus, Israel controlled most of the territory of Eretz Israel from 1949 to 1967, while the rest was controlled by Jordan (the West Bank and East Jerusalem) and Egypt (the Gaza Strip).

Another upheaval occurred in the country in June 1967 – the Six-Day War. In the wake of the Israeli victory a new map was drawn which remained unchanged until the mid-1990s, with the exception of the Sinai Peninsula, returned to Egypt in 1982. Arab hostility toward Israel, which dates back to the start of the century, was rigid and appeared immutable. However, a change occurred in 1977: Anwar Sadat, president of Egypt, came to Jerusalem, and the long journey toward peace began. A peace agreement was concluded with Egypt in 1979. Fifteen years later, several more steps were taken: a second peace agreement was signed – with Jordan, and an agreement with the Palestinians was attained regarding Gaza and Jericho, later extended to include parts of the West Bank. The Arab boycott is in the process of disbandment, and although the road to true and lasting peace between Israel and the Palestinians, and with the Arab states, is still long, several stages have been completed.

These major dramas, as well as events linked to war and peace and developments in society, economy, culture, entertainment, sports and everyday life, are reflected in The Twentieth Century in Eretz Israel - A Pictorial History, a first in its scope and reach. Each year of the century is presented separately with a detailed calendar of events and short articles on important developments, while generously accompanied by visual documentation. The book contains approximately 2,000 color and black and white photographs, some of them rare, along with illustrations, caricatures and maps. This year-by-year mosaic, framed in decades, coalesces to create a complete picture of the twentieth century in Eretz Israel.

Spanning over almost ten decades, up to and including the year 1997, the book will be updated at the end of the century.

The history of Eretz Israel is a sensitive subject and some readers will undoubtedly take exception to one or another perspective or to the inclusion of certain material and the exclusion of other. While every effort has been made to follow a broad approach, undeniably the book has been compiled and written from the point of view of an Israeli writer. Other writers, of course, may have different views.

Dr. Mordecai Naor, 1997

The First Decade
1900-1909

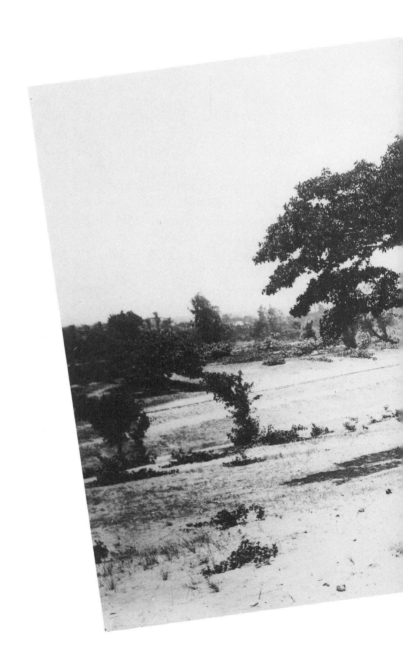

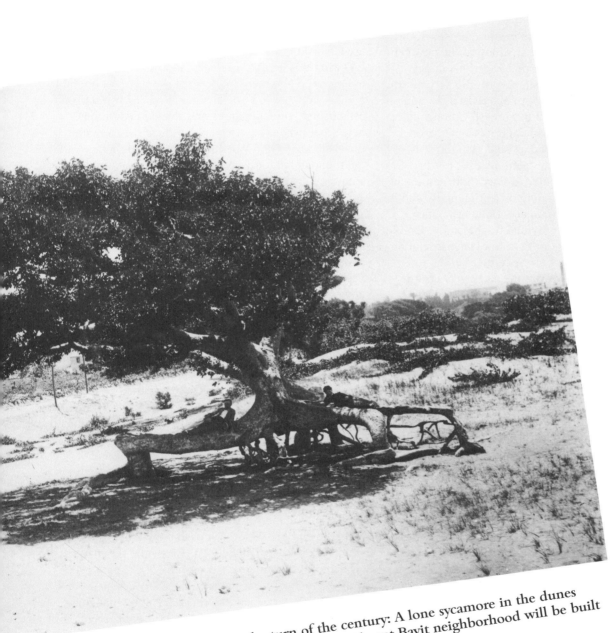

A scene in Palestine at the turn of the century: A lone sycamore in the dunes north of Jaffa. Some ten years later, the Ahuzat Bayit neighborhood will be built there, later to be renamed Tel-Aviv.

The first decade of the 20th century witnessed ups and downs in the country and in the small Jewish Yishuv for both internal and external reasons. The Turkish government had long been in a process of decline, while the influence of the foreign consuls – the representatives of the Great Powers – was practically unlimited under the terms of the Capitulation agreements. Although the Young Turk Revolution toward the end of the decade promised basic governmental change, none actually took place in Palestine.

Even so, the Jewish Yishuv underwent vast change during the course of the decade, so much so that by the end of the period it hardly resembled what it had been at the beginning. The turn of the century, however, did not bode well. Precisely on the first day of the new century, Baron Edmond de Rothschild ended his direct involvement in, and massive support of, the agricultural villages (moshavot) founded with his assistance, transferring supervision of them to the Jewish Colonization Association (I.C.A.), which, in contrast to the baron's personal image, was perceived as hostile to the settlement endeavor and even as anti-Zionist.

In fact, the I.C.A. contributed greatly to the entrenchment of the villages, functioning unsentimentally and in a businesslike fashion to attain economic efficiency, with backing and aid still provided by the baron. Unlike his previous administrators in Palestine, the association granted maximal autonomy to the farmers in the running of their villages. However, the early years of the decade constituted a period of serious economic and social crisis in the Yishuv, exacerbated by a storm that emanated from the newly formed Zionist Organization – the Uganda affair. Since 1897, Palestine had been the sole focus of attention by the Zionist movement, headed by Theodor Herzl. This changed in 1903 when, as a result of the desperate situation of the Jews of Eastern Europe, Herzl sought territorial solutions outside Palestine, although not far from it (two proposals were the Sinai Peninsula and Cyprus). Following the Kishinev pogrom (1903) and the growing emigration of Jews from Eastern Europe, Herzl adopted a British proposal to settle the oppressed Jews of Europe in Uganda in East Africa as a temporary refuge until a charter for Palestine became available.

Starting from the sixth Zionist Congress, held in Basle in August 1903, the Zionist movement was caught up in a storm of dispute and confrontation between supporters of the Uganda Plan, led by Herzl, and opponents of it, led by Menahem Ussishkin and most of the Russian Zionist leadership. This bitter debate, which nearly split the movement, was conducted in full force in Palestine as well. Herzl and the Ugandism were supported by Eliezer Ben-Yehuda, while their opponents termed themselves the Zionists of Zion.

The early years of the decade were a time of scant immigration to the country. This situation changed, however, in late 1903 and thereafter with the arrival of a wave of young, mostly single immigrants who were later to be depicted as the vanguard of the Second Aliyah. Within a few years, several thousand such young people had arrived, motivated by a combination of Zionist ideology, fear of pogroms and anti-Semitism, and despair over the chances of integration into society at large, especially in Russia.

Older immigrants with families and means began joining them after 1905. Compared with the massive Jewish emigration from Eastern Europe to America (some 1.5 million from 1900 to 1914), the migration of Jews to Palestine was only a trickle. Nevertheless, the Jewish Yishuv, which at the end of the First Aliyah (1903) consisted of hardly more than 50,000 persons, grew steadily, if slowly, year by year.

During this period, a Jewish labor movement began to emerge. The young immigrants, some of whom laid greater emphasis on Socialism and others on Zionism, established political parties and related institutions, began publishing newspapers, initiated the formation of the Hashomer ("the Watchman") association, and laid the foundations for a Jewish political system in the country.

The Zionist Organization, which under Herzl had sought to obtain an international charter in order to establish a Jewish state in Palestine, did not at first attach very much importance to Jewish settlement in the country. After Herzl's death in 1904 and the election of David Wolffsohn as president of the organization, however, the "practical" Zionists, who were strong advocates of settlement, gained influence. Eventually, during the second half of the decade, an integrated policy – "synthetic" Zionism – was adopted, stressing both practical activity in Palestine and the continuation of diplomatic efforts.

In 1908, the Zionist Organization opened a Palestine Office in Jaffa, under the directorship of Dr. Arthur Ruppin, who would be called "the father of the Zionist settlement." By the end of the decade, Ruppin established three training farms, founded the Palestine Land Development Company (which was in charge of purchasing land), helped in the foundation of Ahuzat Bayit (later, Tel-Aviv), and was involved in almost every field of Zionist activity in the country.

By the end of 1909, the Jewish population in the country was approximately 65,000, while the number of agricultural settlements had risen by 50% since 1900, from 22 to 34. Two Hebrew high schools, in Jaffa and Jerusalem, had opened; the revived Hebrew language was becoming entrenched; and overall the perception of the future was optimistic.

1900

January ————
1 Baron Rothschild announces the halt of financial support for the Jewish agricultural villages in Palestine and transfers their administration to the Jewish Colonization Association (I.C.A.). The Yishuv is in an uproar. Some 5,000 people live in the 22 villages established since 1878. Land under cultivation encompasses 38,000 dunams (9,500 acres), two-thirds of it vineyards.

A distinguished guest, the writer and editor Ahad Ha'am (Asher Ginsberg), arrives for an extended visit in November 1899 and leaves in April 1900. He will later assert in an important article (*The Yishuv and its Patrons*, 1902) that the Jewish villages will survive only if they are detached from dependence on Rothschild, on his emissaries, and on the I.C.A.

Another guest, the Swedish writer Selma Lagerloff, spends several months in the country, primarily in Jerusalem, and will later write the noted book, *Jerusalem*, for which she will receive the Nobel Prize.

Eliezer Ben-Yehuda's weekly *Hazvi* ("The Deer"), begins to appear twice-weekly, on tuesdays and fridays. Its rival, *Havazelet* ("Lily"), remains a weekly.

February ————
3 A workers' convention decides to conduct a population census, which is held during the months that follow. The results show that the agricultural villages established during the First Aliyah (1882-1903) employ 524 Jewish workers, including 161 workers in Zikhron Ya'akov and 103 in Rishon Lezion.

March ————
30 The founding conference of the Labor Organization of Palestine is held in Jaffa. The guest of honor is Ahad Ha'am. The organization does not last long.

Reports from the Galilee indicate that the Turks have completed building a bridge over Wadi Amud, enabling passage from Tiberias northward in all weather conditions.

April ————
The I.C.A. makes drastic cuts, announcing that farmers will no longer be subsidized, unprofitable agricultural branches will be closed down, and "surplus" farmers will be turned out of the villages. The association dismisses the baron's entire administrative staff. Unemployment grows and emigration increases.

The I.C.A. appoints Hayim Kalvaryski-Margolis as manager of the Sejera farm under its administration. The farm becomes the "mother of Jewish settlement in the Lower Galilee."

May ————
The Ottomans announce a plan to lay a railroad from Damascus to Medina and Mecca. A line will later be laid from Haifa to Dar'a – the Valley Line.

June ————
Economic circumstances force *Hazvi* to resume publishing on a weekly basis only.

The Pe'ulah craftsmen's association is established in Jaffa with the aim of improving its members' economic condition and locating work for unemployed members.

July ————
The Ottomans begin building a new city in the Negev – Beersheva.

September ————
9 Chief Ashkenazi Rabbi of Jerusalem, Shmuel Salant, pronounces the wines of the Rishon Lezion winery strictly kosher, following doubts raised by various circles, mostly abroad.
12 Bedouins attack the village of Hadera as part of a dispute involving one of the Bedouin village guards employed there. The village sheep herd is plundered. Order is restored following intervention by young farmers from Zikhron Ya'akov and by Turkish soldiers.
30 A delegation of four Jewish workers from Palestine appears at the I.C.A. general meeting in Paris and appeals to the company to aid in the establishment of villages with housing for workers in Palestine. The request is rejected, as is their request to meet with Baron Rothschild.

October ————
Emigration increases in the wake of the worsening economic situation. The I.C.A. aids unemployed workers by providing transportation costs to Europe.

November ————
27 The Judean (Southern) Villages Committee meets in Rishon Lezion and decides to take action on behalf of the villages' interests in reaction to the cutbacks announced by the I.C.A.

December ————
11 The Judean Villages Committee decides to send a mission to the "Odessa Committee" – the leadership body of the Hovevei Zion ("Lovers of Zion") movement in Russia – in order to put forward the claims of the villages in light of the transfer of authority by Baron Rothschild to the I.C.A.
19 The Pardess cooperative society for the marketing of citrus, the first such body in the country, is founded in Petah Tikva.

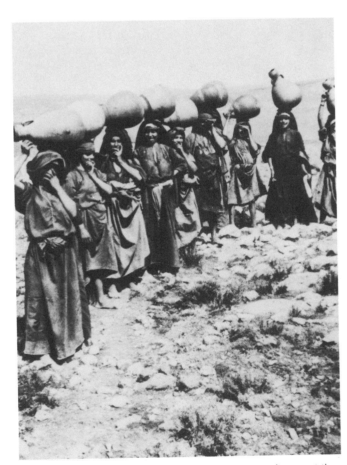

A scene in Palestine, circa 1900: Arab peasant women line up at the well. Water is scarce.

▷ The population of Palestine is 400,000-500,000 at the turn of the century, most of them Muslim Arabs, some Christian. A substantial proportion of the Arab population lives in villages, often in huts made of clay and straw. Jews constitute approximately 10% of the population. Most belong to the old Yishuv, with only a tenth living in the farming villages, Jaffa, Haifa and the parts of Jerusalem known as the new Yishuv.

◁ A small but significant minority in the country are the German Templers, who establish a series of successful farming villages, such as Sharona (today the Kirya district of the city of Tel-Aviv).

▽ Jewish holy places, which draw thousands of pilgrims annually, include the Western Wall in Jerusalem and the Tomb of Rahel near Bethlehem, shown.

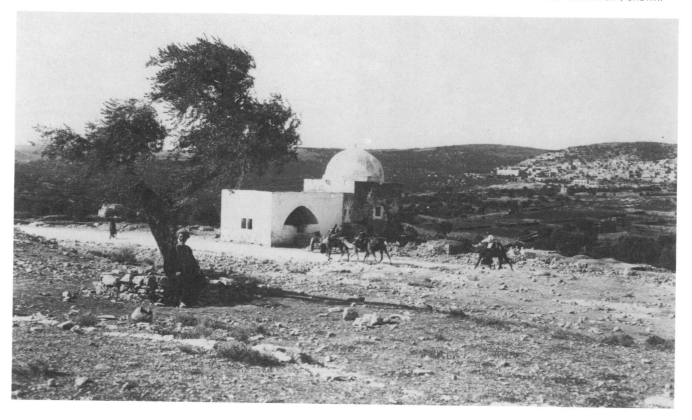

▽ Palestine in 1900 straddles both sides of the Jordan River. The Jerusalem district is an independent province answerable directly to Istanbul. The vilayet (province) of Beirut stretches along the western Jordan River area from Beirut southward to Acre and Nablus. The sanjaks (districts) east of the Jordan River are part of the vilayet of Damascus.

THE TRANSITION FROM BARON ROTHSCHILD'S PATRONAGE TO SPONSORSHIP BY THE I.C.A.

The Jewish Colonization Association (I.C.A.), founded in Paris in 1891 by Baron Maurice de Hirsch, aided Jewish emigration from Europe and Asia and promoted agricultural settlement in the Americas. Most of its activity centered in Argentina, where 21 agricultural settlements were founded. In January 1900, Baron Edmond de Rothschild transferred responsibility for the agricultural villages he supported in Palestine to the association, marking the end of the period of his direct patronage. Rothschild was disappointed in the development of the settlement project and in the continuous criticism directed at him by the settlers. Poor health and worry about the villages led him to seek some other solution for the continued existence of the Yishuv. He chose the I.C.A. because it was a French body and had experience in settling Jews throughout the world.

The move plunged the villagers in Palestine into deep despair, as they were convinced that the I.C.A. was anti-Zionist and that the end of the settlement of Palestine was at hand. The association, for its part, instituted a new policy, eliminating previous convoluted administrative procedures, reducing the extent of subsidization of grape prices, closing unprofitable enterprises, and at the same time minimizing its involvement in the running of the villages.

In retrospect, the transition was beneficial: the association established a new settlement bloc in the Lower Galilee while also setting the villages on the track of economic efficiency. After a difficult period, the I.C.A. was acknowledged by many as having made an important contribution to the growth of the Yishuv.

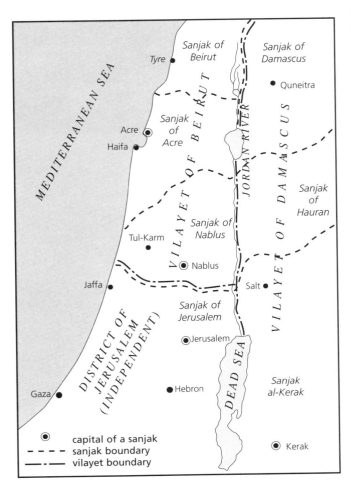

MEDITERRANEAN SEA

Tyre

Sanjak of Beirut

Sanjak of Damascus

Quneitra

Acre

Haifa

Sanjak of Acre

VILAYET OF BEIRUT

JORDAN RIVER

VILAYET OF DAMASCUS

Sanjak of Hauran

Tul-Karm

Sanjak of Nablus

Nablus

Jaffa

Salt

Sanjak of Jerusalem

DISTRICT OF JERUSALEM (INDEPENDENT)

Jerusalem

DEAD SEA

Gaza

Hebron

Sanjak al-Kerak

⊙ capital of a sanjak
- - - sanjak boundary
—·— vilayet boundary

⊙ Kerak

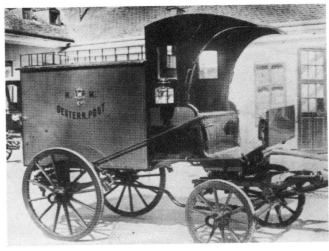

△ The Ottoman authorities have to acquiesce to the existence of autonomous postal services operated by Austria (as shown), Germany, Italy, and Russia, alongside their own service.

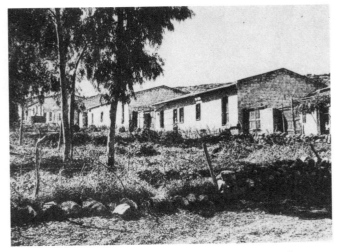

△ The first Jewish settlement in the Lower Galilee, the Sejera farm. Within a few years, a new area of settlement is to develop in the region.

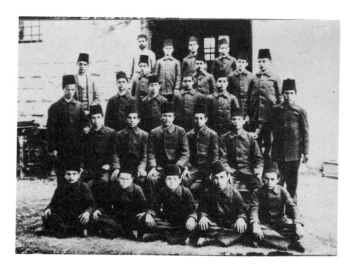
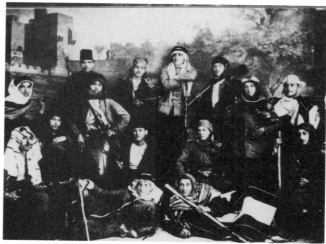

△ Side by side in 1900: (l.) Pupils at the Alliance Israelite Universelle school in Jerusalem, in Ottoman-style uniforms. (r.) Pupils at the Mikveh Israel school, not far from the city of Jaffa, in another Levantine style of attire.

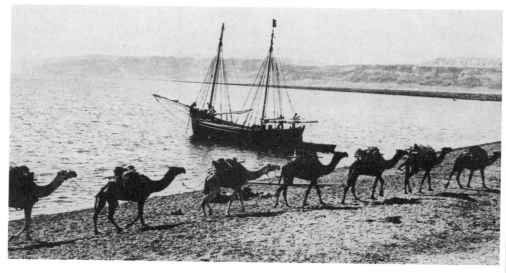

▷ Bread for Jerusalem: A camel caravan transports wheat shipped by boat from the eastern side of the Jordan to the northern shore of the Dead Sea.

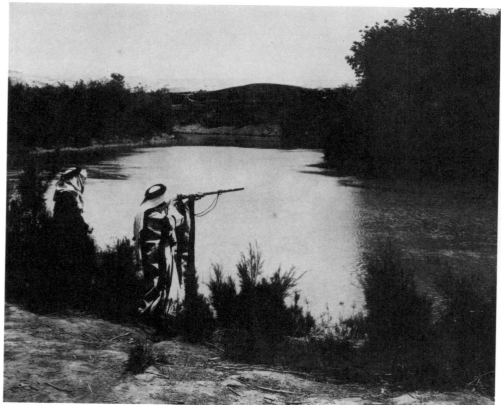

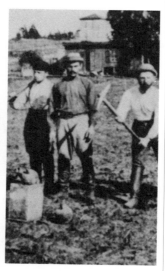

△ Jewish workers in the village of Rehovot, established in 1890.

◁ Two Bedouins at the shore of the Jordan River. Palestine at the turn of the 20th century is perceived as a desert country, its population largely nomadic.

14

1901

January
A strike is held in the Rishon Lezion winery following lay-offs announced by the I.C.A. The head administrator, Shem-Tov Priente, is ultimately compelled to pay the dismissed workers a full year's wages.

February
Delegations from various villages (Zikhron Ya'akov, Petah Tikva, Rosh Pina, and probably others) travel to Europe and make efforts to meet with Baron Rothschild and the heads of I.C.A., but are unsuccessful. Attempts to involve the Zionist Organization leadership are similarly unsuccessful. Herzl claims that he cannot oppose the I.C.A.
26-27 A general assembly of Hovevei Zion ("Lovers of Zion") deals with the question of the Jewish settlements in Palestine. Representatives of the workers also take part. A decision is reached to send a delegation of 20 members–representatives from Palestine and leaders of Hovevei Zion–to Paris.

March
An atmosphere of despondency descends upon the villages. Eliezer Ben-Yehuda writes in *Hazvi* ("The Deer") at the beginning of the month: "A spirit of gloom, sadness, sorrow and despair reigns in all the villages."
20 The village committees choose representatives for a delegation to Paris comprising five farmers and two laborers. Their primary demand: to allow the villages to function on their own, without patronage.

May
13-14 A delegation of representatives of the villages in Palestine and of the Hovevei Zion movement present themselves to Baron Rothschild in Paris and request him to assist them in gaining authority over the management of the villages. The baron rejects the request.

At the end of April 1901, most parts of the country suffer from drought. Jerusalem has had less than 300 mm of rain, which leads to a serious shortage of water.

June
A new governor is appointed in Jerusalem – Muhammad Jewad Bey, replacing Taufiq Pasha.
27 The Kibbutz Brothers society is established to provide financial support for the workers of the First Aliyah to enable them to remain in the country.

Tension and confrontation between the villagers and Priente, the administrative director of the I.C.A., come to a head in the village of Metula. Priente, arriving there for a visit, is "detained" in the administrative building and the wheels of his carriage are removed until he acquiesces to the farmers' demands.

September
Hayim Kalvaryski-Margolis is appointed manager of the I.C.A. in the Lower Galilee. He gives a push to new settlement in the area.

October
7 I.C.A. establishes the first village in the Lower Galilee –

Yavne'el – called at first Yemma. A second village in the same region, Kfar Tavor (originally Messha), is established on the 25th.

November
29 The Ottoman authorities complete the repair of the

The village of Metula, place of confrontation with the head of the I.C.A.

ancient aqueduct from Solomon's Pools to Jerusalem, a distance of 16 km, in time for Sultan Abd al-Hamid II's birthday. This provides significant relief to the inhabitants of the city, who, before, suffered from the scarcity of water.

December
29 The fifth Zionist Congress, meeting in Basle, establishes the Jewish National Fund (J.N.F.), a Zionist vehicle for purchasing plots of land in Eretz Israel.

In early summer 1901, the Abarbanel Library moves to a new building in Jerusalem. Eventually, it will grow into the National and University Library.

The citrus plantation in Petah Tikva expands to 30 groves. Experiments are also made in growing tobacco.

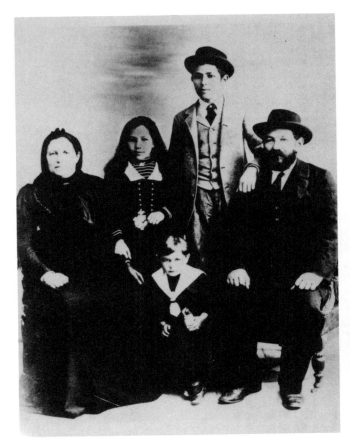

A farming family of Petah Tikva, the Raabs, (l. to r.) Mother Lea, daughter Esther (later to become a poet), son Eliezer, son Barukh father Yehuda.

Kfar Tavor (Messha), with Mount Tavor in the background.

15

▷ Baron Edmond de Rothschild (1845-1934) continues to be involved in the development of the villages in Palestine, while ending his formal patronage.

▽ The first segment of a Writ of Authorization handed over to delegates of the Yishuv in 1901 with the intention that they appeal to the baron to reconsider transferring responsibility for the villages to the I.C.A.

A NEW SETTLEMENT BLOC

The Jewish Colonization Association, which in 1900 took on administrative responsibility for the Jewish agricultural villages, did not elicit esteem within the Yishuv, which perceived it as uninterested in the development of Jewish settlement in the country.

This perception was erroneous, for the work of the association was a continuation of that conducted by Baron Rothschild and his staff. Testimony lay in the fact that from 1900 onward, the I.C.A. acquired new lands in the Lower Galilee, and established new villages on them.

The person in charge of expanding settlement in this region was Hayim Kalvaryski-Margolis, who, unlike most of the other I.C.A. officials, was an avowed Zionist. Two villages were established in the Lower Galilee in late 1901 – Yavne'el (Yemma) and Kfar Tavor (Messha). Kalvaryski selected the start-up farmers carefully. Some of them were by then second-generation farmers, sons of the founders of the first Jewish villages. Three more villages were established in the region by 1904: Bet-Gan, near Yavne'el; Milhamiya (later Menahemiya); and Sejera (later Ilaniya), next to the farm Sejera started by immigrant workers there. The addition of five villages and a farm to the 20 villages existing in 1900 within the space of a few years constituted an important contribution to the Jewish settlement drive in the country. At the same time, the I.C.A. also established, Atlit, Giv'at Ada, and Kfar Saba. During the decade, it added Kinneret and Mitzpeh to the settlements in the Lower Galilee.

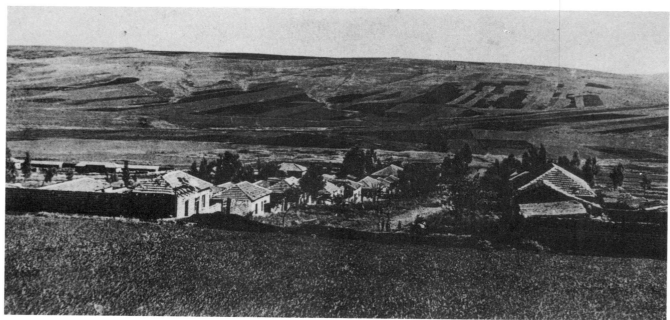

△ The village of Yavne'el (Yemma), "mother of the villages of the Lower Galilee," is founded by the I.C.A. in late 1901. Its settlers come from Metula, from the villages founded by the baron in Hauran and from several other agricultural villages established since the 1880s. The establishment of Yavne'el is to be followed by the founding of other Jewish villages in the Lower Galilee, not far from Tiberias.

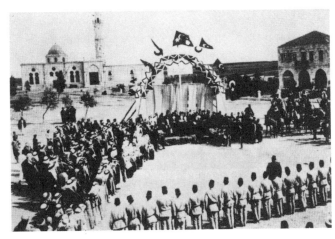

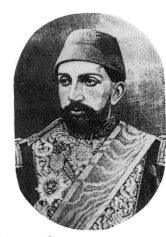

▷ Sultan Abd al-Hamid II, ruler of the Ottoman Empire, including Palestine.

▽ Herzl hopes to receive title to Palestine from the sultan. A meeting between the two in May 1901 is commemorated by a special edition of the Zionist weekly, *Die Welt*.

△ Beersheva, a new city in the Negev built by the Turks. Shown: the inauguration ceremony of the city.

▽ A guest at Beersheva's inauguration is the governor of Jerusalem, whose carriage is shown in the foreground.

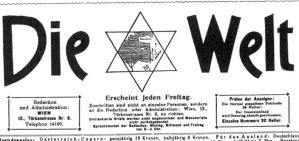

Extra-Ausgabe.

Die ✡ Welt

Erscheint jeden Freitag.

| Redaction und Administration: **WIEN** IX., Türkenstrasse Nr. 9. Telephon 14199. | Zuschriften sind nicht an einzelne Personen, sondern an die Redaction oder Administration: Wien, IX., Türkenstrasse Nr. 9, zu richten. Unfrankierte Briefe werden nicht angenommen und Manuscripte nicht zurückgesendet. Sprechstunden der Redaction: Montag, Mittwoch und Freitag von 3—4 Uhr. | Preise der Anzeigen: Die viermal gespaltene Petitzeile 36 Heller. Der Inseratentheil wird Dienstag abends geschlossen. Einzelne Nummern 30 Heller. |

Bezugspreise: Oesterreich-Ungarn: ganzjährig 12 Kronen, halbjährig 6 Kronen. Für das Ausland: Deutschland ganzjährig 13 Mk. 70 Pf., halbjährig 6 Mk. 85 Pf., England ganzjährig 14 Shg., halbjährig 7 Shg., Russland ganzjährig 7 R., halbjährig 3 R. 50 Kop., Schweiz, Frankreich, Italien, Türkei, Rumänien, Bulgarien, Serbien, Griechenland, Aegypten ganzjährig 17 Frcs., halbjährig 8 Frcs. 50 Cts., Amerika ganzjährig 3 Doll. 40 Cl.

Constantinopel, 17. Mai 1901.

Doctor Theodor Herzl, Präsident des zionistischen Actions-Comités, wurde heute von Sr. Majestät dem Sultan in längerer Audienz empfangen.

△ Hayim Kalvaryski-Margolis, a key figure in Jewish settlement at the start of the century.

◁ The winery at Rishon Lezion is the scene of a prolonged strike over the I.C.A.'s intention to lay off workers.

THE FOUNDING OF THE JEWISH NATIONAL FUND

The idea of establishing an active arm of the Zionist Organization for the purpose of land purchase in Palestine was broached as early as the first Zionist Congress in Basle (1897) by Prof. Zvi Herman Shapiro but was approved only at the fifth congress, in late 1901.

The goal of the J.N.F. was "to purchase, through donations from the people, land in Palestine that would be the property of the nation." The premise was that all such land would remain in the national domain, that they would be non-transferable to other parties, and that they would be leased for a period of 49 years (a jubilee) only. Financing for the earliest purchases in the Jordan Valley came from numerous small donations collected by means of the "blue box" that was to be found in many Jewish homes around the world, and by the sale of J.N.F. stamps and trees to be planted in Palestine.

▷ A poster by the artist Efraim Lilien prepared for the convening of the fifth Zionist Congress in Basle, during which the Jewish National Fund is established (December 1901). It reads: "The Fifth Zionist Congress in Basle, 5662. May Our Eyes Behold Your Return to Zion in Compassion."

▽ The Jewish Colonial Trust is the monetary arm, or bank, of the Zionist Organization. Herzl at first encounters difficulty raising sufficient sums to establish it, but by late 1901, £ 250,000 are collected, facilitating the founding of the bank. Shown: A founders' share.

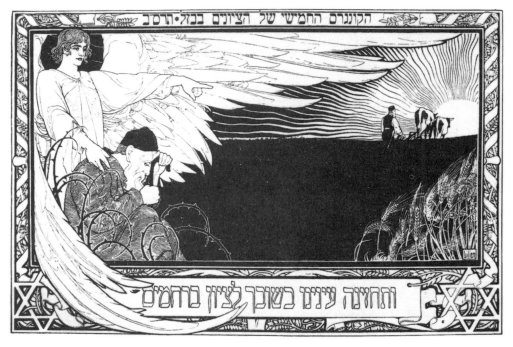

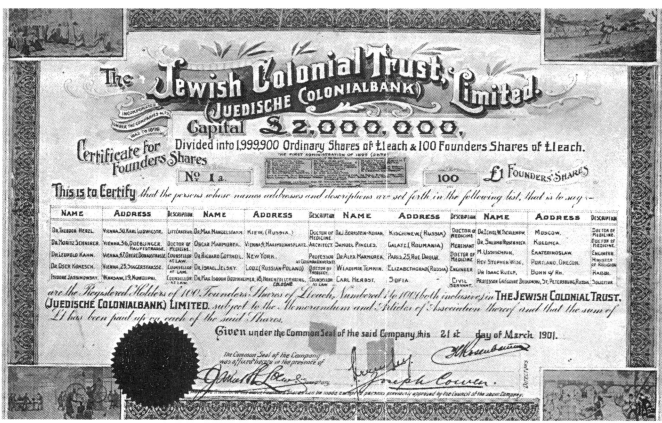

1902

January
The birth of the "red slip" – a three months residence permit established by the Turkish authorities to Jews arriving in the country in exchange for the deposit of their passport.
28 The opening of the Sha'arei Zedek hospital in Jerusalem under the

The new Sha'arei Zedek hospital building opens in Jerusalem.

directorship of Dr. Moshe Wallach. The hospital is built at the end of Jaffa Road far from the Old City walls.

February
Uthman Kazim Bey replaces Muhammad Jewad Bey as governor of Jerusalem.
26 The Anglo-Palestine Bank is founded in London. Today it is known as Bank Leumi of Israel.

March
5 The Mizrahi movement, a religious Zionist movement, is founded in Vilna under the leadership of Rabbi Isaac Jacob Reines.
21 The Committee of Zionist Societies in Eretz Israel

is founded in Rishon Lezion with the participation of delegates from Jaffa and the villages in its environs. Notification is sent to Herzl.

May
14 Herzl responds that the establishment of the Committee of Zionist Societies is

undesirable at that time (to avoid angering the Turks).
26 Trade union organization in Jerusalem: the print workers form a union after a similar attempt in 1896 had failed. They prepare a "Written Oath" which shall oblige every worker to join any strike declared by the union. One of the workers' demand is, among other things, the shortening of the work day to 10 hours.

June
A representative of the Hovevei Zion ("Lovers of Zion") movement, the agronomist Ya'akov Akiva Ettinger, arrives to observe the condition of the Jewish

The first grave in the new cemetery of Jaffa's Jewish community (today in central Tel-Aviv), dug in 1902. The deceased, Manishka Bromberg, dies in "the accursed year 5663."

villages. Touring the country for several weeks, he reaches optimistic conclusions.
19 Rabbi Naftali Herz Halevi, rabbi of the city of Jaffa, dies.

July
Herzl offers to liquidate the entire Ottoman national debt in return for a concession to "Haifa and its environs."

A general strike is called by the print workers of Jerusalem, who demand improved working conditions and better wages. The strike lasts three weeks, ending with the workers forced to discontinue their union activity, a factor that contributes to emigration.

October
Herzl's utopian novel, *Altneuland* ("Old-New Land"), about the future Jewish state as foreseen by the father of Zionism, is published in Vienna. It appears nearly simultaneously in a Hebrew translation, *Tel-Aviv*, by Nahum Sokolov.

A cholera epidemic spreads through the country. Jaffa is quarantined. Schools in Jerusalem are closed. The railroad stops running. The situation is difficult in Hebron and Tiberias as well.

The I.C.A. lays the foundations for a new village in the Lower Galilee – Sejera (later Ilaniya). Ten leaseholders from the adjoining farm are allotted 250 dunams (62.5 acres) each.

November
Jaffa physician Dr. Hillel Yoffe reports that 3,000 persons in Gaza have died of cholera in a total population of 15,000-20,000; 700 in Lydda in a population of 4,000; and nearly half the population of several Arab villages. The death toll in Jaffa is 300, nearly all Arabs; within the Jewish population, 22 have fallen ill (among them, Kalvaryski-Margolis, I.C.A. official) and 8 have died.
10 A new Jewish cemetery is opened outside Jaffa in order to bury the victims of the epidemic. It is located in the dunes far to the north (today, Trumpeldor Street in Tel-Aviv).

December
The I.C.A. establishes a new village, Menahemiya (at first known as Milhamiya), the first Jewish settlement in the Jordan Valley.

Heinrich August Meissner, a German engineer employed

Heinrich Meissner, "father of the Valley Railroad Line."

in railroad construction by the Ottoman Empire, begins the laying of the Dar'a-Haifa line (the Valley Line).

The first Jewish National Fund stamp is issued in 1902, imprinted with the word Zion and a Star of David. Sale of the stamps over many years enables the acquisition of land in Palestine and the initiation of afforestation. The J.N.F. "blue box" also emerges and will become one of the best-known symbols of Zionist activity.

◁ Like every self-respecting Jewish village in Palestine, Milhamiya, not far from Tiberias, has a bilingual seal in Hebrew and French.

▽ The first Jewish village in the Jordan Valley, Milhamiya, is founded in late 1902.

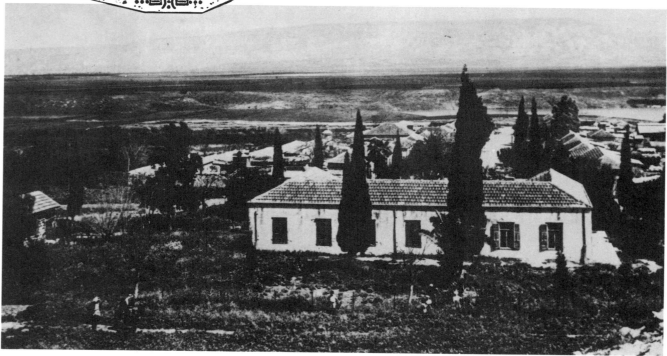

▽ Another village founded in the Lower Galilee is Sejera, established next to the farm of the same name that was started several years previously and served as the basis for Jewish settlement in the region. Ten farmers are allocated 250 dunams (62.5 acres) each. The young David Ben-Gurion will work at Sejera several years later.

THE BIRTH OF THE VALLEY (EMEK) RAILROAD LINE

Heinrich August Meissner, the German railroad engineer who was known as Meissner Pasha, began construction in 1900 of the ambitious railroad that would connect Damascus with the Muslim holy cities in the Arabian Peninsula, a distance of some 1,500 km, under contract with the Ottoman Sultan Abd al-Hamid II.

During the course of the work, Meissner came up with an additional idea: linking the long Hejaz Railway with the Mediterranean shore by means of a separate line to avoid dependence on the French-controlled Damascus-Beirut line and the Beirut port. Late in 1902 he began planning a 160-km line from Haifa in the west to Dar'a on the Hejaz Railway to the east.

The line was to bisect the Jezreel Valley, pass through the northern Bet-She'an Valley, descend to the Jordan rift, and climb along the length of the Yarmuk River to Dar'a in southern Syria. One of its railroad stations would be the lowest in the world, near today's Kibbutz Gesher, 173 m below sea level.

Construction was concluded by late 1905. The section that passed through western Palestine, mostly in the Jezreel Valley, was soon named the Valley Line by the Jewish population. Although infamous for its slowness, the line was operational until 1948 and in part even until 1952.

△ The Abarbanel Library acquires a new home in Jerusalem. An important cultural institution in the city, it will eventually grow into the National and University Library.

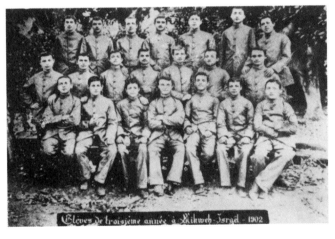

△ The 30th graduating class of the Mikveh Israel school – the first Jewish agricultural school in Palestine – has 21 pupils in 1902.

▷ Herzl, the versatile Zionist leader, publishes a utopian novel, *Altneuland*. He writes in his introduction, in his own hand (above): "If you desire it, it is no dream," which becomes the motto of the Zionist movement. At the far right, the Hebrew translation: *Tel-Aviv*.

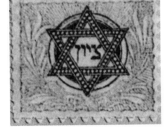

△ The first Jewish National Fund stamp. The word Zion appears at the center.

1903

January
8 The cholera epidemic ends. The quarantine is lifted from Jaffa and the first train in three months reaches Jerusalem.

March
A commission of experts sets out for Sinai at Herzl's initiative to examine the possibilities for large-scale Jewish settlement in the peninsula (the al-Arish Project). The commission's opinion is favorable but the project is discontinued as a result of the opposition of the British, who rule Egypt.

Eliezer Ben-Yehuda enters into partnership with the publisher Shlomo Israel Shirizli. The latter becomes responsible for financing and distributing Ben-Yehuda's weekly, *Hashkafah* ("Outlook").

30 A strong earthquake takes place in Jerusalem, although there are no reports of injuries.

In light of the recent cholera epidemic, no tourists arrive for the Passover holiday, as was customary.

Dr. Hillel Yoffe, a member of the al-Arish Commission, at Wadi al-Arish.

April
19 The Kishinev pogrom starts. Dozens of Jews are murdered, hundreds are wounded, and Jewish property is pillaged. In its aftermath, the poet Hayim Nahman Bialik writes the epic, *In the City of Slaughter*. The pogrom shocks the Jewish world and heightens Jewish emigration from Russia, including to Palestine.

The first parcel of land in Palestine is acquired by the Jewish National Fund. The noted philanthropist Isaac Leib Goldberg of Vilna transfers ownership of 200 dunams (50 acres) in the village of Hadera to the new national fund.

May
3 In Jaffa, immigrants from Yemen found the Pe'ulat Sakhir ("Employee's Activity") association, with the intention of starting an agricultural settlement. The project fails, but they find work in other Jewish villages.

July
26 The first branch of the Anglo-Palestine Bank – the Zionist bank – opens in Jaffa. Its manager is Zalman David Levontin, one of the founders of Rishon Lezion, who had returned to his native Russia and arrived back in Palestine in June 1903.

August
4 In Jerusalem, the Lemel school inaugurates a new building with the presence of mayors and Jewish elders, representatives of different religious communities and the consuls of Austria, Germany and England. Included in the school's curriculum are music and drawing lessons, as well as gymnastics.

23 The sixth Zionist Congress – the "Uganda Congress" – opens in Basle. It is the site of bitter confrontations between Herzl and his supporters, on one side, and the Zionists of Zion, who reject the plan for settlement in Uganda out of hand, on the other.

The First Assembly of representatives of the Jewish Yishuv in Palestine takes place in Zikhron Ya'akov with 67 delegates. The dominant figure of the event is Zionist leader Menahem Ussishkin, who achieves passage of a decision to reject the Uganda Plan. The assembly establishes the Palestinian Federation.

26-28 Following the First Assembly, the founding conference of the Hebrew Teachers Association is held in Zikhron Ya'akov, marking the establishment of the first trade union in the country.

September
11 A pogrom breaks out in the city of Gomel in Belorussia. For the first time, Jewish self-defense is organized.

October
Herzl opposes the activity of the Palestinian Federation and it dies out.

14 A new village is established south of Zikhron Ya'akov, Giv'at Ada, settled by second-generation farmers from nearby villages.

November
11 The first large area of land is acquired by the Jewish National Fund – the Dalayika lands – Um Juni in the Jordan Valley.

23 The "Gomel Group" immigrates to the country. It includes some of the Jewish defenders during the pogrom. The Second Aliyah begins.

December
A group of 37 orphans of the Kishinev pogrom is brought to the country by educator Israel Belkind. He wants to establish a youth village for them in Bet-Arif (near Ben-Shemen).

Caricature of Herzl the "giant." He attains new heights in 1903, but also encounters bitter resistance to his Uganda Plan.

Bedouin sheikhs from the Negev propose a Jewish-Bedouin alliance to Herzl for the purpose of conquering Palestine from the Turks.

Settlement of Atlit begins. Only in 1909 will it be a permanent settlement.

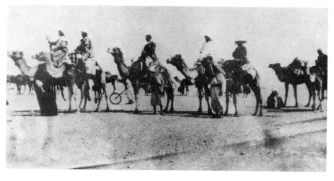

The al-Arish Commission touring the Sinai Desert on camelback.

▷ Members of the al-Arish Commission to the Sinai Peninsula. L. to r.: (seated on floor) Col. Oliver Goldsmith, Brit. Army; (seated above him) Zelig Soskin, agronomist; Leopold Kessler, mining engineer, head of the commission; (seated on floor) Henry Stephens, civil engineer; (at r.) Dr. Hillel Yoffe, physician.

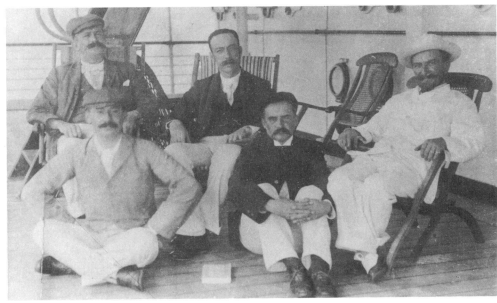

▽ The German-language Zionist weekly, *Die Welt*, publishes the British government's declaration on the allocation of a "Jewish territory" in West Africa (the Uganda Plan).

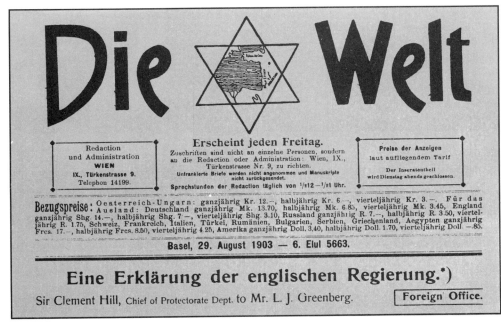

△ Dr. Yosef Levy, director of the Anglo-Palestine Bank in Jerusalem.

▽ The Templer village of Wilhelma, founded south of Petah Tikva in 1903.

THE BEGINNINGS OF THE SECOND ALIYAH

The Kishinev pogrom in the spring of 1903, the sixth Zionist Congress (the "Uganda Congress") in August of that year, and the pogrom in the town of Gomel in September all evoked widespread agitation throughout the major centers of Jewish population in Eastern Europe. The distress of the Jews, along with protest against Dr. Herzl's "treason" toward Eretz Israel by his preference for the territorial solution of Uganda, led some young Jews to resume immigration to Palestine, which had ceased for several years. Moshe Smilansky, the poet farmer from the village of Rehovot, wrote in the Warsaw newspaper *Hazofeh* ("The Observer"), in November 1903:

"We see new faces of late. Several young people have come to seek work in Eretz Israel and to live by their labor. During the last few years we had become accustomed to receiving only 'guests' – people who came and left again. Now, after a long pause, people who want to be 'citizens' are coming."

The first immigrants of the Second Aliyah are considered to be those from the town of Gomel, which included members of the town's self-defense body, who arrived toward the end of 1903. The stream of immigration grew in 1904.

▽ The presidium of the First Assembly. Seated at the center: the rising Zionist leader Menahem Ussishkin, who calls upon the Yishuv to oppose the Uganda Plan.

▷ The First Assembly convenes in Zikhron Ya'akov in August 1903 with 67 delegates. The list of delegates shows that while such villages as Sejera, Metula and Rehovot had two delegates each, only one came from the tiny settlement of Haifa.

רשימת הצירים שבאו להכנסיה הראשונה
לבני ישראל בארץ ישראל

צפת	35 שמעון לוין	יפו	1 שמעון רוקח
"	36 יוסף קיזרמן	"	2 משה שינברג
ראש פנה	37 דוד שוב	"	3 בצלאל לאפין
"	38 ש' וילקומיץ	"	4 יעקב גולדמן
"	39 יהודה ענתבי	"	5 שמואל מויאל
"	40 זלמן בנדל	"	6 יחזקאל סוכוואלסקי
יסוד המעלה	41 אפרים פישל סלומן	"	7 דוד חיים
מטולה	42 אריה קורנפלד	ראשון-לציון	8 מ' פריימן
"	43 אהרן אהרנזון	"	9 ברוך ספירמיסטר
סג'רה	44 שלמה ויינשטיין	"	10 מנשה מאירוביץ
"	45 צבי שכטר	ודי-חנין	11 אפרים קומורוב
מסחה	46 דוד כהן	"	12 ירושבסקי
יבנאל	47 יחיאל בערקוביץ	קוסטני	13 אליהו איזרליט
ארטוף	48 יהושע איגנשטט	פתח-תקוה	14 יהושע שטמפר
מיצא	49 יחיאל מיכל פינס	"	15 משה סלור
ירושלים	50 הר' נחמן בטיטו	"	16 זלמן ניסן
"	51 הר' מרדכי שריולי	"	17 מרדכי סלומן
"	52 דוד ילין	"	18 יעקב שאבעוויץ
"	53 א' בן יהודה	נדרה	19 מרדכי ניסן
"	54 חיים מיכל מיכלין	עקרון	20 משה סמילנסקי
"	55 יצחק עדס	רחובות	21 אהרן איזנברג
"	56 ח' לניאדו	"	22 יצחק הנקין
"	57 יח מרנובסקי	זכרון-יעקב	23 ד"ר נפתלי וייץ
"	58 יחיאל צבי צימרינסקי	"	24 ד"ר הלל יפה
"	59 ישאול לוי	"	25 חיים דוד שו"ב
"	60 ליבוש קופרשמיד	"	26 שבתי לוי
"	61 אברהם בלומנפלד	"	27 מתתיהו המשיד
"	62 רפאל חיים כהן	"	28 לופו ניסן
"	63 סימן-טוב אמין	"	29 שמעון פרידמן
"	64 שלום אלשיך	חיפה	30 חיים מרגלית קלווריסקי
"	65 אח נדאף	טבריה	31 יהושע חנקין
"	66 אלכסנדר לונזון	"	32 מיכאל אראניאס
"	67 אברהם איסר הירשנזון	"	33 זלמן ברזל
		צפת	34 נחמן עבו

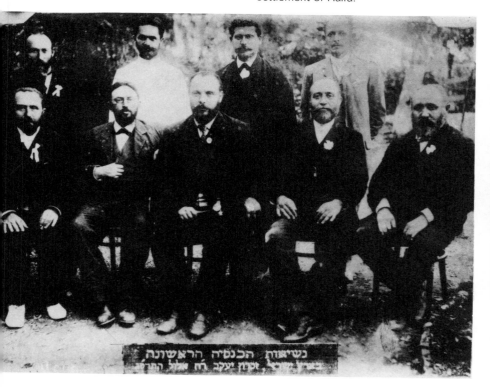

נשיאות הכנסיה הראשונה
בארץ שיכר, זכרון יעקב, בת אמל התניה

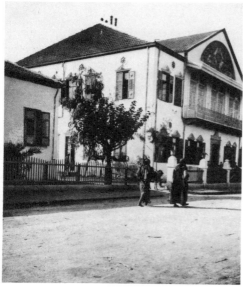

△ The Jewish Colonization Association building in Zikhron Ya'akov, site of the First Assembly sessions.

△ A first in the country: A Zionist bank, the Anglo-Palestine Bank (later, Bank Leumi). The first branch opens in Jaffa in 1903.

▷ Notice for a memorial prayer for the victims of the Kishinev pogrom.

הזכרת לנפשות
המומתים שבקישנוב

ביום ג' כ"ט אייר דנא בשעה

העשירית לפנות ערב

△ Zalman David Levontin, a noted early First Aliyah pioneer, returns to Palestine in 1903 and establishes the Anglo-Palestine Bank.

▷ A group of 37 youngsters orphaned in Kishinev are brought to Palestine by Bilu leader and educator Israel Belkind. They are shown dressed in the local garb of the time. Belkind establishes a youth village for them in Bet-Arif.

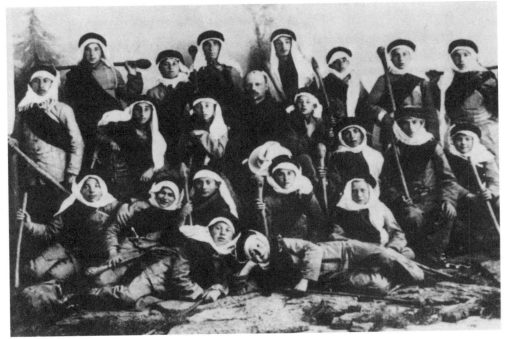

1904

January

Another new village is founded in the Lower Galilee – Bet-Gan – near Yavne'el. Some of its settlers are Jewish converts who immigrated from Russia.

14 Meissner Pasha completes construction of the Haifa-Bet-She'an railroad line.

February

7 The first Zionist Organization research expedition departs to explore Palestine and Transjordan for potential settlement sites, headed by a German geologist, Max Blanckenhorn, and the young Yishuv agronomist, Aharon Aaronsohn. Other expeditions will follow in the coming years.

27 Aharon David Gordon, one of the most prominent figures of the Second Aliyah, arrives in the country. At age 48, he is far older than most of the pioneer immigrants.

March

Israel Shohat, 17, arrives in Palestine. He will lay the foundations for the Bar-Giora and Hashomer Jewish self-defense organizations.

April

The Zionist Executive, led by Herzl, approves the proposal put forward by the Palestine Committee to collect contributions in the Jewish world for the purpose of planting olive groves in Palestine.

A fist fight breaks out in Jaffa between a merchant, Moritz Sheinberg, and the head of the Hovevei Zion Committee, Dr. Hillel Yoffe, who is injured. All the Jewish institutions in Jaffa shun Sheinberg.

May

13 A new rabbi arrives in Jaffa – Avraham Itzhak

Hacohen Kook – who chooses to fill the position of rabbi and head of the religious court of Jaffa and the villages, i. e., the new Yishuv. Rabbi Kook decides to establish his residence in the Neveh Zedek neighborhood north of Jaffa. He replaces Rabbi Naftali Herz Halevi, who died in 1902.

27 The Valley Railroad Line reaches Jissar al-Majama (today Gesher) at the Jordan River.

June

21 Agreement is reached between the Jewish Colonization Association and the village of Petah Tikva regarding the lands of Kfar Saba, marking the start of the establishment of Kfar Saba as a separate village.

The Ottoman government prohibits the sale of land to foreign subjects, especially Jews. In practice, the prohibition is circumvented by means of *baksheesh* (bribes).

July

3 (20 Tamuz 5664) Theodor Herzl, founder of the Zionist movement, dies in Austria at age 44. The entire Jewish people, and the small Yishuv in Palestine, are grief-stricken.

August

A new governor for Jerusalem is appointed – Ahmed Rashid Bey – replacing Uthman Kazim Bey.

8 The Anglo-Palestine Bank opens a second branch, in Jerusalem. Two flags fly on the facade of the building – the Ottoman and the British.

The Ge'ula company for land purchase in Palestine is founded in Warsaw.

The Tavor company, a Hebrew travel center in Palestine and abroad, opens in Jerusalem under the management of Messrs. Amdursky

and Greivsky. The company promises to care for incoming and outgoing tourists, debarkation from ships, etc.

October

The village of Rishon Lezion is up in arms over an article in *Hazfira* in Warsaw criticizing life in their village as reflected by the local orchestra. In the writer's view, the orchestra performs frequently "because the young people have no other work except to put on concerts."

The Second Aliyah gathers momentum during the course of the year. New immigrants include Eliezer Shohat (brother of Israel, later a prominent labor leader), Alexander Zeid (later a founder of Hashomer) and Shlomo Zemah (later a writer, editor and critic).

The debate in Palestine between the Zionists of Zion and the Uganda Zionists intensifies, with the latter prepared to leave the country in order to establish a Jewish state in East Africa. Leading this group is Eliezer Ben-Yehuda.

Report cards with Hebrew nomenclature. Below, from the

The biggest and saddest event of the year is the death of Dr. Theodor Herzl. The grief in Palestine is reflected in several issues of *Hashkafah* ("Outlook"), Ben-Yehuda's newspaper. In the copy above, the name Theodor is replaced by Mattatiyahu, which means in Hebrew: "granted by God". The whole newspaper appears with a black frame.

Rishon Lezion school. To the far right (p. 27), from the Rehovot religious school.

▷ A number of immigrants of the Second Aliyah who are later to become prominent arrive in 1904, including Aharon David Gordon (below, r.) and Israel Shohat, photographed to the right of Mendel Portugali, another founder of Hashomer.

△ Another immigrant in 1904 – Rabbi Kook, at age 44.
▽ Announcement of the arrival of Rabbi Kook in Jaffa. It begins: A Sage Has Arrived in the City!

▷ The Anglo-Palestine Bank expands in 1904 and opens a second branch, in Jerusalem. It is located in the building of the Austrian consulate.

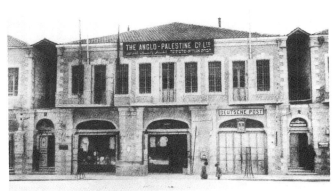

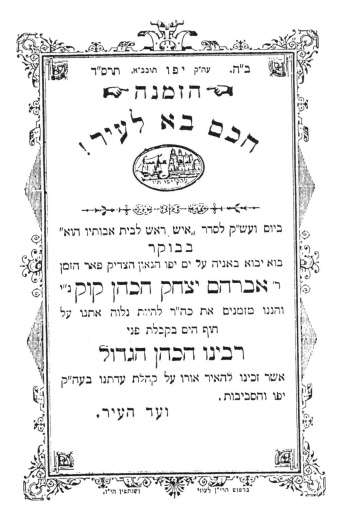

△ The No. 1 Ugandist in Palestine, Eliezer Ben-Yehuda, lexicographer and editor of *Hashkafah* ("Outlook").

▽ An appeal by Hemda Ben-Yehuda that the women of the Yishuv mark Herzl's death by wearing black.

THE UGANDA ISSUE IN PALESTINE

In the summer of 1903, when it became clear to Herzl that there was no chance of receiving a charter for Palestine from the Ottomans, and when at that very time a pogrom had occurred in Kishinev and Jewish emigration from Eastern Europe was intensifying, he proposed to the sixth Zionist Congress to give priority to the Uganda option over Palestine, at least temporarily. The Zionist movement faced a split. Part of it supported Herzl, both because of the force of his personality and because the situation of the Jews in Europe was so grave that any political solution, even in Africa, deserved consideration. Part of the movement, however, rejected out of hand any national solution outside Palestine.

The small Jewish Yishuv in Palestine was in turmoil over the issue as well. The majority followed Herzl and were prepared to leave and go to Uganda (the area in question actually lay in today's Kenya and not Uganda). Relatively few, terming themselves Zionists of Zion, denounced Ugandism. The outstanding local Ugandist was none other than Eliezer Ben-Yehuda, reviver of the Hebrew language.

One of the centers of Ugandism in the country was the village of Rishon Lezion. A founding father there, Aharon Freiman, published an appeal for the Uganda Plan, claiming that the determining consideration was land and arguing that if the Jewish people was offered territory in Africa, it must take it. Ultimately, the Uganda affair receded. Herzl died; the seventh Zionist Congress removed the proposal from its agenda; and Ben-Yehuda, too, ceased advocating it in light of information that the territory was unsuitable for settlement and concentrated on compiling his monumental Hebrew-language dictionary.

הַאֲפָנָה.

אין אני צריכה לאמר לקוראותי, כי אפנה זו שחורה כשחור
מעמדנו, באותו יום שהגיענו השמועה המחרידה, כי הרצל
אֵינֶנּוּ — נשים ועלמות צעירות לכשו אבלות עמוקה. אל תשאלנה
אחיותי: כמה? האם נעזר בזה? כשהלב נשבר ושותת דם יאות כי
יהיה הגוף עטוף שחור, אז נדמה כאלו העולם חשך כלו—והוקל לנו.
נסינה אחיותי, ללבוש אבל ותמצאינה בזה קצת תנחומים, בלי ספק.
אבלות—זו האפנה שלנו בימים העצובים האלה, אבלות בתלבשתנו,
אבלות בביתנו ובחיינו.

ראיתי בחורים כותבים את מכתביהם על ניר מֻזֶּקֶף שחור, שטעתי
ילדה קטנה בת חמש מכקשת מאמה לקשור שערותיה בעניבה שחורה
ולא בורדה הורדה מפני — שמת הרצל! כמה זה נוגע כנפש!..
 חב"י

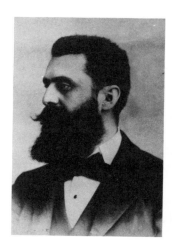

△ Theodor Herzl, founder of the Zionist Organization. He is only 44 years old when he dies in 1904.

▷ Thousands of Jews take part in Herzl's funeral procession in Vienna.

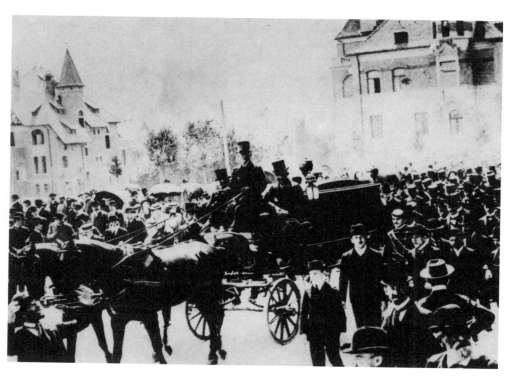

January

The first Russian revolution. In its wake, a wave of anti-Jewish persecution.

March

Publication of Yosef Vitkin's pamphlet *Kol Koreh* ("A Call"), an appeal to young Jews in Eastern Europe to settle in Eretz Israel. It is regarded as one of the important influences on the immigration of young people to the country.

22 A group of amateur actors present Karl Gutzkow's play *Uriel Acosta* in Jaffa before an audience of 600. One of the actors, Menahem Gnessin, will later join the Habimah Theater.

August

The seventh Zionist Congress, convened in Basle, rejects the Uganda Plan conclusively. The plenum accepts with acclaim Otto Warburg's proposal to name the newly planted olive groves in Palestine the Herzl Forest.

September

A former immigrant returns: Meir Dizengoff, who had lived and worked in the country in the early 1890s, and will later become the first mayor of Tel-Aviv. He heads the Ge'ula company, which purchases land in Palestine for Jewish investors abroad, especially in Russia.

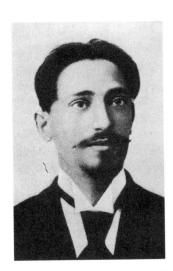

Yosef Vitkin, author of the noted *Kol Koreh.*

October

15 The first run of the Haifa-Dar'a railroad line. The directorship of the Hejaz Railway is transferred to Haifa, engendering significant development of that small town.

21 The first political party is founded in Petah Tikva – the labor movement's Hapo'el Hatza'ir ("Young Worker").

22 The beginning of secondary school education in the country. A Hebrew gymnasium (later Gymnasia Herzliya) is opened in Jaffa under the direction of Dr. Yehuda Leib Metmann-Cohen. It is the first Hebrew

Dr. Hayim Hisin assumes the post of representative of the Hovevei Zion movement in the country in 1905.

high school in the world. Within a few years, similar schools will open in Jerusalem and Haifa.

31 (18 October according to the old Russian calendar) The October pogroms in Russia. Over 1,000 Jews are murdered in dozens of cities and towns. Manifestations of Jewish self-defense. The pogroms motivate Jewish emigration from Russia.

November

The second labor party, Po'alei Zion ("Workers of Zion") is founded, opening branches throughout the country. News of the pogroms in Russia causes agitation throughout the country. Reports circulate that about 100 towns and cities have been attacked. Memorial

services are held in most towns and villages in the Yishuv.

December

25 The newspaper *Hashkafah* ("Outlook") reports, under the heading "And Beauty and Art Shall Go Forth From Zion," that the Bezalel School of Art, under the directorship of Prof. Boris Schatz, will be established soon in Jerusalem.

Work on the enlargement of the small port of Haifa is conducted during 1905, prompted mainly by the need to unload equipment for the Haifa-Dar'a railroad line.

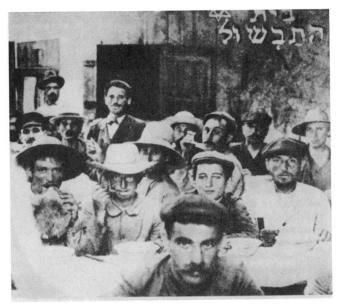

The Second Aliyah streams into the country, becoming a large flow by 1905. Some of the pioneers are drawn to Petah Tikva, where they find work in agriculture. Here, the first workers' kitchen is established for them.

The first workers' residence in Petah Tikva. Hundreds of men and women pioneers live in Petah Tikva, as in several other villages.

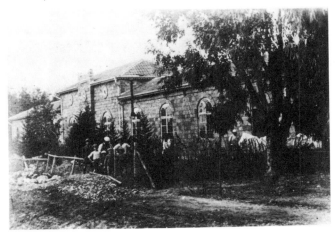

29

THE ESTABLISHMENT OF THE GYMNASIA HERZLIYA

The first Hebrew high school in the world was founded in Jaffa in October 1905 with an enrollment of 17 pupils. Called at first the Hebrew Gymnasium of Jaffa, it was later renamed Gymnasia Herzliya. Its founder and first principal was Dr. Yehuda Leib Metmann-Cohen, assisted by his wife, Fania. The first announcement to parents of the opening of the "middle school," also called the "gymnasial school," was affixed to the walls of buildings in Jaffa on October 13, 1905, as shown below.

After a modest start, when the viability of the institution was in some doubt, Metmann-Cohen overcame initial difficulties and recruited quality teachers such as Dr. Hayim Bograshov and Dr. Ben-Zion Mossinson, and the school's reputation spread far and wide.

In 1909, a new building was planned for the school, in Ahuzat Bayit – the new Jewish neighborhood north of Jaffa.

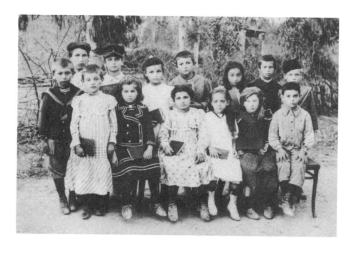

△ Yehuda Leib Metmann-Cohen at first attempts to establish a school in Rishon Lezion, whose pupils are shown above.

◁ Symbol of the Ge'ula company, which purchases land for Jewish settlement.

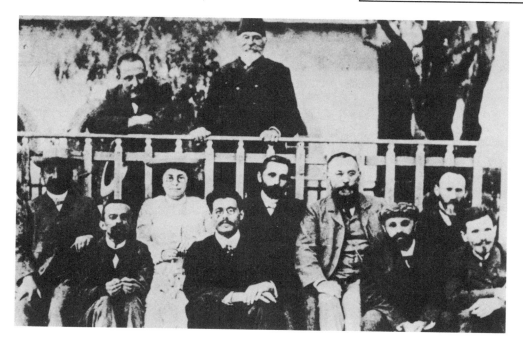

◁ The decision to establish a gymnasium is adopted at a conference in Jerusalem. Metmann-Cohen is seated at center (and in picture above), his wife Fania (to his r.), and Z.D. Levontin (4th from r.).

▽ Detail on the monument showing the 0-4-2 engine, then in use.

▷ 1905 is an important year in the railroad annals of Palestine, with the opening of the Haifa-Dar'a line. A commemorative monument is erected in Haifa in honor of the occasion.

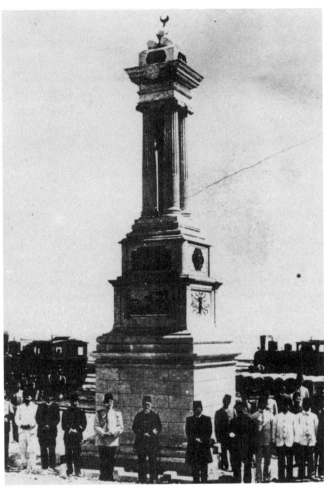

▽ The train at Fula, later the town of Afula, in the center of the Jezreel Valley. The laying of the line, a branch of the Hejaz Railway, constitutes a major challenge for the Ottoman government, which is anxious to demonstrate that not only great powers such as England, France and Germany are capable of laying railroad track in the Ottoman Empire.

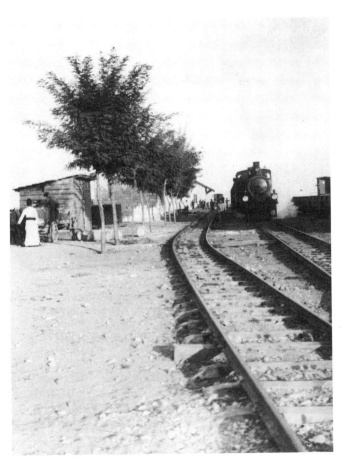

VITKIN'S *KOL KOREH* ("A CALL")

Yosef Vitkin was born in Russia in 1876 and immigrated to Palestine in 1897, where he was employed as a teacher. His name became widely known both in the Yishuv and the Diaspora in early 1905 when, while teaching in the village of Kfar Tavor, he published "A Call to the Young People of Israel Whose Hearts are with their People and Zion," which is thought to have had an important impact on the pioneers of the Second Aliyah.

In it he called upon the youth of the Diaspora to come to Palestine and rescue the faltering settlement movement there. Citing the challenges and difficulties involved, including disease and danger, he appealed to them to prove to themselves that these could be overcome. Not everyone, he explained, was suitable for this task. "We shall choose the people's soldiers from the most exceptional...," and these would be trained in groups and would come to Palestine to work and to establish new villages, with no assistance or support. His pamphlet concluded with an emotional appeal: "Make haste and come, heroes of Israel, renew the days of the Bilu pioneers with vigor, for soon we will be lost."

1906

January

Prof. Boris Schatz and artists Lilien and Rothschild arrive in Jerusalem for the opening of the Bezalel School of Art.

February

1 Founding of the Cooperative Association of Vineyardists. Baron Edmond de Rothschild hands over the wineries of Rishon Lezion and Zikhron Ya'akov to the association.

12 The farmers of Petah Tikva announce a boycott of the Jewish workers and force them to leave the village.

25 Prof. Boris Schatz opens enrollment at the Bezalel School of Art.

The governor of Jerusalem, Sa'dat Pasha, organizes horse races in the city.

Nahum Wilbush opens a factory for extracting edible oil from olive waste at Hadid (later, Ben-Shemen).

March

1 The Bezalel School of Art opens. It has two departments at the first stage, one for art and one for crafts.

Rental prices of housing in Jaffa have soared by 50% in one year as a result of growing Jewish immigration.

Menahem Sheinkin

April

The last remaining workers in Petah Tikva leave the village demonstratively.

May

The Bezalel School of Art opens another department, for rug weaving.

25 The Stein metal factory in Jaffa, then the largest industrial factory in the country then, becomes a shareholding company: L. Stein and Partners – Industrial Company.

July

5 Jewish residents in Jaffa, meeting in the local Yeshurun Club, decide to form an association – Ahuzat Bayit – for the establishment of a Jewish neighborhood outside the built-up district of Jaffa, thus marking the start of Tel-Aviv's history.

21 Rabbi Ya'akov Shaul Elyashar, (the Hakham Bashi or chief rabbi of the country under Ottoman law, also designated by the title Rishon Lezion) dies in Jerusalem. His death is the start of a prolonged struggle over his successor.

August

7 The governor of Jerusalem, Rashid Pasha, appoints Rabbi Suleiman Mani as temporary Hakham Bashi until a permanent choice is made.

A group of armed Jewish watchmen, led by Israel Shohat, assumes responsibility for the guarding of part of the vineyards in Zikhron Ya'akov – a breakthrough in the field of Jewish self-defense.

The Jewish workers return to Petah Tikva.

The Anglo-Palestine Company Bank opens its third branch, in Beirut.

September

1 The 30th anniversary of the reign of Sultan Abd al-Hamid II is commemorated in the cities of Palestine.

7 A 20-year-old immigrant, David Gruen (later, Ben-Gurion), arrives at the Jaffa shore, making his way on foot to Petah Tikva that same day.

10 Elections in Jerusalem for the position of Hakham Bashi. The 80-member Sephardi General Council chooses Rabbi Ya'akov Meir by a vote of 71 to 4. The appointment ceremony is held on 25 September in the Yohanan Ben-Zakai Synagogue in the Jewish Quarter of the Old City.

October

1 Following months of tension verging on war, a border agreement is signed between Egypt (in effect, Britain) and Turkey regarding border delineation from Rafah to the Gulf of Aqaba (Taba).

4-6 A study conference held by the Po'alei Zion party, attended by 70 participants, appoints a 10-member committee to draw up its platform. Chairman of the committee is David Ben-Gurion.

4-10 The Helsingfors (Helsinki) Conference of Russian Zionists adopts, in

First page of the pamphlet issued by L. Stein and Partners.

addition to the goal of creating a Jewish nation in Eretz Israel, a resolution to "work in the present," i.e., a recognition of the existence of the Diaspora, which arouses criticism within the Zionist movement.

8 Po'alei Zion's platform committee, secluding itself at an Arab inn in Ramleh, formulates a socialist-Zionist credo named the Ramleh Platform.

Furor in Jerusalem over a challenge by part of the Sephardi leadership to the choice of Rabbi Ya'akov Meir as Hakham Bashi. Appeals to the Ottoman government in Istanbul and to the Hakham Bashi of the Ottoman Empire, Rabbi Moshe Levi, to disqualify the appointment result in the latter instructing Rabbi Meir to step down.

A new export good: Jordan waters shipped to America for Christian religious use. The water is transported in large barrels to Jaffa port.

November

The Lovers of the Stage association mount Yevgeni Chirikov's play, *The Jews in Jaffa*. Leading roles are played by Menaham Gnessin and Rivka Fefer. The play is also presented in Jerusalem, where it is banned by the rabbis.

December

Ali Akram Bey replaces Ahmed Rashid Bey as governor of Jerusalem. Rashid was considered a friend of the Jews.

Nahum Wilbush opens a second edible-oil factory, Atid, in Haifa near the sea. Later, the large Shemen concern will be established there.

First general meeting of the Vineyardists Association. Encouraging reports on its profitability.

Immigrants begin to arrive from Asiatic Russia, called "Mountain Jews."

Immigration increases during the year following the pogroms in Russia. The newcomers include some of the First Aliyah immigrants who had since returned to Russia.

Aharon Aaronsohn, the agronomist, discovers wild Emmer wheat – the "mother of wheat" – in the Galilee.

An information office sponsored by the Hovevei Zion ("Lovers of Zion") movement opens in Jaffa to supply information to Jews planning to come to Palestine and assist new arrivals. It is headed by Menahem Sheinkin.

נפתחה מחלקה חדשה

ב..בצלאל"

מתקבלות תלמידות מבנות י"ב שנים ומעלה
ללמוד מלאכת ה"סריגין" (שפיצען, דאנטילה).

תנאי העבודה והשכר כמו במחלקת השטיחים.

היתרון למדברות עברית

מיד אחרי חג השבועות יתחילו להרשם.

התחלת הלימוד ביום הראשון י"ב סיון

המנהל: פרופ' בוריס ש"ץ.

△ The Bezalel School of Art opens in 1906, an unusual educational institution in the Jerusalem of the early 20th century, still functioning today. The city's religious population opposes the opening of the school.

△ An announcement of the opening of a knitting department in the Bezalel School of Art promises priority to Hebrew-speaking girls.

▽ Prof. Boris Schatz, founder and director of the Bezalel School of Art, wears the decorations awarded him in the field of art.

△ Besides expanding the new Yishuv, the Second Aliyah brings thousands of Jews to Jerusalem from dozens of Diasporas. Shown above: Four children from Bukhara, who arrived in 1906.

THE ESTABLISHMENT OF AHUZAT BAYIT ("HOME PROPERTY") – TEL-AVIV

"On 13 Tamuz 5666 (5 July 1906) I went with my neighbor, Mr. David Smilansky, to a public meeting that took place in the Yeshurun Club. At that meeting, I proposed the construction of an entirely Hebrew city before an audience of 120 persons. For a start, I suggested to build a modest 40 to 50 homes."

This account is from the memoirs of Akiva Aryeh Weiss, a watchmaker from Lodz, Poland, who had visited Palestine in 1904 and returned as a settler on the very day of the meeting. That evening, participating in the gathering, which was attended by many of the Jews of Jaffa, Weiss proposed establishing a modern Jewish neighborhood outside the city to be called Ahuzat Bayit, later Tel-Aviv.

Matters moved along, and several dozen Jaffa residents joined Weiss, depositing sums in a bank as a down payment for property in the new neighborhood.

Years later, they received a large loan from the Jewish National Fund, which came to their aid on the recommendation of Dr. Ruppin.

Retrospectively, quite a number of individuals claimed to have been the originators of the idea, including Meir Dizengoff, David Smilansky and Yosef Eliyahu Chelouche. As far as can be ascertained, however, credit belongs to Weiss, the moving spirit of Ahuzat Bayit during its early years and the person who organized the lottery to distribute properties in April 1909.

▷ The Yeshurun Club in Jaffa meets on the third floor of this building, not far from the railway station, where the decision is made in July 1906 to found what is later to become the city of Tel-Aviv.

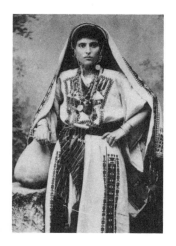

◁ The initiator of Ahuzat Bayit, Akiva Aryeh Weiss.

▷ Moshe Sokhovolsky of Jaffa, and a girl named Miriam (above), photographed by Krikorian, an Armenian photographer, in 1906.

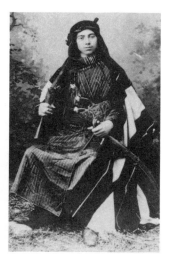

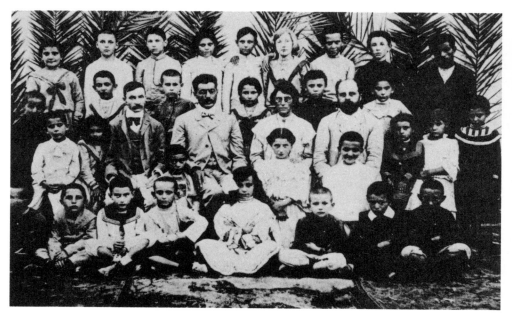

◁ The Hebrew Gymnasium of Jaffa, which opens with only a small group of pupils in late 1905, has nearly 30 pupils by the spring of 1906. Center: Principal Yehuda Leib Metmann-Cohen and his wife, Fania, a teacher.

▽ The export of Jordan waters seems a promising idea in 1906. R.: Filling barrels with water at the Jordan. L.: Transporting the barrels from Jericho to Jerusalem, where they are forwarded to the U.S. After a while, it becomes apparent that the venture is unprofitable and it is discontinued.

▷ A new immigrant, David Gruen (later Ben-Gurion), photographed in Warsaw (r.) with a friend before his departure. On the day he arrives, he sends a postcard to his father in Plonsk, Poland, which begins (above): "Hurrah! Today at 9 a.m. I alighted on the shore of Jaffa!"

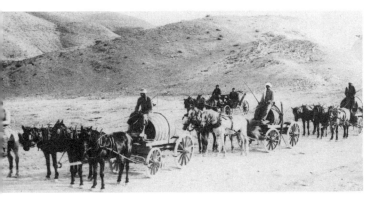

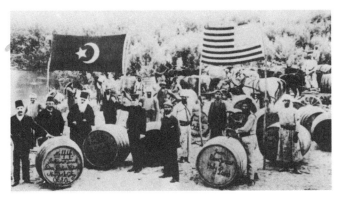

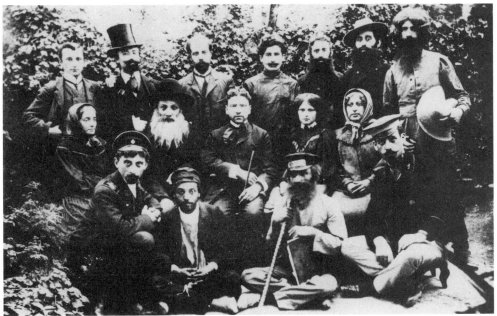

◁ There is theater, too, in 1906. The Lovers of the Stage association of Jaffa mounts its first play, *The Jews*, by Yevgeni Chirikov, on a current theme: the persecution of Jews in Russia. Most of the actors are amateurs. One, however, Menahem Gnessin (standing far l.), will become a noted actor in the Habimah Theater. Highly successful, the play then opens in Jerusalem, but is immediately banned by the rabbis and Turkish police close it down during its first performance.

1907

January

5-10 A conference of the Po'alei Zion party is held in Jaffa. It approves the Ramleh Platform.

10 A distinguished guest arrives in the country – David Wolffsohn, president of the Zionist Organization.

February

The management of the Stein metal factory in Jaffa announces that shareholder profits for 1906 will reach 25%. The company employs over 60 Jewish workers.

Following Wolffsohn's visit, the Palestine Council is established as a representative body of the new Yishuv. Dr. Hayim Hisin is elected chairman.

March

The workers at the Rishon Lezion winery declare a strike as a result of the layoff of six workers. One of the organizers is David Gruen (Ben-Gurion).

24 Chief Rabbi Moshe Levi of Istanbul appoints Rabbi Eliyahu Moshe Panigel temporary Hakham Bashi in Jerusalem. The storm over the permanent appointment

Announcement of the arrival of Rabbi Panigel, the new Hakham Bashi, in Jerusalem. His appointment, too, is only temporary.

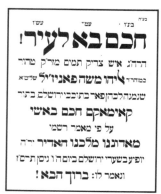

continues in Jerusalem. Rabbi Panigel postpones elections for it repeatedly.

A new Hebrew periodical, *Ha'omer* ("The Sheaf"), appears, edited by S. Ben-Zion. It is the first newspaper published in Jaffa.

April

Itzhak Ben-Zvi, later to become president of the State of Israel, immigrates to the country.

15 The Jerusalem Printers Association is reestablished for the third time by six workers representing five printshops.

The articles of association of the London-based Jewish National Fund are approved by the British government.

May

2 (Lag Ba'omer 5667) The first issue of *Hapo'el Hatza'ir* ("The Young Worker"), the

Dr. Arthur Ruppin, 31, visits the country.

first labor newspaper in the country, appears. Because the Turkish authorities had prohibited publishing anything of a political nature, the place of publication is listed as Cairo.

7 The first meeting of the board of directors of the Jewish National Fund is held.

30 Another guest arrives in Jaffa – Dr. Arthur Ruppin, 31, a German Jewish attorney and sociologist who has been sent by the Zionist Executive and the Jewish National Fund to observe the situation of the Jewish Yishuv.

June

23 The Ahuzat Bayit committee of Jaffa requests a

loan of 300,000 Francs from the board of the Jewish National Fund in Cologne for the purpose of building 60 homes in the new neighborhood.

27 The first issue of the Yiddish newspaper, *Der Anfang* ("The Beginning"), the organ of the Po'alei Zion party, is published in Jerusalem.

July

16 The Jewish National Fund, with the encouragement of Dr. Ruppin, approves the loan to Ahuzat Bayit.

25 (14 Av 5667) The village of Rishon Lezion celebrates its 25-year existence.

August

The eighth Zionist Congress convenes in The Hague. It approves the establishment of a permanent representation of the Zionist Organization in Palestine, to be called the Palestine Office. For the first time, delegates representing the labor parties in the country participate in the congress. British philanthropist Jacob Moser announces a contribution of 90,000 Marks to erect a building for the Gymnasia Herzliya and to assist the Bezalel School of Art.

September

The young Zionist leader Dr. Hayim Weizmann arrives for a visit. He tours the country for three weeks accompanied by Yehoshua Hankin, who is active in land purchases for

the Jewish national cause. Weizmann is impressed by the Jewish villages.

Orders from Istanbul prohibit the sale of land to Jews even if they are Ottoman subjects. The law remains in force until the Young Turk Revolution of 1908.

29 (Simhat Torah eve) The secret Bar-Giora society is formed in Jaffa with the aim of "conquering" the task of guarding the Jewish settlements in Palestine. Its founders include Israel Shohat, Itzhak Ben-Zvi and Alexander Zeid.

October

A collective is formed at Sejera in the Lower Galilee made up of members of the Po'alei Zion party and the Bar-Giora society. They take responsibility for operating the farm on their own. The Hashomer ("The Watchman") association later evolves from the group.

December

3 A new village, Be'er Ya'akov, is established between Rishon Lezion and Ramleh.

A series of business bankruptcies in Jerusalem leads to rumors of a failure of the Anglo-Palestine Bank branch there, prompting a run on the bank. The bank meets the demand. Another branch is opened during the year, in Hebron.

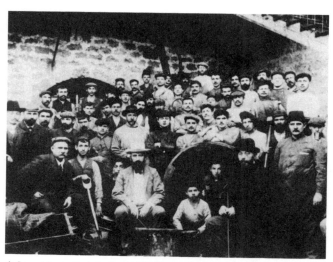

A "presidential" visit: David Wolffsohn (bot. r.), president of the Zionist Organization, with workers at the Stein factory in Jaffa. Owner Leon Stein is seated at far left.

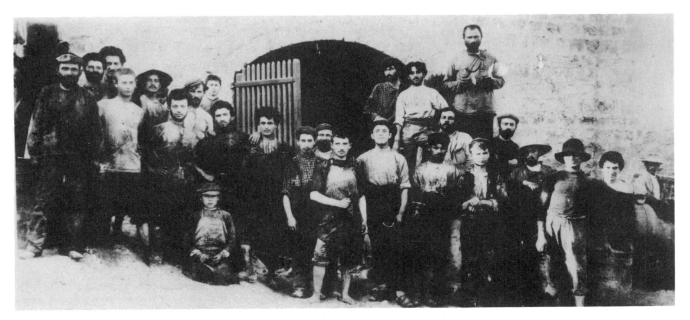

◁ The new village of Be'er Ya'akov, the only Jewish settlement established in 1907, is founded near Rishon Lezion.

▽ Festivities are held marking the 25th anniversary of the founding of Rishon Lezion. The commemorative poster shows its founding fathers. In the center is the British vice-consul for Jaffa, Hayim Amzaleg .

△ The labor parties and their affiliated organizations begin to gain strength, which is reflected by strikes called by the print workers in Jerusalem and the winery workers in Rishon Lezion, shown above. One of the leaders is a worker named David Gruen (later, Ben-Gurion), shown at center, holding a bunch of grapes.

THE BAR-GIORA SOCIETY AND THE COLLECTIVE AT SEJERA

On the eve of Simhat Torah, Sept. 29, 1907, seven young immigrants of the Second Aliyah gathered in Itzhak Ben-Zvi's room in Jaffa to form a secret organization devoted to the defense of the Jewish Yishuv. It was to be named after Shim'on Bar-Giora, a leader of the Jewish revolt against the Romans in the 1st century.

In order to gain military experience and to take over the task of the defense of the Jewish villages from outside guards, part of the Bar-Giora group joined the collective formed at that time by Mania Wilbuschewitz (later, Shohat) at the Sejera farm in the Lower Galilee – the first productive workers commune in the country. The group expanded there and succeeded in acquiring the responsibility for guarding the villages. The first watchman was Zvi Becker.

A year and a half later, in the spring of 1909, the leader of the Bar-Giora group, Israel Shohat, together with his comrades, decided to widen its scope and establish a guard organization that would operate by permit from the Turkish authorities. This decision grew into the formation of the Hashomer ("Watchman") association, which was to absorb the Bar-Giora group, although they, and especially Shohat, retained a determining influence on it.

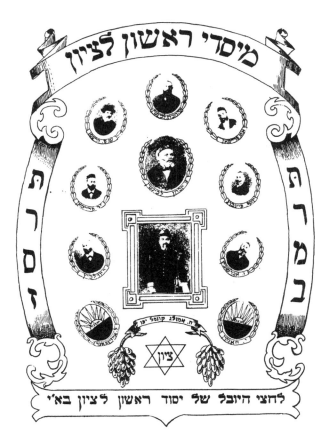

THE EARLIEST LABOR PRESS

The year 1907 witnessed a new development in the country – a labor press. Although the two labor parties, Hapo'el Hatza'ir ("The Young Worker") and Po'alei Zion ("Workers of Zion"), had only a small membership – several hundred each – the publishing of a periodical was viewed as an important goal, with both groups making concerted efforts to publicize their activities and ideas to their membership and to outside supporters.

The first to produce such an organ was Hapo'el Hatza'ir, which made a decision to put out a periodical of the same name in 1907. Begun as a monthly, it was published in Jerusalem, although "published in Cairo" appeared on its masthead in light of the absence of a publishing license from the Turkish authorities.

Following the Young Turk Revolution (1908), the periodical appears to be published twice a month in Jaffa and later weekly. It aimed at quality and published several literary works.

The other labor party, Po'alei Zion, did not lag far behind. Several weeks after the appearance of the first issue of *Hapo'el Hatza'ir* ("The Young Worker"), it published *Der Anfang* ("The Beginning"), in Yiddish. Criticism of this linguistic choice was voiced in various quarters in the Yishuv, including in Po'alei Zion itself, and the publication closed after two issues. A new Po'alei Zion periodical, *Ha'ahdut* ("Unity"), this time in Hebrew, began to be published in Jerusalem in 1910.

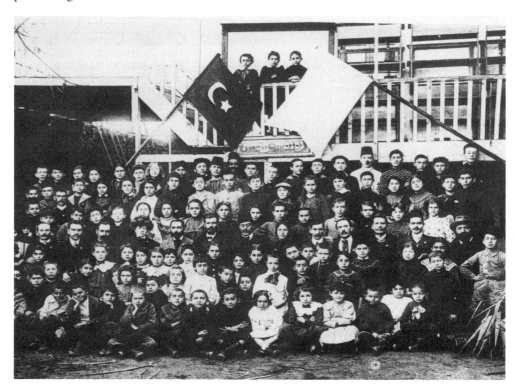

◁ An "explosion" in enrollment at the Hebrew Gymnasium of Jaffa, 1907.

▽ The first periodical to be published in Jaffa: *Ha'omer* ("The Sheaf"), edited by S. Ben-Zion.

▽ Artists and writers immigrate to the country as well, including (l.) sculptor Boris Schatz, director of the Bezalel School of Art, and writer Simha Gutmann (later, S. Ben-Zion).

△ Two labor periodicals appear in 1907: the Yiddish-language *Der Anfang* ("The Beginning"), published by the Po'alei Zion party, and *Hapo'el Hatza'ir* ("The Young Worker"), published in Jerusalem and later in Jaffa by the party of the same name.

January _____
Zvi Becker, a member of the Bar-Giora society and of the collective at Sejera, replaces the Circassian watchman there, marking a turning point in the annals of Jewish self-defense.

The Hapo'el Hatza'ir ("The Young Worker") party calls for immigration to Palestine.

February _____
The final research expedition sponsored by the Zionist Organization sets out for the Dead Sea and Transjordan region. Its members again include Blanckenhorn and Aaronsohn, as well as zoologist Israel Aharoni.

March _____
16 A violent incident between young Jews and Arabs takes place in Jaffa following an attack by Arabs on Jewish immigrants, with injured on both sides. As far as is known, this marks the first Jewish-Arab violence in an urban setting in Palestine.

The first automobile reaches Palestine, driven by one Charles Glidden of Boston, who tours dozens of countries in this way.

April _____
1 The Palestine Office, the official representation of the Zionist Organization, is established in Jaffa, headed by Dr. Arthur Ruppin, a new immigrant from Germany. He takes on the task of implementing practical steps to further Jewish settlement in Palestine.

Workers who have pulled out the seedlings in Ben-Shemen (see May).

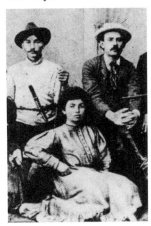

A new transportation service at the Dead Sea: a motor launch sails from shore to shore daily.

L. Stein and Partners, the metal company in Jaffa, publishes its financial report for 1907, indicating a turnover of 2.83 million Francs. Sales for the year increased substantially, as did the number of workers, reaching 125. Shareholders are to receive a dividend of 27% on their investment. Stein is the largest Jewish industrial plant in the country.

The Bezalel School of Art moves into new premises in Jerusalem, acquired with the aid of the Zionist Organization and the Jewish National Fund.

19 A new development in the village of Rehovot: sports matches during the intermediate days of Passover between athletes from the Jewish villages.

May _____
19 The Bezalel School of Art buildings are inaugurated

H A Z E W I

Hazvi, the country's first daily.

in a public ceremony. Guests of honor include the representative of the pasha, the mayor and the British, German and Russian consuls.

Shmuel Yosef Czaczkes (later Agnon) immigrates to the country. He will be awarded the Nobel Prize for literature in 1966.

The planting of the Herzl Forest begins in Ben-Shemen. Jewish workers protest when the Palestine Office employs Arab workers for the task. Eventually, Jewish workers replace the Arabs, demonstratively pulling out the seedlings which the Arabs have planted, and plant them anew.

June _____
4 The head of the village council of Petah Tikva, Yehoshua Stampfer, dies, at

age 56. He was a founder of the village and one of the first Jewish orange growers.
7 The Kinneret farm is founded by the Palestine Office of the Zionist Organization with the aim of training pioneers for agriculture and settlement. It will become an important vocational and social center for the Second Aliyah pioneers.
21 The first workers' settlement in the country – Ein-Ganim – is founded near Petah Tikva.

July _____
24 The Young Turk Revolution erupts. The Ottoman Empire enters a new phase. Palestine enjoys greater freedom.

A new economic activity is introduced – raising ostriches.

August _____
15 Israel Shohat signs an agreement providing Jewish guard services to the village of Kfar Tavor (Messha). The watchmen are members of the Bar-Giora society.

Shock and dismay are registered in Jaffa and throughout the small Jewish Yishuv at the news that the Stein factory is in crisis, that its past reports were exaggerated, and that profits were smaller than declared. Leon Stein is dismissed. He is replaced by writer and businessman Mordechai Ben-Hillel Hacohen.

September _____
The governor of Jerusalem, Ali Akram Bey, is dismissed from his post in the wake of the Young Turk Revolution. He had displayed a hostile attitude to the Jewish population and to Zionist aspirations. He is replaced by Subhi Bey.
9 One result of the Young Turk Revolution is a decision by Eliezer Ben-Yehuda to publish his Jerusalem weekly, *Hashkafah* ("Outlook"), several times a week with the intention of turning it into a daily.
30 The first Hebrew daily newspaper appears, an achievement for Eliezer Ben-Yehuda. The name *Hashkafah* is retained by the publisher, Shlomo Israel Shirizli, while

1908

Ben-Yehuda revives a previous name of the paper – *Hazvi* ("The Deer").

October _____
Itamar Ben-Avi, 26, Eliezer Ben-Yehuda's son, returns from Berlin and takes charge of *Hazvi*.

The second issue of *Ha'omer* ("The Sheaf") appears in Jaffa. New contributors to it include S. Y. Agnon, age 20, who publishes his first story, *Agunot* ("Abandoned Wives").
25 Renewed agitation among the print workers in Jerusalem following a work dispute in the N. Levi and Partners Press that culminates in a general strike of all print workers. The strike lasts some two months and ends with the workers forced to return to work and the union disbanded.

A new sensation in Jerusalem: a movie house, the Olympia. It shows "living pictures" every evening at 8 p.m., with two screenings after Sabbath and on Sunday.

November _____
The newly appointed Hakham Bashi of Istanbul, Rabbi Hayim Nahum, dismisses the temporary Hakham Bashi of Jerusalem, Rabbi Panigel, and replaces him, again temporarily, with Rabbi Hizkiya Shabtai of Aleppo.

The director of the philanthropic Esra organization in Germany, Paul Nathan, tours Palestine for the purpose of locating a site for the establishment of a school for "higher technical education." Jerusalem wants such an institution but Nathan decides to locate it in Haifa. The decision is to lead to the founding of the Technion, Israel's most important technological academic institution.

THE ESTABLISHMENT OF THE PALESTINE OFFICE IN JAFFA

The Palestine Office of the Zionist Organization was established in Jaffa in 1908 under the directorship of Dr. Arthur Ruppin, who was assisted by Ya'akov Thon.

German-born, trained in law and social sciences, Ruppin laid the foundations for expanded rural as well as urban settlement. He introduced the notion of agricultural training for the new pioneers to facilitate their absorption in the country, establishing national training farms at Kinneret, Ben-Shemen, and Hulda for this purpose. He also stimulated investment in the country and the acquisition of private land.

The Palestine Office made a singular contribution to the development of communal settlement (Deganya, Merhavya, and others) and to urban settlement (Tel-Aviv and Haifa); land purchase; the establishment of educational and cultural institutions; aid to the Yemenite immigration and much else during the last years of the Ottoman rule in Palestine. It merged, after World War I, into the Zionist Commission of Palestine.

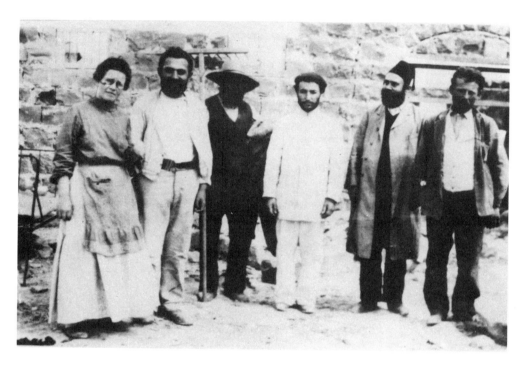

◁ The establishment of the Kinneret farm on the shore of Lake Kinneret (Sea of Galilee), not far from Zemah, is one of the first activities undertaken by the Palestine Office. Shown is a group of the farm's founders, photographed in 1908.

△ Director of the Palestine Office, Dr. Arthur Ruppin (l.), and his assistant, Ya'akov Thon.

◁ The buildings of the Kinneret farm overlooking the lake are visible from afar, particularly the two-story building that houses the administrator of the farm. The village of Kinneret will be established next to the farm in 1909. The farm serves as a laboratory for various types of settlement until the 1940s.

▽ Eliezer Ben-Yehuda devotes most of his energies to publishing his dictionary of the revived Hebrew language, while his son, Itamar Ben-Avi (below), is called back from Europe to edit the daily *Hazvi* ("The Deer").

◁ A group of intellectuals in Jerusalem, 1908. Standing, center, in white: director of the Bezalel School of Art, Prof. Boris Schatz. Seated, l.: artist Eira Yan. Next to her: Itzhak Ben-Zvi, who will later become the second president of the State of Israel. Standing, far r.: Rahel Yana'it, labor leader and writer, later to marry Ben-Zvi.

▽ The new Bezalel School of Art complex, dedicated in May 1908.

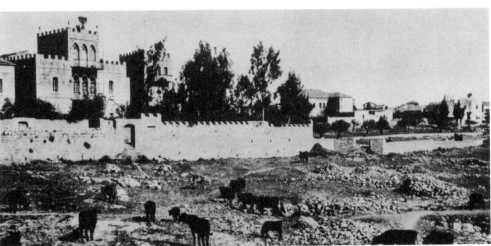

THE YOUNG TURK REVOLUTION AND ITS EFFECT ON PALESTINE

The rebellion that broke out in 1908 in various parts of the Ottoman Empire under the leadership of officers who belonged to the Young Turks organization led Sultan Abd al-Hamid II to concede defeat, announce the restoration of the constitution of 1876, and hold elections to parliament. After the sultan himself was deposed, in 1909, the Young Turks established a centralized military regime and forced Turkish culture on the peoples subjected to the empire.

While the revolution was initially welcomed enthusiastically in Palestine, in time it became apparent that the new Turkish regime retained the flaws of the old one. The Arabs of Palestine, who underwent a nationalist awakening at this time, were also disappointed with the new rulers in Istanbul and decided to pursue an active campaign for autonomy with the aim of establishing an Arab state that would include Palestine. They managed to seat a delegate of their own, representing Jerusalem, in parliament in Istanbul, and maligned the Zionist movement.

◁ Until 1908, Ottoman rule is monarchic and autocratic, qualities satirized in this caricature of Zionist leader Menahem Ussishkin as a Turkish pasha.

▽ Tents of the Zionist research expedition that explores the Judean Desert in early 1908.

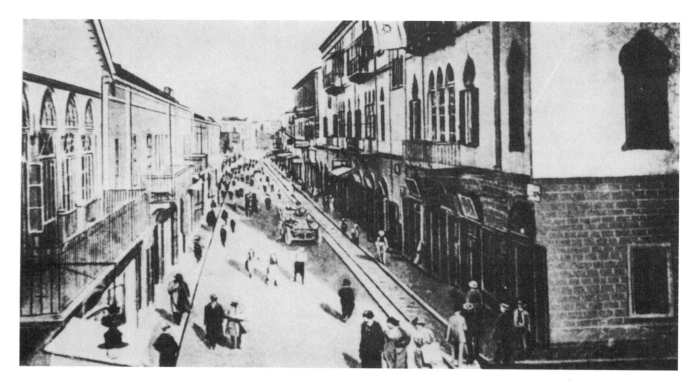

△ The first automobile appears in Palestine, arriving in March 1908 and attracting widespread attention. It is driven by Charles Glidden of Boston, who tours dozens of countries, including the Holy Land. The automobile is shown on Bustrus Street in Jaffa. Glidden will continue on to Jerusalem, Hebron, and the Dead Sea, securing the cooperation of the Turkish governor of Jerusalem by taking him out for a ride.

▽ Another scene in Jaffa: The L. Stein and Partners metal factory, which reported good profits in the preceding years, is in a state of collapse – a shock to the Yishuv. Leon Stein is dismissed as manager in August 1908. The company ultimately goes bankrupt and many of its shareholders lose their money. This first case of bankruptcy in the Yishuv makes an indelible impression on the Jewish community.

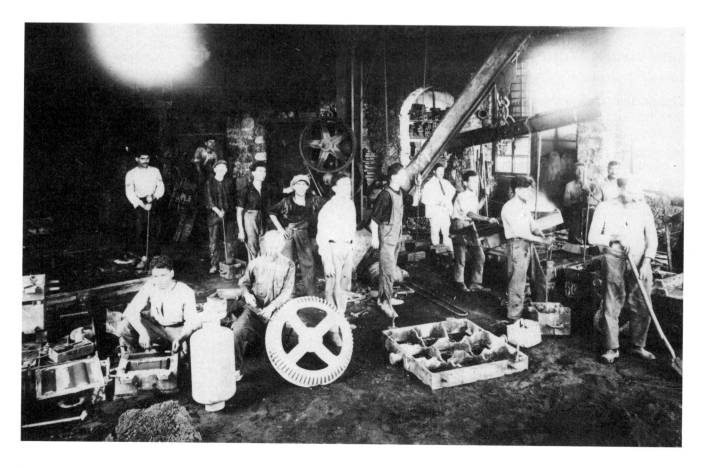

January

9 The members of the Ahuzat Bayit society, their families, and their friends gather on the dunes north of Jaffa, where the new Jewish neighborhood is slated to be built.

The crisis at the Stein factory is not resolved. Leon Stein is brought back as manager.

February

6 The Lovers of the Hebrew Stage association (successor of the Lovers of the Stage) presents in Jaffa an evening of short plays, which is concluded with Sholom Aleichem's play, *Scattered and Dispersed.*

(Tu Bishvat 5669) Hundreds of Jewish residents of Jaffa congregate at the Ahuzat Bayit site, north of the city, to hear speeches and watch a gymnastic performance. Because the date falls on the Sabbath, the traditional tree-planting ceremonies are held the following day.

Rabbi Hizkiya Shabtai leaves Jerusalem, appointing Rabbi Nahman Batito as his temporary replacement for the position of Hakham Bashi and as responsible for holding elections to fill the position permanently. The elections, however, continue to be postponed.

Yosef Hayim Brenner, the writer, immigrates. An introvert, he attempts to conceal his identity by using a pseudonym, but is exposed a few days after his arrival.

March

29 Hayim Nahman Bialik, the poet, visits the country

and is welcomed enthusiastically everywhere. He spends two months in Palestine.

April

The Rehovot Games are held during the intermediate days

The logo of the new Jerusalem newspaper, *Haherut* ("Freedom").

Members of the executive committee of the Printers' Association in Jerusalem, 1909.

of Passover for the second time.

11 A lottery is held for the allocation of plots of land in the Ahuzat Bayit neighborhood, north of Jaffa. The date is considered as marking the founding of the city of Tel-Aviv.

12 The Hashomer watchmen association is founded in Kfar Tavor (Messha), headed by Israel Shohat. The security situation in the Lower Galilee and in the south of the

country deteriorates. On the very day of the founding of Hashomer, a farmer and a worker are killed at Sejera. Bedouins raid the villages in the south, uprooting trees and attacking Jewish farmers.

A second Jewish company is organized in Jaffa for the purpose of building another new neighborhood outside the city near Ahuzat Bayit. It is called Nahlat Binyamin ("Benjamin's Estate").

May

A new weekly (later a daily) appears in Jerusalem – *Haherut* ("Freedom") – published and edited by young Sephardi Jews with a nationalist Zionist viewpoint.

30 After some delay, the first house is built in Ahuzat Bayit. It belongs to Reuven Segal (later, house No. 25 in Yehuda Halevi street).

June

1 *Haherut* reports that export from Palestine has reached 12 million Francs per year. Citrus exports account for a third of the total.

July

28 The cornerstone-laying ceremony for the Gymnasia Herzliya building is held in the new Ahuzat Bayit neighborhood where the school will relocate.

August

6-7 In a daring escape, prisoners break out of the Acre prison by means of ropes lowered from the roof. The police fail to apprehend eight of the escapees.

16 Rabbi Samuel Salant, the most prominent rabbi of the Ashkenazi community of Jerusalem and the acknowledged leader of the old Yishuv, dies at age 94.

September

Berl Katznelson, later to emerge as a central figure of the Second Aliyah and of the labor movement, immigrates.

27 A violent incident involving Jewish and Arab workers occurs on the Ahuzat Bayit grounds over a labor dispute. Several Jewish workers are injured.

1909

November

The first families move from Jaffa to their new homes in Ahuzat Bayit. By the end of the month, 50 families have moved in.

December

A new governor of Jerusalem, Nazzi Bey, replaces the previous governor, Subhi Bey.

The Palestine Workers' Fund (Kapai) is founded by Po'alei Zion to aid workers.

The village of Rehovot proposes that the poet-physician Shaul Tchernochowsky become the village doctor. The idea is vetoed when it becomes known that he is married to a Christian woman.

The ninth Zionist Congress is held in Hamburg. It decides, among other things, to sponsor cooperative settlement in Palestine (the Oppenheimer Plan).

A second Hebrew gymnasium is established in 1909, in Jerusalem, directed by Shlomo Schiller. Two of its first teachers are Itzhak Ben-Zvi and Rahel Yana'it.

The Austrian Postal Service in Palestine entitles the village of Petah Tikva to issue a stamp of its own. Half the revenues from it are donated to the Jewish National Fund.

A Hebrew Magistrates Court is established in Jaffa for the adjudication of disputes between Jews. Its judges are leaders of the Yishuv, intellectuals, institutional officials' and members of various professions.

When the masseuse is also midwife. Notice from 1909.

◁ The hut where writer Yosef Hayim Brenner lives as a new immigrant. The place is in Ein-Ganim, near Petah Tikvah.

▽ The Hashomer watchmen association is founded in the spring of 1909, an outgrowth of the secret Bar-Giora society formed a year and a half previously. Below, five of the founders of Hashomer.

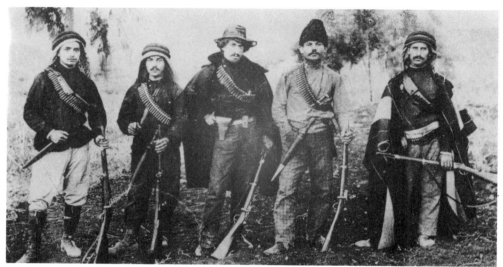

▽ The most distinguished guest to visit the country in 1909 is the national Jewish poet Hayim Nahman Bialik, who spends two months there, his first visit to Palestine. Below, at the School for Girls in Jaffa, he is seated in the center, holding a stick. To his left: his loyal colleague and editor Yehoshua Rawnitzki. At far left, writer S. Ben-Zion. The others in the photo are teachers at the school and Jewish communal leaders of Jaffa.

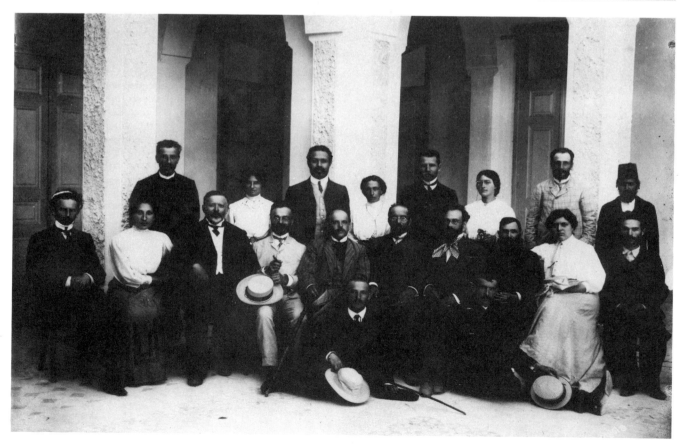

הצבי

HAZEWI

עתון יומי

העורך הראשי:

אליעזר בן־יהודה

שנה חמש ועשרים

ירושלם, יום ג' י"נ אייר. אתת"ס לחרבן.

גליון קס"ג (163)

1200

A HISTORIC TWO DAYS

History sometimes bunches events together, as occurred on the Sunday and Monday of the second week of April 1909. On April 11, some 150 men, women and children gathered at a desolate beach site in Jaffa – or more precisely some 3 km north of the city – to participate in a lottery of housing plots at that location. They were the founding families of a new neighborhood, Ahuzat Bayit ("Home Estate"). The secretary of the neighborhood committee, Akiva Aryeh Weiss, conducted the lottery. Earlier that day, he had gathered 60 white shells and 60 gray shells at the shore, writing the name of each member family of the society on the white shells and lot numbers on the gray shells in black ink. During the ceremony, a boy and a girl simultaneously pulled out a shell from each set, which had been placed in two hats, and the two sets were paired upon each draw.

That day is considered to be the founding day of the city of Tel-Aviv.

The next day, April 12, another foundation was laid, far away in the Lower Galilee, not for a neighborhood but for an association – Hashomer ("the Watchman"). Several dozen young men, some of them armed with pistols and rifles and dressed in the native attire of the region, gathered in the village of Kfar Tavor (Messha) and established "an element of Jewish watchmen fit for this work."

It may be said without too much exaggeration that in those two days the foundations were laid for two central elements of the Jewish Yishuv and the state in format-ion: the city of Tel-Aviv, the first Hebrew city, and Hashomer, progenitor of the Haganah, and subsequently the Israel Defense Forces.

△ *Hazvi* ("The Deer") announces in 1909 that its distribution is 1,200 copies daily, a large number for that time.

◁ The young writer Shmuel Yosef Czaczkes becomes known in 1909 following the publication in late 1908 of his first story, *Agunot* ("Abandoned Wives"), from which he takes his new Hebrew name, Agnon.

△ The Bilu village, Gedera, marks 25 years since its founding.

▽ A satiric monthly, *Hamor-Gamal* ("Donkey-Camel"), edited by Itamar Ben-Avi, appears in Jerusalem.

חמר־גמל

ירחון התולי

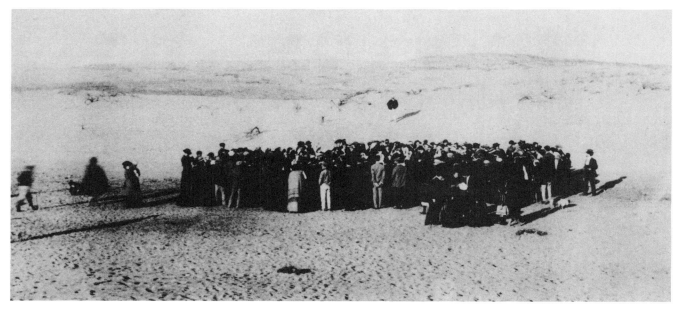

△ The most famous photo-
graph of the year 1909,
and perhaps of the first
decade, in Jewish Pale-
stine – the lottery of plots
for the Ahuzat Bayit
neighborhood north of
Jaffa, April 11, 1909. At
first a small neighborhood,
it soon evolves into the
nucleus of the fast-growing
city – Tel-Aviv.

▷ The original division of the
Ahuzat Bayit neighborhood
following the lottery. Sixty
families participated in the
lottery and an additional six
joined the group later. Each
of the founding members
of the Ahuzat Bayit society,
all of whom are Jewish
residents of the city of
Jaffa, have signed along
the margin of the plan.

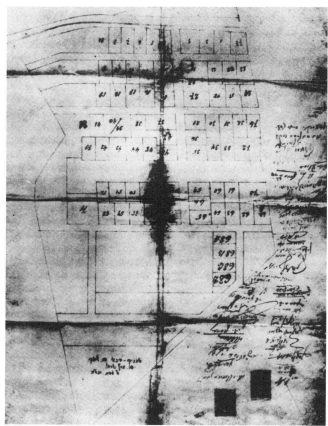

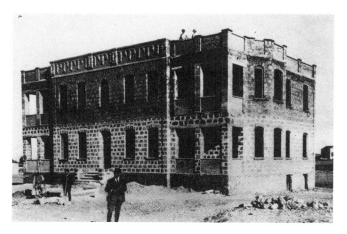

▷ The Gymnasia Herzliya
under construction in the
second half of 1909
(above). The building of
the school in Ahuzat Bayit,
which stands out from
afar, gives significant
momentum to the esta-
blishment of the neighbor-
hood. The building is
designed by architect
Yosef Barsky.

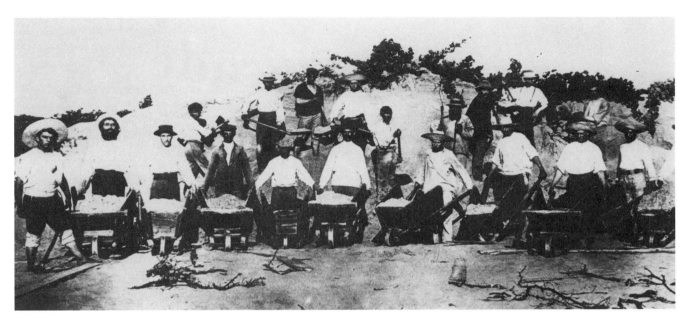

△ Workmen level the dunes of Ahuzat Bayit with the aid of wheelbarrows.

▽ An announcement of the start of construction and a listing of employment conditions for workers sought by the contractor Chelouche.

The public is divided. Some mock and others rejoice. Some jeer at the project and others respond with new buildings. This place, which was once a desert, will be filled with spacious houses and shade trees, and in the center of the neighborhood there will be a park, and around the park we will build a synagogue, and a library, and a community center, and schools, and the streets will be filled with boys and girls. The Gymnasia Herzliya had already begun building its new home in our neighborhood, and any man who wishes to give his children a good Jewish and general education should send them to us, and with them he should send their mother, and then he, too, should come.

S. Y. Agnon, "Tmol Shilshom", on the founding of Tel-Aviv, 1909

AHUZAT BAYIT: THE FIRST YEAR

Disputes sprang up following the lottery in April 1909. They concerned the number of residents; the placement of the streets, and especially the width of the streets, lest they usurp too much from the lots; and the necessity of allocating space for a park. There were also more substantive disputes, for example on the employment of Jewish laborers to dig a well even if this meant paying higher wages than those paid to Arabs. Another weighty question was whether shops should be permitted in the esthetic and serene garden suburb. The first house was that of Reuven Segal. On the fringe of the neighborhood, the large building of the Gymnasia Herzliya was constructed.

When the time came to move into the houses, in November 1909, donkeys had to be used to transfer furnishings, as wagons could not traverse the sand. Within two months, 150 people moved into 50 houses built along six streets. The main road was Herzl Street, which began at the Gymnasia Herzliya building and ended at the Jaffa-Jerusalem railroad that passed close to the new neighborhood, and which was to be Tel-Aviv's main thoroughfare for many years.

בעזה

ביום א' כ"ט תמוז נגשים אנחנו לבנין הגמנסיה ובתים באחזת בית ביפו. על כן הננו פונים בזה אל כל הבנאים והמסתתים ושאר פועלים עברים הדורשים עבודה לבא אלנו במשך השבוע הבא לרשום את שמותיהם על פי התנאים האלה:

א) העבודה כל יום עשר שעות לא פחות ולא יותר
ב) ביום הששי
ג) אם נצטרך לשביתת ימים אחרים מצד חוסר חומר לבנין נודיע את הפועלים קודם ואין להם לדרוש שכירות על אותו זמן.

המקחים:

שכירות יום הבנאי – – – 18—22	גרוש כפי ערכו
הבונה בצרורות – 12—14	· · ·
המסתת 12—16	· · ·
נושא אבנים – – 8—10	· · ·
פועלי מים עפר וצרורות 8	
להילדים נושאי מים – 4—5	· · ·

הקבלן יוסף אליהו שלוש – יפו.

The Second Decade
1910-1919

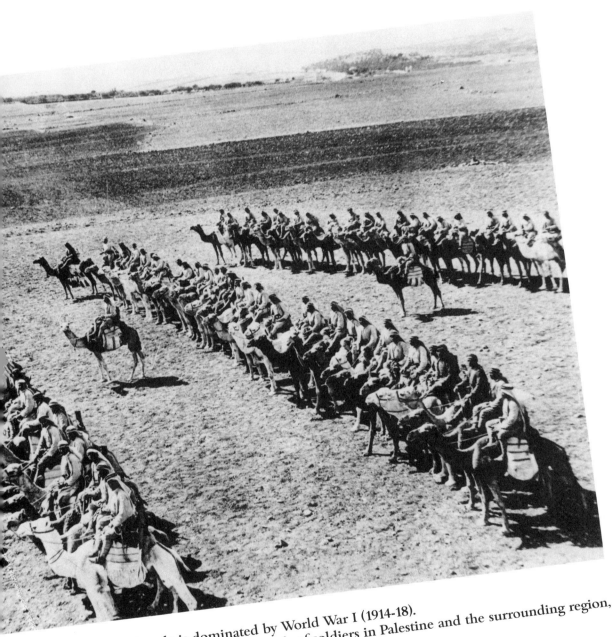

The decade is dominated by World War I (1914-18).
The Turks mobilize thousands of soldiers in Palestine and the surrounding region,
including the camel brigade shown above.

The second decade of the 20th century in Palestine, particularly in Jewish Palestine, may be divided into three periods, the first two lasting just over four years each, and the last one and a half years.

The first period, from early 1910 to mid-1914, marks the conclusion of what is commonly referred to as the Second Aliyah. The second period, beginning in the summer of 1914 and ending in the fall of 1918, encompasses World War I, whose main theater was mostly in Europe but also affected Palestine. The third period extends from the end of the war to the end of 1919. It was a period of transition. The war had ended. The British had taken over the rule in Palestine. Yet the significant changes brought about by the British, did not come into being until the early twenties.

The final years of the Second Aliyah were a period of boom. Although the nature of Turkish rule had barely changed, despite the Young Turk Revolution of 1908, ongoing progress was made in the country in the economic, technological and even political spheres. For the first time, delegates from Palestine (all Arabs) were elected to the Ottoman parliament, while Jewish students (including David Ben-Gurion and Itzhak Ben-Zvi) studied law at the University of Istanbul in preparation for entering political life in Turkey as delegates of the Jewish community of Palestine. Other Jews, from the agricultural settlements in particular, attained officer rank in the Turkish army.

The Jewish Yishuv moved forward in significant ways during this period. The Ahuzat Bayit neighborhood was renamed Tel-Aviv. A group of pioneers laid the foundations for the "mother of the kibbutzim," Deganya, forming the basis for the kibbutz movement. The Hashomer watchmen association entrenched itself and expanded, acquiring a level of prestige that would soon turn it into a legend in the country and throughout the Jewish world. The first institution of higher education – the Technion – was under construction in Haifa, while the Zionist Organization, with the support of Baron Edmond de Rothschild, weighed the possibility of establishing a Hebrew university in Jerusalem. The foundations were laid for the establishment of various other public bodies and institutions as well, including the General Federation of Labor (Histadrut) and the Sick Fund (Kupat Holim).

Immigration increased. Although the pogroms in Russia ended, anti-Semitism did not. On the contrary, the Beilis trial there proved to Jews that anti-Semitism was deeply rooted in all strata of Russian society and that the only solution for them was emigration. A small portion of this emigration reached Palestine, including Menahem Beilis himself. Immigration from Middle Eastern countries arrived as well, especially from Yemen. For the first time, the Zionist and Yishuv organizations coordinated efforts to assist in the reception of hundreds, and even several thousands, of new immigrants annually. Most of them joined established settlements like Rehovot, Petah Tikva and Hadera, but their absorption did not go very smoothly.

The period witnessed the growth in stature of the Palestine Office of the Zionist Organization, headed by Dr. Arthur Ruppin, who acted as an important catalyst in the development of the country. Baron Rothschild, who had not visited Palestine since the end of the previous century, arrived for a visit in 1914 and was openly astonished by the many changes he observed. From then on, he strengthened cooperation with the Zionist movement. By the summer of 1914, the Yishuv numbered 85,000 out of a total population of 500,000-600,000. Development had taken place in nearly every sector.

With the outbreak of World War I, the country, and the Jewish Yishuv in it, regressed markedly. Conditions during the entire length of the war were harsh and sometimes dangerous. Governmental rule was put in the hands of the military; restrictive decrees, harassment and the confiscation of foodstuffs, supplies and equipment were constant; and the Turks demanded that Jews who held foreign nationality either leave the country or become "Ottomanized," i.e., accept Ottoman nationality.

Mass exile, voluntary departure due to rejection of the Ottomanization option, want and disease soon resulted in the dimunition of the Jewish Yishuv from 85,000 to 56,000 during the course of the war. Nevertheless, communal cohesiveness was maintained by dint of heroic efforts on the part of its leadership, especially that of the new Yishuv, as well as by aid from abroad, especially from the Jews of the United States. The American Jewish community, which had grown rapidly during the preceding two decades, took upon itself the task of protecting the small Jewish Yishuv in Palestine. Until the spring of 1917, it made use of the neutrality of the United States to send money and foodstuffs on board American war ships. The government in Washington played its part and gave orders to deliver the goods to their destination. The Jews of Germany, Turkey's ally, also contributed to this effort, and in some instances German and Austrian officers serving in Palestine as instructors, physicians and pilots for the Turkish army, offered assistance as well.

In 1916, the British in Egypt mounted an offensive and advanced eastward, conquering Palestine during 1917-18. Thereafter, they moved northward and within a short time defeated the Ottoman Empire entirely. Four hundred years of Ottoman rule over Palestine came to an end.

Recovery began slowly in 1918-19. Palestine was now under British military rule, while negotiations went on between the two powers that took control of the region, Britain and France, regarding the division of territory and spheres of influence.

The Jews were in a state of euphoria. The end of Turkish rule, the cessation of harassment and danger, and especially the Balfour Declaration of November 2, 1917, led them to believe that the "national home," in the words of the declaration, would be established in Palestine in the foreseeable future under British sponsorship.

1910

January

26 The first general meeting of the residents of the Ahuzat Bayit neighborhood takes place in the neighborhood itself. Thirty-six of the 60 tenants attend.

February

25 The newspaper, *Hazvi* ("The Deer"), run by the Ben-Yehuda family, starts to appear under the name of *Ha'or*, ("The Light"), which was already in use at the end of the 19th century.

April

A first-time exhibition of the accomplishments of the Jewish Yishuv is mounted at the annual Rehovot Games during Passover.

A new ultra-Orthodox weekly, *Moriah*, is published in Jerusalem.

May

21 A proposal is made at a general meeting of the Ahuzat Bayit residents to change the name of the neighborhood. Suggestions include: New Jaffa, Yefeifiya, Neveh Jaffa, Aviva, Ivriya and Tel-Aviv ("Springhill"). The last is chosen.

June

A guest in Palestine, Rabbi Hayim Nahum of Istanbul, Hakham Bashi of Turkey, manages to quell the disputes in the Sephardi community of Jerusalem and proposes the appointment of Rabbi Ya'akov Meir as chief rabbi of the city, with Rabbi Eliyahu Moshe Panigel as his assistant.

The number of Jewish workers expands. Each village has a workers house, like this one in Petah Tikva.

27 During a visit by Rabbi Nahum to Petah Tikva, the Zionist flag, raised by the workers and the young people of the village, is taken down by force by the farmers, an act that causes a furor, especially on the part of the Second Aliyah pioneers.

The first issue of *Ha'ahdut* ("Unity"), the Po'alei Zion ("Workers of Zion") party organ, is published. After three monthly issues, the paper becomes a weekly.

July

2 The residents of Tel-Aviv reject a proposal raised at a general meeting to change the article of the association, approved before construction began, barring shops from the neighborhood.

August

6 The Arabs of Qalqilya attack the village of Kfar Saba and demolish it.

The sheep herd of the village of Yavne'el is stolen. The farmers and watchmen manage to retrieve it.

The City of Jerusalem adopts a series of decisions aimed at municipal development, including operating

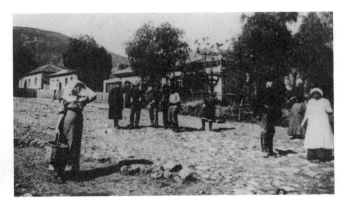

By the second decade of the 20th century, most of the villages (moshavot) are well established. Above, a street in Yavne'el.

electric trams, laying a piped water system, installing a central drainage system, and introducing a municipal telephone service.

October

26 The Gymnasia Herzliya moves into its new home in Tel-Aviv at the start of the school year.

28 The first kibbutz is born. A group of pioneers is allocated land at Um Juni at the Jordan River, later to be named Deganya.

For the first time, Hashomer steps outside its boundaries (the Lower Galilee) and takes charge of the guarding in Hadera.

The issue of the appointment of Rabbi Ya'akov Meir as Hakham Bashi of Jerusalem is not yet resolved. Although he agrees to accept the position, the community he leads in Salonica begs him not to leave. He announces that he will not be coming to Jerusalem.

November

24 Yosef Hayim Brenner, the writer, publishes an article in *Hapo'el Hatza'ir* (" The Young Worker") about

conversion by Jews in Europe to Christianity, which arouses great controversy and is dubbed the "Brenner Incident." The Odessa Committee in Russia threatens to cut off support of the periodical if the editorial board is not replaced. The Yishuv is up in arms over the incident.

December

11 The residents of Tel-Aviv decide at a general meeting to disband the Ahuzat Bayit society. A new neighborhood committee is formed, headed by Meir Dizengoff.

History on paper: Ahuzat Bayit is crossed out in the letter, and Tel-Aviv is written down instead.

24 The Tel-Aviv Committee sends a letter to Baron Rothschild in Paris requesting his assent to naming its boulevard for him.

During the course of the year, the Palestine Land Development Company of the Zionist Organization acquires the first large tract of land in the central Jezreel Valley. It will later be called Merhavya.

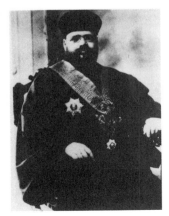

Rabbi Hayim Nahum.

51

THE ESTABLISHMENT OF THE FIRST KIBBUTZ – DEGANYA

The pioneers of the Second Aliyah were the initiators and implementors of an original concept – the kibbutz.

This form of settlement was born of failure. The pioneer immigrants of the Second Aliyah had not adjusted to the norms of agricultural work in the established villages (moshavot). Fortunately, this crisis coincided with settlement activity undertaken by the Zionist Organization and the establishment of the Palestine Office headed by Dr. Arthur Ruppin. It was he who conceived the idea of establishing a national farm – the Kinneret farm – on Jewish National Fund land for the purpose of training young pioneers in working the land.

In 1909, however, the young workers at this farm declared a strike as a result of a dispute with its manager. Ruppin then proposed handing over responsibility for running part of the farm – on the Um Juni tract – to a group of the more experienced of these pioneers for a year's trial period without supervision.

The idea, conceived as a solution to a local problem, turned into a revolutionary and daring social experiment that evolved into the kibbutz format. By the end of the year, the group had fulfilled its tasks in good spirits and Ruppin proposed that an additional group, the Hadera commune, try the same experiment. This group replaced the first group at Um Juni in October 1910. It, too, completed its work successfully and decided to remain and establish a permanent settlement, Deganya, the first cooperative settlement in the country. Yosef Busel was the life and soul of the group. He insisted that families too had to join, and that the education of children should be the concern of the whole commune.

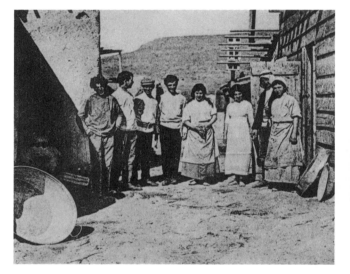

◁ The first members of Deganya near the first wooden hut in the kibbutz.

▽ A husha (Arab-style hut) at Deganya that serves as living quarters for the first members of the kibbutz.

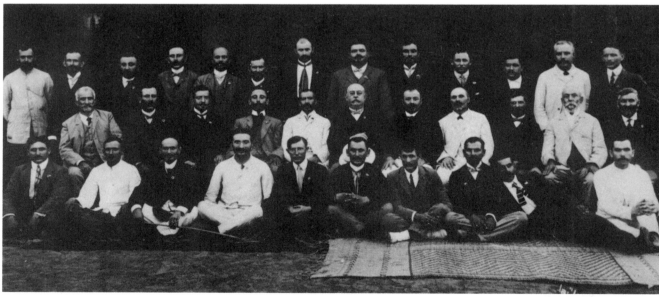

△ Second-generation farmers of Petah Tikva, 1910, with several of the first-generation settlers. The younger farmers rebel against their parents' conservative norms, causing an intergenerational war in the village. For instance, they cooperate with the workers – their parents' "foes" – who mount a play in the village.

△ Three of the editors of the Po'alei Zion ("Workers of Zion") weekly, *Ha'ahdut* (l. to r.): David Ben-Gurion, Itzhak Ben-Zvi and Ya'akov Zerubavel. A fourth editor is Rahel Yana'it.

האחדות

עתון לעניני הפועלים והמוניי-העם בארץ ישראל.

יוצא לאור על ידי מפלגת הפועלים העברים הסוציאל-דימוקרטים בארץ ישראל (פועלי-ציון)

ירושלם. תמוז, תר"ע ═══ № 1 ═══ שנה ראשונה.

בצאתנו.

הננו נגשים להוצאת עתון חדש. המיקדש לעניני הפועלים והמוני העם העברי בא"י ובתעירמה.

שהמספר קטן וישנם שני אלה. —סוף הישוב להתקק ואף להתרבות בכמותו. אך במקום שאין עבודה עצמית מבפנים. הנובעת מהחיים וגשענת בהם עצמם. שם הישוב הולך ומתנון ואין חיי חיים.

◁ The first issue of *Ha'ahdut*, ("Unity"),1910.

▽ Tel-Aviv at about one year, in mid-1910. The first 60 houses are built, the Gymnasia. Herzliya is established and the neighborhood has acquired the look of a modern town. Dozens of Jewish families from Jaffa apply to join the new neighborhood.

1911

January

24 The Merhavya cooperative farm, the first Jewish settlement in the Jezreel Valley, is established. This is made possible by Hashomer guards.

The garden suburb of Tel-Aviv now has 70 houses, and two additional neighborhoods are about to be built nearby for other Jews from Jaffa.

February

11 Intellectuals from all parts of the country gather in Jaffa to protest the intervention by the Odessa Committee in freedom of expression in Palestine and its cessation of backing for the *Hapo'el Hatza'ir* ("The Young Worker") newspaper, following the publication of a controversial article by Yosef Hayim Brenner (see November 24, 1910).

March

The Turkish-Italian war in Libya causes an economic crisis that is especially acute in Jerusalem. The flow of charitable monies from Europe is cut off. Some yeshivot (orthodox religious schools) are close to collapse. There is fear of the death of the old and the needy.

April

13-14 The first conference of the Agricultural Workers' Federation of the Galilee is held in Um Juni.
The first members of the cooperative of Merhavya arrive at the place.

The Young Women's Farm opens at the Kinneret farm – the first training center for women in agriculture and institutional administration. It is directed by Hanna Meisel.

May

25 Arab-Jewish violence occurs in Merhavya. The settlement watchman, Mordechai Yiga'el, is attacked by Arabs in the fields of the settlement and kills one of the attackers. Hundreds of Arabs surround the settlement and burst into it with the tacit consent of the authorities. Twelve settlers are arbitrarily imprisoned by the Turks in the Acre jail, most of them for about a year.

A stormy session is held in the Turkish parliament on the "Palestine problem" (the Jewish settlement in Palestine). The Arab delegates oppose it, but other delegates praise it.

Representatives of the villages of Rehovot, Rishon Lezion and Petah Tikva meet with the governor of Jaffa, Ra'uf Bey, and demand that he take steps to end Arab incitement against the Jews. They invite him to visit the villages and observe the contribution they are making to the government, to the country and to the Arab fellahin as well.

June

1-2 The first conference of the Agricultural Workers' Federation of Judea (southern Palestine) is held at Ein-Ganim.

July

According to a survey conducted in Rishon Lezion, of the 76 guards employed by the settlement, only four are Jewish. They work in the vineyard of I.L. Goldberg, from Vilna.

August

9-15 The tenth Zionist Congress is held in Basle. The agenda includes a discussion on practical work in Palestine and the Arab problem.

September

25 Ahad Ha'am, the writer, arrives and tours the country for seven weeks, impressed by the development of the Yishuv.

November

Hashomer takes charge of guarding the village of Rehovot.

The question of the appointment of the Hakham Bashi of Jerusalem is resolved. The Hakham Bashi of Istanbul, Rabbi Hayim Nahum, dismisses the temporary chief Sephardi rabbi of Jerusalem, Nahman Batito, and appoints Rabbi Moshe Yehuda Franco of Rhodes in his place. Rabbi Franco receives a government appointment as Hakham Bashi, the last to fill this position.

December

18 A conference of the Agricultural Workers' Federation of Judea adopts a decision to establish a sick fund, which will eventually grow into the mass Kupat Holim Klalit (General Sick Fund) health insurance network.

Shmuel Yavne'eli (Warshavsky), a young labor activist, leaves Palestine for Yemen with the aim of stimulating immigration to Palestine in the Jewish community there. Subsequently, some 2,000 Yemenite Jews come to Palestine.

The building of Nahlat Binyamin, the new neighborhood next to Tel-Aviv, is at its peak. Over 20 houses are in various stages of construction.

The first houses of the Hadar Hacarmel neighborhood in Haifa (called at first the Herzliya neighborhood) are built in 1911, later to become the center of Jewish Haifa.

A memorial book commemorating the pioneer watchmen, *Yizkor* ("In Memoriam"), is published.

Ahad Ha'am, the writer, tours the country in the fall of 1911.

Yosef Hayim Brenner evokes a storm in 1910 by an article in which he claims to be untroubled by Jewish conversion to Christianity in Europe.
The affair reached the satirical magazines as well, for example, in a fictitious engagement notice of the betrothal of "Y. Hever" (Brenner's pseudonym) to "Mary Magdalene" below.

מרים מגדלינה. י. חבר.

מְאוֹרָשִׂים

יסו נצרת

An engagement notice:
We wish our friends Miriam Magdalena and Y. Hever all the best for their engagement. We have donated the price of the telegram to the printers' fund of our delegation.

Bethlehem The Members of the Association

THE FIRST FOOTHOLD IN THE JEZREEL VALLEY

The large and generally flat Jezreel Valley in the northern part of the country attracted the first Jewish pioneers and settlers, although it was desolate and marshy in parts. Most of its land belonged to a wealthy effendi, named Sursuk, who lived in Beirut. At the beginning of the century, the Zionist movement made efforts to obtain a charter for the land in the region, but was unsuccessful.

In 1910, the foremost Zionist land purchaser, Yehoshua Hankin, saw an opportunity to acquire an area of 10,000 dunams (2,500 acres) in the central part of the valley, on behalf of the Zionist Organization's Palestine Land Development Company. The Jewish National Fund was allocated a third of the area for the purpose of establishing a cooperative settlement ("cooperatsia") – based on a plan developed by Prof. Franz Oppenheimer – while the rest would be sold to private buyers – according to a plan projected by Dr. Ruppin, the head of the Palestine Office, and Hankin. The official transfer of the land to Jewish ownership was fraught with obstacles stemming from the opposition of the governor of Nazareth. Only with great perseverance, along with considerable *baksheesh*, was the matter finalized, and in early 1911 the first parcel of land passed into Jewish hands. A few months later, Merhavya, the first Jewish settlement in the Jezreel Valley, was founded.

△ A view of the Jezreel Valley. In 1911, Jewish settlement is initiated in the region.

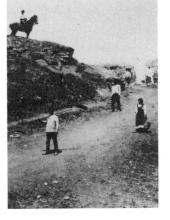

◁ The first Jewish settlement in the valley – Merhavya. As the Arabs oppose the establishment of the settlement, Hashomer guards attend to its security.

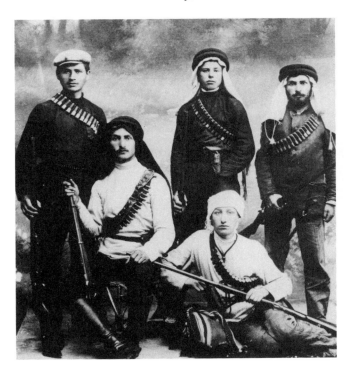

△ A group of Jewish guards in Kfar Saba, 1911. The Hashomer association stimulates the spread of Jewish self-defense. The guards also protect the established towns of the Yishuv.

▷ An Arabic caricature of 1911: Hankin "pours money" into an anonymous Arab hand in the valley, while Salah al-Din, the Muslim conqueror, warns him to get out.

◁ The first participants in the
Young Women's Farm at
the Kinneret training farm,
the first institute training
women for agriculture.

▽ The main street of Tel-Aviv,
named after Herzl. The
Gymnasia Herzliya can be
seen, and a camel – ap-
parently visiting.

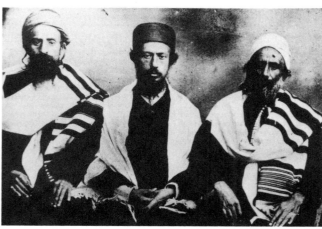

◁ Shmuel Yavne'eli as a
pioneer (r.). Above

Yavne'eli (c.) as a rabbi,
during his mission to Yemen.

YAVNE'ELI'S MISSION TO YEMEN

Shmuel Yavne'eli's mission to Yemen was undertaken in light of a debate that emerged during the Second Aliyah period about the poor quality of Jewish labor. Citing a distinction between "natural" and "idealistic" workers, the pioneers of the Second Aliyah, who saw themselves as the latter, realized that the quality of their labor failed to measure up to that of the Arab workers employed in the established village farms, and conceived the idea of finding Jewish "natural" workers capable of hard labor under harsh conditions.

Their search led to the industrious Jews of Yemen, who had immigrated as early as the time of the First Aliyah. With the support of the Palestine Office of the Zionist Organization, an idea took shape to bring wor-

kers from Yemen to Palestine. Late in 1911, Shmuel Yavne'eli, a leading figure of the Second Aliyah, was sent to Yemen, disguised as a Sephardi rabbi in order to spread the idea of immigration to Palestine. Traveling from village to village for a period of a year, equipped with a letter from Rabbi Kook, he aroused excitement and enthusiasm everywhere.

Subsequently, some 2,000 Yemenite Jews immigrated to Palestine, many of them settling in the villages of Rehovot, Rishon Lezion, Hadera, Zikhron Ya'akov and others. As expected, they worked industriously in the Jewish farms, hardly complaining or protesting, in spite of low wages and harsh conditions.

△ The leaders of the Tel-Aviv Committee, 1911. Place: Dizengoff's house on Rothschild Boulevard. Below, the four guards of the neighborhood.

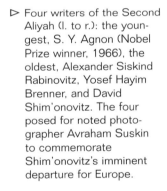

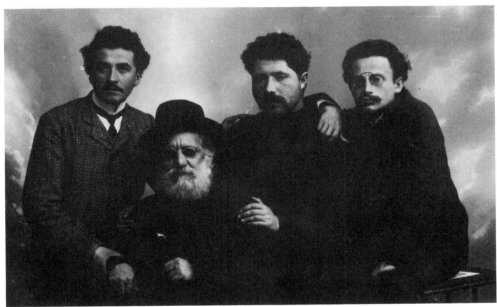

▷ Four writers of the Second Aliyah (l. to r.): the youngest, S. Y. Agnon (Nobel Prize winner, 1966), the oldest, Alexander Siskind Rabinovitz, Yosef Hayim Brenner, and David Shim'onovitz. The four posed for noted photographer Avraham Suskin to commemorate Shim'onovitz's imminent departure for Europe.

THE BRENNER INCIDENT

The affair began late in 1910 with the publication of a short piece by Yosef Hayim Brenner in a labor weekly, *Hapo'el Hatza'ir* ("the Young Worker"). In it he expressed the opinion that conversion to Christianity by Jews in Europe was nothing to be alarmed about, for it posed no danger to the Jewish people. Airing his views on related issues, he commented, among other things, that he did not consider the Bible to be the "book of books," "holy scrip-ture", or the "eternal book."

Brenner's article evoked a storm. The Hovevei Zion ("Lovers of Zion") Committee in Odessa announced cessation of its modest monthly support for the labor periodical and demanded the replacement of its editorial board. Ahad Ha'am and most literary figures in the Eastern European Jewish world were outraged. Feelings ran high in the Yishuv as well, whether in justification or condemnation of the writer. Nearly all intellectuals and artists in formation denounced the crude interference of the Hovevei Zion Committee and advocated true freedom of expression in the country to be, even for nonconformist views.

Following this highly charged debate, the stature of the emergent literary and cultural milieu created during the Second Aliyah period was actually enhanced, with *Hapo'el Hatza'ir* turning into a literary and political publication of importance.

1912

January
23 Yosef Vitkin, the educator who in *Kol Koreh* infused young Jews with a desire to immigrate to Palestine, dies at age 36. He is considered one of the founders of the labor movement and a forerunner of the Second Aliyah.

Contractor Shmuel Wilson, an immigrant from the U.S.

March
3 (14 Adar 5672, Purim) The Hadassah Organization of America is founded in New York at the inspiration of Henrietta Szold. Because of the Purim holiday, the organization takes Queen Esther's other name – Hadassah. The

organization will play an important philanthropic role in Palestine and Israel.

April
11 The cornerstone-laying ceremony for the Technion in Haifa is held, marking an important milestone in higher education in the country and in the growth of Jewish Haifa.

The Rehovot Games, held annually at Passover, evolve into a kind of national holiday for the new Yishuv in Palestine. The event includes sports competitions, exhibitions, and the weddings of three Hashomer ("The Watchman") couples.

May
17 The Jerusalem-based weekly, *Haherut*, becomes a daily.
28 Agudat Israel, the world federation of ultra-Orthodox Jews opposed to Zionism, is founded in Kattowitz, then in Germany.

June
The Sephardi and Ashkenazi communities of Haifa announce their unification into a single body.

July
The Palestine Office of the Zionist Organization reports that 1,200 immigrants from Yemen have arrived in the country during the first half of 1912.

August
1 A new development in the field of education: an extension course for teachers is held in Zikhron Ya'akov with the

participation of over 100 men and women teachers. The intention is to offer the course annually.

September
The attitude of the Arab population toward the Jews worsens. Violence and attacks occur in Merhavya, Sejera, Gedera, and elsewhere. *Ha'ahdut* ("Unity") reports at

Two Hashomer guards. The organization plays an increasingly vital role in 1912.

the end of August that the Sublime Porte in Istanbul has ordered the governors in Palestine to assure public order.

October
1 The Maccabi sports associations of Jaffa, Jerusalem and Petah Tikva, which have been operating since 1906, form the Maccabi National Sports Federation.

Hashomer takes on the guarding of Rishon Lezion.
23 Yoel Moshe Salomon, pioneer journalist, a leader of

the Yishuv in Jerusalem, and a founder of Petah Tikva, dies at 74.

November
16 Hashomer head Israel Shohat, sends a memorandum to the Zionist Executive Committee outlining a first-time overall plan for the defense of the Yishuv.

December
5 The village of Ruhama is established in the northern Negev, marking the southernmost settlement point of the Jewish Yishuv in Palestine.

S. Y. Agnon's first book, *And the Crooked Shall be Made Straight*, appears.

The Poriya farm is established in the Lower Galilee, the first settlement founded as part of the Ahuzot ("Estates") Plan.

A daring retaliatory raid is carried out by Hashomer in Hadera against the Damayera Bedouin tribe for harassment of Jewish farmers and guards. It is dubbed "the first act of reprisal in 2,000 years."

Among the immigrant pioneers arriving during the year is Yosef Trumpeldor, later to play a heroic role in Jewish self-defense. He

An advertisement for the contractor Wilson.

works at the village of Migdal and later at Deganya.

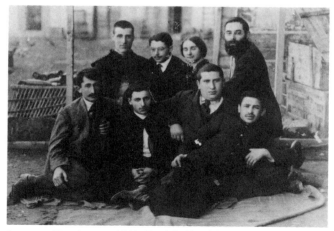

A group of immigrants, 1912. Top left: Yosef Trumpeldor.

▷ The "Yavne'eli Aliyah" begins to arrive. Shown, immigrants from Yemen.

▽ A Yemenite immigrant guards the Ben-Shemen farm.

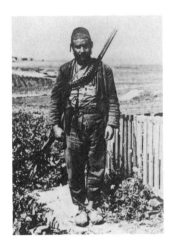

▽ The Rishon Lezion orchestra performs at the Rehovot Games, held at Passover, 1912.

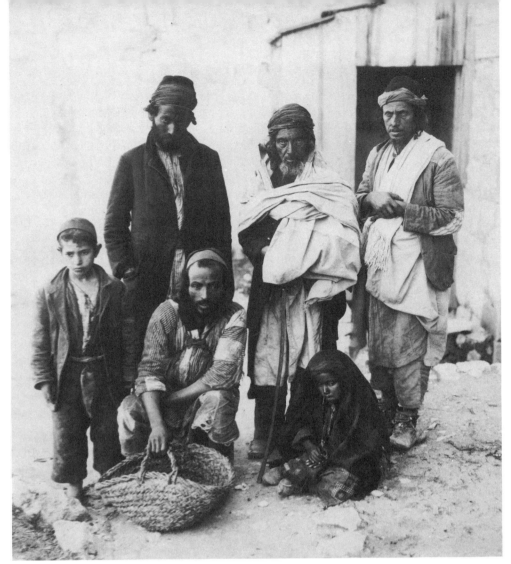

THE AHUZOT ("ESTATES PLAN")

Seeking ways of attracting private capital to the country, the Palestine Office of the Zionist Organization, headed by Dr. Arthur Ruppin, developed the Estates Plan by which Jews in the Diaspora who were planning to immigrate to Palestine in the future would invest in plantation companies in the country.

Each investor would make regular payments to the company while continuing to reside abroad. Meanwhile, the plantation would be developed by the company, at the same time providing work for local laborers. In an estimated ten years, the investors could move to the country, settle on their estate, and support themselves by the produce of their groves or vineyards.

Sixty such investment groups were organized during 1910–14 in Russia, England, and the United States for the development of estates, but only five began to implement the idea in practice. The first companies to be established were in Poriya in the Lower Galilee and Ruhama in the south. Although the project did not fulfill its initiators' hopes, it contributed toward land purchase, investment of Jewish capital in the country, and the creation of jobs, while expanding Jewish-cultivated areas.

The outbreak of World War I in 1914 terminated the initiative. One estate, however, would be imprinted on the map of Israel. The Ahuza A group from New York, which intended to settle in the Sharon area, realized its aim after World War I and founded Ra'anana. Its main street is called Ahuza.

◁ The Second Aliyah workers struggle with the farmers in the agricultural settlements to be accepted as farmhands. Shown, two such workers in Rehovot.

▽ Probably the best-known photograph of the Second Aliyah labor movement: Deganya, the first kibbutz established in Eretz Israel. All the members gather for a group portrait by a photographer who has come specially from Jaffa.

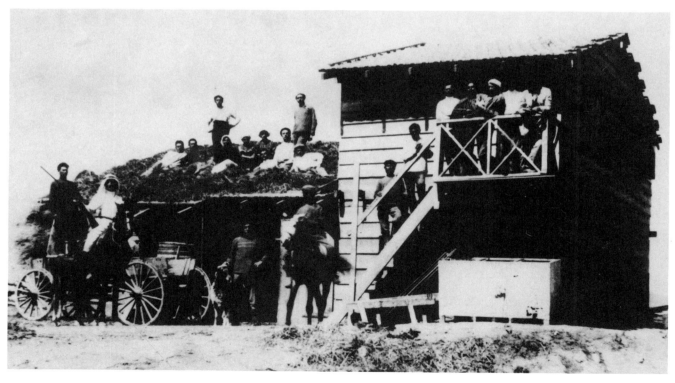

▽ A workers' infirmary, a first step toward the establishment of the Kupat Holim Klalit ("General Sick Fund").

▷ *Layehudim* ("For the Jews"), a humorous paper, strikes at the Turkish constitutional rule.

We have a few small settlement points in the country, and their number will certainly increase.... These points are our Eretz Israel, and in them we find fulfillment of spirit and balm for our national ills... a new national atmosphere unparalleled anywhere in the world.

Ahad Ha'am, 1912.

▽ Despite the opposition of the Muslim waqf (religious trusts body), the Jewish community of Jerusalem receives official permission from the Turkish authorities to set up benches for prayer at the Western Wall.

THE MERHAVYA "COOPERATSIA"

The Merhavya cooperative was a unique settlement experiment inspired by the ideas of Prof. Franz Oppenheimer, a German Jewish expert in agricultural cooperatives whose interest in the idea of Zionist settlement was elicited by Herzl.

According to Oppenheimer's concept, the establishment of the farm necessitated several stages. The first involved establishing a large agricultural farm to be managed by a trained agronomist, in which workers would receive salaries and profits based on individual achievement. In the second stage, which would take place after a trial period and the accumulation of capital, the workers would take responsibility for running the farm. In the third stage, which would mark the formation of the cooperative, the members would decide on an optimal lifestyle – cooperative or independent farms.

The experiment failed, largely as a result of disputes between workers and management. Financial losses and other difficulties increased. In 1914, a group of workers took over the farm in Merhavya, but they too failed. Eventually, the hardships of World War I put an end to the experiment, and the cooperative in Merhavya broke down altogether. Only in 1929 was a permanent settlement established on the site – Kibbutz Merhavya.

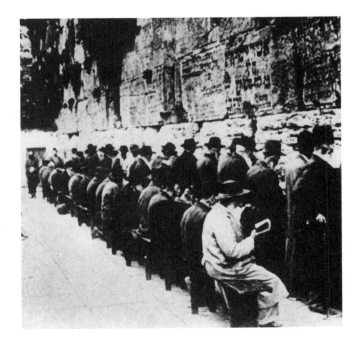

1913

January
15 The cornerstone is laid for the second workers' settlement, Nahlat Yehuda, near Rishon Lezion.

March
15 Yehiel Michael Pines, an outstanding figure of the First Aliyah period and one of the earliest religious Zionists, dies. He assisted the Bilu pioneers in establishing the village of Gedera. He also wrote the lyrics for the song "*Hasten, Brothers, Hasten*," a Zionist favorite in Palestine and the Diaspora.

Hashomer guards leave Hadera after a dispute with the farmers.

A view of Rishon Lezion, 1913. The village cowherd has just returned from the pasture.

April
30 A cornerstone-laying ceremony takes place near the Tel-Aviv neighborhood for the third new Jewish quarter, north of Jaffa – Hevrah Hadashah ("New Company") – later, the Allenby Street area.

July
23 Arabs from the village of Zarnuga attack neighboring Rehovot.

August
13 The first graduating class completes its studies at the Gymnasia Herzliya in Tel-Aviv. A spokesman for the class pledges in the name of his fellow students that they will devote their lives to the national cause in Eretz Israel.

September
2-9 The 11th Zionist Congress meets in Vienna. Jewish settlement in Palestine is discussed. Dr. Hayim Weizmann presents plans for the establishment of a university in Jerusalem.

October
Hashomer guards leave Rehovot, at the same time establishing Tel-Adash, the second Jewish settlement in the Jezreel Valley.

The Gid'onim (Gideonites) society is founded in Zikhron Ya'akov by the sons of the original farmers for the purpose of self-defense and the advancement of the villages, as an alternative to Hashomer, which is identified ideologically with the labor movement.

23 A crisis develops over the opening of the Technion in Haifa when its board of governors, in Berlin, decides that the language of instruction in the sciences will be German, marking the start of the "Language War" in Palestine.

November
2–3 Two Turkish pilots fly the first airplane in Palestine skies.

19 The "Rabbis' Tour" is begun by five rabbis of Palestine, led by Rabbi Kook, who embark on a trip through the country aimed at bridging the gaps between the old and new Yishuv.

22-24 Two murders of Jews by Arabs in the Jordan Valley shock the Yishuv. The first victim, on November 22, is Moshe Barsky, killed near Deganya. The second, two days later, is Yosef Zaltzman, near the village of Kinneret. A baby born to Devora and Shmuel Dayan of Deganya in May 1915 – Moshe Dayan – is named for Moshe Barsky.

December
14 The Language War reaches a climax. The Hebrew Seminary for Teachers in Jerusalem is established as an alternative to the seminary sponsored by the German Esra organization, which is on strike over the language issue. Teachers and pupils in most of the other Esra schools leave and establish Hebrew schools.

Negotiations are begun to purchase the estate on Mount Scopus belonging to Lord Grey-Hill as the site for the future Hebrew University of Jerusalem.

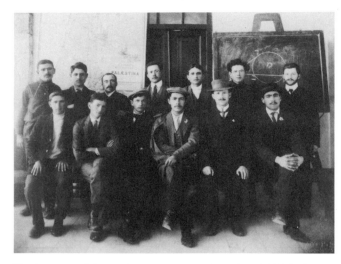

The first year of the teachers seminary in Jerusalem, 1913. In the first row, third from right, A.L. Sukenik, later a notable archeologist.

The laying of the cornerstone for a new neighborhood near Tel-Aviv – Hevrah Hadashah ("New Company")

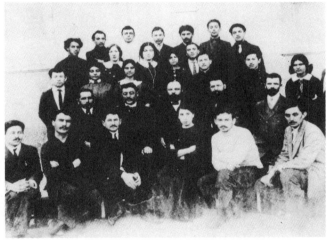

△ Matriculation certificate of an outstanding graduate, Dov Hoz, later to become a leader of the Haganah.

▷ The first graduating class of the Gymnasia Herzliya, 1913.

△ The Kesari brothers, 1913. At left: Uri, later a prominent journalist.

▷ Two sons of village settlers, 1913. At left: Avshalom Feinberg, later to play an active role in the Nili organization.

△ The Rabbis' Tour to the north of the country. Rabbi Kook is seated at the center.

▽ Plowing in the new settlement of Nahlat Yehuda, 1913.

THE RABBIS' TOUR

In late 1913, Rabbi Avraham Itzhak Hacohen Kook, the rabbi of Jaffa and the villages in the region, became convinced that action must be taken to eliminate the barriers between the new and old Yishuv that had developed over the past 30 years. He decided to organize a tour of the established villages and agricultural settlements of the new Yishuv, to try to bridge the widening gap.

For this purpose, he recruited four Jerusalem rabbis to join him: Yosef Hayim Sonnenfeld, a leader of the Hungarian kolel and later head of the ultra-Orthodox community; Ben-Zion Yadler; Ya'akov Moshe Harlap; and Yonatan Binyamin Horowitz.

The five rabbis traveled from Jaffa to Metula in the north by carriage, horseback, train, and boat on a tour that lasted nearly a month, visiting a total of 20 new settlements with the aim of bringing about a religious revival in communities which, in the rabbis' view, had distanced themselves from religion. They did not meet with much success, however, except for the supply of religious articles to the villages. In most places they were challenged by the local teachers, who were not about to revert to the heder and the talmud torah – the traditional religious schools that taught religious texts exclusively – as the rabbis demanded. The farmers, including those who were religiously tradition-minded, generally supported the teachers' view.

Rabbi Kook made further attempts in the following years to be in contact with the pioneers while most of the other rabbis opposed them. The gap between the established tradition-oriented Yishuv and the new settlements widened from year to year.

▷ Progress comes to Tel-Aviv in the form of the "diligence" service, conveying passengers to and from Jaffa several times daily. In his complaint (below), Rabbi Kook disapproves of the operation of the diligence on the Sabbath.

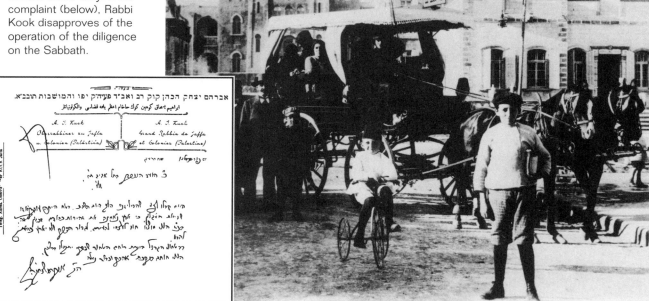

▽ A group of young Jewish Palestinians studying law in Istanbul. Seated, second from left: Itzhak Ben-Zvi, who will serve as second president of the State of Israel.

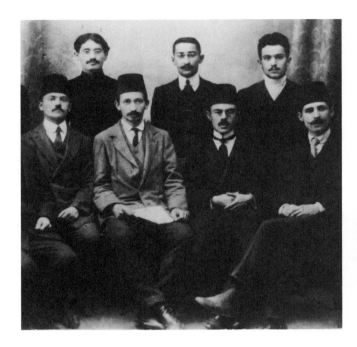

△ Merhavya is built and operated on the "cooperatsia" principle, developed by Prof. Franz Oppenheimer.

THE LANGUAGE WAR

From the start of the revival of Jewish settlement in Palestine, the use of Hebrew, especially in the educational system, was the subject of contention. Intellectuals, journalists, writers, and educators made every effort to ascribe a superior position to Hebrew, and to supress other languages. The conflict came to a head in late 1913, when the board of directors of the Technion, then under constuction in Haifa, decided that the language of instruction for scientific subjects would be German, whereupon the Zionist contingent of the board resigned in protest.

A storm of controversy broke out in the Yishuv. Leading the struggle were the students of the Esra teachers seminary and school in Jerusalem – part of a German Jewish network of educational institutions that also sponsored the establishment of the Technion. The students declared a strike that encompassed the entire Esra school network and were joined by some of the teachers. They were given full backing by the Hebrew Teachers Association, which rejected the very existence of an educational network that taught in German. The struggle lasted several months. Eventually, alternative institutions of education, bearing a national Hebrew character, were founded in Jerusalem, Haifa, and Jaffa supported by the Zionist Organization.

In the wake of the protest, the decision regarding the Technion was altered, and the language of instruction for most of the subjects was to be Hebrew. This decision could not be implemented, however, for the outbreak of World War I in 1914 delayed the opening until 1925, by which time the curriculum was entirely in Hebrew.

▽ An advertisement in the Jerusalem press in 1913: *A Powder That Will Enhance Longevity.* The Hebrew text lists all the ailments for which the medicine is intended, in addition to the credentials of the inventor and the approval of the Academy of Medicine in Vienna.

△ The Jewish villages produce the first generation of "sabras" (native-born Jews of Eretz Israel) – young people who are courageous and physically fit, prepared to take on any challenge. Shown, sabras from Rehovot.

אבסה לאריכות החיים.

של חדיר וילהילם אייכלר.

מאושרת ע"י האקדמיה לרפואת בוינה.

Poudre de Longue Vie
du Dr. W. EICHLER.
Approuvée à l'Académie de Medécine
Mention Honorable à VIENNE.

נבשר לתקהל הנכבד וביחוד להקהל הארצי־
ישראלי בכלל כי הובאה תרופה למחלות שונות
כמו מחלת האצטומכא, הכבד והמעיים והיא
המצאת חדיר וילהילם איכ'ר „אבקת החיים"
שנתאשרה ע"י האקדמיה לרפיאה בוינה—לרפ:

1914

February

15 Baron Rothschild begins his fourth visit to Palestine, after an absence of 15 years. He is welcomed warmly everywhere. Among other places he visits Rothschild Boulevard in Tel-Aviv, built five years before, where the trees planted along the street are waist-high.

March

11 A Turkish airplane crashes in Palestine while taking off along the Tel-Aviv shore and both pilots are killed. The Jewish community of Jaffa announces that it will collect funds for the Turkish air force to acquire a new plane.

April

The founding ceremony for a municipal hospital in Tel-Aviv is held. However, the impending war will delay construction until the postwar period.

May

10 Israel Dov Frumkin, an outstanding figure in Jerusalem and editor of the weekly *Havazelet* ("Lily") for some 40 years, dies. He was an advocate of the modernization of the Yishuv within the ultra-Orthodox sector.

June

A Jewish-Arab conference to resolve the conflict between the two sides in Palestine is scheduled to be held at the beginning of July in Bromana, near Beirut, with the participation of ten delegates from each side. Nahum Sokolov is to lead the Jewish delegation. The conference, however, does not take place, partly because of prewar tension.

July

By mid-1914, the population of the Jewish Yishuv reaches a new peak: 85,000, compared to 25,000 thirty years previously. There are 48 agricultural settlements, with the plantation areas of the Jewish villages taking up 71,000 dunams (17,750 acres). Nearly half the area is devoted to almond cultivation; some 20% to wine grapes; 15% to olives; and 13% to citrus.

28 World War I breaks out.

August

Palestine is plunged into an economic crisis. The Turks halt sea transport and the country is cut off from Europe. A general economic moratorium is declared: debts are postponed and economic activity is frozen.

7 A Temporary Committee for Crisis Relief is organized in Jaffa, headed by the chairman of the Tel-Aviv Committee, Meir Dizengoff.

September

8 The Turks revoke the Capitulation agreements, bringing an end to the dependence of large numbers of Jewish inhabitants on foreign consuls. Subjects of countries aligned against Turkey must decide whether to leave Palestine or become Ottomanized, i.e., accept Ottoman citizenship. An Ottomanization movement begins in the Jewish Yishuv.

October

6 The U.S. warship North Carolina anchors at Jaffa. It brings $50,000 in aid for the Yishuv from the American Jewish community.

30 Turkey enters the war on the German and Austrian side. Palestine, as part of the Ottoman Empire, becomes a party to the war.

November

10 The Turks initiate a search campaign for weapons in the Jewish settlements. Tel-Aviv and the villages in the south are searched first.

The membership of the Po'alei Zion ("Workers of Zion") party, including Hashomer guards, seeks to demonstrate loyalty to the government. They lead efforts to establish a Jewish militia that will fight alongside the Turks. Israel Shohat, David Ben-Gurion and Itzhak Ben-Zvi are involved in these efforts.

December

6 The Turks arrest Mania Shohat.

7 The sum of 10,000 Francs, collected by the Jews of Jaffa, is transferred by Meir Dizengoff to the governor of Jerusalem for the purpose of acquiring a new airplane (see March 11).

Dr. Hayim Weizmann begins talks with the British government about the future of Palestine.

17 "Black Thursday" in Jaffa and Tel-Aviv. Hundreds of Jews are expelled from the country by the Turks indiscriminantly.

18 The heads of the new Yishuv, Meir Dizengoff and Arthur Ruppin, telegraph the German and American ambassadors in Istanbul with an urgent request for their intervention on behalf of the Yishuv.

23 The governor of Jaffa, Baha al-Din, is relieved of his post for his role in expelling the Jews.

24 The American cruiser Tennessee stops in Jaffa and takes on Russian subjects bound for Egypt.

Most of the Jewish press in Palestine is closed down by the Turks at the end of December. Only the Jerusalem-based *Haherut* ("Freedom") is permitted to continue publication.

28 Dr. Hayim Weizmann meets with Baron Rothschild in Paris and is advised that in light of Turkey's entry into the war, overt efforts should be made to establish a Jewish state under the sponsorship of Britain.

The first movie house – the Eden – opens in Tel-Aviv.

The American Standard Oil Company receives a franchise from Turkey for oil exploration in Palestine. The first survey is conducted in the Negev Desert.

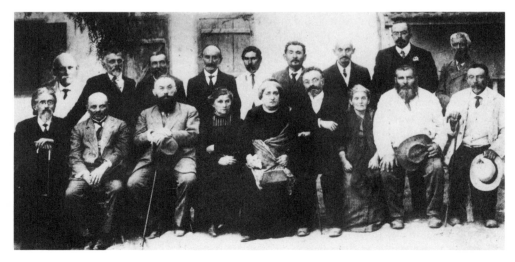

Founding fathers of the Bilu generation who arrived in Palestine in 1882 gather in Gedera in 1914 for a historic photograph. This group laid the foundations for the State of Israel. Seated in the 1st. row, from left to right: M. Meirowitz, I. Belkind, Z.D. Levontin, F. Feinberg-Belkind, F. Hisin, H. Hisin, H. Zlelikhin-Benenson, Y. Zlelikhin, D. Leibowitz. Standing, from left to right: M. Stein, S. Belkind, Z. Horwitz, Y. Drubin, S.Z. Zuckerman, B. Fuchs, E. Sverdlov, A. Solomiak, Y.S. Hasnov.

△ Baron Edmond de Rothschild visits the country after an absence of 15 years. Shown here in Yavne'el in the Lower Galilee.

▷ Another guest is the American ambassador in Istanbul, Henry Morgenthau.

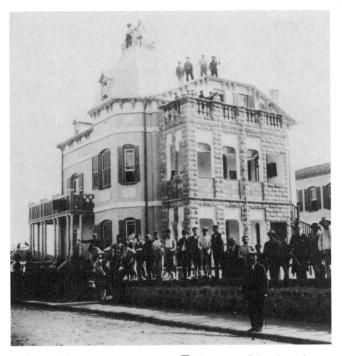

△ One of the imposing buildings in Tel-Aviv, shortly before the outbreak of World War I. Guests of honor are brought to see the new neighborhood.

▽ The map of the Jewish Yishuv, 1914. The Jewish settlements are concentrated in three main blocs: Judea (south), the Shomron (south of the Carmel), and the Galilee.

▽ David Ben-Gurion, who will become Israel's first prime minister, as a law student completing his second year of studies at the University of Istanbul.

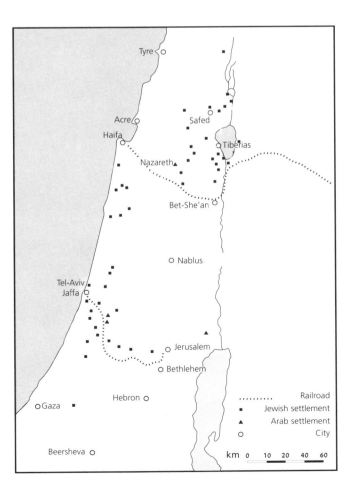

▽ A new immigrant to Palestine in 1914: Mendel Beilis, exonerated after years of an infamous blood libel trial in Russia.

"BLACK THURSDAY"

Thursday, the sixth day of Hanuka 5675, December 17, 1914, began in Jaffa and its Tel-Aviv neighborhood as a day of the usual distresses, in light of the wartime restrictions, and ended as one of the blackest days that the residents of the city had ever known.

That Thursday, the Turks decided to expel on the spot anyone who refused to become Ottomanized. Turkish soldiers and policemen spread out in the Jewish neighborhoods during the afternoon and dragged away every Jew they caught, even those who showed certified proof of Ottoman citizenship. Hundreds were loaded onto a waiting Italian ship bound for Egypt. The cries of the deportees and their helpless relatives on shore were heartbreaking, but the Turks were unmoved.

As an immediate consequence, emigration intensified, with hundreds and later thousands leaving the country as a precautionary measure. Within a few months, the Yishuv drastically shrank in size. Most probably, it was what Jamal Pasha had sought to achieve.

מתבקש שומר!

המושבה שרונה הסמוכה ליפו
מבקשת שומר יהודי חרוץ שיקבל עליו את השמירה
במושבה—בפרדסיה ושדותיה.
הרוצה ומוכשר לקבל עליו הנהלת השמירה הזאת, יפנה תיכף
לראש ועד המושבה ה' יוהנס ויניגל עפ"י הכתבת דלמטה:
Herrn Johannes Wennagel, Sarona bei Jaffa.

▷ Four young Jews of the Second Aliyah, which ended in 1914. Top to bottom: Zvi Nisanov, a Hashomer member; Mania Shohat; the poet Rahel; Moshe Shertok (later, Sharett).

△ Evidence of the superiority of Jewish guards: The German Templer village of Sharona advertises for a Jewish watchman.

◁ Eden, the first movie house, is opened in Tel-Aviv. In the notice, the administration promises "pictures in outstanding beauty and content" to the public.

△ A diligence in Rehovot, the main means of public transport in 1914, caricatured by the young artist Arthur Schick, then visiting Palestine.

THE FIRST MONTHS OF THE WAR

As of the summer of 1914, World War I cast a heavy shadow over Palestine, even though it was at first conducted far away. The cutoff from Europe was immediate and nearly total, with the Yishuv – especially the religious sector – paralyzed by the cessation of the flow of monies from Europe. The new Yishuv suffered as well from the inability to export agricultural produce and import foodstuffs and fuel. Moreover, soon after the outbreak of the war, the Turks declared a moratorium, i.e., the deferment of debt payment. The banks closed, the value of the Turkish pound dropped, and prices rose rapidly.

The old Yishuv was in a state of shock. The new Yishuv, however, soon recovered, setting up a relief committee as early as August 7, 1914.

At first Turkey did not align itself with either side in the conflict. It did, however, take two highly significant steps during the fall of 1914. The first was the abolishment of the Capitulations, which had granted such extra rights to foreign subjects as exclusive jurisdiction by their consul. Since the majority of the Jews of Palestine retained their former nationalities, the Turkish decision meant a drastic and dangerous change for many thousands of inhabitants. From then on, they were at the mercy of the Turkish authorities and at risk for confiscation of property, harassment, and induction into the army.

The second step taken by Turkey, in late October 1914, was its alliance with the Central Powers – Germany and Austria-Hungary – and its declaration of war against the Entente Powers – Russia, France and Britain. Citizens of the latter countries had to choose between leaving Palestine immediately or "Ottomanization" – accepting Turkish citizenship.

Neither option was desirable to most of the population. The situation deteriorated further in the winter of 1914-15, when the Turks outlawed Zionist signs and symbols. Hunger spread. No wonder hundreds, and later thousands, of settlers chose to leave.

△ With the abolishment of the Capitulations, the need for the kavass – the consular guard – rapidly disappears.

▽ A temporary bank note issued by the Anglo-Palestine Bank.

▷ The Aaronsohn family of Zikhron Ya'akov, photographed before the forthcoming marriage of daughter Sara (center) to Hayim Avraham (to her left). The family is to be closely identified with Nili, the spy ring for the British.

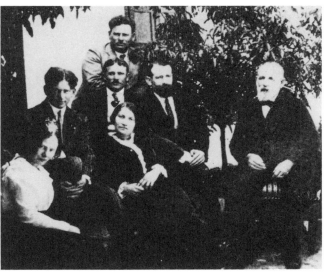

1915

January

Both the American and the German ambassadors in Istanbul – Morgenthau and von Wangenheim, respectively – come to the aid of the Jewish Yishuv.

Deportees from Palestine who fear imprisonment and persecution by the Turks, among them Eliezer Ben-Yehuda and his family, sail for Egypt and from there to the United States. They will return to Jerusalem in 1919.

14 The former governor of Jaffa, Baha al-Din, becomes political advisor to Jamal Pasha, commander of the Turkish army in Palestine and in effect governor of the country. He bans every Zionist symbol or reference, including Hebrew signs and Jewish National Fund stamps. The Turkish authorities' anti-Zionist stance becomes more pronounced.

18 The Turks arrest Israel Shohat and Yehoshua Hankin. Together with Mania Shohat, they are later exiled in Turkey for the duration of the war.

Jamal Pasha summons thirty Yishuv leaders to Jerusalem, and threatens to expel them to Turkey. But then he relents and declares that only half of them will be expelled to Tiberias, for two weeks.

February

3 The British army repels a large-scale Turkish attack from Sinai at the Suez Canal.

9 David Ben-Gurion and Itzhak Ben-Zvi are arrested in Jerusalem by the Turks. Husni Bey, a Turkish police officer, is brought to Palestine to interrogate Yishuv leaders and officials suspected of "Zionist subversion." Hassan Bey, governor of Jaffa, persecutes the Jewish residents of Jaffa and Tel-Aviv.

28 A "royal" visit to Jaffa and Tel-Aviv by Jamal Pasha. He is impressed by the Gymnasia Herzliya and complimentary about Tel-Aviv.

March

10 Locust swarms invade Palestine. Waves of locusts will continue to invade the country for three months, causing severe damage to agriculture. Jamal Pasha appoints Aharon Aaronsohn, the agronomist, to head a locust-control task force.

17 David Ben-Gurion and Itzhak Ben-Zvi are expelled by the Turks to Egypt. They proceed from there to the United States. Another of the numerous deportees is Dr. Ben-Zion Mossinson, principal of the Gymnasia Herzliya.

April

1 The soldiers of the Zion Mule Corps are sworn in to the British army in Alexandria, Egypt. Most of them are Jewish deportees from Palestine. The corps is organized by Vladimir (Ze'ev) Jabotinsky and Yosef Trumpeldor, the latter serving in it as an officer. In the middle of the month, the Zion Mule Corps is sent to the front at Gallipoli, Turkey.

The Nili underground is formed when Aharon Aaronsohn and Avshalom Feinberg travel to Egypt to make contact with the British.

10 Jamal Pasha visits Rishon Lezion and grants it the dune area to the west.

The Turks confiscate pumping engines and irrigation pipes from Jewish villages.

21 The American navy vessel Vulcan arrives at Jaffa bringing food supplies to the Yishuv. The Turks claim a substantial part of the shipment, but the American consul, together with two representatives of the American Jewish community who accompany the shipment, refuse to hand it over.

May

The situation in Palestine is grave. The population faces hunger, persecution by the Turks, and disease. The old Yishuv is in a particularly desperate situation as a result of the cutoff of Halukah funds from Europe.

The American navy vessel Vulcan returns with a large cargo of food donated by the American Jewish community. An agreement is reached with the Turks whereby half the

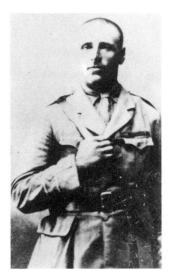

Yosef Trumpeldor in British uniform.

supplies will be distributed to the non-Jewish population and to government officials. The foodstuffs, as well as money that has also been sent, help the Yishuv survive. Other ships are permitted to anchor thereafter.

July

14 The British high commissioner in Egypt, Sir Henry McMahon, initiates a correspondence with Sharif Hussein, ruler of Hejaz, that continues until January 1916. In it he pledges, in the name of the British government, to recognize Arab independence. The territories in Lebanon populated by Christians, and all of Palestine, are excluded.

August

15 Eleven Arab communal officials in Syria, accused by the Turks of maintaining ties with foreign governments, are publicly hanged in Damascus.

September

American ships continue to arrive, bringing food supplies and evacuating both deportees and departees. The population of the Jewish Yishuv decreases by over 10,000, or some 12%.

16 The committee of Rishon Lezion asks Jamal Pasha for the dune area he has promised them. Their request is granted.

November

8 The American ship Des Moines brings money contributed by the American Jewish community to sustain the Yishuv. The Turks claim a part of it. A war of nerves is triggered and the ship remains unloaded.

12 The American ambassador in Istanbul gives instructions to the captain of the De Moines not to hand the money over to the Turks and to leave the port in case they refuse to forward the money to its addressees.

15 A compromise is reached concerning the money on the De Moines.

It is delivered to the American consul, Glazebrook, while the list of addressees is passed to Hassan Bey, governor of Jaffa.

A Palestinian soldier in the Turkish army, Na'aman Belkind.

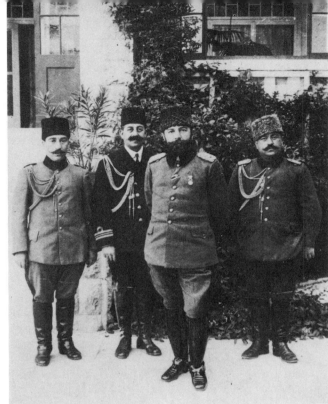

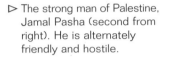

▽ The "eighth plague," locusts, descends on Palestine for a period of several months. They devour everything, even the prickly sabra branches (below). Thousands fight the plague by every possible method, including waving flags and banging on cans.

△ Jamal Pasha, (foreground toward r.), visits Rishon Lezion in April 1915.

▷ The strong man of Palestine, Jamal Pasha (second from right). He is alternately friendly and hostile.

THE LOCUST PLAGUE

Fraught as the first year of the war was with hardship and persecution by the authorities, an additional enemy materialized in Palestine, relentless and cruel as the plagues of ancient Egypt – locusts.

One day between Purim and Passover of 1915, the hot and dry hamsin wind from the east brought with it clouds of locusts that descended on every patch of cultivated land. As was customary then, the farmers tried to drive off the locusts by raising a din, and the sight of people standing in fields beating empty cans and pots became commonplace. The attack lasted 12 days, and when nothing green was left, the swarms moved off, heading westward.

The farmers barely revived from the attack when new swarms appeared, to be followed by a third wave that hatched from larvae laid by the previous swarms.

In the Jewish settlements, the farmers managed to repel the locusts by digging canals around the fields and orchards, and filling them with oil and boiling water.

Aharon Aaronsohn, the famous agronomist, was assigned by the Turks to deal with the problem, but even he failed to find a solution. Turkish army units were diverted to fight the locusts, and a state of emergency was declared. School classes were halted, and the authorities demanded that each inhabitant collect 20 kg of locusts a day. The plague and the damage it caused preoccupied the entire country for weeks.

A fourth and final swarm descended shortly before the Shavu'ot holiday. When they moved off, every tree in Tel-Aviv was destroyed, and fences and poles were damaged.

Opinion was widespread that the damage to agriculture was irreversable. Yet within several months, most of the planted areas revived: the trees sprouted leaves, and crop yields were acceptable.

The locusts returned in the following years, but their damage was minor compared to that they had caused in 1915.

AMERICAN AID FOR THE YISHUV

The situation of the Jewish Yishuv in Palestine after the outbreak of World War I became increasingly desperate. Links with Europe were severed; the Turks confiscated equipment, work animals and fodder; export ceased; and thousands of people were in danger of starvation.

The leaders of the Yishuv, seeking aid from every possible quarter, approached the American ambassador in Istanbul, Henry Morgenthau, as well as the Jewish community in the United States. Shortly thereafter, Jewish institutions and groups in America organized shipments of money and foodstuffs. With wartime conditions precluding sailings of civilian vessels, the United States government agreed to allocate space on its Mediterranean-bound warships for supplies to Palestine.

The first such ship to arrive, the North Carolina, anchored in Jaffa in October 1914, to be followed by others, including the Vulcan, which carried food supplies, and the Tennessee, which transported deportees from Palestine to Egypt. The Turks attempted to commandeer part of the shipments, especially foodstuffs, which were scarce in the country. On a few occasions, the unloading process took weeks as a result of difficulties posed by the Turks.

By the start of 1916, some $700,000 in currency, food, and equipment had been transferred to Palestine, a vast sum at that time, which saved the Yishuv from starvation.

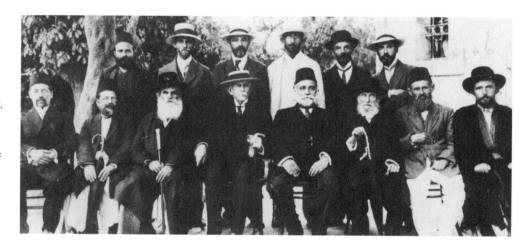

▷ The Aid Committee in Jerusalem includes representatives of the various communities and organizations in the city. One of its active members is the American consul in the city, Alan Otis Glazebrook (seated, fourth from l.), a Protestant clergyman from New Jersey and a friend of President Wilson. Based in Jerusalem during most of the war, he makes special efforts to aid its inhabitants.

I am sometimes plunged in total despair. Perhaps we will not be able to continue this immense undertaking that we have begun. Can we weather this storm that shakes the foundations of our country?

Dr. Arthur Ruppin, 1915.

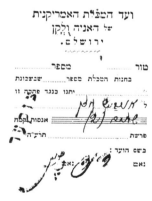

△ A voucher for 2 ounces of sugar brought in by the Vulcan. The ounce is equivalent to 250 gm.

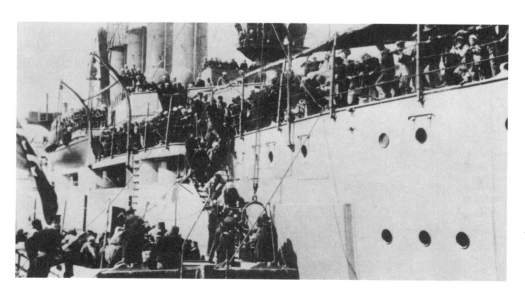

◁ Jewish deportees from Palestine board the Tennessee in Jaffa, bound for Egypt.

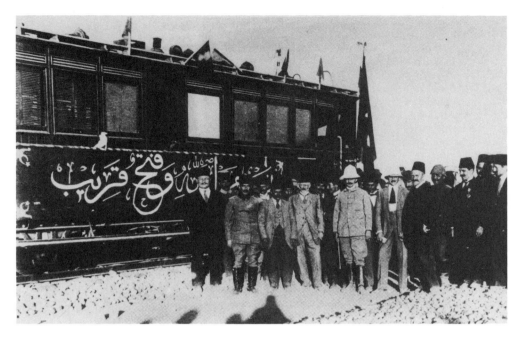

◁ In their attempt to capture the Suez Canal from the British, the Turks develop an extensive logistics network in the Negev and Sinai and lay a railway from the north of the country southward. It reaches Beersheva in October 1915. Meissner Pasha, fourth from l., the German engineer in charge of laying the Damascus-Mecca-Medina line at the start of the century, heads this project as well.

▽ Ottomanization is the key word in 1915. Below, three of the new Ottomans from Tel-Aviv: Meir Dizengoff (c.), Ben-Zion Mossinson, (r.), Hayim Bograshov (l.).

THE ZION MULE CORPS

In Egypt, a group of Jewish deportees from Palestine led by Vladimir (Ze'ev) Jabotinsky and Yosef Trumpeldor broached the idea of forming Jewish fighting units to fight with the British army and take part in the conquest of Palestine from the Turks. About 200 young men gathered around them, ready to join up. The British turned down the proposal but agreed to establish a volunteer mule drivers unit which would function on whatever front needed. Jabotinsky rejected the offer, but Trumpeldor, who was eager to have Jews from Palestine participate in the war effort, accepted it.

As a result, the Zion Mule Corps was established under the command of the Irish Lt. Col. John Henry Patterson, with Trumpeldor serving as his aide. Half the corps was made up of volunteers from Palestine and the rest were Jews from Cairo and Alexandria. The British viewed them as an auxiliary unit only, allocating meager equipment and minimal training to it.

The corps took part in the landing of the British forces at Gallipoli, Turkey, in the spring of 1915. Their mission was difficult and dangerous. They were to deliver water supply and ammunition to the soldiers on the front line, while constantly exposed to the fire of the Turks. The corps suffered casualties of 8 killed and 52 wounded during the course of the campaign. It was disbanded in May 1916, but 120 of its men were transferred to London, where a year later they constituted the basis for the 38th Battalion of the Royal Fusiliers, established at Jabotinsky's initiative.

The Zion Mule Corps was the first Jewish fighting unit "in 2,000 years," as the saying went. All its soldiers and a large number of its officers were Jews.

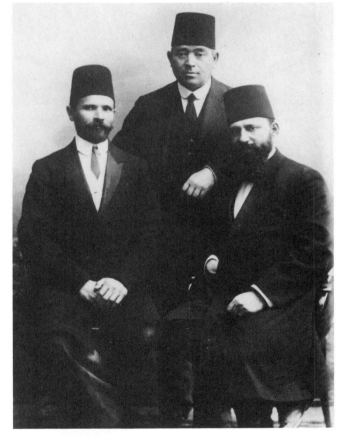

◁ The symbol of the British army's Zion Mule Corps, whose soldiers take part in the British invasion of the Gallipoli Peninsula, Turkey. The invasion fails and the Jewish corps is disbanded.

1916

January
The harsh situation continues. Many settlements are at the point of starvation.

9 Two French warships shell targets in the Haifa port area. Jaffa as well is shelled from the sea. The metal factory owned by Wagner, a German, is hit.

Avshalom Feinberg, a leader of the Nili.

The British army advances through Sinai toward Palestine. Shown, a Scottish soldier in military kilt, and pack camels.

February
Locust swarms descend on the country once again.

March
The value of the Turkish pound note plummets. Many inhabitants transact commerce in gold and silver coins only.

17 A large exhibition opens at the Gymnasia Herzliya despite the crisis, celebrating 25 years of work of the poet Hayim Nahman Bialik.

April
14 Moshe Azriel, publisher of *Haherut* ("Freedom"), the only newspaper to appear in the country at this time, dies of typhus in Jerusalem. The paper subsequently appears irregularly.

19 The draft of high school graduates into the Turkish army begins. Some are arrested as soon as they report to induction centers and are released only after the intercession of parents and relatives.

May
6 More public hangings in Damascus and in Beirut: 21 prominent persons in both cities are executed by the Turks for charge of treason.

16 The Sykes-Picot Treaty defining the postwar British and French spheres of influence in the Middle East, including Palestine, is signed.

18 The Turks draft all 18-year-old gymnasium students, including those who have not completed their studies.

19 Hassan Bey, governor of Jaffa, known for his hostility to the Jews, is replaced by Ahmed Shukri, former governor of Haifa.

26 The Zion Mule Corps, which participated in the fighting on the Gallipoli front, is disbanded.

June
10 The Arab Revolt against the Turks erupts in the Arabian Peninsula, backed by the British.

Five defectors from the Turkish army, two of them Jewish, are hanged in the Jaffa Gate square, Jerusalem.

July
15 Aharon Aaronsohn, leader of the Nili group, leaves the country, ostensibly for Sweden. He reaches Denmark and from there sails for the United States. En route, he is removed from the ship at a British port of call as if for questioning, thereby precluding suspicion of his going over to the British side voluntarily. His sister, Sara, takes charge of the Nili network in Palestine, aided by Avshalom Feinberg and Yosef Lishansky.

August
Another Turkish attempt to take the Suez Canal fails. The British respond with a counterattack in Sinai and begin moving eastward toward Palestine.

The value of the Turkish pound continues to sink, down from 43 bishliks at the start of the year to 20.

27 The Turks announce plans to draft 17-year-old high school students. Parents are in a state of anxiety.

September
Dr. Arthur Ruppin is expelled from the country by Jamal Pasha, the Turkish governor. He leaves for Istanbul.

October
21 A group of Hashomer guards led by Israel Gil'adi settle in the Galilee and establish Kfar Bar-Giora, later to be named Kfar Gil'adi.

25 Among the deportees from Palestine is Albert Antebi, a leading Jewish liaison figure with the Turkish authorities and until then a personal friend of Jamal Pasha.

November
The Turks suspect the Arab leaders in Palestine of involvement with the Arab Revolt in the Arabian Peninsula. Subsequently, a number of prominent community workers in Jaffa are expelled to Anatolia.

December
12 Aharon Aaronsohn arrives in Egypt and expands the scope of Nili activity.

21 The British army in Sinai occupies al-Arish.

The first building in Kfar Bar-Giora (later Kfar Gil'adi), established in the fall of 1916.

△ Dr. Arthur Ruppin, director of the Palestine Office of the Zionist Organization, is expelled from Palestine in September 1916 by order of Jamal Pasha, although he is a German citizen.

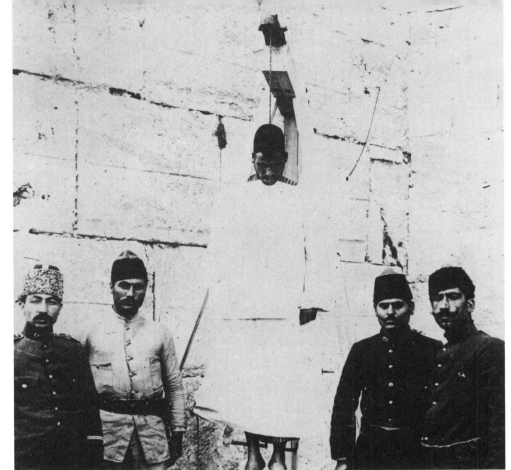

◁ Accused spies and deserters are sometimes executed by hanging by the Turkish authorities, as here in the center of Jerusalem.

△ Voucher of the American Relief Committee for 3 ounces of matza. These supplies are intended for the starving Jewish community of Jerusalem.

▷ Thousands of Jerusalemites are aided by a soup kitchen.

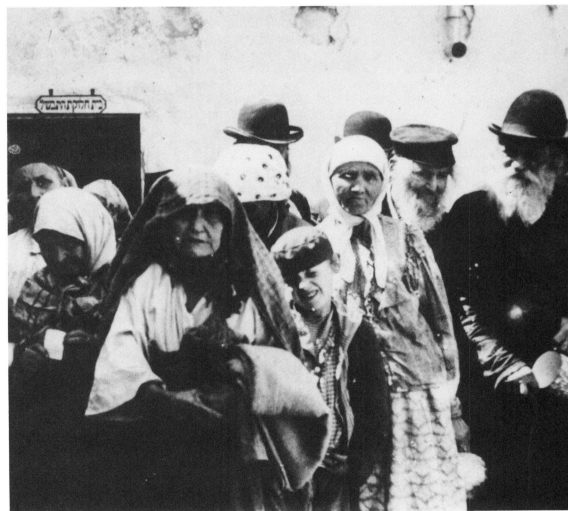

THE SYKES-PICOT TREATY

A secret agreement concluded between Britain and France in May 1916, named for its two signatories – Mark Sykes, representing the British, and George Picot, representing the French – divided up control of the territories of the disintegrating Ottoman Empire between the two countries. Tsarist Russia, too, was a party to the treaty.

The provisions agreed upon regarding Palestine were:

The Galilee from the Acre-Tabgha line (approximately) northward would be under direct French control as part of Lebanon.

Haifa Bay, including the towns of Acre and Haifa and their ports, would be under direct British control.

The central region, from the Acre-Tabgha line at the north, bounded on the east by the Jordan River, and on the south by a line below Gaza extending to the center of the Dead Sea, would be under the tripartite control of England, France, and Russia.

The Negev and Transjordan would be part of an Arab state in the British sphere of influence.

The Golan, Syria, and northern Iraq would constitute another Arab state, in the French sphere of influence.

The map, which was not drawn with precision, later evoked controversy over the exact location of the boundary lines. The Zionist leadership opposed the plan, favoring rule over the country by one power only – Britain. Britain itself was dissatisfied with the agreement regarding Palestine as well, and was therefore prepared to hear out the Zionist viewpoint. Its discussions with the Zionist leaders paved the way for the Balfour Declaration of November 1917.

△ One of the young Jews of Palestine to serve in the Turkish army is Moshe Shertok (Sharett), shown with his sister, Rivka.

▷ The Sykes-Picot Treaty map, 1916.

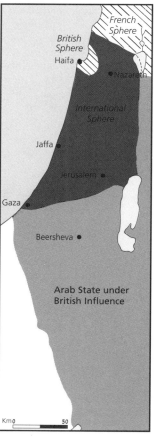

French Sphere

British Sphere

Haifa

Nazareth

International Sphere

Jaffa

Jerusalem

Gaza

Beersheva

Arab State under British Influence

Km 0 50

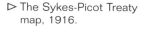

◁ The British army advances into Sinai toward the end of 1916 and besieges al-Arish in December.

January

The British army, approaching from Sinai, penetrates into Palestine, conquering Rafah and Khan Yunis. Conditions worsen in Jerusalem. Hundreds of inhabitants die of starvation and disease monthly.

20 Nili members Avshalom Feinberg and Yosef Lishansky attempt to infiltrate British lines with the aim of reaching Egypt. Feinberg is killed in an incident with Bedouin near Rafah while Lishansky, wounded, reaches British lines. Aharon Aaronsohn and Lishansky decide to conceal Feinberg's death from Nili members so as to preserve morale.

February

20 The British vessel, the Managem anchors off Atlit for the first time. It will serve as the main contact between the Nili group and the British in Egypt in the coming months.

March

11 Hashomer association takes on the guarding in Rehovot again.

26-28 The first battle for Gaza is waged. The Turks repel the British attack.

28 The governor of Jaffa assembles representatives of the inhabitants and instructs them to evacuate the city in light of the approaching fighting. The expulsion from Tel-Aviv begins.

April

The Yishuv leaders send cables to Istanbul, Berlin, and New York reporting on the expulsion. The impression abroad is that the Turks are massacring the Jews.

Meir Dizengoff heads a newly established body, the Central Emigration Committee.

17-20 The second battle for Gaza results in another British defeat.

May

Exiles from Jaffa and Tel-Aviv attempt to resettle elsewhere in the new Yishuv, primarily in

Lord Balfour's letter to Lord Rothschild: The Balfour Declaration.

Kfar Saba, Zikhron Ya'akov, Haifa, and the Lower Galilee.

Following the entry of the United States into the war on the side of the Entente Powers (April 1917), the Turks order all American citizens to leave the country.

June

28 Change in command of the British forces on the Palestine front: General Edmund Allenby replaces General Archibald Murray.

July

The situation in the Jewish settlements deteriorates. The Turks confiscate everything within reach, especially farm and transport animals, food, and fodder. Thousands of deserters roam about the country, pursued by Turkish soldiers.

Under pressure from abroad, Jamal Pasha orders that the deportees from Jaffa be given aid in the form of food and medicine.

August

23 The formation of the Jewish Legion is announced in London, to consist of the 38th Battalion of the Royal Fusiliers. Vladimir (Ze'ev) Jabotinsky, who conceived the idea, joins up.

September

The Turks expose the Nili spy network. They capture Na'aman Belkind and extort information on the ring from him.

October

1 The Turkish army surrounds Zikhron Ya'akov and arrests the members of the Nili. The Yishuv is alarmed, fearing atrocities by the Turks.

20 Yosef Lishansky, a member of the Nili network, attempts to reach British lines in the southern part of the country. He is captured by the Turks not far from Rishon Lezion.

31 The British offensive in southern Palestine begins. The British capture Beersheva in a diversionary move.

November

2 The British government issues the Balfour Declaration, expressing support for a "national home" for the Jews in Palestine.

7 Gaza falls to the British. The British campaign in southern Palestine is at its height.

16 Jaffa, including its suburb, Tel-Aviv, falls to the British.

Another Jewish battalion is formed, this time in the United States – the 39th Battalion of the Royal Fusiliers. Initiators and early recruits include David Ben-Gurion and Itzhak Ben-Zvi.

30 Following the British occupation of Tel-Aviv, its inhabitants return home.

December

9 (The first day of Hanuka) The British take control of Jerusalem following the evacuation of the Turks. The 400-year rule of the Turks comes to an end.

11 The British army under the command of General Allenby enters Jerusalem in a ceremonial victory march.

16 Nili members Yosef Lishansky and Na'aman Belkind are executed by the Turks in Damascus.

20 General Hill calls on the young Jewish men in the British occupied zone of the Yishuv to volunteer to the British army and help conquer the rest of Palestine.

1917

Foreign Office,
November 2nd, 1917.

Dear Lord Rothschild,

I have much pleasure in conveying to you, on behalf of His Majesty's Government, the following declaration of sympathy with Jewish Zionist aspirations which has been submitted to, and approved by, the Cabinet

His Majesty's Government view with favour the establishment in Palestine of a national home for the Jewish people, and will use their best endeavours to facilitate the achievement of this object, it being clearly understood that nothing shall be done which may prejudice the civil and religious rights of existing non-Jewish communities in Palestine, or the rights and political status enjoyed by Jews in any other country"

I should be grateful if you would bring this declaration to the knowledge of the Zionist Federation.

THE CONQUEST OF SOUTHERN PALESTINE BY THE BRITISH

The Egyptian Expeditionary Force, as the British army advancing into southern Palestine was called, mounted an attack on Gaza in March 1917 but was repulsed. Another attack shortly thereafter also ended in failure.

Changing command, the British replaced General Archibald Murray with General Edmund Allenby, a veteran cavalry officer, who was transferred from France. Allenby reorganized the troops and developed a diversionary plan during the course of the summer by which he would defer a third attack on Gaza until after an incursion on, and the capture of, Beersheva.

Following a series of diversionary tactics, the British attacked Beersheva on October 31, 1917, and after a brief battle the Turks retreated. Gaza fell to the British on November 7.

Pressing the Turks continually, the British forces moved north, reaching Jaffa after several battles on the coastal plain and capturing it on November 16. They halted at that stage at the banks of the Yarkon. Less than a month later, on December 9, 1917, they captured Jerusalem.

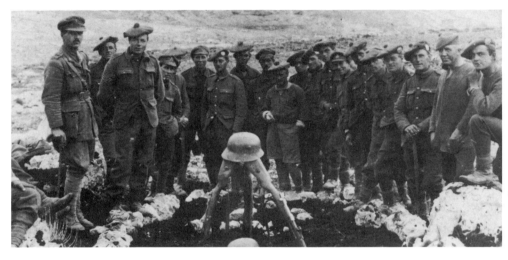

◁ British soldiers at a grave of a Turkish soldier, 1917.

▽ The British forces suffer from the extreme heat, as shown in a caricature in 1917.

▽ A Turkish soldier against the background of the settlement of Udja al-Hafir, which serves as an important logistic base for the Turks on the Sinai-Negev border. Throughout 1917, the British advance to Jaffa and Jerusalem.

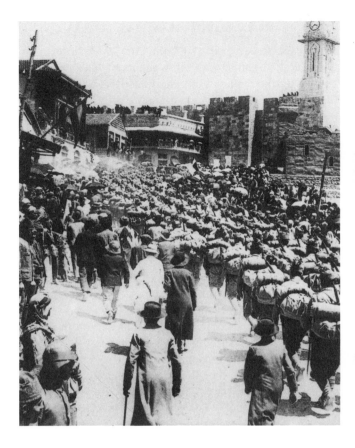

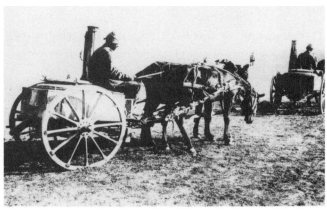

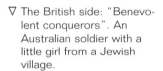

◁ The Turkish side: Austrian soldiers arrive in Jerusalem to back up the Turks.

△ The Turkish side: A field kitchen on the way to the Gaza front, winter, 1917.

▽ The British side: "Benevolent conquerors". An Australian soldier with a little girl from a Jewish village.

▷ The British side: Camels in the British Expeditionary Force struggle through a flood in the south of the country.

△ British officers of the 60th Division under the command of General G.S.M. Shea, which captures Jerusalem in 1917. The British dispatch tens of thousands of soldiers to Palestine, including Indians, Australians, and New Zealanders.

1917

79

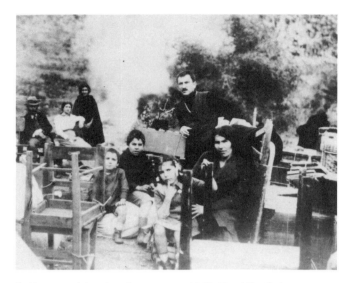

△ Evacuated families from Tel-Aviv arrive in the small village of Kfar Saba with their possessions, April 1917. But Kfar Saba is too small to absorb the thousands of Tel-Avivians expelled.

△ The expulsion from Tel-Aviv as perceived by the artist Nahum Gutman, one of the young people who volunteer to stay behind to guard the suburb. Gutman portrays himself, apparently, in the company of lizards.

▷ Evacuated Tel-Avivians at the train stop at Rosh Ha'ayin. To the credit of the Turks, property left behind is not looted, and when the evacuees return after a year and a half, they find their possessions intact.

THE EXPULSION FROM TEL-AVIV

Just before Passover of 1917, the Turkish authorities announced the expulsion of all residents of Jaffa and Tel-Aviv, with the explanation that the British advance in the south would lead to an attempt to attack Jaffa from the sea as well and the population must be evacuated for their own safety.

The decree applied to Jews and Arabs, but the fellahin were allowed to remain until the harvest was completed, while many Arabs made do in the surrounding groves. The Turks were especially hostile to the Jews, however, insisting that they evacuate entirely, to the north.

An Emigration Committee established by the inhabitants of Tel-Aviv to deal with all aspects of evacuating the population called representatives of the Jewish villages in the north to a meeting, at which their aid was requested. On April 1, the Turks announced that the evacuation must be completed within eight days. Jamal Pasha himself arrived to Tel-Aviv to meet with the heads of the town and assure them the evacuation was but for the safety of the inhabitants.

The settlers from the Galilee immediately answered the call and came to help, placing their carts at the disposal of the evacuees. There were, however, also those who charged money for their carts.

By the eve of Passover, on April 6, 1917, Tel-Aviv was nearly deserted, with the last inhabitants evacuating during the intermediate days of the holiday. Only a small contingent of young people remained behind to guard property. Most of the several thousand exiles found shelter in the villages of the Galilee, in Safed and Tiberias, and in the small settlement of Kfar Saba.

The expulsion from Tel-Aviv reverberated throughout the Jewish world and in the press, with the result that international pressure on the Central Powers caused the Turks to halt further evacuations. The return of the evacuees to their homes was slow and lasted until the end of 1918.

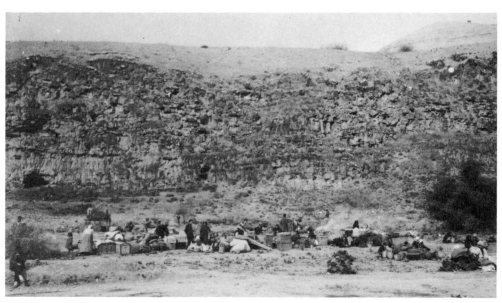

▷ Two of the leaders of the Nili group, which aids the British: Sara Aaronsohn and Yosef Lishansky.

◁ Ze'ev Jabotinsky, initiator of the establishment of the Jewish Legion in London.

▽ Life continues despite the war: a scene in Rishon Lezion, 1917.

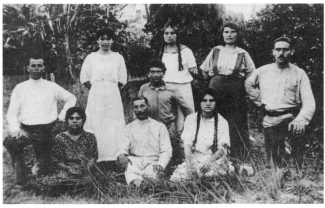

THE NILI AFFAIR

Although many Jews in Palestine were pro-Turkish at the start of World War I and hoped for a victory of the Ottoman Empire, the harsh and even hostile treatment of the Yishuv meted out by the Turks during the war engendered embitterment and led, among other things, to an organized initiative on the part of a group of young people in the established settlements who resented the Turks and wished for their defeat. These young people also believed that the question of a national Jewish entity would be advanced if the British were to take control of the country. The group organized a spy ring that established contact with the British in Egypt and supplied them with intelligence. Its members named the organization Nili – an acronym for the Hebrew verse "the strength of Israel will not lie" (I Samuel).

The organization, based in the agricultural experimental station at Atlit, was founded by the director of the station, Aharon Aaronsohn, a noted agronomist who had discovered wild Emmer wheat in the Galilee, and his colleague, Avshalom Feinberg, of Hadera. Other members included Sara Aaronsohn, Aharon's sister, and Yosef Lishansky.

From its establishment in 1915 until the fall of 1917, Nili members carried out wide-ranging intelligence assignments financed by the British. Contact with the British in Egypt during 1917 was made through the vessel Managem, which anchored off Atlit at intervals.

This activity, however, was viewed with distrust by those in the Yishuv who knew of the group's existence,

as they feared reprisals that the Turks had shown themselves capable of exacting, in light of the massacres of the Armenians, should the activity be discovered. But the members of the Nili network did not suspend their activity, convinced as they were that the dependence on the Turks was a mistake. The money which streamed through them to the hungry settlement, further complicated matters.

Eventually, a series of mishaps brought about the exposure of the organization. A carrier pigeon dispatched from Zikhron Ya'akov to Egypt landed instead in the courtyard of the Turkish police headquarters in Caesarea and was caught. A member of the Nili, Na'aman Belkind, was caught by the Turks in the Negev, who extracted information about the organization from him. Moreover, the members were careless about maintaining secrecy. On October 1, 1917, the Turks spread out in Zikhron Ya'akov and arrested dozens of suspects. Included was Sara Aaronsohn, who was tortured and, rather than divulge information, took her own life. Lishansky managed to escape but was eventually caught by the Turks in the south. Several weeks later, he and Belkind were hanged in Damascus. Other members were also caught and tortured. Aharon Aaronsohn, who had slipped out of the country beforehand, operated the network from Egypt and so was not harmed when the Nili group was exposed. For months, Jews in Palestine feared acts of revenge by the Turks, but these did not occur.

1918

January

2-3 A meeting attended by 42 delegates from British-held territory in the Yishuv takes place in the Palestine Office of the Zionist Organization in Jaffa. It deals with current issues and with a proposal to recruit a Jewish battalion from Palestine and elects a representative body – the Provisional Committee.

5 The British appoint Ronald Storrs governor of Jerusalem.

February

15-16 Representatives of hundreds of volunteers for a Jewish battalion from Palestine, which would join the other such regiments from abroad, meet in Tel-Aviv.

March

1 The 38th Battalion of the Royal Fusiliers arrives in Egypt and trains for combat at the front.

April

1 The Zionist Commission to Palestine, led by Dr. Hayim Weizmann, arrives in the country and visits Jerusalem, Tel-Aviv, and the villages in the south.

4 The weekly *Palestine News*, published by the British army command, appears. A Hebrew version, *Hadashot Meha'aretz*, is also published.

27 Governor Storrs entertains Dr. Hayim Weizmann and heads of the various other communal groups in Jerusalem. Weizmann puts forward the Zionist aspirations. The Mufti of Jerusalem delivers a conciliatory speech.

May

Dr. Weizmann holds numerous meetings in Jerusalem during the month with rival factions among the Jewish community, with Ashkenazi and Sephardi rabbis, and with public figures. He demands of the ultra-Orthodox rabbis to change their attitude toward Zionism and to institute Hebrew as the language of instruction in their yeshivot (orthodox religious schools).

15 The Torah scrolls removed from Tel-Aviv during the evacuation are returned there in a public ceremony attended by Dr. Weizmann.

16 The British command orders the inhabitants of Petah Tikva to evacuate the village because of its proximity to the front lines. Weizmann appeals to General Allenby to rescind the order but is unsuccessful.

23 The evacuation of Petah Tikva begins. Most of its population moves to Tel-Aviv.

June

4 Weizmann meets with Emir Faisal, leader of the Arab Revolt, at his camp in southern Transjordan. They discuss cooperation between

Deganya: an aerial photograph, 1918.

the two national movements, Jewish and Arab.

9 The 38th Battalion is deployed at the front in the Samarian Mountains.

17-19 The Provisional Committee of the Yishuv confers in Jaffa, with the participation of Dr. Weizmann. The subject that stirs the conference is the right to vote for all. The ultra-Orthodox oppose the suffrage for women. Wide support is heard for the recruitment of a Jewish battalion.

18 The British approve the formation of an additional Jewish battalion – the 40th – to be composed of Palestinian Jewish recruits. Hundreds volunteer. A debate emerges in the Yishuv between supporters and opponents of recruitment, the latter fearful for the fate of the Jewish population in the northern part of the country, still under Turkish control. The supporters win out. The recruitment committee is headed by Maj. James Rothschild, son of Baron Edmond de Rothschild.

27 Weizmann meets again with the rabbis of Jerusalem.

July

3 The 40th Battalion volunteers leave for Egypt following a festive send-off by the residents of Tel-Aviv. Training begins on July 11th.

5 *Shai Shel Sifrut* ("A Literary Present") appears as a supplement to *Hadashot Meha'aretz*, the Hebrew weekly published by the British army. Twenty copies are issued, edited by the writer S. Ben-Zion.

24 The cornerstone-laying ceremony for the Hebrew University of Jerusalem is held on Mt. Scopus with the participation of Dr. Hayim Weizmann and General Allenby.

August

18 Elections are held for the Jewish Council of Jaffa.

20 A medical delegation from the Hadassah Organization of America arrives in Palestine, consisting of several dozen physicians, nurses and administrative personnel. Its aim is to aid casualties of the war in the Jewish Yishuv.

The 39th Battalion of the Royal Fusiliers – the "American" Jewish Legion – arrives in Egypt.

September

Parties and ceremonies are held during the first ten days of the month, bidding Dr. Weizmann farewell, as he concludes a long visit to the country.

19 The British mount a large-scale campaign to rout the Turks from northern Palestine and Syria. The 38th and part of the 39th Battalions take part in the fighting.

20 The British conquer Zikhron Ya'akov, the Jezreel Valley, and Nazareth.

23 Haifa falls to the British.

25 British conquest of Zemah and Tiberias. The Galilee is conquered in the following days.

October

1 Damascus is taken by the British.

The residents of Petah Tikva return to their homes.

6 Beirut falls to the British.

26 The British army reaches Aleppo in northern Syria and conquers it.

31 Turkey surrenders. The war on the Middle East front ends.

November

2 The Yishuv celebrates the anniversary of the Balfour Declaration. Agitation among the Arabs.

11 World War I ends in Europe.

Nearly every political party and organization in the Yishuv convenes during November and December to determine postwar goals.

December

18-22 The Provisional Committee meets in Jaffa for the third time, calling itself the Palestine Council in view of the participation of representatives from all settlements, institutions, and the Jewish Legion. It elects Dr. Hayim Weizmann and Nahum Sokolov as delegates of the Jewish community of Palestine to the Peace Conference in Versailles.

Two new settlements are established in the Galilee in 1918 – Tel-Hai and Ayelet Hashahar.

Following friction between the French and the British, the French take control of Syria, including Lebanon and part of the Upper Galilee.

The photographer Ya'akov Ben-Dov shoots the first Hebrew film, *Liberated Judea*.

THE FINAL PHASE OF THE WAR, SEPTEMBER 1918

With the British crossing of the Yarkon River and the conquest of Jerusalem in late 1917, fighting in Palestine came to a halt, to be resumed only in the fall of 1918. In the interin, General Allenby developed a diversionary plan. He reinforced his units on the coastal plain, which had retreated from the Jordan Valley and the Mounts of Efraim, and, in this way, misled the Turks to believe that his intention was to launch a new attack on the Jordan Valley.

The renewed attack, which began on September 19, 1918, saw the British pin down the enemy's array in the central arena while an agile cavalry broke through enemy lines in the Sharon Valley and moved northward. On the same day, British units reached Wadi Ara and Wadi Milek to hinder the Turks from blocking the passages. The British forces reached the Jezreel Valley on the 20th, destroyed a German force that attempted to gain control of the Megido pass, and proceeded to attack the Turkish-German command in Nazareth. That same evening, they captured Bet-She'an and the Jordan River bridges and blocked any Turkish retreat.

During the next few days, the Turkish forces in Samaria were overcome and British recruits (including the soldiers of the Jewish battalions) crossed the Jordan and captured al-Salt and, thereafter, Amman.

On October 1, 1918, Damascus surrendered. Over 400 years of Ottoman rule in Palestine had come to an end. Its inhabitants, both Jewish and Arab, knew that a new era had begun.

△ The cornerstone-laying ceremony for the Hebrew University of Jerusalem, in the presence of Dr. Hayim Weizmann and General Allenby.

▷ Rivka, a young Jewish girl from Merhavya, photographed by a German pilot shortly before the Turkish defeat.

▽ The armistice ceremony at the Government House in Jaffa, November 1918.

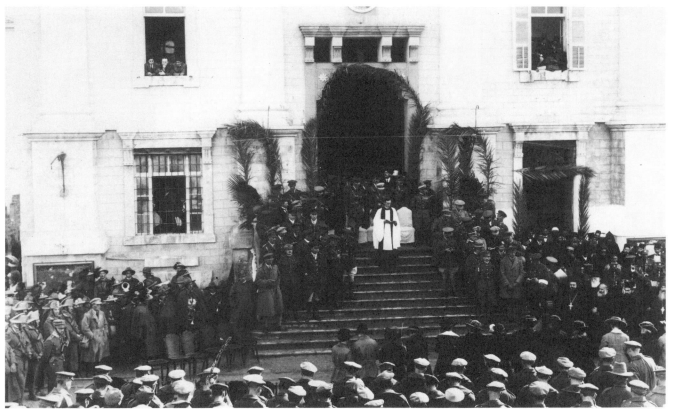

THE JEWISH BATTALIONS

Not satisfied with the formation of the Zion Mule Corps in 1915, Ze'ev Jabotinsky carried on his efforts, with the support of Hayim Weizmann, to establish a Jewish fighting force.

In 1917, the British were persuaded to establish a Jewish Legion – a supra-battalion force – that would join the British army fighting in Palestine. The first such unit was the 38th Battalion of the Royal Fusiliers, organized in England by Jabotinsky, who signed up for it himself and served as an officer. The second, the 39th Battalion, was organized in the United States by David Ben-Gurion and Itzhak Ben-Zvi, who had been deported from Palestine by the Turks. The third battalion, the 40th, was composed entirely of Jewish volunteers from the Yishuv following the capture of southern Palestine by the British.

The 38th and 39th Battalions took part in the final battles in the region. With the conclusion of the fighting, the soldiers in the Legion hoped to be included in the British garrison force in Palestine, but this did not occur. Most of the recruits were discharged in 1919, with a single battalion created for the remainder of all three – the First Judeans. By May 1921, however, this last battalion, too, was disbanded. At their peak the Jewish battalions comprised over 5,000 soldiers and officers.

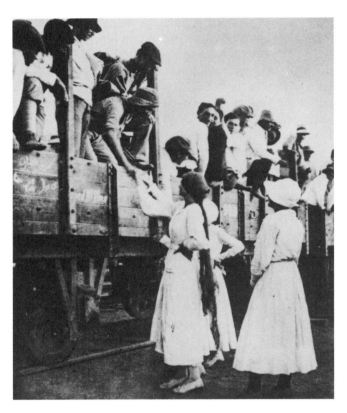

△ Two recruits in the Jewish battalions: David Ben-Gurion (l.) and Itzhak Ben-Zvi.

◁ Volunteers for the 40th Battalion depart from Jaffa.

△ Moshe Smilansky, the writer, is a volunteer from Palestine.

◁ The weekly Hebrew-language *Hadashot Meha'aretz* (The Palestine News) is published by the British army. At first, it appears in Jerusalem and then, for about a whole year, in Cairo.

▽ Dr. Hayim Weizmann (l. foreground), arrives in Palestine by train in April 1918. The second officer from the left is James Rothschild, son of the "well-known philanthropist".

▷ Life begins to return to normal in Tel-Aviv in 1918: a "festival of flowers" is celebrated on the holiday of Shavu'ot.

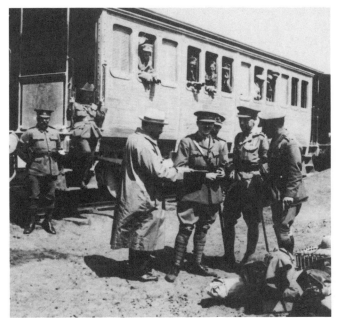

▷ The Zionist Commission to Palestine tours the country, meeting with political leaders, British military commanders, rabbis, and institutional leaders. Shown, a reception in Rishon Lezion with British officers. Weizmann spends nearly half a year in the country, returning to England thereafter. He and his colleagues are regarded as constituting a "Jewish government." During his stay, he works to further the Yishuv's interests, in accordance with the Balfour Declaration.

THE ZIONIST COMMISSION TO PALESTINE AND THE PROVISIONAL COMMITTEE

Although the war was not yet over, the leadership of the Zionist movement and of the small Jewish Yishuv in Palestine made efforts during the first half of 1918 to establish institutions and organizations that would support activity aimed at founding a Jewish national home based on the Balfour Declaration.

On January 2, 1918, the Provisional Committee was elected at the first founding conference, held in Tel-Aviv, with the participation of a portion of the representatives of the Yishuv. In June, a second such meeting was convened, dealing with the issue of the right of women to vote in that forum, which was opposed by the ultra-Orthodox bloc.

Participating in this meeting was Dr. Hayim Weizmann, who had arrived in Palestine in April, at the head of the Zionist Commission to Palestine. This body functioned for three years, centralizing Zionist Organization activities in Palestine and absorbing the Palestine Office that had played an important role since 1908. The Provisional Committee too functioned for three years, until it was replaced by the National Council in 1920.

1919

January

The first issue of *Ha'ezrah* ("The Citizen") appears. The magazine is published by the Ha'ezrah party, which aspires to represent the circles of the center. On the 12th of the month, a meeting is held with the participation of 24 delegates from different villages. They are headed by Meir Dizengoff from Tel-Aviv and David Yellin from Jerusalem. They decide to call the new body Ha'ezrah, Histadrut Medinit Amamit ("The Citizen, a Political National Federation").

3 Dr. Hayim Weizmann meets with Emir Faisal again. They sign an agreement between both national movements by which the Arabs accept the Balfour Declaration and the Jews promise to aid in the development of the Arab state.

February

Much activity among workers' associations and parties for the purpose of uniting all forces. Po'alei Zion ("Workers of Zion") and non-party workers are for unity. Hapo'el Hatza'ir ("The Young Worker") is hesitant.

26 A general conference of workers in Palestine decides to establish a united political movement to be called Ahdut Ha'avodah ("The Unity of Labor"). The Hapo'el Hatza'ir party does not join, and establishes separate bodies.

April

19 The Hebrew Scouts Movement is founded in Palestine.

Israel and Mania Shohat, leaders of Hashomer ("The Watchman"), return to the country after a long exile in Turkey.

May

1-5 The rabbis of Palestine hold a first conference, which is boycotted by the ultra-Orthodox. Rabbi Avraham Itzhak Hacohen Kook is asked to serve as chief rabbi.

15 Aharon Aaronsohn, the noted agronomist who had discovered wild Emmer wheat in the Galilee and had led the Nili group, is killed in a plane crash over the English Channel at age 43.

June

The first commission of inquiry arrives in Palestine – the King-Crane Commission – appointed by President Wilson to assess the situation in the region and recommend future steps. Its two members adopt an anti-Zionist position and recommend annexing Palestine to Syria.

18 *Hadashot Ha'aretz* ("News of the Land"), the first postwar daily in Jerusalem, begins to appear. It is published under the title *Ha'aretz* ("The Land") as of December and develops to be one of the most respected dailies until today. Its first editor is Dr. Nissan Turov.

25-26 The first national conference of the Mizrahi (religious Zionists) party in Palestine is held.

July

9 U.S. Chief Justice Louis D. Brandeis, a prominent American Zionist leader, visits Palestine.

August

8 A second daily in Jerusalem, *Do'ar Hayom* ("Daily Mail"), edited by Itamar Ben-Avi, appears.

29 Rabbi Kook arrives in Jerusalem.

September

10-11 The Provisional Committee chooses October 26 as election day for the Elected Assembly. The religious and the ultra-Orthodox oppose the elections, mainly on account of women's right to vote.

October

6 Menahem Ussishkin, the Zionist leader, immigrates to Palestine and is appointed head of the Zionist Commis-

Aharon Aaronsohn.

sion to Palestine, the highest Zionist leadership forum in the country.

Yosef Trumpeldor returns to Palestine to prepare the foundations for the immigration of the members of the Hehalutz ("The Pioneer") movement in Russia which he heads.

November

15 Arabs steal work animals, arms, and money from Kibbutz Kfar Gil'adi.

December

The situation in the north worsens. The Muslim Arabs oppose French rule and rebel. They accuse the population of the four Jewish settlements of the Upper Galilee (Metula, Kfar Gil'adi, Tel-Hai, and Hamara) of collaboration with the French. The Jews declare neutrality.

9 The remaining soldiers of the three Jewish battalions (the 38th, 39th and 40th Battalions of the Royal Fusiliers) are reorganized in a new battalion, named the First Judeans. Their regimental commander is Eliezer Margolin. The regimental symbol is a seven-branched candelabrum with the Hebrew word *kadima* ("forward").

12 Arabs attack Tel-Hai. One member of the settlement is killed.

18 The Ruslan arrives at Jaffa from Odessa with 671 returning residents and new immigrants. The event, which marks the start of the Third Aliyah, causes a stir in the Yishuv.

The *Hapo'el Hatza'ir* ("The Young Worker") weekly publishes an appeal by Yosef Trumpeldor to unite the labor movement in Palestine in order to prepare the way for the mass immigration of Jews from Russia. The article is reprinted in *Kunteres*, the weekly published by the rival Ahdut Ha'avodah party, on December 30th.

Women and children are evacuated from Kfar Gil'adi and Tel-Hai in light of the tension in the Upper Galilee.

27 (or 29 – according to other sources)

Yosef Trumpeldor arrives in Tel-Hai at the request of Hashomer leader Israel Shohat and takes command of the defense of the settlement.

Prolonged negotiations between the British and the French over the border of northern Palestine are held during 1919. The border is shifted several times, finally placing the Galilee "finger" on the French side. Yesod Hama'ala becomes the northernmost Jewish settlement point under British control.

ביום השלישי, י״ט סיון, תרע״ט, 17 JUNE 1919

יתחיל לצאת בירושלים עתון יומי בלתי מפלגי לעניני החיים והספרות

חדשות הארץ

העורך: דר נ. טורוב. המו״ל: י. ל. גולדברג.

A notice announcing the first issue of the daily, *Hadashot Ha'aretz*.

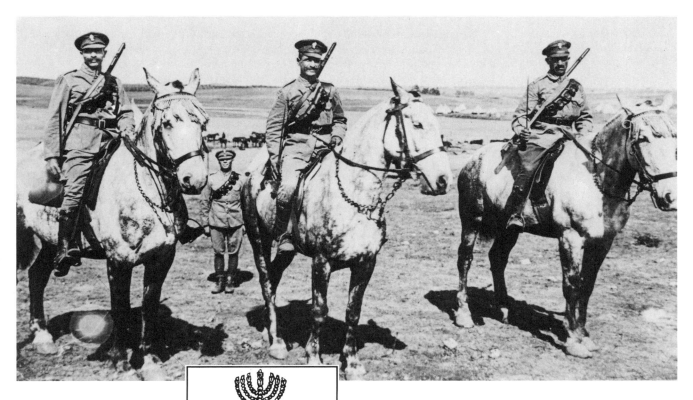

△ Soldiers of the Jewish battalion (the First Judeans), and the regimental symbol, 1919.

◁ A First Judeans new year greeting for the year 5680. Many hope the British will keep the battalion as their garrison force in Palestine.

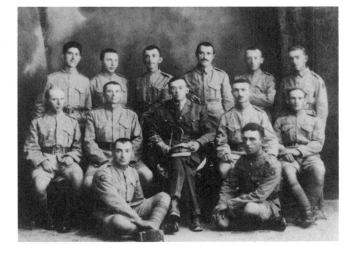

△ Ze'ev Jabotinsky (c.) and a group of volunteers in the Jewish battalion from Palestine.

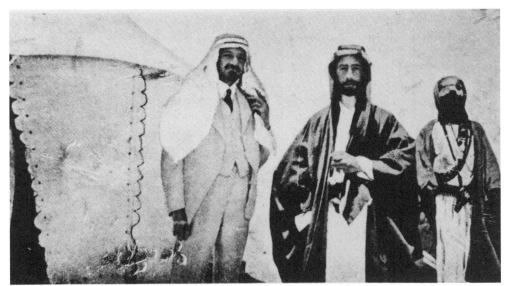

◁ A historic meeting between Emir Faisal (c.), leader of the Arab movement, and Dr. Hayim Weizmann (l.), leader of the Zionist movement. The two men agree on cooperation between the two national movements. Faisal is to accept the Balfour Declaration, while Weizmann promises monetary aid to the Arabs.

∇ The year 1919 is a difficult one. The Yishuv struggles to recover from the war, Turkish oppression, and forced evacuation. The year also witnesses the passing of several important figures, including the legendary hero of the First Aliyah, Michael Helpern (seated).

T he question of Palestine is linked to that of the rest of the states of old Turkey and will take time to resolve. It is imperative, therefore, to be patient and wait for that day.... No one should consider dismantling his home or his business affairs before he is assured that he can settle in the country. Unorganized and unprepared mass emigration will be the worst calamity for the immigrants and for the renascent country.

From a notice published by the Zionist Executive, 1919.

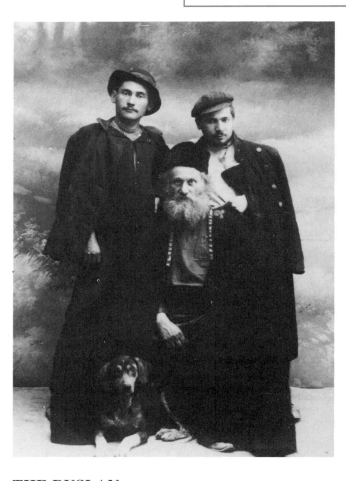

▷ Yosef Busel, originator of the idea of the kibbutz (shown with his wife, Hayuta), drowns in lake Kinneret in 1919.

∇ The only existant photograph of the Ruslan, Israel's Mayflower, the ship that initiates the Third Aliyah. It reaches Jaffa in December 1919.

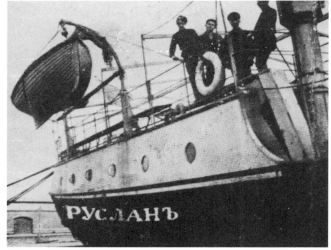

THE RUSLAN

Every people needs symbols to signify national achievements and entrench them in the public consciousness. The Ruslan, like the American Mayflower, became such a symbol in relation to the saga of the various waves of Jewish immigration to Palestine.

The ship's sailing was arranged in Odessa, in southern Russia, in late 1919, as a result of pressure exerted by the Zionist movement to allow a group of wartime exiles from Palestine deported by the Turks to return home. News of the voyage spread rapidly, and many others sought to join the sailing as well, including well-known personalities as historian and literary critic Dr. Yosef Klausner, who brought his vast library with him, journalist Moshe Gluecksohn, artists, architects, and physicians. All these new immigrants were required to pose as returning refugees and display familiarity with Palestine to the British authorities,

who at the time were prepared to admit only returnees.

Setting sail from Odessa on November 14, 1919, after several deferments, the Ruslan took a month's time to reach Palestine, but despite a difficult journey, the passengers' spirits remained high. Landing at Jaffa port on December 19, the 671 arrivals on board were welcomed so enthusiastically that the police had to be called out to control the throngs in the city at the time of disembarkation. The ship's captain, impatient at the delay in unloading caused by the melee, weighed anchor before the passengers' baggages could be put ashore, relenting and turning back only after repeated exhortations.

The entire Jewish Yishuv celebrated the arrival of the Ruslan, which became the harbinger of the Third Aliyah, eliciting forecasts in the Yishuv of the inauguration of a regular Odessa-Jaffa line.

THE BEGINNING OF THE THIRD ALIYAH

One of the greatest moments for the Zionist movement was evoked by the Balfour Declaration of November 2, 1917. The establishment of the Jewish state, or at least a "national home," in Palestine appeared to be attainable. At the same time, the embrace of Zionist ideals in the Jewish communities of Poland and Russia was accelerated by a wave of pogroms there immediately upon the conclusion of the war. In light of the inhospitable conditions in Palestine, however, the Zionist leadership at first opposed unregulated immigration. British military rule in force there since late 1917 aimed at preserving the demographic status quo and banned immigration. Moreover, the economic situation was at a low ebb as a result of the destruction caused by the war.

Nevertheless, the immigrants, at first mostly pioneers and single persons, would not be put off, either by British restrictions or by the qualms of the Zionist leadership. By the end of 1919, some 2,000 newcomers had arrived, harbingers of a new wave of immigration – the Third Aliyah.

▽ Hopes soar with the British conquest and the Balfour Declaration. Everything assumes a national character, including the ferry on lake Kinneret, which is named Nordau after the noted Zionist leader.

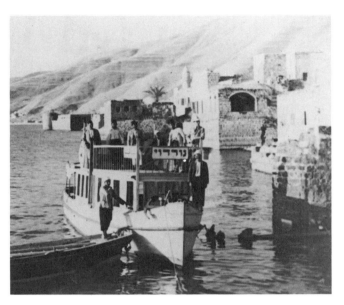

△ Yosef Trumpeldor returns to Palestine and after pleading for the unity of the workers movement is immediately called to the Galilee.

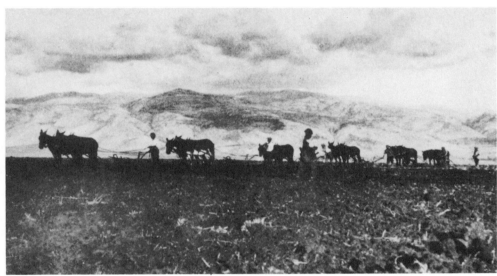

△ Plowing at Hamara in the Upper Galilee.

▷ The Zionist claim as presented at the Peace Conference at Versailles. The area included in Palestine contain parts of Lebanon, Syria, Transjordan, and Sinai.

◁ Do'ar Hayom ("Daily Mail"), the second daily to appear in Jerusalem, follows the appearance of Hadashot Ha'aretz ("Palestine News") by a few weeks.

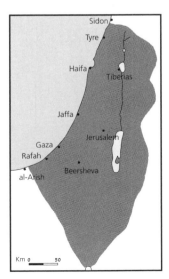

The Third Decade
1920-1929

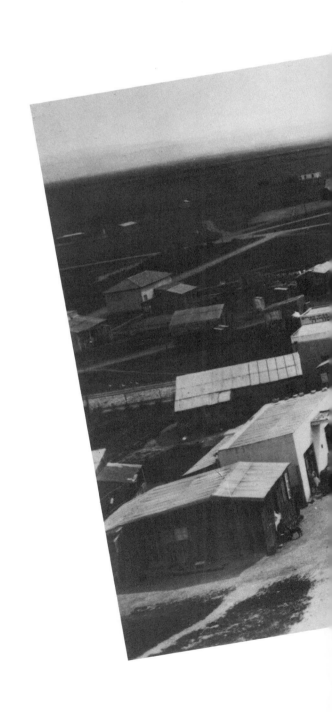

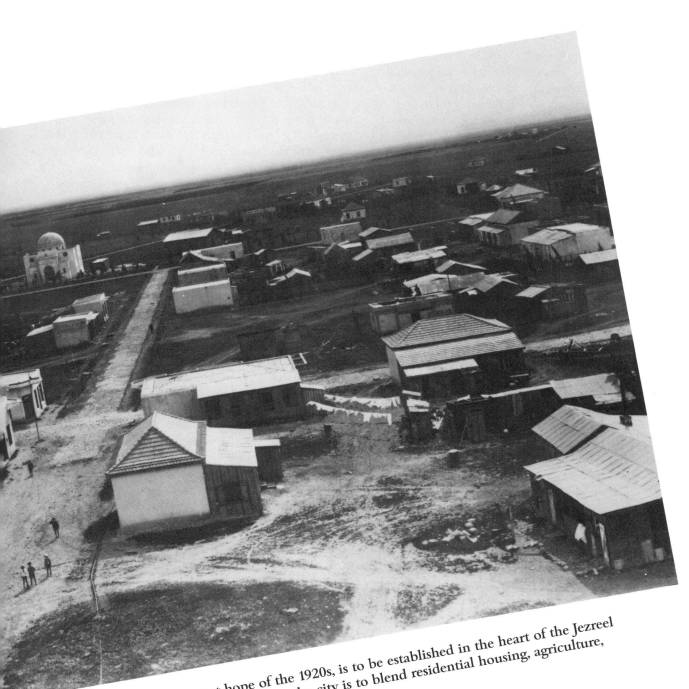

Afula, the great hope of the 1920s, is to be established in the heart of the Jezreel Valley. According to plans, the city is to blend residential housing, agriculture, crafts and services.

The decade of the 1920s began with high hopes in Jewish Palestine, progressed with a series of ups and downs in the country and in the Yishuv, and ended with a violent Arab outburst of unprecedented intensity – the Riots of 1929.

The year 1920 marked the institutionalization of British rule in Palestine. That spring, at the Conference of San Remo in northern Italy, the Entente Powers ratified the handing over of the mandate for Palestine to Great Britain. Two months later, the military rule – in effect since late 1917 – was ended, and civilian rule under a high commissioner in Palestine began on July 1, 1920.

The first high commissioner, Sir Herbert (later Viscount) Samuel, was a British Jew who had served as a member of parliament and as a minister of government. Known for his sympathetic attitude toward Zionist aspirations, he was, not surprisingly, welcomed by the Jewish Yishuv and apprehended by the Arab population. During his five-year tenure, however, attitudes toward him changed considerably: the Jews were disappointed by what they perceived as his neutrality and by the limitations that he imposed on Jewish immigration, while the Arabs discovered that despite his Zionist background he tried to understand their side as well. Samuel's replacement, Field Marshal Lord Herbert Plumer, was a highhanded ruler whose tenure was unmarred by disturbances, the first and only such period during the Mandate. The third high commissioner, Sir John Chancellor, who took office in 1928, was a pale figure who contributed little in any area.

In sum, the three high commissioners and the British administration generally invested considerable means and effort in the development of the country, much to the benefit of its inhabitants. Centuries of Ottoman rule, concluded with the devastating World War I, had reduced the country to a most deteriorated state. The British paved roads, expanded the railroad network, assisted in the draining of swampland, established Jerusalem as the capital of Palestine, and issued local currency.

The Yishuv at the start of the decade was in a difficult state. Consisting of only 60,000 souls, it had not yet recovered from the vicissitudes of the war. The immigration of the early years of the decade (the Third Aliyah) did not develop into a mass immigration, and by the end of 1922 the Jewish population was only 83,000 – 11% of the total population of the country. The flow of immigrants increased markedly in 1924 (the start of the Fourth Aliyah), expanding the Jewish population by some 60,000 in two years. But a deep economic and social crisis developed as of mid-1926, manifested in a drastic drop in immigration to the point of near cessation, along with rising emigration. The crisis of the Fourth Aliyah lasted three years, but its aftermath was felt until the early thirties.

Arab hostility to the development of the Jewish Yishuv manifested itself at the beginning of the decade.

Two violent attacks against Jews in early 1920, in the Galilee and in Jerusalem, resulted in loss of lives, damage to property and the evacuation of several settlements. One opinion had it that this was a one-time outburst that did not necessarily point to a trend. A year later, however, in the spring of 1921, Arab violence erupted anew and with greater intensity in four places: Jaffa, Petah Tikva, Hadera, and Rehovot. The number of lives lost was much greater this time – 47. Half a year later, on November 2, 1921, the anniversary of the Balfour Declaration, another series of violent incidents occurred, albeit of brief duration. This period was followed by seven years of tranquility, during which time the Yishuv and the Zionist movement began to believe that the Arabs had accepted the permanent, and expanding, Jewish-Zionist presence in the country.

The Riots of 1929, however, resulting in 133 Jewish fatalities, hundreds of injured, the destruction of settlements, widespread damage, and shock at the outburst, proved how baseless Jewish hopes had been. The Mufti of Jerusalem, Haj Amin al-Husseini, played a major role in spreading fanatic religious propaganda and sowing the seeds of hatred in the hearts of the Arab population.

The development of the Yishuv in the 1920s was characterized by both progress and regression simultaneously. Despite difficulties, delays, and even the Arab riots, the Yishuv marked a series of substantial achievements. The Jewish population grew from 60,000 to 160,000. The number of agricultural settlements rose by 80%, from 55 to 100. Land under Jewish cultivation grew impressively, and a large agricultural bloc that was almost entirely Jewish was established in the Jezreel Valley with over 20 settlements. The city of Tel-Aviv also blossomed, evolving from a suburb of Jaffa with some 2,000 residents to a full–fledged city of 45,000, all Jewish.

The 1920s witnessed the growth and expansion of Jewish administrative, religious, educational, cultural, and artistic institutions. Representative bodies began to function in the Yishuv, namely Asefat Hanivharim ("the Elected Assembly") and the Va'ad Leumi ("National Council"). The Zionist leadership still constituted the major forum for Jewish self-government, establishing the Jewish Agency for Palestine at the end of the decade. The Chief Rabbinate was founded. The educational system was expanded, and the first two institutions of higher learning were opened – the Technion in Haifa and the Hebrew University of Jerusalem. Theaters, opera, folklore troupes, newspapers, and publishing houses emerged and were extremely productive, proving the enhancement of society in the country despite the fact that the Jewish population totaled only 100,000-150,000 during that period.

Still, the road to a Jewish majority in Palestine and to a Jewish state proved much longer than expected.

January

1 Hamara in the Galilee is attacked by Bedouin and is abandoned.

3-5 The situation in Metula deteriorates. The French army clashes with Bedouin and Arabs. Over 100 inhabitants of the village leave for Sidon.

30 Sir Herbert Samuel, an English Jewish statesman who has promoted the Balfour Declaration, is a guest in Palestine.

February

6 Aharon Sher, one of the Tel-Hai group in the Galilee, is killed in an Arab raid.

8-9 Arabs raid Metula. The remaining inhabitants leave for Sidon and Kfar Gil'adi.

13 Yosef Trumpeldor, commander of Tel-Hai, appeals for reinforcements of the settlements in the Galilee.

23-25 The Provisional Committee meets. The defense of the Galilee settlements is discussed.

25 The Tel-Hai group, led by Trumpeldor, gains control of Metula.

March

1 (11 Adar 5680) The battle of Tel-Hai takes place. Yosef Trumpeldor and five other defenders are killed. The settlement is abandoned in the evening and is set on fire. The survivors arrive at nearby Kfar Gil'adi.

3 Kfar Gil'adi is abandoned in anticipation of an Arab attack. Its inhabitants, along with the Tel-Hai group, are evacuated to Sidon and to Ayelet Hashahar.

8 In Jerusalem, Arabs demonstrate against Zionism and the Jews.

April

4-6 The Arab Riots of 1920 break out. Arabs attack Jewish neighborhoods in Jerusalem. Casualties include six dead and some 200 wounded. The British arrest the commander of Jewish defense in Jerusalem, Ze'ev Jabotinsky, and 19 other defenders.

17-26 Arab raids on Jewish settlements in the Jordan Valley and in the Galilee. They are deflected, partly with British military aid.

19 The British sentence Jabotinsky to 15 years imprisonment with hard labor, and his colleagues to three years with hard labor, for "illegal" defense activity during the riots. In response, protest demonstrations and strikes are called on throughout the Yishuv.

The first elections for the Asefat Hanivharim ("Elected Assembly") are held. Elections in Jerusalem are scheduled for early May in light of the tension there.

24 At the Conference of San Remo, the Entente Powers decide to hand over the mandate for Palestine to the British. The British prime minister offers Sir Herbert Samuel the position of civil high commissioner in Palestine. Samuel accepts.

May

18 The Hashomer ("Watchman") council decides to disband the association to make way for the formation of the Haganah.

20 The Provisional Committee creates the Ge'ula Fund for the building of Palestine. Donations are accepted in cash, jewels, and other valuables.

June

13-15 The Ahdut Ha'avodah ("Unity of Labor") party convenes in Kinneret. It decides, among other things, to establish the Haganah organization for countrywide Jewish self-defense.

30 Sir Herbert Samuel lands in Jaffa and is received with a military ceremony.

July

1 British military rule in Palestine ends. Sir Herbert Samuel takes up his position as first civil high commissioner.

7 High Commissioner Samuel pardons Jabotinsky and his colleagues as well as the leaders of the Arab side who were imprisoned following the incidents in Jerusalem in April.

7-24 The London Conference of the Zionist movement takes place, marking the first major Zionist assembly after World War I. Decisions include the establishment of Keren Hayesod, a financial body to implement the Zionist enterprise in Palestine.

25 The French government in Syria expels King Faisal from Damascus.

August

15 The British divide Palestine into seven districts: Jerusalem, Jaffa, Haifa, Gaza, Beersheva, Samaria, and the Galilee.

20 Transjordan is included in the British Mandate over Palestine.

25 The Labor Legion in Memory of Yosef Trumpeldor is founded, six months after the battle of Tel-Hai.

26 The Mandate government announces the first Jewish immigration quota: 16,500 permits for the coming year. Each permit entitles a family to enter.

October

5 The Kfar Gil'adi settlers, followed by those of Tel-Hai and Metula, return to the Galilee and restore their settlements.

7-11 The first Elected Assembly is convened in Jerusalem. It elects an executive body, the Va'ad Leumi ("National Council"), headed by David Yellin.

November

The Hebrew Theater in Eretz Israel presents its first performance – a collection of one-act plays, directed by David Davidov. The theater will operate for a year and mount dozens of plays.

10 Emir Abdallah, second son of Sharif Hussein of Hejaz, arrives in Ma'an, Transjordan, with 1,200 men, with the intention of attacking the French in response to the expulsion of his brother, Emir Faisal, from Damascus.

December

5-9 The founding of the Histadrut Ha'oudim – ("Federation of Labor") – takes place in Haifa. The new body unifies the various institutions and economic bodies founded by the labor parties and takes responsibility for the Haganah.

13-18 An Arab Palestinian congress is held in Haifa. It calls on the British to recognize the rights of the Arabs in Palestine and to nullify the Balfour Declaration and Zionist demands. An Arab executive body is established.

The number of Jews who immigrate to Palestine in 1920 is 8,223.

Delivery note issued by Major General Bols, military governor of Palestine, to High Commissioner Sir Herbert Samuel.

THE BATTLE OF TEL-HAI

The agreements concluded between the British and the French after the conquest of Palestine placed the Upper Galilee finger in Syrian territory (which also included Lebanon) under French control, outside the boundaries of the Jewish national home. Four Jewish settlements lay in this region then: Metula, Kfar Gil'adi, Tel-Hai, and Hamara.

The entire territory was in a state of anarchy in late 1919 and the first few weeks of 1920. The Arab and Bedouin population opposed French rule and rebelled. The Jewish settlements declared themselves neutral, but were accused by the Arabs of cooperating with the French. Yosef Trumpeldor, who had acquired combat experience during his service in the Russian and the British armies, was sent to the Galilee to take command of Tel-Hai and, in effect, of the entire Jewish population of the Galilee. His demands for reinforcements of people, weapons, and supplies, however, were only partially answered.

An Arab attack on Tel-Hai was launched on the morning of March 1, 1920. Failing to break into the courtyard of the settlement, the Arabs demanded to be allowed to search the interior to ascertain that no French were there. Trumpeldor accepted the Arab commander's word of honor and permitted a small group of Arabs to enter. While they were inside, a bullet was accidentally fired from a pistol, triggering a shooting that left five of the defenders dead – among them two women – and others wounded, including Trumpeldor. With the approach of the evening, the defenders decided to evacuate to Kfar Gil'adi. Trumpeldor died on the way, and his last words were: "It is good to die for our country." The fatalities at Tel-Hai thus reached eight, counting two killed during the preceding two months. Thereafter, Kfar Gil'adi was evacuated as well, but in October 1920 the settlers of Kfar Gil'adi and Tel-Hai returned, followed by the inhabitants of Metula.

▷ The first report (handwritten) of the battle of Tel-Hai and its victims.
The obituary (r.), by Berl Katznelson, for the fallen of Tel-Hai will serve later as a model for the official State of Israel *Yizkor* ("In Memoriam") obituaries.

▽ The Tel-Hai courtyard, site of the battle of March 1, 1920. At this time, three of the four settlements in the north of Galilee still exist.

יזכור עם ישראל את הנשמות הטהורות של בניו ובנותיו

שניאור שפושניק
אהרן שֶר
דבורה דראכלר
בנימין מונטר
שרף
שרה צ'יזיק
מוקר
יוסף טרומפלדור

הנאמנים והאמיצים, אנשי העבודה והשלום, אשר הלכו מאחרי
המחרשה ויתרפו נפשם על כבוד ישראל ועל אדמת ישראל.

יזכור ישראל ויתברך בזרעו ויאבל על זיו ־ העלומים
וחמדת ־ הגבורה וקדושת ־ הרצון ומסירות ־ הנפש אשר נספו
במערכה הכבדה.

אל ישקט ואל ינחם ואל יפוג האבל עד בא יום כו ישוב
ישראל וגאל אדמתו השדודה.

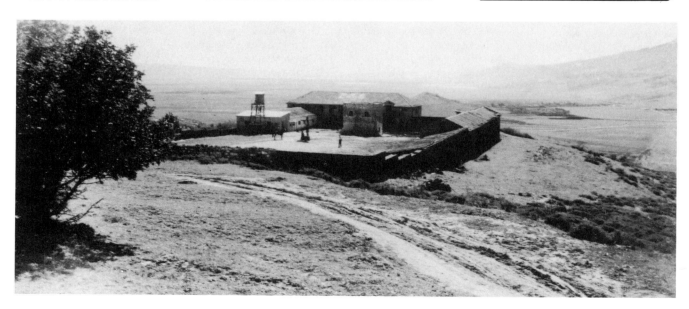

94

המעשה הרעיון

השגה

בירושלם

נציב לאדוננו שובו ישובו עד לא אב הרצל דה תקותנו

לשנה טובה

תרפא

גרינשפן דר

△ High Commissioner Herbert Samuel (l.) is welcomed by the Yishuv with deep emotion, as reflected in this new year greeting card sold in Jerusalem several months after his arrival. He is viewed as no less than Herzl's (r.) successor.

◁ A civil administration is instated, on July 1, 1920, and the British insignia becomes the country's official emblem.

△ A "royal" wedding: Edwin, son of High Commissioner Samuel, weds the native-born Hadassah Grazovski in December 1920.

▷ Avraham Shapira, father of Jewish self-defense, and his daring colleagues from Petah Tikva, are called upon to guard High Commissioner Samuel upon his arrival in the country.

THE RIOTS OF 1920 IN JERUSALEM

Arab violence broke out in Jerusalem for the first time in April 1920. It was a result of the Arab nationalist radicals' determination to act against the implementation of the Balfour Declaration, making use of the national awakening that spread through the Arab population at the end of World War I. These extremists used the Muslim Nebi Musa festival to incite the masses of Arabs gathered at the Temple Mount to attack the adjacent Jewish quarter of the Old City. The quarter was unprotected, as the population of the old Yishuv had confidence in its neighborly relations with the Arabs, maintained over generations. The toll of the riot was six Jews killed, hundreds injured, and heavy damage to property. A Jewish self-defense group under the command of Jabotinsky, who tried to deflect the attack, was arrested.

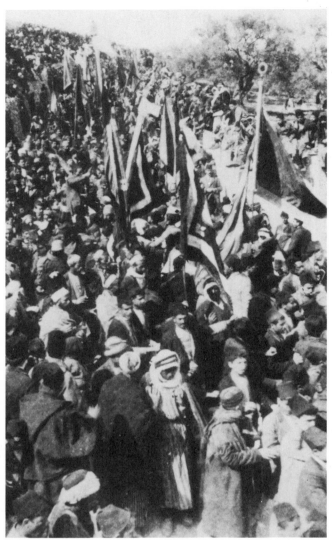

◁ Ze'ev Jabotinsky (seated first, r.) and his colleagues in the Acre jail. They will be released several weeks later simultaneously with the release of Arab rioters.

△ Thousands of agitated Arabs demonstrate in Jerusalem on the occasion of the Nebi Musa festival. It soon turns into a bloody riot.

▷ One of the first tasks taken on by the Gedud Ha'avodah ("Labor Legion") named after Trumpeldor, is the paving of the Tiberias-Zemah road. The Gedud's triangular stamp becomes widely recognized in the country.

VIEWS OF PALESTINE IN THE LATE 19TH CENTURY

▷ A view of Jaffa Road, c. 1890. Painting by Gustav Bauernfeind.

▽ Scenes of Jerusalem, including the Dome of the Rock, the Western Wall, and parts of the city walls.

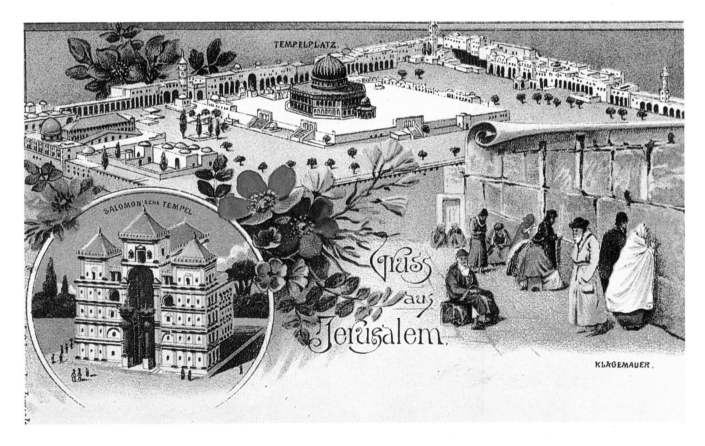

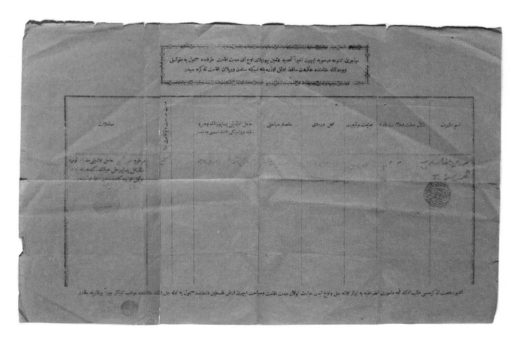

▷ A solitary Jew at the Western Wall, c. 1880. Painting by Jérôme.

△ A Sephardi Jew of Jerusalem.

▷ The "red slip" – a Turkish permit allowing a brief stay in Palestine, early 20th century.

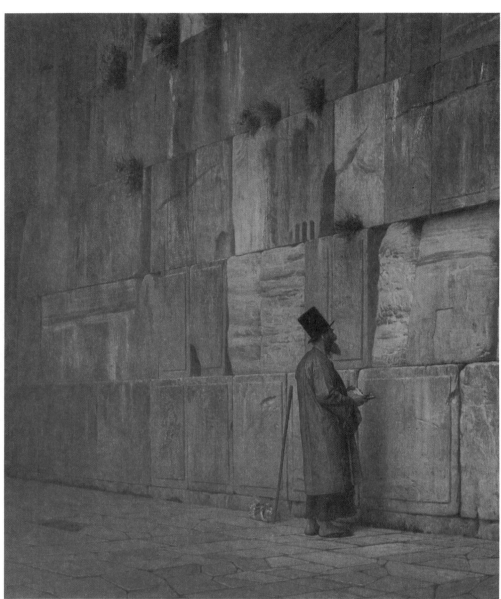

PALESTINE OR AMERICA?

△ The value of the Turkish pound is minimal. Most residents prefer gold and silver coins.

▷ A new year greeting from America, early 20th century. Most of the Jewish emigration heads west. Only a minority come to Palestine.

▽ A new year greeting from Rishon Lezion, early 20th century. The sender is Ze'ev Gluskin, an organizer of the Cooperative Association of Vineyardists.

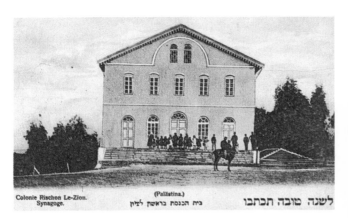

Colonie Rischon Le-Zion.
Synagoge.

(Palästina.)

לשנה טובה תכתבו

בית הכנסת בראשון לציון

△ A new year greeting from Rishon Lezion.
The large synagogue of the settlement is
built on a hill and visible from a distance.

▷ Eliezer and Hemda Ben-Yehuda, leaders of
the new Yishuv in Jerusalem.

▽ The Government House in Jaffa (sérail),
built toward the end of the 19th century.

JAFFA
SERAIL.

יפו, ארמון הממשלה.

Rechobhoth.

Rue à Zikhron-Jacob.
Strasse in Sichron-Joakob.

Puits à Ekr
Brunnen in Ek

Pethach-Thikwah.

Grüsse
aus dem
Heiligen Lande. Saluts
de la Palestine.

Anna Palm.

△ Illustrated postcard from the new Jewish villages.
▽ Greetings from the Mikveh Israel agricultural school for boys.
 Pupils cool off in the local reservoir.

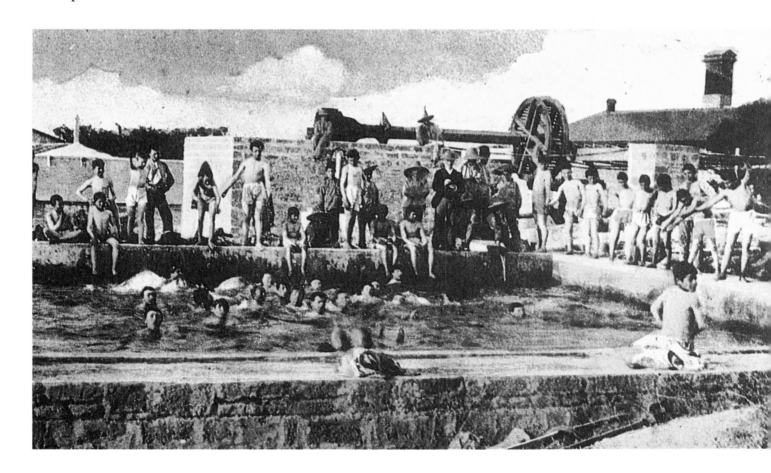

▷ With the outbreak
of the war, the
Turkish authorities
ban the display of
all Zionist symbols,
including these
Jewish National
Fund stamps.

▽ Pastoral scene of a
British soldier at
the Jerusalem
front, 1917.

▷ An Australian soldier picks wild anemones in southern Palestine.

▽ Not only the Turks use camels in the war in Sinai and Palestine. The British army has mounted camel battalions and brigades as well.

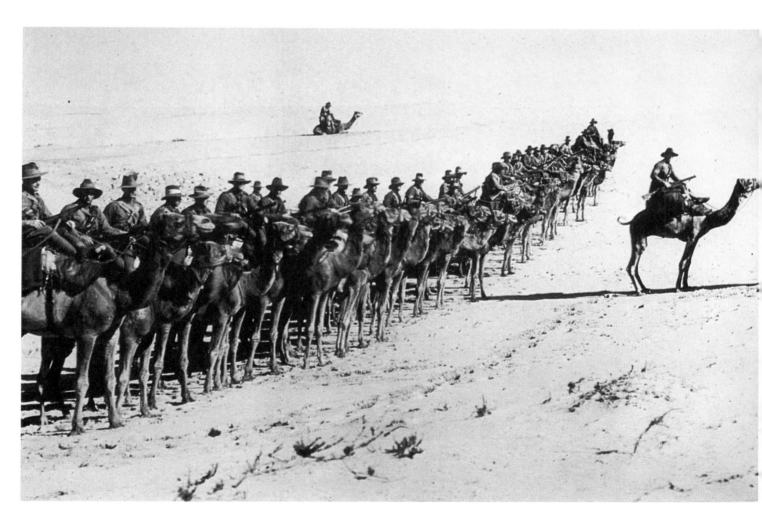

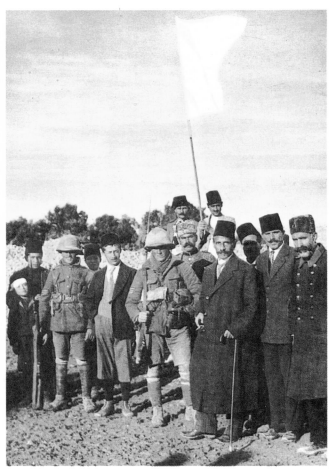

△ Portrait of General Edmund Allenby, conqueror of Palestine, 1917-18.

▷ The surrender of Jerusalem to the British army, December 9, 1917. At center, with cane: Mayor Hussein al-Husseini.

▽ Postcard published in Jerusalem to commemorate the role of the Jewish battalions in the conquest of Palestine from the Turks.

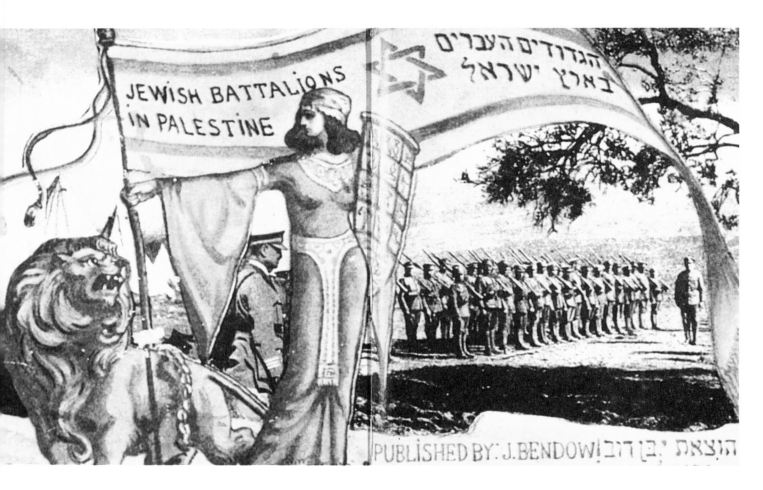

SCENES OF THE 1920S

▷ The Jezreel Valley is the focus of Zionist activity during the 1920s. Here, Moshav Nahalal, painted by Yehoshua Brandstaetter.

▽ Posters published in the 1920s by the two Jewish national funds devoted to land purchase for the new agricultural settlements: The Jewish National Fund (l.) and Keren Hayesod (r.).

△ Two of the first stamps of Palestine, issued in 1927.

▷ Rothschild Boulevard, Tel-Aviv, in the 1920s. Painting by Ziona Tagger.

▽ The land between Tel-Aviv and Ramat Gan in the 1920s. Painting by Aryeh Lubin.

△ The emblem of the City of Tel-Aviv, designed in the 1920s by Nahum Gutman.

▷ Tel-Aviv, "City of Kiosks," in the 1920s. Painting by Aryeh Elhanani.

Two tourist posters of the 1920s. Designer: Ze'ev Raban, associated with the Bezalel School of Art.

THE 1930S

Statue of the roaring lion by Avraham Melnikoff, dedicated in 1934, 14 years after the battle.

טוב למות בעד ארצנו

דרכלר דבורה
טוקר יעקב
טרומפלדור יוסף
מונטר בנימ'ן
צ'יזיק שרה
שמושניק שראור
סר אהרן
שרף וולף

א' אדר תרפ

▷ The country's first hydroelectric plant, Naharayim, 1932, commemorated on an Israeli stamp in 1991.

▷ A 1930s scene: A stockade-and-watchtower settlement, Ma'oz Hayim. Painting by Ziona Tagger.

▽ A 1930s scene: The new synagogue on Allenby Street, Tel-Aviv.

▷ The 1930s witness the rise of the young poet Natan Alterman, who also writes prose pieces, lyrics, and rhymed journalistic satire in *Davar* ("A Matter") and *Ha'aretz* ("The Land"). His famous *Seventh Column* will appear in *Davar* beginning in 1943. Painting by Eliyahu Sigard.

▽ Two posters of the 1930s depict two different struggles. Left: Thousands sign up for the Jewish Settlement Police to help combat Arab terror during the Arab riots of 1936-39. Right: The public is warned that buying imported products will lead to unemployment.

▷ One of the major events of the year is the founding in Haifa of the Histadrut Ha'ovdim ("Federation of Labor") with 87 delegates representing 4,433 workers. The meeting is opened by Yosef Baratz from Deganya. After five days of intense debate, the new body emerges. Included among its delegates in this historic photograph are such leaders of the Yishuv and the future state as Berl Katznelson (seated in 1st, row, third from r.) and Yosef Sprintzak (seated in 1st row, extreme l.).

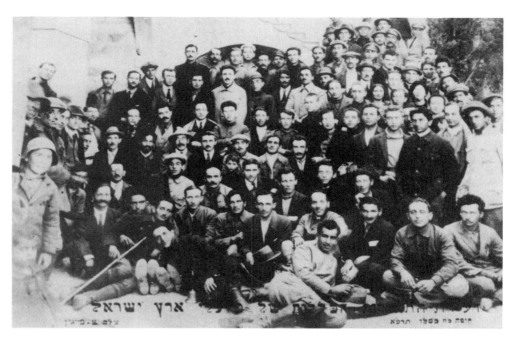

ארץ ישראל

◁ Delegates sketched by Nahum Gutman, (r. to l.): Shmuel Dayan, Berl Katznelson, Yosef Hayim Brenner. Although Brenner is not a delegate, he keeps interfering in the discussions. When he is told that he does not have the right of speech, he replies, "But I still have the right to cry out."

▽ Notice posted by the Ahdut Ha'avodah party appealing to its members to vote for Ze'ev Jabotinsky.

קלפי מיוחדת לנשים

תהי' ביום הבחירות לאסיפת הנבחרים בבית השטרים למשתלטות של .הסתדרות נשים מזרחי פתח ותקוה בשכונת . א ה ו ח 'ו. ובשכונת .שערי חנה.

ועדת הבחירות של ה.מזרחי'

△ Religious women vote for the Elected Assembly in special polling booths. Ultra-Orthodox men, however, vote on behalf of their wives.

◁ The Elected Assembly convenes for the first time in October 1920 and elects the National Council. David Yellin, community leader and teacher, is elected chairman.

אל הבוחרים!

זאב זבוטינסקי

נחן למאסר לחמש עשרה שנה על עמדו בראש הרגנה העצמית של יהודי ירושלים .חפאר של זבוטינסקי הוא .חפא כלנו.

נכתוב כלנו.

כל הבדל מטלה את שם זבוטינסקן בראש הטעטרים .לאסמת ונבדרים של יהודי אר׳ישראל. ירשום כל בוחר בראש הפתקא של רמטלה או הגבוצה׳ שלו את השם זאב זבוטינסקי.

העד הפועל של .אדרתהעבודה.

1921

January

Over 1,000 unemployed in Tel-Aviv.

7 A governmental commission led by Norman Bentwich recommends appointing a joint supreme religious council (Chief Rabbinate) for the Sephardi and the Ashkenazi communities and eliminating the position of Hakham Bashi (chief Sephardi rabbi during Turkish rule).

The Bnei-Binyamin association of young farmers in the established settlements is founded, headed by Alexander Aaronsohn.

February

22 The Chief Rabbinate is established. Rabbis Avraham Itzhak Hacohen Kook and Ya'akov Meir are chosen to be chief rabbis.

March

24 British Colonial Secretary Winston Churchill arrives for a visit. He meets with senior Mandatory officials, Arab leaders – who protest Britain's pro-Zionist policy, and Jewish leaders.

27 Emir Abdallah is invited to Jerusalem to meet with Churchill, Samuel and Col. T. E. Lawrence. He is offered the leadership of a Transjordanian entity under British influence.

28 Arabs stage a violent demonstration in Haifa, demanding a halt to Jewish immigration and the renunciation to the Balfour Declaration. The police open fire and two Arabs are killed. Jewish bystanders are injured.

29 Churchill is welcomed enthusiastically in Tel-Aviv.

April

4 The British establish a Palestinian military force to consist of a Jewish battalion, manned by the remaining Jewish battalion soldiers serving in the British army, and an Arab battalion.

27 The founding conference of the Eretz Israel Writers Association is held in Tel-Aviv with the participation of 70 writers and poets.

May

1-6 Outbreaks of Arab violence occur throughout the country, later to be referred to as the Riots of 1921. Arabs kill 47 Jews, and wound 116.

The government appoints a commission of inquiry, headed by the Chief Justice of Palestine Sir W. Haycraft, to investigate the causes of the riots.

8 High Commissioner Samuel appoints Haj Amin al-Husseini, a leading Arab nationalist, as Grand Mufti (Islamic legal authority) of Jerusalem and as head of the Supreme Muslim Council. Samuel rejects protests by the Jewish leadership over the appointment.

11 The Mandate government decides to grant partial autonomy to Tel-Aviv, which until then has been classified as a neighborhood of Jaffa. Its new legal status is a township. Official notification of the change is published on June 1st.

14 The British announce a deferment of Jewish immigration in light of the current tension. The Jewish community protests vociferously.

June

3 High Commissioner Samuel explains, in a major speech, that from now, Jews will be allowed to enter Palestine based on their, and the country's, economic capacities.

23 The Mandate government announces a plan to establish an elected legislative council.

August

1 The British publish new immigration regulations that limit the entry of Jews into the country.

During the first week of August, elections are held for the Palestinian delegation to the 12th Zionist Congress in Carlsbad, Czechoslovakia. From the 20 delegates, 9 represent the workers parties, 7 the General Zionists, and 4 the Mizrahi.

September

1-14 The 12th Zionist Congress convenes in Carlsbad. Plans for aid for the Yishuv in Palestine are discussed. The congress protests against the Riots of 1921 and the restrictions on Jewish immigration. It approves further land purchase and the establishment of settlements in the Jezreel Valley.

11 The first workers' moshav is established – Nahalal, in the Jezreel Valley.

22 The Gedud Ha'avodah ("Labor Legion") establishes a settlement in the eastern Jezreel Valley, Ein-Harod.

The first Commanders Course of the Haganah is conducted in Tel-Aviv and in Kfar Gil'adi.

October

19 The Industrial Owners and Employers Association is founded in Tel-Aviv.

The report of the Haycraft Commission of Inquiry into the causes of the 1921 disturbances is published. The commission finds that the Arabs caused the riots as a result of their "discontent with, and hostility to the Jews due to political and economic causes and due to Jewish immigration."

November

2 An Arab outburst occurs in Jerusalem on the fourth anniversary of the Balfour Declaration. Five Jews are killed and dozens are injured in violent rioting. A Haganah force deflects an attack on the Jewish Quarter in the Old City. Three of the defenders are arrested and sentenced to 6-11 years of prison with hard labor. They will be acquitted by the Supreme Court in 1922.

In the wake of the riots, the institutes of the Yishuv protest the behavior of Storrs, the ruler of Jerusalem, before the high commissioner.

7 The Zionist Executive replaces the Zionist Commission to Palestine, which has functioned as the representative body of the Zionist movement in Palestine since 1918.

30 Bank Hapo'alim ("The Workers Bank") is established as the financial arm of the Histadrut ("Federation of Labor").

December

13 Gedud Ha'avodah members establish a second kibbutz in the eastern Jezreel Valley – Tel-Yosef.

17 Two more settlements are established in the same region: Kfar Yahezkel and Geva.

David Ben-Gurion becomes a member of the Histadrut Executive Committee and emerges as acting secretary-general of the entire body.

The number of immigrants to Palestine in 1921 is 8,294.

Arabs attack Petah Tikva in 1921. Woodcut by Nahum Gutman.

FIVE SETTLEMENTS IN 100 DAYS

September 1921 marked the start of an intensive Jewish settlement drive in the Jezreel Valley. By the end of the decade, 23 farming settlements would be established in the region, constituting over half the Jewish settlement in Palestine then. The first of the five settlements to be established in 1921 was Moshav Nahalal, which was founded in a malaria-infested area of the western valley on September 11th.

Eleven days later, on September 22nd, members of the Gedud Ha'avodah ("Labor Legion") established Ein-Harod, the first of the large kibbutzim, in the eastern valley. The movement demanded that all the lands in the eastern valley be handed over to it. The Histadrut ("Federation of Labor") refused. To preempt other new settlements in the region, Gedud Ha'avodah founded a second kibbutz, Tel-Yosef, four km. away, on December 12. The two kibbutzim were inhabited by 300 members of the movement – a large number for the harsh conditions of the time.

Two more settlements were established west of Ein-Harod shortly thereafter: Moshav Ein-Tiv'on (later Kfar Yahezkel) and Geva.

All told, five new settlements were founded in the Jezreel Valley in the space of 100 days – an unprecedented accomplishment, especially in comparison with the rate of new settlements during the previous 40 years – one to two annually.

△ The Nahalal area is marshy and the early settlers are confronted with malaria, which they fight by draining the swamps.

▽ The first of the new wave of settlements in the Jezreel Valley is Moshav Nahalal, laid out in a circle, according to a plan by architect Richard Kaufmann.

△ The second settlement to be established in the Jezreel Valley, in September 1921, is Kibbutz Ein-Harod, founded by members of Gedud Ha'avodah. They pitch their tents close to the Harod spring.

▷ The leading land-purchaser of Jezreel Valley lands on behalf of the Zionist movement is Yehoshua Hankin, shown with his wife, Olga. In the early twenties, he buys about 50,000 dunams.

THE RIOTS OF 1921

In the spring of 1921, shortly after the visit to Palestine by British Colonial Secretary Winston Churchill, anti-Jewish riots and attacks were mounted by Arabs in Jaffa, Tel-Aviv, and various Jewish settlements. In Jaffa alone, over 40 Jews were killed by Arabs on May 1-2, among them the writers Yosef Hayim Brenner and Zvi Schatz. Over 100 were wounded.

One of the settlements targeted by local Arabs was Petah Tikva. However, its plucky defenders, aided by the British army, which sent an airplane and armored vehicles to the area, repulsed the attack. Rehovot and Hadera were also attacked. An attack on Kfar Saba forced its settlers to evacuate.

This time, the British responded with alacrity, making arrests and imposing group fines on villages that participated in the attacks. Seven years of tranquility followed the Riots of 1921, except for some individual incidents.

△ Writer Yosef Hayim Brenner is killed in Abu Kabir at age 40.

△ Shown, destruction at Hadera. At left, Haj Amin al-Husseini, a leading Arab nationalist.

▷ Avraham Shapira, the noted Jewish defense figure, leads the defenders of Petah Tikva.

◁ The riots elicit the formation of a British Commission of Inquiry under Chief Justice Sir Haycraft. It reaches the conclusion that the riots resulted from Arab opposition to Jewish immigration.

PALESTINE.

DISTURBANCES IN MAY, 1921.

Reports of the Commission of Inquiry
WITH
Correspondence Relating Thereto.

Presented to Parliament by Command of His Majesty, October, 1921.

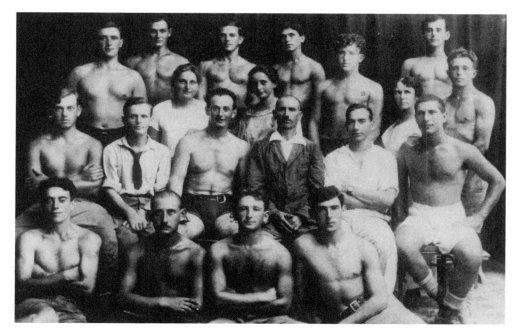

◁ Within less than a year, the Haganah, founded in the summer of 1920, is put to a series of tests during the riots of 1921. Shown, members of the first Commanders Course, held in 1921 in Tel-Aviv and in Kfar Gil'adi. (They say members of Kibbutz Kfar Gil'adi mocked their discipline drills.) Commander Elimelekh Zelikovitz (Avner) is seated at center, in jacket. Next to him, l., is Itzhak Landoberg (Sadeh), later to become a central figure in the Haganah.

כל ידיעות כלליות ירושלים 27

הטלפונים.

הטלפון בא״י היה מסודר בימי המלחמה בשביל הצבא. ורק בסוף שנת תר״פ הרשו גם לאורחים להשתמש בה תנאי סדור הטלפון הוא: בשנה הראשונה 15לירים (10 לירם התשלום שנתי, 5 לירם בעד הסדור) ובשנים הבאים 10 לירם לשנה.

אלו הם התנאים, אם צריך לסדר את הטלפון בטרחק לא יותר מקילומטר אחד מתחנת הטלפון. אם הטרחק הוא יותר גדול, אז צריך לשלם לירה אחת 1751 מילים בעד כל 250 מטר נוספת. התשלום של 10 לירות לשנה בעד הטלפין הוא בעד השתמשות בהעיר נופא. בעד השתמשות בטלפין מאיוה עיר אחרת משלשה רגעים אבל לא יותר משלשה רגעים נקבעו מחירים שונים: בעד שלשה רגעים שמוש הטלפין למשל „יפו—ירושלים״ צריך לשלם 5גרם, ירושלים—חיפה 7 גר״מ, יפו—חיפה 5 גר״מ. וכו׳.

מספרי הטלפנים בירושלים ובשארי נקודות א״י.
הטלפנים בארמון הנציב העליון על הר הזיתים.

22	לים.י.. מכנציק–סנן ראש המשטרה (D.A·A.)		7	ליט.קולונל פ. ב. ברומלי — משטרה
27	מיור סימרסט — אופיצר פולימי		2	קפטון לורד א. האי — מוכירצבאי ושליש (A.B.C)
26	המפקח על המכם		15	ט. ניורוק סנן המזכיר הפרטי
24	מחלקת הדאר והטלנרף		20	ו. דירם — מוכיר אורחי
25	לים. קיל. מ. הורסון–מנהל משרד הדאר והטלנרף		29	כתב ראשי
3	י. פ. ק. גרונב–מוכיר פרטי		4	משרד לעיני כסף ומכם
30	סניף „ק R. Branch		16	מחסן איטומובילים
14	הרינגטון–סניף „ק O." Branch		1	בית האוכך של הנציב
			11	קולוניל נ. ח. הרון–משרד הבריאות A.D.M S.
	הטלפון בבתי הדאר והטלנרף		9	ר. א. סיבלי D.A.D.M.S. "
7	מנהל ספרים ראשי		17	מיור ר. בריוקליף "
2	מהנדס ראשי		18	נ. בנטוביטש — מוכיר משפטי
5	סגן המנהל הדאר		13	מיור ר. ב. בורקיך –סניף „פ. Branch–"P
1	המהנדס בשביל צפן ודרום		12	לים. סולמן — סניף „פ. Brancn "P
62	הטלפון בשביל הקהל			

△ An early "yellow pages" telephone directory, 1921, titled *All Jerusalem*, carries information on the city, its institutions, leading personalities, and businesses. It is announced that from the end of 1920, private citizens will be allowed to keep a telephone. The annual subscription fees cost 10 Egyptian Pounds, while local calls are free.

מגרשים לבנין בתים

בבקשות ישנים על גבולות תל-אביב. ע״י הרחוב אהובי על שפת הים אפשר לקנית בתנאים נוחים אצל

ש. ברסקי, תל-אב-ב.

עומדים למכירה 1300 דונם של אדמה טובה

ע״י גדרה

△ Tel-Aviv continues to develop. Plots are available at good prices near Allenby Street.

▽ Yosef Aharonovitz, writer and editor, is appointed director of the new bank established by the Histadrut ("Federation of Labor"), Bank Hapo'alim.

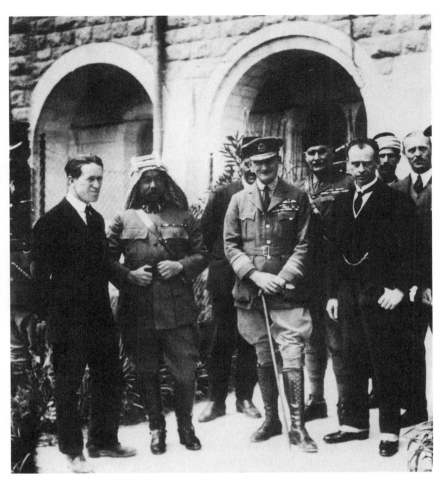

△ Colonial Secretary Winston Churchill visits Tel-Aviv. Standing alongside is Meir Dizengoff, head of the township of Tel-Aviv.

▽ An ultra-Orthodox poster in Jerusalem takes note of Churchill's "historic visit."

△ British and Arabs, 1921. At left, Col. T. E. Lawrence. Next to him, Emir Abdallah of Transjordan.

▽ A criticism of the plethora of political posts in the Yishuv. David Yellin, chairman of the National Council, is depicted on stilts.

Prayer For The Well-Being Of The Kingdom

in commemoration of the historic visit in Eretz Israel of the English Colonial Secretary Mr. Winston Churchill and in commemoration of the great day, 19 Adar II, the day of the open declaration in favor of our national home in Eretz Israel.
It is incumbent upon our brethren in Eretz Israel to pray after the reading of the Torah in all the synagogues for the well-being of His Majesty, King of Great Britain

GEORGE THE FIFTH

And to recite the blessing for the well-being of His Excellency our High Commissioner Eliezer son of Menahem Sir

HERBERT SAMUEL

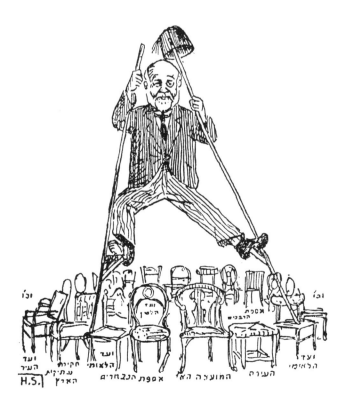

January

9 Ahad Ha'am (Asher Ginsberg), a leader of spiritual Zionism, immigrates to Palestine and settles in Tel-Aviv.

February

6 The ultra-Orthodox delegates to the Elected Assembly hold a conclave and decide to boycott the assembly sessions unless the right of women to vote is rescinded.

7 In Jerusalem, the representatives of the ultra-Orthodox in the Ashkenazi city council create a public commotion by presenting Lord Northcliff, the British guest, a sharp anti-Zionist memorandum.

Several circles in the Yishuv, beside the ultra-Orthodox, express their dissatisfaction with the activity of the National Council and the Elected Assembly.

22 Aharon David Gordon, a father of the labor movement in Palestine, dies at 66.

March

1 The presidium of the National Council proposes a compromise to the religious and ultra-Orthodox factions: the decisions of the present sitting of the Elected Assembly will be valid only for its duration, and a referendum will be held – for males only – on the issue of the women's vote.

6-9 The second sitting of the Elected Assembly takes place. It is boycotted by the ultra-Orthodox and a portion of the Sephardi delegates. The issue of the women's vote is considered but no decision is reached.

11 Benches set up by Jews in front of the Western Wall incite Arab protest and demonstration. The police order the Jews to remove the benches.

A new theater is founded in Tel-Aviv, the Dramatic Theater, directed by Miriam Bernstein-Cohen. The first play to be presented is Ibsen's *Ghosts*.

April

16 The Histadrut Hapo'el Hamizrahi is established by religious Zionist workers.

17 The cornerstone is laid for the Borokhov neighborhood, a workers' housing complex east of Tel-Aviv. Later, it will become a major component of the city of Giv'atayim.

May

18 Ra'anana, an agricultural settlement, is founded in the Sharon region.

June

2 Three of the large settlements are granted the status of local councils: Petah Tikva, Rishon Lezion, and Rehovot.

July

3 The British government issues a White Paper, drawn up by Winston Churchill, on its projected policy in Palestine. It announces the severing of Transjordan from Palestine; continued support for the Balfour Declaration and the establishment of the Jewish national home, although Jewish immigration will be limited by the country's economic capacity to absorb new arrivals; and the establishment of a legislative council to represent all the inhabitants of the country.

24 The League of Nations Council ratifies the British Mandate over Palestine.

August

22-24 The fifth Arab Congress convenes in Nablus. It hardens its attitude toward the Jewish Yishuv and Zionism. Arabs are forbidden to trade with Jews or to sell land to them.

September

10 Histadrut Ha'ovdim ("Federation of Labor") conducts the first census of Jewish workers in Palestine. 16,600 men and women are counted. More than half are members of the Histadrut.

11 The British Mandate is officially inaugurated. Sir Herbert Samuel is sworn in as high commissioner and as supreme commander of the army in Palestine. The Arabs protest the Mandate's alignment with the Balfour Declaration.

16 The League of Nations Council ratifies a British proposal to sever Transjordan from Mandate jurisdiction. The Zionist leadership demurs but does not mount a protest.

October

22-28 The first population census is conducted in Palestine. Its results indicate that the total population is 757,200, of whom 83,800 are Jews (11%) and 673,400 are Arabs and others.

November

4 Bet-Alfa is founded, the first kibbutz by the Shomer Hatza'ir ("Young Watchman") movement.

13 Representatives of the private farmers decide to form a general association.

December

16 Eliezer Ben-Yehuda, the reviver of the Hebrew language, dies in Jerusalem at the age of 64.

30 Kibbutz Yagur is founded at the foot of the Carmel.

Throughout the year, Ganigar and Binyamina are also set up.
 During 1922, 8,685 Jewish immigrants arrive in Palestine.

Soccer cup finals are held for the first time. An English team takes the cup.

1922

The Jaffa Gate plaza, before and after the removal of the clock tower by the "Pro Jerusalem" association.

THE WHITE PAPER OF 1922

The first in a series of official British policy statements on Palestine, the White Paper of 1922, was issued on July 3 by the Colonial Office in London under Winston Churchill, and, most probably guided by recommendations from High Commissioner Sir Herbert Samuel. The White Paper signified the first British retreat from the original wording of the Balfour Declaration.

It stipulated that the Balfour Declaration did not contemplate that Palestine as a whole should be converted into a Jewish National Home, but that such a home should be founded in Palestine. It also severed Transjordan from the Mandate and granted official approval to the establishment of the Transjordan Emirate, led by Emir Abdallah, which in 1946 was to be given the status of an independent kingdom.

Nonetheless, the British emphasized in the White Paper that the Balfour Declaration was still in force and that the Jews were in Palestine as of right and not on sufferance.

The Zionist leaders considered these changes in British policy very hard to accept, although they eventually had to. Their options were either to take what was left of the curtailed national home, or to come into an open conflict with the British, who were Zionism's most promising ally at the time.

△ Ahad Ha'am settles in Tel-Aviv in January 1922.

◁ A Palestine scene: water buffalos in the marshy Harod Valley.

▽ High Commissioner Sir Herbert Samuel is sworn in officially in September 1922.

△ The tents of the Gedud Ha'avodah ("Labor Legion") at the spot where the Jerusalem neighborhood of Rehavia in will be built.

▽ Aharon David Gordon, an outstanding figure of the labor movement, dies in February 1922.

△ The draining of the swamps in the Jezreel Valley is begun in 1922. The water buffaloes that abound must make way for a series of new Jewish settlements: Ein-Harod, Tel-Yosef, Kfar Yaheskel, and Bet-Alfa.

THE THIRD ALIYAH

Jewish immigration to Palestine resumed with the end of World War I. A large proportion of these immigrants were young, educated pioneers who had been bitterly disappointed by the rise of nationalism in Europe, often accompanied by anti-Semitism. Influenced by the events of the Russian Revolution, they believed that a new socialist Zionist society could be created in Palestine.

Many of the newcomers were employed in public works projects such as road paving and marsh draining. They also contributed to the establishment of new organizational and settlement formats – the Histadrut ("Federation of Labor"), the kibbutz, the moshav and the Gedud Ha'avodah ("Labor Legion").

The Third Aliyah lasted four years (1919-23), during which 35,000 Jews immigrated to the country.

△ The Third Aliyah period witnesses the start of the construction of three-story buildings in Tel-Aviv.

◁ Jews join the British police force. Shown, training in Zikhron Ya'akov.

▷ The Pensaks of Tel-Aviv, an immigrant family from the United States who develop the first commercial center in the city.

THE HALF-PROMISED LAND.

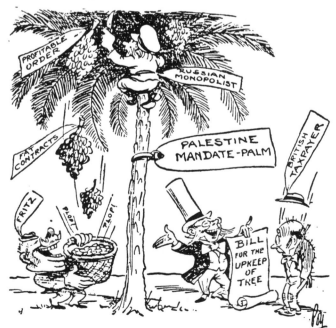

Two anti-Zionist caricatures in the British press (l., *Punch*; r., *the London Evening News*, May 7, 1922) depict Pinhas Rutenberg, who is trying to acquire a concession for setting up an electric grid in Palestine, as a Russian monopolist.

January

1 *Ha'aretz* ("The Land"), published daily in Jerusalem since 1919, moves to Tel-Aviv.

17 Members of a clandestine organization, Hakibbutz, associated with the Gedud Ha'avodah ("Labor Legion"), shoot and kill an officer in the Jaffa police force, Taufiq Bey, in revenge for his role in the murder of Jews during the Riots of 1921.

Lt.-Col. Frederick Kisch, an English Jew, takes up the post of head of the Political Department of the Zionist Executive in Jerusalem, which he will fill until 1931.

Ze'ev Jabotinsky resigns from the Zionist Executive in protest against its submission to British pressure, especially regarding the severing of Transjordan from Palestine.

February

7-20 The second convention of the Histadrut ("Federation of Labor") is held in Tel-Aviv. The Ahdut Ha'avodah ("Unity of Labor") party constitutes an absolute majority (69 delegates of a total of 127). The conference decides to establish the Hevrat Ha'ovdim, a cooperative society of workers in all branches of settlement and industry.

Prof. Albert Einstein arrives and is welcomed warmly all over the country.

14 The National Council makes the permission of the independent Jewish communities a condition for its participation in the elections for the legislative council.

16 The high commissioner promises the representatives of the Yishuv to act towards the fulfillment of their (above mentioned) demand.

18 The Jewish population participates in elections for the legislative council. Most of the Arabs boycott the elections.

February-April

Workers conduct a prolonged strike for improved conditions in the Krinitzi-Goralski carpentry in Jaffa and refuse wage cuts. The police intervene during an attempt by the owners to remove merchandise.

Tobacco plantation becomes an important part in the economy of the Yishuv.

March

29 The Palestine Electric Corporation is established under the management of Pinhas Rutenberg.

April-June

Political tension mounts in Tel-Aviv over elections to the town council. Controversial issues are electoral procedure and Sabbath observance. The Neveh Zedek and Neveh Shalom neighborhoods demand the enforcement of strict Sabbath laws throughout Tel-Aviv, threatening to rejoin the Jaffa municipality otherwise.

May

25 The British announce the official establishment of independent rule in Transjordan under Emir Abdallah.

29 The high commissioner announces the abandon of the plan for a legislative council in view of Arab opposition. Instead, the government will rely on an advisory council composed of 8 Muslims, 2 Christians, 2 Jews and 10 British administration officials. The Arabs oppose this body as well.

June

10 The power station in Tel-Aviv begins operations. The city is electrified.

July

15 A major labor dispute erupts between two unions – the Histadrut and the Hapo'el Hamizrahi – over the rights of religious workers to jobs on a building site in Tel-Aviv. The British police intervene following fistfights and a work stoppage.

A committee formed by the institutes of the Yishuv determines that religious workers are entitled to three quarters of the jobs at this site, and the Histadrut ("Federation of Labor") to the rest.

16-19 The first conference of the Farmers' Federation of Palestine is held in Petah Tikva.

26 The opera *La Traviata* is presented in Tel-Aviv in Hebrew costumes. Founder of the company and musical conductor is Mordechai Golinkin.

Kibbutz Ein-Harod splits over ideological differences. Supporters of the Gedud Ha'avodah ("Labor Legion") leave for nearby Kibbutz Tel-Yosef. The Histadrut ("Federation of Labor") backs Ein-Harod.

The government ends public works projects, including road paving. An economic crisis develops.

August

4 Histadrut Secretary-General David Ben-Gurion leaves for an extended visit to the Soviet Union to represent the Histadrut ("Federation of Labor") at an international agricultural fair. He returns some five months later.

The Histadrut establishes a labor-trend school network.

6-15 The 13th Zionist Congress is held in Carlsbad, Czechoslovakia. A major topic is the establishment of an expanded Jewish Agency for Palestine.

29 Tel-Aviv receives its first Ashkenazi chief rabbi, Rabbi Shlomo Aaronsohn – formerly from Kiev and Berlin. Rabbi Ben-Zion Hai Uziel holds the Sephardi chief rabbi office.

October

4 While the Zionist parties and institutions debate the expanded Jewish Agency, the British propose establishing an Arab agency as well. The proposal is rejected by the Arabs.

A new agricultural settlement is established in the southern Sharon region, Ir Shalom, later renamed Ramat Hasharon.

November

6-7 The National Council rejects a proposal to establish an Arab Agency as infringing on the rights of the Jewish people according to the Mandate. The council is also angered by the concealment of the proposal from the Jews.

11 A first municipalities council of the Haganah is held, convening the organization's leaders from all cities.

26 Growing unemployment prompts the National Council to form a committee to provide odd jobs for the unemployed.

December

31 A Tel-Aviv resident, Shaul Levi, bursts into the office of the mayor, Meir Dizengoff, and attacks him physically over a dispute with the municipality.

Unemployment in the Yishuv is widespread during the second half of 1923 and emigration increases.

Only three new settlements are established in 1923: Kfar Gideon, Mizra, and Ramat Hasharon.

The number of immigrants is the lowest in four years: 8,175. Immigration ceases toward the end of the year, marking the end of the Third Aliyah.

1923

La Traviata is mounted in Tel-Aviv.

THE EMPOWERMENT OF THE HISTADRUT

The early days of the Histadrut Ha'ovdim ("General Federation of Labor"), founded in late 1920, were marked by a lack of leadership which was largely resolved when David Ben-Gurion assured the position of secretary general a year later. Within a short period of time he consolidated a significant power base, held a census of the membership, and successfully opposed efforts by the heads of various affiliated bodies to preserve any significant autonomy.

The year 1923 was decisive in the development of the federation. Its second convention, held at the beginning of the year, approved the formation of the Hevrat Ha'ovdim, a cooperative workers' society defined as an "economic corporation subject to the supervision and direction of the majority." Hevrat Ha'ovdim became the owner of all the financial and cooperative bodies of the Histadrut and held the founding shares of Bank Hapo'alim, Hamashbir (a food, supplies, and equipment distributor), and the other economic concerns created by the Histadrut. During the course of the year, the Histadrut emerged as a major organization taking part in the building of the Jewish national home, and one to be reckoned with in national decision making.

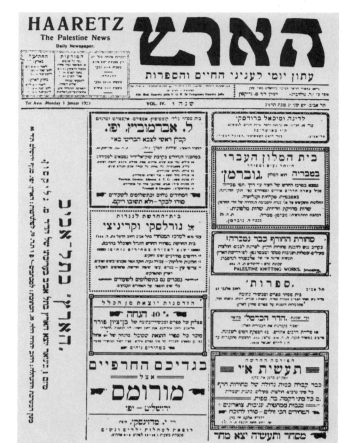

△ A memorial is built by British soldiers in Jerusalem to commemorate comrades fallen in the conquest of the city in 1917.

▷ Frederick Kisch is named head of the Political Department of the Zionist Executive in Jerusalem in January 1923.

△ Ha'aretz ("The Land"), moving from its base in Jerusalem on January 1, 1923, begins to be published in Tel-Aviv, signaling the future central position of the city. Dr. Moshe Gluecksohn (r.) is appointed chief editor.

▽ The first building of the Municipality of Tel-Aviv, on Rothschild Boulevard.

△ Mayor of Tel-Aviv, Meir Dizengoff, is attacked in his office by a resident of the city on December 31, 1923.

▽ Mayor Dizengoff hosts Prof. Albert Einstein in Tel-Aviv. He is received with excitement everywhere. Heads of the city are posing around him for a photograph.

▷ Emir Abdallah, son of Sharif Hussein of Hejaz, becomes the leader of an independant territory established under formal rule of the high commissioner of Palestine in eastern Transjordan. The emirate will become an independent state in 1946.

△ A scandal develops over a proposal for a commemorative statue of Yosef Trumpeldor. Sculptor Y. D. Gordon, an immigrant from the U.S., displays a small model of the proposed statue in Tel-Aviv. It is well received by the public, but funding is unavailable to finalize the project. The artist smashes the model and leaves the country.

The Third Aliyah

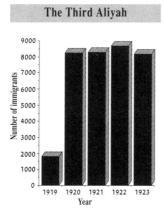

▷ In lieu of cash salaries, workers in Histadrut ("Federation of Labor") concerns are issued store coupons.

▽ A housing shortage in Tel-Aviv forces hundreds to live in tents by the sea shore.

△ A promising new agricultural branch in Palestine: tobacco.

THE CRISIS OF THE THIRD ALIYAH

The rapid growth of the postwar period was followed by a recession in 1923 marked by rising unemployment and emigration. The economic crisis in the Yishuv resulted from the cessation of public works projects that the government had initiated, a decreased inflow of private capital, and the inability of the economy to absorb so large a number of immigrants as had entered the country without both private and public financing.

Worst of all was a crisis in morale among the inhabitants brought on by the gap between the high-flown political hopes and social visions and the disappointing day-to-day reality. The result was a sense of loss of direction, frustration at the failure to establish a national home, and lack of confidence in the future. Some put the blame on the immigrants themselves. In late 1923, the newspaper *Hapo'el Hatza'ir* wrote: "... what is required today is the immigration of **pioneers** and not of **deserters and refugees**. As to the latter, it is better they do not come at all, than come and go back."

THE SPLIT IN THE GEDUD HA'AVODAH ("LABOR LEGION")

One of the innovations to emerge from the Third Aliyah was the Gedud Ha'avodah, a unique social experiment that became a symbol of the labor movement avant-garde and a focus of revolutionary ideas.

Founded in 1920, six months after the battle of Tel-Hai, it was at first called the Yosef Trumpeldor Legion for Labor and Defense, but caution dictated dropping the defense aspect. Coalescing around the road-paving public works projects, the communal movement forged a distinctive image in its adherence to principles of co-operative living, self-sacrifice, and personal dedication to the goal of establishing a new, egalitarian society throughout the country.

The Gedud Ha'avodah only had some 100 members upon its establishment but it soon became a magnet for the pioneers of the Third Aliyah, expanding to a membership of 600-700. Part of the members were drawn to the establishment of rather large communal settlements and founded the kibbutzim of Ein-Harod and Tel-Yosef in the eastern Jezreel Valley in late 1921. Permanent settlement, however, resulted in ideological tension and disputes both within the movement and between it and the emerging Histadrut ("Federation of Labor"), reaching a crisis point in 1923 when part of the Gedud Ha'avodah membership, primarily at Ein-Harod, left the organization. Supporters of the movement there moved to nearby Tel-Yosef. This first split left its scars on the Yishuv in general and on the Gedud Ha'avodah in particular. In the coming years, internal conflicts continued, bringing about further splits. The movement ceased to exist in the late twenties, and its kibbutzim joined the Hakibbutz Hame'uhad.

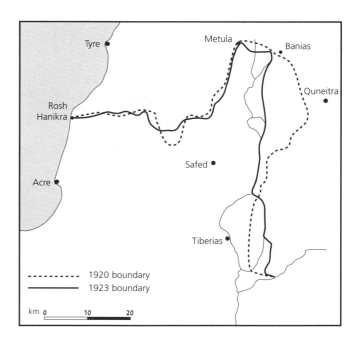

△ The northern border approaches its final status after a series of alterations over a three-year period.

As can be seen, part of the Golan Heights is included in Palestine until 1923.

△ The first power station in Tel-Aviv begins operations in the summer of 1923. It is later to be commemorated in an Israeli stamp.

◁ Builders and operators of the power station are photographed with the director of the electric company, Pinhas Rutenberg (bottom center, with glasses).

1924

January

The noted Jewish soccer team from Vienna, Hako'ah, visits Palestine on a playing tour, marking the first visit to Palestine of an international-class team. It scores victories by large margins.

11 The Jaffa district court sentences Shaul Levi, who struck Mayor Dizengoff, to a fine of 50 Egyptian Pounds or a month's imprisonment.

13 Mayor Dizengoff, claiming that the sentence is too light, announces his resignation. He is finally persuaded to withdraw it.

20 The first Tel-Aviv municipal elections are held, with 4,202 voters electing 41 representatives.

27 A historic meeting takes place between leaders of the Yishuv and the Zionist movement, and King Hussein of Hejaz, who is visiting his son Abdallah in Amman. Participants from the Jewish side are President of the National Council David Yellin, Zionist Executive Committee member Frederick Kisch, and the Sephardi chief rabbi, Rabbi Ya'akov Meir. They lay out Zionist aspirations to the king and emphasize the desire for friendly relations with the Arabs.

31 The Tel-Aviv City Council nominates an executive and a mayor – Meir Dizengoff.

March

12 Solel Boneh, a construction company, is established by the Histadrut ("Federation of Labor").

P.I.C.A., the Palestine Jewish Colonization Association, is founded as the successor to the Jewish Colonization Association (I.C.A.). It is led by James de Rothschild, son of Baron Edmond de Rothschild.

26 Hayim Nahman Bialik, the poet, and his wife, Mania, immigrate to Palestine. Bialik builds his home in Tel-Aviv.

April

3 The British and French end their dispute over the northern border of Palestine. Metula and its environs are included in British Mandate

Reuven Rubin exhibits in David's Citadel in Jerusalem, 1924.

territory once and for all.

The first issue of the bibliographic periodical, *Kiryat-Sefer*, appears, published by the National Library in Jerusalem. It continues to be published to the present day.

May

Immigration grows and is soon referred to as the Fourth Aliyah.

The daily *Do'ar Hayom* ("Daily Mail") accuses Dr. Arthur Ruppin of waste and corruption during the war period.

11-14 The first conference of the General Zionist movement is held in Jerusalem. It decides to establish a General Zionist Federation to amalgamate all centrist factions in Palestine.

12-20 The Ahdut Ha'avodah ("Unity of Labor") party convenes at Ein-Harod. It votes to support the establishment of large kibbutzim and to form a "Hebrew-Arab workers' alliance."

14 Ultra-Orthodox Jews found an agricultural settlement between Ramat Gan and Petah Tikva: Bnei-Brak.

June

1-2 The Histadrut ("Federation of Labor") Council decides to publish a daily, to be edited by Berl Katznelson. Another decision is to begin construction of workers' neighborhoods near Tel-Aviv and Haifa.

10 The Palestine Government Law School in Jerusalem awards graduation certificates to 45 students, most of them Jewish.

30 Ya'akov Israel de Haan, a leader of the Agudat Israel movement and an outspoken anti-Zionist, is shot and killed in Jerusalem.

July

The Chief Rabbinate considers a request by the Galilee Bedouin tribe Arab al-Shimali to convert to Judaism.

Immigration continues to stream in. Most of the newcomers are from Poland, an outcome of repressive economic decrees announced there. The wave of immigration is labeled the "Grabski Aliyah" for Polish Treasury Minister Wladyslaw Grabski, who originated the measures.

August

8 The Hebrew Language Protection Legion, founded to guarantee the status of Hebrew as the official language of the Yishuv, censures the Alliance Israélite Universelle school in Tel-Aviv for teaching in French and urges pupils there to transfer to Hebrew schools.

October

8 The Hebrew-language Te'atron Eretz Israeli ("Eretz Israel Theater") is founded in Berlin by Menahem Gnessin (director and manager), Miriam Bernstein-Cohen, Michael Gur, Ari Kutai, Yosef Ochsenberg, and Menahem Binyamini.

17 Histadrut Hano'ar Ha'oved ("Federation of Working Youth") is founded to protect the rights of working youngsters in cities and villages.

18 The second Haganah municipalities council is held. It draws up a constitution for the organization.

25 The Writers' Organization is founded, later to be called the Writers' Association.

November

3 Menahem Sheinkin, a founding father of Tel-Aviv, is killed in a traffic accident in Chicago.

23 A new settlement, Herzliya, is founded in the Sharon region.

24 Jewish plowers in Afula are harassed by Arabs. A fight breaks out in which an Arab is killed.

December

8 A new neighborhood, Bayit Vegan (later Bat-Yam), is established south of Jaffa.

22 The Institute of Jewish Studies of the Hebrew University is opened in Jerusalem, although the university has not yet opened officially.

Some 14,000 Jews immigrate to Palestine in 1924, an increase of 70% compared to 1923.

▽ Citrus is a growing agricultural branch. Members of the Raab family are shown in their grove in Petah Tikva.

▷ The pace of construction intensifies in Tel-Aviv and the former garden town takes on the appearance of a city.

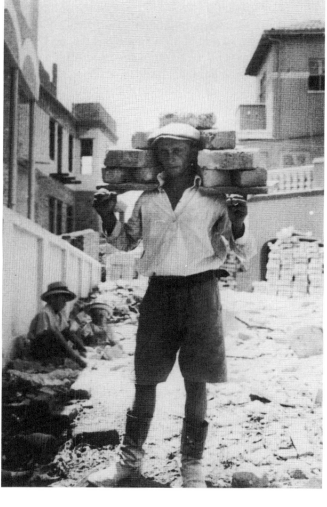

▽ The legendary Jewish Viennese soccer team, Hako'ah, arrives in January 1924, marking the first visit to Palestine of a top-rated European team. Classes are stopped and children are allowed into the streets to receive them. One street is named after the team: "Hako'ah Vienna". Hako'ah, which has taken the Austrian cup several times and has won games throughout the world, beats the local teams by wide margins but enhances Jewish status in the eyes of the English and the Arabs and boosts local soccer. At right, a notice by Maccabi Tel-Aviv welcoming the guest team.

אגדת „המכבי" מתל־אביב

מקדמת בברכה לבית

את חברי „הכ"ה" מוינה

לבאם לארץ ומאחלת להם הצלחה והנאה בבקורם זה.

תקותנו ש.הכ"ה" שהצליח להרים למדרנה כה נכהה את הספורט העברי,

יפתח בבקורו זה, תקופה חדשה בחיי הספורט העברי כאן.

THE FOURTH ALIYAH

A new wave of immigration arrived in Palestine in 1924, ending a period of static immigration and rising unemployment. This new influx stemmed from a deterioration of the condition of the Jews in Poland as a result of measures initiated by Polish Treasury Minister Wladyslaw Grabski, along with a closing of the emigration option to America as a result of restrictive immigration policies introduced there.

The large influx – the first mass immigration to the country – created palpable change in Palestine, especially in Tel-Aviv, where many settled. A large proportion of the newcomers were lower middle class families who arrived not in ideologically motivated groups but on their own, with no Zionist background. Housing construction was immediately stimulated. The immigrants established themselves in small businesses and petty trade, adding to their Grabski Aliyah label yet another: the Kiosk Aliyah.

The Fourth Aliyah, which numbered some 60,000 persons by mid-1926, was not exclusively urban, however. New agricultural villages soon developed as well: Bnei-Brak, Herzliya, Ramatayim, Magdiel, and Kfar Hasidim, in addition to Afula, planned as the Jezreel Valley's regional city.

▷ The Fourth Aliyah is associated primarily with the rapid development of Tel-Aviv, which doubles its population in two years from 20,000 to 40,000, expanding mostly northward. The first houses are set up in the dunes in the Tel-Nordau neighborhood – today's Ben-Yehuda and Mendele streets. Camels are useful for construction.

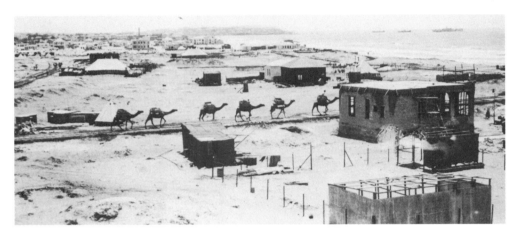

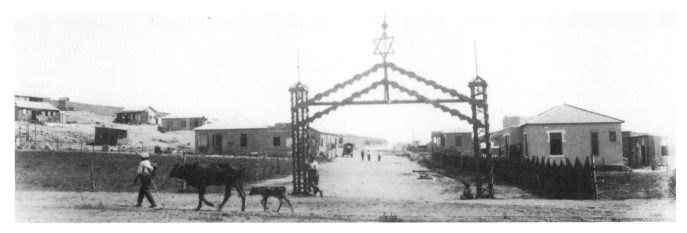

△ A new settlement is established in 1924 by ultra-Orthodox Jews from Poland on land lying between Ramat-Gan and Petah Tikva: Bnei-Brak, later to become a large ultra-Orthodox city.

▷ Industry expands during the Fourth Aliyah. Shown: a new factory for assembling buses – a new necessity in the growing city.

▽ An event that agitates the Yishuv in 1924 is the murder of Dr. Ya'akov Israel de Haan, a leader of the old Yishuv and an avowed anti-Zionist, who is shot in Jerusalem at close range. The Mandate government, in a notice printed in the country's three official languages, offers a large reward for the apprehension of the murderer.

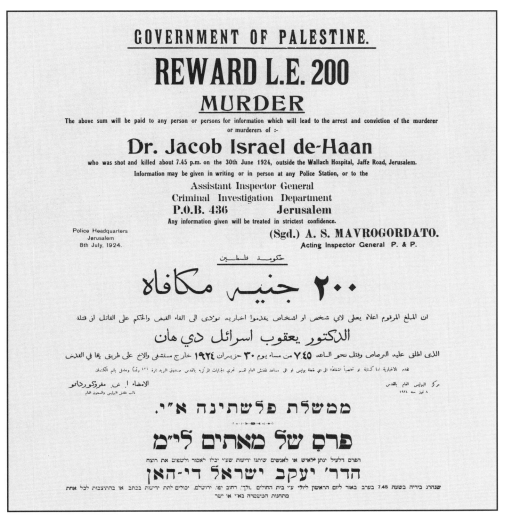

THE DE HAAN MURDER

Dr. Ya'akov Israel de Haan, born in Holland, had been an assimilated Jew, a socialist, and a Zionist as a young man but became a religious repentant, immigrating to Jerusalem in 1919. There he joined the ultra-Orthodox Agudat Israel movement, becoming a leader of the old Yishuv and an avowed anti-Zionist. A complex personality, he was both a poet and a journalist, and had various public and political connections. As spokesman for the ultra-Orthodox community in its dealings with the British administration, he vigorously delegitimized Zionist activity in the country. His affinity with the Arabs was partly explained by his homosexual relationships with young Arab men.

So vociferous were his attacks on Zionist endeavor, that his life was threatened on several occasions, but he ignored all warnings. A small group of Haganah members in Jerusalem, probably with permission from their leadership, decided to terminate his activities. He was shot on June 30, 1924, just after he left the synagogue in the Sha'arei Zedek Hospital after evening prayers. His ambushers were never caught.

The murder marked the first political assassination in the Yishuv. After his death, the ultra-Orthodox community made de Haan a martyr.

△ The cornerstone for the Histadrut building in Jerusalem is laid in 1924. The speaker is Histadrut Secretary General David Ben-Gurion, age 38, under whose leadership the Federation of Labor becomes one of the most important organizations in the country.

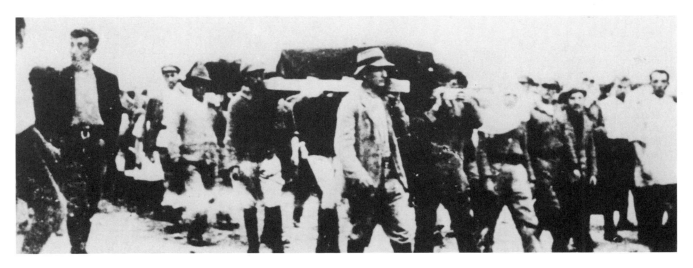

> Our history has always been paved with contradictions, and now we are faced with the most fearsome contradiction of all: The greater our success in Eretz Israel, the more violent the opposition we shall encounter.
>
> Dr. Hayim Weizmann, 1924

△ After prolonged arguments between Kfar Gil'adi and Tel-Hai, the coffins of Yosef Trumpeldor and his fallen comrades are transferred from Kfar Gil'adi in 1924 to a new burial site between the two kibbutzim in the Galilee.

▽ Following prolonged negotiations between England and France, the northern border is fixed at a point that includes Metula, (whose border post is shown), in Palestinian territory.

:LET THERE BE LIGHT:

:OSCAR S. STRAUS:

△ Oscar Straus, formerly American Ambassador to Turkey, donates hundreds of books bearing his ex libris to the new National Library in Jerusalem in 1924.

January

Immigration continues to stream into the country. Some 2,000 newcomers arrive in January alone.

Soccer team Hako'ah Vienna arrives for a second round of matches. It beats the English national team by 4:2 in Jerusalem, and the Hebrew national team in Tel-Aviv by 11:2.

February

3 Builders in Tel-Aviv announce a lockout in response to frequent strikes initiated by the local labor council.

9 The Technion, the first Hebrew institution of higher education in Palestine, opens in Haifa.

17 The National Council mounts a campaign to extend Herbert Samuel's term of office as high commissioner by an additional five years.

19 The National Council founds the Committee of the 15, with 5 representatives of the workers, 5 of the employers, and 5 representing the National Council and the Zionist Executive. The task of the committee is to legislate labor laws concerning minimal wages and to conceive solutions to labor conflicts.

March

3 The Eretz Israel Theater returns to the country with the play *Balthazar*, which has been a success in Berlin.

31 Afula is established as a city in the heart of the Jezreel Valley.

April

Lord Arthur Balfour, former British foreign secretary and father of the declaration bearing his name, visits Palestine for the opening ceremony of the Hebrew University.

1 The opening of the Hebrew University of Jerusalem is marked by a ceremony on Mt. Scopus.

30 The Revisionist movement, led by Ze'ev Jabotinsky, is founded in Paris.

May

3 Elections are held for the municipality of Tel-Aviv. The Labor ticket wins 14 of the 41 seats in the city council, while the rest of the tickets win only several seats each.

18 Meir Dizengoff is reelected mayor of Tel-Aviv.

21 A new high commissioner for Palestine is announced by London – Lord Plumer, a field marshal, age 68.

June

1 A new daily newspaper appears, *Davar* ("A Matter"), an organ of the Histadrut ("Federation of Labor") edited by Berl Katznelson.

15 The Mandate government announces new immigration rules.

15-16 The third session of the Elected Assembly convenes. It rejects, by a vote of 103 to 53, an agreement reached between the Zionist Executive and the ultra-Orthodox regarding the women's vote. The ultra-Orthodox, Mizrahi, Yemenite, and some Sephardi representatives leave the session in protest. The assembly is dissolved and new elections are to be held.

16 The representatives of the factions who left the session of the Elected Assembly (see above) decide to disperse the assembly and to hold elections for a new body which, in their view, would be more representative of the factions of the Yishuv.

Immigration peaks at 4,200 for the month of June alone. Construction in Tel-Aviv peaks as well, with permits for 300 buildings issued for June, an average of 11 buildings daily, excluding Sabbaths.

July

2 In Rishon Lezion, a bloc to represent the centrist factions in the elections for the Elected Assembly is founded. It is led by Menashe Meirowitz, a Bilu veteran.

2 High Commissioner Herbert Samuel leaves Palestine from the port of Jaffa, at the exact point of his arrival five years earlier.

13 A proposal by Mizrahi to hold a referendum on the issue of the right of women to vote in the elections to the Elected Assembly is rejected.

August

1 Representatives of various sports clubs meet in Afula and decide to establish a national sports organization named Hapo'el ("The Worker").

18-28 The 14th Zionist Congress is held in Vienna. In its course, a sharp argument develops between those who are for collective settlements and those who are for private and urban enterprise – practiced mainly in Tel-Aviv by the Fourth Aliyah.

25 The new high commissioner, Lord Plumer, arrives in Palestine.

September

16 The government announces the Citizenship Ordinance.

October

10 A general conference of all societies for the protection of Hebrew as the official language of the Yishuv decides to establish a single movement.

12 The Arabs present their claims regarding their status in the country to the high commissioner.

14 The National Council plenum accepts the demand by the religious factions for a referendum on the issue of the women's franchise. The labor representatives abstain.

30 A rabbinic notice forbids participation in the planned referendum.

November

2 Rabbinic opposition to participation in the planned referendum prompts the Mizrahi and Hapo'el Hamizrahi leadership to go ahead with their proposal and announce their consent to participation in the elections.

7 The first conference of the Union of Collective Settlements is held in Bet-Alfa with 101 delegates representing over 2,600 members.

8 The National Council cancels the referendum on the women's vote and announces elections for the second Elected Assembly.

The Maccabi Tel-Aviv soccer team creates a sensation when it defeats the British Army Lancers 12:0.

December

The continued economic growth of two years shows first signs of a slow-down.

6 Elections are held for the second Elected Assembly, with 36,767 voters (56.7% of the electorate) electing 201 representatives. The Labor parties attain the greatest success, electing 84 representatives, or over 40%. The ultra-Orthodox do not participate. All 26 participating tickets are represented.

15 The Gedud Ha'avodah ("Labor Legion") Council decides to eject its radical left wing, the communist fraction.

17 In a military ceremony, the flag of the Jewish Batallion is handed over to the Hurva Synagogue in the Old City of Jerusalem for preservation. The move stirs agitation amongst the Arabs.

24 A crisis develops in the administration of the city of Tel-Aviv. Mayor Meir Dizengoff announces his resignation following the acceptance of a labor faction's proposal to waive kindergarden and school tuition. Attempts to persuade him to reconsider are unsuccessful. David Bloch-Blumenfeld is appointed to replace him.

The year 1925 marks a new peak in immigration: 34,386, equal to the total immigration figure for the entire Third Aliyah during 1919-23.

Among the newly founded settlements in the course of the year are Kfar Ata, Nesher, Kfar Hasidim, and Ramat Yishai.

In the course of the year, the offices of the Executive Council of the Histadrut ("Federation of Labor") return from Jerusalem to Tel-Aviv.

1925

THE OPENING OF THE HEBREW UNIVERSITY

The opening of the Hebrew University of Jerusalem on Mt. Scopus on April 1, 1925, was a day of celebration for the entire Yishuv. The university was conceived as a research center that would house noted scholars and actualize the concept of an intellectual center and at the same time serve as an educational center for Jewish students from all over the world. In Ahad Ha'am's view, the founding of the Hebrew University was the most important achievement of the Zionist movement.

Taking part in a parade of dignitaries at the opening ceremonies were leaders of the Yishuv and the Zionist movement, noted professors, statesmen, and representatives of various universities, including the University of Cairo. Dozens of foreign correspondants covered the event.

The guest of honor was Lord Arthur Balfour. Addresses were delivered by him and by General Edmund Allenby, High Commissioner Herbert Samuel, poet Hayim Nahman Bialik, Dr. Hayim Weizmann, and Rabbi Kook.

△ Lord Balfour, visiting Palestine in 1925, is warmly welcomed by the Jewish Yishuv but greeted with black flags by the Arab population.

▷ Balfour is the central speaker at the dedication ceremony of the Hebrew University on April 1, 1925.

▽ Balfour participates in other events as well, including various corner-stone-laying ceremonies.

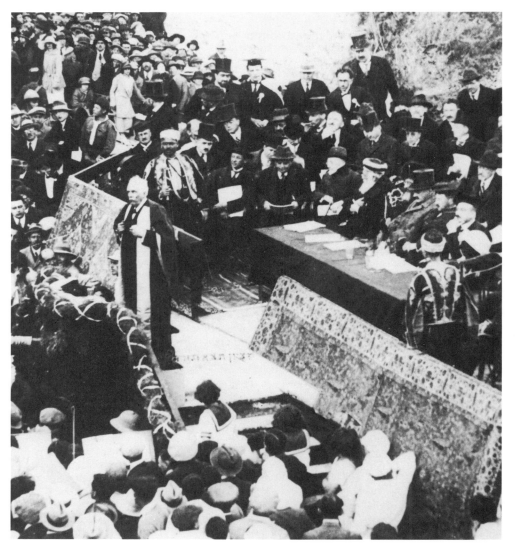

עד מתי ?

△ "'til when?" asks this 1925 cartoon referring to a long series of strikes and lockouts, especially in the burgeoning city of Tel-Aviv during 1924-25.

△ The third daily in the Yishuv, *Davar* ("A Matter") appears on June 1, 1925. An organ of the Histadrut ("Federation of Labor"), edited by Berl Katznelson, it competes with *Ha'aretz* ("The Land") and *Do'ar Hayom* ("The Daily Mail") but quickly becomes the most widely read of the three, maintaining its lead for many years.

◁ Immigration streams in, including on foot. These six pioneer hikers are photographed in August 1925 en route to Palestine by way of Vienna where they stop off to attend the 14th Zionist Congress.

THE DISPUTE IN THE ZIONIST CONGRESS OVER SETTLEMENT METHODS

A sharp dispute arose in the 14th Zionist Congress in Vienna in August 1925 over the nature of Zionism and the future development of Palestine in light of growing class friction in the Yishuv. Delegates from the middle class, who opposed giving preference to investment in national rather than private projects in Palestine, lauded the achievements of "bourgeois Zionism," and attacked the labor movement, claiming that its cooperative settlement experiments were doomed to failure. They cited economic growth in Palestine during 1924-25 (the start of the Fourth Aliyah) and successful results obtained from private enterprise as evidence of the inappropriateness of "socialist experiments" in Palestine, and depicted the labor camp as "eating the bread of charity."

In protest of this attack, Dr. Ruppin resigned from his office as head of the settlement department, while Dr. Weizmann hastened to praise the devotion of the pioneers and the achievements of the workers factions.

Despite these differences of opinion, the congress closed with renewed approval for continuing the support of cooperative settlement in Palestine.

THE RAPID GROWTH OF TEL-AVIV

The year 1925 marked the peak of immigration in the Fourth Aliyah and a spurt of intensive development of Tel-Aviv. Thousands of immigrants arrived in the city monthly, purchased lots, built new residential buildings, and invested in stores and workshops. New streets and neighborhoods sprouted rapidly and the prices of plots spiraled. The city spread northward, with the dunes making way for buildings. Commerce also flourished, and small hotels, shops, restaurants, and numerous kiosks opened. A previous municipal decision not to permit multi-story construction was dropped, and instead of the garden suburb envisioned over a decade previously, a full-fledged city rose up rapidly.

Since the beginning of 1924, Tel-Aviv had doubled its population to a total of 40,000 by the end of 1925.

△ The "Pagoda House" on Nahmani Street in Tel-Aviv.

▷ 1/2 acre land is the first price in the lottery arranged by the Ra'anan chocolate company.

▽ Baron Rothschild and his wife (in safari hats) sitting on the balcony of the municipality building in Tel-Aviv, 1925.

חברת "רענן" בע"מ.

במגרש של 2 דונמים או בששים לירות מצריות במזומן
יוכל לזכות בתור פרס כל מי שיקנה את טבלאות השוקולדה
של חברת "רענן" בשם "בית וגן"
שמרו על המעטפות! ההגרלה תהיה בזמן הקרוב.

דפּס קואפּרטיבי "הפּועל הצעיר", ת"א-אביב.

◁ One of the country's outstanding creative figures is poet Avraham Shlonsky, shown in a painting by Ziona Tagger.

▽ Afula, the city of the future according to architect Kaufman, is founded in 1925. The poster is titled in Yiddish: Afula – "The largest city in Eretz Israel."

עפולה—"די גרעסטע שטאָט אין ארץ ישראל"

◁ The agricultural villages also blossom. Shown, Irena Lancet, a founder of Herzliya, with her children Batia (l.), who will become a theater actress, and Moshe.

△ Another village to develop is Ra'anana. Shown, the Persol family, photographed with its means of transportation.

1926

January

12-15 The first session of the new (second) Elected Assembly is held. It elects a National Council of 38 members.

February

14 The Mandate government announces changes in the security forces. The Palestine Gendarmerie, in which Jews serve, is disbanded, and the Transjordan Frontier Force is formed, which does not accept Jewish recruits. The Yishuv leadership protests this discrimination.

25 The Eretz Israel Theater mounts *the Dibbuk*, by Anski. Reactions are mixed, most are negative.

25-27 The Board of Eretz Israel Writers decides to set up the Fund of Hebrew Literature as well as a publishing company.

27-28 The holiday of Purim is celebrated in Tel-Aviv with a masked carnival and humoristic parade.

Unemployment in the Jewish economy develops during the winter, especially in Tel-Aviv. The prosperity of 1924-25 is over.

March

5 High Commissioner Plumer signs a franchise allowing the Palestine Electric Corporation to utilize Palestine's river waters for the production of electricity.

24 The Aviv ("Spring") Fair opens in Tel-Aviv featuring exhibits by manufacturers and firms from Palestine and neighboring countries.

25 An art exhibit opens at David's Citadel in Jerusalem, with proceeds for the Jewish National Fund.

A society for Jewish-Arab understanding, Brit Shalom ("Covenant of Peace"), is founded. Its initiators include Dr. Arthur Ruppin, Hayim Kalvaryski-Margolis, and Yehuda L. Magnes.

April

Conferences and assemblies are held throughout the country protesting the discrimination against Jews in the government security forces.

Mutual visits of Egyptian and Jewish teachers from Palestine take place.

The economic crisis and unemployment worsen.

1 Hebrew Book Day is mounted in Tel-Aviv. Book stands are set up in the streets and assemblies and special events are held.

2 In Petah Tikva, the Socialist Youth is founded, an organization connected to Ahdut Ha'avodah ("Unity of Labor").

19 A demonstration by the jobless in the Tel-Aviv municipality square involves a violent confrontation with the police.

May

4 In Tel-Aviv thousands attend the funeral of Max Nordau, the noted Zionist leader and one of Herzl's chief aides. A national day of mourning is declared in the Yishuv.

20 The Ohel workers theater debuts with *Peretz Sketches*, based on stories by the noted writer Y. L. Peretz, directed by Moshe Halevi.

26 The National Council plenum votes to establish the Yishuv Fund for unemployment relief.

29 The Gedud Ha'avodah ("Labor Legion") Council convenes in light of growing internal friction between factions. At the center of debate is the leftist radicalization of part of the membership, who reject the Zionist idea.

June

7 Three immigrants from Poland burst into the editorial board of *Ha'aretz* and beat up the editor, Moshe Glueck-sohn, because of some articles which, according to them, have offended the new immigration from Poland. Two of the assailants are sentenced to short terms in prison.

30 A serious dispute erupts between Kibbutzim Kfar Gil'adi and Tel-Hai in the Upper Galilee as a result of Tel-Hai's intention to leave the Labor Legion. Kfar Gil'adi demands the amalgamation of the two kibbutzim. The Histadrut ("Federation of Labor") backs Tel-Hai, which wants to preserve its independence.

July

2 The high court in Jerusalem reviews a case filed by the Homeowners' Association of Tel-Aviv against the "leftist" municipal council, asking for its dissolution on the basis of unlawful elections. The city is in an uproar.

11 The Acre-Safed road is opened, a significant shortcut between Haifa, Acre, and Safed.

23 The first copy of *Ktuvim* ("Hagiograph") appears, published by the Writers' Association and edited by Eliezer Steinman.

29 Tension mounts between the Right in Tel-Aviv (the Homeowners' Association) and the Center and Left following the high court's decision in the homeowners' favor, i.e., that only taxpayers are entitled to vote in municipal elections.

August

Members of Kfar Gil'adi who did not obey the instructions of the Histadrut and amalgamated Tel-Hai with their kibbutz by force are expelled from the Histadrut.

Friction escalates in the Gedud Ha'avodah.

Emigration grows as a result of the economic crisis. Hundreds leave each month.

31 The executive council of the Histadrut discusses the activities of Hakibbutz, an underground defense body, operating within the Gedud Ha'avodah ("Labor Legion").

October

11 The National Council demands that the Mandate government include a Jewish unit in the Transjordan Frontier Force.

The Municipal Elections Ordinance is published. The rights to vote and to be elected are conditional upon the payment of taxes and elections are to be held separately for Jews, Muslims, and Christians. The Yishuv leadership demands changes that would make it easier for Jews to vote and to be elected. The ordinance does not apply to Tel-Aviv, which has its own set of rules.

30 The Gedud Ha'avodah Council debates the future of its leftist fraction.

November

5 The first conference of the Union of Zionists-Revisionists in Palestine is held under the leadership of Ze'ev Jabotinsky.

10 Former mayor of Tel-Aviv Meir Dizengoff joins the Zionist Executive as head of its department of commerce and industry.

December

5 Elections are held for the third Tel-Aviv municipal council. The Histadrut ("Federation of Labor") ticket wins 15 of the 41 seats. Negotiations begin for the establishment of a municipal coalition.

13 The residents of Tel-Aviv protest that their right to vote for the Jaffa municipal council, to which they formally belong, has been denied.

15-17 The Gedud Ha'avodah ("Labor Legion") splits. The leftist group is excluded.

19 The municipal council of Tel-Aviv joins the protests concerning the right of its inhabitants to vote for the Jaffa city council.

26 The Histadrut ("Federation of Labor") holds elections for its third convention. Ahdut Ha'avodah ("Unity of Labor") obtains 53.2 % followed by Hapo'el Hatza'ir ("Young Worker") with 26.7 %. All other parties achieve small percentages.

The settlement drive is renewed in the western sector of the Jezreel Valley. Kibbutzim Gvat, Hasharon, Ayanot (later Ramat David), Sarid, and Mishmar Ha'emek are founded, as is Moshav Kfar Yehoshua and the village of Kfar Barukh.

Some 14,000 immigrants arrive in Palestine in 1926, but thousands emigrate as a result of the economic crisis.

▷ The economy is still thriving at the beginning of 1926, as evidenced by the opening of Tel-Aviv's first quality hotel, the Palatin, on the corner of Nahlat Binyamin and Ahad Ha'am streets. Advertisements prior to the opening boast that construction of the hotel is keeping pace with the development of the city and that the hotel will even have an elevator. The hotel opens in 1926, just as the economic crisis breaks out.

◁ The Palestine Railway conveys passengers both within the country and to neighboring countries.

▽ The first Hebrew Book Day is held in Tel-Aviv on April 1, 1926. The idea will be renewed years later as the Hebrew Book Week, held annually throughout Israel at the end of spring.

THE RENEWAL OF SETTLEMENT IN THE JEZREEL VALLEY

The economic crisis that struck the Fourth Aliyah during the winter of 1926-27 mainly affected the urban sector, which had enjoyed a sudden boom. By contrast, the agricultural sector, both cooperative and private, was relatively unaffected, and in fact was given a boost by a large-scale national settlement drive initiated then by the Settlement Department of the Zionist Executive. Lessons from former settlements were learned, resulting in more efficient planning and improved construction.

Eight new settlements (mainly kibbutzim and moshavim) were established in the western Jezreel Valley, joining the bloc of agricultural settlements in the region that were the pride of the Yishuv and of the Zionist movement. By 1929, there would be 23 such settlements, accounting for approximately a quarter of the Jewish agricultural sector of the country.

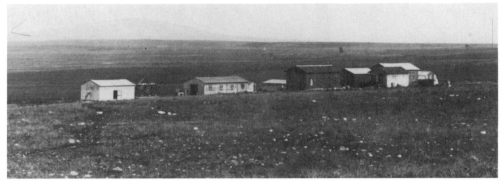

◁ A new settler in the Jezreel Valley, Alexander Zeid, formerly of Hashomer ("The Watchman"), settles in Sheikh Abriq near what is later named Tiv'on.

▽ The school in Moshav Nahalal is located in a wooden cabin. Cowsheds, however, are built of concrete.

△ A new kibbutz in the western Jezreel Valley: Mishmar Ha'emek, one of eight new settlements.

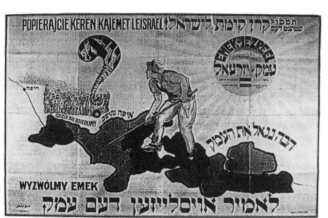

A large swamp is dried up in Herzliya. Visitors are standing beside the opening of a Roman tunnel which drained swamp waters into the sea.

The draining of the swamps proceeds at full speed during 1926. Shown, swampland north of Haifa.

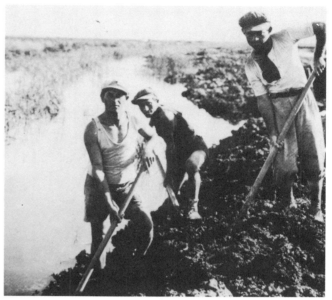

Land purchase and the settling of the Jezreel Valley continue to be primary Zionist concerns. The trilingual poster appeals to the Jews of Poland in Hebrew, Yiddish, and Polish: "Let us Redeem the Valley!" (Jezreel).

Dr. Itzhak Rosenbaum services the Jezreel Valley settlements with his mobile dental clinic.

The dentist travels from one settlement to the other in the Jezreel Valley to treat his patients.

Note the young woman in the middle who seems to have just had a tooth pulled out.

The patient on the chair does not look like he is having an easy time either.

\mathbb{W}e were also glad for the panic immigration, in that it increased the Jewish population in Eretz Israel, although we rejected its unhealthy underpinnings. We rejected its illusory prosperity, its unsupported growth, the road that led to this situation, whereby a Jew who brought several thousand pounds with him did not see the need to start a farm in the country, to plant, or to establish some sort of industry, but rather invested his capital in real estate speculation.

Berl Katznelson, 1926

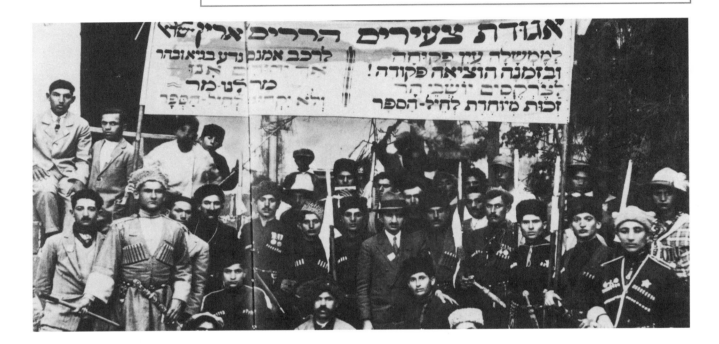

FROM PROSPERITY TO RECESSION

The prosperity that characterized the start of the Fourth Aliyah period stemmed essentially from the influx of private capital into the country by middle class immigrants who thought that the Yishuv establishment ought to support private enterprise, too, and not only the labor settlement movement. The labor parties, for their part, were concerned that Jewish society in Palestine become altered and socialist Zionist values harmed.

Ultimately, it was external developments that brought about social and economic change. A slowdown in the import of foreign capital by Polish Jews, along with a drop in the value of the currency, started a crisis that led to the rapid impoverishment of many of the Fourth Aliyah newcomers. Loss of capital resulted in failures and bankruptcies of businesses and factories. The ensuing confusion and insecurity led to a sequence of negative events. Banks reduced their credits, and that, in turn, severed economic activity. Layoffs followed, and the Yishuv was unable to provide alternative sources of employment at such short notice.

The winter of 1926 ushered in a prolonged depression during which thousands left the country.

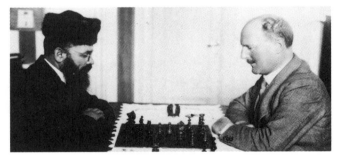

∇ A symptom of unemployment: the entrance fee for workmen, previously 2 piasters, is reduced to 1 piaster.

△ Ronald Storrs (r.), shown playing chess with Rabbi Kitruni of Petah Tikva, ends his term of office as governor of Jerusalem in 1926.

△ Protracted ideological friction overshadows Jewish settlement in the Upper Galilee. Kibbutz Kfar Gil'adi (shown) is anxious to amalgamate with neigh-

boring Kibbutz Tel-Hai, but the members of the latter are opposed, supported in their position by the Histadrut ("Federation of Labor"). When the members of Kfar

Gil'adi take steps to unify the two settlements forcibly, the Histadrut cancels their membership, including medical benefits. A compromise is finally reached.

▽ A movie house is opened in Bet-Ha'am ("Peoples' House") in Tel-Aviv. Entrance fees: 2 piasters.

▽ One immigrant from Poland in 1926 is the young Avraham Stern, later to become commander of the Lehi underground.

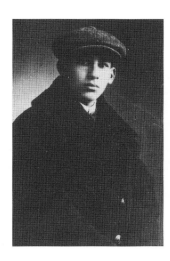

▷ The Red House – the Tel-Aviv labor council – is built (today the site of the Sheraton Hotel).

1927

January

2 Ahad Ha'am, the writer and journalist, dies.

9 The settlers of Kfar Gil'adi resume their membership in the Histadrut ("Federation of Labor").

16 The Ben-Shemen youth village is established east of Lydda.

17 An agreement is signed between Dr. Hayim Weizmann and Louis Marshall, the non-Zionist American Jewish leader, regarding the establishment of the Jewish Agency for Palestine and the dispatch of a team of experts to Palestine – the Joint Palestine Survey Commission.

26 David Bloch-Blumenfeld, Histadrut ("Federation of Labor") candidate and acting mayor of Tel-Aviv, is elected mayor.

The crisis in Gedud Ha'avodah ("Labor Legion") sharpens. The executive council of the Histadrut recognizes only the majority as the Trumpeldor Labor Legion. Members of the communist faction are excluded.

February

8 Political bodies on the right, including the Homeowners Association of Tel-Aviv, the Farmers' Federation and the Bnei-Binyamin association, convene in Tel-Aviv with the aim of establishing an umbrella organization.

16 A strike is declared in the Nur match factory in Acre, with the participation of both Jewish and Arab workers. It will last over four months, involving confrontations with the police.

March

10 Worsening unemployment in Jerusalem prompts demonstrations in the offices of the Zionist Executive by hundreds of jobless workers.

17 The deepening economic and social crisis in the Jewish Yishuv leads the Jaffa-based Arab newspaper *Filastin* ("Palestine") to write: "There is no longer any doubt about the bankruptcy of the Zionist endeavor."

April

1 The Hashomer Hatza'ir ("Young Watchman") kibbutzim and training groups establish a national organization in Haifa called Hakibbutz Ha'artzi ("The National Kibbutz").

5 Elections are held for the Jerusalem municipality. Despite the Jewish majority in the city, the elections ordinance allocates four seats for Jews and eight for Arabs. Raghib Nashashibi is elected mayor. Deputy mayors are Hayim Salomon and Ya'akub Faraj (a Christian).

21 Warnings of the danger of foreign languages to Hebrew – especially English and Yiddish – are voiced at a conference of the Hebrew Language Protection Legion in Tel-Aviv.

24 The Betar movement in Palestine is founded.

25 Signs of the easing of the economic crisis are visible in Jerusalem with the start of large-scale construction projects for the National Library on Mt. Scopus and infrastructure work in the commercial center of the city.

The Haifa soccer team Maccabi Hagibor is the first to go for a match tour to the United States. From 11 matches, it comes up with 5 victories, 5 losses, and 1 draw.

May

1 The first satiric theater, the Kumkum ("Kettle"), opens in Tel-Aviv, directed by Avigdor Hame'iri.

5 The Hebrew Language Protection Legion protests the use of Yiddish during visits to the country by two noted writers, Peretz Hirschbein and Sholem Asch.

27 Two Jewish candidates are elected to the Jaffa municipality – Meir Dizengoff and Hayim Mutro.

31 The League of National Farmers is founded in Magdiel, in the Sharon. It calls upon Jewish farmers to employ Jewish workers.

June

The ongoing economic crisis is manifested in the bankruptcy of the Solel Boneh company – the Histadrut-owned construction firm. Its large work force joins the ranks of the unemployed.

July

5-22 The third convention of the Histadrut ("Federation of Labor") is held in Tel-Aviv in the shadow of the crisis of the Fourth Aliyah, unemployment and emigration.

11 A severe earthquake strikes Palestine resulting in some 200 dead and 1,000 injured. Destruction is particularly serious in mountain areas where the Arab population resides.

August

1 The Labor parties of the Yishuv attain an absolute majority of the 27 delegates elected to the 15th Zionist Congress.

Work is begun on the hydroelectric power station at Naharayim.

5 The Ein-Harod kibbutz movement, together with other kibbutzim, establish a new national body – Hakibbutz Hame'uhad ("The United Kibbutz").

8 The Eretz Israel Theater inaugurates its hall in Tel-Aviv.

30 (until September 11) The 15th Zionist Congress is held in Basel. It addresses the grave crisis in Palestine. It is decided to establish a minor Zionist Executive in Jerusalem to deal with crises. Its members are Frederick Kisch, Harry Sacker, and Henrietta Szold.

September

20 A national agricultural exhibition, organized by the Mandate government, is opened in Haifa. On display are products of the Jewish settlements.

Several dozen members of the leftist faction of the Gedud Ha'avodah ("Labor Legion") leave Palestine and return to the Soviet Union.

November

1 A significant national event in Palestine: local currency is minted, ending ten years of use of Egyptian currency.

12-13 Ahdut Ha'avodah ("United Labor") party elects a commission to negotiate with Hapo'el Hatza'ir ("Young Worker") party. Two years later they will found the Mapai party.

25 The council of the Gedud Ha'avodah ("Labor Legion") decides to conduct a referendum on its joining the Hakibbutz Hame'uhad.

December

15-16 Violent incidents take place in Petah Tikva as part of the struggle by Jewish workers to obtain employment in the citrus harvest, thereby replacing Arab labor. The Jewish workers set up lockout shifts. The grove-owners call the police and violence erupts. Dozens of workers are injured and many are detained. Protests are mounted throughout the Yishuv denouncing the groveowners.

The year 1927 marks an immigration low, with only 2,700 newcomers arriving. The number of emigrants, by contrast, is over 5,000.

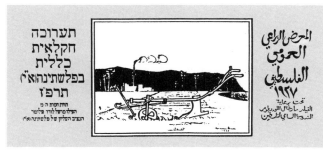

An agricultural exhibition under the patronage of the high commissioner is held in Haifa in September 1927.

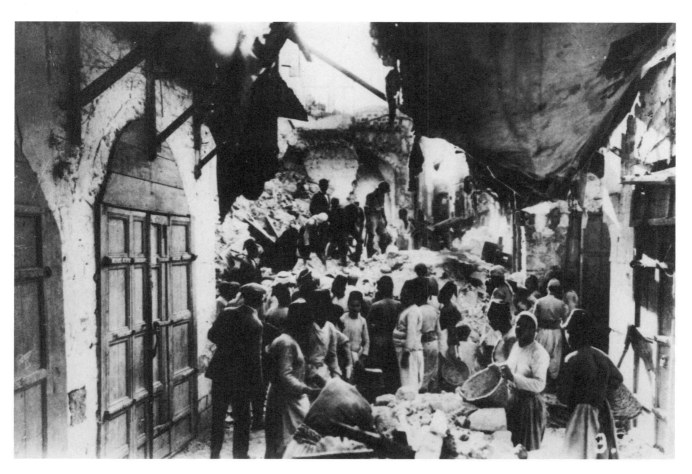

THE EARTHQUAKE OF JULY 1927

A strong earthquake struck Palestine on July 11, 1927, causing the loss of many lives and severe damage. Lasting seven seconds, it occurred shortly after 3 p.m. during a hamsin when hot winds blew in from the east. The panic-stricken population fled their collapsing homes. Rumors of a catastrophe with many hundreds of fatalities spread rapidly, replete with awesome reports of the broiling of the Dead Sea, towers of water shooting up all about, and the collapse of multi-story buildings.

By the end of the day, the recorded toll was 192 dead and 923 injured. Most of the damage occurred in the mountain areas and most of the casualties were Arabs. Approximately a third of the buildings of Nablus were destroyed. Whole streets collapsed in Lydda and Ramleh.

Additional lighter tremors recurred a week later but caused no damage.

The Jewish Yishuv made notable efforts at aid and reconstruction for the Arabs. Tel-Aviv adopted Nablus and sent rescue teams and supplies. The American Jewish philanthropist Nathan Straus forwarded a special financial grant. The Arabs were so amazed by the aid of the Jewish Yishuv that an Arab journalist announced that out of gratitude, he would refrain, on that day, from bad words against the Jews. On the other hand, sharp criticism was heard of the little help received from the Arab countries.

△ The July 1927 earthquake in Palestine affects the Arab-populated mountain regions in particular. Shown are damages in the Old City of Jerusalem.

▽ Among the damages by the earthquake is the Church of the Ascension on the Mt. of Olives in Jerusalem. The Augusta-Victoria building next to it, dwelling of the high commissioner, is not spared.

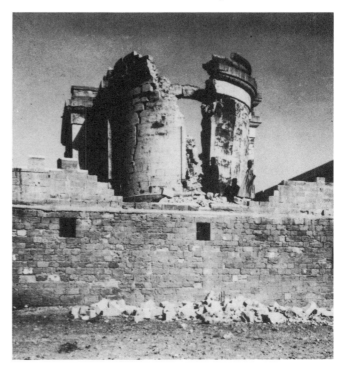

THE FIRST PALESTINIAN CURRENCY

For centuries, Palestine had no currency of its own. Conquerors and rulers came and went, bringing with them their own coins and, later, bills.

A historic change took place ten years after the arrival of the British when High Commissioner Lord Plumer issued a manifest in the fall of 1927 announcing the introduction of local currency: the Palestine pound, equivalent to a pound Sterling, divided into 1,000 mils. Coins of 1 and 2 mils were minted in bronze; 5, 10 and 20 mils (with a hole in the center) in nickel and bronze alloy; and 50 and 100 mils in silver alloy. Bills were issued in denominations of half a pound and over. The coins and bills bore printed information in the country's three official languages – English, Arabic, and Hebrew. In Hebrew, the country was designated as: "Palestine (E.I.)". The Jews were displeased with Palestine, while the Arabs were indignated by the initials of Eretz Israel between brackets.

On October 30, 1927, the banks closed for two days and when they reopened, the Egyptian currency was replaced with the new Palestinian one.

The Mandatory currency remained in use until the establishment of the State of Israel in 1948 and even thereafter, until the new government minted Israeli currency.

▷ Pinhas Rutenberg donates the first 50 pound bill to the Jewish National Fund. Below, a 10 mil coin, also called a grush (piastre).

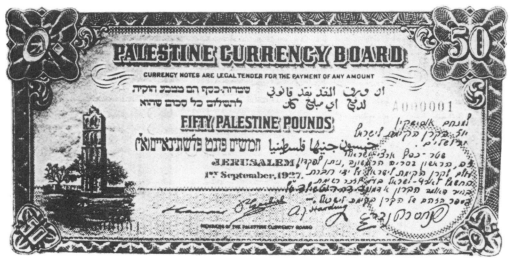

▽ Kumkum ("Kettle"), a satiric theater, opens in Tel-Aviv in May 1927, directed by Avigdor Hame'iri.

▷ Ahad Ha'am, shown in a painting by Reuven Rubin, dies on January 2, 1927.

△ The automobile opens up new vistas to Jewish youth in Palestine. Shown, a group of pupils from the Gymnasia Herzliya on a tour of the Upper Galilee in the summer of 1927. Always included in such tours are the Hermon and Tel-Hai.

▷ Some inhabitants of Palestine – Arab, Jewish and British – can afford to purchase automobiles in the late 1920s. The Renault company is one of the first to open a sales office.

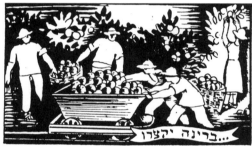

◁ The deepening economic crisis in 1927 does not affect the large villages, led by Petah Tikva, where the citrus branch flourishes. Illustrations are by Nahum Gutman.

THE CITRUS HARVEST INCIDENTS OF DECEMBER 1927

The growth of the Jewish population during 1924-27 brought about a doubling of the membership of the Histadrut ("Federation of Labor"). Its leaders took an uncompromising stand in the ongoing struggle to per-suade Jewish private farmers to hire Jewish, rather than Arab, labor. The struggle turned violent in December 1927 during the citrus harvest in Petah Tikva. There, Jewish workers seeking employment staged a series of incidents protesting the hiring of Arab labor by the far-mers for their harvest. Demontrations at the groves by the Jewish workers and an attack on the Agricultural Committee building led to the intervention of the British police. Workers were beaten and injured in the melee and some were arrested and sentenced to several weeks imprisonment. Their cause, however, won them a wide public sympathy.

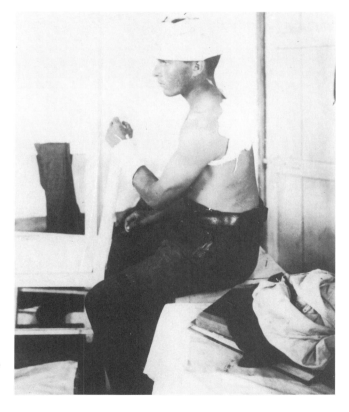

▷ The large groves in Petah Tikva require the hiring of hundreds of workers for the harvest season. The farmers prefer giving the work to Arabs. The Jewish workers protest, demonstrate, and fight with the police, sustain-ing injuries. Dozens are put on trial.

THE CRISIS OF THE FOURTH ALIYAH REACHES A PEAK

The economic crisis that began in late 1925 and deepened in 1926 reached a peak in 1927. Unemployment, especially in Tel-Aviv, spiraled to a new high. Over 8,000 jobless registered in the city's unemployment offices, with only a small number able to obtain even several days' employment intermittently. According to reliable estimates, over a third of the work force was wholly or partially unemployed. The unemployed received a minor financial aid from the Histadrut ("Federation of Labor") and from the Zionist Executive. Some donations were collected among the steadily employed workers.

Another aspect of the crisis were bankruptcies, especially in the construction field, which was almost entirely paralyzed. Many small businesses closed as well,

such as restaurants and kiosks. Approximately half the ventures that had been established in 1924-25 are thought to have closed down during the two years that followed.

The height of the crisis was marked by the shutdown in mid-1927 of the Histadrut construction company, Solel Boneh, which was a large employer. Hamashbir (a food and equipment distributor to workers) was also on the verge of collapse.

Only toward the end of the decade did the crisis begin to recede. Large development projects such as the building of the electric works in Naharayim, the startup of the potash company, and accelerated growth in the citrus branch in the agricultural settlements contributed to the gradual revival of the economy.

▽ Advertisement for local cigarettes in 1927: "Whoever smokes is providing bread to the workers".

▷ The numerous bankruptcies in Tel-Aviv are caricaturized in 1927.

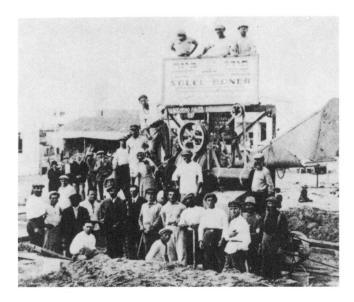

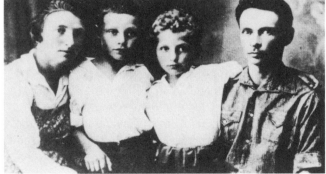

◁ The Solel Boneh shutdown epitomizes the current crisis. Hundreds of additional workers become unemployed.

△ Emigration to Russia by Gedud Ha'avodah members is another sign of the current crisis. The emigrants are led by Menahem Elkind, shown with his family.

January

1 The constitution of the Jewish Community is published in the Mandatory government's *Palestine Gazette*, and brought into effect immediately.

10 The National Council approves the constitution of the Jewish Community, in spite of its shortcomings.

30 The chairman of the Joint Palestine Survey Commission, Sir Alfred Mond (later Lord Melchett), arrives for a prolonged visit.

31 A cornerstone-laying ceremony is held for a health center in Tel-Aviv built with a donation by American Jewish philanthropist Nathan Straus.

February

Tel-Aviv is in an uproar over Sabbath observance. The district court has overruled the judgment of the municipal court which found a resident guilty of violating the Sabbath. The district court views the lower court's judgment as contrary to the Mandate's writ guaranteeing freedom of religion.

25 The first soccer derby is held in Tel-Aviv. Maccabi beats Hapo'el-Allenby 3:0.

March

15-20 A general strike of caretakers is held in Jewish schools throughout the country.

27 The Habimah theater of Moscow arrives for its first visit. Attended by a large audience, it presents the play *The Golem*, written by H. Livick.

April

An agreement is reached between the Histadrut ("Federation of Labor") and the Zionist Executive regarding large-scale development projects in the Jewish economy. Monies earmarked for unemployment relief are to be used for this purpose.

18 A split in the Kumkum theater elicits the establishment of a second satiric troupe: Hamatateh ("The Broom").

May

8 After prolonged deliberation, the Mandate govern-ment decides to develop the country's major port in Haifa rather than Jaffa.

27 The Mandatory immigra-tion department gives instruc-tions to expulse six Jewish families who have entered the country without permits. The news arouse public commotion and protest rallies in different parts of the Yishuv.

31 High Commissioner Plumer grants two of the families the permission to stay. Protests continue in the Yishuv.

June

2 Two Jewish teams reach the country's soccer cup finals for the first time. Ha-po'el-Allenby Tel-Aviv tops Maccabi Hashmonai Jeru-salem 2:0.

18 The report of the Joint Palestine Survey Commis-sion is published in London. Its findings regarding settle-ment activity raise a storm in the country and within the Zionist Organization.

20-21 The seventh Arab Congress, meeting in Jeru-salem, calls on the govern-ment to establish the legis-lative council speedily and to cancel the concession obtained by the "Jewish" potash company at the Dead Sea.

28 The National Council, after prolonged debate, accedes to demands by the Sephardi delegates to increase their representation in the next elections to the Elected Assembly.

July

Protests and rallies organized by the Left during the course of the month attack the Joint Palestine Survey Commis-sion findings, while the Right supports them.

6 The British government appoints a new high com-missioner for Palestine, Sir John Chancellor.

27 Controversy in the Yishuv between advocates and opponents of the Man-date's constitution of the Jewish Community comes to a head during a farewell meeting with outgoing High Commissioner Plumer. The opponents are joined by

Sephardi Chief Rabbi Ya'akov Meir.

31 High Commissioner Plumer ends his term of office and leaves the country.

August

14 The Palestine Soccer Association is established by representatives of Maccabi, Hapo'el and an Arab team from Jerusalem.

27 The Arabs of Jerusalem celebrate the dedication of the new silver dome of the al-Aqsa mosque.

September

24 (10 Tishrei 5689) The Yom Kippur incident occurs at the Western Wall in Jerusalem. British police forcibly remove a cloth partition separating the women's and men's prayer areas. The Jewish public is outraged.

25-27 Protests and assem-blies are organized through-out the country following the Western Wall incident. The government announces that the Jews had no right to put up the partition.

October

5 An incident occurs in Tel-Aviv over the use of Yiddish. Betar members, together with the Hebrew Language Protection Legion, break up a gathering devoted to Yiddish organized by Po'alei Zion ("Workers of Zion"). Several persons are injured. Institu-tions throughout the city and the Yishuv condemn the incident.

12-14 The Western Wall affair continues. The Zionist Executive requests the inter-vention of the League of Nations Permanent Man-dates Commission. The heads of the Jewish national bodies protest to the governor of Jerusalem over a change in the status quo introduced by the Arabs – the construction of an additional row of stones atop the Western Wall.

20 Another incident occurs at the Western Wall: Arabs attack Jews at prayer.

21 With the improvement of the economic situation, the Mandate government agrees to grant the Jewish institu-

tions 600 entry permits for the next six months.

November

1 A Muslim conference on the protection of holy places meets in Jerusalem. The dispute over the Western Wall continues.

20 The Jewish National Fund announces the purchase of an additional 22,000 dunams (5,500 acres) in the Zebulum Valley.

28 The British government publishes a memorandum on the Yom Kippur incident at the Western Wall. It calls on both sides, Jewish and Muslim, to reach a solution by agreement.

30 High Commissioner Chancellor arrives in Pales-tine.

December

17 Another violent incident is reported in the groves of Petah Tikva, as Jews struggle for employment.

18 Netanya is founded as an agricultural settlement by the Bnei-Binyamin association, which consists of second-generation farmers.

31 Elections to the Tel-Aviv municipal council result in an upheaval: center and right tickets gain 9 seats, labor gains 5 and the religious gain 1. Meir Dizengoff is reelected to the city council after an absence of three years.

During 1928, 2,178 Jews immigrate to Palestine and 2,186 emigrate. Only three settlements are established during the year. Never-theless, the first indication of an end to the crisis is manifested in the fall by a governmental thawing of the prolonged freeze on the immigration quota.

1928

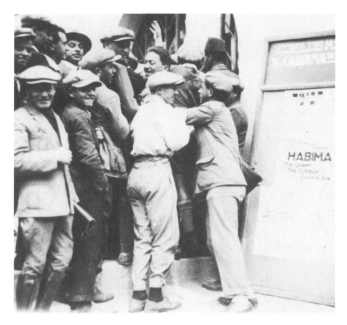

„הבימה" מגיעה לחוף יפו באניה „שמפוליון" ביום השלישי 27 לחדש מרץ • הצגת הפתיחה בבית-התא"י במוצ"ש 31 למרץ • בתל-אביב תערכנה רק 13 הצגות לפי התכנית שנתפרסמה • הכרטיסים שנשארו נמכרים במשרדו של מר סופר, רח' אחד העם 24

▽ Crowds try to acquire
tickets for Habimah per-
formances (above). Sholom
Aleichem's play, *The Trea-
sure* (l.), features the actor
Aharon Meskin (r.), later to
achieve fame.

△ Great excitement is gene-
rated by the arrival of the
Habimah theater in Palestine
for the first time, ten years
after its founding in Russia.
Only 13 performances will
be held in Tel-Aviv.

◁ Purim celebrations in Tel-
Aviv are climaxed by the
celebration of a Queen
Esther – Zipora Zabari.

△ Purim is celebrated in
Tel-Aviv in the shadow of
the harvest incidents at
Petah Tikva.

THE YOM KIPPUR INCIDENT AT THE WESTERN WALL

The Western Wall plaza, located not far from the two mosques of the Temple Mount, was formally under the custody of the Muslim waqf (religious trusts body), but for generations a status quo had been maintained allowing Jews to pray there. The radical Arab leadership, however, headed by Grand Mufti of Jerusalem Haj Amin al-Husseini, repeatedly accused the Jews of not contenting themselves with the Western Wall alone and wanting to usurp the mosques of the Temple Mount.

On Yom Kippur (September 24, 1928), Jews praying at the Western Wall set up a partition to separate the men's and women's areas. In the middle of the prayers, British police called upon by the Arabs burst on to the plaza to remove the partition, claiming it was a breach of the status quo. The audience protested, and in a short time the city was up in arms.

Leading the inciters was Haj Amin, who, anticipating only a mild reaction by the British, instigated a series of provocations aimed at heightening tension. His followers broke through a wall near the Western Wall and turned the Jewish prayer site into a passageway for pedestrians and animals. The Mufti was aware that religious clashes would add a Muslim tinge to the national Arab struggle and win further support in Palestine and other Muslim countries. The Western Wall crisis intensified up to a climax in the Riots of 1929.

△ The issue of the Western Wall preoccupies the Jewish public in Palestine and the Jewish world abroad almost daily during several months after the incident on Yom Kippur in September 1928.

▽ A report on the Western Wall incident is prepared by a British commission of inquiry.

△ Anger in the Yishuv over the incident at the Western Wall is directed at the British, as shown in this contemporary caricature.

The Western or Wailing Wall in Jerusalem

Memorandum by the Secretary of State for the Colonies

THE STORM RAISED BY THE JEWISH AGENCY JOINT SURVEY COMMISSION

Aiming at studying the economic state of Jewish settlement in Palestine, the Zionist Organization dispatched three commissions of experts during the 1920s. The last of them, which visited Palestine in 1927-28, evoked anger and bitterness, especially on the Left, although it led, ultimately, to the legitimation of the ideology of the labor camp.

The organization of the Jewish Agency in an enlarged format, proposed by Dr. Hayim Weizmann, was made conditional by the non-Zionist leadership on the formation of a commission of experts that would examine the economic achievement of the settlement in Palestine. In practice, two commissions were set up: the Joint Survey Commission, headed by British industrialist Sir Alfred Mond (later Lord Melchett), and a second commission of world experts in agriculture, industry, cooperatives and other areas.

The commissions toured the country during its most difficult period, at the peak of the Fourth Aliyah crisis. The report submitted by the commission of experts was highly critical and recommended the "ending of social experiments," a conclusion that the Joint Survey Commission then adopted.

This raised a storm in the Yishuv, with the report subjected to vociferous attacks by the labor camp, while supported by the Right. A sharp debate was also conducted in a conference of the Zionist Executive in Berlin in July 1928, resulting in a compromise: an amended proposal was adopted expressing demurral from the economic recommendations on the ground that they had not taken into consideration the special conditions in Palestine. Eventually, the report strengthened the ties between the two major labor parties and sped up their merger, in early 1930.

△ Agriculture and cooperative settlement have a superior status in the Yishuv in the later 1920s. The Joint Survey Commission report, which recommends limiting "social experiments" (i.e., the kibbutzim), evokes a storm, but in the end the cooperative-settlement approach is largely ratified.

REPORT

of the

JOINT PALESTINE SURVEY COMMISSION

Commissioners :
THE RT. HON. LORD MELCHETT, P.C., LL.D.
LEE K. FRANKEL, PH.D., L.H.D.
FELIX M. WARBURG.
OSCAR WASSERMANN.

Secretariat :
MAURICE B. HEXTER, PH.D.
MICHAEL NAAMANI, M.A. (CANTAB.)

LONDON
June 18th, 1928
PRICE 2s. 6d. ($0.50)

△ Meir Dizengoff and his wife, Zina, cast their votes for the Tel-Aviv municipal council on the last day of 1928. Shortly after, Dizengoff is re-elected mayor.

▷ The Joint Survey Commission report of 1928 raises a storm in the Zionist movement.

△ The advertisement reflects the pride in a Jewish soccer team, Hapo'el Tel-Aviv, winning the Palestine Cup for the first time.

▷ *Do'ar Hayom* ("The Daily Mail"), edited since 1919 by Itamar Ben-Avi, has a new editor in 1928: Ze'ev Jabotinsky.

153

1929

January
A serious land dispute breaks out in Hadera between Jewish farmers and Bedouin who have leased lands but refuse to relinquish them.

6 Meir Dizengoff is elected mayor of Tel-Aviv after a three-year hiatus.

22 The Hebrew University of Jerusalem reports on the discovery of the ancient synagogue in Bet-Alfa.

A new wave of immigration starts, after a prolonged decline caused by the economic crisis. Some call it the Fifth Aliyah.

February
21 Unemployed workers in Tel-Aviv stage violent protests. Mayor Dizengoff refuses to meet with them.

26 The Western Wall issue is ignited once again when Arab workers tear down a bordering wall.

March
13 The first copy of the writers' newspaper *Moznayim* ("Scales") appears.

24 The National Council publishes the number of registrants in the Mandatory Jewish Community lists: 89,985. The number of ultra-Orthodox non-registrants is 4,657.

26 A German zeppelin hovers through the sky of Palestine.

27 Purim. Thousands come from all parts of the country to celebrate in Tel-Aviv. Special trains leave Jerusalem hourly.

31 The cornerstone ceremony is held for the Rockefeller museum of archeology in Jerusalem.

April
26 A cornerstone ceremony is held for the Jewish National Fund building in Jerusalem,

part of the complex of national institutions under construction in the Rehavia neighborhood.

May
3 Jews praying in the Western Wall plaza are attacked by Arabs.

8 An announcement is made in London that the concession for exploiting the Dead Sea resources has been granted to the Palestine Potash Company, managed by Moshe Novomeysky, an engineer.

10 A joint memorandum to the Mandate government by the chief rabbis, the National Council and Agudat Israel demands a halt of all construction work being carried out by Muslims near the Western Wall.

13 The Mandate government announces an immigration quota of 2,400 permits for a half-year period, beginning April 1929. The reaction in the Yishuv is positive.

23 An agreement is signed on the merger of the two labor parties, Ahdut Ha'avodah ("Unity of Labor") and Hapo'el Hatza'ir ("The Young Worker").

28 An incident at the grave of Rabbi Shim'on Hatzadik in Jerusalem, in which a British police officer, Douglas Duff, beats a Jewish student, arouses protests in the Yishuv. Duff is transferred to the prisons service.

The religious youth group Bnei-Akiva is established.

June
13-18 Jews and Arabs alike complain to High Commissioner Chancellor about discrimination. The Jews demand greater participation in the workings of the government, including in the police force and the Transjordan Frontier Force. The Arabs demand the speedy establishment of the legislative council.

28 Arabs disrupt Sabbath eve prayers at the Western Wall by sounding musical instruments and drums.

July
1 Elections are held for the

16th Zionist Congress. The labor tickets in the Yishuv win by a large margin – 17 of the 28 delegates. The Revisionists and the religious factions receive 3 seats each, the General Zionists 2, National Citizens 1, and one seat for each of the two Yemenite tickets.

5 Arabs disrupt prayers at the Western Wall on the second Sabbath eve in succession.

6 The international soccer association, F.I.F.A., recognizes the Palestine association.

24 A conference is held by representatives of the Jewish Middle Eastern communities in Jerusalem. They complain over discrimination, as well as the lack of understanding shown by the Yishuv institutions for their demands.

25 The labor parties – Ahdut Ha'avodah and Hapo'el Hatza'ir – announce a merger.

27 The 16th Zionist Congress begins in Zurich.

30 Friction at the Western Wall intensifies. The chief rabbis meet with the deputy high commissioner, Harry Luke, who explains that he is unable to halt the construction which is being carried out by the Arabs.

August
1 A joint letter of protest by the Zionist Executive, the chief rabbis and the Agudat Israel leadership to the British government demands immediate intervention in events at the Western Wall plaza and a halt to Muslim construction work there.

3 An incident at the Western Wall plaza during Sabbath eve services occurs when Arabs enter through an opening that has been made during construction, and interrupt the prayers.

4 A delegation of Yishuv representatives leaves for London to protest the situation at the Western Wall.

11 Following prolonged debate, a decision is made to include non-Zionist world Jewish leaders in the Jewish Agency. Participants at the founding conference of the new body in Zurich include Albert Einstein, Leon Blum

and Lord Melchett.

14 (Tisha B'Av eve 5689) Thousands of Jews arrive at the Western Wall to pray on the traditional fast day and as an act of solidarity.

15 Hundreds participate in a procession by the Betar and the National Youth movements that ends at the Western Wall.

16 A large Arab protest proceeds from the Temple Mount area to the Western Wall and chases away Jews praying there. Several Torah scrolls are set on fire.
Tension in Jerusalem reaches a peak.

17 A young Jew, Avraham Mizrahi, is stabbed to death in Jerusalem in a fight with Arabs.

22 The leaders of the Yishuv, the Zionist Executive, the chief rabbis and the Agudat Israel rabbis publish an appeal to the Yishuv to keep the peace, and to the government to punish the Arab rioters. Representatives of the Yishuv meet with the Deputy High Commissioner and inform him of their fears of an Arab riot. The British official assures them that the government is in control of the situation.

23-29 Arabs perpetrate a series of bloody acts against Jews throughout Palestine, later to be known as the Riots of 1929. A total of 133 Jews are killed and over 300 are wounded. More than 8,000 Jews (5% of the Yishuv) become refugees.

The Yishuv and the Jewish world are shocked. The British close all the newspapers and disconnect the international telephone and telegraph lines.

29 High Commissioner Sir John Chancellor, returns to Palestine from a holiday in London and issues a manifesto condemning Arab brutality during the riots, announcing that the guilty parties will be punished to the fullest extent of the law.

September
4 An additional manifesto by the High Commissioner balances the first one and announces that the accused parties from both sides will be brought to justice.

12 The newspaper *Do'ar Hayom* ("The Daily Mail"), which denounced the conduct of the British rule during the riots, is closed down. It will reappear in October.

13 The British government announces the establishment of a commission of inquiry to be headed by Sir Walter Shaw, a jurist, to investigate the causes of the outbreak of the disturbances.

24 The National Council decides to broaden its leadership by coopting additional personalities. Pinhas Rutenberg, Meir Dizengoff and Zvi Butkovsky join the body. Rutenberg is later appointed president of the council, a newly created position.

28 The Arabs protest the attitude toward them in the wake of the latest incidents, addressing the government in Jerusalem and in London, as well as the League of Nations. The Arab Executive Committee decides on a general strike.

The Haganah dispatches dozens of its members to protect settlements in the Galilee, Safed in particular. So far, each settlement defended itself and its surroundings.

October

5 The Gedud Ha'avodah ("Labor Legion") Council convenes in Tel-Yosef and decides to merge the movement with the Hakibbutz Hame'uhad ("United Kibbutz").

13 (Yom Kippur eve) The British authorities forbid the sounding of the shofar at the Western Wall.

16 The Supreme Muslim Council announces an Arab general strike.

18-21 Arabs convicted of the murder of Jews in the Riots are condemned to death or to long prison sentences.

24 The Shaw Commission arrives in Palestine and begins hearing testimony.

November
Arab violence against Jews in Jerusalem, the environs, and in Hadera, intensifies during the first half of November. The noted Jerusalem ophthalmologist, Dr. Avraham Ticho, is stabbed by an Arab.

3 The Palestine Potash Company is formed in London with an investment of LP400,000.

18 Angered students bar Hebrew University President Dr. Yehuda Magnes from delivering an address in light of his advocacy of Jewish-Arab understanding.

20 Yosef Urfali, convicted of killing two Arabs, is sentenced to death.

24 An Arab assaults Dr. Norman Bentwich, an English Jew serving as the legal counsel to the Mandatory government.

December

3 A car driven by Jews in the Galilee is attacked by Arabs. Dr. A. Berkowitz, the physician of the village of Yesod Hama'ala, is seriously wounded.

△ The star of the year is actress Hanna Rovina in the Habimah production of *David's Crown*. The troupe leaves the country in 1929 but returns for good in 1931.

△ A Tel-Aviv billboard in early 1929 announces a large variety of entertainment events.

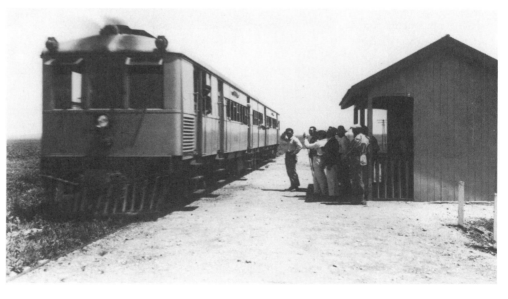

▷ The Palestine Railway improves service during the 1920s. Four motorcoaches are acquired toward the end of the decade, shown here at the Kfar Barukh station in the Jezreel Valley.

△ A Jewish family from Hebron in hospital after the massacre.

▷ A Jewish home in Hebron after the massacre.

P 157. Above: with the outbreak of the Riots, hundreds of inhabitants of the Jewish quarter in the Old City of Jerusalem flee their homes for safer shelter in the new city. Below: a bitter caricature in a Jewish newspaper. Governor of Jerusalem to Elijah and the Messiah, at the gate: "To my regret, I can't allow you to enter. I'm guarding the status quo."

THE RIOTS OF 1929

Tension between Jews and Arabs reached a new peak in August 1929, culminating in violent rioting by Arabs throughout the country during August 23-29.

On Friday, August 23, Arabs streamed into the Old City of Jerusalem armed with clubs and knives and charged into the Jewish neighborhoods. At the time, High Commissioner Chancellor was in London, and the police were unprepared to combat the attackers. The rioting continued for six days until British reinforcements were brought in. In the absence of Haganah for-

ces in cities, where the population of the old Yishuv had refused to permit them to operate, many fatalities occurred. Over 60 Jews were massacred in Hebron, and the rest were evacuated. The Jewish quarter of Safed was set on fire. Ramat Rahel, Motza, Hartuv, Kfar Uriah, Be'er Tuvia and Hulda were evacuated and subsequently destroyed by the rioters. Haganah forces in Tel-Aviv and Haifa managed to repulse the attackers. The Jewish toll was heavy: 133 killed, hundreds wounded, and widespread destruction. Over 8,000 Jews became refugees.

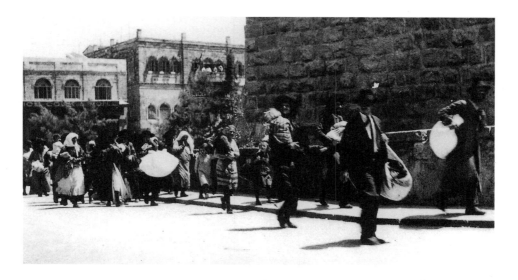

עַל חוֹמוֹתַיִךְ, יְרוּשָׁלַיִם, הִפְקַדְתִּי שׁוֹמְרִים

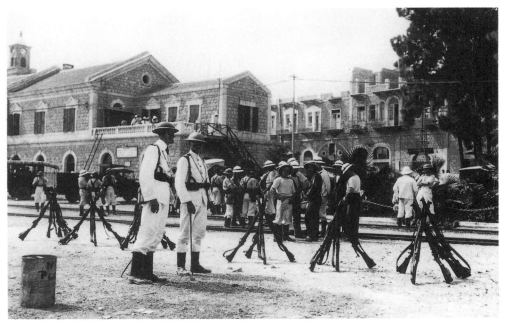

▷ British soldiers are sent to Palestine from Malta during the rioting of 1929. Below, Sir John Shaw, head of the commission of inquiry.

◁ A caricature by Nahum Gutman mocks the effectiveness of British protection of the Jews of Safed. The drawing is banned from publication.

▽ Clubs are distributed to Haganah members in Tel-Aviv for defense. The attacks are repulsed wherever the Haganah functions.

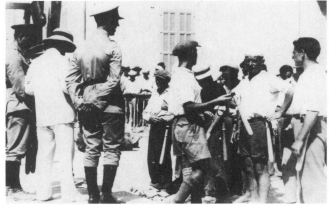

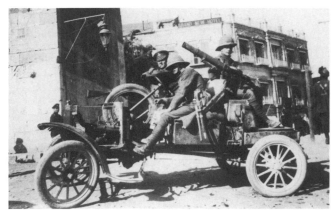

△ A British combat vehicle in Jerusalem. The British mobilize only after several days of rioting.

▷ Devastation at Ramat Rahel near Jerusalem following the Arab attack. Several other settlements are similarly destroyed after evacuation.

THE ESTABLISHMENT OF THE JEWISH AGENCY FOR PALESTINE

The Jewish Agency for Palestine was initiated during the 1920s by Dr. Hayim Weizmann, president of the Zionist Organization, in accordance with the stipulations of the British Mandate. In addition to representatives of the Zionist Organization, Weizmann was anxious that it include representatives of the non-Zionist communities as well, namely well-appointed Jewish figures with public stature who were prepared to support the Zionist endeavor even though it negated the Diaspora.

Disappointed with the limited success of the Zionist Organization in raising funds, Weizmann hoped in this way to obtain large-scale resources for the building of Jewish Palestine. However, he encountered opposition to his plan from most of the Zionist factions and had to struggle mightily until he achieved a majority for it. Following the close of the 16th Zionist Congress in the summer of 1929, a group of Jewish personalities, including Albert Einstein and Leon Blum, met in Switzerland and announced the establishment of the Jewish Agency.

This body was endowed with the authority to represent the Jewish people in its dealings with the British government, and also took on the task of recruiting resources for building up the Yishuv in Palestine.

◁ The poet Uri Zvi Greenberg (portrayed by Ziona Tagger), still labor, is invited by Ben-Gurion to the 25 years anniversary of the Second Aliyah.

▽ Pinhas Rutenberg, director of the Palestine Electric Corporation, is called upon, after the riots of 1929, to serve as president of the National Council.

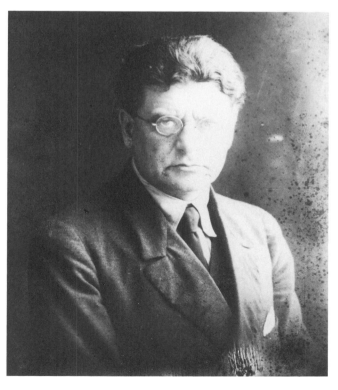

△ The economic crisis is not over. The Kehiliyat Zion, one of the largest land purchase and settlement companies, does not stand up to its financial obligations. The debitors demand it be closed down. Among the properties for sale is an "entire settlement called Herzliyah."

The Fourth Decade
1930-1939

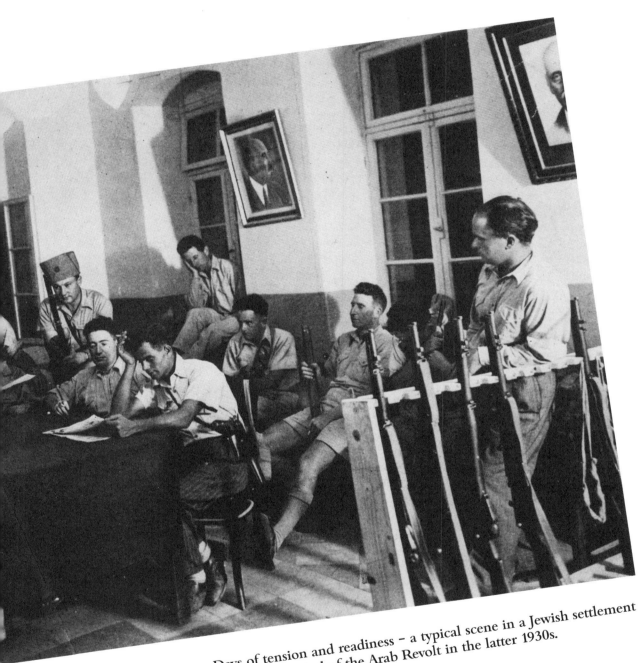

Days of tension and readiness – a typical scene in a Jewish settlement during the period of the Arab Revolt in the latter 1930s.

Palestine witnessed far-reaching changes during the 1930s. First and foremost, the population increased significantly. If at the start of the decade it approached 1 million, by the end of 1939 the figure was 1.5 million, nearly a third Jews and two-thirds Arabs and others. The growth of the Jewish population, in particular, was even more pronounced, nearly tripling during the course of the decade from 160,000 to approximately 475,000.

Two other major developments characterized the decade as well and had long-lasting effects on the country. The first was an unprecedented expansion of the economy, bringing a period of stagnation to an end. Some 150,000 Jews immigrated to the country during 1933-35, and brought in considerable capital, which they invested in various branches of the economy, generating impressive economic growth that benefitted the entire population, not only Jews.

The second development related to the growing opposition of the Arabs of Palestine to the expansion of the Jewish Yishuv. This opposition was mostly latent during the first half of the decade. However, the 1936-39 period witnessed the Arab Revolt in all its intensity, directed initially at the Jews and later at the British as well.

The British, who ruled the country, tried in the course of the decade to satisfy both the Arab and the Jewish sides as much as possible. In the light of the Riots of 1929, they adopted a balanced policy at the start of the decade. This policy reduced their commitment to the Zionist movement and to the Yishuv – as it had been defined in the Balfour Declaration of 1917 and in the Mandate of 1922.

The implementation of British policy, which was formulated both in London and in Jerusalem, was the responsibility of the High Commissioner for Palestine, whose personality and predilections had considerable impact on the Yishuv. This was clearly visible during most of the 1930s. Until 1931, the post was filled by Sir John Chancellor, who displayed indifference bordering on hostility toward the Jewish-Zionist question. By contrast, his successor, Sir Arthur Wauchope, who served as high commissioner from 1931 to the start of 1938, revealed great sympathy for the Yishuv and its needs and allocated a larger number of immigrant entry permits than in the past. After the outbreak of the Arab Revolt in 1936, however, Wauchope appeared to be at a loss for solutions to the Arab-Jewish question and his status diminished. He was replaced by Sir Harold MacMichael, who displayed a quite different approach from Wauchope's. He was regarded as the most pro-Arab high commissioner. MacMichael served for six and a half years – longer than any other high commissioner. During his service, the British shifted their policy into an outright pro-Arab one. This position was articulated in the White Paper of 1939.

During his first years in office, until 1936, Wauchope made great efforts to revive the idea of a legislative council, an idea born in the early twenties. The Arabs had opposed it in the past, seeing in the council a body which derived its authority from the Balfour Declaration and in the Mandate of 1922. In the thirties, they changed their opinion, assuming such a representative body could grant them the influence to halt the rapid growth of the Yishuv. But then it was the Jews who rejected such a council, for fear of its Arab majority. As the issue stagnated and no conclusions were reached, the rage of the Arabs burst into violence.

The Arab Revolt, which lasted three years, plunged the entire country into a cycle of blood-letting, suffering and fateful decisions. The Yishuv and the British alike were taken aback by the intensity of the Arab violence, although each party reacted to it differently. The British were at first hesitant and only later deployed large military forces that essentially suppressed the revolt. At the same time, they reached the conclusion that for both internal and external reasons (the deterioration of the situation in Europe following the rise of Nazism and fascism, and an appreciation of the growing strength of the Arab states), it was in their best interest to adopt a pro-Arab policy in Palestine, which would have to be at the expense of the Jews.

The Zionist movement and the leaders of the Yishuv arrived at the opposite conclusion. Arab violence and British betrayal – as the new British pro-Arab policy was perceived – galvanized their resolve. Although Arab violence caused serious loss of life and property, it also unified the Yishuv and advanced it as a state in the making. The number of new settlements actually rose significantly during the years of bloody outbursts. Constabulary units were formed under the British administration which included thousands of Jews who underwent military training. By 1939, David Ben-Gurion, the leader of the Yishuv, aptly observed that the period of "political Zionism" had ended and that of "militant Zionism" had begun. In less than a decade, this spirit would bring about the establishment of the State of Israel.

Close to the end of the decade the Arabs appeared to be losing ground militarily, with the harsh repression of the revolt by the British aided by the Yishuv. However, they attained a significant political achievement with the publication by the British of the White Paper of 1939, which introduced curtailment of Jewish immigration to the point of complete cessation; a nearly total prohibition of land purchase by Jews; and a plan to establish an independent Palestinian state within ten years that would be representative of all its inhabitants. In other words, the Arab majority would dominate the Jewish minority in every area.

The Jews protested and demonstrated against the White Paper of 1939, yet the Arabs rejected it as well, unwilling to assent to even the minimal concessions demanded of them. This was probably a grave error on their part. In any event, with the outbreak of World War II, new, more urgent issues had to be addressed.

January

1 The Palestine Potash Company Ltd. is formally established with the aim of extracting natural resources from the Dead Sea.

6 The Palestine Labor Party – Mapai – is founded at the close of a unity conference of the two major labor parties, Ahdut Ha'avodah ("Unity of Labor") and Hapo'el Hatza'ir ("Young Worker").

23 The Jerusalem district court acquits 12 Arabs accused of the murder of the Makleff family of Motza during the Riots of 1929.

27 The commander of the Ceylon police, Herbert Dowbigin, arrives in Palestine at the request of the Mandate government to examine the security situation in the wake of the Riots of 1929.

February

5 A Jewish policeman, Simha Hinkis, tried for killing Arabs while in pursuit in Jaffa during the Riots of 1929, is sentenced to death. The Yishuv is agitated and protest rallies are held.

13 The Moghrabi movie house opens in Tel-Aviv.

March

11 The Supreme Court allows policeman Simha Hinkis' appeal against the death sentence. He is resentenced to 15 years in prison.

15 Haganah arms concealed in three metal safes are discovered during unloading at Haifa port. The British confiscate 148 rifles and some 60,000 bullets.

21 A delegation of Palestinian Arabs leaves for London to present Arab claims to the British government.

31 The Shaw Commission findings are published: the Arabs are to blame for the rioting, but the outburst stems from their disappointment over Jewish immigration, the growth of the Yishuv, and the purchase of land by Jews, which causes the dispossession of the Arab fellahin. Jewish settlement must therefore be limited.

April

1 President of the Zionist Organization Dr. Hayim Weizmann, speaking at a press conference in London, voices disappointment over the findings of the Shaw Commission report.

3 An appeal by Yosef Urfali against the death sentence handed down to him for his role in killing Arabs (see 11.20.1929) is rejected. Another appeal is lodged.

9 A dedication ceremony is held for the Great Synagogue in Tel-Aviv.

A ceremony is held for the establishment of the Learning Youth movement.

15 The National and University Library is inaugurated on Mt. Scopus, Jerusalem.

25 The appeals court rejects Yosef Urfali's second appeal and upholds the death sentence.

29 The central hospital in the Jezreel Valley near Afula, built by the Kupat Holim ("Sick Fund"), is inaugurated.

May

Work conflicts erupt in Kfar Saba between Histadrut ("Federation of Labor") and Betar (of the Revisionist movement) workers.

13 Talks between the heads of the Colonial Office and the Palestinian Arab delegation are concluded. Arab demands to end the growth of the Jewish Yishuv, immigration and land settlement are unfulfilled. The Arab camp is disappointed.

14 The Yishuv is agitated upon the announcement by the Deputy High Commissioner to the head of the political department of the Zionist Executive, Col. Frederick Kisch, that the quota for immigration permits is to be canceled for the coming half year.

20 Sir John Hope-Simpson, a senior British official, arrives in Palestine to investigate questions of immigration, land settlement and development.

22 The Yishuv holds a general strike to protest the blocking of immigration.

31 Twenty-two (of 25) Arabs sentenced to death for their role in the rioting are pardoned.

June

7 The Red Shield of David (equivalent to the Red Cross) is founded in Tel-Aviv, later to be established in other localities as well.

15 The Arabs call a general strike over a demand for the pardon of the three Arab convicts who were not pardoned.

16 A British commission of inquiry, the Western Wall Commission, arrives in Palestine and collects testimony on the dispute over the Western Wall.

17 The three convicted Arabs are executed. Tension is widespread in the Arab sector.

July

19 The Western Wall Commission concludes its investigation and leaves the country.

31 The land dispute in Hadera is resolved (see January 1929). The court recognizes the ownership of the Jewish farmers and rejects the Bedouin claim on the land.

August

7 Yosef Urfali's death sentence is rescinded to ten years in prison.

22 The Hope-Simpson report is published. It echoes the Shaw Commission report and rejects further Jewish settlement in Palestine. It also recommends halting Jewish immigration, unless large-scale development plans are implemented. The Jewish-Zionist camp is angered by the report.

23 Ceremonies are held in the Yishuv to mark a year from the Riots of 1929. General strike in the Arab sector.

September

25 Hamashbir Hamirkazi, the main food and equipment supplier of the Histadrut ("Federation of Labor"), is founded in Afula.

October

2 (The close of Yom Kippur 5690) Moshe Segal of Brit Habiryonim, a clandestine anti-British group, blows the shofar at the Western Wall despite a British prohibition. He is detained by the British.

1930

20 The White Paper issued by Colonial Secretary Lord Passfield is published. It echoes the Hope-Simpson report. Zionist Organization President Dr. Hayim Weizmann announces his resignation in protest. Protest rallies are held in the Yishuv and in the Jewish world.

November

14 The British government attempts to pacify the Zionist leadership. It invites the leaders for a clarification of the issues in dispute.

December

8 A violent incident breaks out in Nes Ziona. Unemployed Jewish workers demonstrate and cause damage to houses owned by Jewish farmers. Further clashes of the sort take place in the settlements of the Sharon and the Shomron.

16 The National Council and the Jewish Agency call upon the public, especially organized workers, to condemn all acts of violence.

19 Further incidents occur in Petah Tikva over the struggle of Jewish workers to obtain employment in the orange groves. Dozens of Jewish workers who organize lockout shifts against Arab workers are arrested by the police. In response, other workers attack a grove-owner's home, are themselves arrested, and are sentenced to a month in prison. The Yishuv leadership bodies attempt to resolve the problem in the citrus sector.

27 The most exclusive hotel in Palestine, the King David, opens in Jerusalem.

◁ Lord Passfield (with his wife Beatrice), father of the anti-Zionist White Paper of 1930.

▽ The poster calls for a protest rally against Britain's restriction of Jewish immigration.

▽ The lead headline in *Davar* ("A Matter") on October 24, 1930, after the publication of the Passfield White Paper reads: "Stand Firm as a Rock! – Weizmann Appeals to the Yishuv."

THE BRITISH RETREAT FROM THEIR PRO-ZIONIST LINE

1930 was a bad year in Jewish-British relations regarding Palestine. During this period, the Jews increasingly sensed that England had betrayed them and was retreating step by step from the sweeping commitment expressed in the Balfour Declaration of 1917.

First came the Shaw Commission of Inquiry, which examined the reasons for the Riots of 1929 and found the primary cause to be the Arabs' fear that they would be harmed by Jewish immigration and the expansion of Jewish settlement. The commission recommended that the government prohibit large-scale Jewish immigration, as it could lead to a deterioration in intercommunal relations in the future. A senior British official, Sir John Hope-Simpson, was sent to Palestine to recommend ways of implementing the Shaw Commission findings. His proposals were even more one-sided: terminate Jewish immigration, prohibit further Jewish settlement, and improve the living conditions of the Arab fellahin.

The British government adopted the findings of the Shaw Commission and the Hope-Simpson report in their entirety, and in October 1930 published the White Paper signed by Colonial Secretary Lord Passfield. This document, eschewing any mention of the Balfour Declaration, emphasized that Britain had an obligation to both sides in Palestine; that there was insufficient land in Palestine for additional Jewish settlement; that Jewish immigration must be restricted; and that in the interests of ensuring fair representation of the inhabitants, a legislative council should be established promptly.

The Yishuv and the Zionist movement were infuriated. Ben-Gurion went so far as to suggest declaring war against Britain. Dr. Hayim Weizmann resigned from his post as president of the Zionist Organization and chairman of the Jewish Agency. The British government, alarmed by internal criticism, sought and found a solution in early 1931 in the form of the "MacDonald Letter" sent by Prime Minister Ramsay MacDonald to Weizmann reaffirming Britain's former pro-Zionist position.

164

Arab leaders hold frequent conclaves to discuss their problems following the Riots of 1929. At center, with canes, (l.) Haj Amin al-Husseini, the grand mufti of Jerusalem, and (r.) Musa Kazim al-Husseini, former mayor of Jerusalem.

The case of policeman Simha Hinkis, who is sentenced to death, agitates the Yishuv.

A cigarette advertisement: "Even Marx could err. No class struggle here in Eretz Israel, where all are equal and all smoke Maspiro."

קרל מרכס

בספרו הרכוש הוכיח לנו ש.בראשית היתה מלחמת
המעמדות. אולם אללי אם גדול ראשו למטות
אבן מעה האיש: כי לו הי בימינו אלה בארץ ישראל
היה נוכח לדעת כי שוין. אחה ושלום שורים בין
המעמדות כלם בלי הבדל פועלים כבורגים
באברים בחלוצים

מעשנים ומהללים את
סיגריות מספירו

The new luxury hotel that opens in Jerusalem, the King David, promises an especially high standard.

Tel-Aviv's Great Synagogue on Allenby Street is dedicated in a mass ceremony after more than eight years under construction.

THE PALESTINE HOTELS Ltd.

King David Hotel Jerusalem.

General Information

△ Immigrants in Venice en route to Palestine in 1930. Second from left: Pinhas Koslowsky (later Sapir), future finance minister in the State of Israel.

THE FOUNDING OF MAPAI

In contrast to the right and center parties, which were factionalized during the 1920s, the Left was relatively unified, with essentially two large parties – Ahdut Ha'avodah and Hapo'el Hatza'ir. Ahdut Ha'avodah ("Unity of Labor") was a large party which held socialist views, while Hapo'el Hatza'ir ("The Young Worker") was smaller and more moderate in its social and Zionist views. In the second half of the twenties, the two parties started getting close to each other, as a result of the economic and social crisis following the Fourth Aliyah.

These two parties reached a unity agreement whereby, despite the larger size of Ahdut Ha'avodah, both would have an equal share in the leadership of a new unified party, with each major post to be filled by two candidates, one from each camp.

Each of the parties held a final conference in January 1930, followed by a unity conference in Tel-Aviv that concluded with the founding on January 6, 1930, of the Palestine (later Israel) Labor Party, immediately dubbed Mapai, an acronym of the party's Hebrew name.

Noted leaders from the Ahdut Ha'avodah camp included David Ben-Gurion, Berl Katznelson, Itzhak Tabenkin, Eliyahu Golomb and David Remez, and from the Hapo'el Hatza'ir Yosef Sprintzak, Eliezer Kaplan and Dr. Hayim Arlozoroff.

△ The founding conference of Mapai in Tel-Aviv, January 1930. The Mapai party will control the Yishuv and the government of Israel for nearly 50 years, until the upheaval of May 1977.

▽ The National and University Library on Mt. Scopus, Jerusalem, is opened. The transfer of books is accomplished by means of donkeys. Library hours: 6 a.m. to 9 p.m.

בית הספרים הלאומי
והאוניברסיטאי בירושלם

בית הספרים הלאומי והאוניברסיטאי
פתוח לימבקריו

משעה 6 בבקר עד שעה 9 בערב
מיום א' עד ה' ומשעה 9 עד 3 ביום ו'

רבע לפני כל שעה יוצא אוטו ממול משרד הדאר הראשי
ועשר דקות אחרי כל שעה חוזר האוטו מהר־הצופים·
מחיר הנסיעה 10 מא"י

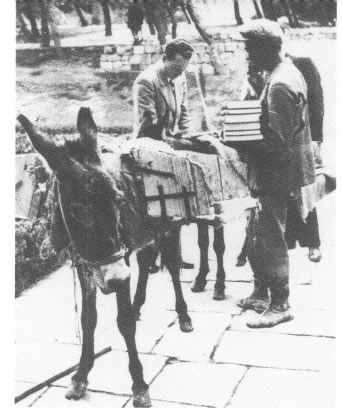

▽ The Shemen company in Haifa is typical of large new factories being built in Palestine.

"Shemen" Ltd.
HAIFA
OIL- and SOAP-FACTORY

LARGEST AND MOST UP TO DATE FACTORY IN THE NEAR EAST

OILS
for Table and Kitchen

SOAPS
for Toilet and Laundry

OIL CAKES
for Cattle Feeding

Special Items for Export: FINEST OLIVE OIL,
CASTILE SOAP (100% OLIVE OIL),
LUXURY TOILET SOAP

הנהלת קולנוע אופרה מוגרבי
נעננתה לדרישת המוסדות
המקומיים ועירית תל־אביב
והוציאה את כל הדיאלוגים
ושירה בזירגון
בסרט
האם היהודיה
עירית תל־אביב

△ The new Moghrabi movie house in Tel-Aviv. The notice by the municipality says that Yiddish dialogues and songs have been removed from the film The Jewish Mother.

▷ Tel-Aviv scene: Hayim Nahman Bialik has his shoes shined in the street. Painting by Itzhak Frankel.

1931

January
5 Elections for the third Elected Assembly are held. Mapai ("Palestine Labor Party"), with over 40% of the vote, is the clear winner. The Revisionists constitute the second largest party.

February
9-12 The third Elected Assembly holds its first session. It decides to transfer responsibility for

Headline in *Davar*, 11.15.1931: The bodies of the 2 missing hikers are found.

education and health from the Zionist Executive to the National Council of the Jewish Community. Itzhak Ben-Zvi is elected chairman of the National Council.
10 The Habimah theater relocates to Palestine permanently. Its first performance is Shakespeare's *Twelfth Night*.
13 Jordan and Yarmuk river floods cause serious damage to the power station under construction at Naharayim. Transformers are set adrift and cracks develop in the floor of the artificial lake that has been built, causing a long delay in making the station operational.

The MacDonald Letter, which restores British policy to its former pro-Zionist line and articulates Britain's commitment to those principles, in contrast to the Passfield White Paper of 1930, is published in London. The Zionist camp is relieved. Weizmann rescinds his resignation.

15 The Arabs protest the MacDonald Letter.

March
15 Marc Chagall, the Jewish artist, visits Palestine.
26 In the elections for the agricultural workers committee, Mapai's ("Palestine Labor Party") strength is put to the test for the first time. It gets 79% of the votes, while Hashomer Hatza'ir ("The Young Watchman") obtains 13%, and Po'alei Zion ("Workers of Zion") 7%.

April
5 Three members of kibbutz Yagur are murdered on the road to the kibbutz by the Sheikh al-Qassam band – the first major incident since the Riots of 1929.

A horse race is held on the sea shore of Tel-Aviv.

The Haganah branch in Jerusalem splits. A group of commanders led by Avraham Tehomi leaves and forms a separate underground body, the Haganah Haleumit ("National Defense"), or Irgun Bet ("B Organization"), the precursor of Etzel.
16 The poet Rahel (Bluwstein) dies at age 41.

The government announces plans to conduct the second population census (the first was held in 1922). The Yishuv is concerned that the results will accelerate the establishment of the legislative council, in which Jews will be a minority.

Ha'am ("The People"), a Revisionist daily, starts to appear and lasts four months.

May
25 Elections are held for the 17th Zionist Congress, which will meet in Switzerland in the summer. The Yishuv delegation of 36 consists of 24 Mapai and Hashomer Hatza'ir delegates,

7 Revisionists, 2 Mizrahi, 2 Hapo'el Hamizrahi, and 1 Yemenite.
29-31 The Railroad, Postal, and Telegraph Workers Organization convenes in Tel-Aviv. Both Arab and Jewish delegates participate. The organizational bodies are based on a parity arrangement, and include both a Jewish and an Arab secretary-general.

June
6 A confrontation occurs at the Maccabi soccer field in Jerusalem between ultra-Orthodox and secular demonstrators. The ultra-Orthodox oppose holding soccer games on the Sabbath. The National Council proposes that games be held on Friday.

July
The 17th Zionist Congress meets in Basle on June 30-July 17. Sharp disagreement between the Revisionist camp led by Ze'ev Jabotinsky and the central camp led by Weizmann concerning the "final aim" (of Zionism).

Two young people, Celia Zohar and Yohanan Shtal, disappear after setting out on a hike to a deserted region north of Tel-Aviv. Extensive searches are mounted.
13 The British government announces the appointment of Sir Arthur Wauchope as High Commissioner for Palestine, replacing Sir John Chancellor, who is scheduled to leave. The appointment is made with the concurrence of Dr. Weizmann, a sign of improved relations with the Zionists.
31 An Arab conference in Nablus calls for armed struggle against the Jews. It protests against the British distribution of weapons to the Jewish settlements (safes which are to be opened only in case of emergency).

August
1 An order by the High Commissioner allows all illegal immigrants to legalize their presence in Palestine as a preparatory step for the census scheduled for the end of the year.
23 The Arab sector holds a general strike to protest the

distribution of weapons to Jews.

After protracted debate, a Haganah national command is established in the summer of 1931 sponsored by all the Jewish national bodies.

September
2 High Commissioner Sir John Chancellor leaves the country at the completion of his term of office.
20 An Arab conference in Nablus decides to make all contact with the British administration conditional upon its commitment to Arab independence in Palestine.

October
Revisionist opposition to the approaching census grows. The Revisionists call upon the inhabitants of the Yishuv not to be counted.

November
2 The first copy of *Hazit Ha'am* ("The People's Front"), a radical Revisionist paper, appears. It is edited by Uri Zvi Greenberg, Abba Ahimeir, and Y.H. Yevin.
13 The bodies of Celia Zohar and Yohanan Shtal, who disappeared in July, are discovered near Herzliya. Three Bedouin are accused of murdering them.
18 The second census under the auspices of the British reveals the population of Palestine to be 1,035,154, of whom 759,952 are Muslims, 175,006 Jews, 90,607 Christians and 9,589 other.
20 The new high commissioner, Sir Arthur Wauchope, arrives in the country.

December
6-17 An international Islamic conference is held in Jerusalem with the participation of delegates from Muslim countries. It adopts nationalist decisions: "to redeem Palestine from the hands of the Zionists, to guard the holy places, and to open a Muslim university in Jerusalem." The Jews protest to the High Commissioner over incitement by the conference.

The production of potash is begun by the Palestine Potash Company at the northern Dead Sea.

◁ One of the parties in the elections for the Elected Assembly in January 1931 is the United Women's party. A cartoon mocks its feminist platform.

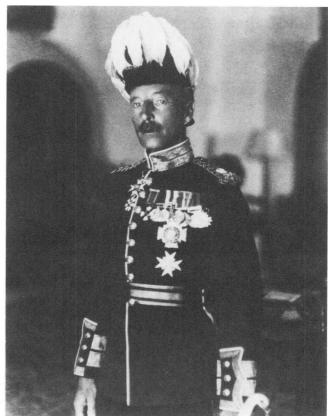

◁ Hayim Nahman Bialik (r.), the poet, as a delegate to the 17th Zionist Congress. His impressions will be summarized in a biting poem.

△ Sir Arthur Wauchope, the new High Commissioner for Palestine, November 1931.

THE "FINAL AIM" CONGRESS

The 17th Zionist Congress, held in Basle, Switzerland, in the summer of 1931, was one of the stormiest ever witnessed by the Zionist Organization. Antagonism between Left and Right reached a new high, while the president of the organization, Dr. Hayim Weizmann, lost his seat and was replaced by Nahum Sokolov.

The General Zionists, who in previous congresses had held a majority, had become weakened over the years. By 1931 they controlled no more than a third of the delegates, who were divided in two hostile parties. The Labor faction attained some 30% of the seats, while the Revisionist movement tripled its strength from 7% to 21%. The main contest was between Labor and the Revisionists. Weizmann, all-powerful in the past, was weakened as a consequence of the Passfield White Paper, which the MacDonald Letter could not quite remedy. The general feeling was that the time had come for a leadership reshuffle. The only question was whether the mantle would pass to the leaders of the Labor movement – Ben-Gurion, Berl Katznelson, and Hayim Arlozoroff, or the leader of the Revisionists – Ze'ev Jabotinsky.

Jabotinsky and his party stirred up a storm by demanding that the congress unequivocally define the final aim of Zionism as the establishment of a Jewish state in Eretz Israel. The Labor faction and other elements, however, felt that coming out with such a declaration was premature. Before reaching a decision concerning Jabotinsky's proposal, the opinion of informed personalities in Palestine was asked. A telegram from Eliyahu Golomb and Sa'adia Shoshani, two Haganah leaders, replied that a radical Zionist decision at that stage could lead to further violence on the part of the Arabs. The National Council in Jerusalem held a similar view.

Labor's proposal to defer discussion of Jabotinsky's demand was accepted, whereupon Jabotinsky, infuriated, tore up his delegate's card and left the plenum. The new leadership that was elected included representatives of the Labor movement filling central posts for the first time. Heading the political department in Jerusalem was Dr. Hayim Arlozoroff, aged 32.

To a great extent, the stormy congress was disappointing and frustrating. One of the delegates, Hayim Nahman Bialik, expressed his aversion to the prevailing contentiousness in his poem *Again Have I Beheld Your Powerlessness*.

▽ Outgoing: Col. Frederick Kisch ends an eight-year stint as head of the political department of the Zionist Executive and the Jewish Agency in Jerusalem.

△ Incoming: The young Dr. Hayim Arlozoroff, aged 32, replaces Col. Kisch.

THE RISE OF THE LABOR MOVEMENT'S POWER

The ascendancy of the Jewish Labor movement in Palestine in 1931 was a notable development in the Zionist movement and the Yishuv. While the Labor movement had already emerged as an important force during the 1920s, by the end of that decade it explicitly dedicated itself to the goal of "conquering" Zionism in order to steer it along the path of its sociopolitical ideology.

During this period, David Ben-Gurion, the increasingly prominent secretary of the Histadrut ("Federation of Labor"), and one of the leaders of Ahdut Ha'avodah ("Unity of Labor"), repeatedly stated that the goal of the Labor movement was to replace the veteran "bourgeois" leadership of the Zionist movement – which consisted of a coalition between the General Zionists, the religious parties, and sometimes the moderate section of the Labor movement, Hapo'el Hatza'ir ("The Young Worker"). At the same period the power of the Revisionist movement, led by Ze'ev Jabotinsky, rose as well. It was obvious, in retrospect, that a confrontation between the two parties over the leadership of the Zionist Organization was imminent.

The year 1931 presented the Labor movement with its opportunity when it overpowered the Revisionist movement in two separate contests: the elections to the third Elected Assembly in Palestine in January, 1931, when Mapai won over 40% of the seats and the Revisionists obtained only 20%; and the 17th Zionist Congress in Basle during the summer, when Weizmann's and the Labor movement's approach was ratified (even though Weizmann himself was deposed from the presidency of the Zionist Organization) and the militant line of the Revisionist movement was rejected.

△ Every year or two, an "airship" passes over the skies of Palestine, causing great excitement.

▷ The Yishuv, and the population of Jerusalem in particular, is agitated over demands by the Orthodox and the ultra-Orthodox to prohibit football games on the Sabbath. The National Council requests the teams to schedule games on weekdays. The police intervene during a confrontation in June between secular Jews and the ultra-Orthodox on the Maccabi field in Jerusalem.

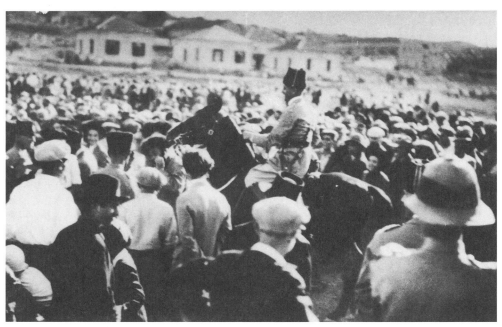

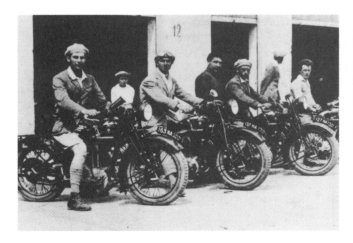

התבערה היותר גדולה בקורות ארצנו
תחנית שלמה עלתה באש—סכנה רחפה על כל הרבע
4 שעות של חרדה—63 מכוניות נשרפו כליל—30 אלף לא"י נזוקים—אראלות הסכנים
(ע"י השתת-רחוק מאת משרדנו בת"א)

△ A large fire breaks out in Tel-Aviv, destroying the Ma'avir garage and dozens of buses parked there. Headlines (left) in *Doar Hayom* ("Daily Mail"): 36 cars burned, 30,000 Pounds worth of damage.

△ Motorcycles are much favored by the young men of the Yishuv in the early 1930s. Many take motorcycle trips to neighboring countries and through Turkey to Europe.

▷ The poet Rahel (Bluwstein), a Second Aliyah pioneer, who started writing in the twenties, dies of tuberculosis in the spring of 1931 at age 41.

▷ The maximalist wing of the Revisionist movement calls on the Jewish population to boycott the census scheduled to be conducted in Palestine toward the end of 1931. Shown, one of the first activists, Abba Ahimeir. The graffiti reads: "Don't Be Counted."

▽ An international Islamic conference held in Jerusalem in December adopts anti-Zionist decisions. Delegates are shown in front of the new Palace Hotel. The moving spirit behind the conference is the Grand Mufti of Jerusalem, Haj Amin al-Husseini.

A NATIONAL COMMAND FOR THE HAGANAH

From the start, the Haganah ("Jewish self-defense organization"), established in 1920, was associated with the Histadrut ("Federation of Labor") for two reasons: the affinity of the Haganah's active members with the Labor movement, and the unwillingness of any other major body in the Yishuv to assume responsibility for the Haganah.

After the Riots of 1929, however, it was clear that the Haganah could no longer continue as a loosely organized partisan group. In the summer of 1930, the defense committee of the National Council decided upon formal recognition of the Haganah as based on two essential components of the Yishuv – the Left, embracing the Histadrut and Labor settlement, and the Right, as represented by the Farmers' Federation and various civic urban groups. A national command for the Haganah was established in the summer of 1931 consisting of six members – three from the Left and three from the Right.

This parity structure, which was political in nature, was to hinder the functioning of the Haganah, and on more than one occasion it plunged the national command into crisis. Nevertheless, the format enabled the Haganah to exist during the next 17 years as a single body with representation from the two main sectors of the Yishuv.

△ Spectators at a horse race along the Tel-Aviv shore during Passover of 1931 include artist Marc Chagall (second from left), poet Hayim Nahman Bialik (center) and to his left, Sephardi Chief Rabbi of Tel-Aviv, Rabbi Ben-Zion Uziel.

האם יושם קץ לשערוריית המכוניות בעירנו?
שתי ילדות נרמסות ברחוב.—אחריות המשטרה ברורה

◁ As more cars are imported, the number of car accidents increases. The newspaper appeals for an end to the "scandal of vehicles" in Jerusalem.

1932

January

14 The Yishuv teachers announce a general strike over nonpayment of salaries and other issues. It lasts nearly four weeks.

16 A member of Moshav Balfouriya, Yosef Burstein, is shot to death in his home by the Sheikh al-Qassam band.

25 The first commencement ceremony is held by the Hebrew University of Jerusalem. Thirteen graduates receive M.A. degrees.

February

10 Students affiliated with the Revisionist movement disrupt Prof. Norman Bentwich's inaugural lecture for the Chair for International Peace by throwing a stink bomb. Right-wing student activists are suspended from the university for various lengths of time.

The first shipment of locally produced potash is sent to England.

March

5 A member of Kfar Hasidim, Shmuel Guterman, is murdered by the Sheikh al-Qassam Black Hand band.

10 Arab-Jewish violence occurs at Kuskus-Tab'un (today the Tiv'on-Alonim area) during plowing. Injuries are sustained on both sides. Work is stopped.

14 The head of the political department of the Jewish Agency, Dr. Hayim Arlozoroff, and the secretary of the department, Moshe Shertok, visit Emir Abdallah of Transjordan.

27 Rabbi Yosef Hayim Sonnenfeld, considered the leader of the ultra-Orthodox community and the old Yishuv, dies at age 83.

28 The first Maccabiah, a Jewish olympics, opens in Tel-Aviv with participants from 21 countries.

The celebrations marking fifty years for the First Aliyah and to the movements Hibat-Zion and Bilu begin.

April

2 The Tel-Aviv Museum is opened in the former home of the Dizengoff family. It is named after the late Zina Dizengoff.

7 The Levant Fair, the first international fair in Palestine, opens in Tel-Aviv with exhibitors from 24 countries.

May

Jewish immigration to Palestine grows. Some of the newcomers are athletes, escorts and tourists who arrive with the Maccabiah and remain, with or without immigrant permits. At the same time, the economy improves after years of stagnation and crisis.

June

6 The Center and Right emerge as victors in elections for the Tel-Aviv municipal council.

8 One of the two Bedouins tried for the murder of Celia Zohar and Yohanan Shtal is sentenced to 15 years imprisonment. The other is acquitted for lack of evidence.

9 The hydroelectric power station in Naharayim is inaugurated in the presence of Pinhas Rutenberg, manager; Emir Abdallah, in whose territory the station is located; and High Commissioner Wauchope. The fact that leaders of the Yishuv are not invited arouses anger.

19 Meir Dizengoff is reelected mayor of Tel-Aviv. Israel Rokach becomes deputy mayor.

July

5 Due to financial problems, Kupat Holim ("The Sick Fund") is forced to close down its only hospital near Afula for two months.

13-14 The General Zionists convene in Tel-Aviv. Among other things, they advocate nonpolitical unemployment offices. They also call for the retention of the Revisionist movement in the Zionist Organization despite Ze'ev Jabotinsky's demonstrative exit from the Zionist Congress in 1931.

21 Alexander Zeid, the noted Hashomer ("The Watchman") veteran at Sheikh Abriq, is wounded, as is his son, in an Arab attack.

August

16 Rishon Lezion marks 50 years since its founding.

September

The debate about Sabbath observance in Jewish localities is renewed. The chief rabbis meet with the High Commissioner to obtain governmental intervention. A Sabbath observance law is imposed on the Tel-Aviv municipality.

October

7 A strike in the Froumine biscuit company in Jerusalem becomes a landmark in labor relations in the country. It involves a confrontation between the Histadrut ("Federation of Labor") on the one hand, and the owner and a portion of the workers, who are Revisionist supporters, on the other. Lasting four months, it involves physical assaults, arrests, and prison sentences and continuing political tension.

12 The government enlarges the immigration quota as compared to recent years: 4,500 immigration certificates are issued for the forthcoming half year.

20 An international seaplane port is inaugurated on Lake Kinneret opposite the Tiberias shore to serve the London-Bombay line. Flight time from London to Tiberias: $4\,1/2$ days.

November

9 Jewish economic bodies combine efforts to block the planned imposition by the government of an income tax.

12 At a meeting of the Permanent Mandates Commission in Geneva High Commissioner Wauchope announces his firm intention to establish a legislative council in Palestine.

December

1 An English-language daily, the *Palestine Post*, appears in Jerusalem. The newspaper is linked to the Jewish Agency.

22 Two members of Moshav Nahalal, Yosef Ya'akobi and his son David, are murdered by the Sheikh al-Qassam Black Hand band by means of a hand grenade thrown into the family's home at night.

25 Elections for the fourth Histadrut ("Federation of Labor") convention result in Mapai ("Palestine labor Party") gaining over 80% of the seats. Po'alei Zion ("Workers of Zion") and Hashomer Hatza'ir ("The Young Watchman") attain less than 10% each.

29 The first Hebrew-language feature film, *Oded Hanoded* ("Oded the Wanderer"), directed by Hayim Halahmi, premieres in Tel-Aviv.

Other events in 1932: An organization is created to send Jewish children from Germany to Palestine – the prelude to the Aliyat Hano'ar ("youth Aliyah") movement initiated by Recha Freier from Berlin.

Hityashvut Ha'elef – the settlement of a thousand workers and their families in new communities – is initiated in the Judean and Sharon plains.

Fifteen new settlements are founded, the largest number in one year since the start of the Jewish revival of Eretz Israel.

The Palestine Soccer League starts its first season with nine participating teams. The British Police Force team takes the cup.

The tradition of pilgrimages to Tel-Hai is institutionalized.

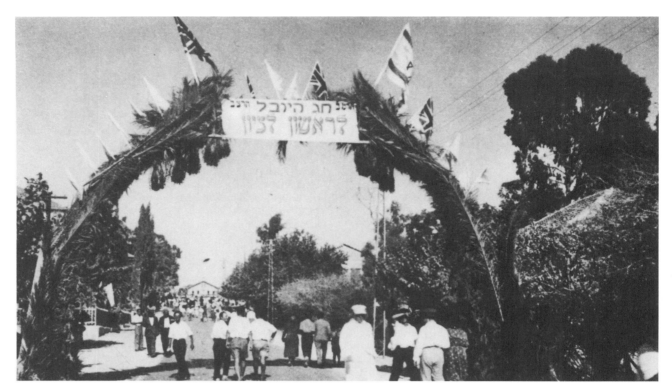

△ The Yishuv marks 50 years since the start of the First Aliyah and the establishment of the first agricultural settlements, commemorated in Rishon Lezion.

◁ Imperial Airways advertises a Tiberias-London connection in 4 1/2 days by seaplanes flying the Bombay-London route and using the Tiberias port for seaplanes, inaugurated in October, 1932, as a stopover.

◁ The flying camel is the symbol of the first international Levant Fair, which opens in Tel-Aviv on April 7, 1932, with exhibitors from 24 countries. The origin of the symbol, according to local legend, is a skeptical remark by the mayor of Jaffa regarding the ability of Tel-Aviv to implement such a project: "Such a fair will take place only when camels fly." The fair draws many visitors and tourists to the small town.

COMFORT SPEED

IMPERIAL AIRWAYS

———

Tiberias-Cairo	in 3 hours
Tiberias-London	in 4½ days
Tiberias-Baghdad	in 5 hours

THE BEGINNING OF ECONOMIC RECOVERY

The Yishuv suffered an economic crisis since 1926. Years went by and the crisis did not end. The intensity of the crisis waxed and waned, but the abundance last seen in 1925 did not return.

The economic crisis was expected to be exacerbated by two grave developments in 1929: the domestic rioting and bloodshed of that year, and the worldwide economic slump. The latter, originating in the collapse of the stock market in New York, was also felt in Europe. Its influence on Palestine would be but a matter of time, economists assumed.

To everyone's surprise, the severity of the economic crisis in the United States and Europe was not replicated in Palestine, and marked signs of recovery were evident in 1932. Large development projects such as the hydroelectric power station at Naharayim and the Palestine Potash Company at the northern Dead Sea began operating at full speed. The township of Tel-Aviv, which had languished in the doldrums since the mid-

1920s, revitalized itself with the help of two major events in the spring of 1932: the international Levant Fair – on a new site north of the city near the Yarkon River – and the first Jewish olympics, the Maccabiah. Thousands of tourists joined masses of local residents who thronged the city for both events.

Moreover, the worsening economic situation abroad revived immigration to Palestine, with 9,500 immigrants arriving in 1932 along with some 3,000 Jewish tourists who decided to remain in the country. Most of the immigrants were from Poland, although a sizable group came from Germany. Some 1,000 newcomers also arrived from the United States, apparently as a result of the depression there.

With the growth of immigration and the development of economic projects and of tourism, the national spirit lifted as well. The only question was whether this promising state of affairs would last.

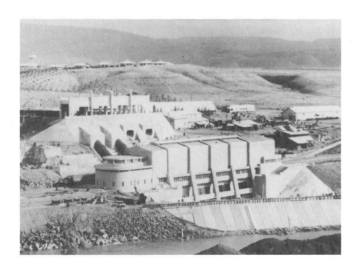

▽ The hydroelectric plant in Naharayim, in Transjordanian territory, is inaugurated in June 1932.

△ Emir Abdallah of Transjordan starts up the turbines that put the hydroelectric plant into operation.

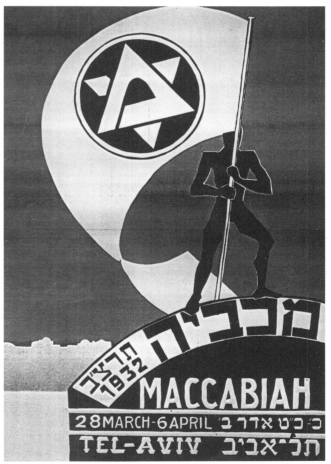

△ The first Jewish olympics – the Maccabiah – attract hundreds of athletes from 21 countries and thousands of Jewish tourists in the spring of 1932. Many stay as illegal immigrants.

Sabbath observance is again an issue in the Yishuv in 1932. In Tel-Aviv, an observance law is imposed on the municipality. A special trumpeter circulates in the streets to announce the start of the Sabbath.

▽ The first Hebrew feature film, *Oded the Wanderer*, is produced in 1932, later commemorated with an Israeli stamp.

◁ Another cinematic event: Polish director Alexander Ford films *Tzabar* ("Native"), starring Habimah actress Hanna Rovina, in Palestine.

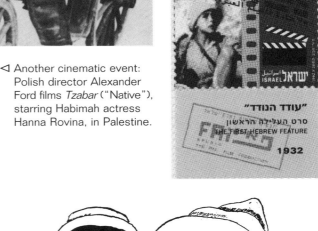

▽ The first English daily, the *Palestine Post* (later the *Jerusalem Post*), appears in Jerusalem in 1932.

▷ Writers and friends Avraham Shlonsky (r.) and Israel Zmora have a literary fallout in 1932 and part ways. Caricature by Aryeh Navon.

THE PALESTINE POST

INCORPORATING *The Palestine Bulletin*

Telephone Numbers 733 & 734

TELEPHONE Your News To Us CALL 733

1933

January

1 Four bus companies merge and establish the Egged bus cooperative. The name is invented by the poet Hayim Nahman Bialik.

30 Hitler comes to power in Germany and is appointed Chancellor by President Hindenburg. Repressive anti-Jewish laws are immediately announced. Immigration to Palestine from Germany, which began several months earlier, increases monthly.

The Youth Aliyah movement is established to bring children and young people, without their parents, to Palestine. At first geared to Germany, it later embraces other countries as well.

February

Tension mounts among the Arabs. An incident on February 22 involving Bedouins and Jewish plowmen in Emek Hefer (Wadi Hawarith) results in the death of a Jewish guard. After two days, the Arabs organize a meeting in Jerusalem which calls upon the government to prohibit Jewish immigration and land sale to Jews.

March

The Yishuv is agitated by the disturbing political developments in Germany. Rallies and assemblies throughout the country call for aid for the Jews there.

April

1 Germany declares a governmental boycott of Jewish professionals, Jewish-owned shops, and other Jewish enterprises.

7 An international telephone link between Palestine and England, as well as other European countries, is inaugurated.

8 A historic meeting takes place between Zionist and Yishuv leaders and dignitaries from Transjordan at the King David Hotel in Jerusalem. The Jewish leaders include Dr. Hayim Weizmann, Dr. Hayim Arlozoroff, Itzhak Ben-Zvi and Avraham Shapira.

11-19 Sir Philip Cunliffe-Lister, British Colonial Secretary, visits Palestine.

He tours the Jewish settlements, accompanied by Weizmann and Arlozoroff. The Arabs protest his visit.

12 The cornerstone is laid for the Daniel Ziv Institute, later to become the Weizmann Institute of Science.

17 A violent confrontation occurs in Tel-Aviv between participants in a Betar parade and Labor supporters. Tension between the Revisionist and Labor camps runs high.

May

2 The United Committee for the Settlement of German Jews is organized to aid immigrants arriving from Germany.

Other efforts by the Yishuv and the Jewish world to assist the Jews of Germany are intensified. Zionists and non-Zionists join forces in this activity. The Revisionist movement calls for a boycott of German merchandise. The Jewish Agency searches for ways to bring out Jewish assets from Germany.

31 (the Shavu'ot holiday) A violent incident occurs in Haifa between participants in a Betar parade and Hapo'el (Labor) group. The Betar members accuse their rivals of attacking them. The police arrest participants from both sides.

June

7 The Anglo-Palestine Exhibition is opened in London, displaying achievements in Palestine.

16 The head of the political department of the Jewish Agency, Dr. Hayim Arlozoroff, is shot on the Tel-Aviv shore and dies of his injuries. The Yishuv is deeply agitated.

23 Members of the maximalist wing of the Revisionist movement, Brit Habiryonim, are arrested in connection with Arlozoroff's murder.

The conflict in Emek Hefer comes to an end: the courts uphold the legality of Jewish ownership of the lands at Wadi Hawarith in a series of appeals. The Bedouin tenants are evacuated.

July

17 Elections in the Yishuv for the 18th Zionist Congress

result in a large victory for Mapai ("Palestine Labor Party"), running together with Hashomer Hatza'ir ("The Young Watchman"): 34 of the 50 delegates. The Revisionists, constituting the primary opposition, obtain 5 delegates.

August

21 (until September 4) The 18th Zionist Congress is held in Prague. Dubbed the "Upheaval Congress," it is marked by the attainment by the Labor movement, led by Mapai, of some 45% of the seats, enabling it to form the leadership coalition of the Zionist Executive for the first time. The Revisionists, led by Ze'ev Jabotinsky, obtain less than 20% of the congress seats. The congress decides to dispatch a committee to inquire into the activities of radical Revisionist groups in Palestine. Sokolov is reelected president of the Zionist Organization. Moshe Shertok is elected head of the political department in Jerusalem. Ben-Gurion is given no particular portfolio, but he is to help Shertok with the political work.

September

1 The Ha'avara ("Transfer") arrangement is implemented in Germany, whereby Jewish assets are transferred to Palestine through a trust transaction with the agreement of the Nazi government.

October

3 Seven of the detained Brit Habiryonim members (see June 23) are arraigned for trial, including Abba Ahimeir and Dr. Yehoshua Heschel Yevin.

Jewish immigration increases monthly. The atmosphere in the Yishuv is optimistic and the economic situation improves.

13 The Arabs of Palestine hold a general strike to protest the growth of the Yishuv.

27 A large Arab demonstration in Jaffa is followed by an Arab general strike throughout the country lasting over a week in some places. Confrontations with

the police result in many Arab casualties: 24 dead and over 200 injured.

31 Haifa port, the country's first deep-water harbor, is inaugurated.

November

In order to satisfy the Arabs, the British announce they will prevent Jewish tourists from staying in the country after their permits expire (a way in which thousands of Jews have managed to remain in Palestine).

17 *Dror* ("Liberty"), a Hebrew weekly in Latin script, edited by Itamar Ben-Avi, appears in Tel-Aviv.

December

Arab-inspired tension continues. The Arabs threaten to boycott the British administration and announce that they will go on strike again.

9 Police and Revisionist activists exchange blows during a protest by the Revisionists against British restriction of immigration, resulting in 18 wounded, including policemen.

Other events in 1933: A new record is achieved with the establishment of 21 new Jewish settlements – wich represent over a sixth of all the settlements founded in Palestine during 50 years of Jewish settlement.

Immigration also soars, with over 37,000 Jewish newcomers in 1933, the largest influx since 1925.

A Jewish soccer team, Hapo'el Tel-Aviv, takes the Palestine Soccer League cup for the first time. The team did not lose a single game during the year.

177

△ One of the newcomers from Germany is child actress Hanna Maierzuk (Meron), who is to become a prominent theater actress in Israel. Shown in a scene from a German film.

▽ Immigrants from Germany undergo job retraining. A group of academics become window cleaners in Tel-Aviv.

A DRAMATIC RISE IN IMMIGRATION

Jewish immigration to Palestine slumped in the latter 1920s, with only a few thousand newcomers arriving annually. In 1927 and 1928, the number of immigrants did not surpass 3,000, while emigration cancelled this demographic increase. In the next three years, 1929-1931, immigration increased slightly, and the number of newcomers reached 4,000-5,000 a year.

A turnaround developed in 1932 with the intensification of anti-Semitism in Germany on the one hand, and the improvement of the economic situation in Palestine on the other. Moreover, for the first time in years, the number of immigrants arriving with capital, i.e., £500-1,000 or more, increased. These immigrants were not required to obtain an entry permit.

With Hitler's rise to power in 1933, this trend intensified. Over 37,000 Jewish immigrants arrived in Palestine that year to join the extant Jewish population of some 190,000 – a population increase of 20% in one year. Although most came from Eastern Europe, with approximately a fifth coming from Germany, the Fifth Aliyah, as this population movement became known, was perceived by the public as originating from Germany and was referred to as the German Aliyah, or the "Aliyah of the Yekim" – as the German immigrants were dubbed.

Since the First Aliyah, at the end of the 19th Century, there had been only one year, 1925, which had brought more than 30,000 immigrants. 1933 broke this record.

חיים ארלוזורוב נרצח

נרצח חיים ארלוזורוב. שלשה ימים
אחרי שובו ממסעו בתפקידי הציונות
בחו"ל. הצמיתתה יד פושעת וטמאה את
חייו הצעירים והיקרים. על משמרתו
נרצח. בעצם אונו ופריחת כוחו, כולו
רענן ושופע חיים ופעולה, תסיסה ומרץ,
כולו מסירות לתפקיד הקשה וכבד-
האחריות שהטילה התנועה הציונית על
שכמו, מלא אמונה ומעורר אמונה
ביכלתו הרבה לעשות את שליחות
האומה ואת שליחות תנועתנו בשעה
הזאת, רבת הפורענות ורבת התחולת.

הננו מזועזעים ונדהמים מנדול האסן –
נדהמים מכרי שנוכל להביע במלים
את אשר ירחש לב רבבות חברים
בארץ ובכל רחבי הגולה. איננו
איננו יודעים עדיין מאיזו פנה חשכה
הגית אלינו האסון, איננו יודעים
מי יד אשר קפחה את נפשו של חבר
יקר זה, ישר הקומה וישר הנתיבה, אשר
בשנות חייו הקצרים הספיק לחשוף שפע
כה גדול של כוחות לשירות מפעלנו,
ועוד גדולות ונצורות מאלה היו שמורות
במעין נפשו, שאר החל לפכות. איננו
יודעים מי יד המרצחת ומה היתה
כוונתה, אין אנו רשאים לקבוע וראיות על
פי השערות וחישובים. אבל יודעים אנו
– יד הזאת היתה שלוחה אלינו
ופגעה בארלוזורוב, שליחה של תנועתנו.

עדיין מתנו מוטל לפנינו. מתח של
האומה, מתח של התנועה. האבדה איננה
חוזרת. אין אנו יכולים להטיף תנחומין,
אף לא לקבל תנחומין. רק דבר אחד
בכינו לומר עתה: החץ פגע בלבנו. אבל
אם יש מי שחושב, כי ברצח בחוריגו
אשר לרצוח את מפעלנו, את מפעלה
ההיסטורי של הציונות ואת מפעלה של
תנועת הפועלים – הרי לא עמד על
רוחה של תנועתנו. דגל הגאולה והשח-
רור, דגל עם עובד עברי, חפשי, נישא
אותו נישא ואתו נפל ארלוזורוב, יישא
באמונות ובקשיות עורף בידי רבבות
חברים, בידי התנועה כולה.

הועד הפועל
ש" הסתדרות העובדים העברים הכללית
בארץ ישראל

אחים בכאב,
מתוך הכאב יש הכרה לקרוא
להתאפקות.
רבבות אנשים כואבים, מזועזעים.
אין יודע פשר הפשע, אין מבין, מי יכול

האסון בא בליל שבת, כ"ב סיון (16 ביוני).
בשעת 10.15, חיים ארלוזורוב טייל עם אשתו על
שפת ימה של ת"א. הם עם קצה בית הקברות הער-
בי, שכב העירה. והנה נגשו אליהם שני בני אדם
ואחד מהם ירה בארלוזורוב שתי יריות. כדור אחד
פגע בבטנו. ארלוזורוב נפל. הרוכחים נמלטו במעלה
הנגבה מזרחה. חלומה מן האסון האים, יתירה בחז-
שך ליד אישה נגצעע, שיעה חברה סמה ארלוזו-
רוב לעזרה. ניסתה לסמוך את הנופל, הפציעו אתי
אתו, אשר דברי הרגעה לאשתו והחל לזחול כדי
להתקרב העירה. לצעפת האשה נענה אחד המיסיים
שישב במרחק עשרים מטר בערך. הוא קרא לאחרים
שהיושב ראשונה, כי נשמעו עוד יריות, עבר זמן
מי עד ששלישיה בחורים לקחז את ארלוזורוב
ישאתו העירה, אשת רצה לחשיג עזרה רפואית
ראשינה ולהודיע למישטרה. עוד בטרם השיגוה בעו-
דה הטלפון את סבונית העזרה המהירה, נמצאה מכו-
נית פטמנה פשוטה שבה הובל הפצוע ל"הדום".

האסון וחפשו נורעו בעיר. מיהירות הכביעית
עוברים ושבים, למסעדות, לבתים. בחץ פגעה בל"ב
בל פועל העברי, ידיד, אדם, כרעט ירח, בכשית-
חורבן על ראש כולם. החלום ריוח לכאן ולכאן, קה-
התאסף כשני מקוומה: ליד שער "הדם" ולזד מירון
פגה ת"א. שמעה יצא ארלוזורוב למניל" האמהרי
ראשר בו פצעה חמישטרה את נוזרת החקירות הרא
שונה. "מי שלזמו", עבדה שאלה כפה לפה, וחרצון
קווביד תקוה, תקות חיים.

כל הדרך ובכוה התליים נקשף החולף מדי רגע
ציית כמאובים, נצון חחזון התאבכם בכל היום המתה
מ"כ, קציות חנגה נגרבות ומסתיררות, כרי סבב מת-
נכר חמה הכביר. העינים נפשחות מכיטות בצליהיה
ומסיגרות בל איש חפלב. בדרך מכעים ארלוזורוב:
"אסמר על הכל", בששאלים אותו לפרשי הרצח.
בבית החולים הוא מכי" את מ" ח. ריזנגוף, שבא בן
חייתאשונים לראות. "ראה, את ח" ריזנגוף, מה עשו
ל": ירו בי". את ניסו, חח" רווזזלין, הוא שואל:
"מ" לסימה, איזה" את האחית שהבי" מיבני שנה
היא שואל: "העורך עובדת כאן?". הוא מוסר על
מצבו: לר"ר קליבבצ שנזרבכו רסקיס. הוא מעדר ליר-
זיירין על תיק חתעגורות שבבים: ומכסכי לשים לב
לפרהרן של עולה מכרפנית שהעצילה זפרהי אצלו.

הריפאים חתכינו ביד לנית. זמן חברתי
עינב לחבנות. מסתת-בם: לר" ח. סטין, ד"ר אלוי-
בץ, ד"ר ריזובברוג, לר"ר העצטי ולר"ר כרבים. מיד
באר: מברבי דבם לחולה. אך צריך לבחון את דם
אם הוראים. נמצא אחד, והם נ"לפח בםכזכ, אך ישוא
הניזינים נעשה. הפכנותח עד חתעי"ד מהבירקוה.
באחה בליזל בא חיץ.

והמישטרה כמה בינתיים על יתדה, ראשית
רשבי" דברי סימה ארלוזזרוב, שתיפרה:

היא וחיים יצאו מבית ככפה דן לטיזל על שפח
הים. חיים ביקש לנות ולחשי" את מחשחות העבודה
הרבה. הם חרחיקו ליד הירקון. היא ראתה עוקבים
אחריהם ואמרה זאת לחיים. הוא ענה: "מה יש לא-
מריד" אנו בין יהודים כמונג. גם אלה (כלומר, העוק-
בים) מטיילים. ליד מקום האסון חספו להם שנים

ההרוגים אחרי הריצאים בעיניו נראים.
את הערבים הראשינים חקרו הפציגים שיח
סודרו. באו: מלבד שוטרי ת"א גם שוטרים בליסיים.
הגבב נשש עבכי ובעצרת מנזרים לוכם נסעו אחרי
חצות לגשש. אחר העצבנות.
פציני המישטרה הודיעו למיכזי המישטרה את

The lead article on the front page of Davar ("A Matter") on June 18, 1933, is titled: "Hayim Arlozoroff is Murdered."

THE ARLOZOROFF MURDER

A rising Zionist leader and luminary of the Mapai party, Dr. Hayim Arlozoroff, aged 32, was elected by the 17th Zionist Congress to head the important political department of the Zionist Executive and the Jewish Agency. With the rise to power of the Nazis in Germany, he became a moving force in efforts to increase Jewish immigration from Germany and to transfer Jewish assets to Palestine (by means of the Ha'avara arrangement).

The Left-Right rivalry in the Yishuv, and especially Arlozoroff's advocacy of establishing ties with Germany, made him a hated target of the radical wing of the Revisionist party.

Returning in mid-June 1933 from a trip to Europe, Arlozoroff went out for a walk with his wife Sima along the Tel-Aviv beach on the evening of Friday, June 16. Two unknown persons approached them, asked for the time, and shone a flashlight on Arlozoroff. They then shot him twice and ran off. Arlozoroff was brought to Hadassah Hospital, where he died two hours later.

The Yishuv went into deep mourning. Many, especially in the Labor movement, were convinced that the act was politically motivated and accused the Revisionists of being behind it. On the same day as the murder, *Hazit Ha'am* ("The People's Front"), the radical Revisionist newspaper, published an article criticizing Arlozoroff's contacts with the Nazi regime and asserted that the Jewish people would know how to react.

The British arrested three Revisionist activists, Avraham Stavski, Abba Ahimeir, and Zvi Rosenblatt. The Yishuv was split between those who believed them to be guilty and those who were convinced that the murder was a case of mistaken identity or even part of an anti-Revisionist libel. A court case in 1934 failed to resolve the question of the identity of the murderers. A state commission of inquiry reopened the case fifty years later, in 1983, but it reached no conclusions either.

ON THE BRINK OF CIVIL WAR

The polarization between the Labor movement, led by the Histadrut ("Federation of Labor") and Mapai ("Palestine Labor Party"), and the Revisionists, led by Ze'ev Jabotinsky, intensified in the early 1930s. Each side verbally assaulted the other relentlessly. The maximalist wing of the Revisionists – Brit Habiryonim – aggressively castigated the Labor leadership in its newspaper Hazit Ha'am ("The People's Front"). The Labor camp responded by attempting to exclude Revisionist sympathizers from work projects, claiming that they were non-unionized, disturbing their gatherings, and harassing them by means of its membership,

Plugot Hapo'el ("Workers Units"). The Revisionists, for their part, broke strikes and called for the downfall of the Histadrut- and Mapai-led "red regime."

Tension between the two camps peaked after the Arlozoroff murder. Many members of Labor suspected the Revisionists of the murder, as the latter had sharply attacked Arlozoroff for his contacts with the Nazi regime on account of the transfer of Jewish assets from Germany to Palestine. Ben-Gurion declared, "We won't rest before the Zionist movement and the Yishuv are washed clean." Jabotinsky replied in the same coin. The Yishuv seemed close to civil war.

▽ Ze'ev Jabotinsky at the 18th Zionist Congress, 1933.

▷ David Ben-Gurion, a rising leader in 1933.

◁ The Arabs protest against the increase of Jewish immigration in the fall of 1933. Forbidden by the British to demonstrate, the Arabs take to the streets without a permit. The police open fire on them in Jaffa (shown). By November 5, 1933, 24 Arabs are killed and 204 are wounded in a series of violent protests.

Page 181: Arab-Jewish rapprochement in April 1933: Transjordanian sheikhs meet in Jerusalem with Yishuv leaders, including Dr. Hayim Weizmann (seated 4th from l.) and Dr. Hayim Arlozoroff (next to him).

△ The Yishuv celebrates the 60th birthday of its national poet, Hayim Nahman Bialik.

▷ Dozens of delegations, including children, visit Bialik to congratulate him in person. Shown, a drawing by Nahum Gutman who has illustrated several of the poet's books.

MEHHIR HA MENIYA
be Eretz-Yisrael
 le shana 75 gerush
 le hhatzi shana 40 gerush
mi hhutz le artzénu
 le shana 1.25 gerush
 le hhatzi shana 65 gerush
sarhhoq (Tel.) 278, Tel-Aviv

DEROR
(L I B E R T Y)
an illustrated hebrew weekly in latin characters

Kérekh I | (ha gillayon ba àretz 10 mil) | TEL-AVIV, Yomwaw, 11 Tevet 5694 (29 Dec. 1933) | (mi hhutz la àretz 90 mil) | Mispar 7

MEHHIR HA MODAOT
be âmmud rishon
 Kol inch qatann 8 gerush
bi shear Ammudim
 Kol inch qatann 5 gerush
LE MODAÒT SEKHATITOT HEHHZIR HAYUHHADIN

EYN ÂSHAN BE-LO ESH...
me-hékhan la âravim yediôtéhem âl ha „canton" ha îvri?

Sof-Sof Hhoref ba àretz
Yamm soêr, mattar tored be-kol maqom u pardessénu — nitzálu!

◁ Journalist Itamar Ben-Avi – son of lexicographer Eliezer Ben-Yehuda – creates a minor sensation with the publication of a Hebrew newspaper in Roman script. Following public fury, the newspaper soon closes down.

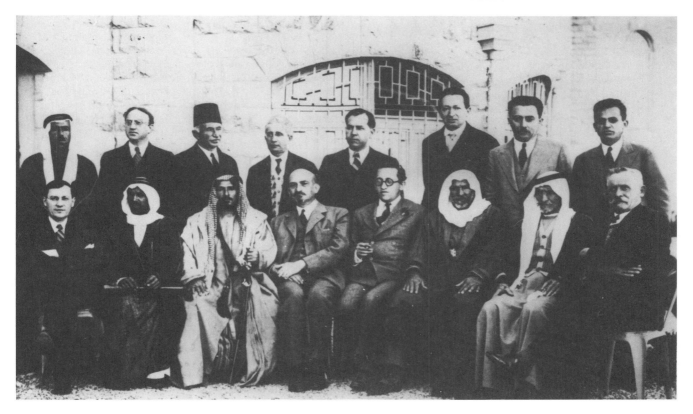

1934

January

1 The Revisionist movement begins its petition campaign. World Jewry is to appeal to Britain's leaders to permit free Jewish immigration to Palestine. The leadership of the Zionist movement opposes this direction of activity.

12 Tel-Aviv attains the official status of a city according to the new Municipal Corporations Ordinance. Although it has had a municipal council since 1921, until now it has formally been a part of Jaffa.

Violent incidents occur during the month between Betar Revisionist activists and Histadrut labor activists.

30-31 The Farmers' Union calls upon the workers to consider the farmers' position in the struggle over Hebrew work.

February

17 Dr. Hayim Weizmann, although no longer holding a post in the Zionist Organization, continues to represent the Zionist movement, meeting with Italian leader Mussolini in Rome.

19 The first Youth Aliyah group of Jewish youngsters

Massive flooding of Tiberias, May, 1934.

from Germany arrives at Haifa port, bound for an agricultural training program in Kibbutz Ein-Harod.

22 The large monument of a roaring lion by sculptor Avraham Melnikoff is unveiled in Tel-Hai.

27 Relations between the Revisionists and the Zionist movement deteriorate. Responding to a reduction in their share of immigration certificates to Palestine, the Betar executive instructs its membership to boycott the official Zionist bodies.

היום
ביום ה'
26
א פ ר י ל
בשעה 4 אחה"צ
הפתיחה החגיגית
של יריד המזרח
ע"י ה. מ. הנציב העליון
▼
הכניסה לפתיחה משעה 3 עד 4
▼
מוסיקה בקטע מנגן אלגני נ"ב ובקטע חירי

A poster announcing the opening of the 2nd Levant Fair.

March

Violent incidents between Betar and Histadrut members continue.

Confrontations also recur between workers and Jewish grove-owners who hire Arab workers, as the citrus harvest peaks. The grove-owners claim that there is a Jewish labor shortage. The Yishuv national bodies attempt to recruit high school and university students for this work.

13 The National Council tries to mediate in Left-Right labor disputes and between the workers and the grove-owners.

16 The Palestine All-Star soccer team participates for the first time in the world cup semifinals. It loses to Egypt in Cairo, 7:1.

25 (until April 5) The Zionist Executive convenes in Jerusalem for the first time.

April

3 The Ziv Institute opens in Rehovot. It will become part of the Weizmann Institute of Science in 1949.

4 Jewish workers organize lockout shifts in Kfar Saba to protest the hiring of Arab labor by Jewish farmers, creating a major incident. The British police intercede and arrest workers.

6 The Palestine All-Star team loses to Egypt again in a rematch in Tel-Aviv, 4:1.

9 The Histadrut Ha'ovdim Hale'umit ("National Labor Federation"), identified with the Revisionist movement, is founded in Jerusalem. It rejects socialism.

13 The police capture a well-known Arab bandit, Ahmed Hamad al-Mahmud, known as Abu Jilda.

23 The Arlozoroff murder trial opens. The accused are Avraham Stavski, Zvi Rosenblatt, and Abba Ahimeir. The trial further polarizes the Yishuv.

A new daily, *Hayarden* ("The Jordan"), is published by the Revisionist movement.

26 The second annual Levant Fair opens on the new fairground north of Tel-Aviv. Lasting six weeks, it features exhibitors from 30 countries.

May

1 The Palestine Potash Company builds a second plant in Sodom at the southern end of the Dead Sea. The plant at the northern end is linked to it by boat.

2 Tel-Aviv marks 25 years since its founding. Thousands of foreign guests and tourists throng its streets. Visiting dignitaries include President of the Zionist Organization Nahum Sokolov and the first High Commissioner Sir Herbert Samuel.

4 The Yishuv is disappointed and distressed by a quota of only 5,600 immigration permits for the forthcoming half year instead of the 20,000 permits requested by the Jewish Agency in light of the worsening situation for Jews in Europe.

14 A severe natural disaster occurs in Tiberias when freak cloudbursts cause flooding and rockfalls. Homes are swept into Lake Kinneret. Dozens of lives are lost and many persons are injured. Hundreds are left homeless.

16 The court acquits Abba Ahimeir of the murder of Arlozoroff for lack of evidence.

23 A general strike is announced in the Yishuv and rallies are held to protest the restriction of immigration.

In the course of the month, lockout shifts continue in Kfar Saba. Writers and artists like Shaul Tchernochowsky and Moshe Gluecksohn (editor of *Ha'aretz* – "The Land ") join the workers.

June

8 The Arlozoroff murder trial ends. Avraham Stavski is sentenced to death. Zvi Rosenblatt is acquitted. Stavski appeals.

20 The Kadoorie Agricultural School for Jewish boys opens at the foot of Mt. Tavor, funded by a Jewish philanthropist from Hong Kong. A parallel, larger school has been built by the same donor for Arab boys at Tul Karm.

26 Abu Jilda, the bandit, and an associate, Saleh al-Ermit, are sentenced to death.

July

4 Hayim Nahman Bialik, the poet, dies in Vienna while undergoing surgery. The Jewish world and the Yishuv are in deep mourning.

16 Bialik's funeral in Tel-Aviv is attended by tens of thousands of mourners.

20 The Court of Appeals in Jerusalem revokes the death

△ Jerusalem scene, 1934: a money changer advertises his services in Hebrew, Yiddish, and Arabic.

THE ARLOZOROFF MURDER TRIAL

In the wake of the murder of Hayim Arlozoroff in June 1933, the arrest of three Revisionist activists as suspects, and their trials in the spring and summer of 1934, two camps formed in the Yishuv, deeply divided one from the other: that which was convinced of the suspects' guilt, and that which rejected this possibility out of hand.

The suspects – Abba Ahimeir, Avraham Stavski and Zvi Rosenblatt – were detained, interrogated at length and tried in the Jerusalem district court in April 1934. After proceedings that lasted over a month, ending on June 8, Ahimeir was acquitted for lack of evidence, Rosenblatt was acquitted for lack of corroborating testimony to the main testimony, and Stavski was sentenced to death. While the Court considered him guilty, he was released because the judges did not wish to rely on the evidence of a single witness, the victim's wife Sima Arlozoroff.

The trial, Slavski's conviction and release, caused a continual storm in the Yishuv. Most of the Labor camp was convinced the Revisionists were involved in the murder. The centrist and right-wing parties opposed them, while Chief Rabbi Kook believed in Stavski's innocence.

The murder and trial left deep scars in the Yishuv that would be felt for a long time.

sentence handed down to Avraham Stavski on the grounds of insufficient testimony to corroborate that of the victim's wife, Sima Arlozoroff.

29-30 Ben-Gurion holds intensive talks with High Commissioner Wauchope in the Government House in Jerusalem on immigration, the proposed legislative council and the possibility of Jewish settlement in Transjordan.

31 The arrival of the Vellos, the first illegal immigrant ship, marks the start of organized Ha'apalah – the clandestine immigration of Jews without permits to Palestine. It carries 350 immigrants.

Thereafter, the Arabs post guards along the shore in shifts to detect such arrivals.

August

21 Abu Jilda and al-Ermit, the Arab bandits, are executed. The Arab community protests.

25 A second illegal ship, the Union, sponsored by the Revisionist movement, lands.

September

First Haganah countrywide communication exercise. Light signals are transmitted at night from Be'er Tuvia to Metula, passing through eight settlements. The transmission takes three and a half hours. After a series of exercises, the time is reduced to a quarter of an hour.

26 Elections for the Jerusalem municipal council are held. Although Jews constitute a majority of the population of the city, a Jewish candidate may not stand for election as mayor. The winning Arab candidate for mayor is Hussein al-Khalidi.

The Vellos arrives at the Palestine shore a second time. Only 50 immigrants are able to go on shore before the ship is forced to return to Europe.

The first long Haganah commanders training course takes place in Lower Gvat. It lasts ten weeks, from September through November.

October

16 The foundation stone ceremony for the Hadassah Hospital is held on Mt. Scopus, Jerusalem.

18 Friction between the Revisionists and the Histadrut increases. Plugot Hapo'el ("Worker Units") disrupt a Revisionist gathering in Haifa and fistfights ensue, resulting in dozens injured. The police intervene and arrest dozens of participants.

26 An agreement between Ben-Gurion and Jabotinsky is signed in London, aimed at ending the conflict between the Labor movement and the Zionist Organization on the one hand, and the Revisionist movement on the other. The Yishuv is taken by surprise.

Immigration continues rising monthly. Some 6,000 Jews arrive in Palestine in October alone.

November

2 Baron Edmond de Rothschild, the philanthropist known as the "Father of the Yishuv" and the "well-known benefactor," dies aged 89.

28 The Mandate government grants a concession for the Hulah Valley to the Palestine Land Development Company connected to the Jewish Agency. Thousands of dunams of land for Jewish agriculture are acquired.

December

9 The Mandatory post office allows the use of Hebrew characters in telegrams in the large Jewish settlements.

15 Following the Ben-Gurion-Jabotinsky agreement, the Zionist Executive and the Revisionist movement agree on restoring the original proportion of immigration permits to Revisionist control and on annulling the Revisionist boycott of the Zionist official bodies.

Immigration to Palestine breaks all previous records: some 45,000 newcomers arrive in 1934. Many are from Germany.

Tel-Aviv becomes the largest city in Palestine, with 100,000 residents.

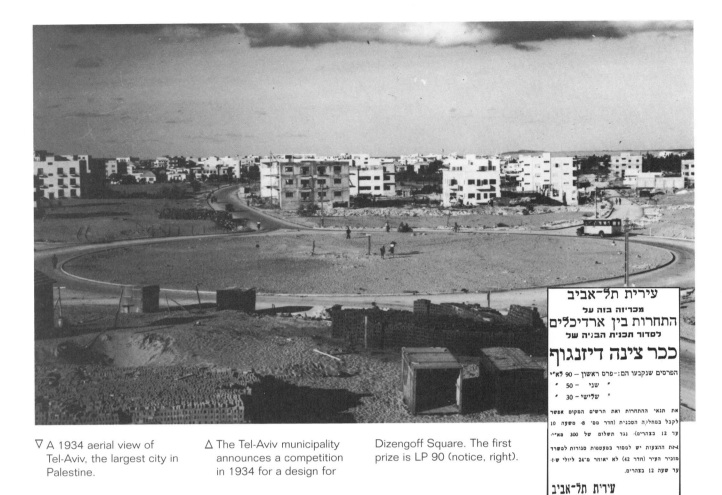

עירית תל־אביב
מכריזה בזה על
התחרות בין ארדיכלים
לסדור תכנית הבניה של
ככר צינה דיזנגוף
הפרסים שנקבעו הם: פרס ראשון — 90 לא״י
" שני — 50
" שלישי — 30

את תנאי ההתחרות ואת חרשים המקום אפשר
לקבל במחלקה הטכנית (חדר מס' 8. משעה 10
עד 12 בצהרים). נגד תשלום של 300 מא״י.
את ההצעות יש למסור במעטפות סגורות למזכיר
מזכיר העיר (חדר 42) לא יאוחר מ־24 ליולי ש.ז.
עד שעה 12 בצהרים.
עירית תל־אביב

▽ A 1934 aerial view of Tel-Aviv, the largest city in Palestine.

△ The Tel-Aviv municipality announces a competition in 1934 for a design for

Dizengoff Square. The first prize is LP 90 (notice, right).

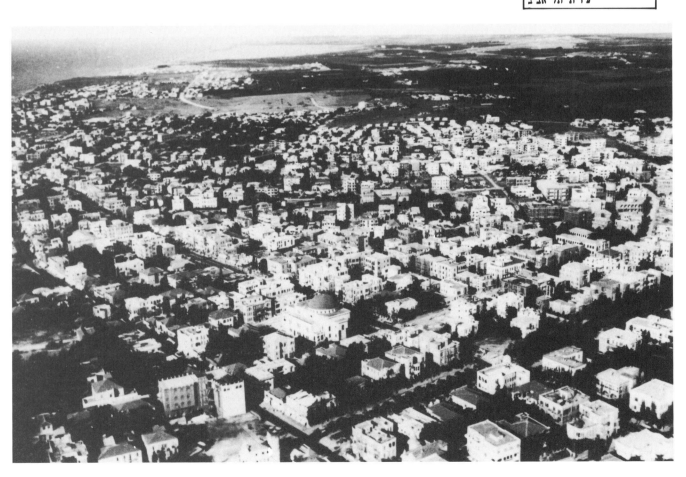

184

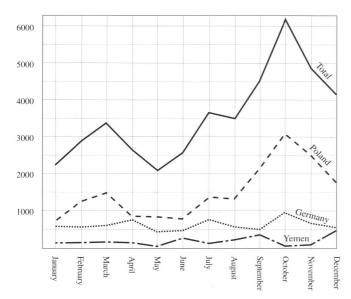

△ Immigration grows during 1934, with thousands arriving monthly. A record-breaking 6,000 immigrants arrive in October alone, most of them from Poland.

THE START OF ORGANIZED MARITIME CLANDESTINE IMMIGRATION

At the height of officially approved immigration to Palestine in the first half of the 1930s, new illegal immigration channels were devised in response to the growing pressure on Jews in Europe after the Nazi rise to power.

The Hehalutz ("Pioneer") movement in Poland – devoted to immigration and agricultural settlement in Palestine – was under particular pressure in mid-1934 from thousands of members anxious to immigrate with or without a permit. This prompted the Haganah leadership and the noted Labor leader Berl Katznelson, to approve a mission by Kibbutz Hame'uhad ("The United Kibbutz") volunteers to organize an illegal immigrant ship in Europe bound for Palestine. A Greek ship, the Vellos, was chartered, ostensibly for a "student trip." Loaded with 350 Hehalutz members who had arrived in Athens, the ship reached the Palestine shore after a few days' sailing and its passengers were brought ashore clandestinely by Haganah members.

A second sailing by the same ship, however, was unsuccessful, as British coastguard boats prevented it from nearing the shore. Only 50 (of 350) passengers managed to leave the ship before it was forced to return to Europe. In between these two voyages, another ship, the Union, sponsored by the Revisionist movement, landed as well.

The difficulties encountered during these early sailings, however, discouraged further such attempts until 1937.

△ In spite of the mass immigration, the Mandate goverment issues in May a relatively small number of immigration permits. Shown, a poster announcing the rallies held to protest this restriction.

▷ The monument of a roaring lion sculpted by Avraham Melnikoff is unveiled in Tel-Hai in the Upper Galilee, 14 years after the battle.

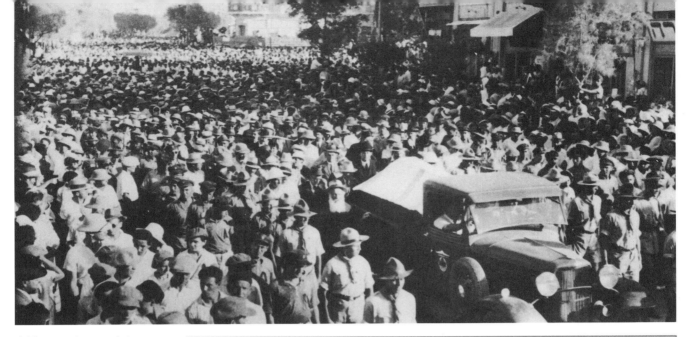

△ Thousands attend the funeral of Hayim Nahman Bialik, the poet, who dies during surgery in Vienna on July 3, 1934. The main streets of Tel-Aviv are blocked for hours. In the first row behind the hearse are D. Ben-Gurion and writer A.S. Rabinovitz. At right, a segment from one of the last pieces Bialik wrote.

Signs of the illness were revealed recently, first of all in the attitude toward our brothers who escaped the sword – the disaster in Germany and in other countries. Instead of looking after them, of preparing a shady corner for them, a roof above their heads, let it even be a hut, we exploited their tragedy for monetary gain… we raised our rents and took away their last pennies. The second sign of the illness is this contemptible speculation, which consumes us like fire… We take pride in our prosperity and expansion, [yet] a single dunam changes hands ten times, its price rising each time, and we think of this as growth and prosperity…

Hayim Nahman Bialik, 1934

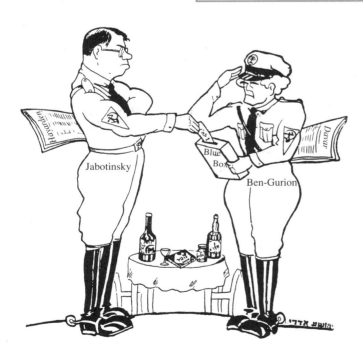

△ The surprise of the year is the Ben-Gurion-Jabotinsky agreement signed by the rival leaders in the fall of 1934. In this contemporary caricature the two leaders have exchanged notes (newspapers).

THE BEN-GURION-JABOTINSKY AGREEMENT

In October 1934, with contention between Revisionists and Histadrut ("Federation of Labor") supporters at fever pitch, a move was made that took the public by surprise: the heads of the rival movements, David Ben-Gurion and Ze'ev Jabotinsky, signed a conciliatory agreement.

Aided by mediation efforts of Pinhas Rutenberg, the two leaders met in London and hammered out an agreement on three points: (1) an end to the conflict between the movements; (2) a fair division of work places between the members of both movements and the avoidance of violence; and (3) the reintegration of the Revisionist movement in the Zionist Organization.

The agreement evoked intense reactions in both movements. Jabotinsky's personality and his status in his movement guaranteed the acceptance of the measure by the Revisionists. Opposition to it was widespread in the Labor camp, however, despite the support of Berl Katznelson and other veteran leaders, and despite intense efforts by Ben-Gurion to change this mood. The results of a referendum within the Histadrut membership in March 1935 were 15,000 opposed to the agreement and 10,000 in favor. The issue was therefore dropped from the agenda.

1935

January

11 Hakibbutz Hadati ("Religious Kibbutz") movement is founded by several religious agricultural training groups. Its first kibbutz, Tirat Zvi, will be established in 1937.

18 The composition of the municipal council in Jerusalem is announced: mayor – Dr. al-Khalidi (Muslim); and his two deputies – Daniel Auster (Jewish) and Ya'akub Faraj (Christian).

22 An oil pipeline from northern Iraq to Haifa is inaugurated.

February

12 A group of approximately 100 Jewish immigrants who arrived in the country without permits and were detained for months by the British start a hunger strike in Acre prison. An arrangement is eventually made allowing them to remain in the country.

The Bialik Institute, founded by the Jewish Agency, starts its publication activity.

23 The first talking movie made in Palestine, *This is the Land*, directed by Barukh Agadati, premieres in Tel-Aviv.

25 The ship Tel-Aviv, owned by Palestine Maritime Lloyd Ltd., inaugurates a Haifa-Trieste line.

March

13-16 A census of Mapai ("Palestine Labor Party") members is conducted. 10,217 members are counted.

21 An immigrant from Greece, Leon Recanati, opens the Discount Bank in Tel-Aviv, later to become one of the country's major banks.

24 A referendum conducted within the Histadrut ("Federation of Labor") membership rejects the Ben-Gurion-Jabotinsky agreement by a large majority – 15,227 to 10,187.

25 The Ashkenazi Chief Rabbi of Tel-Aviv, Rabbi Shlomo Aaronsohn, dies at age 73.

31 A new monthly immigration record is set in March with the arrival of 6,800 Jewish immigrants. With 277 tourists who received permits to stay, the number surpasses 7,000 newcomers.

April

2 The second Maccabiah competition opens in Tel-Aviv with participating athletes from 27 countries.

25-27 Immigrants from Germany form an association and hold their first conference, which deals largely with issues of integration into the country.

June

3 High Commissioner Wauchope announces a pardon of all prisoners convicted for the 1929 rioting. These include two Jews who received long sentences – Simha Hinkis and Yosef Urfali. The reason for the pardon is "the improvement in the general atmosphere and in the security situation".

20 A cornerstone ceremony is held for the Habimah theater in the presence of the High Commissioner.

July

11 Moshe Shertok, who succeeds Arlozoroff as head of the political department of the Jewish Agency in Jerusalem, meets with Emir Abdallah in Amman.

24 Elections are held in the Yishuv for the 19th Zionist Congress in Lucerne, Switzerland. Of the 90 delegates, 61 are from the Labor parties, 12 from the religious parties, 11 from the two General Zionists parties, and the rest are delegates from the small parties.

Unprecedented prosperity is recorded as a result of large-scale Jewish immigration and an uninterrupted inflow of capital.

August

10 (until September 3) The 19th Zionist Congress is held in Lucerne, Switzerland. The Revisionists do not participate. David Ben-Gurion is elected chairman of the Jewish Agency in Jerusalem. He forms a coalition with the General Zionists A and Mizrahi. Dr. Hayim Weizmann is elected president of the Zionist Organization after a four-year hiatus.

September

1 Ashkenazi Chief Rabbi of Palestine Avraham Itzhak Hacohen Kook dies aged 70.

A major banking crisis develops in Palestine during the first week of September as a result of panic withdrawals in expectation of a war between Italy and Ethiopia. Several small banks founder.

12 The Revisionist movement quits the Zionist Organization and in a conference in Vienna establishes the New Zionist Organization under the leadership of Ze'ev Jabotinsky.

October

3 Italy invades and conquers Ethiopia. The war has repercussions in North Africa and the Middle East, prompting a second run on the banks in Palestine.

18 Several barrels of cement addressed to Jewish destinations burst during unloading at Jaffa port and reveal concealed pistols and bullets. The British are unable to uncover the consignees – the Haganah.

26 The Arab sector declares a general strike in the wake of the discovery of the weapons at Jaffa port.

An economic crisis develops as a result of the run on the banks. Several Tel-Aviv contractors suffer reverses. Signs point to the end of the period of prosperity.

31 The Mandate government sets a limit to the entry of further physicians, due to the "surplus" of physicians amid the immigrants from Germany. The early announcement of the regulation incites about 500 physicians – most of them from Germany – to speed up their immigration.

November

3 The new Ashkenazi Chief Rabbi of Tel-Aviv is Rabbi Moshe Amiel.

6 The Sheikh al-Qassam band strikes again. Police Sergeant Moshe Rosenfeld is shot at Mt. Gilbo'a.

20 The British manage to rout the Sheikh al-Qassam band. The sheikh is killed in a shootout with the police near a village in the Jenin district. The Arab population declares him a martyr.

25 Arab representatives meet with the High Commissioner and present a series of demands: a halt to Jewish immigration, a ban on land sales to Jews, and the granting of self-rule to the Arab majority.

December

11 The Center for Domestic Produce is established with the participation of various economic and social bodies representing all elements of the Yishuv. It aims to protect Jewish products and improve productivity.

15 Elections to the Tel-Aviv municipal council result in 6 seats for the Labor faction and one seat each for the other nine parties and factions.

21 High Commissioner Wauchope announces his intention to form a legislative council of 28 members: 14 Arabs, 7 Jews, 5 British and 2 representatives of commercial interests. The Jewish community rejects the plan.

22 The Ohel Theater mounts a premiere, *The Brave Soldier Shweik*, by Yeruslav Hashek. The leading role is played by Meir Margalit. It is considered a major success.

Immigration in 1935 reaches a new peak – 65,000, the largest number during the entire period of the state in formation.

Ten new settlements are established in the course of the year. Among them Bet-Hashita, Gan Hayim, and Havazelet Hasharon.

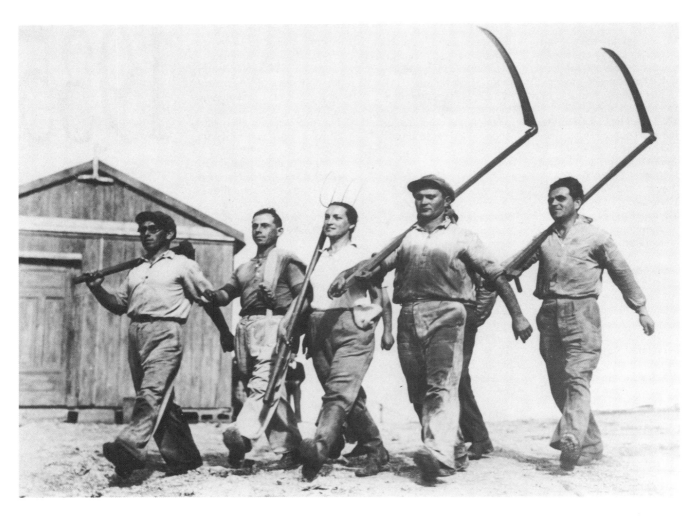

△ The most famous photo-
graph of the year, by Zoltan
Kluger, shows kibbutz
pioneers returning from
work with their farm tools.

▽ The end of the Ben-Gurion-
Jabotinsky agreement: A
Histadrut ("Federation of
Labor") referendum rejects
the agreement in early
1935, reflecting
widespread opposition to it
in the Labor camp, as illu-
strated in the caricature.

Hashomer Hatza'ir
Bama'aleh (magazine)

opposition to peace

Thus shall it be done
unto the man...

The Agreement

Jabotinsky

THE COMPLETION OF THE UPHEAVAL
IN THE ZIONIST LEADERSHIP

The far-reaching upheaval within the Zionist leadership
that began in 1933 ended during 1935.

The upheaval had three facets: 1. the election of Ben-
Gurion, leader of Mapai ("Palestine Labor Party"), as
the chairman of the Jewish Agency; 2. Weizmann's
position was on the decline, in spite of his reelection as
president of the Zionist Organization in 1935; 3. the
Zionist center of gravity passed from London to
Jerusalem.

This development was induced by the rise in power of
the Labor faction in the Yishuv and the Jewish world,
especially in Eastern Europe; the weakening of the Revi-
sionists under Jabotinsky, who failed in efforts to domi-
nate the Zionist Organization and left it to found the
New Zionist Organization; and the formation of a histo-
ric alliance between Mapai and the two religious Zionist
parties, Mizrahi and Hapo'el Hamizrahi, which was to
last until 1977.

From 1935 until the establishment of the State of
Israel in 1948 and thereafter, the same group of leaders,
with only a few newcomers, were to play the central
roles. The most prominent were David Ben-Gurion,
Hayim Weizmann, Moshe Shertok and Eliezer Kaplan.

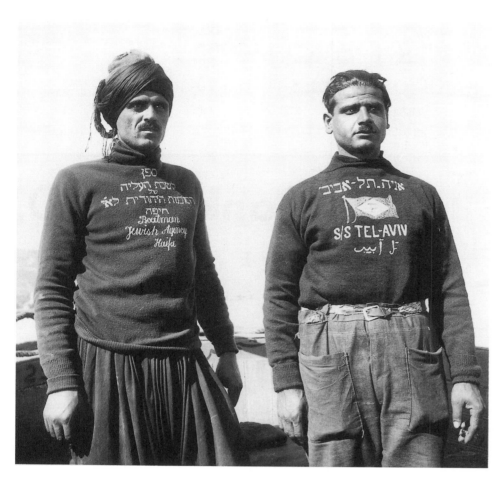

◁ Immigration reaches a new peak in 1935: an average of over 5,000 newcomers arrive monthly. Arab stevedores unload the immigrant ships.

▽ The economic situation improves from month to month, but the gap between imports and exports is unfavorable, as shown in the table.

PROSPERITY

Prosperity was the key word in Palestine during 1933-35. The Yishuv expanded month by month as a result of unprecedented immigration and the inflow of large amounts of capital. Jewish capital imports for 1935 amounted to LP 10 million. By way of comparison, Mandate government revenues that year were only LP 5.4 million.

Capital was heavily invested in construction in Tel-Aviv, which grew from a small town almost to a metropolis and became the country's largest city. Investment was also channeled into the agricultural sector, especially citriculture, as well as industry, the service sector, and banking. Agricultural settlement, too, proliferated impressively, expanding from 107 settlements at the end of 1931 to 159 at the end of 1935 – an increase of 50%.

People were dazed. The director of the Kupat-Am bank reported in its general meeting: "The flow of money is too powerful... the pace is most unusual..."

In the same spirit, the poet Natan Alterman wrote a song called *Prosperity*, for the Hamatateh ("Broom") theater: "Prosperity, prosperity, sellerity, traderity, / the joyous people make a din, / the orchards are making profits, the money flies into our pockets, we're raking it in ... / the people cry "Oh Veh", things are going our way..."

All the inhabitants of the country – Jewish, Arab, and British – were wondering: until when?

The Balance of Trade, 1935

Imports into Palestine (= 100) are shown on the left-hand scale while the percentage value of corresponding exports is indicated on the right-hand scale

הבנק הלאומי הארץ-ישראלי בע"מ.

THE NATIONAL BANK OF PALESTINE LTD.

תלפון 909. ת. ד. 272 תל-אביב משרד ראשי: רח' הרצל 17

כל עסקי בנק בתנאים נוחים. קשרים ברוב מרכזי תבל.

BANK ASHRAI

COOPERATIVE SOCIETY

TEL-AVIV

בנק אזרחים בע"מ

CITIZENS' ¡BANK LTD,

תל-אביב, רח' יפו – תל-אביב 18-20

טלפון 737 ת. ד. 504

מנהל כל עסקי בנק
בתנאים נוחים

Bank P, K, O,

T E L - A V I V

בנק נורוק – אידלזק בע"ג

BANK NUROCK – IDELSACK LTD

תל-אביב / רחוב הרצל 13 / טלפון 662 / ת. ד. 937

Tel-Aviv 13, Herzl street Telephone 662 P. O. B. 937

עוסק בכל עסקי בנק בתנאים נוחים
קנית שכר-דירה ואבנסים לשכר-דירה
מחלקה להנהלת בתים

All kinds of Banking Transactions
Department of House Management
and advances on Rent

THE BANK CRISIS

Early in September 1935, at the height of the wave of prosperity, an unexpected banking crisis developed in Palestine.

Warnings by Italy in the summer that it would invade Ethiopia caused general tension internationally and particularly in the eastern Mediterranean region. Fears mounted in Syria and Lebanon of an impending war there and of the possibility that it could lead to a world war. Panic spread from there to northern Palestine and finally to the country's economic center, Tel-Aviv.

During the first week in September, thousands of depositors caused a run on the banks by withdrawing their money. No central bank existed then, nor did the British administration intervene in the opening of banking institutions. Over 50 banks operated in Tel-Aviv alone, some of them small and insubstantial.

The Ashrai Bank, a private institute, which only the

Anglo-Palestine Bank surpassed in size, suffered most. It was known for its large, at times rashly undertaken enterprises, especially in the domain of property. Its clients swarmed and withdrew their money, as clients were doing in other, smaller banks. The panic went on for days. The Mandate government did not interfere, but it transferred large amounts of cash into the country. Gradually, the run slowed down.

A month later, with the actual invasion of Ethiopia by Italy, a second, smaller run on the banks took place.

Although the episode passed and most of the banks survived, the crisis constituted a warning, illuminating the overabundance of banking institutions in the Yishuv and insufficient supervision. Among the banks that were unable to recover was the Ashrai Bank (Credit Bank), which closed several years later.

▷ The Arabs, concerned about Jewish immigration to Palestine, hold demonstrations and rallies. Shown, a rally in front of the Dome of the Rock.

▽ In November 1935 the British rout the anti-Jewish terrorist band and its leader, Sheikh Izz al-Din al-Qassam.

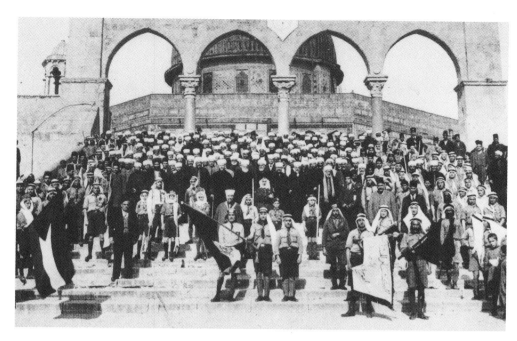

▷ A 60-km long water pipeline from Ras al-Ein (later Rosh Ha'ayin) to Jerusalem marks the end of perennial water shortages in the capital city, reflected in this typical scene.

▽ Large parts of the country are in a state of desolation in the mid-1930s. Shown, the Gulf of Eilat shore.

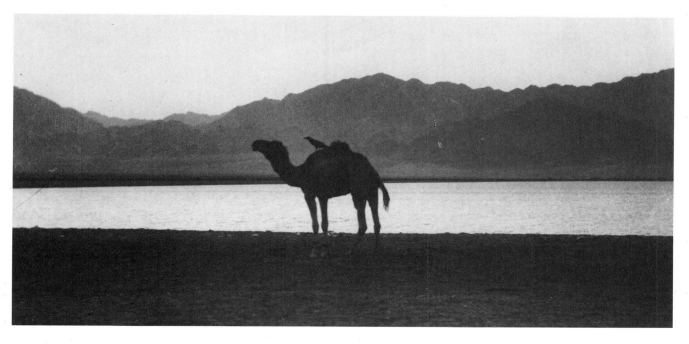

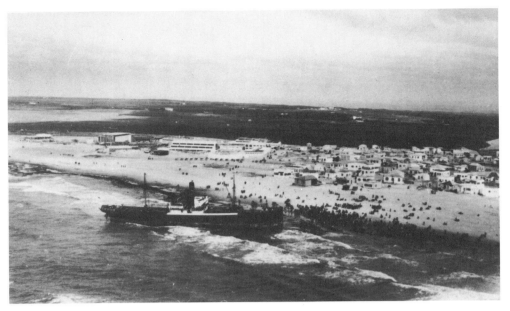

◁ A freighter that runs aground off the shore of Tel-Aviv in early 1935 draws hundreds of the city's residents, who loot its cargo of apples. The poet Natan Alterman writes about the episode in the daily Ha'aretz: "To New Zealand I haven't been, / Nor Korea have I seen, / No Tahitian maiden has bewitched me, / Nor her parents for dinner cooked me…" He also notes that he has never seen "Wild men loot a ship that run aground… / But don't despair, hope abounds, / The gale took me to the seashore too / and there I had a perfect view…"

▷ Ashkenazi Chief Rabbi Avraham Itzhak Hacohen Kook dies on September 1, 1935.

▽ Widespread flooding occurs in the winter of 1935. The Yiddish paper *Radio* (l.) published in Warsaw, reports on "a major disaster in Eretz Israel." One of the flooded areas is the southern Jordan Valley.

January

2 Rabbi Zvi Pessah Frank is elected as Ashkenazi Chief Rabbi by the rabbis of Jerusalem. The National Council makes his office conditional on his joining "the Jewish Community" (the governing body of the Yishuv). Rabbi Frank refuses.

February

4 The Arabs of Palestine declare a general strike in support of the struggle of the Syrians against French rule. A general strike has been ongoing in Syria since the beginning of the year.

March

10 A Jewish bus passenger is shot and killed in the Tul Karm area.

12 Schools sponsored by the Labor movement are approved as part of the Jewish Community school system.

30 The Mandate Palestine Broadcasting Service begins operations. Broadcasts are in three languages – English, Arabic and Hebrew. The name of the station in Hebrew is Kol Yerushalaim ("Voice of Jerusalem"), chosen after the Arabs had opposed "Eretz Israel", and the Jews refused to shorten it to "E.I.".

April

3 The British government invites a delegation of Palestinian Arabs to discuss plans for the legislative council. The Arabs accept the invitation but the talks are not held because of the outbreak of the riots (see below).

15 Another incident takes place near Tul Karm when armed Arabs stop Jewish cars and shoot passengers, killing one and wounding two. One of the wounded dies five days later.

16 Members of Irgun Bet (the National Defense) kill two Arabs near Petah Tikva.

17 The funeral of Israel Hazan, killed at Tul Karm, turns into a major demonstration in Tel-Aviv.

19 The outbreak of rioting that will continue for three years – the Arab Revolt – begins. Nine Jews are killed in Jaffa.

20 The second day of rioting in Jaffa ends with seven more Jews killed. Thousands of Jewish residents flee Jaffa and the neighborhoods bordering Jaffa-Tel-Aviv.

The Arabs declare a general strike until their demands are met: a halt to Jewish immigration and land sales to Jews, and the transfer of government to Arab control.

23 The rioting spreads. Trees in Jewish groves in the Jezreel Valley are cut down. Kibbutz Ramat Hakovesh in the Sharon region is attacked. Buses to and from Jerusalem form convoys.

25 An Arab inter-party congress in Nablus establishes a senior representative body, the Arab Higher Committee, headed by Grand Mufti of Jerusalem Haj Amin al-Husseini.

Fires are set throughout the country.

26 The Jewish economic and financial community demands that the government open a port in Tel-Aviv in light of the shutdown of Jaffa port by its Arab workers and stevedores.

29 Arabs attack Jewish-driven cars near Jenin.

30 The Levant Fair opens in Tel-Aviv despite the disturbances. Exhibitors from 16 countries participate.

The Arab Higher Committee announces to the High Commissioner that the halt of Jewish immigration will end the Arab general strike.

May

Rioting and bloodshed occur daily in the form of attacks along roads, ambushes, fields set on fire, and orchards and groves cut down.

An unofficial attempt is made by a Jewish "Group of Five" to calm the atmosphere. Dr. Yehuda L. Magnes, Pinhas Rutenberg, Moshe Novomeysky, Moshe Smilansky and Gad Frumkin attempt, unsuccessfully, to mediate between Jews and Arabs.

11 The British rush reinforcements to Palestine from Malta and Egypt. The High Commissioner announces on the radio that the government will suppress any outburst and punish the perpetrators.

13 Arabs kill two Jews in the Old City of Jerusalem.

16 A bomb thrown by Arabs kills three Jews as they leave the Edison cinema in Jerusalem.

18 The British government announces the appointment of a Royal Commission of Inquiry into the causes of the riots in Palestine. The commission, however, will not begin its work until the disturbances and the Arab general strike have ended.

19 The Tel-Aviv port is opened following the acceptance by the Mandate government of the Yishuv's demands for it in light of damage incurred by the shutdown of Jaffa port by its Arab staff.

25 The Jewish Auxiliary Police units are established – with British permission – to guard Jewish settlements and rural roads. Thousands of Jews are recruited. The units become a legal arm of the Haganah.

June

2 Commenting on the rioting, David Ben-Gurion, at a conference of British Zionists, declares: "A people that has been tested by blood and terror for thousands of years is not afraid."

7 A convoy of Egged buses is attacked on its way to Jerusalem.

8 A newly created Haganah mobile unit, Hanodedet ("The Wanderer"), carries out its first counter-terrorist operation in the Judean hills. It is led by Itzhak Landoberg (later Sadeh) and Eliyahu Cohen (later Ben-Hur). Other Nodedot operate in the Jezreel and Jordan Valleys.

Jewish settlements in the Jezreel Valley are attacked.

12 Arabs attack a British officer in Jerusalem.

13 The Mandate government decrees new emergency regulations: death sentence or life sentence for those who open fire on Mandate security officials.

15 The High Commissioner, attempting to pacify the Arabs, proposes holding talks on the future of relations between the various communities in Palestine and the British administration.

17 The National Council embarks on an aid campaign for the 10,000 Jewish refugees in the Yishuv, who were forced to flee their homes in Arab or mixed Arab-Jewish towns.

26 The High Commissioner's proposal is rejected by the Arabs, who insist on the fulfillment of all their demands.

July

Arab attacks continue during the entire month. Hundreds of incidents occur.

The Center for Domestic

Dr. Hayim Weizmann and Arturo Toscanini in Tel-Aviv, December, 1936.

1936

VISIT PALESTINE

△ The Mandate government seeks tourism at the start of 1936.

▽ The Egged company promotes tourism, too.

TOURIST IN PALESTINE HUNDRED YEARS AGO

TODAY TRAVELLING WITH

EGGED

Produce uses the Arab strike to introduce the products of the Yishuv to the local market.

21 The composition of the Royal Commission of Inquiry regarding the riots in Palestine is announced in London. It will have six members and will be led by Earl Peel.

27 The Arabs mark the hundredth day for the general strike.

British forces kill six Arabs in a battle near Nablus, with one British fatality.

August

Arab-inflicted British casualties mount.

13 A brutal incident in Safed involves the murder by Arabs of a Jewish father and his three children.

21 Fauzi al-Kaukji, an army officer of Iraqi origin, arrives in Palestine to organize the Arab forces operating against the Yishuv.

Thirty Jews are murdered on the roads, in settlements and in the mixed-population cities during the month of August.

September

7 Following months of debate and hesitation, the British decide to suppress the Arab Revolt in Palestine resolutely. Large-scale military reinforcements stream into the country.

24-29 A British attack on Arab bands in the Samarian mountains ends in success, but Kaukji slips away into Transjordan.

29 Mayor of Tel-Aviv Meir Dizengoff dies at age 75. Deputy Mayor Israel Rokakh succeeds him on October 30.

30 High Commissioner Wauchope announces a state of emergency.

October

10 The kings of the Arab states call upon the Arab Higher Committee in Palestine to end the Arab general strike.

12 The Arab strike ends after nearly six months.

31 Due to the cessation of Arab hostilities following the end of the Arab general strike, the Nodedet ("Wanderer") terminates its activities in the Judean hills.

November

7 The Peel Commission is on its way to Palestine. The Arab Higher Committee announces that it will not cooperate with it since the British have not halted Jewish immigration.

11 The Peel Commission arrives in Palestine.

12 The commission begins its hearings, which will continue until mid-January 1937.

25 Dr. Hayim Weizmann, president of the Zionist Organization, is the first witness from the Jewish side to appaer before the peel Commission. The Arabs boycott the commission.

December

1 Two chief rabbis are elected following prolonged delay: Rabbi Itzhak Halevi Herzog (Ashkenazi Chief Rabbi) replaces the late Rabbi Kook, and Rishon Lezion Rabbi Ya'akov Meir (Sephardi Chief Rabbi) is reelected.

10 Kibbutz Tel-Amal is established in the Bet-She'an Valley by a new method – the stockade-and-watchtower plan.

26 Despite the state of emergency, the muses continue to inspire: The Palestine Symphony Orchestra, established at the initiative of violinist Bronislaw Huberman, plays its first concert in Tel-Aviv. Conducting is Arturo Toscanini.

Immigration in 1936 slows in comparison with previous years. Less than 30,000 Jewish newcomers arrive. For the first time, the British do not restrict immigration during periods of tension, but they tighten overall quotas.

An international airport east of Lydda begins operations.

The Yishuv establishes an aerial branch, the Aviron ("Airplane") company, financed by the Jewish Agency and the Histadrut ("Federation of Labor").

CAUSES FOR THE OUTBREAK OF THE RIOTS (THE ARAB REVOLT) IN 1936

The Arabs of Palestine watched the rapid growth of the Yishuv during the first half of the 1930s with dismay and fear. Within four years, the Jewish population nearly doubled in size, growing to almost half the size of the Arab population. The threat, in their view, was not only a demographic one, but economic and political. They realized that within a number of years, intensified Jewish immigration would in fact turn Palestine into "a Jewish national home."

Side by side with this development, Nazi Germany and Fascist Italy, adopting aggressive foreign policies, supported the Arabs and encouraged them to rebel against Great Britain, the dominant power in the Middle East. The weakness shown by Britain and France (which held the mandate for Syria) during the Ethiopian crisis of 1935, and their timid response to Hitler's aggression in Europe, further encouraged the Arabs of Palestine.

The prolonged general strike against French rule in Syria, too, pointed the way for the Palestinian Arabs.

These elements combined to propel the Arabs in Palestine to mount a revolt in the spring of 1936, which was to last until 1939.

△ Fauzi Kaukji, a former Iraqi officer, reaches Palestine with 200 Iraqi, Syrian, and Druze volunteers. He entrenches himself in Samaria and becomes known as the supreme commander of the Arab Revolt.

△ The British have only a small force in Palestine at the start of the riots. It includes Scottish soldiers armed with clubs.

▽ Upon the outbreak of the Arab Revolt, the Arabs of Palestine establish a militant body, the Arab Higher Committee, headed by the Grand Mufti of Jerusalem, Haj Amin al-Husseini (1st row, 2nd from left.).

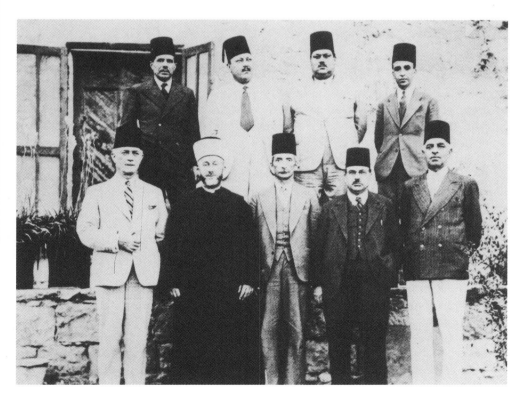

No! Our blood will not be spilled cheaply!
Blood is holy,
Human life is holy,
Even so, we will sanctify and give up our lives,
And every ambusher behind every wall will know
That our blood will not be spilled cheaply!

David Shim'onovitz (Shim'oni) on the day of the outbreak
of the rioting, 1936

▷ Specially fitted brooms are devised to reduce the damage from nails scattered on roads by Arabs.

▽ Following the outbreak of the riots, the British agree to establish Jewish auxiliary police units ("ghaffirs") to guard the settlements and rural roads.

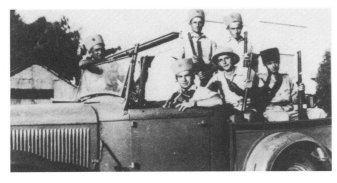

△ The Yishuv organizes accordingly following the initial shock of the Arab terror. Despite the danger, agricultural work does not stop and farmers go out to the fields armed. The tractor driver in the picture anticipates the words of a song, written years later: "No deep plow (is made) without a weapon."

THE RIOTS OF 1936: THE FIRST STAGE

The Arab Revolt broke out on April 19, 1936, with attacks on Jews in Jaffa, spreading within a few days to all parts of the country. In parallel, the Arabs declared an open-ended general strike.

An emergency conference in Nablus called by the Arabs on April 25th established the Arab Higher Committee, headed by Haj Amin al-Husseini. The committee put forward three basic demands: a total halt to Jewish immigration, a ban on the sale of land to Jews, and the establishment of a national Arab government. The Arabs hoped to weaken the Yishuv by blocking food supplies and paralyzing the economy, but the effect of the strike was other. The Jewish economy reorganized rapidly and devised alternatives that contributed to empowerment and independence. Work on a port in Tel-Aviv was begun on May 19 to replace Jaffa port, which the Arabs had shut down.

In the Yishkuv, the toll of the first six months of rioting was 91 dead and 369 wounded, in addition to vast damage to property.

In response, the Jews organized self-defense based on the principle of restraint laid down by the Jewish national bodies, namely retaliation against the perpetrators of terror but not against the Arab community per se. Haganah policy was at first limited to static defense of the settlements. However, during the summer of 1936, a more aggressive strategy of attacking the raiders in their bases and villages was adopted. Nodedot – mobile attack units – were formed throughout the country, the best known operating in the Jerusalem area under the command of Itzhak Sadeh and Eliyahu Ben-Hur.

The British response was hesitant at first. Later, however, large military forces were brought in and aid was given to the Jews to establish the Jewish Auxiliary Police. Following the mediation of Arab kings, the general strike was ended on October 12, 1936. Only then did the Peel Commission start its inquiry work in Palestine.

THE JEWISH REFUGEES IN PALESTINE

The Arab Revolt is mainly remembered for the brutal attacks on the Jewish population and the burning of farmland. Yet it also engendered a grave problem of Jewish homelessness.

In the first weeks, some 10,000 Jews living in mixed Arab-Jewish cities and towns were forced to abandon their homes, mainly in Jaffa, Jerusalem, and Haifa but also in Hebron, Bet-She'an, Nablus, Acre, and elsewhere. Most of the evacuees were cared for by Jewish communal services such as the Tel-Aviv municipality, the Jewish Community Council in Jerusalem, and the social services department of the National Council. The Mandate government bore half the immediate costs.

Solving the problem, however, was costlier than these bodies could handle, and in mid-June 1936 the National Council appealed to the public to contribute to the rehabilitation of the refugees. The aid project set out to collect LP 100,000 but, due to the difficult economic situation, which began in Palestine in mid 1936, only half the amount was collected.

Monies that were collected served to house the evacuees in 85 temporary camps set up throughout the country, and thereafter in permanent relocation. Nearly all the refugees were rehoused by November, 1936.

△ Despite the riots, construction is completed on the new airport near Lydda, today Ben-Gurion International Airport.

△ Jewish refugees (1): Evacuating the Old City of Jerusalem.

▽ Jewish refugees (2): Household possessions of evacuees from Jaffa.

THE START OF THE STOCKADE-AND-WATCHTOWER PLAN

Jewish settlement activity came to a halt during the first months of the Arab Revolt as a result of the widespread attacks, the state of emergency, and the burning of farmland. The risk to settlers precluded the establishment of new farming communities, with a few exceptions in relatively safe areas.

However, toward the end of 1936, the members of a Hashomer Hatza'ir ("The Young Watchman") kibbutz trainee group at Bet-Alfa who had been allocated land for settlement at Tel-Amal in the nearby Bet-She'an Valley decided to implement their goal without further delay. A team of kibbutz members, headed by Shlomo Grazovski (later, Gur) devised a detailed plan for a fortified wooden camp of just over a dunam (1/4 acre) in size that could be erected in a single day. The plan was for four sheds, a watchtower, a peripheral double wall filled with gravel, and an outer barbed wire fence to prevent grenade throwing.

The group then prepared all of the wooden components to exact specifications, broken down and marked for rapid assembly. Still, to realize their plan, they needed the permission of the leadership of the Yishuv and of the Haganah command. It was given, not without hesitation, as many feared that the new settlement would be attacked on its first day, when it was still defenceless.

On December 10, 1936, the Tel-Amal trainee group set out from Bet-Alfa accompanied by Jewish Auxiliary Police and members of surrounding settlements, bringing with them all the components of the camp and the equipment necessary to construct and defend it. By evening, the job was done and the camp was built. The Arabs, taken by surprise, did not attack it, either then or thereafter.

A new settlement method had been inaugurated – the stockade-and-watchtower plan.

▷ The first stockade-and-watchtower settlement: Kibbutz Tel-Amal in the Bet-She'an Valley, later re-named Kibbutz Nir David.

▽ Guard duty at the Tel-Amal fence.

▷ The new port of Tel-Aviv opens in May 1936, prompted by the shutdown of Jaffa port by its Arab staff as part of the Arab general strike.

198

1937

January

5 The second stockade-and-watchtower settlement is established – Hasadeh (later Sdeh Nahum) in the Bet-She'an Valley.

7-8 David Ben-Gurion and Dr. Hayim Weizmann appear before the Peel Commission.

12 The first Arab testimony is given to the Peel Commission following a decision by the Arabs to revoke their boycott of the commission.

18 The Peel Commission concludes its work in Palestine.

22 Arabs attempt to kill Haifa Mayor Hassan Shukri, the only Arab mayor who did not join the Arab general strike.

February

11 Ze'ev Jabotinsky, banned by the British from entering Palestine, appears before the Peel Commission in London.

15 The water company Mekorot, is established by the Jewish Agency, Keren Hayesod, the Jewish National Fund, and the Histadrut ("Federation of Labor"). The first water pipeline is extended from the foot of the Carmel to the western Jezreel Valley.

23 Another kibbutz is founded by the stockade-and-watchtower method – Ginosar.

26 Dr. Yosef Lahrs, a physician and the only Jew in the town of Bet-She'an, is murdered. He had left there on orders of the British but had returned at the request of the Arab residents.

March

Numerous incidents of the murder and wounding of Jews occur during the month despite a cease-fire announced by the Arabs.

2 In a census of Jewish workers, more than 100,000 are counted, four times as many as in 1930.

21 Two more settlements are established on the same day by the stockade-and-watchtower method – Massada and Sha'ar Hagolan.

25 The Histadrut ("Federation of Labor") publishes an Arabic weekly titled *Hakikat al-Amr* ("The Truth of the Matter").

Petah Tikva, until now a local council, is granted municipal status.

April

9 The first moshav is established on the stockade-and-watchtower plan – Bet-Yosef in the Bet-She'an Valley.

13 The Af-Al-Pi ("In Spite Of") Revisionist illegal operation is launched with the arrival at the Palestine shore of a boat with 15 illegal immigrants. Since then, the Revisionist illegal immigration is called the Af-Al-Pi Immigration.

26 The Irgun Bet (National Defense) splits. Approximately half its members, led by Avraham Tehomi, return to the mainstream Haganah, and the rest form the Etzel – an acronym for Irgun Zva'i Le'umi (National Military Organization).

May

20 Immigrants from Germany establish a new settlement – Kfar Shmaryahu.

June

13 An Arab attempt upon the life of police Inspector General Roy G. Spicer fails.

29 Etzel holds a large parade in Tel-Aviv.

30 The first religious kibbutz is established – Tirat Zvi, in the Bet-She'an Valley. It, too, is based on the stockade-and-watchtower model.

July

4-6 On the eve of the publication of the report of the Peel Commission, a wave of settlement takes place in order to attain "a good partition." Four new settlements are established in three days on the stockade-and-watch-tower pattern: Moledet (on the 4th), Ein-Hashofet (on the 5th) and Ma'oz Hayim and Ein-Gev (on the 6th).

7 The Peel Commission publishes its report (see next page).

Elections in the Yishuv for the 20th Zionist Congress, which will be held in Zurich in August, result in 85 seats for the Labor (Mapai and Hashomer Hatza'ir) parties

(68%), 20 for Mizrahi and Hapo'el Hami-zrahi, and 18 for the three General Zionist factions.

August

3 The 20th Zionist Congress opens in Zurich. The central issue is the partition plan proposed by the Peel Commission and the establishment of a Jewish state in a small part of Palestine, which evokes stormy debate.

29-30 Violence resumes after several months of uneasy calm. Arabs attack Jews in the north, and the Jews retaliate.

September

26 Arab attackers murder the British District Commissioner of the Galilee, Lewis Andrews, as he emerges from prayer in a church in Nazareth.

30 A new road is opened between Tel-Aviv and Haifa, passing through Hadera. Till then, vehicles had to drive through the Shomron and the Jezreel Valley.

October

The government responds harshly to the Arab renewal

1 violence. It disbands the Arab Higher Committee and the other national bodies, deposes the Grand Mufti, Haj Amin al-Husseini, and exiles a group of Arab leaders to the Seychelles Islands in the Indian Ocean. The Mufti disappears, later revealed to have been hidden in the al-Aqsa mosque.

14 Haj Amin al-Husseini slips out of the country dressed as a woman and escapes to Beirut.

The Arab Revolt is relaunched intensively. Targets of attack are the Jews and the British.

24 The Mandate government announces the appointment of Sir Charles Tigart as responsible for the elimination of terrorism in Palestine.

November

9 Five Jewish workers are murdered in an ambush near Kibbutz Kiryat Anavim in the Jerusalem hills. A kibbutz will be founded there in their memory in 1938 –

Ma'aleh Hahamisha ("Hill of the Five").

The British announce the establishment of military courts with the authority to hand down the death sentence for illegal possession of arms.

14 Black Sunday: Etzel attacks Arabs in Jerusalem and Haifa. Withhin the Yishuv, the question of offensive or defensive behaviour is strongly debated. From now on, Etzel openly espouses ending the Haganah policy of restraint. The Yishuv leadership, however, calls for an eschewal of acts of vengeance.

22 Sheikh al-Sa'di, aide to Sheikh al-Qassam, is executed by hanging.

December

Arab terrorism intensifies in Jerusalem.

23-25 The British army suppresses Arab bands in the Galilee.

27 The Haganah decides to establish the Field Companies under the command of Itzhak Landoberg (later, Sadeh, "Field").

31 Since the renewal of Arab attacks in the fall, 19 Jews have been killed.

Immigration during 1937 is at its lowest since 1931: 10,629.

The Yishuv sinks into an economic crisis. Thousands of Jews are unemployed.

During the course of the year, 16 new settlements are established, 13 on the stockade-and-watchtower plan.

THE PEEL COMMISSION RECOMMENDATIONS

Spending over two months in Palestine, beginning November 11, 1936, the Peel Commission toured the country and met with senior British officials and leaders of the Jewish and the Arab communities – the last only toward the end of its stay when the Arab leadership decided to revoke their boycott of the commission.

The commission report, published on July 7, 1937, proposed defusing the growing tension between the two peoples by means of partition. The Jews would be allocated the Galilee, the northern valleys and the coastal plain until Be'er Tuvia. The Arabs would acquire the mountain regions in the center of the country and the Negev, and would eventually be annexed to Transjordan. The British, according to the proposal, would continue controlling Jerusalem and its environs as well as a "corridor" from Jaffa to Jerusalem, which would bisect the Jewish state. The mixed Jewish and Arab cities would have a special status.

The Jewish state was to be allocated a total of 6,000 square kilometers. – less than a quarter of the area of Palestine. Reactions in the Jewish community were divided. Many rejected the additional severing of territory intended (by the Balfour Declaration) to be Jewish and opposed the notion of so tiny a Jewish state out of hand. Others, including the Yishuv and Zionist movement leadership – Weizmann, Ben-Gurion, and Shertok – highlighted the opportunities rather than the drawbacks inherent in the plan. It was the first time that the Jews were offered a state of their own, no matter how tiny it was.

Jewish debate not withstanding, the Arabs unanimously rejected the proposal and at the end of the summer of 1937 resumed armed confrontation.

Map legend:
- Jewish state
- Arab state
- British "corridor"
- —·—· International boundary

△ The partition plan according to the Peel Commission proposal, July 1937. The tiny Jewish state is to be bisected in its south by a "corridor" from Jaffa to Jerusalem under British control. The Arab state is to be annexed to Transjordan, under the rule of Emir Abdallah.

▷ Aerial view of the stockade-and-watchtower settlement plan, here Moshav Bet-Yosef in the Bet-She'an Valley. Thirteen such settlements are founded in 1937.

200

△ Relations between the
stockade-and-watchtower
settlers and their Arab
neighbors are not always
strained, as shown in this
photograph taken at Ein-Gev,
July 1937.

THE CEASE-FIRE YEAR

An uneasy cease-fire prevailed in Palestine for nearly a
year, from October 1936 to September 1937. Arab ter-
ror, which had erupted in April 1936, diminished, al-
though it did not cease, surfacing sporadically in attacks
against the Jews, the British, and even Arab rivals.

All sides awaited the findings of the Peel Commission
with relative restraint for some eight months. With the
publication of the report on July 7, 1937, however, Arab
unrest was resumed and violence intensified during the
autumn. The murder of Galilee District Commissioner
Lewis Andrews on September 26, 1937, marked the end
of the cease-fire and the full resumption of hostilities.

The Yishuv used the cease-fire period to reinforce
itself. The Jewish Auxiliary Police was expanded, new
settlements, based on the stockade-and-tower plan, were
established, and the foundations were set for a country-
wide combat force: the Field Companies.

▷ The British combine
defense with search
measures in an effort to
prevent raids. With typical
British neutrality, both Arabs
and Jews are searched.

THE PARTITION CONGRESS

The 20th Zionist Congress, held in Zurich from August 3-16, 1937, addressed itself to the Peel Commission proposals, which had been under debate by the Zionist leadership ever since their publication in July. Advocates of partition stressed that in light of the Nazi danger in Europe, the plan for the establishment of a Jewish state, however small, should be accepted in order to provide refuge for the masses of Jews whose fate was threatened. Ben-Gurion regarded the proposal as a historic turning-point.

Opponents, headed by Menahem Ussishkin, Itzhak Tabenkin, and Berl Katznelson, rejected the idea of dividing the country, on the grounds that so small a state could not solve the problem of the Jews of the Diaspora; would be overly dependent on Britain; and would be outbalanced by the proposed new Arab state.

After prolonged debate, which at times threatened to break up the congress, a proposal by Ben-Gurion was accepted by a majority of 299 to 160: no explicit decision on the partition issue, but negotiation with Britain in order to clarify the conditions of the proposal.

The Zionist Organization was spared internal crisis when, within a short time, it became clear that the British themselves tended to reject the partition proposal.

△ Immigration to Palestine continues, although at a reduced rate. Newcomers from Germany who join the agricultural sector develop and expand poultry breeding. Shown, poultry at Ramot Hashavim.

△ Fiat displays its Topolino model, which costs LP 130-140 – about 16 monthly salaries.

▷ Chairman of the National Council Itzhak Ben-Zvi represents the Yishuv at the coronation of King George VI in May, 1937.

△ Although 1937 witnesses a halt in the riots, the state of alert is maintained. Jewish Auxiliary Police guard railroad tracks and stations at sensitive points. Others guard the airport, settlements, and government buildings.

△ A monument to the 1929 defenders of Kibbutz Hulda by sculptor Batia Lishansky is unveiled in the summer of 1937. The Jewish Auxiliary Police is present here, too.

▷ A photograph from the 1936-39 period shows Jewish Auxiliary Police and men from the Field Companies on assignment.

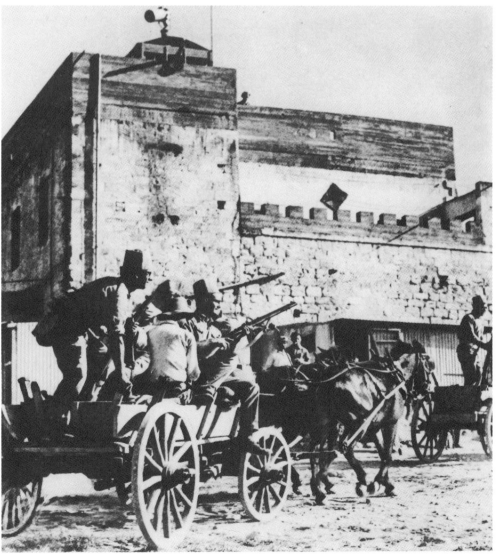

1938

January

4 The British appoint a new commission of inquiry – the Woodhead Commission – to recommend methods of implementing the Peel Commission report.

12 The Poseidon arrives at the Palestine shore with illegal immigrants. Organized by the Haganah and Hehalutz, it marks the resumption of their clandestine maritime immigration effort.

13 The Rockefeller Museum, formally the Palestine Arche-

High Commissioner Wauchope ends his term of office.

ological Museum, opens in Jerusalem.

22 Greece beat Palestine in a soccer World Cup semi-final in Tel-Aviv, 3:1.

February

22 Greece beat Palestine once again in a return match in Athens, 1:0.

28 An Arab attack on Kibbutz Tirat Zvi is repulsed.

March

1 High Commissioner Wauchope ends his term of office and leaves Palestine.

3 The new High Commissioner Sir Harold MacMichael, arrives in Palestine.

21 The best-known stockade-and-watchtower kibbutz, Hanita, is established.

April

17 Etzel members attack an Arab café in Haifa.

21 The British arrest three Etzel members from Rosh Pina who fired on an Arab bus.

May

29 The construction of the northern fence along the Syrian and Lebanese border – the Tigart Wall – is begun.

June

Orde Charles Wingate, a British officer, establishes the Special Night Squads which consist of Haganah fighters

Notice for Kofer Hayishuv ("Yishuv Tax"), 1938.

and British soldiers trained to combat Arab terror.

Three illegal immigrant ships sponsored by Etzel and Betar arrive at the Palestine shore during the month with some 400 immigrants.

3 Shlomo Ben-Yosef and Avraham Shein, Etzel members from Rosh Pina who were arrested by the British, are sentenced to death for firing on an Arab bus and for possession of weapons.

24 Avraham Shein's sentence is commuted to life imprisonment. Personal and institutional appeals to commute Shlomo Ben-Yosef's sentence are rejected.

29 The British execute Shlomo Ben-Yosef, the first Jew executed by the authorities.

July

Violent incidents proliferate during the first week of the month. Twenty Jews are killed in terrorist acts throughout the country. Etzel responds by planting bombs in Arab markets.

1 A railroad unit is established in the Jewish Auxiliary Police force to guard tracks and stations.

10 Alexander Zeid, a central figure in the pioneering and defense history of the new Yishuv and a founder of the Bar-Giora and Hashomer ("The Watchman") groups, is murdered in an ambush near his home at Sheikh Abriq.

27 The self-imposed Kofer Hayishuv ("Yishuv Tax") is established to finance Haganah activity.

A new office is established in the Haganah: Head of the Countrywide Command, assigned to Yohanan Rattner, professor of architecture in the Technion.

August

Jewish forces suffer heavy losses in combatting Arab terror, including eight fatalities from a landmine near Ramat Hakovesh in the Sharon region (August 4) and 10 fatalities on the Haifa-Carmel Forest road (August 15).

September

Arab attacks continue in all parts of the country.

October

The Arabs take control of the Old City of Jerusalem except for the Jewish quarter. The British army regains control on October 18.

2 Tiberias Night: An Arab band penetrates into the Kiryat Shmuel neighborhood of Tiberias and kills 19 Jews, many of them children.

27 The Jewish mayor of Tiberias, Zeki Alhadif, is murdered by Arabs.

November

9 Kristallnacht ("Crystal Night") in Germany. The flight of Jews from the country is accelerated. Palestine is one of their destinations.

The Woodhead Commission recommends amended partition plans that reduce the size of the Jewish state to the coastal area.

30 The Haganah ship Atrato brings 300 illegal immigrants ashore at Herzliya. It will return with a similar cargo six more times by May 1939.

A total of 244 Jews are killed by Arabs during the year.

Seventeen settlements are established during the year, most of them based on the stockade-and-watchtower plan.

Heated discussions over the policy of restraint continue. The Yishuv bodies and the Haganah support the policy, while Etzel is against it.

Some 15,000 immigrants arrive in the country with permits during the year.

The illegal immigration operation grows. Fourteen ships arrive during the year, bringing in 3,250 persons.

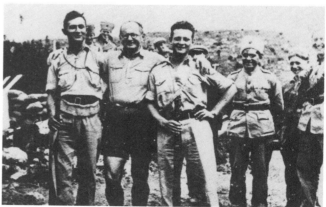

(l. to r.) Dayan, Sadeh, Allon – at the founding of Kibbutz Hanita.

▷ Four pioneers of Kibbutz Hanita, March, 1938.

▽ A barbed-wire, "the Tigart Wall", is put up in mid-1938 by over 1,000 Jewish workers along the northern border, from Lake Kinneret to Rosh Hanikra, to block terrorist infiltration from Syria and Lebanon.

▽ Jewish Auxiliary Police and workers with defense and fencing equipment at the establishment of Kibbutz Hanita. 600 Haganah members assist in the biggest settlement operation so far.

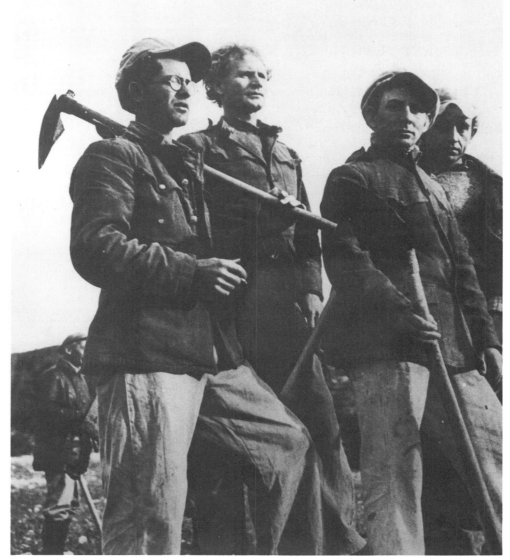

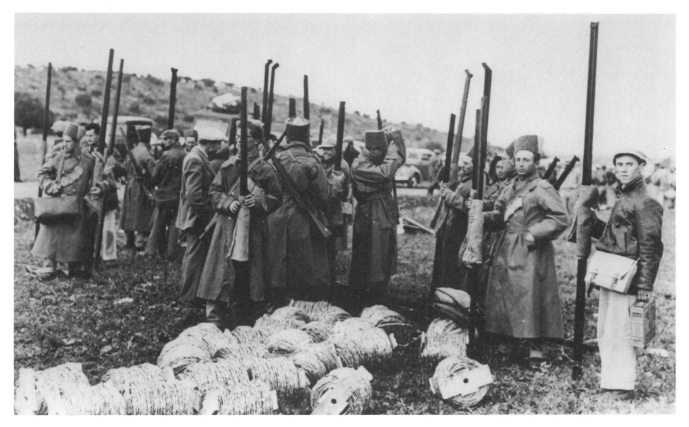

THE WORST YEAR OF THE RIOTS

With the resumption of Arab violence in the fall of 1937, the situation in Palestine deteriorated monthly, and 1938 was to become the worst year of the uprise, at least in terms of Jewish casualties. Total Jewish fatalities during this period were nearly 250, constituting over half the overall figure during the entire three years of the riots. As far as is known, the Arab population suffered much higher losses, including some 500 fatalities as a result of internecine conflicts and account-settling.

In the fall of 1938, the Arab Revolt reached its height. The Arabs succeeded in taking control of the Old City of Jerusalem and other Arab cities, and in driving away British police and officials. Only with much effort and with British reinforcements, did the Mandate regime manage to regain its control in these cities.

Cooperation between British military forces and the Haganah reached a peak in 1938, with the Yishuv contributing its share to the suppression of the Arab Revolt. Other major developments during the year were the construction of the northern fence on the Syrian and Lebanese border; the establishment of a large number of settlements based on the stockade-and-watchtower plan, epitomized by Kibbutz Hanita; the formation of new Jewish defense bodies such as the Haganah Field Companies, the Special Night Squads, and the Jewish Auxiliary Police; and, on the British side, an apparently resolute decision to suppress the revolt by force.

▷ The Woodhead Commission, which arrives in Palestine in the spring of 1938, proposes three alternate plans to implement the Peel partition plan of July 1937. All three have in common a reduction of the area of the Jewish state and an enlargement of the area to remain under British control. In Map C, for instance, the proposed Jewish state is reduced to a minimal coastal strip between Zikhron Ya'akov and Rehovot, bisected by a British enclave south of Tel-Aviv. The conclusions of the Woodhead Commission are published on November 9, 1938. On the same day, in Germany, the Kristallnacht takes place.

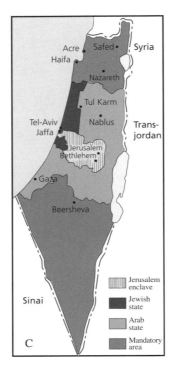

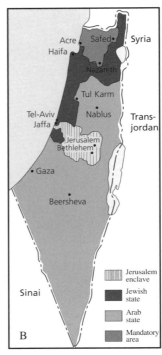

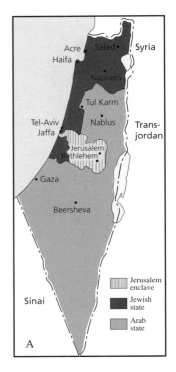

△ Crime: Train track is mined near an Arab village.

▷ Punishment: Villagers are brought into custody by the British police on a trolley pushed by a railroad engine.

WINGATE AND THE SPECIAL NIGHT SQUADS

Captain Orde Charles Wingate, a Scottish officer with a keen knowledge of the Bible and pronounced pro-Zionist sympathies (dubbed "The Friend" by the Yishuv), initiated the formation of the small, daring Special Night Squads. They were aimed at combatting the Arab bands who were sabotaging the Iraq-Haifa oil pipeline and perpetrating other terrorist acts. The squads, made up of Haganah members and volunteer British soldiers, proved effective, and the special combat techniques instilled by Wingate served as a model that shaped the Haganah and, later, the Israel Defense Forces.

Wingate taught his men the method of night combat, the efficient use of field intelligence, the importance of surprise attacks, and stratagems to trick the enemy. In September 1938, he initiated a training course for junior Haganah commanders, which he himself conducted.

Wingate's unqualified support for the Zionist cause prompted his superiors to transfer him from Palestine in 1939, and the squads were dismantled thereafter.

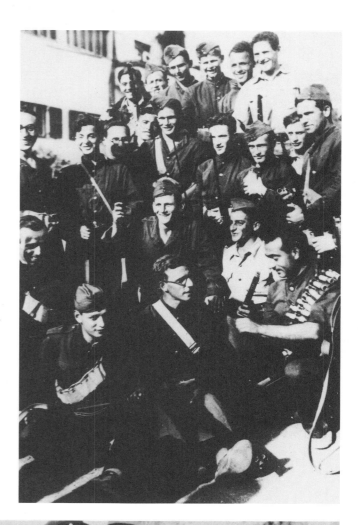

◁ Orde Charles Wingate establishes the Special Night Squads consisting of both British soldiers and Haganah members (right).

שלמה בן יוסף הוצא להורג

◁ Shlomo Ben-Yosef, a member of Etzel from Rosh Pina, is sentenced to death for shooting at an Arab bus. His execution is published in *Davar* ("A Matter").

△ In the lion's den: Moshe Shertok (top, center), head of the political department of the Jewish Agency, pays a visit in 1938 to the Arab village near Ramallah where he lived as a child.

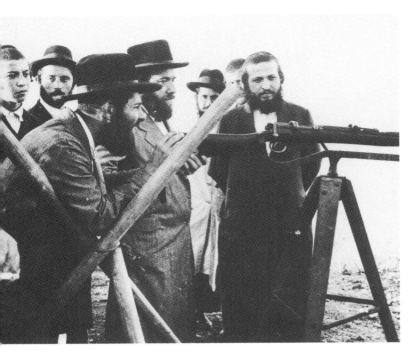

THE FIELD COMPANIES

In the last week of 1937, the Haganah organized Field Companies as "mobile units for defense, assistance to settlements under attack, to engage the enemy, pursue him, combat him outside the perimeters of settlements, and undertake special operations."

The innovation in the Field Companies was that they functioned on a countrywide basis and, for the first time, Haganah members served in a frame that was not under local or regional command. Not coincidentally, the commanders of the companies, Itzhak (Landoberg) Sadeh and Eliyahu Ben-Hur, had been the initiators of an earlier version of mobile defense units (the Nodedet) in the Jerusalem hills at the start of the riots.

Within a few months, the companies counted some 1,000 fighters who had undergone intensive training. Linked to the Jewish Auxiliary Police, they made use of its legal arms. They also cooperated closely with Wingate's Special Night Squads. The Field Companies assisted in the stockade-and-watchtower operations, guarded sensitive areas, and initiated special operations.

Once the Arab violence died down, in 1939, the Field Companies were disbanded. Their commanders and some of their members would be found in later special combat units, like the Palmah.

△ All sectors of the Yishuv pitch in for the defense effort. Shown, Haganah weapons-training in Tiberias.

▽ The Zina Dizengoff Square is dedicated in Tel-Aviv in 1938 and immediately becomes a symbol of the first Hebrew city.

January

1 The Jewish Settlement Police (J.S.P.) is established, a major component of the Jewish Auxiliary Police and in effect an arm of the Haganah.

February

7 The Round Table Conference opens in London, a British attempt to foster talks between the Jewish and Arab leadership, including leaders of some Arab countries, aimed at solving the Palestine problem. It is also known as the St. James Conference, for the palace where it is held.

26 The Arabs demonstrate in all parts of Palestine following reports of Britain's decision to grant independence to the country. Three Jews are killed in violent events in Haifa.

Etzel plants bombs in various Arab population centers. Dozens are killed and wounded.

March

17 The St. James Conference ends in failure. The British adopt a new pro-Arab policy in Palestine, eliciting apprehension in the Yishuv.

April

The illegal immigration operation intensifies. Five ships reach the Palestine shore; one ship sinks off Crete. The British force back ships into the open seas. They announce that they will deduct the number of illegals that are apprehended from the Jewish immigration-permit quota.

With the improvement in British-Arab relations, the Arab Revolt dies down, ending three years of insurrection.

21 The first aviation course is concluded at Lydda airport. Six graduates receive their licences from High Commissioner MacMichael, who does not suspect it to be an Etzel training course.

May

9 The Hadassah-University Hospital opens on Mt. Scopus in Jerusalem.

17 A new British White Paper is published, stating unequivocally that British policy does not aim at Palestine becoming a Jewish national home. Zionist aspirations suffer a severe blow.

18 The Yishuv holds mass demonstrations protesting the White Paper.

21 The British arrest the Etzel leadership, including Commander David Raziel.

23 An unprecedented seven settlements are founded in one night, including five based on the stockade-and-watchtower plan. For the first time, the British have not been informed of the operation.

28 The illegal immigrant ship Atrato, operated by the Haganah, is caught on its seventh voyage.

June

The Haganah, backed by the Yishuv national bodies, establishes special squads aimed at retaliation against Arab marauders (and later against the British as well).

Etzel members sabotage British installations.

27 Rabbi Ben-Zion Meir Hai Uziel is appointed Rishon Lezion (Sephardi Chief Rabbi) following the death of Rabbi Ya'akov Meir.

July

The discussion over a policy of restraint crops up again in the Yishuv. The chief rabbis condemn aggressive actions, whether against the Arabs or the British.

The campaign to promote local products over imported products intensifies.

30 Elections in the Yishuv for the 21st Zionist Congress result in Mapai ("Palestine Labor Party") obtaining two-thirds of the delegation seats; the two General Zionist factions 11%; the religious 10%; and the rest divided between the small parties.

Ten graduates of the aviation course organized by the Aviron company (in fact, a Haganah course) conclude their training in Afiqim.

August

Anti-British sentiment grows in the Yishuv.

2 Etzel sabotage of the Mandatory radio station in Jerusalem results in two deaths. Broadcasting is resumed shortly from Ramallah.

9 The Haganah sinks the British coastguard craft Sindbad 2 which hunts illegal ships.

16 The British announce that illegals who are caught will be imprisoned at the Atlit detention camp. The camp will serve to incarcerate illegals for nine years to come.

The 21st Zionist Congress opens in Geneva. A harsh forecast is projected for the Jews of Europe.

The newspaper Davar ("A Matter") is closed down for two weeks for having criticized the policy of the Mandatory government on illegal immigration.

23 The Parita lands demonstratively on the Tel-Aviv shore in broad daylight and offloads hundreds of illegal immigrants, who are immediately taken into nearby houses.

September

1 World War II breaks out.

2 The Tiger Hill repeats the Parita strategy and lands in Tel-Aviv.

6 The Haganah sets up general headquarters, headed by Ya'akov Dostrovski (later, Dori).

12 Chairman of the Jewish Agency David Ben-Gurion defines the position of the Yishuv and the Zionist movement after the outbreak of the war thus: "We must assist the British in the war as if there were no White Paper and we must resist the White Paper as if there were no war."

The Yishuv national bodies and the Haganah organize a countrywide draft of volunteers for Jewish national service. Over 136,000 individuals respond (86,000 men and 50,000 women), prepared to serve the Yishuv and assist the British in their war effort.

The first Jewish volunteers are recruited into the British army.

October

5 The British arrest 43 participants in a Haganah officers' training course.

17 The National Council is expanded in light of the emergency situation. It is headed by Pinhas Rutenberg.

30 One of the participants in the Haganah officers' training course is sentenced to life imprisonment and the rest to 10 years. The Yishuv is shocked.

November

18 Thirty-eight Etzel members are arrested at Mishmar Hayarden where they are undergoing weapons training.

December

11 The British begin recruitment for the war effort. The Yishuv protests and boycotts the campaign because most of the recruits are assigned to the Pioneer (auxiliary) Corps only.

A new daily, Yedi'ot Aharonot ("Latest News"), appears in two editions – afternoon and evening.

20 Sentences of 5-10 years' imprisonment are handed down to the Etzel members arrested at Mishmar Hayarden.

A total of 34 illegal immigrant ships reach the Palestine shore in 1939. Only some of them manage to get their passengers ashore. A few are forced back to the open seas. Others are caught and the immigrants are detained for short periods.

More than 100 Jews are killed in Arab terrorist actions throughout the year.

Seventeen new settlements are founded in 1939, most of them based on the stockade-and watchtower plan.

1939

EXPANSION OF THE CLANDESTINE IMMIGRATION MOVEMENT

Growing Nazi anti-Semitic persecution in Germany, as in most of Central and Eastern Europe, accelerated the flight of Jews from there. However, nearly all the countries of the free world were closed to them, while the British in Palestine permitted only a meager rate of entry. One of the results of Britain's policy was the expansion of illegal immigration into Palestine.

The number of boats attempting to slip past British surveillance jumped from a total of 19 during the 1934-38 period to 34 in 1939 alone. Until then, this clandestine operation had been undertaken independently by various organizations without the support of the Yishuv as a whole. In 1939, however, the Mosad for Aliyah Bet ("Institute for B [Illegal] Immigration") was established as an arm of the Haganah with Jewish Agency support. Additionally, the Revisionist movement and certain private groups continued to bring in shiploads of illegals.

The flow of illegal immigrants increased in summer 1939, as Europe stood on the brink of war, and as the British published the White Paper, which reduced Jewish immigration drastically.

△ Jewish Palestine is exhibited at the New York World's Fair of 1939. The pavillion of the Yishuv attracts throngs of visitors. A statue of the anonymous pioneer by sculptor Moshe Zipper is placed at its entrance.

▷ The British attitude to Jewish immigration to Palestine is caricatured by Aryeh Navon in April 1939.

▽ The Parita illegal immigrant ship lands at the Tel-Aviv shore in August 1939.

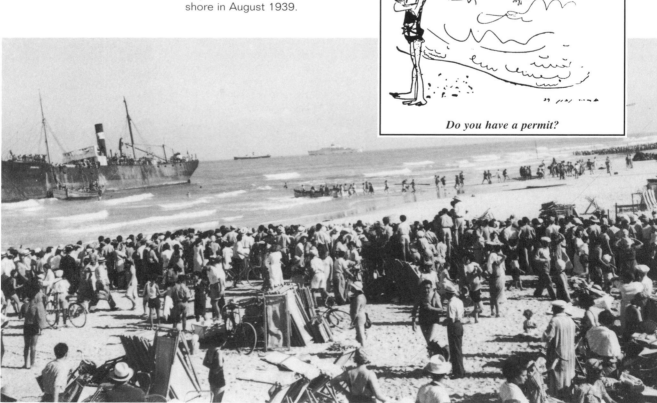

▽ The Jewish-Arab Round Table Conference is held in London at the beginning of 1939 in an attempt to solve the Palestine problem. Delegates of the Arab population in Palestine and several heads of Arab states participate in the talks, which are unproductive. Since the Arabs refuse to meet with the Jews, the British hold the conference twice: first with the Arab side (r.) and then with the Jewish side in the same location (below). Shown in foreground, below (l. to r.): Dr. Hayim Weizmann, David Ben-Gurion, Henrietta Szold, and Moshe Shertok (Sharett).

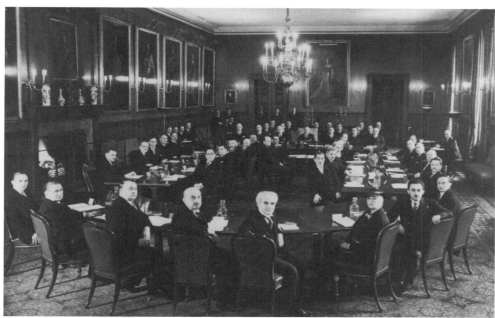

▽ A Jewish farmer sets out for the fields. The riots, which began in the spring of 1936, subside in 1939.

◁ The Zionist Congress in Geneva, 1939 (l. to r.): Moshe Shertok (Sharett), David Ben-Gurion, and Dr. Hayim Weizmann. Their expressions convey their apprehension regarding the looming war.

> The axe now hangs over the one hope of the people – the hope of redemption in the homeland. But the homeland is not like the Diaspora. Here we do not stand by helplessly. This is the one place in the world where the Jew will stand and fight. He will fight and he will succeed. He will fight for his country as well as for the honor of his people…
>
> David Ben-Gurion reacting to the White Paper, 1939

△ A demonstration in the Sharon region: the White Paper is publicly "buried".

▽ Yishuv leaders in the front row of a demonstration in Tel-Aviv include Levi Eshkol (far r.) and Golda Myerson (Meir), next to him.

THE WHITE PAPER OF 1939

The White Paper is an official published statement by the British government on public issues and reports of government commissions of inquiry. The White Paper of 1939, published on May 17, dealt with the future of Palestine. In it the British government explained that it had fulfilled the commitments contained in the Balfour Declaration and that the time had come for "the establishment within ten years of an independent Palestine state" in which the essential interests of both Arabs and Jews should be safeguarded.

The significance of this decision was the establishment of a state with an Arab majority and Arab-dominated rule. The inevitability of this majority would be guaranteed by the announced restriction of Jewish immigration to 75,000 during the coming five years, with further immigration requiring the consent of the Arabs. The number of Jews in Palestine was fixed by a ceiling of no more than a third of the total population. The sale of land to Jews was similarly restricted.

The White Paper was viewed by the Jews as a betrayal of Britain's promises and evoked strident protest. The anti-British struggle, which began in 1939, was based on the negation of the White Paper regulations. It is hardly surprising that immediately after the declaration of the State of Israel in 1948, the White Paper regulations were annulled by the new state.

△ With the outbreak of the war in September 1939, Jewish recruitment to the British army begins.

▷ The establishment of new stockade-and-watchtower settlements continues throughout 1939, even without British consent. Shown, Kibbutz Negba in the south, established in July, 1939.

STOCKADE-AND-WATCHTOWER AGAINST THE BRITISH

From the start of the stockade-and-watchtower settlement program in December 1936, operations were generally carried out in cooperation with the British administration. The British supported the establishment of new settlements in remote regions of the country and in border areas, viewing them as an asset in controlling Arab terror.

This attitude changed in the spring of 1939 with the waning of the Arab Revolt and the publication of the White Paper of May 1939. British cooperation with the Yishuv, its institutions, and its defense force – the Haganah – was drastically reduced, and the British no longer supported the stockade-and-watchtower settlement program. This change, however, prompted a new wave of Jewish settlement: a week after the publication of the White Paper, seven settlements were established in various parts of the country in one night, including five on the stockade-and-watchtower plan. By the end of 1939, nine more settlements were established, some of them in open defiance of the British, who by this time were seeking to limit Jewish settlement.

Owing to the new circumstances, the method of operation changed. Instead of carrying out the preparations the night before and the actual construction of the camp in the daytime, both stages were now realized in one night, in the small hours between midnight and daybreak.

ידיעות אחרונות

הוצאת צהרים המחיר 2 מיל

האנגלים עברו להתקפה בחזית המערב

▽ The Jewish Auxiliary Police, which earlier made do with open vehicles, receives armored carriers.

△ *Yedi'ot Aharonot* ("Latest News"), a new evening daily, appears toward the end of 1939. It will become Israel's most popular newspaper.

The Fifth Decade
1940–1949

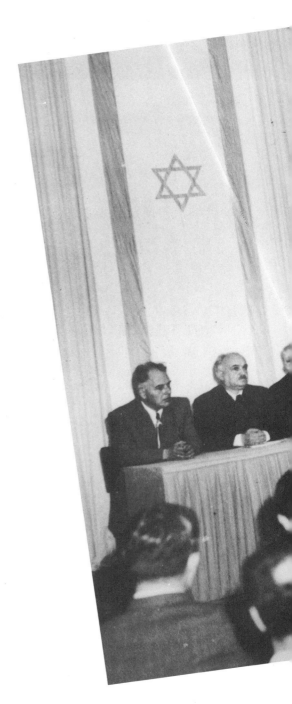

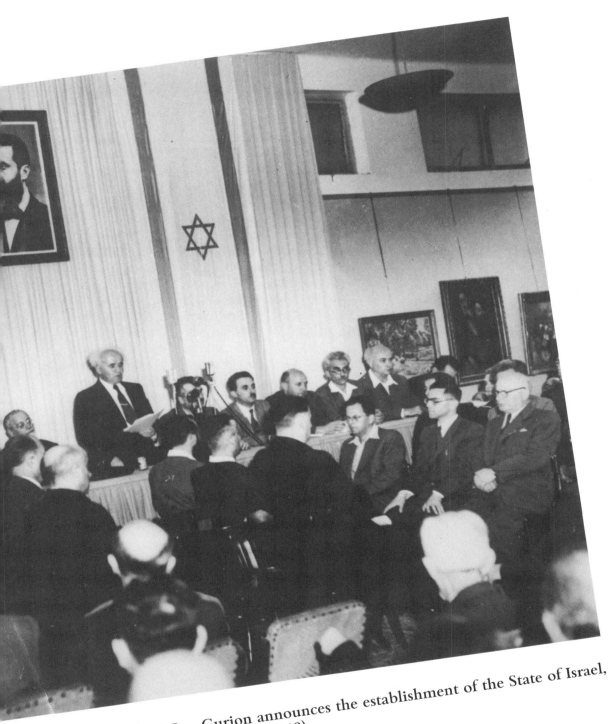

David Ben-Gurion announces the establishment of the State of Israel,
5 Iyar 5708 (May 14, 1948)

The 1940s may be divided into three periods. The first spans the first half of the decade. The second and third, while shorter, were far more fateful for the country, its inhabitants, and its future.

The first period, 1940-45, encompassed World War II. Palestine experienced the war peripherally, during the first few years only, and even then mostly indirectly. Loss of life and property as a result of enemy activity (mainly bombing) was relatively light. The economy, however, was hit harder, although again during the first few years only. Exports and imports nearly ceased and unemployment was widespread. But from 1942 onward, the situation reversed itself and, ironically, the country entered a period of unprecedented prosperity. Palestine was rapidly converted into a vast logistic base for the entire British army in the Middle East. Camps were built, roads paved, and airfields installed. Industry and agriculture were harnessed to the war effort and unemployment melted away. It was a sharp contrast to the situation in Europe, where people had to endure the hardships of war. Furthermore, while millions of Jews were being annihilated under Hitler, there reigned in Palestine an atmosphere of "business as usual."

The second period, from the summer of 1945 to the fall of 1947, was marked by a sharp deterioration in relations between the British administration and the Yishuv. The prolonged confrontation between the Jews and the British, which elicited a notably passive response from the Arab population and its leaders, reached a peak during this period when it became apparent that the British would not alter their anti-Zionist policy. In world opinion, however, the "Palestine problem" came to be viewed as a combination of the Jewish struggle for independence on the one hand, and on the other as the problem of the displaced survivors in Europe, who insisted on immigrating to Palestine.

The Jewish underground groups – Haganah, Etzel and Lehi – fought British rule in various ways, some of the time jointly as part of the newly organized Hebrew Resistance Movement. The Haganah, the military arm of the Yishuv leadership, concentrated its activity on illegal immigration and on the expansion of Jewish settlements all over the country, and only partly on armed struggle against the British. From the spring of 1947 onwards, it began to prepare itself for a possible confrontation with the armies of the Arab states. Etzel and Lehi focused solely on terror activity against the British. The British made large-scale arrests of resistance activists, imposed frequent curfews, carried out searches, worked systematically to foil the Jewish illegal immigration operation – the Ha'apalah – executed captured members of Etzel and Lehi, and came to be viewed as the enemy. Manifestations of anti-Semitism were also evidenced by some of the British civil officials and soldiers.

Early in 1947, the British government decided to shift the "Palestine problem" to the newly created United Nations. A special session of the General Assembly in the spring of 1947 resulted in the formation of an international committee, the U.N. Special Committee on Palestine (U.N.S.C.O.P.), consisting of representatives of 11 countries. After a visit to Palestine of several weeks that included meetings with leaders of all sides and a stopover at the displaced persons camps for Jewish refugees in Europe, the committee proposed a partition plan that would divide Palestine into a Jewish and an Arab state with Jerusalem as an international zone under U.N. patronage.

The third period of the decade began the day after the U.N. decision to accept the proposal. Despite the small area and contorted shape of the state proposed to them, the Jewish population rejoiced. The Arabs, however, rejected the plan out of hand and set out immediately to cancel it by force. Riots broke out, which soon developed into a war – the war of 1948, or the War of Independence.

The war lasted over one and a half years, from the end of November 1947 to July 20, 1949, when a fourth and final armistice was signed, with Syria. During this period, the Yishuv mobilized itself to repel attacks, mounted major counterattacks, and in mid-May 1948, with the end of the British Mandate, declared the establishment of the State of Israel. The Arabs of Palestine suffered a severe blow. Hundreds of thousands fled during the war and became refugees.

The Arab states tried to turn back the tide, with five armies (Egyptian, Transjordanian, Syrian, Lebanese, and Iraqi) attacking Israel in concert as soon as the Mandate expired. This effort to wipe out the "Zionist entity" was repulsed swiftly and successfully by the new state, which thereafter counterattacked and managed to rout the invaders in most arenas. Four Arab states signed cease-fire agreements with Israel during the first half of 1949. Israel's success in surviving and repelling the attacks by the Arab armies, given its population then of only 650,000, was viewed with surprise throughout the world.

At the height of the war, and for several years thereafter, the new state confronted a different series of difficulties: the immense challenge of absorbing hundreds of thousands of Jewish immigrants, most of them penniless. A country that had just emerged from a brutal war, lacked natural resources, and had an undeveloped economy, took on the responsibility of doubling its population within only a few years. Forecasts were dim in this area as well, and the widely held assumption was that the country's infrastructure would collapse in a short time. Yet, as was the case on the battlefield, the pessimistic forecasts were not borne out in this area either.

In November 1949, the Jewish population of Israel reached a million. One third had arrived during the twenty months following the Declaration of Independence. It was a dramatic and impressive ending to a stormy decade.

January

6 The British search Yavne'el and find Haganah weapons there.

22 Haganah weapons and arms are discovered at the Ben-Shemen youth village. Eleven persons are arrested, including the head of the village, Dr. Siegfried Lehmann.

23 The British apprehend the illegal immigrant ship Hilda.

February

13 The largest illegal immigrant ship yet, the Sakaria, with 2,300 persons on board, is caught by the British. Its passengers are detained in camps.

28 The Mandate government publishes the Land Transfer Regulations in accordance with the provisions of the White Paper of May 1939. The Yishuv responds with protests and demonstrations.

Palestinian recruits into the Pioneer Corps of the British army, most of them Jewish, are dispatched to the front in France.

March

13 The underground Haganah radio station, Kol Israel ("Voice of Israel"), begins broadcasting.

April

22 Sentences of 3-7 years imprisonment are handed down to the Ben-Shemen detainees. Over 100,000 inhabitants of the Yishuv sign a petition demanding their release.

27 Palestine beats Lebanon in a soccer match in Tel-Aviv, 5:1.

May

15 General George J. Giffard, commander of the British army in Palestine, demands that the Haganah relinquish its arms to the authorities. The Yishuv leadership rejects the demand.

29 First country-wide conference on war against foreign languages. It deals with changing foreign names into Hebrew and the acquisition of the Hebrew language.

June

The threat of war in Palestine grows with the surrender of the French to the Germans and the alliance of the Italians with Nazi Germany. Neighboring Syria and Lebanon are now ruled by French forces loyal to the pro-Nazi Vichy regime.

A blackout is ordered in all parts of the country.

11 The Yishuv leaders, in a meeting with the High Commissioner, declare their loyalty to Britain and offer their assistance in the war effort.

18 The British release the members of the Etzel command who have been imprisoned since the summer of 1939.

26 The Lehi (acronym for Lohamei Herut Israel – "Israel Freedom Fighters") underground is founded, headed by Avraham Stern (Ya'ir). It is made up of a group who have split away from Etzel because they refuse to aid the British in their war effort.

Recruitment into the British army is expanded. The Yishuv national leadership bodies assist in mobilizing volunteers with vital skills. They demand that the British admit recruits into the regular infantry corps rather than the auxiliary corps as is current policy.

July

5 The British rescind the demand that the Haganah turn over its weapons.

15 Italian aircraft bomb Haifa.

24 Haifa is bombed again, with 50 fatalities.

August

4 Ze'ev Jabotinsky, leader of the Revisionist movement, dies in New York aged 60.

18 A violent confrontation takes place between members of the Haganah and Etzel in Herzliya. An Etzel member is wounded and later dies.

27 Pinhas Rutenberg resigns as president of the National Council.

September

9 Italian aircraft bomb Tel-Aviv. Over 100 residents are killed, many are wounded, and damage is extensive.

13 The Italian army crosses into Egypt from Libya.

14 The British permit Palestinian Jews to be recruited into infantry companies, known as Buffs, for the first time. Arab companies are also formed. Jewish recruitment is handled by Yishuv bodies side by side with the British.

16 Lehi members rob the Anglo-Palestine Bank of thousands of pounds for the purpose of subsidizing their activities.

21 Italian aircraft bomb Haifa again. Thirty-nine fatalities result from a hit in an Arab neighborhood.

The intelligence service of the Haganah, "Shay" (an acronym for Sherut Yedi'ot), is established, which will serve as the basis for the future Israel Defense Forces intelligence corps.

November

Two illegal immigrant ships, Pacific and Milos, arrive at Haifa at the start of the month carrying some 1,800 Jewish escapees from Europe.

10 The Soldiers' Welfare Committee is founded. Its aim is to attend to the needs of Jewish soldiers from Palestine serving in the British army.

20 The British announce their intention of exiling the illegals who arrived at the beginning of the month to the island of Mauritius in the Indian Ocean. Protests and demonstrations are held throughout the Yishuv.

24 The Atlantic, an immigrant ship, is caught by the British and brought into the Haifa harbor.

25 Sabotage of the Patria in the Haifa harbor, a ship loaded with some 1,700 illegal immigrants caught by the British and bound for exile to Mauritius, results in the drowning of over 200 immigrants. The Yishuv is shocked. The survivors are transferred to the Atlit detention camp. Protests result in a British decision not to exile them.

December

4 First agreement on cost-of-living increases is signed between the Histadrut ("Federation of Labor") and the Industrial Owners and Employers Association.

9 Some 1,600 illegal immigrants from the Atlantic, who had not boarded the Patria, are exiled to Mauritius. They will be detained there until August 1945.

14 Another maritime tragedy occurs involving the illegal immigration operation: the Salvador sinks off the Turkish shore en route to Palestine, with 103 of its 180 passengers lost at sea. The survivors are brought to the Turkish shore.

29 Dov Hoz, deputy mayor

יהודי פתח את הרדיו

בגלים קצרים 42 מטר בשעה 7.30 בערב

ושמע את „קול ישראל"

הקול היחיד החפשי מצנזורה

שמע והשמיעהו בקול גדול ו

A notice for broadcasts by the Haganah: "The Voice of Israel. The only uncensored voice."

of Tel-Aviv and a noted Haganah leader, is killed in a car crash with his wife and daughter.

The war and the severance of the country from foreign markets engender an economic crisis in 1940 and a marked increase in unemployment.

Some 10,600 Jewish immigrants arrive in 1940, over half of them illegals.

Seven new settlements are established during the year, four of them in the Galilee.

Some 9,000 Palestinian volunteers are recruited into the British army by the end of 1941, 72% of them Jews.

△ Jewish recruits are sworn into the British army.

▽ The Arab recruits are sworn in by taking an oath on the Koran.

WAR NEARS PALESTINE

During the course of 1940, it became apparent to the inhabitants of Palestine that the war – World War II – which had appeared so distant, was approaching their region. Italy openly joined Nazi Germany following the fall of France in June 1940. This meant that the Italian army in Libya, which made no secret of its aggressive intentions regarding Egypt, was not very far from Palestine. Italian forces, along with aircraft and battle-ships, were also based in nearby Rhodes.

Moreover, Syria and Lebanon, under the French Mandate, were now controlled by the Vichy govern-ment, so that a pro-Nazi military force was located just across the Palestinian border.

A series of aerial bombings of Tel-Aviv and Haifa by Italian aircraft flying from Rhodes accentuated the threat. In Haifa, the primary targets were the port and the large oil storage facilities (which included the termi-nal of the oil pipeline from northern Iraq) and the refi-nery complex. As for Tel-Aviv, the Italians officially declared it a base for British imperialism.

Several of the bombings took a heavy toll in human life. On September 9, 1940, 117 were killed in Tel-Aviv and 400 were wounded. Direct hits were recorded on the neighborhood of Nordia (today, the Dizengoff Center), and in the Arab village of Sumeil (today, near the crossroads of Ibn Gvirol–Arlozoroff).

▽ A vigorous campaign is mounted in the Yishuv to stimulate recruitment into the British army. During 1940 the British finally consent to recruit Jewish volunteers for infantry companies. They will later grow into battalions.

△ Fear of German gas warfare prompts the training of soldiers in the necessary self-defense measures.

Italian planes sow destruction and death in Tel-Aviv in the fall of 1940. Over 100 residents of the city are killed and hundreds are injured.

Jewish recruits in tropical uniforms undergoing weapons training at the central British training camp, Sarafand (today Tzrifin).

EGYPT WATCHES ITALY

TAKING FINAL PRECAUTIONS

CAIRO, Tuesday (R). — While the world press seems of the opinion that Italy will enter the war shortly, Egyptian opinion on Italian inten-

BLACK-OUT CONTINUES

PEDESTRIANS URGED TO WEAR WHITE

It was notified yesterday that the black-out arrangements as practiced on Monday night are to be maintain-

JEWS' OFFER OF ARMY UNIT

MR. SHERTOK REVEALS AGENCY PLAN TO BRITAIN

That the Jewish Agency had made a definite offer to the British Government, before the outbreak of war, to raise a Jewish fighting unit for service in Palestine and elsewhere, in the persent war, was revealed by Mr. M. Shertok, head of the Political Department of the Jewish Agency Executive, in answer to a question at a press conference held in the Agency's offices in Jerusalem yesterday afternoon.

△ The start of the Patria disaster in Haifa: the ship lists.

▽ The conclusion of the Patria disaster, two minutes later: the ship sinks.

△ *Lights in the Dark*. A notice for the satiric Hamatateh ("The Broom") Theater in Tel-Aviv. Its main subject is the occasional blackouts in the city, due to Italian air raids.

THE PATRIA AFFAIR

Toward the end of 1940, the British decided to toughen their policy regarding the illegal immigrants whom they caught, shifting punitive measures from detention within the country until administrative procedures were completed (i.e., the deduction of the appropriate number of immigrant permits from the limited quota as stipulated by the White Paper) to exile. Return to country of origin was rendered impossible by the wartime conditions.

In November 1940, three ships reached Palestine in quick succession – the Pacific, the Milos, and the Atlantic – with a total of over 3,500 illegal immigrants on board. All three were caught by the British, who, acquiring a French vessel, the Patria, intended to utilize it to transport the immigrants to exile on the island of Mauritius in the Indian Ocean. The transfer of the immigrants to the Patria aroused vociferous opposition. Protests and demonstrations in the Yishuv, however, were to no avail. The Yishuv national bodies then instructed the Haganah to prevent the sailing by means

of sabotage. A small quantity of explosives was smuggled aboard, and, with the aid of several of the immigrants, was attached to one of the inner walls of the ship. The quantity of explosives was considered small enough not to endanger the ship or its 1,700 passengers.

On November 25, 1940, the sound of a muffled explosion was followed immediately by a sharp listing of the ship, and in a matter of minutes the vessel was flooded and sank. An examination later on revealed that the ship was much more rundown than had been apparent and that the hole created by the explosive was much larger than planned. Over 200 passengers drowned, and the rest were transferred to the detention camp at Atlit. Only after further protests and demonstrations did the British agree to forgo exiling the survivors. However, the passengers who had arrived on the Atlantic and who had not yet boarded the Patria were exiled to Mauritius as planned.

▷ Dov Hoz, a noted Yishuv
and Haganah leader, dies in
a car accident in December
1940.

▽ Jewish Agency Chairman
David Ben-Gurion (l. with
wife Paula, and son Amos,
r.) visits the desolate Eilat
shore to explore new
settlement possibilities.

△ Settlement continues.
Here, saline earth is treat-
ed by a rinsing method at a
new kibbutz north of the
Dead Sea, Bet-Ha'aravah.

▽ Forty-three Haganah
prisoners spend the year
1940 in the Acre prison.
At right: Moshe Dayan.

1941

January

11 The Habimah Theater mounts a première of a biblical play, *Michal Bat-Shaul*, written by Aharon Ashman.

The British attack the Italians in Libya, Eritrea, and Ethiopia.

February

17 The British release Haganah prisoners, including the 43 held since October 1939 and the Ben-Shemen group. Some Etzel prisoners are also released.

23 Recruitment of engineers, drivers and other skilled volunteers for Palestinian units of the British army continues.

March

The Darian 2 reaches Haifa port with some 700 illegal immigrants. The British, fearing a repetition of the Patria incident, change their plan to force it back onto the high seas and instead transfer the immigrants to the Atlit detention camp, where they will be held for a year and a half.

23 A pro-Nazi regime takes power in Iraq, headed by Rashid Ali al-Gaylani. The Jewish population there is under threat.

April

The Haganah formulates an overall defense plan for the Yishuv, labeled Program A, in the event of a German invasion of Palestine.

1 The German campaign in North Africa under General Rommel begins in Libya and moves eastward toward Egypt. Palestine is under threat as well.

27 Greece falls to the Germans. Tens of thousands of British soldiers are taken prisoner, including 1,500 Jewish soldiers from Palestine. The Yishuv is concerned about their fate.

May

2 A draft for the British army is issued by the Yishuv national bodies to bachelors aged 20-30.

15 The Haganah national command establishes a mobilized permanent force, the Palmah (acronym for Plugot Mahaz, "assault troups"). On the same day, the Foundations of the Haganah are published. They define the rights and duties of its members.

The presence of German forces in Syria is reported.

18 Twenty-three Haganah members accompanied by a British officer embark on a British mission to sabotage oil refineries in Lebanon by small boat and disappear.

20 Etzel Commander David Raziel is killed in Iraq during German bombing while on a British sabotage mission.

29 Rommel's army reaches the Egyptian border.

30 The British suppress the pro-Nazi uprising in Iraq.

June

1-2 A pogrom erupts against the Jews of Baghdad. Over 140 Iraqi Jews are killed.

8 The British army invades Syria and Lebanon from Palestine with the aim of routing the pro-Nazi Vichy French forces there. Haganah and Palmah scouts accompanying the British forces include Moshe Dayan, Yigal Allon, and Itzhak Rabin. Dayan loses an eye in a battle in southern Lebanon.

10 Haifa is bombed by Italian aircraft at night, with no casualties.

The insignia of the Palmah, established in 1941.

12 Tel-Aviv and Haifa are bombed. Tel-Aviv suffers 12 fatalities.

For fear of further air raids, thousands of the inhabitants of Tel-Aviv and Haifa flee to Jerusalem and to the agricultural settlements nearby.

22 Germany invades the Soviet Union. The war enters a new phase.

July

1 Moshe Kleinbaum (later Sneh) is appointed head of the Haganah national command.

3 An Italian plane is shot down while bombing Haifa. Its pilot parachutes down and is caught by Jewish Auxiliary Police.

31 The British deport some 1,000 Germans in Palestine classified as enemy aliens to Australia. They are escorted by Jewish police from Palestine.

August

7 Kibbutz Ein-Harod is searched by the British for weapons, an unusual step during a period of close relations with the Yishuv in light of British reliance on assistance from the Jewish community for the war effort.

24 The first issue of *Eshnav* ("The Window"), an underground magazine printed by the Haganah, appears.

September

1 An income tax ordinance is issued for the first time in Palestine.

October

3 Zionist leader and Jewish National Fund chairman Menahem Ussishkin dies aged 78.

The Yishuv national bodies and the Haganah intensify recruitment for the British army.

November

9 Dr. Hayim Weizmann reports on the failure of talks with the British aimed at establishing a Jewish combat division in the British army.

30 (until December 1) Elections for the fifth board of Histadrut Ha'ovdim ("Federation of Labor").

Zionist leader and chairman of Jewish National Fund, Menahem Ussishkin, dies in October 1941, leaving his mark on the map of the Jewish settlement.

Mapai receives a majority of 70%; Hashomer Haza'ir ("The Young Watchman") and the Socialist League receive over 19% of the votes. The results represent a loss for Mapai and a gain for the left wing.

December

7 Japan attacks the American navy in Pearl Harbor. The United States enters the war.

12 The British counter-attack in Libya.

Immigration slumps as a result of wartime conditions and British restrictions. Only some 4,600 Jews enter Palestine during 1941. The illegal immigrant operation comes to a near halt.

Five new settlements are established during 1941, including the first one in the northern Negev – Dorot.

Poet Shaul Tchernochowsky is awarded the Bialik Literary Prize.

The economic crisis continues but shows signs of receding toward the end of the year as a result of British army orders and accelerated construction of army camps and airfields.

▷ From 1940, Mandatory Palestine borders on territory controlled by a pro-Nazi regime – Syria and Lebanon, governed by Vichy France. The British flag at the northern border post at Rosh Hanikra faces the flag of Nazi-controlled France.

▽ British forces take over Syria and Lebanon in June 1941. The headlines announce the advance of "our armies."

הצהרה בשם גנרל דה-גול על חירות ועצמאות! עם כניסת צבא בנות-הברית לסוריה והלבנון

התקדמות צבאותינו בתחומי סוריה נמשכת

ב-15 ביוני עמדו הגרמנים להשתלט על מחוז חלב.—וישי טודיעה שהיא תגן על סוריה בכל כוחה

ARE THE GERMANS COMING?

The German army, following a series of victories in the spring and early summer of 1941, appeared invincible. Its Afrikakorps in Libya under Rommel's command pushed the British eastward in Egypt. The Balkan states of Yugoslavia and Greece were taken by the Germans in a brief campaign. Anti-British feelings prevailed in the Arab states, where the people and their leaders alike waited for Britain's fall and the arrival of the German armies. Syria and Lebanon were under the rule of the pro-Nazi Vichy French. Iraq staged a rebellion against Britain, and its prime minister, Rashid Ali al-Gaylani, who was assisted by the Mufti of Jerusalem Haj Amin al-Husseini, openly announced his pro-Nazi sympathies. The Arabs in Palestine, too, who had ended their revolt two years before, seemed prepared to recommence it. Obviously, the Jews in Palestine would be their first victims if the Germans invaded the country.

Britain appeared to be on the losing side of the war in April and May of 1941. Rumors were rife in Palestine about a British retreat to India, the evacuation of families of British officials and soldiers, and the distribution of evacuation permits to Yishuv leaders and their families. The intentions of the Germans regarding the Yishuv were not difficult to imagine.

The situation changed, however, in late May and early June when the British suppressed the rebellion in Iraq and invaded Syria and Lebanon. Moreover, with the start of the German campaign in the Soviet Union on June 22nd, pressure on the Middle Eastern front eased. Many in Palestine breathed more easily.

△ Australian soldiers who take part in the invasion of Lebanon befriend local children at Metula in northern Palestine in June 1941. The village, which was largely evacuated before the fighting, is shelled heavily by the French forces. The French, however, are routed by the British, who take control of Lebanon and Syria.

△ Thousands of Jewish
soldiers from Palestine
serve in infantry companies,
the Buffs, in the British army.

△ A recruitment campaign for
the British army is kept up
by the Yishuv. The poster
declares: "10,000 have
already signed up. Help
start the second ten
thousand!"

△ The struggle against the
British takes another
shape. While the Haganah
supplies military aid to the
British army, it also starts
to issue, in summer 1941,
an underground magazine,
Eshnav ("The Window"). It
will continue to be printed
until the spring of 1947.

◁ Jewish recruits from
Palestine reach all parts of
the world. Here, Jewish
police stroll through
Sydney after escorting a
group of Germans – mostly
Templers – exiled from
Palestine to Australia by
the British.

THE ESTABLISHMENT OF THE PALMAH

The Palmah (an acronym for Plugot Mahatz, or assault troups), founded in May 1941, constituted the Haganah's permanent recruited force serving in combat units for an extended period (two years or more) and prepared to undertake any assignment. This distinguished them from the rest of the Haganah membership which, except for a small command force, consisted of civilians called up as the need arose.

The Palmah was founded in spring 1941, when the country was threatened by a German invasion. At first, it was trained by the British and was assigned by them to sabotage missions as well as to maintain an underground network in the event of the conquest of the country by the Germans. The first six units were recruited in the summer of 1941. They were trained for a short period before being sent home, to be called up if the need arose. Some of them took part in the invasion of Syria and Lebanon in June-July. The first commander of the Palmah was Itzhak Sadeh. Among the first unit commanders were Yigal Allon and Moshe Dayan. (Dayan could not take the command of the Palmah because of his eye injury in the invasion of Lebanon.)

▷ The British employ a carrot and stick policy, aiding the Yishuv on the one hand, yet striking out at it on the other, as during a weapons search at Kibbutz Ein-Harod in August, 1941, which causes damage. Everything reflects war, including advertising, as shown in this Kodak ad (below right).

▽ A reception attended by High Commissioner MacMichael (c.) is held to mark 60 years of the American Colony in Jerusalem, despite the state of emergency and the danger of a German invasion.

1942

January

3 Pinhas Rutenberg, founder and director of the Palestine Electric Corporation and president of the National Council (in 1929 and 1939), dies aged 62.

9 A chase following an attempt by Lehi members to rob a bank in Tel-Aviv ends with the death of two Jewish bystanders.

15 Food rationing is begun.

18 The recruitment of Jewish women in Palestine for the British Auxiliary Territorial Service (A.T.S.) begins. By the end of the war, 4,000 Jewish women volunteers will have been mobilized.

20 Three police officers, two of them Jewish (Shlomo Schiff and Nahum Goldman), are killed by explosives laid by Lehi members. The Yishuv is infuriated.

27 The British police break into an apartment in Tel-Aviv and kill two Lehi members. Two others are wounded and caught.

The German army in Libya mounts an attack against the British.

February

12 Lehi Commander Avraham Stern ("Ya'ir"), 34, is caught by the British in south Tel-Aviv and shot dead.

24 The Struma, carrying 770 illegal immigrants bound for Palestine, is torpedoed by a Soviet submarine in the Black Sea off Istanbul and sinks. There is only one survivor.

An illegal immigrant operation by land begins over the northern border, organized by the Mosad ("Institution") for Aliyah Bet and implemented by the Palmah.

March

27 The Yishuv national bodies issue a second recruitment call-up for married men aged 20-30 without children.

April

26 The first Palmah sabotage and commando course is begun at Kibbutz Mishmar Ha'emek, conducted and financed by the British. Details about British evacuation plans in the event of a German advance from Egypt are divulged behind closed doors, as is a Haganah plan to fortify the civilian population of the Yishuv on the Carmel and its environs.

Lehi carries out a series of sabotage acts against the British.

May

9 The Biltmore Program, formulated at a conference of Zionist leaders at the Biltmore Hotel in New York, demands the establishment of a Jewish state in Palestine. Initiators of the conference include David Ben-Gurion and Hayim Weizmann.

The Palmah forms a "German section" to operate behind enemy lines in the event of the conquest of Palestine. Palmah companies train in the groves of Kibbutz Mishmar Ha'emek.

June

The German army in Libya under Rommel pushes the British eastward.

21 The worsening political-military situation prompts the Yishuv national bodies to issue a general recruitment order.

July

Danger nears. Rommel's army in Libya crosses the Egyptian border and reaches el-Alamein, 100 km from Alexandria. Germany also meets with success on the Russian front, while Japan scores successes in the Far East. The Axis Powers are at their height.

Palmah units are deployed in southern Palestine and in the coastal settlements in order to repel German land and amphibian forces.

August

6 The British announce the formation of Jewish battalions to consist of the Buffs troups.

11 Ihud ("Unity") is founded, an organization for Jewish-Arab understanding, the successor of Brit Shalom ("Alliance of Peace").

25 League V is established by the Yishuv to aid the Soviet Union in its war effort against the Nazis.

Recruitment for the British army is intensified in the Yishuv during the summer. Some 4,000 new recruits are mobilized during June-August.

The Haganah cooperates with the British in drawing up the Palestine Scheme for resistance warfare behind enemy lines in the event of a German conquest. Most of the responsibility will be borne by the Palmah.

September

The Kibbutz Hame'uhad, followed by the Association of Collective Settlements and the Kibbutz Ha'artzi, adopt the Training and Labor credo of the Palmah: members of the Palmah will work and train in the kibbutzim. The tie between the Palmah and the settlement movement is thus reinforced.

19 Habimah Theater presents *Ha'adama Hazot* ("This Earth"), written by Aharon Ashman. It is set in Hadera's early days and is received with enthusiasm.

October

23 The tide begins to turn

Avraham Stern ("Ya'ir").

on the North African front. The British 8th Army launches a counterattack against Rommel's forces at el-Alamein in Egypt.

30 A new political party is formed in the Yishuv – Aliyah Hadashah ("New Immigration"), founded primarily by immigrants from Germany.

November

8 American forces land in Morocco (Operation Torch). American and British forces attack Algeria. Their plan is to adjoin the British units advancing from Libya. Rommel's forces are in retreat, routed from Egypt on November 12.

The Americans score successes in the Far East, as do the Russians at Stalingrad.

30 The Yishuv national bodies hold three Emergency Protest Days upon receiving verified reports of the slaughter of Jews in occupied Europe.

December

6 A fourth recruitment order is issued by the Yishuv national bodies. Recruitment reaches a total of some 30,000 men and women by the end of the year, approximately two-thirds for the British army and the rest for the Auxiliary Police, the regular police, and the Palmah.

17 The Yishuv national bodies announce a 30-day period of mourning to commemorate the tragedy of the Jews of Europe.

The economic situation improves as the country turns into a major base for British deployment in the Middle East. Unemployment gradually disappears.

Settlement activity and immigration are at a low ebb as a result of the war and fear of a German invasion.

The soccer final for the Palestine Cup produces a new record: Betar Tel-Aviv beats Maccabi Haifa 12:1.

THE RECRUITMENT DEBATE: SERVICE IN UNIFORM OR WITHOUT?

Throughout the war, but especially in 1942, when the danger of a German invasion of Palestine was greatest, the Yishuv debated the question of which type of national service was preferable: recruitment into the British army, or the channeling of recruits into the army in formation – the Auxiliary Police, the Palmah, and other Haganah units.

Some of the opponents of recruitment into the British army argued against excessive aid to Britain as well as against the likely transfer of recruits outside of Palestine. Certain leftist elements viewed the conflict as an "imperialist" war between Germany and Britain in which the Yishuv should play no part, although this stance was altered once the Soviet Union entered the war. The radical Right opposed recruitment in the British army as well in view of their anger at Britain's anti-Zionist policy.

The leaders of the Yishuv and the Haganah thought otherwise. "We will not reach maximal strength... if we neglect either recruitment in uniform or recruitment without uniform," declared David Ben-Gurion. A similar view was expressed by the head of the Haganah, Eliyahu Golomb: "I advocate neither the approach that favors army over Haganah, nor that which favors Haganah over army; both are our forces..."

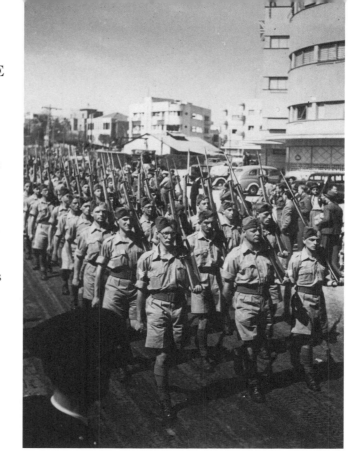

△ Jewish soldiers in a parade in Tel-Aviv.

▽ Recruitment of Jewish women begins in 1942 for the A.T.S., the Auxiliary Territorial Service of the British army.

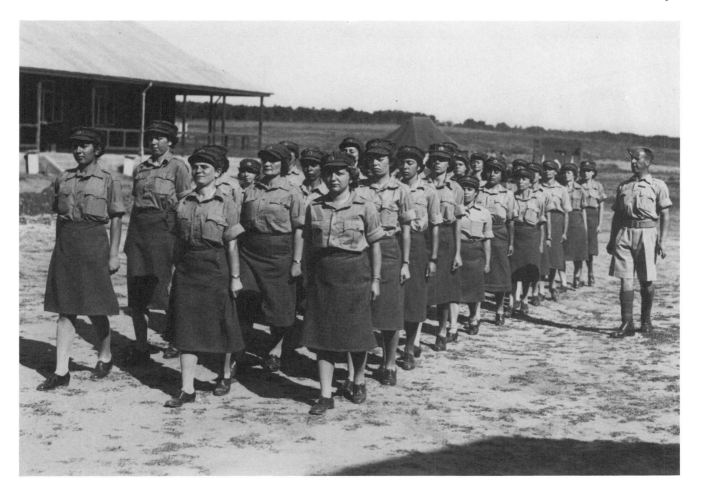

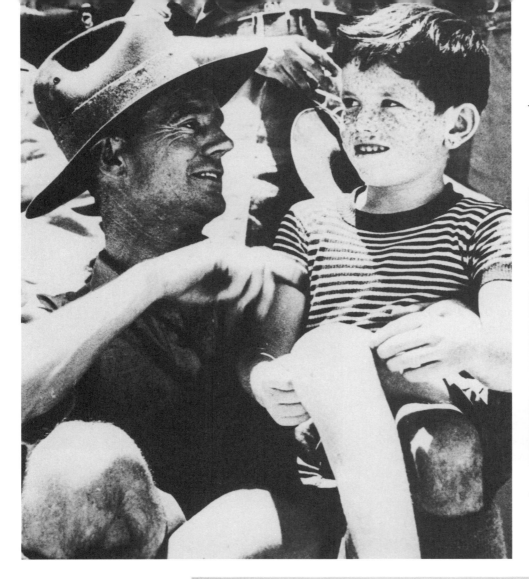

◁ Palestine is filled with Allied soldiers deployed in the area during 1942. Particular favorites are the Australian soldiers.

△ A poster in Tel-Aviv in 1942: World War I veterans are called upon to sign up, too.

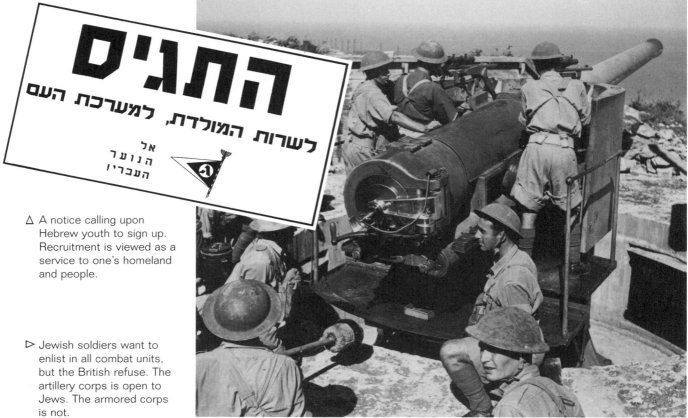

△ A notice calling upon Hebrew youth to sign up. Recruitment is viewed as a service to one's homeland and people.

▷ Jewish soldiers want to enlist in all combat units, but the British refuse. The artillery corps is open to Jews. The armored corps is not.

228

פרסים

נחמן שולמן	יעקב פולני נודע בשם פוליאקוף	אברהם בן מרדכי שטרן \ נודע בשם יאיר

פרס 200 לא"י	פרס 400 לא"י	פרס 1000 לא"י

אהרן צוקרמן נודע בשם אש " " העברי	חנוך סטרליץ	ירוני בנימין נודע בשם בן-צבי " " יבניאל " " אבני " " קרנר

פרס 100 לא"י	פרס 200 לא"י	פרס 200 לא"י

ואברהם מארי – פרס 100 לא"י

△ A Hebrew poster announcing rewards for Lehi leaders is issued by the British in early 1942 as part of their campaign against that organization. Avraham Stern (top, r.) is the most wanted figure.

▷ High Commissioner MacMichael is blamed for the murder of the immigrants in an unsigned poster that appears on walls throughout the country following the sinking of the Struma.

THE STRUMA EPISODE

The Struma, an illegal immigrant ship sponsored by private sources, set out for Palestine from Rumania in December 1941. Reaching the Dardanelles Straits, it was prevented from passing through by Turkey, under pressure from Britain, and was blocked in Istanbul for some two months. The Yishuv national bodies requested the British to permit the ship to land in Palestine under the limited quota dictated by the White Paper, but the British refused.

On February 23, 1942, the Turks towed the ship, whose engines were inoperable, out to the Black Sea and left it there to be carried along by the waves. Several hours later, a loud explosion was heard and the ship sank, torpedoed by a Soviet submarine unaware of its identity. All but one of the 770 passengers on board were drowned.

The sinking of the Struma was the worst disaster to strike the illegal immigration effort. Anti-British rage in the Yishuv reached a peak. Rallies were held and protests conveyed abroad. Although the British banned reports of the episode in the Yishuv press for several days, the press outmaneuvered the authorities, publishing details framed in black mourning borders on the front pages every day.

נפש תועה מישראל...

אברהם שטרן נתפס והומת ביריות

נמצא בעלית-גג בשכונת פלורנטין בתל-אביב

△ A headline in *Haboker* ("The Morning") reports the killing of Stern and describes him as a confused soul.

▷ Close relations with Egypt during the war years. Jews travel to Cairo and smoke Egyptian cigarettes.

THE NORTHERN PLAN

The threat of a German invasion was first envisaged in 1941, when the British army seemed to lose ground before the German attacks in North Africa. The national bodies of the Yishuv demanded of the Haganah to work out a defense plan in case such a threat was realized.

Palestine, and the Yishuv in particular, faced grave danger during the summer of 1942 with Rommel's advance toward Egypt. The British also feared that stopping him on his way to Palestine might not be possible.

A fallback plan drawn up by the Haganah envisioned concentrating the population of the Yishuv in the Carmel range and its surroundings in northern Palestine, with the port of Haifa serving as a food and ammunition lifeline supported by the industrial infrastructure already in place. The plan was developed by Itzhak Sadeh and Yohanan Rattner. Their intention was to recruit dozens of Haganah battalions, into which Haganah members serving in the British army would be integrated. The goal was to set up a Jewish center of resistance to permit long-term survival in siege conditions until the British could revive themselves.

Ultimately, the defeat of the German army at el-Alamein in the fall of 1942 distanced the war from Palestine, and the Northern Plan was shelved.

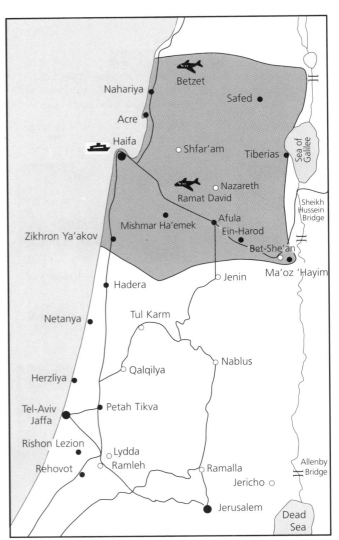

△ A map of the Northern Plan shows the establishment of an armed Jewish enclave in the north. The plan will never be implemented in view of the German retreat from Egypt.

▽ The Syrian section of the Palmah is geared to operations behind enemy lines should the Germans gain Palestine and the neighboring countries. Most of its members are Jews originating from Arab countries.

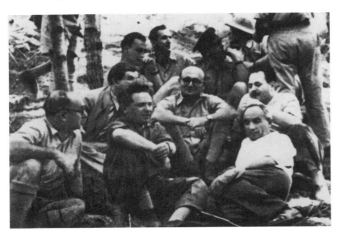

△ The Haganah leadership in 1942 (l. to r.): Dori, Galili, Sadeh, Sneh, and Golomb.

▽ The Palmah German section in training.

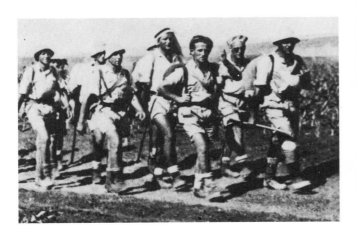

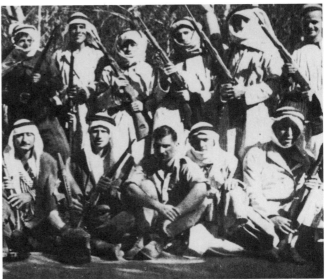

230

THE YISHUV AND THE HOLOCAUST

With the start of World War II, published reports appeared in the Yishuv on the deportations, mass murder, and atrocities perpetrated by the Germans against the Jews in occupied Europe. These reports increased during 1942, the third year of the war, yet the entire topic failed to elicit sustained public or press concern, as might have been expected from a retrospective vantage point. At least three factors may account for this ambivalence: (1) the painful news was viewed dubiously, both because of its intrinsically shocking nature and because of the effective wall of silence thrown up by the Germans around the occupied zones, so that reports that leaked out were unverifiable; (2) the possibility of the existence of a Nazi "death machine"

was incomprehensible, and the instinctive feeling was that the Jewish people, who had suffered so much in the past, would survive this trouble as well; and (3) the Yishuv in Palestine was faced with grave problems of survival of its own in 1942, sharply exacerbated by the threat of a German invasion from the north, or, even more likely, from the south.

This threat receded in November 1942, when Rommel's army was defeated and pushed back. At that very time, the first authenticated reports were received from Europe and the United States about the existence of death camps and the slaughter of millions of Jews. The mood of the Yishuv turned grim. Little could be done, however, by way of assistance.

SLAUGHTER OF EUROPE'S JEWS

EXECUTION OF HITLER'S DESIGN | ANNIHILATION OF ENTIRE COMMUNITIES

△ The lead headline in the Palestine Post upon receipt of the first authenticated reports of the Holocaust.

▽ Habimah Theater presents *Ha'adama Hazot* ("This Land"), by Aharon Ashman, in 1942, commemorating 50 years since the establishment of Hadera. Despite the difficult times, the play is a hit. Seated, c., is leading actor Aharon Meskin.

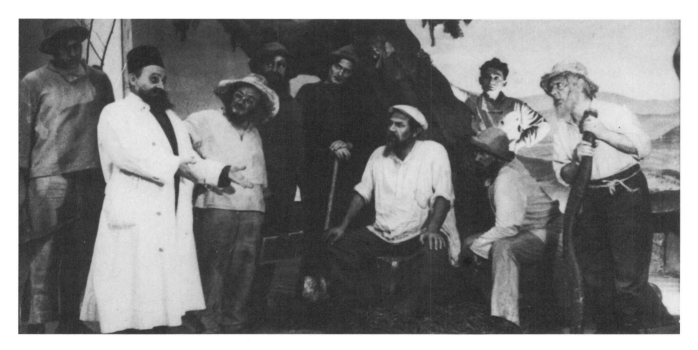

1943

January

1 Dr. Arthur Ruppin, the "father of Zionist settlement," dies aged 66.

8 The Ohel Theater presents the hit *King Solomon and the Cobbler*, by Sami Gronemann.

21 The first Palmah sea commando course begins near Caesarea.

February

18 The Teheran Children, over 700 young Holocaust survivors smuggled into Iran, arrive in Palestine.

March

Cooperation between the Palmah and the British army ends. The British remove weapons from Kibbutz Mishmar Ha'emek that the Palmah claims are theirs. The Palmah raids a British arsenal in Haifa on March 28 and removes 22 machine guns and 277 rifles.

23 The High Commissioner announces a comprehensive postwar economic plan. To the distress of the Yishuv, it is based on the foundations of the White Paper, i.e., the demographic restriction of the Jewish sector, and includes reduced immigration and a ban on the acquisition of land. The Yishuv national bodies announce their refusal to cooperate with the authorities regarding the plan.

April

11 The highest ranking officer from Palestine in the British army, Brigadier Frederick Kisch, serving as an engineer in the 8th Army, is killed by a mine in Tunisia.

19 The Warsaw Ghetto revolt breaks out.

Itamar Ben-Avi, the first Hebrew child, dies in the United States at age 57.

28 Kibbutz Kfar Etzion is founded in the Hebron hills area.

29 The British search the Jewish Agency recruitment office in Tel-Aviv. Relations between the Yishuv and the British deteriorate. The Jewish Agency halts recruitment in the Yishuv for the British army.

A convoy of ambulances from the Yishuv makes its way to Iran and from there to Russia as a contribution to the Red Army in its war effort against the Nazis. The Russians accept the gift with emotion.

May

1 The sinking of a British transport ship bombed by the Germans while sailing from Egypt to Malta takes the lives of 140 Yishuv soldiers in the British army.

12 The surrender of the German-Italian military force in Tunisia completes the Allied victory in North Africa.

Kibbutz Gvulot, the first outpost settlement, is founded in the Negev to test settlement conditions in the region.

22 The first of the Yishuv paratroopers in the British army, Peretz Rosenberg of Moshav Bet-She'arim, is dropped into Yugoslavia.

The Jewish Agency reopens its recruitment office in Tel-Aviv.

June

15 The Yishuv announces a general strike to protest Allied inaction in the rescue of European Jews.

July

To the dismay of the Yishuv, the British dispatch the 2nd (Jewish) Infantry battalion to Libya. The 1st Infantry battalion will later be stationed in Egypt.

22 A new radio weekly program, *Hagalgal* ("The Wheel"), begins.

28 A second outpost settlement, Kibbutz Revivim, is established in the Negev.

30 A new daily, *Mishmar* ("Guard"), appears, sponsored by Hashomer Hatza'ir. It will later be renamed *Al Hamishmar* ("On Guard").

August

9 A third Negev outpost settlement, Moshav Bet-Eshel, is founded near Beersheva.

12 The trial of two civilians begins – Aryeh Syrkin and Avraham Reichlin, charged with stealing British arms for the Haganah.

September

27 After 60 court sessions, Syrkin and Reichlin are sentenced to prison terms of 10 and 7 years respectively.

October

A "flag revolt" is staged by Jewish soldiers in the 2nd battalion of the Palestine Regiment in Libya who demand to show their blue and white national flag. The British are opposed. A compromise is reached.

1 The first Jewish parachutists from Palestine are dropped into Romania by the British.

2 The British stiffen their attitude toward the Yishuv and the Haganah. They search Kibbutz Hulda for arms.

5 Yehezkel Saharov, a member of the Haganah and bodyguard to Hayim Weizmann, is sentenced to seven years' imprisonment for possessing a rifle bullet.

14 Shaul Tchernochowsky, the poet, dies at age 68.

Am Lohem ("Fighting People") is founded. The small body, in fact linked to the Etzel, tries to persuade all underground movements to join forces against the British. The Haganah prohibits its members to take part. Am Lohem ceases its activity after a short while.

November

1 Twenty Lehi prisoners escape the Latrun detention camp through a tunnel they have dug. They soon resume sabotage activity against the British.

16 Kibbutz Ramat Hakovesh is searched for arms. The kibbutz members resist and a violent confrontation ensues. One member is killed. Dozens are wounded and many arrests are made.

18 All the Jewish dailies print the identical lead headline, which has not been submitted in advance to the censor: "Brutal Act in a Jewish Settlement – Police Assault on Ramat Hakovesh."

19 In response to the breach of the censorship regulation, the British order the suspension of *Davar* ("A Matter") and *Haboker* ("The Morning") for two weeks as a prelude to a similar punishment planned for the rest of the press. All the other papers cease publication in solidarity for 11 days.

December

1 The new commander of Etzel is Menahem Begin, replacing Ya'akov Meridor.

17 Seven members of Kibbutz Hulda, accused of illegal possession of weapons, are sentenced to two to six years in prison.

△ Simha Zahubal (l.) and Haya Sharon in *King Solomon and the Cobbler*, in the Ohel Theater, Tel-Aviv.

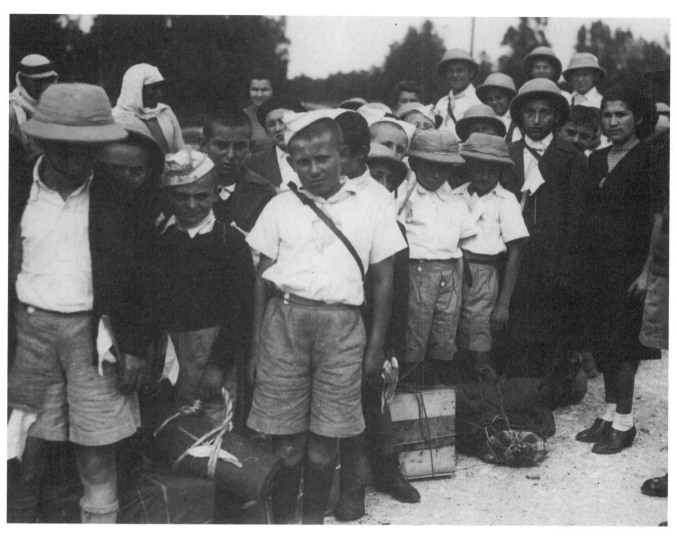

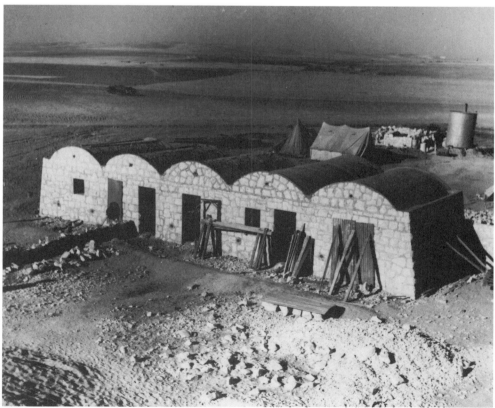

△ A group of the Teheran
children. Smuggled out of
Europe to Iran, over 700
orphaned Jewish Children
travel through India to
Palestine in 1943.

△ The insignia of the
Palestine Regiment of the
British army, 1943.

▷ Kibbutz Bet-Eshel, the third
and last of the outpost
settlements established in
the Negev in 1943.

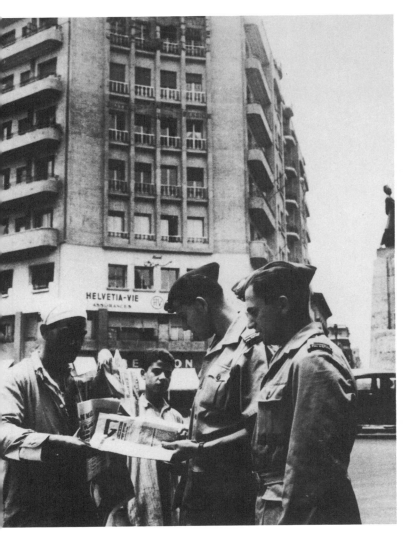

ARMS SEARCHES AND TRIALS

With the improvement of Britain's military position on its various fronts in 1943, the British turned their attention to implementing the White Paper policy in Palestine, including reducing the strength of the Yishuv.

Investing considerable effort in exposing the Haganah arms acquisition network, they discovered several weapons shipments and sentenced Haganah members, as well as British soldiers who aided them, to long prison terms. At first these trials were held behind closed doors, but in August 1943, two arms trials were conducted publicly, the first involving two British deserters from the army and the second involving two members of the Haganah, Aryeh Syrkin and Avraham Reichlin. The latter were sentenced to 10- and 7-year prison terms respectively. Another Haganah member was sentenced to seven years imprisonment simply for possession of a single rifle bullet.

The Yishuv was further angered in October and November 1943 by arms searches in two kibbutzim, Hulda and Ramat Hakovesh, the latter leading to a major confrontation between the British government and the Yishuv leadership that was reflected, among other things, in a closedown of the Jewish press.

△ Leaders of the Yishuv and the Haganah, including David Ben-Gurion (seated, second row, extreme l.), bid farewell to Jewish paratroopers from Palestine bound for occupied Europe.

THE NEWSPAPER STRIKE

On November 16, 1943, large British forces raided Kibbutz Ramat Hakovesh in the Sharon region and conducted an exhaustive search, claiming that the kibbutz was hiding deserters from the Free Polish Army, which was then serving in Palestine with the British, and that illegal Haganah arms were hidden there as well. The kibbutz members resisted the search and the British resorted to force. Dozens of kibbutz members were wounded and one died of his injuries.

An official report of the incident released by the British stated, among other things, that the settlers had used violence against the police and that only one person had been injured, not seriously.

The Hebrew press refused to print the British version and, at the inspiration of the Haganah, all the newspapers came out with the identical headline and the full story of the event on November 18, 1943, without submitting their material to the Mandatory censor as was required. The British responded by suspending two of the papers, *Davar* ("A Matter") and *Haboker* ("The Morning"), for two weeks, and announcing that they would follow suit with all the rest of the newspapers that had violated the censorship regulations. At that point, a Response Committee made up of the editors of all the Jewish newspapers announced a solidarity strike. The press strike continued for 11 days. In the end, the British rescinded their threat of suspension and the Hebrew press resumed publication.

▷ British forces cause destruction in the Palmah camp at Kibbutz Ramat Hakovesh.

▽ The entire Jewish press closes down in solidarity with the two suspended Hebrew newspapers following the coordinated appearance in all the papers of the full report of the Ramat Hakovesh incident without prior submission to the British censor. The British try to break the strike, unsuccessfully, by publishing a bulletin titled *Hadashot Hayom* ("Daily News").

NO HEBREW PAPERS APPEARING

No Hebrew papers appeared on Friday following a decision taken by all nine dailies to show solidarity with the two papers which had been suspended by Government order.

The afternoon newspaper "Yedioth Achronoth" was suspended until further notice, as had been the morning daily "Haboker."

The first number of a Hebrew bulletin issued by the Public Information Office, printed on one side, in small format and containing telegrams and the official communique on the Ramat Hakovesh search was published on Friday. It is called the "Daily News."

△ The forged identity card used by Menahem Begin, under the name Yona Konigshoffer. After his release from the Polish army, Begin is named Commander of Etzel on December 1, 1943.

1944

January

5 The Mapai Council is divided on the issue of the Biltmore Program. The majority support it, while a minority – Faction B – is opposed.

12 The Elected Assembly calls a special session devoted to the desperate situation of European Jewry. The Yishuv population is called upon to increase contributions for the recruitment and rescue effort.

14 The United Kibbutz Council hears shocking testimony from three Holocaust survivors who have reached Palestine.

February

1 The Etzel command announces a revolt against the British and demands the transfer of local rule to a Jewish government.

Over 750 immigrants arrive from Portugal, which they managed to reach from occupied Europe.

12 Etzel attacks the Mandatory immigration offices in three cities – Jerusalem, Jaffa, and Haifa.

24 Three British police officers are wounded by explosives laid by Lehi in Haifa.

27 Etzel attacks the Mandatory income tax offices in the three major cities.

March

5 The crisis in Mapai between the moderate majority and the extreme leftist minority intensifies.

23 Etzel blows up British C.I.D. headquarters in Jerusalem, Jaffa, and Haifa.

April

6 The Histadrut ("Federation of Labor") Council decides to hold elections in light of the crisis in Mapai.

The Yishuv national bodies make efforts to isolate Etzel and Lehi, threatening to take action against them if they do not halt their anti-British attacks.

More Jewish parachutists depart on missions to Yugoslavia, Romania, and Hungary.

The Yishuv national bodies issue a decree for compulsory service after high school graduation. The service may be carried out in the British army, in the Auxiliary Police units, or in the Palmah.

May

12 The Palmah holds its first conclave in the groves of Mishmar Ha'emek, marking three years since its founding.

17 Etzel attacks the Mandatory broadcasting station in Ramalla.

20 Mapai splits. Faction B establishes a new party, Hatenu'ah Le'ahdut Ha'avodah ("United Labor Movement") and announces its intention to run for the Histadrut and the Elected Assembly elections.

24 Koor, the industrial arm of the labor-owned Solel Boneh construction company, is founded. It will become a major conglomerate.

June

5 An Emergency Protest Day to Save the Remnant is held throughout the Yishuv in support of European Jewry. Rallies are organized, work is stopped, and entertainment events are cancelled.

July

14 As Faction B leaves Mapai, the latter conducts a wide campaign to win the votes of non-party sympathizers.

19 Field Marshal Lord Gort is appointed High Commissioner of Palestine.

The Palmah companies form battalions.

August

1 Elections to the fourth Elected Assembly, the first in 13^1/$_2$ years, result in some 60% of the votes going to the various Labor parties.

3 The Mafkura, an illegal immigrant vessel carrying some 400 persons, is sunk by the Germans in the Black Sea. There are only five survivors.

6-7 Elections to the sixth Histadrut ("Federation of Labor") convention result in the retention by Mapai of its majority by a narrow margin.

8 Outgoing High Commissioner Harold MacMichael is slightly wounded in an attempt on his life by Lehi members. The Jewish Agency and the National Council comdemn the act.

13 Berl Katznelson, ideological leader of the Yishuv Labor movement and editor of *Davar* ("A Matter"), dies aged 57.

15 A Palmah settlement, Bet-Keshet, is established in the Lower Galilee.

22 Etzel again attacks British C.I.D. headquarters in Jaffa as well as police stations in the Tel-Aviv area.

September

12 The new Elected Assembly convenes and elects a new National Council.

14 A group of Jewish parachutists from Palestine is dropped into Slovakia.

20 The British government announces the establishment of a Jewish Brigade Group. It will consist of three regimental Palestinian battalions, an artillery battalion, and additional units. In the last days of September, the different units are concentrated in Burj al-Arab, Egypt.

27-28 Etzel attacks a series of police stations throughout the country.

October

8 The head of the Haganah National Command, Moshe Sneh, demands that Etzel Commander Menahem Begin halt his organization's anti-British activities until the end of the war. Begin refuses.

19 The British exile 251 Etzel and Lehi prisoners to Eritrea (later to Sudan and Kenya as well). The National Council issues a protest.

The Yishuv national bodies demand of Etzel and Lehi to cease their anti-British activity until the end of the war. The Haganah prepares to block their operations.

24 A new theater group, the Cameri Theater, is established, directed by Yosef Pasovsky (later, Millo).

31 The new High Commissioner, Lord Gort, assumes office. He replaces Harold MacMichael, who has been in office for over six and a half years.

The Jewish Brigade Group sails from Egypt to southern Italy.

In a decisive agreement between the pioneering youth movements and the Palmah command, the training of all graduates of the movements – men and women – is to be under the auspices of the Palmah.

November

6 Two members of Lehi assassinate Lord Moyne, the British minister of state in the Middle East, in Cairo. The Jewish Agency and the National Council denounce the "loathesome crime" and call for the eradication of the "growing danger posed by the terrorist gang that still exists in Eretz Israel."

7 Hannah Senesh, the Jewish Palestinian parachutist, is executed by the Hungarians in a prison in Budapest.

13 Changes in the leadership of the National Council: Itzhak Ben-Zvi is elected president, David Remez, chairman.

21 The Haganah, using Palmah volunteers, launches a campaign to halt Etzel activity by force, euphemistically labeled the Season. Lehi ceases its activities unilaterally. Etzel Commander Menaham Begin instructs his people not to resist detention by the Palmah by force.

December

12 The British Labor Party, at its conference, adopts a platform that supports the establishment of a Jewish state in Palestine and the voluntary transfer of the Palestinian Arabs.

22 Palmah member Avraham Eisenberg is sentenced to 10 years in prison for possessing a grenade.

▽ The surprise of the elections is a small party, Aliyah Hadashah ("New Immigration"), signified by the letter *ayin*, which turns out to be not so small after all, gaining some 11 % of the vote. Its supporters are mainly immigrants from Germany who arrived in the 1930s.

▷ Elections to the fourth Elected Assembly, held on August 1, 1944, take place in a stormy atmosphere, especially within the leftist camp, which is still preoccupied by the recent split in Mapai. But Mapai manages to retain its central position in the elections.

TWO ELECTIONS IN ONE WEEK

In the early summer of 1944, Mapai split. Its left wing – consisting of most of the Kibbutz Hameuhad as well as urban workers and Faction B – established a new body, the United Labor Party. Mapai responded with a wide campaign, hoping to win the votes of its non-party sympathisers. Residents of the Yishuv were called upon to cast their votes for a new Elected Assembly on August 1, 1944, following repeated postponements of the elections. (The previous election was in early 1931.) The main contest was within the labor camp, as the centrist parties were factionalized and most of the right wing, along with the Sephardi party, boycotted the elections over issues related to representation. Mapai emerged with a significant 36.5% of the vote, the breakaway United Labor Movement gained 9%, and the Hashomer Hatza'ir ("The Young Watchman") left bloc obtained 12%. The election surprise was the success of the Aliyah Hadashah party, comprising mainly immigrants from Germany, which gained approximately 11% of the votes. The religious parties, too, received 11% of the votes, while the centrist parties garnered only a few percent each.

The second set of elections, on August 6-7, was for the sixth Histadrut ("Federation of Labor") convention. Here, Mapai managed to retain its absolute majority (53%), while the parties to its left – Hashomer Hatza'ir and United Labor – obtained some 38% of the votes. Mapai, although challenged on all sides, continued to be the party in power in the Yishuv.

◁ Amid the 22 tickets is the Religious Worker, with leanings to Mapai. Its primary representative is Dr. Yesha'yahu Leibowitz, scientist and philosopher.

▽ Chairman of the Jewish Agency David Ben-Gurion greets the new High Commissioner, Lord Gort, at a reception in Jerusalem. Behind him stands his wife, Paula.

THE ESTABLISHMENT OF THE JEWISH BRIGADE GROUP

After prolonged, frustrating negotiation, the British consented to the formation of a Jewish combat corps in its army late in 1944. Until then, Jewish recruits from Palestine had been accepted into British infantry, transport, engineering, communications, air, sea, women's, and other units, but these were not Jewish national units as, for example, the Indian or Australian national units were.

From the start of the war, the Yishuv national bodies and the Zionist movement demanded of the British to form at least one battalion consisting of the volunteers from Palestine, with its own insignia and flag. The British, however, rejected these demands repeatedly.

Only in September of 1944 did they agree to a reinforced Jewish brigade, to be commanded by Brigadier Ernest Benjamin, a British Jewish officer in the British army. The brigade, based in Egypt, consisted of 5,000 Jewish soldiers. It was composed of three infantry battalions, one artillery company, and other auxiliary units. Early in November 1944, it sailed for Italy, where it saw action against the Germans in the winter of 1945.

A total of approximately 1.5 million Jewish soldiers served in the Allied armies, of whom 30,000 were Palestinian Jews. Only the Jewish Brigade Group, however, which functioned during 1944-46, had its own insignia and flag.

△ A group of six parachutists from Palestine pose before leaving for Europe. Seated, l. to r: Haviva Reik, Aryeh Fichman (Orni) and Surika Braverman. Standing, l. to r: Abba Berdichev, Zadok Doron (Dorogur), and Reuven Dafni.

△ Thousands of Jewish soldiers from Palestine serve in Italy during 1943-46. Jewish Brigade trucks are to be seen everywhere.

◁ Lahayal ("For the Soldier"), a Hebrew-language British army daily distributed to the Palestinian Jewish forces in Europe, announces the formation of the Jewish Brigade Group.

▽ In 1944, the Mandatory
government eases the food
ration regulations. "Ration
cards are no longer
required in restaurants,"
the notice says.

מ-1 בספטמבר
ביטול „נקודות"
במסעדות

◁ Etzel initiates a campaign
on February 1, 1944, against
the British presence in Pales-
tine and attacks government
installations. Shown, C.I.D.
headquarters in Jerusalem.

▽ Etzel newspaper *Herut*
urges its members not to
retaliate against the Palmah.

תשובתנו לאמני ההסתה

לבית־הַקְּבָרוֹת, קַבְּצָנִים!
וְחָפַרְתָּם עַצְמוֹת אֲבוֹתֵיכֶם וְעַצְמוֹתְכֶם אַחֵיכֶם הַקְּדוֹשִׁים
וּמִלֵּאתֶם תַּרְמִילֵיכֶם וַעֲמַסְתֶּם אוֹתָם עַל־שְׁכֶם וְיָצָאתֶם
לַדֶּרֶךְ, עֲתִידִים לַעֲשׂוֹת בָּהֶם סְחוֹרָה בְּכֹל הַיְּרִידִים;
וּקְרָאתֶם לַחֶסֶד לְאַפִּים וְהִתְפַּלַּלְתֶּם לְרַחֲמֵי גּוֹיִם, וְכַאֲשֶׁר
פְּשַׂטְתֶּם יָד תִּפְשֹׁטוּ, וְכַאֲשֶׁר שְׁנוֹרַרְתֶּם תִּ...רוּ.

חרות

יִ"ד כסלו תש"ה גליון ל"ט 3 בד צמבר 1944

לא תהיה מלחמת אחים!

THE SEASON

Etzel, initiating a campaign against the British presence
in Palestine on February 1, 1944, attacked a series of
government installations. Lehi, too, resumed sabotage
activity following a quiescent period resulting from the
arrest of most of its members. The Yishuv leadership
opposed Etzel's and Lehi's anti-British terror activity
during that period, at the height of the war and the anti-
Nazi struggle. The leaders of the Haganah met with
their counterparts in Etzel and Lehi, demanding that
they halt all such operations until the end of the war.

With the assassination in Cairo of Lord Moyne, the
British minister of state in the Middle East, by two Lehi
members on November 6, 1944, the Yishuv leaders
decided to take firmer action, unequivocally ordering
the two small organizations to halt all anti-British
activity. Lehi complied. Etzel refused, whereupon a
decision was made to block its operations by force.
Groups of Haganah volunteers detained and held Etzel
members, and the organization was shut down. Some of
the Etzel people held by the Haganah were turned over
to the British. Etzel Commander Menahem Begin or-
dered his people not to retaliate. Etzel was effectively
silenced until May 1945.

The entire episode acquired the label "the Season". It
bore two interpretations. For Haganah members, the
name expressed the limited time and restrained charac-
ter of the operation. Etzel members bitterly viewed it as
a "hunting season" and themselves as the prey.

Haganah cooperation with the British evoked debate
and criticism within the organization itself, although the
majority viewed it as a necessary evil so as to avoid
damaging the accomplishments of the Yishuv in antici-
pation of the final test of strength.

▽ Palmah scouts in the
Negev. Despite a British
ban on such activity, the
Palmah recruits scout the
entire country, especially
desolate regions.

▷ Palestine continues to serve as a base for Allied soldiers. Here, two American Air Force soldiers examine entertainment notices in Tel-Aviv. American bombers based in Palestine target the Germans in the Balkans.

Please, come on up!

△ Ongoing British anti-immigration restrictions elicit bitterness in the Yishuv, as reflected in this contemporary caricature.

▽ The first conclave of the Palmah, the recruited arm of the Haganah, is held in May 1944, in the groves of Mishmar Ha'emek.

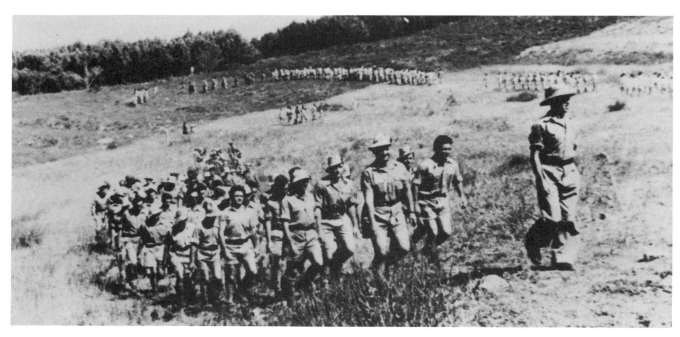

January

30 Chief Rabbis Itzhak Herzog and Ben-Zion Meir Hai Uziel are reelected for an additional five-year term.

February

13 Henrietta Szold, prominent Zionist leader of the National Council and Youth Aliyah, dies aged 85.

27 The Jewish Brigade reaches the Italian front in northern Italy and participates in combat against the Germans during the following months until close to the end of the war.

March

14 Five Palmah members from Kibbutz Bet-Ha'aravah are caught with weapons and are sentenced to prison terms of five to seven years.

A day of mourning for the victims of the Holocaust is declared. Appeals are made for intensified rescue efforts.

22 The two Lehi members who assassinated Lord Moyne on November 6, 1944, Eliyahu Hakim and Eliyahu Bet-Zuri, are executed in Cairo after being sentenced to death by an Egyptian court.

A major crisis develops in the Jerusalem municipality over the succession to the mayoralty following the death of the Arab mayor. The High Commissioner proposes a Jewish-Arab rotation arrangement, which is acceptable to the Jews but rejected by the Arabs.

April

4 The blue and white Jewish national flag is officially hoisted in the Jewish Brigade headquarters in Italy.

The Palmah forms a marine unit – Palyam.

May

8 VE Day in Europe. Germany surrenders to the Allies.

22 The British Labor Party once again adopts a pro-Zionist platform on the Palestine issue at its convention.

Etzel renews attacks against the British, sabotaging police stations, telephone lines, the Haifa oil pipeline, and other installations.

Jewish Brigade soldiers and other Palestinian Jews serving in units of the British army mount an aid operation

aimed at rehabilitating Holocaust refugees and directing them to Palestine.

June

7 The Jewish Agency, the Histadrut ("Federation of Labor"), and the Palestine Maritime League found a national navigation company, Zim, for merchant shipping.

8 Four hundred Jewish POWs from Palestine return home.

11 Eliyahu Golomb, head of the Haganah, dies aged 52.

July

11 The Mandatory government dissolves the Jerusalem municipal council following the failed attempt to institute communal rotation. A British administrative committee takes charge of running the city.

23 A combined Etzel-Lehi operation blows up the railroad bridge at Yavneh.

26 In Britain the Labor Party wins the elections by a landslide. The Yishuv, pleased, anticipates the repeal of the White Paper policy by Britain.

The movement of Jewish refugees from eastern Europe toward central and southern Europe grows. The operation, which acquires the name Brihah ("Flight"), is guided by Palestinian soldiers serving in the British army in Europe, especially in the Jewish Brigade.

August

1 The first Zionist conference since the war's end is held in London. It demands that the British grant 100,000 entry permits to Holocaust survivors immediately for entry into Palestine.

16 The British arrest 20 young Etzel members training at Shuni, south of Zikhron Ya'akov, most of them teenagers.

27 The illegal immigrants exiled in Mauritius since 1940 arrive in Palestine.

28 The final, and largest, chapter of the illegal immigration operation begins with the resumption of clandestine sailings from Italy. The Dalin reaches the

Palestine shore at Ceasarea with 35 immigrants, returning to Europe with several dozen emissaries who will handle clandestine immigration, arms acquisition, and aid to Holocaust survivors.

Instructions in Hebrew addressed to soldiers of the Jewish Brigade at the Italian Front.

31 American President Harry S. Truman demands that the British permit the entry of 100,000 Holocaust refugees into Palestine.

September

The Zionist leadership realizes that the new British government in London intends to continue the White Paper policy.

Etzel and Lehi heighten their efforts at funding their operations by means of bank robberies.

20-27 Jewish and Arab civilian workers at British army camps hold a general strike for higher pay and better working conditions.

30 The Habimah Theater building in Tel-Aviv is inaugurated, 10 years after the laying of the cornerstone.

"What marksmen!"
"What snipers! They managed to hit such small targets!"

This cartoon by Aryeh Navon in *Davar* ("A Matter") following violent British suppression of demonstrations in Tel Aviv on November 14th results in the suspension of the newspaper.

241

△ Young Holocaust survivors display the concentration camp numbers tattooed on their arms.

▽ The Palestine Folk Opera company mounts an indigenous opera about the lives of the Jewish pioneers and watchmen.

October

4 The Haganah renews its underground broadcasting on the Kol Israel station, which it had ended in 1940 with the looming Axis threat in the Mediterranean region.

6 A violent incident occurs at Kibbutz Kfar Gil'adi when the Transjordan Frontier Force fires on settlers aiding illegal Jewish immigrants from Arab lands crossing the Syrian border on foot. Fatalities result. Some of the illegals are interned at the Atlit detention camp.

9-10 The Palmah raids the Atlit camp and frees 208 immigrants, including the group arrested at Kfar Gil'adi, who face possible deportation.

11 British forces surround and search the Montefiore neighborhood in Tel-Aviv for arms. The inhabitants resist.

16 The Etzel detainees from Shuni are sentenced to prison terms of three to seven years.

The joint Hebrew Resistance Movement is organized by the Haganah, Etzel, and Lehi to coordinate anti-British activity.

November

1 The Night of the Trains – a large-scale anti-British operation, is carried out by the Hebrew Resistance Movement. The Palmah damages the Mandatory railroad network at 153 points and sinks three coastal patrol launches assigned to track immigrant ships. Etzel and Lehi attack the central railroad station in Lydda.

2 High Commissioner Lord Gort resigns due to ill health.

8 General Sir Alan Cunningham is appointed new High Commissioner.

13 British Foreign Secretary Ernest Bevin, in an anti-Zionist statement, announces the establishment of the Anglo-American Commission of Inquiry regarding the problems of European Jewry and Palestine, and a decision to permit a limited number of Jews – 1,500 – to enter the country monthly.

14 Demonstrations held in Tel-Aviv to protest Bevin's announcement are brutally suppressed by the British, resulting in six Jewish fatalities and dozens of wounded.

19 Thousands of soldiers serving in the Jewish Brigade in Western Europe hold a fast day in protest against Bevin's announcement.

23 The Berl Katznelson, an illegal immigrant ship, is spotted by the British at the coast of Shfayim after most of its passengers have been taken ashore. Six ships that preceded it landed success-fully.

25 Palmah units blow up British police and maritime tracking stations at Sidna Ali near Herzliya and Giv'at Olga near Hadera.

26 Violent incidents result from British efforts to uncover the perpetrators of the attacks on police stations. Large British forces raid Kibbutz Givat Hayim, Kibbutz Shfayim, and Moshav Rishpon, resulting in nine Jewish fatalities, dozens of wounded, and hundreds of arrests.

December

1 The Dan bus cooperative is founded.

3 The Arab League announces a boycott of Jewish produce in Palestine.

20 The British exile an additional 55 Etzel and Lehi prisoners to Eritrea.

25 The illegal immigrant ship Hanna Senesh successfully offloads its passengers at the Nahariya shore.

27 Etzel and Lehi forces attack British police headquarters in Jerusalem and Jaffa. The British announce a curfew for Jerusalem and Tel-Aviv and interrogate and arrest hundreds of suspects.

According to Jewish Agency estimates, 592,000 Jews reside in Palestine in 1945, constituting 32% of the population.

At the end of the world war, the Yishuv prepares itself to absorb the Holocaust survivors. It assumes that the British will permit their immigration.

ידיעות אחרונות

דניץ הודיע:

גרמניה נכנעת לכל בנות הברית האש נפסקה

צ'רצ'יל טלפן לסטלין וטרומן: „הערב יוכרז השלום. זאת היא השעה הגדולה"

△ Thousands gather at the Jewish national buildings in Jerusalem on V.E. Day. Newspapers issue special editions. Left: *Yediot Aharonot* ("Latest News") writes: "Germany surrenders. Shooting stops."

▽ One of the officers of the Jewish Brigade, which took part in the rout of the Germans from Italy toward the end of the war, is Hayim Laskov, later chief of staff of the Israel Defense Forces.

A SAD VICTORY

Millions celebrated the conclusion of World War II on the European front on May 8, 1945. The Jews rejoiced as well, but their joy was mixed with grief. By then, they knew that incredibly large numbers of Jews had been murdered by the Nazis.

The reaction in Palestine was subdued. David Ben-Gurion, the leader of the Yishuv, who was on a political mission in London at the time, wrote in his diary on May 8: "Victory Day - very, very sad."

The Jews of Palestine anticipated that the British would alter the White Paper policy and, among other things, take into account the contribution of the Yishuv to the British war effort. They soon realized their error.

THE RESUMPTION OF THE HA'APALAH (CLANDESTINE IMMIGRATION)

Efforts to bring Jewish illegal immigrants to Palestine – the Ha'apalah – resumed in the summer of 1945 on a large scale. They were prompted by the growing realization by the Yishuv leaders that the British did not intend to alter their policy of restricting Jewish immigration, even with the victory of the Labor Party in the British elections in July 1945 and despite the agony of the Holocaust.

Eight small vessels loaded with immigrants sailing from Italy and Greece broke the British blockade of the Palestine coast between August and December 1945, but the British tightened surveillance and from January 1946 intercepted most of the immigrant boats.

The unified Hebrew Resistance Movement formed in late 1945 functioned in coordination with the illegal immigration operation, which was supported by all sectors of the Yishuv. From then until the establishment of the State of Israel in 1948, the Ha'apalah effort constituted an integral part of the struggle of the Yishuv and the Zionist movement for independence.

▷ Thousands of Jews throughout Europe are on the move through snow-covered mountain passes and by every possible route to leave the killing fields behind. The migration soon swells into a mass movement of hundreds of thousands who are channeled to Displaced Persons camps in central and southern Europe. Most want to reach Palestine, but the British, who rule the country, bar them.

△ Poster for the annual self-imposed security tax – Kofer Hayishuv – contributed by the Jewish community in Palestine to aid in establishing new settlements.

◁ Jewish immigrants who reach Palestine on the scarce British entry permits are sprayed with D.D.T. on arrival.

244

△ A daring trek to Eilat is undertaken by Hano'ar Ha'oved ("Working Youth") together with the Palmah. Pictured on camelback is Shim'on Peres.

▷ A new high commissioner arrives in Palestine in November 1945, General Alan Cunningham. He will be the last.

PALESTINE'S BIGGEST CITY BESIEGED
EL AVIV'S 200,000
EING CHECKED BY
TWO DIVISIONS

△ The 1946 headline in the Palestine Post refers to the four-day curfew imposed by the British on Tel-Aviv at the end of July and the beginning of August. Confrontation between the Jewish population and the British becomes a daily occurrence.

▷ In the summer of 1945 the British return some 1,500 illegal immigrants who were deported from the Haifa harbor to detention camps on the island of Mauritius in the Indian Ocean in 1940. Conditions there were particularly harsh and many died of tropical diseases.

1946

January

The struggle against the British spreads to Europe. The Haganah establishes branches in the D.P. camps.

7 The Anglo-American Commission of Inquiry regarding the problems of European Jewry and Palestine begins its investigation abroad.

17 The Enzo Sereni, with 900 illegals aboard, is intercepted by the British.

20 The Giv'at Olga police station is blown up a second time by the Palmah.

28 The Mandate government publishes emergency regulations.

Etzel attacks the British air base at Tel-Nof.

The British step up arms searches in the Jewish settlements.

31 Eleven members of the Palmah involved in the overland illegal immigration operation are arrested in the Galilee.

February

6 An attempt to extricate the 11 Palmah members being held in the Safed police station fails.

Lehi attacks the British military camp near Holon and takes weapons from it. In response, soldiers from the camp run amok in the streets of Holon, shooting in all directions. Three bystanders are killed and many are wounded.

10 A referendum circulated in the D.P. camps in Germany indicates that 97% of the respondents want to go to Palestine.

18 The British trace a secret Lehi transmitter in Tel-Aviv. Among the arrested members is announcer Ge'ula Cohen.

20 The Palmah blows up a British radar installation for maritime tracking in Haifa.

22 Haganah units attack the Palestine Mobile Force (P.M.F.) bases.

Hashomer Haza'ir ("The Young Watchman") turns into a political party.

26 Etzel and Lehi attack British military airfields throughout the country. Dozens of aircraft are destroyed and damaged.

28 The British arrest all the members of the settlement of Biriya near Safed upon the discovery of weapons there.

March

5 A British force is stationed in Biriya.

6 The Anglo-American Commission of Inquiry arrives in Jerusalem and begins its investigation. The Hebrew Resistance Movement announces that it will halt military operations during the commission's deliberations.

14 Thousands of young people and Haganah members arrive in Biriya and set up a tent camp next to the British-occupied settlement.

23 Etzel attacks the Ramat Gan police station.

26 The Anglo-American Commission of Inquiry concludes its meetings and talks in Palestine.

27 Haganah forces clash with British military and police forces in Tel-Aviv when the illegal ship Orde C. Wingate is sighted. The incident is dubbed Wingate Night.

April

3 Etzel and Lehi groups attack targets along the railroad lines. Thirty-one Etzel members are caught.

6 British forces in Italy arrest 1,014 Jewish refugees who are about to board two illegal immigrant ships at La Spezia on the Italian coast. The refugees begin a hunger strike, which is joined by the leaders of the Yishuv in Palestine. Eighty-four hours later, the British relent and issue immigration permits for the group.

23-25 Etzel and Lehi attack a series of British targets, including the Ramat Gan police station and the Tel-Aviv railroad station.

May

1 The Anglo-American Commission of Inquiry report recommends the immediate granting of 100,000 immigrant permits to Holocaust refugees and a partial cancellation of the White Paper regulations. British Prime Minister Clement Attlee announces that his government will adopt the recommendations only after the private armies in Palestine have been disbanded. President Truman expresses satisfaction with the recommendation to settle 100,000 Holocaust refugees in Palestine.

13 The "illegal" immigrants of La Spezia reach Palestine on the ships Dov Hoz and Golomb.

14 The British intercept the Max Nordau and transfer 1,666 illegal immigrants to the detention camp at Atlit.

June

Hebrew Resistance Movement activity resumes.

3 A cornerstone ceremony is held for the Weizmann Institute of Science in Rehovot.

A commission of Anglo-American specialists (the Morrison-Grady Commission) discusses the application of the recommendations of the Anglo-American Commission of Inquiry.

10-11 Etzel and Lehi again attack the railroad network.

12 British Foreign Secretary Ernest Bevin pointedly attacks the Jews and Zionism.

13 The British hand down death sentences on Etzel members Yosef Simhon and Michael Ashbel for their role in an attack on a military base.

16-17 Palmah forces blow up 10 bridges linking Palestine with neighboring countries in the Night of the Bridges. Fourteen Palmah members are killed during the operation at the bridge near al-Zib north of Nahariya.

18 Lehi attacks railroad maintenance facilities at Haifa Bay. Eleven of the raiders are killed and 22 are caught.

Etzel abducts five British officers as hostages for the release of Ashbel and Simhon. The Hebrew Resistance Movement instructs Etzel to relase them. A curfew is imposed on Tel-Aviv and Jerusalem. Etzel releases two of the hostages and a third escapes.

29 Black Saturday dawns with mass arrests by the British, including of the leaders of the Yishuv; arms searches; and a general curfew. Thousands of Jewish Palestinians are imprisoned in the Rafah and Latrun detention camps. The leadership is held at Latrun.

July

1 An assembly of Yishuv representatives decides to sever all contacts with the British Mandatory authorities until they release the detainees, lift all restrictions, and allow the 100,000 immigrants in.

3 The High Commissioner pardons Ashbel and Simhon. Etzel releases the two remaining hostages that it holds.

22 Etzel blows up the southern wing of the King David Hotel in Jerusalem, which houses the central offices of the Mandate government and the British army headquarters. Casualties are 91 dead and hundreds wounded. The Yishuv is shocked. The incident ends the activity of the Hebrew Resistance Movement.

24 The British accuse the Jewish Agency of directing Haganah sabotage activity.

30 (Until August 2) The Great Curfew is imposed on Tel-Aviv. The British search the city house by house for terrorist suspects.

30 The Morrison-Grady Plan is published. It proposes regional autonomy for the Jewish and Arab populations in Palestine, with Britain retaining control of the country.

The British army commander in Palestine, General Barker, issues an order to the British soldiers in which he instructs them not to befriend the Jews. He warns that "the pocket is the Jewish race's weakest point."

△ Black Saturday at Kibbutz Yagur. On this day, June 29, 1946, the British mount a major campaign against the Yishuv. One of their primary targets is Yagur, in the Carmel foothills, where weapons stores are discovered.

▽ Black Saturday in Jerusalem. The complex of Jewish national buildings is taken over by the British, who carry out an exhaustive search. Arms hidden there, however, are not discovered.

August _____

5 The Jewish Agency Executive, convening in Paris, decides to suspend armed struggle and concentrate on the immigration operation, settlement, and political activity.

8 The British government repeals General Barker's orders.

13 The British begin to deport illegal immigrants from intercepted ships to detention camps in Cyprus. Angry demonstrations in Haifa in response result in three fatalities and many wounded.

17 Eighteen members of Lehi who took part in the raid on the railroad maintenance facilities are sentenced to death.

18 A Palmah group sabotages the British deportation ship Empire Heywood in the Haifa harbor.

22 The Palmah sabotages another British deportation ship, the Empire Rival.

26 Kibbutz Sdot Yam is put under siege and is searched by thousands of British soldiers in an attempt to reveal the saboteurs at the Haifa harbor. The British arrest 83 members of the kibbutz.

Ben-Gurion at the 22nd Zionist Congress in December 1946.

28 The British begin exhaustive searches at the northern Negev kibbutzim of Dorot and Ruhama lasting five days.

The death sentence for the 18 Lehi members is reduced to life imprisonment.

September _____

9 The British government holds a conference on the Palestine issue with the participation of all sides.

Neither the Jews nor the Arabs of Palestine do appear.

October _____

4 President Truman, in a message for Yom Kippur, announces his support for the partition of Palestine and the establishment of a Jewish state.

5-6 (Upon the close of Yom Kippur 5707) Eleven settlements are established in one night in the Negev – the largest settlement operation ever.

November _____

5 The British release the leaders of the Yishuv who have been imprisoned at the Latrun camp. The last of the remaining Black Saturday detainees are released during the following days.

Etzel and Lehi sabotage activity continues.

December _____

7 The illegal immigrant ship Rafiah sinks off the Cyclades Islands in the Aegean Sea. Eight of its 800 passengers drown. The immigrants are taken by the British to the detention camps in Cyprus.

9-24 The 22nd Zionist Congress is held in Basle. It is marked by deep conflict over the strategy for attaining statehood. Ben-Gurion champions the activist approach. Weizmann, advocating restraint, resigns and is not reelected as president of the Zionist Organization. Ben-Gurion is given the organization's defense portfolio.

A Jewish settlement record is set in 1946 with the establishment of 25 new settlements in all parts of Palestine.

During the year, 22 illegal immigrant ships reach Palestine with over 20,000 Holocaust survivors. Most are intercepted by the British and the immigrants arrested but released after short periods. From August onward they are detained in camps in Cyprus.

THE HEBREW RESISTANCE MOVEMENT

Founded in late 1945 and functioning until the end of July 1946, the Hebrew Resistance Movement was a unified operational framework established by the Yishuv national bodies headed by the Haganah with the cooperation of Etzel and Lehi. While each of the three resistance organizations continued to function separately, they coordinated their activities through approval from a senior authority, known as the X Committee.

Most of the Haganah activity, carried out by its recruited arm, the Palmah, centered on extricating interned illegal immigrants from the Atlit detention camp; sabotage of the coastal police installations, railroad lines and bridges; and attacks on the British mobile police force bases and radar installations. At the same time, the illegal immigration operation was kept up and intensified. Etzel and Lehi operations within the Hebrew Resistance Movement framework included attacks on the railroad network and on British airfields, as well as the abduction of British officers.

Cooperation began to deteriorate after Black Saturday (June 29, 1946), when mass arrests in the Yishuv were carried out by the British. The subsequent explosion in the King David Hotel in Jerusalem carried out by Etzel (July 22, 1946) split the joint resistance movement as well. From then, each underground operated as it saw fit.

▷ The railroad bridge at al-Hamma linking Palestine with Syria is destroyed by the Palmah on the Night of the Bridges.

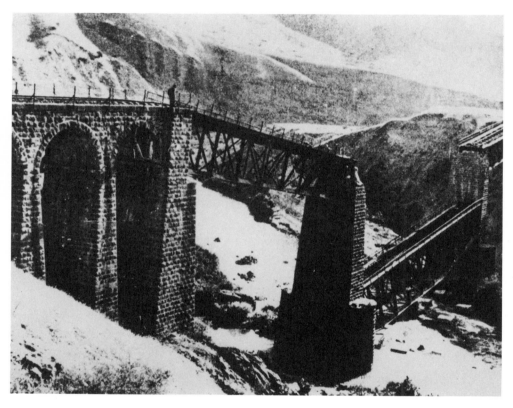

△ British soldiers use dogs in their search for arms at Kibbutz Sdot Yam in August 1946. Such a dog is the hero of Alterman's poem (below).

▷ Biriya will not fall. A camp next to the settlement of Biriya, which was taken over by the British, is set up by thousands of youngsters coordinated by the Haganah.

I smell the odor that won't go away,
Of the terrible end coming this way.
The empire declines before our eyes
No wonder its dog howls and cries.

Natan Alterman, "Lines by a Dog", *Hatur Hashvi'i* ("The Seventh Column") – *Davar* ("A Matter") – 8-30-1946.

◁ The King David Hotel, Jerusalem. British army headquarters in Palestine and the offices of the deputy High Commissioner are housed in the southern wing of the hotel.

▽ The King David Hotel after the explosion set off by Etzel on July 22, 1946. The entire southern wing collapses, resulting in 91 fatalities – British, Jewish, and Arab. The incident causes shock waves in the Yishuv.

▽ Le'asirenu ("For our Prisoners") association attends to the needs of the underground prisoners and of their families.

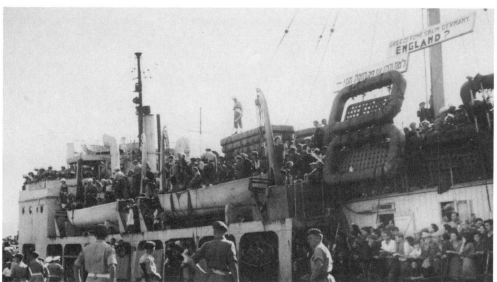

◁ The illegal immigration operation grows from month to month during 1946, with 22 ships reaching Palestine by the end of the year. From August 1946 onward, the British exile the passengers who are caught to internment camps in Cyprus. The immigrants, most of them Holocaust survivors, actively resist. They display banners such as that shown here, which enumerates historic persecutors of the Jewish people, from Greece and Rome to Spain and Germany, asking: And now, England?

THE ANGLO-AMERICAN COMMISSION OF INQUIRY

With the end of World War II, hundreds of thousands of Holocaust survivors streamed into Displaced Persons camps in Germany, their status and fate unclear. United States President Truman dispatched a personal representative, Earl G. Harrison, to examine the situation. Following a tour of Germany, Harrison submitted a series of recommendations based on the Zionist premise that the refugees belonged in Palestine and proposed the immediate transfer of 100,000 of them there as immigrants.

Truman adopted the recommendations, to the chagrin of the British, who then proposed that the Americans join with them in studying the Palestine problem and the question of the Jewish refugees in a formal framework. This led to the formation of the Anglo-American Commission of Inquiry, with six American and six British members. The commission visited the D.P. camps in early 1946, arriving in Palestine in March and meeting with representatives of the Jews, Arabs and British.

Their findings, published at the end of April, 1946, included, among other things, the unanimous recommendation that the 100,000 refugees in Europe immigrate to Palestine by right and that the 1939 White Paper regulations be repealed.

The British, who had promised to carry out the unanimous conclusions of the commission, made it a condition that all illegal fighting units in Palestine, whether Jewish or Arab, be disbanded.

Consequently, the proposals of the Commission of Inquiry were rendered invalid, and the Hebrew Resistance Movement renewed its armed struggle.

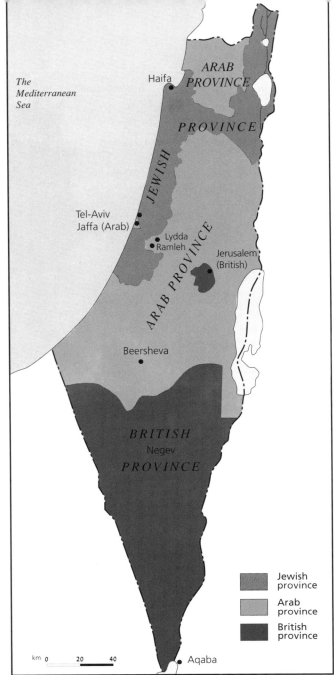

The Mediterranean Sea

Haifa
ARAB PROVINCE

JEWISH PROVINCE

Tel-Aviv
Jaffa (Arab)
Lydda
Ramleh
Jerusalem (British)

ARAB PROVINCE

Beersheva

BRITISH
Negev
PROVINCE

Jewish province

Arab province

British province

km 0 20 40
Aqaba

△ The regional autonomy plan (the Morrison-Grady Plan) proposed in the summer of 1946.

▽ Kibbutz Hatzerim in the Negev, one of 11 settlements established following the close of Yom Kippur, October, 1946.

△ News of the establishment of Kibbutz Yehi'am in the Western Galilee in the fall of 1946 is conveyed by heliograph, a telegraph method using the sun's rays, to Kibbutz Evron.

January

1 The Mekorot water company begins laying a pipeline from the Nir Am area in the Northern Negev to new settlements in the region.

Etzel and Lehi activity intensifies.

31 The British announce the formation of security zones – British enclaves for self-protection (dubbed Bevingrads by the population) – and the evacuation of British women and children from Palestine.

February

2 The British demand that the Yishuv leadership play an active role in eliminating terror. The demand is rejected by the Jewish Agency and the National Council.

4 The Tel-Aviv All-Star soccer team beats the Budapest All-Stars 3:1. The game is broadcast live on the Voice of Jerusalem – a first in Palestine.

13 Palmah saboteurs blow up four British navy vessels assigned to interception of immigrant ships.

18 British Foreign Secretary Bevin announces that talks with the Jews and Arabs regarding the future of Palestine have failed and that the British government will pass on the Palestine problem to the U.N.

27 The Chaim Arlozoroff illegal immigrant ship with 1,350 passengers on board reaches the Bat-Galim beach in Haifa, where it is intercepted by the British. All the immigrants are deported to Cyprus.

March

1 Etzel attacks the British Officers' Club in Jerusalem, resulting in 12 fatalities and over 20 wounded.

2 The British impose martial law on Tel-Aviv and part of Jerusalem, which lasts 15 days.

17 A Lehi member, Moshe Barazani, is sentenced to death for possession of a hand grenade.

29 The British intercept the illegal immigrant ship Moledet with 1,560 on board.

31 Lehi sabotages the oil refineries at Haifa Bay, causing extensive damage.

April

3 Palmah saboteurs damage the British deportation ships Ocean Vigor at Cyprus and Empire Rival en route to Port Sa'id.

13 The illegal immigrant ship Theodor Herzl, carrying 2,640 persons, is caught by the British.

16 The British execute four Etzel members by hanging: Dov Gruner, Yehiel Drezner, Eliezer Kashani and Mordechai Alkahi.

21 Meir Feinstein of Etzel and Moshe Barazani of Lehi, sentenced by the British to be executed, commit suicide in Jerusalem prison.

25 Etzel and Lehi attack British army camps, police stations, and trains in an intensive week-long barrage.

28 A special session of the U.N. General Assembly is called to discuss the Palestine question.

The Hapo'el soccer team leaves for a series of games in the United States, where it is received warmly. It scores four victories, three draws and two defeats.

May

4 Etzel breaks into Acre prison and frees several dozen of its members.

14 The U.N. General Assembly decides to dispatch an international committee to recommend a solution to the knotty tripartite Jewish-Arab-British problem. Soviet delegate Andrei Gromyko delivers a speech supporting the right of the Jewish people to independence in Palestine.

31 The first illegal immigrant ship from North Africa, Yehuda Halevi, arrives.

June

The United Nations Special Committee on Palestine (U.N.S.C.O.P.), consisting of representatives of 11 countries, arrives in Palestine for tours and interviews that take several weeks.

18 Haganah member Ze'ev Verber is killed while un-covering a tunnel dug by Etzel in preparation for a planned explosion in the Bet-Hadar office building in Tel-Aviv, an area in the British security zone.

July

Etzel and Lehi keep up sabotage activity against the British during the course of the month.

12 Etzel abducts two British sergeants in Netanya and holds them as hostages for three of its members sentenced to death. The British, in response, impose a curfew on the Netanya area and conduct exacting searches.

18 The British intercept the illegal immigrant ship Exodus 1947 with 4,515 persons aboard and tow it into the Haifa harbor. The immigrants are transferred to three deportation ships, which sail west, but not to Cyprus.

21 Palmah units blow up radar installations on the Carmel.

23 Palmah saboteurs blow up the British deportation ship Empire Life Guard.

29 The three British deportation ships with the Exodus immigrants on board reach Port-de-Bouc in south-ern France. The passengers are allowed to go free but refuse to disembark.

The British execute three members of Etzel by hanging – Avshalom Haviv, Ya'akov Weiss, and Meir Nakar.

30 In response, Etzel hangs the two British sergeants it held hostage.

31 British soldiers run amok in Tel Aviv, shooting indiscriminately. Five Jewish bystanders are killed and over 20 are wounded.

1947

August

The demand by the Exodus passengers at Port-de-Bouc to be returned to Palestine and their refusal to disembark attract international attention.

5 The British arrest three Jewish mayors as part of their anti-terrorist effort – Israel Rokakh (Tel-Aviv), Avraham Krinitzi (Ramat Gan) and Oved Ben-Ami (Netanya) – along with attorneys, journalists and public figures sympathetic to the Revisionist movement.

10 Resuming terrorist activity after a long lull, Arabs attack diners at the Hawaii Park coffee house along the Yarkon River in northern Tel-Aviv, killing five and wounding seven. Fatalities include actor Meir Te'omi.

14 Arab-induced violent incidents at the Jaffa-Tel-Aviv boundary result in three Jewish fatalities and dozens of wounded. Arab attempts to attack Jewish neighbor-hoods are repulsed by the Haganah.

21 The British announce that the three deportation ships at Port-de-Bouc will sail to Hamburg, Germany. The Jewish world is in an uproar.

A young illegal immigrant en route from Haifa to the detention camps.

September

1 The U.N.S.C.O.P. report is published. It recommends ending the British Mandate and partitioning Palestine into a Jewish state, an Arab state, and an international zone in Jerusalem.

8 The Exodus passengers actively resist disembarking from the British deportation ships at the Hamburg port in front of hundreds of reporters and photographers.

26 British Colonial Secretary Arthur Critch Jones announces that his country is prepared to relinquish the Mandate for Palestine.

27 The first illegal immigrant ship following the Exodus episode is symbolically named the Af-al-pi-khen ("Despite Everything").

29 Etzel blows up police headquarters in Haifa.

October

21 Tension mounts in the Upper Galilee when a Syrian force penetrates Palestine. It is routed by the British. The Haganah assigns a Palmah battalion to reinforce settlements in the region.

Confrontations take place between members of the Haganah and Etzel and Lehi members involving the prevention of mounting posters, fights, and even kidnappings.

November

The U.N. General Assembly discusses the U.N.S.C.O.P. report. Intensive Jewish-Zionist efforts are made to obtain a majority of two-thirds for the partition plan. The Soviet Union supports the plan. The United States wavers.

15 The Jewish Agency and the National Council set up the Headquarters for National Service to organize recruitment in the event of emergency.

16 The Aliyah illegal immigrant ship breaks through the British coastal blockade and brings its 180 passengers ashore at the Nahariya beach.

29 The U.N. General Assembly approves the partition plan for Palestine by 33 to 13 with 10 abstentions, signifying the establishment of a Jewish state in 55% of the country. The news is greeted by an outburst of joy in the Yishuv and in Jewish communities throughout the world and with anger in the Arab population and in the Arab countries.

30 Two Egged buses on the road from Hadera and Netanya to Jerusalem, respectively, are attacked by Arabs between Petah Tikva and Lydda, resulting in six fatalities and many wounded. These incidents are considered the start of the War of Independence.

December

1 The Arab Higher Committee announces a three-day general strike in protest against the U.N. decision.

2 Arabs attack the commercial center of Jerusalem and set it alight.

8 Haganah forces repulse an Arab attack on the Hatikva neighborhood in Tel-Aviv.

10 Arabs attack the water pipeline guard headquarters in the Negev, to be followed by repeated attacks there.

14 Arabs attack an armed convoy to Ben-Shemen, with 14 Jewish fatalities.

15 The British evacuate from the Tel-Aviv area.

30 Arabs attack Jewish workers in the oil refineries in Haifa, killing 39.

31 The Haganah mounts a large-scale reprisal in the village of Balad al-Sheikh in response to the massacre in the refineries.

The most famous photograph of 1947: A mass outburst of joy in Tel-Aviv on the night of November 29, 1947, over the U.N. decision to approve the partition plan.

▽ Derisively dubbed Bevingrad, a security zone is set up by the British in the center of Jerusalem, as in several other cities.

▷ A caricature of General Barker, commander of British military forces, who leaves Palestine following threats on his life made by the underground.

△ The British ban all Jewish traffic in response to acts of sabotage against them.

Only ambulances and hearses are permitted.

IN THE SHADOW OF THE STRUGGLE FOR INDEPENDENCE

Life in Palestine in 1947 was filled with tension. The year was marked by struggle, raids by the Jewish underground, the imposition of martial law by the British, widespread arrests, and frequent curfews.

During the course of the year, the British lost their desire to continue ruling Palestine, passing on the "Palestine problem" to the U.N. Simultaneously, they made every effort to suppress Jewish resistance. The atmosphere was tense, with events unfolding in rapid succession: raids on British targets and security forces; the self-sequestering of the British in security zones, dubbed Bevingrads (after Bevin) by the Jews; the intensification of the illegal immigration operation, which reached a climax with the Exodus episode; the arrival in Palestine of the U.N.S.C.O.P.; the execution of Etzel and Lehi fighters; and internal tension between the Yishuv leadership, the Haganah, on the one hand, and Etzel and Lehi on the other.

The Arabs stood on the sidelines for most of the year, apparently not having recovered from the internal blood-letting that took place during the Arab Revolt. Nevertheless, the economic prosperity, generated during the war, resumed. The British soldiers, who were brought in to suppress the Jewish resistance, also represented important purchasing power. Eventually, this economic strength would prove invaluable to the Yishuv during the forthcoming War of Independence.

No state is given on a silver platter, and the partition plan gives the Jews only a chance... If we do not take advantage of the opportunity that has been given to us [to establish a state], we shall miss our rendezvous with history.

Dr. Hayim Weizmann, from a speech delivered at a United Jewish Appeal conference in Atlantic City, December 13, 1947.

◁ Dr. Weizmann's remark serves as the basis for the famous poem by Natan Alterman, *The Silver Platter*, published six days later, in the *Seventh Column* section in the newspaper *Davar* ("A Matter").

△ Prof. Eliezer Lipa Sukenik acquires the first of the Dead Sea Scrolls (the Qumran scrolls) in late 1947.

△ Etzel forces break into Acre prison in May and free dozens of their comrades imprisoned by the British for their underground activity.

◁ Mounting anti-British activity by the Jewish underground organizations in 1947 prompts the deployment by the British of machine gunners everywhere and the frequent imposition of curfews on the Jewish population, mostly in the big cities.

△ Political discussions in London on the Palestine question reach a dead end in early 1947. David Ben-Gurion, chairman of the Jewish Agency Executive, (left) appears grim as he leaves the British Colonial Office.

THE EXODUS EPISODE

The illegal immigrant ship Exodus 1947 focused world attention on the issue of the post-World War II Jewish refugees in Europe and on the Jewish struggle for independence in Palestine.

The ship set out for Palestine from the port of Sète in southern France on July 11, 1947, with 4,515 immigrants on board. While still outside Palestine territorial waters, it was overcome by British naval forces. The passengers resisted actively, and in the struggle two Jewish immigrants and an American Jewish escort were killed and many wounded. The ship was towed into the Haifa harbor and its passengers forcibly transferred to deportation ships which set out, surprisingly, for Port-de-Bouc in France instead of for the detention camps of Cyprus, the usual British procedure. Arriving there, the immigrants refused to disembark, demanding to be returned to Palestine. The ships remained moored at the French port for three weeks. Finally, the British decided to return the refugees to the country of the origin of their voyage, Germany, and the three ships sailed for Hamburg. There, disembarkment was accomplished with the use of considerable force, receiving wide international press coverage.

The Exodus episode may well have hastened the end of the British Mandate for Palestine. Some of the members of the U.N. investigative committee (U.N.S.C.O.P.), which was then in Palestine, visited Haifa port at the time of the deportation, and the entire committee later followed the episode, which unfolded as the delegation was drawing up its findings. One of these findings defined Jewish immigration as the central problem in Palestine and pointed to the creation of a Jewish state according to the partition plan as the only hope for removing this problem from the arena of the conflict.

▽ The Exodus in the port of Haifa, July 1947. The illegal immigrants are boarded on three ships and deported to Europe.

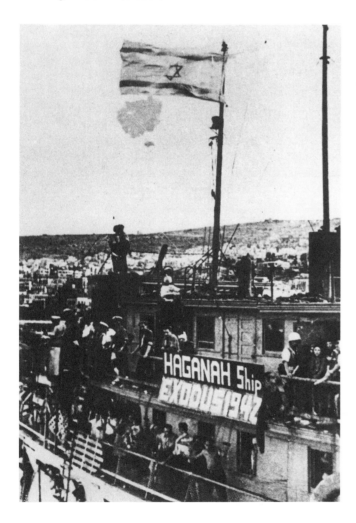

△ The Brihah ("Flight") operation continues throughout Europe. Tens of thousands of Jewish refugees are brought to coastal areas and from there set sail for Palestine on illegal ships.

▷ A small illegal air operation is also mounted, utilizing a single plane flown by American volunteer pilots who land 100 immigrants from Iraq and 50 from Italy in three flights.

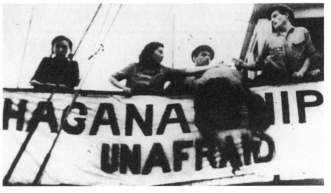

▷ The illegal immigrant ships bear symbolic names and are identified as Haganah vessels, as on the Unafraid, (shown). The ship reaches Palestine in December 1947.

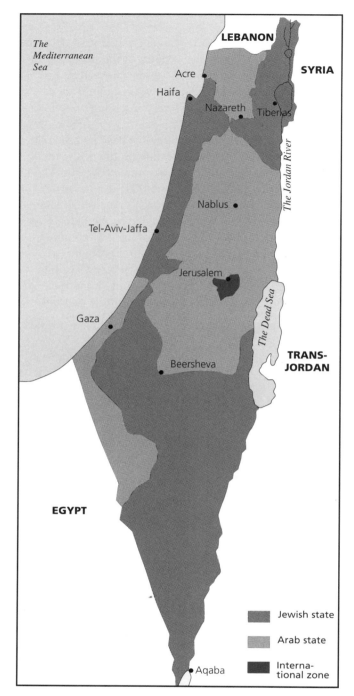

THE UNITED NATIONS SPECIAL COMMITTEE ON PALESTINE (U.N.S.C.O.P.)

A special session of the U.N. General Assembly convened in the spring of 1947 at Britain's request to discuss the "Palestine problem," appointed an investigative committee of 11 members who represented Sweden, Holland, Poland, Yugoslavia, Canada, Australia, India, Iran, Uruguay, Guatemala and Peru. The committee arrived in Palestine in June 1947 and spent several weeks in meetings, including in Lebanon and Transjordan. The members also visited the Jewish D.P. camps in central Europe.

The committee, whose findings were published at the end of August 1947, unanimously recommended that the British Mandate be ended immediately. A majority of seven members recommended partitioning the country into two states, Jewish and Arab. The Jews would be given the Eastern Galilee, the northern valleys, most of the coastal region and nearly all the Negev. The Arabs would receive the Western Galilee, the mountain regions, the Gaza Strip and part of the Negev. According to the recommendation, the two newly established states were to implement "economic unity." Jerusalem would be a separate entity under international supervision.

Three of the committee members (the representatives of India, Iran, and Yugoslavia) submitted a separate report recommending the establishment in Palestine of a binational federal state. The Australian delegate abstained.

The U.N. General Assembly adopted the partition plan submitted by the committee majority – with adjustments that included reducing the area of the Jewish state somewhat – on November 29, 1947.

◁ The U.N.S.C.O.P. partition plan map.

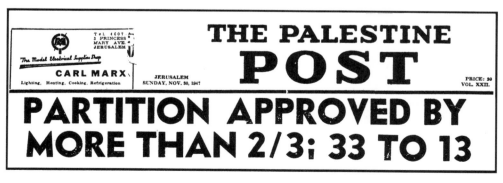

△ Oversized headlines in all the Yishuv newspapers on the morning of November 30, 1947, announce the historic U.N. decision.

▷ The young conductor Leonard Bernstein visits Palestine.

▽ The morning after: British military policemen join celebrating Jerusalemites.

▷ The morning after: an old Jew in Jerusalem celebrating the U.N. resolution – which means the creation of a Hebrew state.

△ The rejoicing is short-lived. Arab violence begins immediately, marking the start of a prolonged war. Tel-Aviv is attacked from the direction of Jaffa. Above, a Jewish casualty on Allenby Street, Tel-Aviv's main artery.

▷ The front has moved to the Carmel market too, situated between Jaffa and Tel-Aviv. The Hebrew sign reads: "Danger, the Enemy Sees You."

1948

January

1 The two largest illegal ships, the Pan York and Pan Crescent, carrying over 15,000 persons, are towed to Cyprus.

4 A Lehi group blows up the Arab command building in the center of Jaffa, causing 14 fatalities and approximately 100 wounded.

14 Defenders of the Etzion Bloc repulse a large Arab attack.

16 A platoon of 35 Haganah fighters (later commemorated as The 35) attempt to reach the besieged Etzion Bloc on foot from Hartuv and is cut down and massacred by Arabs.

23 The Mapam ("United Workers") party is formed by an amalgamation of the Hashomer Hatza'ir ("The Young Watchman") and Ahdut Ha'avodah-Po'alei Zion ("United Labor"-"Workers of Zion") parties.

Arab attacks on Jewish traffic continue in all parts of the country. Cars run only in convoys. The armoring of vehicles is introduced. Bloody incidents occur in the Jaffa-Tel-Aviv boundary neighborhoods, Jerusalem, and Haifa.

February

1 A booby-trapped car, prepared jointly by British soldiers and Arabs, explodes in front of the *Palestine Post* building in Jerusalem, resulting in nine casualties and extensive damage. The newspaper, nevertheless, comes out the next morning.

14-15 The bridges along the northern border are blown up by the Palmah, and the Arab village of Sa'sa' is raided, in Operation 35, named for the Haganah platoon massacred the previous month.

15 Two new evening newspapers appear: *Ma'ariv* ("Evening News"), formed by a group that left *Yediot Aharonot* ("Latest News"), and *Yom-Yom* ("The Daily"), published by *Ha'aretz* ("The Land").

16 Defenders of Kibbutz Tirat Zvi repel an attack by the Arab Liberation Army.

22 Three booby-trapped cars placed by British army deserters explode on Ben-Yehuda Street in Jerusalem, resulting in over 50 fatalities, a large number of wounded, and severe damage.

March

13 A new heavy mortar, the Davidka, invented by David Leibowitz and manufactured by the Haganah underground, is put into use on the Jaffa front.

17 An Arab arms convoy en route from Lebanon to Haifa is destroyed by the Haganah near Kiryat Motzkin.

The Navy Corps is established.

19 The United States informs the U.N. Security Council of the withdrawal of its support for the partition plan and proposes a U.N. trusteeship in Palestine. The Yishuv is deeply disappointed.

28 Arab forces in the Western Galilee block an armed convoy to Kibbutz Yehi'am, which is under siege, resulting in 47 Jewish fatalities.

31 A Jewish convoy is blocked en route to Jerusalem. The city is effectively cut off.

A first arms shipment

Postmark from 1948, before the foundation of the state.

from Czechoslovakia is flown into the Yishuv clandestinely.

April

3-15 Operation Nahshon reopens the road to Jerusalem, permitting the passage of convoys bringing equipment, food, and reinforcements into the city.

4-12 The Arab Liberation Army attacks Kibbutz Mishmar Ha'emek and is repulsed.

8-9 Control of the Castel Hill on the road to Jerusalem changes hands several times in heavy fighting. The commander of the Arab Jerusalem region, Abd al-Kadir al-Husseini, is killed in the fighting.

9 Etzel and Lehi attack the Arab village of Deir Yassin, resulting in over 200 Arab fatalities in the village.

10-12 The Arab League Council approves a plan for the invasion of Palestine by the armies of the Arab states upon the conclusion of the Mandate.

12 The Zionist Executive convenes in Tel-Aviv and decides to establish a provisional government and state council.

12-16 A Druze battalion of the Arab Liberation Army is repulsed in fighting at Kibbutz Ramat Yohanan, followed by the signing of a nonbelligerency agreement between the Haganah and the Druze.

15-20 Operation Harel on the road to Jerusalem, a continuation of Operation Nahshon, maintains security on the highway, allowing the continued flow of convoys of supplies and equipment to the capital.

18 The Arab part of Tiberias falls to the Haganah.

20 The road to Jerusalem is blocked again.

21-22 Haganah forces overcome Arab forces and take control of Haifa.

28 Etzel forces attack Jaffa and take over the Manshiyeh neighborhood. The British intervene and prevent further fighting. Simultaneously, the Haganah encircles Jaffa by capturing outlying Arab villages.

30 The Haganah captures the Katamon quarter of Jerusalem.

May

1-12 The Haganah takes control of the Upper Galilee in Operation Yiftah.

10 The battle for Safed ends with the flight of the Arabs from the city.

12 The Arab town of Bet-She'an is captured.

12-13 Large Arab forces, reinforced by the Arab Legion, capture Kibbutz Kfar Etzion.

13 The Arabs of Jaffa surrender to the Haganah forces.

14 The three remaining settlements of the Etzion Bloc – Massu'ot Itzhak, Ein-Tzurim, and Revadim – surrender to the Arab Legion.

The British evacuate from Jerusalem. Jewish forces take control of most of the areas that the British had held.

(5 Iyar 5708) The State of Israel is established.

The United States recognizes the new state.

15 Five Arab armies invade the territory of the newly established State of Israel – Syrian, Lebanese, Iraqi, Transjordanian, and Egyptian. Tel-Aviv is bombed by Egyptian planes.

17 The Soviet Union recognizes the State of Israel. Many other countries

The aftermath of the Egyptian bombing of Tel-Aviv, May 1948.

Bus on the Burma Road, July 1948.

then follow suit.

18 Acre surrenders. The entire Western Galilee is in the hands of the Haganah.

20 The battle for Kibbutz Deganya ends with the retreat of the Syrian army.

21 The U.N. appoints Swedish Count Folke Bernadotte as mediator for Palestine.

23 Egyptian forces reach Kibbutz Ramat Rahel from the south and attempt to penetrate Jewish Jerusalem. The kibbutz changes hands several times until the enemy is repelled on the 26th.

25 An Israeli attack on Latrun with the aim of opening the road to Jerusalem is repulsed.

28 Defenders of the Jewish quarter in the Old City of Jerusalem surrender to the Arab Legion after prolonged fighting.

Lehi forces join the Israel Defense Forces that are about to be established.

31 An order for the establishment of the Israel Defense Forces (I.D.F.) is issued by the provisional government. The new army is based primarily on the Haganah forces.

The Cameri Theater presents *He Walked through the Fields* by Moshe Shamir. It becomes a hit.

June

1 Etzel agrees to join the I.D.F.

A dirt road is cut through the mountains circumventing Latrun – the Burma Road. The siege of Jewish Jerusalem is thus lifted.

11 The U.N. declares a four-week truce, accepted by all sides.

20 An arms ship sponsored by Etzel, the Altalena,

anchors off Kfar Vitkin. Part of its cargo is unloaded and transferred to the I.D.F. Etzel then halts the unloading and the ship sails for Tel-Aviv.

22 The Altalena goes up in flames off Tel-Aviv after being shelled by the I.D.F. when Etzel refuses to hand over the remaining arms.

July

9-18 The battles of the Ten Days: The I.D.F. mounts attacks in the central region and the Lower Galilee. The Arab cities of Ramleh, Lydda, and Nazareth are captured, as are numerous Arab villages.

17 Finance Minister Eliezer Kaplan introduces the new Israeli currency, replacing the Mandatory currency. The Israeli pound (IL)=$4.00.

19 A second, open-ended truce takes effect.

27 Induction ceremonies for the I.D.F. are held. Army ranks are made public for the first time.

August

9 Soviet Special Representative to Israel Pavel Yershov arrives.

12 United States Special Representative to Israel James McDonald arrives.

17 The new banknotes issued by the Anglo-Palestine Bank come into use.

29 Golda Myerson (later, Meir), special representative to the Soviet Union, leaves for Moscow.

September

13 The Supreme Court of the State of Israel, consisting of five justices, is inaugurated in Jerusalem. Chief Justice is Dr. Moshe Zmora.

17 U.N. Mediator Count Folke

Bernadotte is murdered in Jerusalem by a group called the Fatherland Front, in effect Lehi members. The government declares Lehi illegal.

October

15 Operation Yo'av begins, aimed at pushing back the Egyptians from the Negev. The I.D.F. achieves major victories.

20 The Egyptian siege of the Negev is ended.

21 The I.D.F. captures Beersheva.

26 The Egyptians evacuate the area around Ashdod which they had captured in May and begin retreating toward the Gaza Strip.

29-31 The I.D.F. mounts Operation Hiram in the Galilee, capturing in 60 hours all the territory held by the Arab Liberation Army up to the international border in the north and taking control of 14 villages in southern Lebanon.

For want of coins, the state issues paper pennies.

November

Acting U.N. Mediator Ralph Bunche demands that Israel retreat in the Negev to the positions it held on October 14th. U.N. sanctions are feared if Israel does not accede.

4 The chief U.N. observer in Palestine, United States Brigadier General William E. Riley, turns the tide in Israel's favor, asserting at a Security Council session convened in Paris that the facts in the Negev are irreversible. The council calls for Israel's withdrawal but does not threaten sactions.

7 In a far-reaching

reorganization of the I.D.F. ordered by Defense Minister David Ben-Gurion, the Palmah command is disbanded.

8 A population census is conducted. The total population is 782,000, of whom 713,000 are Jews and 69,000 Arabs.

15 The maiden flight of the newly established national airline, El Al, brings the president of the Provisional State Council, Dr. Hayim Weizmann, from Geneva to Israel.

16 The U.N. Security Council calls upon all sides to begin armistice negotiations. Israel assents and informs the U.N. that its fighting forces have been returned to their bases, with only reduced forces remaining in the Negev.

24-25 Operation Lot results in the takeover by the I.D.F. of parts of the eastern Negev and northern Arava, reestablishing the link to Sodom, which had been cut off.

30 After weeks of cease-fire violations, representatives of the I.D.F. and the Jordanian Legion sign a "sincere" cease-fire in Jerusalem.

Israel applies for membership in the U.N.

December

7 The Road of Valor to Jerusalem is inaugurated, replacing the Burma Road.

25 (Until January 7, 1949) The I.D.F. mounts Operation Horev, ejecting the Egyptians from the Negev although not from the Gaza Strip.

29 I.D.F. forces penetrate into Sinai, capturing Abu Ageila and flanking al-Arish.

From the establishment of the state in mid-May until the end of December 1948, 102,000 immigrants stream into the country, a figure equal to total Jewish immigration during 1940-47.

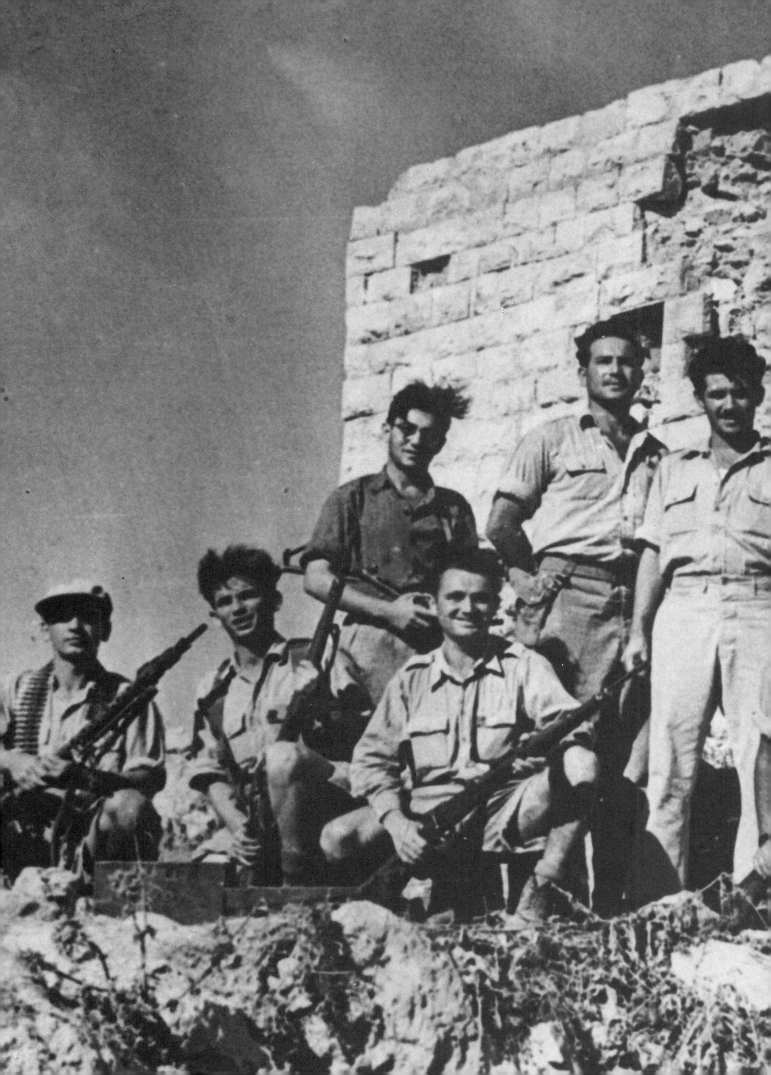

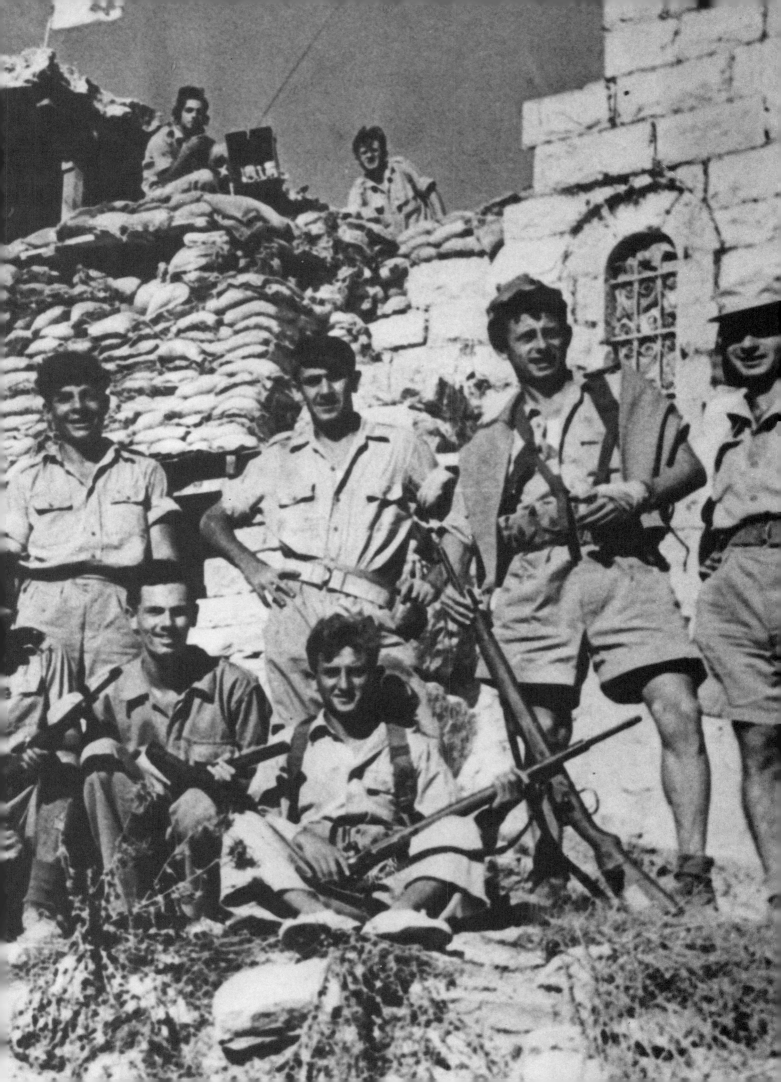

STAGES OF THE WAR OF INDEPENDENCE

The War of Independence lasted over one and a half years, from November 30, 1947, until July 20, 1949. As most of it took place in 1948, it is also called the War of 1948.

The war may be divided into five main stages:

(1) The Jewish defensive stage, or the Battle of the Highways, from December 1947 until March 1948. The Arabs were on the offensive and the Jews generally on the defensive.

(2) The first Jewish attack, from April until mid-May, 1948. The Jewish fighting forces switched to the offensive, subdued the Palestinian Arabs and gained control of a significant portion of the territory of the Jewish state. They captured the mixed Arab-Jewish cities of Haifa, Tiberias, and Safed, and the Arab cities of Jaffa, Acre, and Bet-She'an.

(3) Invasion by the Arab armies, blocked by the Israelis, from mid-May until June 11, 1948.

(4) The major Israeli attacks, from July 9, 1948, until January 7, 1949.

(5) Signing of the armistice agreements, January-July, 1949. Fighting ended and agreements were signed with Egypt, Lebanon, Transjordan, and Syria. Iraq refused to sign an agreement.

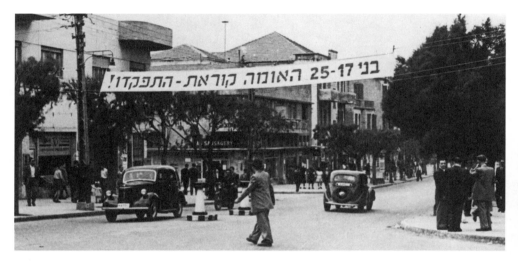

בני 17-25 האומה קוראת - התפקדו!

◁ The banner reads: "17-25-year-olds, your nation calls, enlist!" Thousands, and then tens of thousands, sign up for the Haganah, which later becomes the Israel Defense Forces.

Pages 260-61: A Palmah unit after the capture of the Castel Hill on the road to Jerusalem, April 1948. The Palmah is at the forefront of the fighting during 1948.

▽ An Arab attack on a Jewish convoy, winter 1948. The Arabs have more manpower than the Jews but are less organized and sophisticated. They attain a measure of success until the end of March 1948, staging numerous attacks on Jewish traffic along the Jerusalem-Tel-Aviv road.

△ Women, too, fight in the War of 1948.

△ The image of the fighting sabra (native-born Israeli). Nearly every male below 40 takes part in the fighting.

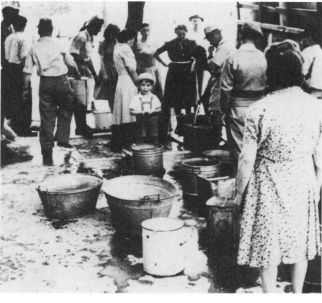

△ A typical scene in Jerusalem under siege: water is rationed. It is collected in cisterns and distributed by pails to the inhabitants.

▽ A homemade armored vehicle. The Haganah Armored Corps consists largely of this type of vehicle in 1948.

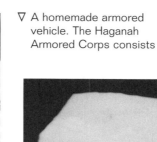

◁ Zohara Levitov, a woman pilot in the country's new air force.

▷ Gunners in the southern part of the country try to bring down an Egyptian fighter plane.

▽ The surrender of Nazareth to the I.D.F. in July 1948. The Arab and the mixed Arab-Jewish cities fall to the Haganah and the I.D.F. one after another.

▷ The high point of the year is the ceremony marking the establishment of the State of Israel, which takes place in Tel-Aviv on Friday, May 14, 1948, eight hours before the British Mandate expires. The ceremony precedes the expiration because of the Sabbath. Shown, David Ben-Gurion reading out the Declaration of Independence.

▽ Following the reading of the Declaration of Independence, the members of the Provisional State Council sign the document one by one. Shown from l. to r.: David Ben-Gurion, Peretz Bernstein, and Moshe Shertok.

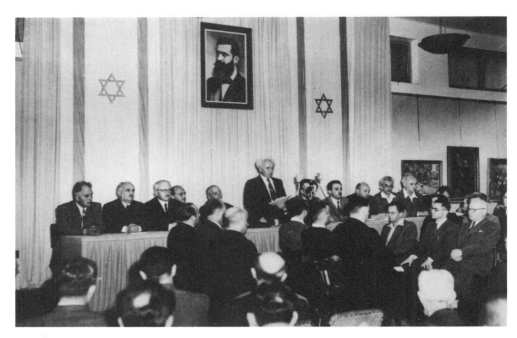

▽ The state's first currency bills, issued by the Anglo-Palestine Bank (later, Bank Leumi), are printed in New York before the name of the state is known. Their design is based on patterns from the printer's workshop which previously served for printing Chinese money.

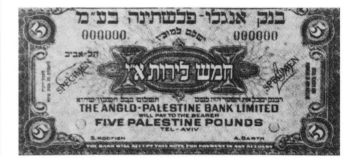

TO DECLARE THE ESTABLISHMENT OF THE STATE OR NOT?

The final week of the British Mandate was particularly stormy. Jewish-Arab fighting was ongoing nearly everywhere. Although the Jews had the upper hand, the Arab armies threatened to attack should the Jews announce the establishment of a state.

The leadership of the Yishuv was caught up in a long series of debates revolving around the fateful question of whether to declare the establishment of the state or defer it for a time. Reports by the Chairman of the Political Department of the Jewish Agency, Moshe Shertok, by Golda Myerson (Meir) of that department, and by the commanders of the Haganah about the threats of invasion by the Arab armies and the absence of American support for the establishment of the state were exceedingly pessimistic and frightened some of the members of the Provisional State Council. The position of the leader of the Yishuv, David Ben-Gurion,

however, was emphatic: It's now or never.

By May 12, three days before the expiration of the Mandate, the council had to decide: declare the establishment of the state immediately upon the termination of British rule, or accept the U.N. proposal for an armistice, which was supported by the United States and which would have meant deferring the declaration. The council voted in favor of an immediate declaration by 6 to 4, with three members absent.

On May 14, 1948, at 4 p.m., the Provisional State Council convened in the hall of the Tel-Aviv Museum and listened with emotion as Ben-Gurion read out the Declaration of Independence. He then signed the document, followed by each of the delegates alphabetically. The entire ceremony took 32 minutes.

The State of Israel was created.

THE INVASION BY THE ARAB ARMIES, MAY-JUNE 1948

Precisely at midnight on May 14-15, 1948, eight hours after David Ben-Gurion had declared the establishment of the State of Israel, five Arab armies invaded Israeli territory with the intention of "destroying the Zionist entity" within 10 days.

According to their plan, the Syrian, Lebanese, Iraqi, and Transjordanian armies would advance from all directions toward the Jezreel Valley and from there attack and capture Haifa, thus severing the newborn country in two. The Egyptian army was to advance toward Tel-Aviv and complete the operation from the south.

The plan failed for two reasons: first, the resistance put up by the young state, its settlements, and its army, the latter metamorphosing from the Haganah underground; and second, the lack of coordination between the Arab armies. King Abdallah of Transjordan prompted this by sending his forces not to the north, as planned, but to Jerusalem. The rest of the Arab armies had to alter their deployments as a result, and the whole offensive was disrupted.

Two weeks after the invasion, the borders of the Jewish state were still intact, although a small number of settlements had been captured or were abandoned. Despite largely pessimistic predictions, the state held fast, and, after a four-week truce which began on June 11, 1948, it launched the first of a series of offensives that turned into a victory in most of the combat arenas within a few months.

Ultimately, the invasion of Israel by the Arab armies proved to be a disastrous military and political failure that was to hound the Arab states for years to come.

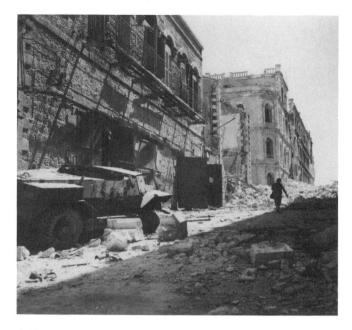

△ The Arab invasion from the east: an Arab Legion armored vehicle is destroyed while attempting to break through to Jewish Jerusalem. The Iraqis, too, attack from the east, while the Syrians and the Lebanese come from the north and the Egyptians from the south.

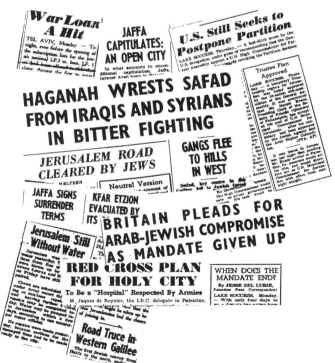

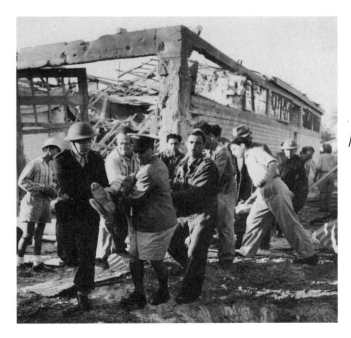

◁ Aerial bombings: Egyptian planes bomb Tel-Aviv and major centers in the vicinity and to the south. Here, the wounded are evacuated after an Egyptian air raid on Tel-Aviv.

△ Headlines during the last week of the British Mandate highlight the fighting in all regions, the successes of the Jewish forces, and the involvement by the great powers in developments in Palestine.

△ The first citizen. On November 8, 1948, the first Israeli census is conducted, and identity cards are issued. Dr. Weizmann is president of the Provisional State Council.

▷ The Etzel-sponsored arms ship Altalena is shelled and burned off the Tel-Aviv shore in June 1948 after the organization refuses to pass on its cargo to the I.D.F.

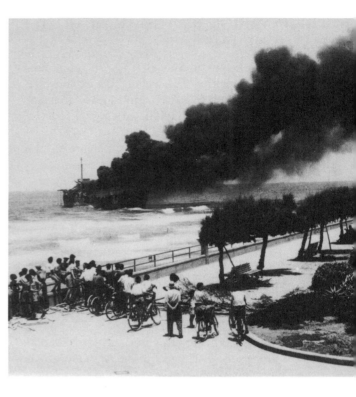

STATE OF ISRAEL IS BORN

◁ The headline of the year – in the *Palestine Post* (today, the *Jerusalem Post*) of May 16, 1948.

▷ Arab flight. Hundreds of thousands of Palestinian Arabs leave their homes, villages, and cities in 1948 and flee to neighboring countries or to areas in Palestine held by the Arab armies – Judea, Samaria, and Gaza. Many leave for fear of the Jews and in the belief, reinforced by the Arab media, that their departure will be temporary.

◁ Cultural life is active despite the fighting: The young writer Matti Meged talks about literary matters with Major General Itzhak Sadeh.

1949

January

6 U.N. mediator Ralph Bunche announces that Egypt is prepared to begin armistice talks.

7 Operation Horev is ended under pressure from Britain and the United States. Israel withdraws its troops from the Sinai.

An international incident at the Israeli-Egyptian border occurs when Israeli fighter planes bring down five British Spitfires that penetrate Israeli airspace, apparently in an effort to ascertain whether Israeli forces are withdrawing from Sinai.

13 Talks between Israel and Egypt begin under U.N. sponsorship on the island of Rhodes.

19 The United States announces a $100 million loan to Israel.

25 Elections are held for the 120-member Founding Assembly. About half a million have the right to vote. Of the 25 tickets, 12 are elected. Mapai is in the first place (35%), followed by Mapam (14.7%), the Religious National Front (12.3%), and Herut (11.5%).

29-30 Following the elections, additional states, led by Britain, recognize Israel.

31 The United States grants de jure recognition to Israel upon receipt of confirmation of the elections in Israel.

February

Immigration to Israel keeps mounting, reaching 1,000 and more daily.

3 Transjordan releases the first group of Israeli prisoners of war.

10 The Cyprus chapter ends. The last of the "illegals" detained there are brought to Israel.

The Provisional State Council approves a symbol for the new state – a seven-branched candelabrum surrounded by two olive branches with the word Israel.

Habimah Theater presents the play *In the Negev Desert*, written by Yigal Mossinsohn. In spite of its success, it is frowned upon because of its criticism of the army command.

14 (15 Shvat 5709) The Founding Assembly convenes in Jerusalem. It adopts the Transition Law establishing the body as the First Knesset. After several sessions in Jerusalem, the Knesset moves to Tel-Aviv.

16 The Knesset elects Dr. Hayim Weizmann as first President of Israel.

17 Weizmann is sworn in as President in a ceremony in the Knesset.

The provisional government submits its resignation to the President, who, on February 24, calls upon David Ben-Gurion to form the first regular government.

24 An armistice agreement with Egypt is signed in Rhodes.

March

3 The exchange of P.O.W.s between Israel and Transjordan is completed.

4 The Security Council votes to accept Israel as a member of the U.N. by 9 to 1 (Egypt), with Britain abstaining.

5-10 Two I.D.F. infantry brigades are deployed to assure control of the southern Negev and the Gulf of Eilat in Operation Uvdah ("Fact").

7 The exchange of P.O.W.s between Israel and Egypt begins.

8 David Ben-Gurion presents the first elected government to the Knesset.

10 The Israeli flag ("the ink flag") is hoisted over Eilat.

23 An armistice agreement with Lebanon is signed at the northern border post of Rosh Hanikra.

The monthly rate of immigration climbs to a record high of over 30,000.

April

3 An armistice agreement is signed with Transjordan at Rhodes.

26 Prime Minister Ben-Gurion informs the Knesset of the introduction of an austerity regime involving rationing, cutbacks, and a reduction of the cost of living, to be administered by the minister of supply and rationing, Dov Yosef.

More and more immigrants gather in temporary camps, most of them former British army camps.

May

4 Israel celebrates its first Independence Day. Festivities in Tel-Aviv and Jerusalem. The parade in Tel-Aviv does not manage to march because of the thousands of enthusiastic onlookers who block the streets.

11 Israel is accepted into the U.N. at the General Assembly by a vote of 37 to 12, with 9 abstentions. It is the 59th state in the organization.

June

The euphoric atmosphere of the previous period gives way to trepidation and distress over the difficulties of immigrant absorption, shortages, the austerity program, and the emergence

of a black market.

July

17 Army Day is marked by an official ceremony in which twelve fighters in the War of Independence are awarded the Hero of Israel decoration.

20 An armistice agreement with Syria is signed in a tent set up near Kibbutz Mahanayim. The War of Independence is thereby officially ended.

August

7 After a pause of over a year, the rail line to Jerusalem resumes its journeys, as Jordan has conceded to Israel, in the armistice agreement, those parts of the railroad line which passed through its territory.

17 The remains of Theodor Herzl, visionary of the state, are brought to Israel from Vienna and reinterred at Mt. Herzl in a state ceremony.

29 The Lausanne Conference, an attempt to bring representatives of Israel and the Arab states together to find a solution to the conflict in the region, ends in failure.

31 The Knesset authorizes the first state budget – about 40 million Israeli Pounds.

September

8 The Knesset passes the

The symbol of the state is adopted early in 1949. Shown are some of the proposed designs that were rejected.

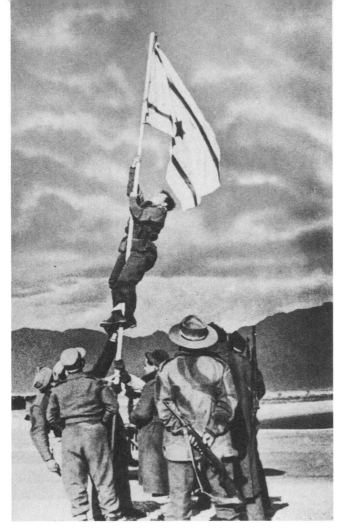

△ The Eilat shore, March 1949. The first Palmah fighters to reach the area discover that they have no national flag. Improvising with alacrity, they use a sheet and blue ink for the purpose and hoist the flag of Israel.

▽ Dr. Hayim Weizmann, elected first president of Israel in February 1949, chats with the first American ambassador to Israel, James McDonald.

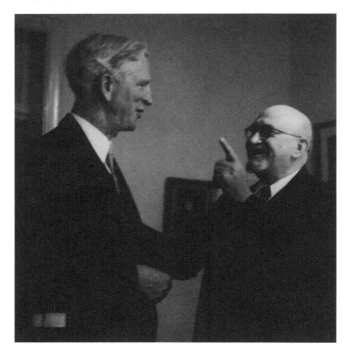

Military Service Law making regular and reserve military service mandatory for all citizens. Emphasis is laid on service in the Nahal ("Fighting Pioneer Youth") Corps for agricultural training for soldiers.

12 The Compulsory Education Law is passed by the Knesset.

13 The office of the State Comptroller is established. The first comptroller is Dr. Siegfried Moses.

The U.N. Palestine Conciliation Commission proposes dividing Jerusalem into two demilitarized zones, Jewish and Arab, under U.N. rule. Israel rejects the plan.

18 Following Britain, Israel devalues its currency. (1 IL now = $ 2.80).

19 A new institute in the country: the Ulpan school which offers Hebrew courses for adults. In Jerusalem, Ulpan Etzion is opened.

October

Governmental efforts succeed in lowering the rate of inflation to 14%. Economists warn about the necessity to rein in inflation, while Mapam vigorously rejects wage cuts.

30 The B.B.C. begins Hebrew broadcasts intended for Israel.

November

2 The Weizmann Institute for Science is inaugurated in Rehovot.

The members of the village of Mishmar Hayarden, captured by the Syrians in June 1948, return to rebuild it. The settlement has been completely destroyed.

8 The first immigrant airlift begins – Operation Magic Carpet, which brings 40,000 Yemenite Jews from Aden to Israel in some 400 flights.

9 A changing of the guard in the I.D.F. command replaces Ya'akov Dori as chief of staff with Yigael Yadin, who is promoted to the rank of lieutenant general.

20 The Jewish population of Israel reaches 1 million.

21 An air disaster over Norway results in the death of 29 Jewish children from Tunisia who were sent to that country for medical treatment prior to their immigration to Israel.

24 The official foundation day of the Nahal Corps ("Fighting Pioneer Youth").

December

9 The U.N. General Assembly decides by a vote of 38 to 14 with 7 abstentions to implement the decision of November 29, 1947, to internationalize Jerusalem.

13 Ben-Gurion announces in the Knesset that the U.N. decision regarding Jerusalem is impracticable. He also states that the Knesset will return to Jerusalem and that the government ministry offices will be transferred there as well. The Knesset approves unanimously.

20 The U.N. Trusteeship Council calls upon Israel to cancel the steps taken to transfer central governmental bodies to Jerusalem.

30 The Israeli government rejects the U.N. Trusteeship Council request regarding Jerusalem.

The year 1949 sets a new annual immigration record: 239,000.

The first Israeli coin, 1949. The Israeli prutah (1 IL = 1.000 prutot) replaces the Mandatory mil.

THE ARMISTICE AGREEMENTS OF 1949

On November 16, 1948, the warring parties in Palestine were called upon by the U.N. Security Council to begin talks under its sponsorship in order to reach an armistice agreement.

The first round of talks, between Israel and Egypt, took place in Rhodes. Lasting from January 13 to February 14, 1949, the negotiations proceeded by fits and starts until agreement was reached. The Egyptians were to keep Gaza, while the rest of the Negev remained in Israeli hands. The next round of talks, with Lebanon, took place at the northern Israeli border point of Rosh Hanikra during March 1-23, 1949. It was settled that the Israelis would retreat from the villages they had captured in southern Lebanon in Operation Hiram. The third round, with Transjordan, was held in Rhodes from March 4 to April 3, 1949, and was the most complex, covering such topics as the inclusion of the railroad line to Jerusalem in Israeli territory, a passage to Mount Scopus, and an arrangement regarding the Jewish holy

sites in the Old City of Jerusalem, which was now in Jordanian hands. The fourth and last round of talks, with Syria, were the most prolonged and exhausting. Taking place on no-man's land between Rosh Pina and Mishmar Hayarden (then in Syrian hands), they lasted three and a half months, from April 5 to July 20, 1949. The outcome included Syria's withdrawal from captured Israeli territory Mishmar Hayarden, and the designation of numerous demilitarized areas along the cease-fire lines. Iraq, which was also a party to the war, refused to sign any agreement with Israel.

July 20, 1949, the date of the signing of the last armistice agreement, is considered the official end of the War of Independence. At the time, the feeling was that peace between the sides was foreseeable. Instead, nearly 30 years were to pass before the first peace agreement between Israel and an Arab state – Egypt – was concluded.

△ I.D.F. officers participating in the Rhodes talks (r. to l.): Yehoshafat Harkabi, Itzhak Rabin, Yigael Yadin, and Aryeh Simon.

▽ The future president of Egypt, Gamal Abd al-Nasser (l.), an officer at the Faluja Pocket east of Kibbutz Negba.

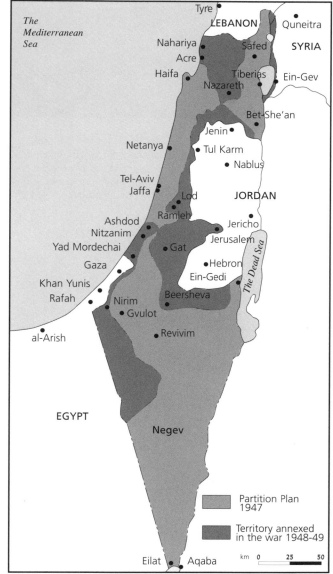

The Mediterranean Sea

Tyre
LEBANON
Quneitra
Nahariya
Acre
Safed
SYRIA
Haifa
Tiberias
Ein-Gev
Nazareth
Bet-She'an
Jenin
Netanya
Tul Karm
Nablus
Tel-Aviv
Jaffa
Lod
JORDAN
Ashdod
Ramleh
Nitzanim
Jericho
Yad Mordechai
Jerusalem
Gat
The Dead Sea
Gaza
Hebron
Ein-Gedi
Khan Yunis
Rafah
Nirim
Beersheva
Gvulot
Revivim
al-Arish

EGYPT

Negev

Partition Plan 1947

Territory annexed in the war 1948-49

Eilat Aqaba km 0 25 50

THE FIRST KNESSET AND THE FIRST ELECTED GOVERNMENT

Elections for the State of Israel's first legislative body, provisionally called the Founding Assembly, were held on January 25, 1949. Twenty-five parties took part in the campaign and 12 emerged with enough votes for at least one of the 120 seats. Mapai, the largest party, obtained 46 seats, far ahead of the other tickets – Mapam 19, United Religious Front 15, Herut 14, General Zionists 7, Progressives 5, and four other smaller parties, each received a small number of seats.

The Founding Assembly convened in Jerusalem on February 14, 1949, led by the president of the Provisional State Council, Dr. Hayim Weizmann. Two days later, on February 16, 1949, the Founding Assembly adopted the Transition Law, which gave the name Knesset to Israel's parliament. The following day, February 17th, Dr. Weizmann was sworn in as first President of Israel. The provisional government then submitted its resignation to him, and the President began talks with representatives of the political parties regarding the formation of a government. This lasted less than two weeks, when, on March 8, 1949, David Ben-Gurion presented the first permanent government to the Knesset for approval. The office of prime minister, as well as the important portfolios (defense, foreign affairs, finance), and the portfolios for labor, transport, and education and culture were distributed among the Mapai leaders. The second largest party in the coalition was the Religious National Front, which received the portfolios for internal affairs, immigration, religion, and welfare. The Progressives and the Sephardis received a portfolio each. Ben Gurion's first government consisted of 12 ministers. The coalition was open to practically every party, he declared, "provided it's not Herut or Maki (the communists)."

△ The campaign for the Founding Assembly in January 1949 is spirited. Walls and billboards are covered with electioneering propaganda. A stands for Mapai; Z, for the General Zionists; H, for Herut; M, for Mapam; B, for the Religious Front. The Founding Assembly is renamed the Knesset.

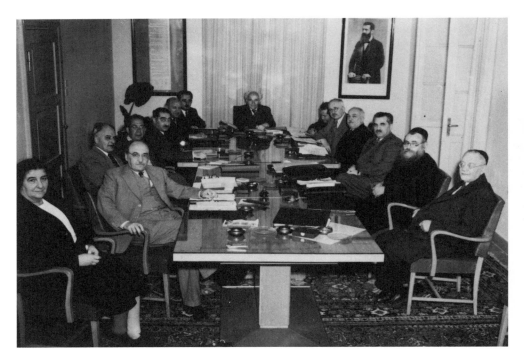

◁ By the winter of 1949, the state has a parliament – the Knesset; a symbol (above); and its first permanent government, consisting of 12 ministers led by Prime Minister David Ben-Gurion (c.), who also holds the defense portfolio. Golda Meir is minister of labor.

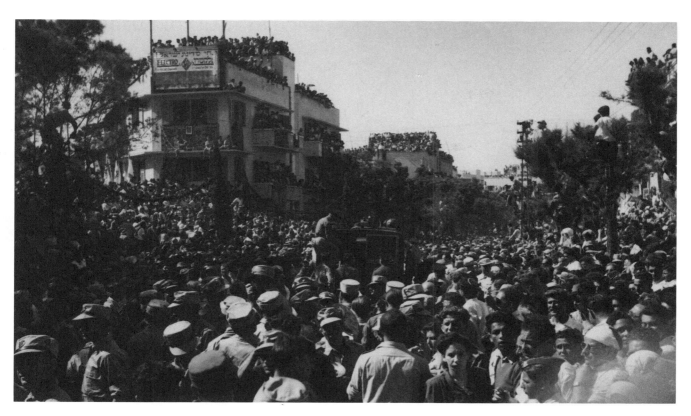

◁ At left, Nahal ("Fighting Pioneer Youth") marches along an alternate route in the city.

△ "The parade that didn't parade." The overenthusiastic crowd of onlookers blocks the streets on Independence Day in Tel-Aviv.

▽ Austerity and strict rationing are the order of the day in 1949. Shown, an office for the distribution of food ration booklets.

▷ Israel is accepted into the U.N. and its flag is hoisted in New York. From r. to l.: David Hacohen, Abba Eban, Moshe Sharett.

A RECORD YEAR FOR IMMIGRATION

Massive immigration to the young country still at war began immediately upon the declaration of independence, reaching an unprecedented figure of over 100,000 from May 15 until December 31, 1948. The phenomenon intensified in 1949, when a total of 239,000 newcomers arrived – the peak year of Jewish immigration to Israel.

At a certain point, the inflow reached 30,000 a month, with an average monthly rate of 20,000. The state was on the verge of collapsing under the burden of absorbing its new citizens, yet in the atmosphere of widespread euphoria the political leadership, the press, and public opinion generally favored unlimited immigration, and only a few lone voices called for slowing it down. In December 1949, Israel celebrated its first million Jewish residents, 350,000 of whom had immigrated since the birth of the state. With a population increase of over 50% within less than two years, the new state could well boast of a world record.

△ Tens of thousands of new immigrants are put up in army camps and tents.

▷ A newly arrived immigrant tries to get his bearings in the immigrant camp at Pardes Hanna. Signs are in Hebrew and in other languages.

▽ Ben-Gurion convenes a meeting with intellectuals in March 1949. At right, front: Prof. Martin Buber. Speaking (standing) is Prof. Samuel Hugo Bergman. Other participants include Natan Alterman, Avraham Shlonsky, Lea Goldberg, and Hayim Guri.

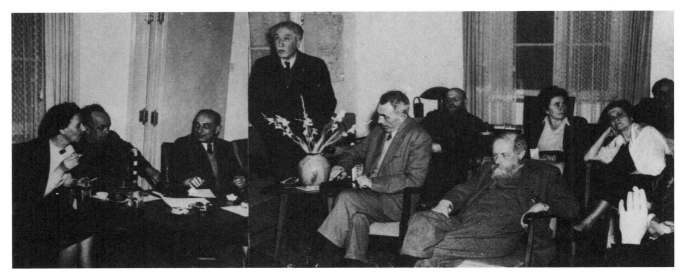

▷ Four thousand Jewish women in Palestine signed up for the A.T.S. (Auxiliary Territorial Service) – the auxiliary women's corps of the British army – during World War II.

▽ Insignias of the Jewish Brigade Group and (below, from l. to r.) the paratroopers, the Buffs (infantry companies) and the Royal Air Force.

◁ Posters during the World War II period call for joining the British Army as well as assisting the Red Army in their struggle against the Nazis.

▷ Palestine is the home base for hundreds of thousands of British soldiers. One cartoonist views the Tel–Aviv shore thus.

▽ The economic boom in Palestine during the war is reflected in this bilingual adaptation of Monopoly for Israeli children.

▽ The arrest by the British of some 2,700 Jews, including Jewish Agency leaders from the Mapai Party, on Black Saturday, June 29, 1946, serves as an electioneering theme for the 22nd Zionist Congress in a poster printed by the party.

△ The struggle against the British during 1945-47 is multi-faceted. The attitude of the Yishuv toward the British White Paper of 1939 is reflected in this 1944 poster, published by the Histadrut ("Federation of Labor"), which shows the map of Palestine (in Hebrew: Eretz Israel) cancelling out the White Paper.

◁ Illegal immigrant ships keep on coming to Palestine, one after another. Artist Salvador Dali commemorates one of them, the Eliahu Golomb.

THE WAR OF INDEPENDENCE, 1948-49

▷ The first stamps of the new State of Israel are issued in 1948 before the name of the country is known. The caption Doar Ivri ("Hebrew Mail") is used instead.

▽ David Ben-Gurion, Israel's first defense minister, consults with the first General Staff of the Israel Defense Forces. Painting by Itzhak Frankel.

△ An armed woman
fighter, 1948.
Painting by Aryeh
Alouil.

▽ Five portraits of
Palmah fighters,
1948. Painting by
Ludwig Blum.

▷"The iron frame is
silent as my com-
rade," wrote Hayim
Guri in his poem
Bab al-Wad. The
remains of armored
vehicles destroyed
in attempts to break
the siege of Jerusa-
lem in 1948 are pre-
served along the
road to Jerusalem to
this day.

1949: THE FIRST YEAR OF INDEPENDENCE

▷ The first elections for the Knesset in 1949 are dominated by the major parties – Mapai, Mapam, Herut, United Religious Front, General Zionists, Maki, and others. A woman's party – W.I.Z.O. (signified by the letter *nun*, N) – captured one seat.

▽ Tens of thousands of immigrants stream into the country monthly. Artist Yossl Bergner, sailing in 1949 from Australia to Europe, disembarks at the port of Aden, where he is amazed to witness the sight of thousands of Jews from Yemen setting out for Israel.

▷Victims of floods in the makeshift immigrant camps during the winters of the early 1950s. The poster reads: "Prevent Tomorrow's Suffering Today. The Fund for Victims of the Floods."

△A poster commemorates the period of austerity by using a ration-card format. It reads: "Rationing Guarantees Food for Everyone."

▽The black market, a product of the austerity period, is portrayed as "the enemy" and a "disaster."

The ma'abarot (immigrant transit camps) become an integral part of Israeli life for years. Beginning in 1950, a total of 139 such camps are put up, from Kiryat Shmona in the north to Yeruham in the Negev. The camps are a focus of public concern and serve as a theme for artists as well – here in paintings by Naftali Bezem (above) and Marcel Janco (right).

▷ A solution to the problem of food shortages, 1950s-style: growing vegetables in home gardens.

שחדרנוך תל-אביב
רק כך!
ח

רק כך

תנועת החרות

▷ Politics are aggressive and volatile during the 1950s. Campaigning in the race for the Tel-Aviv mayoralty, Herut draws on an image of the liberation of Jaffa during the War of Independence.

▽ Mapai relies on the prestige of Prime Minister and Defense Minister David Ben-Gurion, nicknamed The Old Man, using the rhyming slogan: "Say Yes (ken) to The Old Man (zaken)."

הגידו כן לזקן"

מפלגת פועלי ארץ ישראל המרכז-מחלקת הסברה

▷ Dozens of acts of reprisal against Arab infiltrators and fedayeen are carried out by the Israel Defense Forces in the first half of the 1950s. Not all the fighters come home safely, as this painting by Mordechai Ovadyahu portrays.

▽ The Sinai landscape with its lofty mountains is revealed to Israelis for the first time during the Sinai Campaign of 1956, as portrayed by artist Nahum Gutman.

סיני · שמואל כץ

Another view of Sinai by artist Shmuel Katz.

286

▷ The long journey to Eilat is made by Egged's heavy-duty GMC buses, which plow through the unpaved roads.

△ Most Israelis do not own a car in the 1950s but dream of acquiring a French Quatre-Chevaux by Renault.

▷ Rural and border areas are a central part of the national ethos. The government, the Histadrut ("Federation of Labor"), and other national bodies call on the population to leave the city and settle in outlying regions. This Histadrut poster reads: "From City to Country."

מן העיר
אל הכפר

ההסתדרות הכללית של העובדים העברים בארץ-ישראל · הועד הפועל · מרכז לתרבות וחינוך

△ The country's early anniversaries are signified on Independence Day stamps by 5 flowers, 7 candles, a flag-inspired 8, a 9 in sky-writing, and a branch with 10 leaves.

▷ The press in the 1950s is generally soberly political, but there are some exceptions, for example, a weekly titled *Hayei Sha'ah* ("Good Times").

△ A new chief of staff, Yigael Yadin (top photo, at l.), replaces outgoing Ya'akov Dori. Maj. General Dayan, Commanding Officer of the Southern Command, sends a congratulatory telegram.

▽ Ben-Gurion's order to disband the Palmah incites a storm. Shown, some graffiti responses: "Despite everything – Palmah."

△ Habimah Theater presents *In the Negev Desert* by Yigal Mossinsohn, with leading actors Aharon Meskin (seated, center) and Hanna Rovina (far r.). The play, about the War of Independence, is a hit but is criticized in army circles because the military command is depicted as advocating evacuation and retreat from a settlement under siege.

△ The heavy human toll of the War of Independence is 6,000 killed (1% of the population) and tens of thousands wounded. Shown, war-injured at a rehabilitation center.

▽ Dozens of settlements sustain heavy damage during the war. Some are destroyed entirely and others require extensive rebuilding. Shown, a damaged water tower at Kibbutz Be'erot Itzhak.

The Sixth Decade
1950-1959

En route to the ma'abara – the immigrant transit camp – with suitcase and mattress.

The 1950s largely overlapped with the first decade of the existence of the State of Israel and reflected the process of its founding and entrenchment. It was a decade of contrasts – impressive achievements side by side with daily hardships endured by the entire population – yet the final assessment both at the time and with hindsight was decidedly positive. The young state faced a series of challenges that appeared towering and even insurmountable, yet managed to meet most of them successfully.

The first problem was mass immigration and absorption. The vast influx of mostly penniless immigrants who began to arrive immediately upon the establishment of the state in 1948 kept up unabated through 1951. During 1950-51 alone, approximately 350,000 newcomers streamed in, paralleling a similar number of arrivals in 1948-49. By 1950, however, the problems of absorption, employment, and housing had grown far graver in light of the sustained population explosion. In 1950, the ma'abara – immigrant transit camp – came into being, and lasted much longer than planned. By the end of 1951, 139 ma'abarot were erected, in which a quarter million newcomers dwelled. Thereafter, the rate of immigration dipped temporarily, from hundreds of thousands annually to 10,000-20,000, but rose again by the mid-1950s.

The year 1957 was exceptional. Fateful changes in the regimes of Poland and Hungary, as well as the advent of the Sinai Campaign closer to home, together elicited a renewed influx of tens of thousands of Jewish immigrants both from Eastern Europe and Egypt. Thereafter, annual immigration leveled off at approximately 20,000 and the country devoted major efforts to absorption. Development towns as well as housing projects were built to lodge the immigrants who were still in the ma'abarot. Foundations were laid for local industry which would provide employment for hundreds of thousands of Israelis and newcomers.

A second problem was defense. At the start of the 1950s, confidence was still widespread in Israel that the armistice agreements with the Arab states would turn into peace agreements in the foreseeable future. The unfolding of events along the borders, however, was to dispel this belief. Incidents of Arab infiltration into Israeli territory proliferated and by 1951 became a major security issue. Such infiltrators came through the southern and eastern borders. In the north, Syria did its best to hinder Israel from the draining and development works in the Hulah Valley and from diverting the course of the Jordan River.

Hundreds of raids by Arab terrorists from the neighboring countries during 1953-56 elicited reprisals by the Israel Defense Forces (I.D.F.) at first against the fedayeen (suicide fighters) centers and later against Egyptian, Jordanian, and Syrian army bases and outposts. The operative assumption was that such strikes would prompt the governments of the three states involved to curb terrorist activity, but the situation continued to deteriorate. From 1955 on, Chief of Staff Moshe Dayan urged a large-scale military offensive against Egypt in order to break the maritime embargo imposed by Egypt on Eilat and to destroy the bases of the terrorists in the Gaza Strip.

By the mid-1950s, Israel was in a difficult politico-military situation. President Nasser of Egypt, having developed close relations with the Soviet Union, enjoyed generous arms supplies that posed a direct threat to Israel. The United States, by contrast, refrained from supplying any arms to the region, and Britain did so only minimally. Only France, for reasons of its own (its war against the rebels in Algeria), came to Israel's aid, supplying large quantities of arms that included modern aircraft, tanks, artillery, and ammunition.

The Sinai Campaign of late 1956 turned Israel into a regional power overnight. Operating in political and strategic cooperation with Britain and France, both of which had accounts to settle with Nasser's Egypt, Israel used its I.D.F. to overpower the Egyptian army and capture the entire Sinai peninsula and the Gaza Strip. Although the Israeli forces were later forced to withdraw under pressure from the U.N. and the great powers, Israel gained a new status and attained 10 years of quiet along its southern border with the stationing of a U.N. peace-keeping force along the entire Egyptian boundary down to Sharm-al-Sheikh. The border with Jordan, too, quieted down. Only along the Syrian border was there ongoing periodic tension.

Israel's third problem was economic. Burdened by the costs of the War of Independence and the absorption of hundreds of thousands of destitute immigrants, the state was soon in difficult economic straits, lacking sufficient foreign currency even for the acquisition of foodstuffs and fuel. An austerity and rationing program was declared, lasting until the end of the decade, by which time the economy had developed and could meet at least part of the needs of the population.

Contributions from world Jewry, loans from the United States, and reparations from Germany also helped ease some of the problems. By the end of the decade, the state appeared to be on the way to economic viability. The lands utilized for agriculture multiplied. Industry developed and provided employment. A sign of this improvement was reflected in the abolishment of basic foodstuff rationing in 1959.

In many respects, the Israel of the 1950s was a continuation of the pre-state Yishuv. Its leaders were the same figures who had led the struggle for independence, the most prominent of whom had arrived in the country during the Second and Third Aliyot, 40-50 years previously. Social values and norms, too, had changed little. Emphasis was laid on creating an egalitarian society and a welfare state together with fulfilling the Zionist ideal, especially through agriculture and settlement on the land, which were still assigned an elevated status.

January

23 The Knesset declares Jerusalem the capital of Israel.

The austerity program is at its height. Foodstuffs and fuel are in short supply. The black market flourishes.

February

5-6 Snow falls for two days throughout the country, a rare phenomenon for the coastal plain and the Negev.

11 Britain releases £15 million in Israeli assets frozen since the end of the Mandate in 1948.

24-25 Egyptian army units take over the islands of Tiran and Snafir at the entrance to the Gulf of Eilat.

28 An airport is opened at Eilat, which is a small settlement consisting mostly of army personnel.

A government crisis erupts over the issue of the type of state education being made available in the immigrant camps. The three religious ministers abstain from attending government

"For Everybody" – the symbol of the rationing program products.

meetings. A compromise is finally worked out.

March

11 Kol Zion Lagolah ("The Voice of Zion to the Diaspora") radio broadcasting is inaugurated, initially providing broadcasts abroad in Yiddish, English, and French.

13 The Knesset resumes sessions in Jerusalem, temporarily renting the Froumine office building on King George Street in the city center as its base.

The issue of education in the immigrant camps flares up again. The United Religious Front threatens to leave the coalition if religious

teachers and youth counselors are not provided.

Mapai ("Israel Labor Party") fails once more to persuade Mapam ("United Workers Party") to join the coalition.

April

16 A grave disaster occurs in Jaffa when an apartment building collapses, causing 10 fatalities and a large number of injured.

24 Jordan annexes the Palestinian territory west of the Jordan River – the West Bank.

27 Britain formally recognizes the State of Israel and, in parallel, the Jordanian annexation of the West Bank.

The number of immigrants residing in camps reaches 100,000. The press gives wide coverage to their housing and employment difficulties.

May

1 Signs of the political split are showing. The parade on May 1 is cancelled in Tel-Aviv because of the dispute between Mapai and Mapam over the slogans of the parade.

18 Operation Ezra and Nehemiah begins – an airlift of the Jews of Iraq to Israel.

Massive immigration from Eastern Europe and North Africa continues.

The government and the Jewish Agency decide upon the establishment of ma'abarot (immigrant transit camps). The first to be built is located in the Judean hills.

25 The United States, Britain, and France, in a tripartite declaration, guarantee the borders and armistice lines of the states of the Middle East.

June

13 The Knesset decides that the country's constitution will consist of a series of basic laws to be drawn up area by area.

21 The Eilat port is inaugurated with the arrival of a ship from Aden containing Torah scrolls and religious articles transferred from the Jewish community of Yemen to Israel.

29 After considerable delay,

the Knesset approves the 1950-51 state budget of IL 60 million ($168 million), a 30% increase over the previous budget.

July

5 The Knesset passes the Law of Return, which allows any Jew to immigrate to Israel.

31 The austerity program in Israel is widened to include the rationing of clothing and footwear.

August

1 The Knesset passes the Law for the Administering of Justice to the Nazis and their Helpers. The maximum punishment is death.

1-14 Retailers strike in protest against the rationing policy. The strike turns into a general strike on August 7th.

8 The opposition calls for a no-confidence vote in light of what it claims is the government's failure to implement the austerity and rationing policy. The proposal is rejected by a vote of 57 to 36.

September

3 An international conference of Jewish business leaders – the Billion's Conference – is held in Jerusalem with the aim of assisting Israel by raising capital.

Conquered Judaea (above) and Liberated Judaea, an illustration by Aryeh Navon, 1950.

1950

6 A decision is made to float the first State of Israel bond issue in the United States with the aim of aiding Israel in developing its economic infrastructure and absorbing the massive immigration.

24 The Israel Army Radio station ("Galei Zahal") is inaugurated.

Operation Magic Carpet – the airlift of some 50,000 Jews from Yemen and Aden to Israel – is completed.

27 The 3rd Maccabiah opens in Tel-Aviv, resumed after a hiatus of 15 years.

30 The government announces a new economic program, facilitating imports, promoting exports, suppressing inflation, and issuing domestic loans.

October

3 Prime Minister Ben-Gurion personally heads an anti-black market campaign, appealing to the public to end such purchasing practices.

15 A government crisis erupts over Ben-Gurion's intention to dismantle the ministry of supply and rationing and to appoint a business figure as minister of commerce and industry. The United Religious Front is opposed. Ben-Gurion submits his resignation, followed by that of the government, to President Weizmann. The President assigns Ben-Gurion the task of forming a new government.

17 Ben-Gurion forms a minority government consisting of seven ministers from his party, Mapai ("Israel Labor Party"), and one minister from the Sephardi Party. The Knesset does not approve it.

19 President Weizmann assigns a political figure not

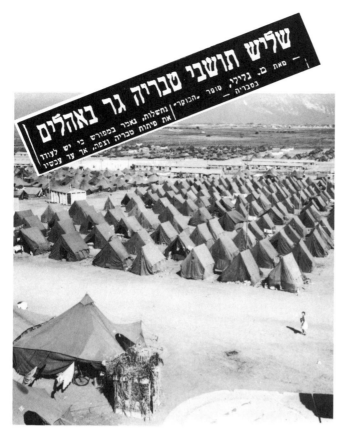

שליש תושבי טבריה גר באהלים

△ Hundreds of tents are put up in one of the largest ma'abarot in the country at Bet-Lid in the Sharon region.

Other such transit camps, housing hundreds and even thousands of immigrants, are established in all parts of the country.

from the largest party – Pinhas Rosen of the Progressives – the task of forming a government. Ten days later, Rosen reports that his efforts have failed.

28 The Israeli soccer team scores a sensational victory over Turkey, 5:1, in a friendly match in Tel-Aviv.

November

1 A new government is formed by Ben-Gurion. Changes in portfolios include the dismantling of the ministry of supply and rationing and the appointment for the first time of a minister who is not a member of Knesset, Ya'akov Geri, as minister of commerce and industry. The Knesset approves it by a vote of 69 to 42, with 2 abstentions.

The Unites States demands that Israel pay compensation to the Arab refugees.

6 The Shelter campaign is launched – an appeal to the Israeli population to house immigrant children for the winter months.

14 The first municipal elections produce a surprise: a large drop for Mapai and a

gain for the General Zionists, who obtain a quarter of the vote, slightly less than Mapai.

29 An incident occurs at Km 78 on the road to Eilat when the Jordanians block the road, claiming that it passes through their territory.

A new dispute develops between Mapai and the religious parties over the issue of education in the ma'abarot (immigrant transit camps).

December

2 An Israeli armored force clears the Jordanians from the Km 78 point and reopens the road to Eilat. In the following weeks, the Jordanians will reject talks at the armistice committee until the passage to Eilat is settled to their satisfaction.

16 A proposal by Belgium in the U.N. General Assembly to supervise the holy places in Israel is defeated.

Nearly 170,000 immigrants have arrived in Israel during 1950, and 62 ma'abarot housing 93,000 newcomers have been erected. Another 40,000 immigrants are housed in other temporary camps.

△ Two young immigrant settlers of Moshav Zelafon in the Jerusalem Corridor. Hundreds of moshavim are established by immigrants during the early years of the state, including in remote areas and areas with a

small Jewish population, such as the Central Galilee and the Jerusalem Corridor. Most of the settlers, immigrants from various countries, have no former experience in agriculture.

△ Snow covers the country in winter 1950. Shown, Ben-Yehuda Street in Tel-Aviv.

▷ Cement-mixers resembling cannons are used at the large building sites for immigrant housing such as in Beersheva, Holon, and Kiryat Yam. This type of "cannon" can pour cement for one or even two apartment buildings daily. Within two or three weeks, a new neighborhood is erected.

▽ A typical scene in Jaffa, where thousands of immigrants are housed in buildings abandoned by the Arabs. Jaffa is formally amalgamated with Tel-Aviv to its north in 1950, becoming Tel-Aviv-Jaffa.

THE ESTABLISHMENT OF THE MA'ABAROT – THE IMMIGRANT TRANSIT CAMPS

Israel's first two years of statehood witnessed the influx of some 400,000 immigrants, who were housed in every possible structure – in available apartments, with relatives, in former British army camps, in abandoned Arab towns and villages, in tent camps, in new moshavim, and in established agricultural settlements. With the flood of newcomers continuing unabated, however, housing options ran out.

One solution, devised by the treasurer and head of the settlement department of the Jewish Agency, Levi Eshkol, was to move the immigrants who were in camps to temporary makeshift villages – usually near some established settlement – provide them with work, and turn them from a passive to a productive element. The idea was that these quarters would be temporary until permanent housing could be built – thus the name ma'abara, from

the word *ma'avar* (transition).

The first ma'abara was built in May 1950 near Jerusalem. By the end of 1951, 139 such settlements had been set up, from Kiryat Shmona in the north to Yeruham in the Negev, housing over 200,000 immigrants. The structures erected were flimsy – tents or huts of canvas-frame construction, plywood, or corrugated tin. They were not supposed to last long. However, some of these camps were in use for five to ten years. Living conditions were harsh, and the ma'abara experience, combined with widespread unemployment, cultural conflicts and other hardships, left its mark on hundreds of thousands of the immigrants of the 1950s. The term ma'abara became synonymous with a residential area or building that was temporary, ramshackle, and substandard.

▷ Government inspectors, checking for black marketeering, discover chickens hidden in the trunk of a car.

▽ Every citizen receives a ration booklet with letters and numbers entitling the bearer to basic consumer necessities.

THE WAR AGAINST THE BLACK MARKET

The government's austerity and rationing policy, introduced in 1949, gave rise to a flourishing black market that sold rationed products "under the table" at inflated prices. The government, making strenuous efforts to fight this development, set up a large supervisory network of officials and inspectors under the ministry of supply and rationing, while the police also pitched in. A number of offenders were apprehended.

The situation worsened in the summer of 1950, however, when clothing and footwear rationing was added as well. Retailers claimed that they were unable to stay in business and organized a strike. But the government was determined to carry out its policy in light of the country's staggering economic burdens, and established Headquarters for the War against the Black Market. Its effect, however, was minor.

With the gradual relaxation of the rationing policy during the course of the decade, the size and influence of the black market shrank as well.

△ A new radio station, Israel Army Radio ("Galei Zahal"), begins operating in September 1950. Shown is Rahel Levison, the first announcer.

▷ Israel's soccer team beats Turkey in a surprise upset, 5:1, in a 1950 match.

◁ The new government formed in October 1950 meets with President Weizmann. The new ministers: Ya'akov Geri (2nd. l.), and Pinhas Lavon (4th. l.).

▽ Prime Minister and Minister of Defense David Ben-Gurion is shown in a rare photo taken during a horseback tour of remote regions in the Galilee, still inaccessible through paved roads. Ben-Gurion's popularity is at an all-time high in 1950.

△ The winter of 1950 is the harshest in decades. Heavy snow covers nearly the entire country during the first week of February, including regions where snow is rare, like Tel-Aviv and the Northern Negev. Extensive damage is caused to the immigrant camps.

▷ The Knesset convenes in the Froumine Building, located in the center of Jerusalem, in 1950. During Knesset meetings, traffic is prohibited in the street. The building will serve as the Knesset's temporary home until 1966.

◁ Eilat in 1950 consists of sea, mountains, desolation and a small number of inhabitants and buildings, and seems like the end of the world. Buses reach it once every few days. It is, however, linked to the rest of the country by Israel's first domestic airline founded that year, Arkia.

▽ Visitors to distant Eilat in 1950 are Prime Minister and Minister of Defense David Ben-Gurion (c.), Finance Minister Eliezer Kaplan (l.) and Chief of Staff Yigael Yadin (r.), all seated in the shade of an airplane wing. Ben-Gurion is holding a coral, taken from the Red Sea.

▷ Although their countries are locked in a cold war, U.S. Ambassador to Israel James McDonald (l.) and U.S.S.R. Ambassador Pavel Yershov (r.) exchange smiles at Israel's second Independence Day celebrations hosted by President Hayim Weizmann.

◁ A confrontation between Jordan and Israel at the Km 78 point on the road to Eilat in late 1950 is mediated by U.N. observers.

1951

January

4 Minister of Religious Affairs Rabbi Yehuda Leib Fishman-Maimon resigns as a result of the crisis over state education in the ma'abarot ("immigrant transit camps").

7 The Israel Philharmonic leaves for a series of concerts in the United States.

9 The immigrant settlement of Yeruham is established.

20 The Hulah Lake drainage project is begun.

February

3 The Arab League decides to settle the Arab refugees from Palestine in the Arab countries, without, however, retracting the demand that they be repatriated to their homeland.

5 Minister of Education David Remez presents a series of proposals to the Knesset regarding school enrollment. The religious parties reject them.

7 Israel carries out a reprisal in the village of Shrafat near Bethlehem in the wake of the murder of three Israelis in the Jerusalem area. The Jordanians report 12 killed and 18 wounded.

14 The Km 78 incident on the road to Eilat is concluded by an Israeli-Jordanian settlement.

The education crisis worsens. The Knesset rejects the education minister's proposals. Prime Minister Ben-Gurion announces that the government views this vote as an expression of no-confidence, and resigns.

27 The crisis in the government is aggravated as the Chief Rabbinate issues a prohibition on women's compulsory military service.

A new city, Ashkelon, is established on the coast in the south near the town of Majdal, which, following the War of Independence, was populated by immigrants and was named Migdal Gad.

March

4 Minister of Agriculture Pinhas Lavon announces that the government possesses sufficient food supplies for half a year.

5 President Hayim Weizmann informs the speaker of the Knesset that consultations with the various factions indicate no possibility of forming a stable government, which necessitates new elections. The resigning government will serve in a transitional capacity.

12 Israel presents a claim for $1.5 billion in reparations from Germany to the four occupying powers.

Tension rises in the north during the last week of March. Israeli drainage work in the Hulah region elicits shooting by Syrian forces. Israel evicts Arab residents from the demilitarized zone.

The winter of 1950-51 is the warmest in 30 years.

April

4 A serious incident occurs in the al-Hamma area when the Syrians infiltrate into the demilitarized zone and kill seven Israeli policemen.

5 Israel bombs the Syrian police station, bunker, and army camp at al-Hamma in an aerial reprisal. Al-Hamma remains in Syrian hands until 1967.

12 The First Knesset passes a law for new elections to be held in July. Electoral eligibility encompasses every resident of Israel as of March 1, 1951, which includes tens of thousands of newly arrived immigrants.

The Knesset declares 27 Nisan as Holocaust and Ghetto Uprising Remembrance Day.

24 Or Akiva, a new immigrant town, is established north of Hadera.

27 U.N. Secretary-General Trygve Lie visits Israel.

Shortages in foodstuffs develop during the month as a result of both international factors (the Korean War and its effects) and a shortage of foreign currency in Israel. The population receives rationed supplies late and must line up for food, ice, and even bus transportation (not all buses are operational because of a shortage of spare parts for repairs).

Aid parcels are received from abroad, mainly from the United States.

May

2-6 Syrian-Israeli fighting breaks out at Tel al-Mutilla north of Lake Kinneret. Syrian units cross the Israeli border and take over several hills. The I.D.F. pushes them back at the cost of 40 Israeli fatalities and over 70 wounded, a shock to the Israelis.

2 Prime Minister and Defense Minister Ben-Gurion leaves for the United States. Two Israeli navy ships arrive in New York with him.

3 Ben-Gurion meets with President Truman.

8 Incidents continue in the northern demilitarized zone. The U.N. Security Council orders a halt to the fighting.

11 Talks are held between Israel and Syria to reduce the tension.

15 The police apprehend several dozen members of the Brit Hakana'im ("Zealots Alliance"), an underground of young religious Israelis who plan, among other things, to attack the Knesset during the debate on the women's military service law.

19 Minister of Education and Culture David Remez dies at the age of 62.

The U.N. Security Council instructs Israel to cease work on the diversion of Jordan River waters in the northern demilitarized zone. Initiators of this decision are the United States, Britain, France, and Turkey. Israel is disappointed.

30 Friction grows within the Hakibbutz Hame'uhad ("United Kibbutz") movement between its Mapam ("United Workers Party") majority and Mapai ("Israel Labor Party") minority.

June

1 A union of Mapai kibbutzim is established within the Hakibbutz Hame'uhad movement.

11 Israel resumes drainage work at the Hulah Lake but excludes Arab-owned lands.

14 A plant for the assembly of Kaiser-Frazer cars is opened in Haifa.

25 The Knesset passes the Law of Immunity for Knesset Members.

29 Chief U.N. observer, General William E. Riley, demands that Israel allow the evicted Arab residents of the demilitarized zone on the Syrian border to return.

Austerity and rationing are reflected in a shortage of agricultural produce in the markets, restrictions on electricity consumption, and a slowdown in housing construction.

July

12 Israel raises the issue of Egypt's embargo of Israeli ships at the Suez Canal before the U.N. Security Council.

The independence spirit is at its height. Illustration by Abba Fnichel.

Nearly everything is scarce. Shown, lines for kerosene distribution.

17 The Knesset passes the Law on Equal Rights for Women.
20 King Abdallah of Jordan is assassinated while leaving the al-Aqsa mosque in Jerusalem. His son and heir Talal, is institutionalized in a psychiatric sanatorium in Switzerland. Abdallah's younger son, Na'if, is named regent.
25 The first Nahal ("Fighting Pioneer Youth Corps") settlement is founded at the Gaza Strip border, later to be named Kibbutz Nahal Oz.
30 Elections for the Second Knesset are held. Mapai ("Israel Labor Party") retains its strength and can form the next government.

August

3 The findings of a commission of inquiry appointed to investigate complaints by the Zealots Alliance detainees arrested in May are published. Most of the accusations regarding beatings, abuse, and insults are substantiated. The government is instructed to correct police procedures.
11 The U.N. Palestine Conciliation Commission calls upon Israel and the Arab states to participate in a conference in Paris.
14 The 23rd Zionist Congress opens in Jerusalem, the first to be held in the State of Israel.
20 The Second Knesset convenes. It elects Yosef Sprintzak as speaker.
Tension mounts along the borders. Chief U.N. observer, General William E. Riley, accuses Israel of violating U.N. decisions on land work in the northern demilitarized zone. Arab infiltration increases, as does the number of military incidents, especially along the Egyptian border.

The Hapo'el All-Star basketball team wins the first place in the Workers Sports Assembly in Liège, Belgium.

September

1 The U.N. Security Council demands that Egypt lift its embargo of Israeli ships on the Suez Canal. Egypt announces that it will not comply.
13 The Palestine Conciliation Commission talks begin in Paris between representatives of Israel and the Arab states.
21 Israel proposes a nonbelligerency agreement with the Arab states during the talks in Paris.
24 The Palestine Conciliation Commission proposes the return of the Arab refugees to Israel, changes in the armistice agreements, and the establishment of economic relations between Israel and its neighbors.

Operation Ezra and Nehemiah is completed. Approximately 115,000 Jews from Iraq have been airlifted to Israel.

The shortage of foreign currency threatens to preclude the distribution of necessary food supplies for the approaching holidays. The minister of agriculture announces that his ministry lacks the budget to release bonded shipments warehoused at the ports.
27 German Prime Minister Dr. Konrad Adenauer announces that his government is prepared to make reparations to the Jewish people.

October

4 Representatives of the Arab states attending the Palestine Conciliation Commission talks in Paris announce that they do not recognize the existence of the State of Israel.

7 Ben-Gurion presents a new government to the Knesset after over two months of meetings. The coalition parties are Mapai, Hapo'el Hamizrahi, Mizrahi, and Agudat Israel.
8 The Knesset accepts the new government by a vote of 56 to 40 with 4 abstentions.
16 Mif'al Hapayis – the state lottery, established by the government and the local councils to raise funds for education and health institutions, holds its first lottery.
Severe shortage of bread in Tel-Aviv.
21 Israel's economic situation is eased with the announcement of a United States grant of $65 million.

The United Groups and Kibbutzim (Ihud Hakvutzot Vehakibbutzim) movement is established, consisting of the Association of Collective Settlements and the Mapai-oriented kibbutzim in Hakibbutz Hame'uhad ("United Kibbutz").

November

1 The United Egged Cooperative is formed.
The Productivity Institute is founded.
12 Israel's merchant seamen announce a labor dispute. They disobey orders issued by the Haifa labor council, are dismissed from their jobs, and are replaced by foreign sailors. This prompts them to mount a lockout of the fleet involving physical assaults. The police intervene and force the

striking seamen off the boats. The strike lasts over a month.
19 Dr. Hayim Weizmann is reelected President of the state unopposed.

December

Harsh winter weather is recorded in all parts of the country. The immigrant camps and ma'abarot are especially hard hit, some of them flooded. Thousands of immigrants are evacuated to schools. The I.D.F. is brought in to assist.

Two new immigrant towns are established in the south – Kiryat Malakhi and Sderot. Residents still live in the ma'abarot (immigrant transit camps) located there.
12 The Palestine Conciliation Commission acknowledges the failure of the talks in Paris, accusing both Israel and the Arab states of presenting rigid positions.
14 The striking seamen clash with Haifa police.
24 The seamen's strike ends.

Approximately 175,000 immigrants arrive during 1951, although the arrival rate tapers off sharply toward the end of the year. The number of ma'abarot peaks at 139.

Rationing and austerity dictate everyday life. Rations are stamped in identity cards. Eggs are distributed once a week.

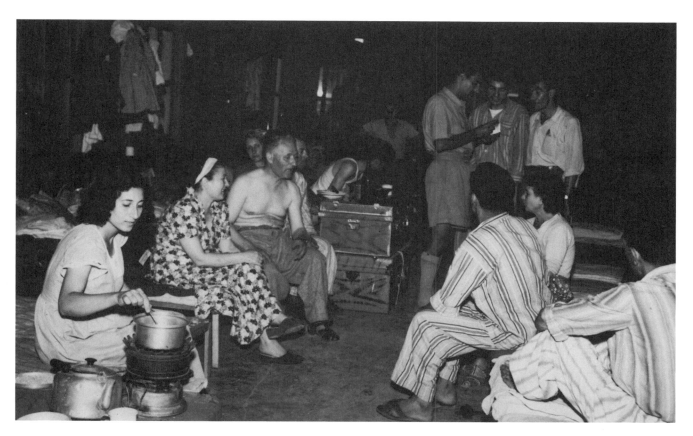

△ The ma'abarot foster a
new communal life style
shared by newcomers from
all parts of the world.

Tensions build up, due to
harsh conditions and cultural
differences, but some en-
counters are pleasant.

▽ Relief work is created by
the government, the
Jewish National Fund, and
other institutions. Here,

immigrants stabilize sand
dunes in the coastal area.

THE HARDSHIPS OF IMMIGRANT ABSORPTION

The year 1951 witnessed continued massive immigration – 175,000 newcomers (a record surpassed only years later, in 1990). However, this wave soon tapered off for various reasons:

(1) the Jewish communities in a number of countries had by then been transferred to Israel virtually in their entirety;

(2) the difficult economic situation in Israel and the hardships of absorption had become known in the Diaspora, and some potential immigrants decided to defer migration;

(3) a new policy of selective immigration was adopted by Israel during the second part of 1951, favoring young and employable immigrants over older, ill, or unskilled newcomers.

Most Israelis still supported the notion of mass immigration, but some voices warned of the need to stanch the flood. The daily *Haboker* ("The Morning") wrote in November 1951: "Many downtrodden, old, elderly, exhausted, chronically ill, disabled and other welfare cases have arrived recently. Bringing them has not strengthened the state, benefited the community or enhanced hopes for the future." The policy of selective immigration cut down the number of newcomers already in the second half of 1951. In 1952, immigration dropped drastically to 24,000, compared with 175,000 in 1951.

▷ Immigrants to Israel arrive from all parts of the world. The shock of encounter with the new state is actually the second shock, the first one being the flight itself – the first in their lives – to the Promised Land. Thousands, and in some cases tens of thousands, are airlifted from Iraq monthly. They include urban residents of Baghdad and Basra as well as villagers from remote mountain areas in Kurdistan, as shown in the picture. Upon their arrival, most immigrants are sent to Sha'ar Ha'aliyah camp, near Haifa. After being registred, they are transferred to ma'abarot ("immigrant transit camps") all over the country.

◁ Corrugated tin huts in a ma'abara. The temperature inside is stifling in summer and freezing in winter.

△ Framed canvas huts in a ma'abara. Enlarging the "house" is not too much of a problem, as shown.

◁ The standard of living in three-year-old Israel is not high. Refrigerators are rare, and most families rely on iceboxes to preserve their food. Shown, the iceman makes his rounds.

▽ Elections for the Second Knesset are held in the summer of 1951. Billboards and walls are covered with electioneering propaganda. Cultural posters can also be seen: film advertisements, *Mother Courage* in the Habimah theater, *Samson and Delilah* at the opera, a lecture about Marc Chagall, a play in Yiddish.

▽ Satirizing the austerity period, the Li-La-Lo theater presents a story about the bitter fate of an egg and a chicken under the austere regime of Dov Yosef (l.).

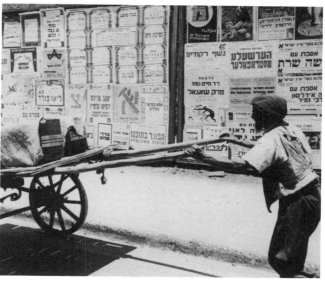

ELECTIONS FOR THE SECOND KNESSET

In February 1951, just over two years after the election of the First Knesset (January 1949), the government resigned over the defeat of proposals made by the minister of education for the schooling of immigrant children, which the prime minister viewed as a vote of no-confidence. Efforts to form a new government were unsuccessful, and in April 1951 the Knesset adopted a law for new elections to be held on July 30.

Mapai ("Israel Labor Party"), the major party, had to struggle on three fronts: with Mapam ("United Workers Party") from the left over foreign policy and social and economic matters; with the religious parties over education; and with Herut and the General Zionists, mainly over the economy.

The main winner in the elections for the Second Knesset was the centrist General Zionist party, which nearly tripled its strength from 7 to 20 Knesset seats. Mapai preserved its position with 45 seats (compared to 46 previously), Mapam dropped from 19 to 15 seats, and Herut sank from 14 to 8. The United Religious Front, which had 15 seats in the First Knesset, split into four separate parties, which together obtained exactly 15 seats. The Israeli Communist Party, Maki, rose from 4 to 5 seats.

Despite the significant gain by the General Zionists, however, the composition of the political blocs remained unchanged: The Labor parties kept more than half the seats in the Knesset, and the religious parties retained their strength. The general impression was that after the stormy elections, matters would remain unchanged.

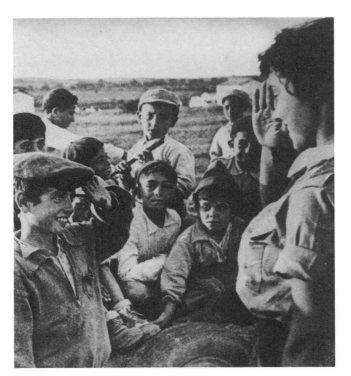

THE DETERIORATING SITUATION ALONG THE BORDERS

A marked deterioration occurred along the country's borders in 1951, from past incidents of Arab infiltration aimed at theft to armed attacks aimed at sabotage and murder. The Syrians repeatedly fired on the Israeli drainage works initiated at Lake Hulah near the northeast border, and in the spring began invading Israeli territory. In April, an Israeli police patrol in the al-Hamma area was ambushed by Syrian forces, who killed seven policemen and effectively took control of the area. A reprisal by the Israeli air force did not bring about any change in the situation. Another Syrian force penetrated Israeli territory at Korazim north of the Kinneret in May, routed by the I.D.F. after a four-day battle in which 40 Israeli soldiers were killed.

Incidents proliferated along the Jordanian and Egyptian (Gaza Strip) borders as well, with the I.D.F. mounting its first reprisals there in response to infiltration and sabotage.

△ In addition to defense, the I.D.F. deals with the education of new immigrants. Soldier-teachers are stationed in immigrant communities to assist with the Hebrew-language instruction of adults and children. Soldiers are also assigned to help evacuate flooded ma'abarot (immigrant transit camps).

▽ Prime Minister Ben-Gurion visits the United States in May 1951, meeting with President Truman as well as with young leaders from both political parties. One of them is Congressman John F. Kennedy, age 34 (r.). At center, Franklin Delano Roosevelt, Jr.

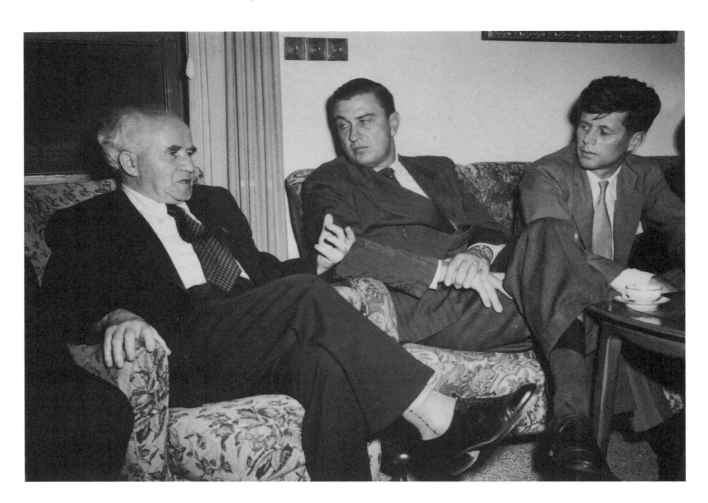

◁ A newspaper advertisement for the model Henry J., which is assembled by Kaiser-Frazer (American capital has been invested in the plant).

▽ The Kaiser-Frazer assembly plant in Haifa is opened in June 1951.

△ The great flood in December 1951: the streets of Tel-Aviv turn into rivers, flooding even the country's sole double-decker bus — which is an attraction for children from all over the country.

▷ The great flood: intense rainfall and cold weather exacerbate harsh living conditions in the ma'abarot. Shown are parents evacuating their baby.

1952

January

7 The Herut movement organizes a mass demonstration near the Knesset in protest against the notion of accepting reparations from Germany. The crowd throws stones, breaking windows in the Knesset. The police respond with tear gas.

9 The Knesset approves Prime Minister Ben-Gurion's announcement of negotiations with West Germany regarding reparations by a vote of 61 to 50.

15 MK Menahem Begin, leader of the Herut party, is suspended from Knesset sessions for three months for threatening violence in the house.

16 Operation Cyrus – the airlift of Jews from Iran – begins.

Heavy rainfall. The Ayalon river floods the Montefiori neighborhood in Tel-Aviv. The ma'abarot (immigrant transit camps) in the region are also inundated.

February

3 A Mapam ("United Workers Party") leader, Mordechai Oren, disappears in Czechoslovakia en route from Germany to Israel. Reports indicate that he has been held there since December 31, 1951.

13 The government adopts a new economic policy, setting three separate exchange rates for the Israeli pound: 2.80, 1.40, and 1.00 to the dollar. Prime Minister Ben-Gurion pledges to stimulate productivity, halt inflation, reduce the size of the government apparatus, and fight the black market.

28 The Israeli government makes contact with Czechoslovakia regarding the arrest of Mordechai Oren.

March

6 The Knesset approves Minister of Defense Ben-Gurion's proposal for compulsory military service for women, including religious women, by a vote of 62 to 28.

16 The ministry of immigration is closed down. Its authority is transferred to other ministries.

20 Negotiations with representatives of West Germany over reparations open in Holland. The talks soon founder.

23 Prague confirms Oren's arrest, claiming that he perpetrated "criminal acts" against the Czechoslovakian state.

26 The heads of the Zealots Alliance underground are sentenced to short prison terms of six months to a year.

April

1 The Knesset passes the Law of Citizenship.

The Israel Water Project is founded.

5 The Physicians' Union warns of health hazards to the public as a result of poor nutrition.

A locust plague reaches Israel. The ministry of agriculture combats it.

30 Israel celebrates its 4th Independence Day with a military parade in Tel-Aviv. Immigration plummets. The government focuses on the construction of public housing for the immigrants in the ma'abarot and immigrant camps.

May

4 The government decides to transfer the ministry of foreign affairs from Tel-Aviv to Jerusalem.

13 The first graduating class of physicians is awarded degrees at the Hebrew University of Jerusalem.

The heavy winter rains have benefited the farmers. Large quantities of fresh produce reach the markets.

June

2 The abundance of agricultural produce leads the government to cancel price control of most vegetables.

5 A cornerstone ceremony is held at Ein-Kerem,

Sprinter David Tabak, Helsinki Olympics, 1952.

Jerusalem, for the new Hadassah-Hebrew University medical center, which will replace the closed hospital in the Israeli enclave on Mt. Scopus.

9 New currency notes are issued bearing the imprint Bank Leumi of Israel. They replace the Anglo-Palestine Bank notes. Simultaneously, the government announces a compulsory loan of 10% on cash and bank balances. Old currency notes are exchanged for new ones at 90% of their value.

13 The Israeli Atomic Energy Commission is established.

15 A severe shortage of foreign currency prompts fuel restrictions. Car owners are ordered to keep their vehicles idle two days a week, including the Sabbath.

22 A hand grenade is exploded in front of the home of Minister of Transport David Zvi Pinkas in connection with the enforced idling of cars.

24 A second round of reparations talks begins.

25 The cabinet is reshuffled. Minister of Finance Eliezer Kaplan resigns for reasons of health and is named deputy Prime Minister. He is replaced by Minister of Agriculture Levi Eshkol. Peretz Naftali becomes minister of agriculture. Attorney General Hayim Cohen is named minister of justice.

30 The *Daily Express* in London writes that an American base for atomic bombers is about to be built in Netanya. The army spokesman denies the news.

July

13 Eliezer Kaplan, Mapai ("Israel Labor Party") leader,

first finance minister, and treasurer of the Jewish Agency since 1933, dies aged 62.

14 Arab infiltrators murder five Israeli guards in the Timna region of the southern Negev.

19 Israel participates in the Olympics for the first time, represented in Helsinki by 26 athletes.

23 A military coup in Egypt. King Faruq is overthrown by a group which calls itself "the Young Officers," led by General Muhammad Neguib.

August

6 The first Zimriyah (choir festival) opens in Jerusalem with dozens of participating choirs from Israel and abroad.

11 The Jordanian parliament deposes King Talal, due to his mental illness. His son, Hussein, aged 17, will accede to the crown and to full authority when he comes of age.

15 Syrian ruler Adib Shishakli threatens to attack Israel.

18 Prime Minister Ben-Gurion proposes a peace agreement to Egypt. He warns Syria against threatening Israel.

Pinhas Lavon joins the government as a minister without portfolio.

21 Itzhak Sadeh, an I.D.F. general and the first commander of the Palmah, dies at age 62.

The U.S.S.R. executes dozens of prominent Jewish authors and intellectuals, causing shock waves in Israel and the Jewish world.

September

10 A reparations agreement is concluded with West Germany.

18 Ben-Gurion again proposes a peace agreement to Egypt. Egypt does not respond.

19 Another government crisis develops over a religious issue, this time the conscription of women into the army.

23 Minister of Social Welfare Rabbi Itzhak Meir Levin, an Agudat Israel leader, resigns.

The Agudat Israel and Po'alei Agudat Israel factions

The second President of Israel, Itzhak Ben-Zvi, takes office in December 1952. He will be elected as president twice more (in 1957 and in 1962), holding office until 1963.

△ The first President of Israel, Dr. Hayim Weizmann, dies in November 1952 after a four, year period in office. Relief by sculptor Moshe Zipper.

△ Lt. Gen. Mordechai Makleff (r.) replaces Lt. Gen. Yigael Yadin as chief of staff, following Yadin's resignation

over differences of opinion with Defense Minister Ben-Gurion over the size of the army and its budget.

withdraw from the government coalition. The government is left with a bare 60 supporting MKs.
24 Britain and France upgrade their representations in Israel to ambassadorial level. Israel takes a reciprocal step.

October

5 An attempt to place a bomb in the ministry of foreign affairs in Tel-Aviv in protest against the reparations agreement is foiled. Two suspects are detained: Ya'akov Heruti and Dov Shilansky.
13 The austerity program is eased further. Minister of Commerce and Industry Dov Yosef announces the cancellation of price controls of housewares and cleaning products.

November

3 MK Mordechai Nurok, a Mizrahi leader, is appointed minister of the postal service.
9 Dr. Hayim Weizmann, first president of the State of Israel, dies.
18 Prof. Albert Einstein declines a request made by Ben-Gurion to serve as president of Israel.
20 Communist party leaders in Czechoslovakia are accused of treachery and spying in a sensational show trial in Prague. One of the witnesses is the Israeli detainee Mordechai Oren, who is depicted as an "international spy."
24 The Knesset passes a law establishing the status of the Zionist Organization and defining its relationship with the State of Israel.
30 The first families settle in the new immigrants' town, Migdal Ha'emek.

December

1 Israel's ambassador to the U.N., Abba Eban, proposes direct negotiations for peace with the Arabs. The Arabs reject the proposal.
6 The Czechoslovakian government declares the Israeli ambassador, Dr. Aryeh Kubovy, persona non grata, claiming that he was involved in espionage activity perpetrated by the discredited Communist leaders.
7 A new chief of staff, Mordechai Makleff, replaces

Yigael Yadin, who resigns over differences of opinion with Defense Minister Ben-Gurion.
10 Israel's second president, Itzhak Ben-Zvi is sworn in. A scholar of Jewish ethnography, he served in the past as president of the National Council.
14 Dov Shilansky is sentenced to 21 months imprisonment for attempting to plant a bomb in the ministry of foreign affairs.
19 Ben-Gurion submits his resignation to the President, signifying the government's resignation as well.
21 President Ben-Zvi assigns Ben-Gurion the task of forming a new government.
22 Ben-Gurion presents a new government to the Knesset. It includes four ministers from the General Zionist party – Peretz Bernstein, Israel Rokakh, Yosef Sapir, and Yosef Serlin. The Progressives return to the government, and, after a short delay, the religious parties follow suit.
23 The new government is approved by the Knesset, by a vote of 63 to 24.
25 The town of Hatzor is founded in the Galilee, developing from the immigrant ma'abara located there.

Immigration drops drastically in 1952 for the first time in years, totaling 24,000 as compared to 175,000 the previous year.
The cost-of-living index rises in the course of the year from 113 to 178 points (57.5%). The standard of living sinks.

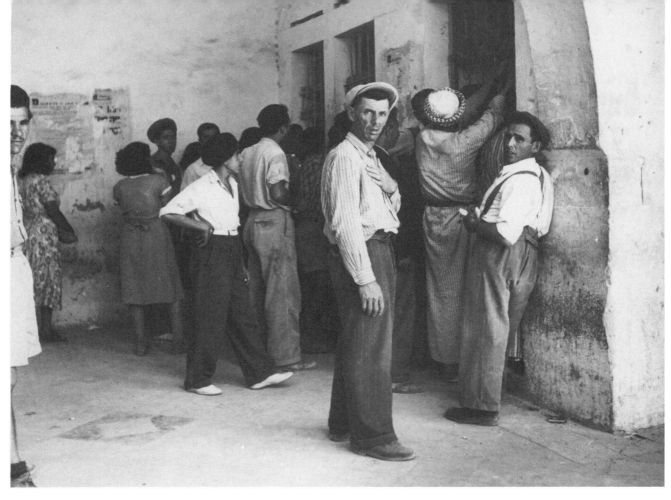

ELECTING THE SECOND PRESIDENT

The death of President Hayim Weizmann in November 1952 left a vacuum in the highest office of state. Following the traditional week of mourning, intensive political activity was initiated to choose a suitable candidate. Typically, Prime Minister Ben-Gurion surprised everyone, proposing Prof. Albert Einstein for the office, but Einstein declined and the Israeli political community had to content itself with a local figure.

The vote for president was held in the Knesset on December 8, 1952. Mapai's ("Israel Labor Party") candidate was Itzhak Ben-Zvi, chosen by his party over Knesset Speaker Yosef Sprintzak. The General Zionists proposed Peretz Bernstein; Mapam ("United Workers Party") Itzhak Greenboim; and the religious parties Rabbi Mordechai Nurok. Ben-Zvi received 48 votes in the first round of voting, Bernstein 18, Greenboim 17, and Nurok 15. Ten envelopes were submitted empty. The second round of voting brought hardly any change. Two rounds later, most of Mapam's votes went to Ben-Zvi, who attained a majority of 62 votes and was elected. In this round, Rabbi Nurok received 40 votes and Greenboim only 5. Five envelopes were submitted empty.

Itzhak Ben-Zvi served as president until his death in April 1963.

△ The economic situation in 1952 is worrisome. The government tries to find work for the large number of unemployed who crowd the government employment offices, as in Beersheva, shown. At the beginning of the year, Ben-Gurion promises to promote exports and suppress inflation.

◁ President Itzhak Ben-Zvi's father, 90, is a guest of honor at his son's inaugural ceremony.

▷ In 1952, blackboard and chalk are still used for the notice board of the Knesset. On December 9, 1952, the third sitting takes place to elect the new president. Ben-Zvi is elected with a majority of 62 votes.

▽ An I.D.F. parade is held in Tel-Aviv on Independence Day, by then a tradition.

▷ Itzhak Sadeh, a distinguished soldier, dies in 1952.

▷ New currency notes are issued in 1952 bearing the imprint Bank Leumi of Israel instead of the Anglo-Palestine Bank. The government uses the opportunity to institute a 10% compulsory loan: old currency notes are exchanged for new ones at 90% of their value. This compulsory loan system will not be repeated.

◁ David Ben-Gurion manages to broaden the narrow base of his government in late 1952, a goal he has worked to achieve since the elections for the Second Knesset in the summer of 1951. Following nearly four years in opposition, the General Zionists, the country's second-largest party, join the coalition with four ministers. Seated (l. to r.): Ben-Zion Dinur, Prime Minister Ben-Gurion, President Ben-Zvi, Dov Yosef. Standing (l. to r.): Naftali, Eshkol, Lavon, Serlin, Golda Meir, Rosen, Sharett, Rokakh, Bernstein.

◁ The political struggle
between Mapai (left arm)
and Mapam (right arm)
causes the split-up of
dozens of kibbutzim.
Caricature by Dosh.

▽ A scene that elicits pride in
1952: Permanent housing
in remote Eilat is
constructed with bricks
manufactured from local
clay.

◁ Distinguished guests visit
the country continually.
Here, Eleanor Roosevelt,
chairperson of the U.N.
Commission on Human
Rights, meets Bedouin
Sheikh al-Huzeil near Kibbutz
Shuval in the Negev.

THE REPARATIONS

With the end of World War II, Jewish leaders claimed
reparations from Germany for material damage to the
Jews by the Nazi regime amounting to billions of dollars.

In September 1951, the government of West Germany
announced its willingness to pay restitution. The issue,
however, elicited a major storm in Israel. Opponents
questioned the implicit notion of forgiveness of
Germany and the receipt of money for the six million
murdered Jews. Proponents argued that the murderers
must not be allowed to also inherit their victims' pro-
perty. Raising the issue in the Knesset on January 7,
1952, Prime Minister Ben-Gurion emphasized that the
reparations were needed to absorb the hundreds of thou-
sands of Holocaust survivors in Israel. The opposition,
spearheaded by Herut leader Menahem Begin, mounted
a determined campaign against the receipt of reparations.
A mass demonstration was organized by the Herut
movement through Jerusalem toward the Knesset.
There, the demonstrators clashed with the police,
throwing stones and shattering the windows of the
Knesset. The police responded with tear gas.

Opposition to the idea of reparations crossed political
lines and included M.K.s from the Left, the Right, and
the religious sector. In the end, however, the Knesset
adopted a decision to enter into negotiations with West
Germany by a vote of 61 to 50. Talks began in The
Hague in March 1952 and continued until September.
Jewish interests were represented by the Israeli govern-
ment and the Conference on Jewish Material Claims
against Germany (representing 23 Jewish organizations).
The talks concluded with the signing of an agreement in
Luxemburg on September 10, 1952, by West German
Chancellor Konrad Adenauer, Israeli Foreign Minister
Moshe Sharett, and the president of the Claims
Conference, Nahum Goldmann, for the payment by
West Germany of DM 3 billion ($750 million) to Israel
and approximately DM 500 million ($125 million) to
the Claims Conference within 12-14 years.

In 1956, a law was passed in Germany providing for
personal compensation to Nazi victims. Consequently,
many Israeli citizens started to receive a monthly paym-
ent from West Germany. The reparations contributed
substantially to the Israeli economy during the 1950s
and the 1960s.

January

13 Israel and world Jewry are shocked by reports of the "Doctors' Plot" in the U.S.S.R. in which Jewish physicians are accused of having attempted to poison Soviet leaders.

25-29 The worsening security situation along the border with Jordan prompts several retaliatory raids by the Israel Defense Forces in Samaria and the Mt. Hebron area. The operations fail at a cost of Israeli fatalities and wounded. The Gaza Strip border also heats up.

Relations between Israel's political parties deteriorate. Two violent confrontations occur between Mapai ("Israel Labor Party") and Mapam ("United Workers Party") supporters at Kibbutz Ein-Harod during the course of the month. A listening device is discovered in Mapam leader Meir Ya'ari's office in Tel-Aviv, for which Mapai is blamed. The Mapam council decides to eject the faction led by Moshe Sneh from the party because of its extreme leftism. Sneh forms an independent party.

February

9 An explosion occurs in the U.S.S.R. Embassy building in Tel-Aviv. The injured include Ambassador Yershov's wife.

12 The U.S.S.R. cuts off diplomatic relations with Israel in the wake of the explosion.

26 Nahal ("Fighting Pioneer Youth Corps") founds a settlement in Ein-Gedi.

March

5 Left-wing circles in Israel mourn the death of the Soviet leader, Stalin.

26 A new road linking Beersheva and Sodom is opened, marking a complex engineering achievement.

The Histadrut ("Federation of Labor") initiates a City to Country settlement campaign.

April

4 The "Doctors' Plot" accusation is rescinded by the Soviets and the detainees are released.

9 Foreign Minister Moshe Sharett meets with President Eisenhower in Washington and requests military aid.

17 In Jerusalem, violinist Jascha Heifetz is assaulted after a concert, where he played a piece by Richard Strauss.

20 The Israel Prize awards are granted for the first time, on the 5th Independence Day.

22 A day-long exchange of fire takes place between Jordanian soldiers positioned along the walls of the Old City of Jerusalem and Israeli soldiers.

May

2 Two coronations take place in the Middle East: Hussein in Jordan and his cousin, Faisal, in Iraq. Both kings are 18 years old.

10 The government removes price controls on clothing and footwear.

13 U.S. Secretary of State John Foster Dulles arrives for a visit.

Sharett prepares himself to replace Ben-Gurion (by Dosh).

17-21
17-21 The I.D.F. mounts a series of raids across the Jordanian border in retaliation for acts of infiltration, sabotage and murder. Most of the operations fail to achieve their goal.

25 A crisis erupts in the government over the hoisting of red flags and the singing of the *Internationale* in some schools on May 1. The General Zionists resign from the coalition.

June

1 Infiltrators from Lebanon shoot at a truck carrying children on the Meron-Parod road, killing one youth and injuring another seriously and two others slightly.

3 The coalition crisis is solved. The four General Zionist ministers return to the government.

6-11 A series of grave incidents occur along the Jordanian border: a young man is murdered in the Katamon neighborhood of Jerusalem and his girlfriend is wounded; a hand grenade thrown by a Jordanian soldier wounds two Israelis in south Jerusalem (June 6); a member of Moshav Tirat Yehuda is murdered (June 9); a house is blown up in Moshav Mishmar Ayalon (June 10); and hand grenades thrown into a house in Kfar Hess kill a woman and seriously injure her husband (June 11).

8 Efforts are made by the U.N. to calm the situation. Israel and Jordan sign a new agreement to prevent infiltration.

9 Attorney General Hayim Cohen announces that the police have uncovered an underground organization aimed at bringing down the government by force.

July

1 The new Histadrut ("Federation of Labor") Executive building in Tel-Aviv is inaugurated.

9 The trial of 15 persons accused of belonging to the recently exposed underground organization begins at the Tzrifin army camp.

20 The U.S.S.R. announces the resumption of diplomatic ties with Israel.

22 A large demonstration by the ultra-Orthodox in Jerusalem takes place during the Knesset debate over the Women's National Service Law.

26 The Finaly children affair ends. The two young brothers, orphaned Holocaust survivors in the custody of the Catholic Church for a long period, reach Israel after intensive effort and are turned over to their aunt in Gedera.

The ministry of foreign affairs is transferred to Jerusalem during the course of the month.

August

11 Hand grenades are hurled at a boys' boarding school in Kiryat Ye'arim. Tracks lead to the Jordanian border.

12 The Knesset passes the State Education Law establishing two systems: the state education network and the state religious education network. The 30-year-old Labor education system is thus abolished.

12-13 I.D.F. forces target a series of locations in the southwest region of the West Bank in Operation Revenge and Reprisal – a response to acts of sabotage and murder emanating from Jordan. Most of the operations fail to achieve the desired effect of halting infiltration.

25 A military court sentences the members of the "Tzrifin Underground" to long prison terms.

28 The Jordanians acknowledge that five Israelis who were hiking to Petra in Jordan were killed in an exchange of fire.

The I.D.F. forms a secret commando unit for missions across the border – Unit 101, commanded by Major Ariel Sharon.

September

2 A new dispute breaks out between Israel and Syria over the channeling by Israel of Jordan waters to the Negev.

4 Rabbi Ben-Zion Meir Hai Uziel, the Sephardi Chief Rabbi since 1939, dies at age 73.

7 Infiltrators from Jordan murder two young Israelis walking from Lod to Moshav Ahiezer.

9 The Progressive Party publishes a new daily: *Zmanim* ("Times").

20 The fourth Maccabiah opens in the new Ramat Gan Stadium.

21 New Chief of U.N. Observers General Vagn Bennike supports the Syrian position in the dispute over channeling the Jordan River waters.

22 An exhibition titled *Conquest of the Wilderness* showing Israeli achievements opens in Jerusalem.

29 Another dispute with Egypt develops over the establishment by Israel of a settlement in the Nitzana demilitarized zone.

October

13 Infiltrators from Jordan murder a mother and her two children in Yehud, 8 km from Tel-Aviv.

15 A retaliatory raid by Israel on the village of Qibya in Jordanian territory for Jordanian-based terrorist acts during the preceding months results in heavy casualties among the villagers. Israel is censured worldwide.

19 The United States announces its decision to hold back aid to Israel in light of the Jordan River waters development.

27 Eric Johnston, the American Administration's "water ambassador," arrives in Israel to attempt to find a solution to the water dispute involving Israel, Jordan, Syria, and Lebanon.

The U.N. Security Council addresses the dispute over the diversion of the Jordan River waters. The tone is critical of Israel.

28 Israel informs the U.N. Security Council that it is temporarily halting work on the diversion of the Jordan River waters. President Eisenhower announces the resumption of aid to Israel.

30 Two Israelis accused in the Prague show trials – Mordechai Oren and Shim'on Orenstein – are sentenced to life imprisonment. The sentences are made public only several months after they were handed down.

November

5 Prime Minister Ben-Gurion announces his intention to resign from government office for "a year or two." The decision comes as a surprise both in Israel and abroad.

11 The Mapai ("Israel Labor Party") Executive tries to persuade Ben-Gurion not to resign. Ben-Gurion is adamant. He proposes Levi Eshkol as his replacement for the office of prime minister.

18 The Knesset passes the National Insurance Act.

23 Mapai's political committee chooses Foreign Minister Moshe Sharett as its candidate to replace Ben-Gurion as prime minister.

24 The U.N. Security Council severely censures Israel's raid on Qibya.

December

6 I.D.F. leadership is reshuffled when Chief of Staff Mordechai Makleff completes his tour of duty and is succeeded by Lt. Gen. Moshe Dayan.

David Ben-Gurion announces his resignation from office and his retirement to Kibbutz Sdeh Boker in the Negev.

The year 1953 witnesses a low point in immigration – only 11,000 newcomers arrive.

△ Outlying new residential areas of Tel-Aviv, Israel's largest city, still reflect the agricultural character of the region. Large dairy farms near residential city housing supply milk to the city.

△ A truck transporting produce is mined on the road to Jerusalem.

◁ A new daily appears in September 1953 – *Zmanim* ("Times").

▷ A freight train transporting fuel is derailed near Kibbutz Ayal, by the Jordanian border.

INCIDENTS ALONG THE JORDANIAN BORDER

The state of security along the Syrian and Jordanian borders deteriorated during 1953. The Syrian situation was linked to the diversion of the Jordan River waters, while the Jordanian threat emanated from a series of terrorist bands operating from Jordanian territory with the aim of infiltration, sabotage, and murder especially in the Jerusalem Corridor region.

Dozens of terrorist incidents took place during the course of the year, generally eliciting retaliatory raids by I.D.F. units on villages and bases across the border. Most of these operations, however, failed to achieve their goal of ending this threat. In the summer of 1953, a small secret commando unit – Unit 101 – was formed under Major Ariel Sharon for counterterrorist activity

across the border. Its most highly publicized operation took place on the night of October 14-15, 1953, aimed at the village of Qibya in southwestern Samaria, a known terrorist base. Unit 101 took over the village, and most of the inhabitants fled. The Israeli forces then mined the houses under the assumption that they were empty, unwittingly killing approximately 70 inhabitants who were hiding inside.

The Qibya incident raised a storm and elicited widespread censure of Israel, especially by the U.N. Security Council. The army reached two conclusions. First, to stop its attacks on civilian targets. Second, to merge Unit 101 into the paratroopers and raise their battle readiness.

BEN-GURION RETIRES TO KIBBUTZ SDEH BOKER

In the fall of 1953, Prime Minister and Minister of Defense David Ben-Gurion decided to resign from political office and retire to Kibbutz Sdeh Boker, a new settlement in the Central Negev. In early November, he announced his decision to the general secretary of Mapai ("Israel Labor Party"). The party's attempts to dissuade him were in vain.

His preference for successor was Minister of Finance Levi Eshkol, but Eshkol declined and Mapai's political committee chose Foreign Minister Moshe Sharett instead. Protracted coalition negotiations followed, with the coalition partners presenting new conditions.

Ben-Gurion, however, did not wait for the results of these negotiations, submitting his resignation to the President on December 7, 1953, one day after he had named Moshe Dayan as Chief of Staff to succeed Mordechai Makleff after one year in office.

Ben-Gurion spoke of retirement for a year or two. Most of the population hoped that he would return. Few believed that he would in fact settle in Sdeh Boker. Within a short time however, the 67-year-old statesman became the oldest member in the young kibbutz.

◁ David Ben-Gurion (c.) resigns as prime minister in December 1953 just after appointing Lt. Gen. Moshe Dayan (r.) as Chief of Staff, replacing Lt. Gen. Mordechai Makleff (l.).

▽ Ben-Gurion's retirement to Kibbutz Sdeh Boker astonishes the country. Hundreds of articles in the press analyze this sudden move, and caricatures etch it into the national consciousness. Shown, a caricature by Dosh showing a confused Israeli after Ben-Gurion has exchanged hats with him.

◁ An explosion in the Soviet embassy building on Rothschild Boulevard in Tel-Aviv in February 1953 causes serious damage. It prompts the U.S.S.R. to sever relations with Israel. They will be resumed after 5 months.

◁ The Histadrut, ("Federation of Labor") at the height of its power in the early 1950s, requires a new central building, which is constructed in the "distant" north of Tel-Aviv in an unbuilt part of Arlozoroff Street and is inaugurated in the summer of 1953. Criticism is leveled at the size and luxuriousness of the edifice, which has marble flooring and modern elevators. Histadrut leaders reply in defense that the second largest body in the country (after the government) requires a building of its own, to say nothing of the employment the construction work has provided.

Soviets Surprise World by Releasing Doctors; Malenkov Move Welcomed as Step to Peace
U.S.S.R. Renews Diplomatic Link With Israel After 5-Month Break

◁ Nahal ("Fighting Pioneer Youth Corps") establishes its fifth settlement in the winter of 1953, in Ein-Gedi by the Dead Sea.

▽ March 1953: The Israeli Left mourns Stalin's death. Mapam describes him as "a great leader and glorious commander."

△ Reports from the U.S.S.R. of a Jewish "Doctors' Plot" agitate Israel and the Jewish world. The Israeli press highlights the topic, along with Israel's relations with the Soviet Union. Shown, headlines from the *Jerusalem Post*.

מפלגת הפועלים המאוחדת

נחרדה לשמע האסון הגדול, אשר ירד על עמי ברית-המועצות
על הפרולטריון העולמי ועל כל האנושות המתקדמת

בהלקח המנהיג הגדול והמצביא המהולל

יוסף ויסאריונוביץ
סטאלין

אנו מרכינים את דגלנו בטן לזכר הלוחם הקומוניסטי הגדול,
אדריכל הבניה הסוציאליסטית וקברניט תנועת השלום בעולם.
פעליו ההומניזמיים הכבירים — ודרכו הורות במאבקים
אל משטר הסוציאליזם והקומוניזם בכל רחבי תבל.

מפלגת הפועלים המאוחדת
המרכז

△ Sephardi Chief Rabbi Ben-
Zion Meir Hai Uziel
(r., shown with Ashkenazi
Chief Rabbi Itzhak Herzog)
dies in September 1953.

▷ One way of coping with con-
tinued rationing is through
gifts of foreign-currency
"scrip" from relatives in
the United States, which is
exchanged for food.

△ One of the movie hits of
1953, *Roman Holiday*,
starring Audrey Hepburn,
has an "Israeli connection."
Around the end, the princess
(Hepburn) appears before
a press conference with for-
eign journalists including the
real-life correspondent for
Davar ("A Matter") in Rome,
Dr. Gross. Gross (r.) is posing
with director William Wyler.

1954

January

23 The Soviet Union vetoes a western proposal in the U.N. Security Council calling for a compromise between Syria and Israel in the dispute over the Jordan River waters diversion – the first Soviet anti-Israel veto.

26 The new government formed after Ben-Gurion's resignation is presented to the Knesset. Moshe Sharett is prime minister and foreign minister. Pinhas Lavon is defense minister. The Knesset approves the new government by a vote of 75 to 23, with 3 abstentions.

27 Israel submits a complaint to the U.N. Security Council over the Egyptian ban on Israeli navigation through the Suez Canal.

February

The I.D.F. (Israel Defense Forces) establish the Armored Corps.

16 The Knesset abolishes the death penalty in Israel. It can only be applied to Nazis and their helpers.

18 An immigrant soldier from Morocco, Natan Albaz, throws himself on a live hand grenade during a training mishap, sacrificing himself to save his comrades. The act makes a deep impression on the Israeli public.

A series of strikes is called by various groups – physicians, university students, the unemployed, and even schoolchildren protesting the teachers' treatment of them.

25 Two political upheavals in the Middle East: In Egypt, President Neguib is deposed by Colonel Nasser. In Syria, President Shishakli escapes, and is replaced by Hashem al-Atassi.

March

17 Eleven passengers on an Egged bus returning from the fifth-anniversary celebration of the liberation of Eilat are murdered in an attack by infiltrators from Jordan at Ma'aleh Akrabim.

23 Israel resigns from the joint Armistice Commission with Jordan following the refusal by the U.N.-appointed American chairman of the commission to censure the murders perpetrated at Ma'aleh Akrabim.

28-29 Israel mounts a retaliatory raid on a village outside Bethlehem following the murder of a Jewish watchman in a Jerusalem Corridor settlement. The operation is also connected to the Ma'aleh Akrabim incident. Jordanian casualties are 10 dead and 19 wounded. Israel has no casualties.

29 The Soviet Union vetoes a demand in the U.N. Security Council that Egypt rescind its ban on Israeli ships in the Suez Canal.

April

1 The National Insurance Institute begins operations.

6 The remains of Baron Edmond de Rothschild and his wife Adelaide are reinterred in a state ceremony at a site south of Zikhron Ya'akov.

May

4-6 Two first prizes are won by Israel in the Asian Games in Manila by Ahuva Kraus, in the high jump, and Yoav Ra'anan, in high board diving.

6 The I.D.F. Independence Day parade is held in a new location – the immigrant town of Ramleh.

18-20 Another nationwide physicians' strike takes place.

31 The I.D.F. Command General Staff School is opened.

Terrorist incidents continue along the Jordanian border.

June

10 David Ben-Gurion, making a dramatic appearance, arrives from Kibbutz Sdeh Boker to address an audience of 8,000 young people in an improvised stadium at Sheikh Munis in northern Tel-Aviv, calling on them to commit themselves to a pioneering lifestyle. His motto is: "career or mission."

18 Eric Johnston, President Eisenhower's "water ambassador," arrives in Israel to discuss regional water plans.

19 Infiltrators from Jordan murder three members of Moshav Mevo Betar in the Jerusalem Corridor.

24 The Municipality of Tel-Aviv-Jaffa resolves to establish a university in the city. Two already existing institutes will be integrated into it: the Institute of Science and the University of Law and Economy.

29-30 Following the murder of an elderly farmer in Ra'anana, a small unit of paratroopers mounts a raid on a Jordanian Legion camp east of the village of Azzun in Samaria. One of the Israeli fighters, Itzhak Jibli, is wounded and evacuated by his comrades but is later left behind at his own demand because of the danger to the unit. The Jordanians capture him and torture him. His fellow soldiers do everything possible to rescue him (see Jil campaign, August).

30 A serious incident with the Jordanians in Jerusalem. Intermittent shooting for three days results in four Israeli fatalities.

July

1 An incident at Lake Kinneret involves a Syrian attack on an Israeli patrol boat.

2-23 A series of sabotage acts are perpetrated by an Israeli network in Alexandria and Cairo. The network is exposed. The episode later becomes known as the Lavon Affair, or the Mishap.

7 U.S. envoy Eric Johnston announces that he has obtained agreement by all sides regarding the division of the Jordan River waters. Israel denies that it has made any such commitment.

29 A disaster occurs at Kibbutz Ma'agan when a light aircraft crashes into a gathering of the members at a memorial ceremony commemorating a paratrooper from the kibbutz who lost his life during World War II behind enemy lines in Europe. The aircraft had been assigned to drop a message during the ceremony marking the event. Casualties are 17 dead as well as dozens of injured.

Yad Vashem, the Martyrs' and Heroes' Remembrance Authority, inaugurates its building in Jerusalem.

August

1 Justice Itzhak Olshan is named Chief Justice of the Supreme Court, succeeding the late Justice Moshe Zmora.

3 General Barns from Canada replaces General Bennike from Denmark as chief U.N. observer in Israel.

15 Mapam ("United Workers Party") splits. Its Ahdut Ha'avodah ("Unity of Labor") faction, which had amalgamated with Hashomer Hatza'ir ("Young Watchman") in 1948, establishes a separate party.

I.D.F. paratroopers mount several operations to take Jordanian hostages in order to exchange them for the captured Israeli soldier, Itzhak Jibli. The campaign is called

Headlines in *Ma'ariv* ("Evening News") covering the disaster in Kibbutz Ma'agan.

△ An American soil expert and a worker of Yemenite origin at the Hulah drainage project in northern Israel.

▷ The 50th anniversary of Theodor Herzl's death is marked by an Israeli stamp.

▽ David Ben-Gurion makes a special appearance at a youth rally at Sheikh Munis, Tel-Aviv, in June 1954.

Jil, an acronym for Free Itzhak Jibli.

September

8 Terrorist acts emanating from the Gaza Strip increase. A water line is blown up near Kibbutz Nir Am.

13 Egyptian President Nasser declares that Israel must concede the Negev to the Arabs.

15 The Israeli team at the Chess Olympics in Amsterdam scores an achievement by tying with the Soviet team 2:2.

29 The Egyptians embargo the Israeli ship Bat-Galim at the entrance to the Suez Canal, imprison its crew in Cairo, and confiscate its cargo.

The controversial Gruenwald-Kasztner trial in Jerusalem reaches the summation stage. Malkhiel Gruenwald is accused of slandering Dr. Israel Kasztner, who had been a member of the Jewish Rescue Committee in Budapest during World War II. The court proceedings deal extensively with the period of the Holocaust in Hungary. Gruenwald's attorney accuses the heads of the Jewish Agency then – currently the leaders of the State of Israel – of concealing reports of the Holocaust during the war.

October

Infiltration from the Gaza Strip increases during the month.

Immigration remains at a low ebb. Most new immigrants are housed in development towns immediately upon arrival.

26 The Czechoslovakian authorities release Shim'on Orenstein, the Israeli jailed there since 1952. Efforts to obtain a pardon for the other jailed Israeli, Mordechai Oren, fail.

28 The Maccabi All-Star soccer team, on a tour of England, is trounced by the Wolves 10:0.

November

3 The U.N. Security Council convenes on the embargo of the Bat-Galim at the Suez Canal. It passes the matter over to the Israeli-Egyptian Armistice Commission.

A new railroad terminal is inaugurated at the end of Arlozoroff Street in Tel-Aviv.

19 The Israeli-Egyptian Armistice Commission determines that Egypt must release the Bat-Galim and its crew.

22 A collision of a bus and a train at Haifa Bay causes the deaths of 11 of the bus passengers, with 11 others wounded. All are new immigrants.

During the course of the month, the ultra-Orthodox Me'ah She'arim neighborhood in Jerusalem organizes protest demonstrations against travel on the Sabbath and the establishment nearby of a clubhouse for the Working Mothers Organization.

December

1 The Bank of Israel, Israel's central bank, is established.

6 A new daily, Lamerhav ("Opening Out"), is published by the Ahdut Ha'avodah ("Unity of Labor") party.

7 Five I.D.F. soldiers who crossed into Syria near Kibbutz Dan are captured and accused by the Syrians of spying.

11 The trial of the 11 members of the espionage network in the Mishap begins in Cairo (see p. 320).

12 A Syrian plane is forced down over Israeli airspace. Its passengers and crew are detained but are released two days later.

21 One of the members of the network in the Mishap, Max Bennet, commits suicide in his cell in Cairo (see p. 320).

28-29 Heavy rainfall causes floods all over the country. Roads are obstructed in Tel-Aviv for several hours. Many ma'abarot ("immigrants transit camps") are inundated. A mother and her baby drown in Kfar Saba.

Immigration remains low. Only 18,000 newcomers arrive in 1954.

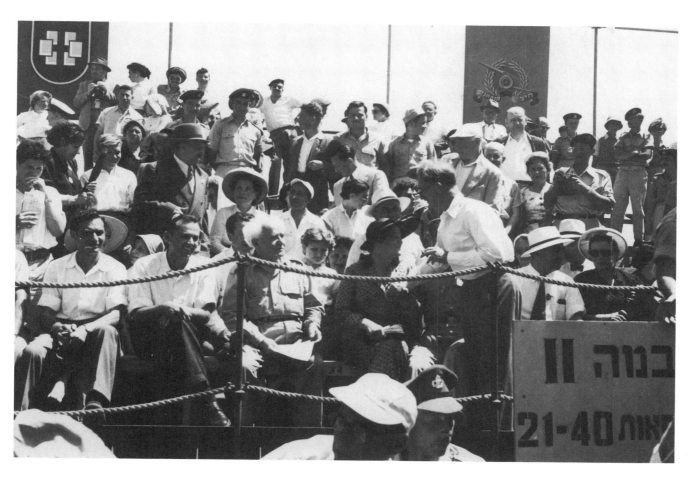

MOSHE SHARETT'S GOVERNMENT

In late January 1954, for the first time in the history of the young state, a government was formed that was not under Ben-Gurion's leadership. It was headed by Moshe Sharett, who also continued holding the foreign ministry portfolio. Another change was the appointment of Minister without Portfolio Pinhas Lavon as defense minister.

Sharett, a moderate person by nature, had difficulty contending with the three dominant personalities who headed the military-defense establishment – Defense Minister Lavon, Chief of Staff Moshe Dayan, and Director-General of the Defense Ministry Shim'on Peres. More basically, the perception was that Sharett had difficulty filling Ben-Gurion's shoes, especially in light of the steady stream of pilgrimages by both Israeli and foreign personalities to Ben-Gurion's home in his Negev kibbutz.

With the forced resignation of Pinhas Lavon over the Mishap in Egypt in early 1955, Ben-Gurion returned to serve as defense minister. Thereafter, the heating up of the security situation along the borders and the retaliatory operations mounted by the I.D.F. at Ben-Gurion's instigation exacerbated relations between Sharett, who disagreed with this policy, and Ben-Gurion.

After the elections of the Third Knesset in July 1955, a new government was formed, headed again by Ben-Gurion. Sharett continued to serve as foreign minister, but not for long.

△ Ben-Gurion (first row, middle), retired from politics, views the 1954 Independence Day parade from the sidelines for the first time. The parade is held in the town of Ramleh mainly for his sake, as Ben-Gurion has announced that he would attend it only if it were held in the Negev or in an immigrant town.

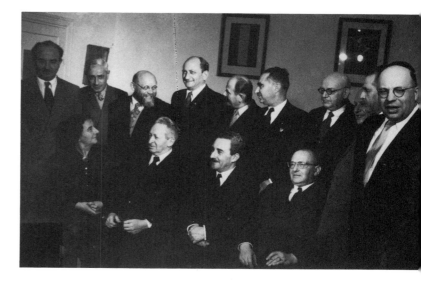

△ Prime Minister Moshe Sharett's government poses with President Ben-Zvi. Seated (l. to r.): Golda Meir, President Ben-Zvi, Prime Minister and Minister of Foreign Affairs Sharett, Bernstein. Standing (l. to r.): Eshkol, Lavon, Dinur, Sapir, Serlin, Dov Yosef, Naftali, Shitrit, Shapira, Burg. Missing from the photo are: Aranne, Rokakh and Rosen.

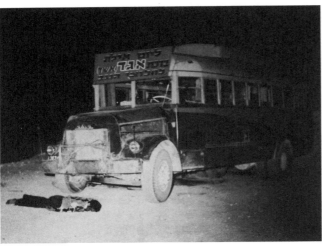

◁ The Liman Toura prison in Cairo as sketched by one of the Mishap prisoners, Robert Dassa.

▽ Malka and Ben-Zion Halfon (later an M.K. and deputy minister) in front of their home, destroyed by terrorists.

◁ Eleven passengers on an Egged bus are murdered in March 1954 at Ma'aleh Akrabim in the country's worst-yet terrorist incident.

THE MISHAP

Progress in talks between Egypt and Britain during 1954 regarding the evacuation of British military forces from the Suez Canal region caused concern in Israel's defense establishment. One imaginative but futile idea developed by I.D.F. intelligence was to delay the British move by means of acts of sabotage of buildings and installations in Egypt, used by Westerners, which would show Britain that the Egyptians were unreliable.

The implementation of this plan was assigned to an Israeli intelligence unit operating in Egypt made up of local Jews who had been trained in Israel. In July 1954, the central post office in Cairo, the American libraries in Cairo and Alexandria, and movie houses in both cities were blown up. The perpetrators, however, were soon apprehended, tried in December 1954, and given harsh sentences, including two death sentences.

The ensuing conflicts in the Israeli leadership, the question of responsibility for the Mishap, the eventual resignation of Defense Minister Lavon, and the reopening of the case in 1960 were only a part of what would later be called the Lavon Affair, or the Affair.

△ Pinhas Lavon (c.) replaces David Ben-Gurion (l.) as minister of defense in a changing of the guard. Their relationship is disturbed by the Mishap in the course of 1954.

THE BAT-GALIM EPISODE

Although Egypt had signed an armistice agreement with Israel, it banned Israeli ships, or foreign ships carrying cargo bound for Israel, from passing through the Suez Canal. The issue was raised repeatedly in the Israeli-Egyptian Armistice Commission and in the U.N. Security Council, but with no result.

In September 1954, Israel resolved to bring the issue to the attention of the world. A small Israeli ship, the Bat-Galim, set sail from Massaua, Eritrea, to Israel by way of the Suez Canal, unarmed and carrying a purely civilian cargo of timber, beef, and hides. The Egyptians blocked the ship at Suez, at the southern entrance to the canal, charging that the crew had killed two Egyptian fishermen and claiming that arms were found on board. All ten members of the crew were arrested and the cargo was confiscated.

Israel submitted a complaint to the U.N., and the Security Council, after considering the issue, decided to pass it on to the Israeli-Egyptian Armistice Commission. On November 20, 1954, the commission ordered the Egyptians to release the ship and its crew immediately. The crew was released only on January 1, 1955. Further discussions concerning the ship and its cargo were resumed in the Security Council, but without any conclusions. Egypt continued to bar Israeli ships from passing through the Suez Canal.

▷ An Israeli warship is sent to France in April 1954 to transport the coffins of Baron Edmond de Rothschild and his wife, Adelaide – both of whom died decades earlier – to Israel for reinterment. A state ceremony is held at the port of Haifa, followed by a funeral procession to the grave site south of Zikhron Ya'akov. Representatives of all the settlements in the country that the Baron helped found are present. Each lays a bag of earth on the grave. The leaders of the country praise the work of the Baron, who is called "Father of the Yishuv" and "the benefactor."

△ The Maccabi All-Star soccer team is roundly defeated on a tour of England in October 1954, especially by the Wolves, 10:0.

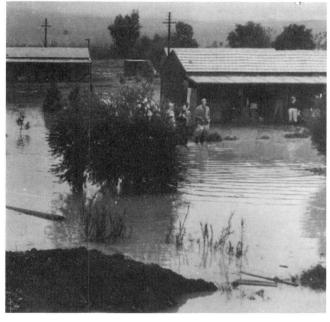

▷ Unusually heavy rainfall throughout the country in December 1954 causes widespread flooding, here at Kibbutz Sdeh Nehemiah in the Galilee.

1955

dence, *Hill 24 Doesn't Answer*, has its premiere.

Archeological excavations in Massada reveal dramatic findings, including Herod's palace.

January

1 The Egyptians release the 10 Bat-Galim seamen after three months of imprisonment.

4 The Western powers call upon Egypt to abolish the maritime embargo on Israeli shipping at Suez. Egypt refuses.

13 Uri Ilan, one of the five soldiers held captive in Damascus since December 1954, commits suicide.

27 Harsh sentences are handed down to the accused in the Mishap in Egypt: two are sentenced to death, two to life imprisonment, and the remaining six to long prison terms.

31 Shmuel Azar and Dr. Moshe Marzuk, sentenced to death by the Egyptians in the Lavon Affair, are executed.

February

13 Israel reacquires four of the Dead Sea scrolls discovered in the Judean Desert in 1947, which had been taken to the United States. All seven scrolls are now in Israel.

16 The Cameri Theater inaugurates its new building in Nahmani Street in Tel-Aviv.

17 Minister of Defense Pinhas Lavon resigns. David Ben-Gurion is recalled to succeed him.

21 Rabbi Itzhak Nissim is named Sephardi Chief Rabbi – succeeding the deceased Rabbi Uziel.

28 A large raid is mounted by Israel in Gaza and the environs, resulting in dozens of Egyptian fatalities.

March

8 After an interlude of 19 years, Tel-Aviv celebrates Purim with a colorful carnival, attended by half a million onlookers.

19 The first feature film about the War of Indepen-

April

3 The Gaza Strip border heats up. The Egyptians shell Kibbutz Nahal Oz. I.D.F. patrols along the border are attacked.

19 The first settlers arrive at the new development town of Ofakim in the Negev.

21 The Bandung Conference of nonaligned states held in Indonesia adopts the Arab position on Palestine, i.e., a return to the partition plan of 1947.

25 A ceremony is held for the first graduating class of the I.D.F. Command General Staff School.

27 Hundreds of thousands of onlookers attend the military parade in Tel-Aviv on Independence Day. New on display this year: the Uzi submachine-gun and the French AMX–13 tank.

May

17 The security situation along the Gaza Strip border deteriorates.

18 The I.D.F. attacks an Egyptian outpost in the Kisufim region on the Gaza Strip border. The U.N. attempts to pacify the belligerent sides.

24 The settling of the Lachish region begins. The first settlement is Moshav Otzem.

28 A bomb explodes in the printing office of the left-wing weekly *Ha'olam Hazeh* ("This

After an interlude of 19 years, the Purim carnival is back in Tel-Aviv.

World") edited by Uri Avneri. The attack is condemned in the press and in the Knesset.

29 Israel welcomes a distinguished guest, Burmese Prime Minister U Nu.

30 Incidents continue at the Gaza Strip border. The Egyptians shell settlements and I.D.F. units across the border. The I.D.F. responds with artillery fire. The situation deteriorates along the Jordanian and Syrian borders as well.

June

1 Automatic interurban telephone dialing is inaugurated, ending the need for operators.

9-12 Operation Yarkon is carried out, anticipating the Sinai Campaign: six I.D.F. soldiers are landed along the Sinai shore, scout the desert terrain for three days, and are airlifted out in six light planes.

22 In a shocking decision, the Jerusalem District Court finds Dr. Israel Kasztner guilty of collaborating with the Nazis during the war.

28 The Herut movement calls for a vote of no-confidence in the government in light of the implications of the Kasztner trial, namely, questions raised about the integrity of former Jewish Agency leaders now in government positions. The General Zionists abstain in the vote, engendering a coalition crisis.

29 Prime Minister Moshe Sharett submits his resignation to President Ben-Zvi, entailing the resignation of the government. The President instructs him to form a new government, which he does the same day. The new government, which does not include the General Zionists, is approved by the Knesset by a vote of 66 to 32 with 3 abstentions.

Attempts are made under the supervision of the U.N. observers to calm the Israeli-Egyptian border during the course of the month.

July

4 A British ship is shelled by the Egyptians in the

Straits of Tiran.

15 Israel receives two destroyers acquired from Britain.

19 The country's largest water project yet, the Yarkon-Negev line, is inaugurated.

26 Elections for the Third Knesset result in a minor upheaval: Mapai ("Israel Labor Party") drops from 45 to 40 seats and the General Zionists from 20 to 13, while Herut rises from 8 to 15. Gains are also made by Mapam ("United Workers Party") (9), Ahdut Ha'avodah, ("Unity of Labor"), running as an independent party for the first time (10), and the religious factions (up from 15 to 17).

27 Bulgarian fighter planes shoot down an El Al passenger plane in its airspace. All 51 passengers and 7 crew are killed. Israel is grief-stricken.

August

5 Important archeological findings in Hatzor in the Galilee. Former Chief of Staff Yigael Yadin heads the excavation team.

7 The religious-oriented Bar-Ilan University is opened.

30 Israel attains a military-sports achievement: a contingent of 23 Nahal ("Fighting Pioneer Youth Corps") soldiers participating in a competitive march in Holland takes first place.

Egyptian attacks and terrorist acts by fedayeen (suicide fighters) operating with Egypt's approval in southern Israel increase during the last week of the month, resulting in a toll of 9 Israeli fatalities, including three soldiers.

30-31 A large-scale retaliatory attack by Israel aimed at an Egyptian police building and camp in Khan Yunis results in dozens of Egyptian fatalities.

Immigration from Morocco increases as a result of the struggle for independence there and attendant anti-Jewish incidents.

The Bank of Israel issues a new series of currency notes, which carry its name for the first time.

September

1 An aerial battle between an Israeli Ouragan plane and two Egyptian Vampires north of the Gaza Strip ends with the downing of the Egyptian planes.

7 The newly elected mayor of Jerusalem is Gershon Agron, editor of the *Jerusalem Post*.

8 The newly elected mayor of Tel-Aviv-Jaffa is Hayim Levanon. Haifa Mayor Abba Houshi is reelected.

19 A new development town in the Negev, Dimona, is established.

21 A new focus of Israeli-Egyptian tension develops in the Nitzana demilitarized zone.

22 A bus is attacked near Meron in the Galilee, resulting in two fatalities and 10 wounded. The Lebanese, anticipating retaliation, are in a state of alert.

23 Oil is discovered at a drilling site at Heletz (Hulykat) in the south, evoking great excitement in the country and interest in the world.

27 Egyptian President Nasser announces the signing of the Czechoslovakian deal, by which large quantities of arms are to be supplied to Egypt from the Eastern Bloc.

A centrally located town, Kiryat Gat, is founded in the Lachish region.

October

The Israeli public responds to the news of the Czechoslovakian arms deal and its implicit threat to Israel by spontaneously initiating collections for a defense fund.

23 Prime Minister and Foreign Minister Moshe Sharett leaves for talks in Europe with the foreign ministers of the four great powers. He will appeal for arms for Israel.

28 Israel mounts a retaliatory operation at al-Kuntilla near the Sinai border in response to an Egyptian attack on the Israeli police station in the Nitzana area.

November

2 Following three months of coalition negotiations, Israel has a new government. Once again, David Ben-Gurion is prime minister and defense minister.

A large Israeli retaliatory raid is carried out in the Nitzana area in response to continued Egyptian attacks. The Egyptians incur dozens of fatalities and large numbers are taken prisoner. The I.D.F. has five fatalities.
Fedayeen terrorist activity increases along the Jordanian border.

9 In a speech at Guildhall, Prime Minister Anthony Eden proposes British guarantees for boundaries of a smaller Israeli state.

15 Ben-Gurion rejects Eden's proposal.

16 President Eisenhower announces that the United States will safeguard the agreed upon borders in the Middle East.

22 Egyptian attacks against Israel along the southern border continue. Israel issues a warning to Egypt.

28 Nasser rejects Eden's proposal as well. He demands the implementation of the 1947 partition plan.

December

11 Syrian attacks on Israeli vessels on Lake Kinneret prompt a large-scale retaliatory operation against Syrian positions northeast of the lake, resulting in dozens of Syrian fatalities and a large number of prisoners taken by the I.D.F. Israel suffers four fatalities. The press reports differences of opinion between Ben-Gurion and Sharett regarding the operation. Israel is censured internationally.

17 Both the United States and the U.S.S.R. censure Israel's Kinneret operation in the U.N. Security Council.

29 Soviet leader Khrushchev attacks Israel and calls it an "instrument of imperialism."

Over 37,000 immigrants arrive during 1955, mostly from North Africa.

◁ A menorah (candelabrum) powered by water is erected near the Yarkon springs at Rosh Ha'ayin in July 1955 for the inauguration of Israel's largest-yet water project – the Yarkon-Negev line, which relays nearly all the waters of the Yarkon River to the Negev in large cement pipes. As a result, the stream will dry up. Since then, sewage flows into the Yarkon while sea water is pumped into its lower part, near its mouth.

▽ The Czechoslovakian deal is reported in the *Jerusalem Post*. The Israeli public responds by spontaneously collecting contributions for a defense fund.

קרן מגן

"Here's my contribution. Take it along with the jewelry."

▽ The threatening security situation impels residents of outlying areas to be at the ready.

△ Most of the retaliatory operations in 1955 are carried out by I.D.F. paratroopers. A group of their commanding officers pose after the operation at Kuntilla, October 1955. Standing (l. to r.): Meir Har-Zion, Ariel Sharon (commander of the paratroopers), Chief of Staff Moshe Dayan, Danny Mat, Moshe Efron, Assaf Simhoni. Sitting (l. to r.): Aharon Davidi, Ya'akov Ya'akov, Rafael Eitan.

◁ Senior I.D.F. commanding officers begin to undergo parachute training in 1955. Shown are two future chiefs of staff: Itzhak Rabin (l.) and Hayim Bar-Lev.

▽ A large-scale retaliatory operation in the Nitzana area in November 1955 results in the capture of a large number of Egyptian soldiers.

▷ Aerial dogfights occur along the Egyptian border in 1955. Shown, an Egyptian plane that is shot down.

THE KASZTNER TRIAL

The Kasztner trial, which ended on June 11, 1955, raised a storm. It was, in fact, the trial of Malkhiel Gruenwald, a religious figure in Jerusalem who publicly accused Dr. Israel Kasztner, a high-ranking government official, of having collaborated with the Nazis during World War II when he was one of the leaders of the Jewish community in Hungary. Kasztner, in turn, sued Gruenwald for libel.

In the course of the trial, Gruenwald's attorney, Shmuel Tamir, accused the leaders of Mapai – wartime leaders of the Yishuv and current leaders of the State of Israel – of failing to do enough to save European Jewry. In his judgment, Justice Binyamin Halevi of the Jerusalem District Court stated that Kasztner had "sold his soul to the devil," by collaborating with the Nazis, saving his relatives and friends, and failing to warn the hundreds of thousands of Jews of Hungary about what awaited them at the hands of the Nazis. Gruenwald was cleared of the charges against him. The verdict prompted a government crisis.

In early 1957, Kasztner was shot and killed. One year later, the Supreme Court concluded that he had not collaborated with the Nazis, although he had testified on behalf of Nazi criminal Kurt Becher in the Nuremberg Trials.

◁ A distinguished guest of Israel in 1955 is Burmese Prime Minister U Nu, on a tour in the pipeline Yarkon-Negev.

△ Dr. Israel Kasztner, according to Judge Halevi a man who had "sold his soul to the devil." Kasztner is shot and killed in 1957.

△ Herut even uses a tractor in its struggle against the Labor party, Mapai. In the elections, Mapai loses 5 seats, while Herut doubles its strength (from 8 to 15). Its new seats, however, are won from the General Zionists, and Mapai can again form the new government.

△ The election campaign for the Third Knesset is stormy in summer 1955, due to the economic situation and the Kasztner affair. In the poster, Mapai ("Israel Labor Party") asks its voters to "let us finish the task."

THE DEVELOPMENT OF THE LACHISH REGION

Following the massive wave of immigration in the early 1950s and the settlement of the newcomers in all parts of the country primarily in agricultural moshavim, the settlement authorities shifted their approach to a region-oriented concept, reflected in the development of the Lachish regional settlement plan.

The renewal of immigration in 1954, largely from North Africa; the deteriorating security situation and the need to populate the vulnerable, uninhabited southern region; and Ben-Gurion's deep commitment to settling the Negev and recruiting young, native-born Israelis to assist the new immigrants, constituted the impetus for the development of the Lachish Region, an area encompassing approximately 1 million dunams (250,000 acres).

The innovative aspect of the Lachish concept was the a priori planning and construction of different types of settlements, namely moshavim, regional centers, an urban center, as well as 3 Nahal ("Fighting Pioneer Youth Corps") settlements in the east, along the Jordanian border.

Begun in 1955, the development of the region involved the establishment of dozens of settlements and the town of Kiryat Gat within a period of only a few years.

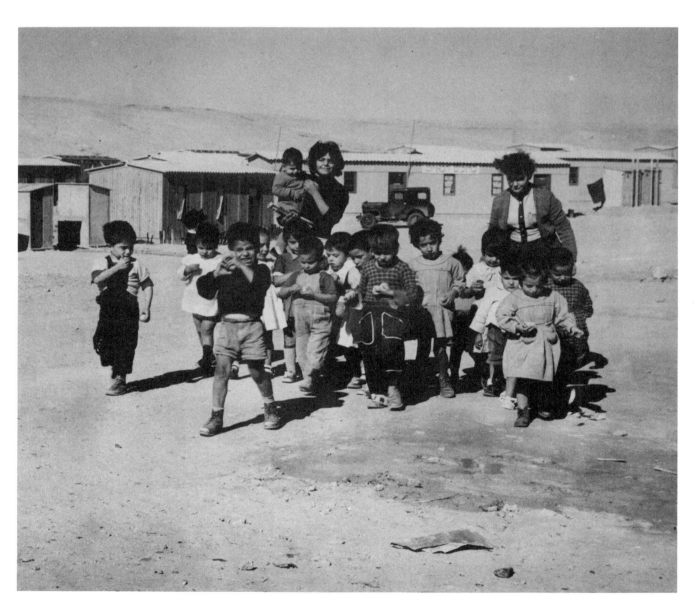

△ The settling of new immigrants in the Lachish Region begins in 1955. Simultaneously, development towns are established throughout the country. Shown, nursery school children and their teachers in the new town of Dimona in the Negev. At first, the newcomers refused to get off the trucks that had brought them to "the middle of the desert" and asked to be taken to "more normal places". Some dubbed it Dimiona ("fantasy"), or even Dim'ona ("place of tears").

326

▽ Oil is discovered at Heletz (Hulykat) in the south in September 1955. Minister of Development Dov Yosef (c.) receives the first bottle. To his right, Pinhas Sapir, general director of the finance ministry.

▷ Some of the financial problems are solved by issuing government loans. To encourage their purchase, the government organizes a lottery that awards prizes to purchasers.

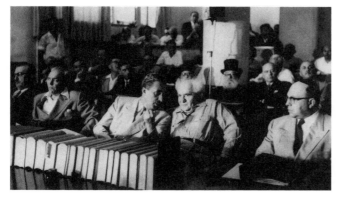

△ Ma'ariv ("Evening News") reports a tragic accident in July 1955. Bulgarian war planes shoot down an El AL passenger plane flying in its airspace. All 58 crew and passengers are killed.

△ A new-old prime minister, David Ben-Gurion (2nd from r.), demonstratively wears khaki work clothes to the Knesset.

▷ The first currency notes to be issued by the Bank of Israel show Israeli land-scapes.

1956

January

19 The U.N. Security Council censures Israel for Operation Kinneret carried out the previous month.

23 U.N. Secretary-General Dag Hammarskjold visits Israel. Due to Arab pressure, he refrains from attending official events in Jerusalem.

France comes to Israel's aid, supplying advanced arms.

26 The Israel Railway introduces German passenger carriages, acquired as part of the reparations.

The ultra-Orthodox block excavation and construction work in the area around the grave site of Maimonides in Tiberias during the course of the month.

February

7 A general strike is called by all academically trained workers, including physicians and engineers. It lasts 11 days.

Justice Minister Pinhas Rosen resigns.

11 The United States refuses to supply arms to Israel but agrees to France supplying Israel with 12 advanced Mystère 4 jet aircraft.

13 The U.S.S.R. announces that it will protect its interests in the Middle East and warns the Western powers not to act unilaterally in the region.

March

1 Dramatic changes in Jordan: King Hussein deposes the British commander of the Jordanian Legion, General Glubb, after long years of service.

4 The Syrians fire on Lake Kinneret, killing four Israeli policemen.

7 Organized groups of volunteers assist border settlements with fortification work, especially in the south, in light of mounting tension in the region.

29 A new railroad line is completed from Tel-Aviv to Beersheva in the Negev.

The Syrians return four Israeli soldiers held by them for fifteen months, and an Israeli civilian.

Tension mounts along the Egyptian border in the wake of a large increase in Egyptian-initiated incidents. Serious incidents occur along the Jordanian border as well.

April

4-11 Egyptian attacks and the infiltration of fedayeen intensify, claiming a high toll in Israeli lives.

4 The U.N. Security Council sends U.N. Secretary-General Hammarskjold to the Middle East in an attempt to dispel the tension along Israel's borders.

9 President Eisenhower pledges American assistance to any victim of an attack in the Middle East.

12 Israeli planes down an Egyptian fighter plane over southern Israel.

France delivers the first shipment of Mystère aircraft to Israel.

15 Ben-Gurion declares, in a radio broadcast marking Israel's eighth Independence Day, that the country is facing a "supreme test."

A monumental menorah ("candelabrum") made by the English Jewish sculptor Benno Elkan is mounted in front of the Knesset building in Jerusalem.

17 The government imposes new taxes to defray rising security costs.

23 Infiltrators from Jordan murder four Tahal (Israel Water Planning) workers in the Aravah region of southern Israel.

24 The 24th Zionist Congress opens in Jerusalem.

29 Two Israeli fatalities result from incidents along the Gaza Strip border: Ro'i Rothberg, commander of the border kibbutz Nahal Oz, and a soldier.

May

1 Workers mark May Day by volunteering for fortification work along the borders.

10 The new development town of Netivot is founded in the Negev, initially named Azata.

12 The Czechoslovakians release Mordechai Oren, imprisoned there 4 1/2 years.

An exceptional guest in Israel: Egyptian journalist Ibrahim Izzat, who tours the country for a week.

June

4-7 The I.D.F. (Israel Defense Forces) initiates a four day march covering 160 kms.

10 The National Religious Party ("Mafdal") is founded, amalgamating Mizrahi and Hapo'el Hamizrahi.

18 Foreign Minister Moshe Sharett announces his resignation. He is succeeded by Golda Meir.

July

11 The U.S.S.R. soccer team beats the Israeli team 5:0 in an Olympics qualification game in Moscow attended by thousands of Jews in an emotional atmosphere.

17 An agreement for the supply of Soviet oil to Israel is signed in Moscow.

20 Two destroyers acquired by the Israeli navy from Britain, the Jaffa and the Eilat, arrive at Haifa port.

26 Egypt nationalizes the Suez Canal as a reaction to the Western powers' refusal to finance the Aswan dam.

31 The Israeli soccer team plays a rematch against the U.S.S.R. team in Ramat Gan. The Israelis improve their performance but lose 2:1.

August

Attacks from Jordan continue along the border during the month.

16 An armed band infiltrates from Jordan and attacks an Israeli bus in the Aravah, resulting in 4 fatalities and 9 wounded among both civilians and soldiers from a military escort.

17 Israel retaliates in a series of attacks against Egyptian forces in the Gaza Strip.

22 The transportation cooperatives strike. The government provides truck transport for the public. The strike lasts 10 days.

September

1 Violent demonstrations by the ultra-Orthodox in Jerusalem protesting travel on the Sabbath result in 1 fatality and many injured.

10 Jordanian fire in the Hebron hills border area results in 7 I.D.F. fatalities.

The Negev railroad line is sabotaged.

11-12 An I.D.F. retaliatory operation aimed at the al-Rahwa police fortification in the southern Hebron hills results in heavy Jordanian casualties.

12 Infiltrators from Jordan kill 3 Druze guards in the Aravah.

13-14 An I.D.F. force attacks the Jordanian Gharandal police fortification in the Edom foothills.

23 A Jordanian soldier fires at Kibbutz Ramat Rahel, where an archeologists' conference is being held. Four are killed. The Jordanians claim the soldier is "unbalanced."

24 Infiltrators from Jordan kill a woman picking figs outside her home in the Jerusalem Corridor and a tractor driver in the fields in Bet-She'an Valley.

25-26 An I.D.F. retaliatory operation targeting the Hussan police fortification in the Bethlehem area results in dozens of Jordanian fatalities and 6 Israeli soldiers killed.

October

4 Infiltrators from Jordan kill 5 Israelis on the Sodom-Beersheva road.

9 Infiltrators from Jordan kill two Israeli workers near Even Yehuda.

10 A large I.D.F. retaliatory operation targeting the Qalqilya police station results in heavy Jordanian casualties. The I.D.F. suffers 18 fatalities and 60 injured.

12 The Iraqi army is poised to enter Jordan. Israel responds by a call-up of its reserve forces. Tension mounts along the borders, especially the Jordanian border.

24 Egypt, Syria, and Jordan establish a joint military command in response to the

△ The population and its leaders are called upon to assist in the fortification of border settlements. Chief of Staff Moshe Dayan lends a hand in the Negev.

▽ A monumental menorah (candelabrum) by Anglo-Jewish sculptor Benno Elkan is mounted at the Knesset building in Jerusalem in the spring of 1956.

growing tension.

28 Israel heightens security preparedness. President Eisenhower appeals for restraint on the part of Israel and the Arab states.

29 (Until November 6) Israel mounts a preventive attack against Egypt – the Sinai Campaign, also known as the Sinai War. I.D.F. forces conquer the entire Sinai peninsula in 8 days.

A massacre at the Arab village of Kafr Qasim in Israeli territory east of Petah Tikva is perpetrated by an Israeli Border Police unit. After placing a curfew on the village, the unit opens fire on villagers returning home, killing 43 men, women, and children. The incident is reported in Israel only after the Sinai Campaign is over.

November

2 The U.N. General Assembly adopts an American proposal calling for an immediate cease-fire by Britain, France, and Israel, by a vote of 64 to 5 with 6 abstentions.

5 The U.S.S.R. threatens to intervene in the Middle East crisis and to mount missile attacks against the British and French capitals. It recalls its ambassador from Israel.

The Anglo-French invasion of Egypt begins. The Egyptians close off the Suez Canal.

The U.N. General Assembly votes to establish an Emergency Force "to secure and supervise the cessation of hostilities."

6 Israel's part in the Sinai Campaign ends. The Israeli flag flies over Sharm al-Sheikh.

The U.N. Security Council demands that Israel withdraw from the territories it captured within 24 hours.

7 Ben-Gurion announces in the Knesset that Israel will not return to the armistice lines with Egypt and will not permit the entry of foreign troops in Israeli territory or in territory it holds. He describes the Sinai Campaign as "one of the most remarkable in the history of nations."

8 The U.S.S.R. threatens to strike at Israel with long-range missiles and to dispatch Muslim "volunteers" to attack Israel.

In an announcement on the radio at midnight, Ben-Gurion states that I.D.F. forces will be withdrawn from Sinai following the arrival of an international U.N. force in the peninsula.

15 The U.S.S.R. claims that the Israeli attack on Egypt threatens Egypt's existence. It demands compensation by Israel to Egypt, and annuls its agreement to supply oil to Israel.

18 Israel rejects the U.S.S.R. demand to compensate Egypt.

25 The first families settle in the new coastal town of Ashdod, initially called Ashdod Yam.

29 The town of Upper Nazareth is established near Nazareth.

The I.D.F. withdrawal from Sinai begins during the last week of the month.

Defense needs prompt the government to impose a series of new taxes and levies. A fuel shortage elicits travel restrictions on private cars and curtailed electrical consumption.

December

Israeli forces withdraw from the Suez Canal area during the first week of the month.

15 Israel begins laying an oil pipeline from Eilat to Beersheva.

16 British and French forces begin to evacuate from the Port Sa'id area.

26 The Israeli frigate Miznak ("Sprint") arrives at Eilat port after sailing around the coast of Africa, inaugurating Israel's navy base there.

30 The United States exerts pressure on Israel to speed up withdrawal from Sinai. Israel demands safeguards for free navigation in the Gulf of Eilat and calm along the Sinai border.

Immigration rises. Newcomers include thousands of Jews from Egypt who were expelled following the Sinai Campaign.

CHANGE IN THE FOREIGN MINISTRY: GOLDA MEIR REPLACES MOSHE SHARETT

Two figures stood at the helm of the Yishuv in Palestine and later the State of Israel: David Ben-Gurion and Moshe (Shertok) Sharett – the former as chairman of the Jewish Agency and then prime minister, and the latter as head of the political department of the Jewish Agency and then as foreign minister. This long partnership ended in June 1956.

Although the two had worked side by side over the years, their outlook differed. Ben-Gurion was considered an activist with hawkish views, and Sharett a moderate and dovish. In November 1955, Sharett asked to be relieved from his duties as foreign minister, but Ben-Gurion refused. Eighteen months later, it was Ben-Gurion who asked Sharett to leave.

Addressing the Knesset on June 19, 1956, Ben-Gurion announced that in light of growing defense problems and external dangers, he had reached the conclusion that "for the good of the state" there must be full accord between the foreign and defense ministries, necessitating a change of leadership in the foreign ministry. Sharett was replaced by Golda Meir, until then minister of labor.

▷ Sharett departs and Golda Meir enters as minister of foreign affairs.

△ The weekly *Ha'olam Hazeh* ("This World") chooses its first "Sabra of the Year" in 1956 – Ofira Erez, later wife of President of Israel Itzhak Navon.

◁ The Israeli soccer team improves its performance in a rematch in Ramat Gan but still loses 2:1.

△ Israel's soccer team plays in Moscow, losing by 5:0.

▷ Despite the tense security situation, the government and the public deal with mundane issues such as the prolonged bus strike. Announcing that it will not yield to the strikers' demands, the government makes available thousands of trucks for public transportation. The driver collects his fares before the passengers climb up the ladder into the truck. The strike lasts ten days.

▽ Ben-Gurion (r., in the foreground) appears in khaki during the entire year, highlighting the priority he assigns to state security. Like other Israelis, he assists in fortification work in the border settlements in light of the deteriorating security situation. The picture is taken in Moshav Mivtahim in the western Negev.

▽ A French motorized cannon is offloaded at Haifa port at night. France supplies Israel with large quantities of arms and equipment.

FRENCH AID

Israel was in dire, almost desperate, need of advanced arms during the first half of the 1950s in order to confront the threat posed by the Arab states. Yet the sources of this aid were not forthcoming. The United States had placed an embargo on arms to the Middle East; Britain supplied only small quantities, following a policy of maintaining an arms balance in the region; and France initially agreed to supply only leftover or used armaments.

A change took place at mid-decade stemming primarily from France's war against the rebels in Algeria, then a French territory. With the rebels supported by Egyptian President Nasser, a sworn enemy of Israel, a confluence of interests emerged between Israel and France that was manifested in cordial political relations and the supply of French arms.

In the wake of the Czechoslovakian deal with Egypt in 1956, which made large quantities of armor, artillery, and aircraft from the Eastern Bloc available to Egypt, France increased its aid to Israel significantly. Under its new socialist-led government, France opened its arsenal to Israel and for the first time large quantities of advanced weaponry of all types, including supersonic jet aircraft, flowed into the country. These arms were soon used in the Sinai Campaign and contributed to Israel's military superiority in the confrontation.

▷ Chief of Staff Moshe Dayan eulogizes Ro'i Rothberg at the Kibbutz Nahal Oz cemetery near Gaza in April 1956. Dayan's remarks make a deep impression on the country. The incident takes place a few months before the Sinai War.

△ Ro'i Rothberg, commander of Nahal Oz, checks the remains of an Egyptian mortar bomb aimed at the kibbutz.

Not from the Arabs of Gaza do we seek retribution for Ro'i's life, but from ourselves. How could we have avoided looking directly at our fate, at the destiny of our generation in all its brutality? Did it slip our mind that this group of boys living in Nahal Oz is carrying the heavy gates of Gaza on their shoulders, gates beyond which hundreds of thousands of eyes and hands pray for our weakening so that they can tear us to shreds – did we forget this?… Ro'i Rothberg, this slim, blond boy who came from Tel-Aviv to build his home at the gates of Gaza, to be a [protective] wall for us. Ro'i – the light in his heart blinded his eyes, as he failed to see the glint of the slaughtering knife. The craving for peace deafened his ears, as he failed to hear the voice of the murderer, lying in wait for him. The gates of Gaza grew too heavy, and overcame him.

From Chief of Staff Moshe Dayan's eulogy for the commander of Nahal Oz, Ro'i Rothberg, killed in an Egyptian ambush, April 1956.

◁ The last large retaliatory operation mounted by the I.D.F. before the Sinai War is aimed at the police station in Qalqilya following the murder of two Israeli workers.

△ Four pupils and a counselor are murdered, while at prayer, by fedayeen at Moshav Shafrir 12 km from Tel-Aviv in 1956. A blood-stained prayer book is mute testimony to the act.

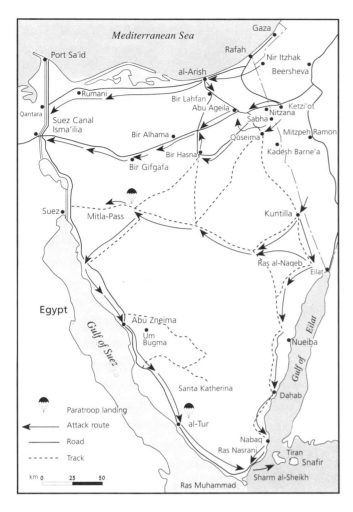

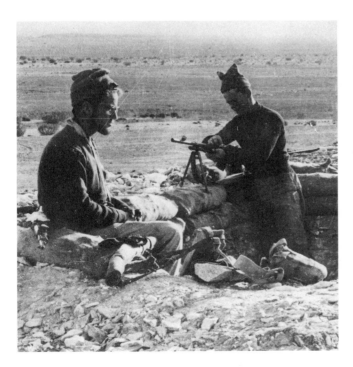

THE BUILDUP TO THE SINAI CAMPAIGN

The year 1956 was one of the stormiest in the history of the state. Violent border incidents and infiltration by fedayeen (Arab suicide fighters) had become almost daily occurrences. Clearly, Israel could not tolerate the situation much longer. Chief of Staff Dayan had urged a military solution since early 1955. Ben-Gurion, at the time both prime minister and defense minister, held him back, insisting that the army should be fortified while Israel enjoyed the support of the great powers.

With Egypt's nationalization of the Suez Canal Company in July 1956, Britain and France, which were shareholders in the canal, began planning a military operation against Egypt to protect their strategic interests, taking Israel as an ally in view of the confluence of interests between the three. Following a series of meetings in France, a campaign was planned involving the takeover of Sinai by the I.D.F., to be followed by the takeover of the canal by British and French forces.

Meanwhile, the situation along the Jordanian border deteriorated, deflecting international attention from preparations being made at the southern border. Fedayeen attacks increased, and I.D.F. retaliatory operations during September and October 1956 were unable to stop them. With international attention focused on the Jordanian arena, the I.D.F. mounted its attack on the Egyptian front on October 29, 1956.

△ Map of the Sinai Campaign, October-November 1956. Israeli forces attack the Egyptians along several routes simultaneously and capture the entire Sinai Peninsula in a few days.

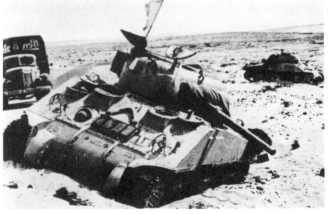

◁ An I.D.F. paratroop battalion is dropped deep into Sinai on October 29, 1956, initiating the campaign. Two paratroopers entrench themselves.

△ Egypt's armored vehicles are quickly immobilized in Sinai during the campaign.

▽ A headline in *Yedi'ot Aharonot* ("Latest News") of October 30: I.D.F. moves toward Suez Canal

צ.ה.ל. עולה על סואץ

ראמללה: היחידות הישראליות שפשטו בסיני כוללות שריון ונשק כבד

בוטלו כל החופשות בצבא המצרי

נאצר הזעיק את מפקדי צבאו

קהיר: כל צבאות ערב החלו נעים לגבול

△ An Israeli motorized convoy encounters an Israeli air force pilot who has landed a light aircraft on a road in Sinai.

▽ Thousands of Egyptian prisoners are taken by the I.D.F. in the Sinai and the Gaza Strip during the brief campaign.

△ The Egyptian destroyer Ibrahim al-Awal, which has bombarded Haifa, is captured by the Israeli navy.

◁ One of the most famous photographs of the Sinai Campaign: boots abandoned by a fleeing Egyptian soldier.

▷ The Israeli air force wreaks havoc on Egyptian convoys throughout the Sinai Peninsula.

△ A ceremony marking the end of the fighting is held at Sharm al-Sheikh, addressed by Chief of Staff Moshe Dayan (r.) and Southern Command Major General Assaf Simhoni.

◁ The Straits of Tiran are opened to Israeli vessels.

1957

January

Israel withdraws from Sinai. It demands guarantees for freedom of navigation in the Gulf of Eilat.

1 A U.N. fleet begins clearing the Suez Canal of mines and ships sunk there by the Egyptians to prevent passage.

5 President Eisenhower announces the main points of the new Eisenhower Doctrine, including the pledge that the United States will aid any Middle Eastern country endangered by the spread of Soviet influence in the region.

15 The I.D.F. withdraw from al-Arish.

20 Israel and Egypt agree on an exchange of prisoners: an Israeli pilot, Yonatan Etkes, the only Israeli P.O.W. taken during the fighting, and three Israeli soldiers taken prisoner previously, are exchanged for thousands of Egyptian prisoners.

23 The Knesset approves a declaration by the prime minister that Israel will retain control of the Gaza Strip after the I.D.F. evacuation from Sinai and that the evacuation of the Straits of Tiran must be preceded by assurances of freedom of navigation.

Israel fears economic sanctions if it does not complete the Sinai evacuation.

February

A wave of cold weather descends upon Israel in the first week of the month. Heavy snowfall in the mountains.

2 The U.N. demands that Israel complete its withdrawal from Sinai within five days.

The most prominent Egyptian P.O.W., General al-Digwi, governor of Gaza, is flown back to Egypt in a U.N. plane.

9 A mass demonstration is held in Tel-Aviv opposing withdrawal from Sinai.

21 The United States demands that Israel withdraw from the Gaza Strip as well.

25 Israeli fears of American sanctions against it for failing to complete the withdrawal mount.

March

2 Foreign Minister Golda Meir announces in the U.N. that Israel is prepared to complete the withdrawal if the U.N. assumes responsibility for civil rule in the Gaza Strip and if freedom of navigation in the Straits of Tiran is assured.

3 Eisenhower assures Ben-Gurion, in a personal message, that Israel will have no cause to regret acting in accordance with the pronounced wishes of the world community.

4 Dr. Israel Kasztner, of the emotionally charged court case, is mortally wounded in an attempt on his life in Tel-Aviv. He dies 11 days later.

5 Israel announces its preparedness to withdraw from Sharm al-Sheikh and the Gaza Strip.

6 Israel evacuates from the Gaza Strip.

8 Israel lowers its flag at Sharm al-Sheikh. The U.N. Emergency Force takes charge of the region.

11 Egypt announces that it will resume its administration of the Gaza Strip. Israel protests. The U.N. and the United States do not respond.

20 Four I.D.F. soldiers acting on their own cross the border into Jordan to hike to Petra and are killed.

23 Nasser announces that he will continue to bar Israeli navigation in the Suez Canal.

24 The Brigita Toft, a Danish ship chartered by Zim, Israel's navigation company, passes through the Straits of Tiran en route to Eilat without being stopped.

April

The laying of the Eilat-Beer-sheva oil pipeline is completed.

6 An American tanker carrying oil to Israel arrives in the port of Eilat.

7 Soviet Ambassador to Israel Alexander Abramov returns to Tel-Aviv after having been recalled to Moscow at the start of the Sinai Campaign.

28 Chief of Staff Dayan awards 33 commendations to soldiers who excelled in the Sinai Campaign.

Kasztner's murderers are brought to trial in Tel-Aviv.

The radio program *Three in One Boat* has record numbers of listeners.

May

6 A large I.D.F. parade is held in Tel-Aviv to mark Israel's ninth Independence Day and the Sinai Campaign victory.

8-11 Over 5,000 soldiers and civilians participate in a four-day march from various regions converging in Jerusalem, which will become an annual event.

10 A strike is declared at Ata, one of the country's major textile and clothing manufacturers.

21 Infiltrators from Jordan attack a car on the road to Eilat, killing one passenger and wounding three others.

29 An Egyptian mine near Kibbutz Kisufim causes one fatality and two injured.

The Hapo'el soccer team leaves for a tour of matches to the United States. On May 12, it beats the American team by 6:4. Marilyn Monroe is Hapo'el's "mascot."

June

The border situation worsens: the Gaza Strip border is mined by the Egyptians, while the Syrians harass settlements at the northern border with sniper fire and shelling.

July

22 Baron James de Rothschild, son of Edmond, bequeathes IL 6 million for the construction of a permanent building for the Knesset.

28 Soviet Jewry – the "Jews of Silence" – react with emotion to a visit by a contingent of young Israelis participating in an international youth festival.

August

Internal instability in Syria causes international tension. The communists attempt to seize power. American diplomats are expelled. Soviet ships are sailing in the Mediterranean.

19 The strike at Ata ends after more than three months.

September

7 The Soviet authorities arrest an Israeli diplomat, Eliyahu Hazan, and interrogate him brutally. Israel protests.

12 Air travel to Israel is revolutionized with the introduction by El Al of Britannia planes, which cut non-stop travel time from London to Tel-Aviv to less than six hours. The planes fly at 650 kph. instead of the old Constellation piston-engine planes' 350 kph. Flying time

American conductor Leonard Bernstein (r.) and violinist Isaac Stern at the opening of the Mann Auditorium, Tel-Aviv, October 1957.

1957

A defense stamp. Part of the price is transferred to the defense budget.

△ Ben-Gurion's unusual exercise routine, which includes headstands, surprises the country. His wife Paula bitterly comments: He could as well open a circus and earn some money.

▽ A bomb thrown in the Knesset during a meeting injures many MKs, including Ben-Gurion. In the picture, the bandaged prime minister talks with American Secretary of Agriculture Ezra Benson.

to New York is reduced to less than a day.

15 The fifth Maccabiah opens at the Ramat Gan Stadium.

24 The Egyptians seize control of an Israeli fighing trawler, the Doron, on the open seas off al-Arish. Its crew of five is imprisoned in Cairo and held for over four months.

30 The Syrians kidnap two U.N. observers and an Israeli escort officer in the north. They release them on the same day.

Excavations headed by Professor Yigael Yadin in ancient Hatzor reveal significant archeological findings.

October

1 The Mann Auditorium is inaugurated in Tel-Aviv.

16 A small hospital is opened in Eilat, a sign of the growth of the town.

28 President Itzhak Ben-Zvi is unanimously reelected for a second term, with several factions abstaining.

29 A hand grenade thrown in the Knesset by a deranged individual, Moshe Duwayk, causes serious injury to Minister of Religious Affairs Moshe Shapira and light injuries to Prime Minister Ben-Gurion, Foreign Minister Golda Meir, and Transportation Minister Moshe Carmel.

November

20 A sulha (Arab forgiveness ceremony) is held in Kafr Qasim a year after the massacre of villagers there by the Israeli Border Police. The organizer of the event is the veteran Shomer ("Watchman") figure Avraham Shapira.

The Jordanians detain a biweekly Israeli convoy on its way to the Israeli enclave on Mt. Scopus, refusing to allow the Israelis to bring in fuel.

The Hulah drainage project is completed. Galilee farmers acquire 60,000 dunams (15,000 acres) of drained swampland for agriculture.

December

1 A public storm is arises when the Rabbi of Pardes Hanna decides to bury a child of a mixed marriage outside the fence of the cemetery.

Eli Tavor, a reporter for *Ha'olam Hazeh* ("This World"), is kidnapped. The police suspects the incident to have been staged by the reporter himself. Editor Uri Avneri claims Tavor has been kidnapped by the Shin-Bet ("Security Service").

A new public storm: it turns out that the tax collection agency possesses an "information service" which keeps an eye on taxpayers.

3 U.N. Secretary-General Dag Hammarskjold visits Israel.

5 Hammarskjold intervenes in the Mt. Scopus episode. The convoy is permitted to reach the Israeli enclave.

17 A government crisis develops when the Ahdut Ha'avodah ("Unity of Labor") ministers are accused by Ben-Gurion of leaking a government secret – a visit by Chief of Staff Moshe Dayan to Germany – to the daily *Lamerhav* ("Opening Out"). The Prime Minister demands the resignation of the ministers.

31 Ben-Gurion submits his resignation to the President in view of the coalition crisis.

Violence along the northern border increases during the final 10 days of the year, including the murder of a member of Kibbutz Gadot by Syrian fire and the blowing up of a children's nursery in Moshav Shomerah by infiltrators.

Immigration continues to rise, primarily from Poland, Hungary, and Egypt, reaching over 71,000 in 1957.

△ Prisoner exchanges with Egypt are conducted in early 1957, several months after the end of the Sinai Campaign. Israel returns over 5,000 P.O.W.s to Egypt, including dozens of high-ranking officers, in exchange for a single Israeli P.O.W., Yonatan Etkes, a pilot. To his right, Col. Ezer Weizman.

THE WITHDRAWAL FROM SINAI

Israel's lightning conquest of the Sinai Peninsula and the Gaza Strip in late October and early November 1956 did not result in the retention of those territories. Intense pressure to withdraw was exerted on Israel by both the United States and the U.N., along with threats by the U.S.S.R. to attack Israel. Despite initial declarations of its intention to retain the captured territory, Israel in fact began a quest to attain maximal guarantees for free navigation in the Gulf of Eilat and quiet along the Gaza Strip and Sinai borders in exchange for withdrawal from most of the territory.

Israel's policy of gradual and dilatory withdrawal evoked annoyance in the United States, while anti-American sentiment was aroused in Israel. The government, led by Ben-Gurion, deliberately delayed the evacuation of the Israeli troops until commitments were received from Washington regarding freedom of navigation in the Straits of Tiran. Only then did the troops leave the last stronghold in Sinai – Sharm al-Sheikh. Israeli efforts to retain control over the Gaza Strip, and a last-ditch attempt to prevent the return of the Egyptian army there, failed. President Eisenhower, praising Ben-Gurion on Israel's decision to retreat, promised that Israel would have "no cause to regret" the move.

Indeed, during the 10 years that followed, from 1957 to 1967, the southern border was quiet and the country was able to devote its energies to the challenges of immigrant absorption, economic development, and the enhancement of its international position.

△ In the end, the Israelis withdraw. The last Israeli soldiers to leave the Gaza Strip in March 1957 witness large-scale anti-Israel demonstrations there.

▷ Thousands demonstrate in Israel against the return of Egyptian territory in early 1957. Yigal Allon of Ahdut Ha'avodah ("Unity of Labor"), later foreign minister, addresses a rally.

◁ A moving episode revealed after the Sinai Campaign involves the discovery by Israeli soldiers in Sinai of a live Bedouin baby girl near her dead mother. The soldiers care for the baby, whom they name Sinaya, and bring her to Israel, where she is adopted by Arab M.K. Faris Hamdan and his wife, who are childless.

▽ Report on Dr. Kasztner's murder by shooting near his home in north Tel-Aviv on March 4 1957. The police interrogate hundreds of suspects. Eventually three are brought to trial and receive life sentences. The issue will agitate the public in Israel for a long time.

△ The Hapo'el All-Star soccer team plays a series of exhibition games in the United States. Marilyn Monroe is the team's "mascot."

300 איש נחקרו ע"י המשטרה בעקבות רצח ד"ר קסטנר

◁ The "whispering giant" – the Britannia passenger plane, considered highly advanced – arrives in Israel in September, 1957. Driven by the newly-developed turbo-prop engines (i.e. with propellers powered by turbo-jets), it makes the London-Tel-Aviv run in under six hours non-stop – a record so far. The press report that airlines are hesitant to introduce the plane, owing to a series of accidents in which it was involved. El Al is one of the first airlines to purchase it.

▽ A future star is 11-year-old Itzhak Perlman, later a noted violinist, who receives a scholarship from the America-Israel Cultural Foundation in 1957 from

Foundation Chairman Moshe Sharett. Sharett, former prime minister and foreign minister, serves in various posts in the cultural field.

△ Media stars of 1957 are the panelists on the Voice of Israel's popular satirical radio show *Three in One Boat.* L. to r.: Gavriel

Zifroni, Shalom Rosenfeld, Shmuel Almog, Amnon Ahi-Naomi and Dan Almagor. Not shown: Dan Ben-Amotz.

LARGE-SCALE IMMIGRATION

Following the mass immigration to Israel upon the establishment of the state, reaching a peak in 1951, the flow ebbed considerably, yet gathered force again in mid-decade and became a large wave in 1957 as a result of political and military events in Eastern Europe and the Middle East.

The rise to power of Gomulka in Poland opened the floodgates of emigration there, and 35,000 Jews, including many who had come from the Soviet Union, immigrated to Israel. A second wave of some 10,000 arrived from Hungary with the failure of the anti-Soviet uprising there in late 1956. A third wave of some 14,000 came from Egypt in the wake of the Sinai Campaign and the worsening treatment of the Jews there.

A total of over 71,000 newcomers arrived in Israel in 1957, the largest immigration figure from 1951 until 1990. As a large proportion were mature adults, and self-employed, they could not be placed in agricultural settlements. Consequently, and against its official policy of population distribution, the government settled most of the newcomers in 1957 in the coastal plain.

January

2 Poet Natan Alterman is awarded the Bialik Prize for literature for his collection *Ir Hayonah* ("City of the Dove"), which deals with the Holocaust and the struggle for national independence.

7 The coalition crisis ends. A new government representing the same coalition composition is approved by the Knesset.

The three convicted murderers of Dr. Israel Kasztner – Ze'ev Eckstein, Dan Shemer, and Yosef Menkes – are sentenced to life imprisonment.

15 The Supreme Court finds no basis to the charge that Kasztner collaborated with the Nazis, thereby reversing the decision of the lower court. Malkhiel Gruenwald is declared guilty of libel, and sentenced to a suspended sentence of one year with probation.

27 Egypt releases the crew of the Doron from prison.

29 Hayim Laskov succeeds Moshe Dayan as chief of staff.

February

1 Egypt and Syria unite to form the United Arab Republic (U.A.R.), constituting an added threat to Israel.

12 The Knesset passes the first basic (constitutional) law, dealing with the composition and power of the Knesset.

14 Another union in the Arab world is effected with the creation of the Jordanian-Iraqi Federation.

27 Swedish Lt. Gen. Carl von Horn assumes the office of chief of the U.N. truce observers in the region.

The ultra-Orthodox riot in Jerusalem in protest against the opening of a public pool with mixed (men and women) bathing.

28 (until March 1) An Israeli plane carrying weapons for a Latin American country is forced to land in Algeria. The French authorities confiscate the weapons, as they suspect them to be bound for rebels. The plane and its crew are sent back to Israel.

March

30-31 The Syrians systematically shell settlements along the armistice line in the north. The I.D.F. returns fire.

April

17-30 Movie theaters close down over a dispute with the government about the taxation of tickets.

24 The state marks its 10th anniversary. A large I.D.F. parade is held in Jerusalem. Military displays take place in the Ramat Gan stadium.

27 The Hebrew University campus at Giv'at Ram, Jerusalem, is inaugurated as part of the country's 10th anniversary celebrations.

May

8 The Chief Rabbinate building in Jerusalem, Heikhal Shlomo, is inaugurated.

26 In a grave incident at Mt. Scopus, Jerusalem, the Jordanians shoot and kill the chairman of the Israeli-Jordanian Armistice Commission, Col. George Flint, of Canada, and four Israeli policemen.

June

5 The First Decade Exhibition opens at the Jerusalem Convention Center (Binyanei Ha'uma).

Lebanon's deteriorating

Amos Hakham, winner of the International Bible Contest held in Jerusalem.

domestic situation and the threat of civil war there cause concern in Israel. The United States plans to dispatch troops there. The Soviet Union and the U.A.R. warn against such a move.

July

1 A coalition crisis develops over guidelines laid down by the minister of the interior for the registration of citizens as Jewish (the "Who is a Jew" article). National Religious Party Ministers Yosef Burg and Moshe Shapira resign.

14-17 Political upheavals in Iraq, Jordan, and Lebanon prompt a state of military preparedness in Israel. Iraq's King Faisal is executed along with a large number of members of the royal family and senior political figures in an anti-Western coup; British paratroopers are flown to Jordan to protect King Hussein's regime; and American marines land in Lebanon.

24 Col. Ezer Weizman is named commander of the air force, succeeding Dan Tolkowsky, and is promoted to the rank of major general.

31 A riot in the Shata prison in the Jezreel Valley results in 13 fatalities, including two warders, and the escape of 66 Arab prisoners, mostly to Jordan.

August

19 Amos Hakham becomes a national hero upon winning the first International Bible Contest, held in Jerusalem.

September

Immigration from East Europe grows, primarily from Rumania.

October

7 The Habimah theater marks 40 years of existence and is named the country's national theater.

1958

Britain announces the sale of two submarines to Israel.

14 A cornerstone-laying ceremony for the permanent Knesset building is held in Jerusalem.

16 Long prison terms are handed down to the Border Guard policemen found guilty of the massacre at Kafr Qasim.

November

6 The Syrians shell Hulah Valley settlements. The I.D.F. responds with artillery fire.

23 Tel-Aviv Chief Rabbi Ya'akov Moshe Toledano joins the government as minister of religious affairs, replacing Moshe Shapira who resigned in the summer.

December

3 The Syrians shell settlements in the Galilee.

20 Israeli planes bring down an Egyptian Mig 17 over Israeli airspace.

31 U.N. Secretary-General Dag Hammarskjold arrives in Israel. He is scheduled for intensive talks with Ben-Gurion at his home in Kibbutz Sdeh Boker.

The Dayan era in the I.D.F. ends with the appointment of his successor, new Chief of Staff Hayim Laskov (r.). Ben-Gurion (c.) looks on.

THE STATE MARKS A DECADE

Israel, celebrating its first decade in May 1958, had a population of close to 2 million – approximately 1.8 million Jews and 200,000 Arabs – an impressive demographic increase over the state's population of 650,000 upon independence in 1948. Half the population consisted of new immigrants.

The occasion was marked by a large I.D.F. parade in Jerusalem, a series of three nightly military displays at the Ramat Gan Stadium, and the First-Decade Exhibition in Jerusalem. The period was one of relative calm along the borders, rapid economic development, and the expansion of international ties. Congratulations streamed in from abroad. It appeared that Israel was stepping into a new age. In spite of the continuing Arab threat, its future looked safer than ever before.

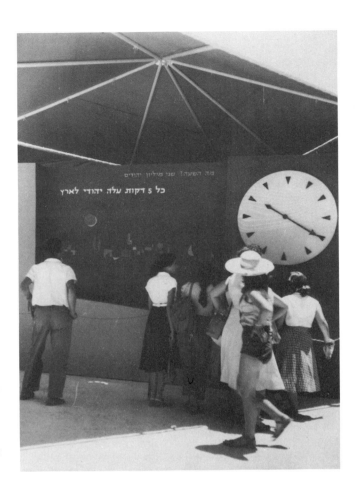

▷ The First-Decade Exhibition at Jerusalem's Convention Center (Binyanei Ha'uma) highlights the country's accomplishments, particularly in the sphere of immigration.

◁ The official 10th-anniversary poster is designed by artist Shmuel Katz.

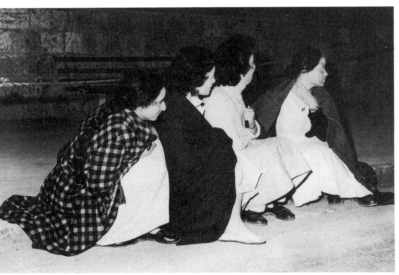

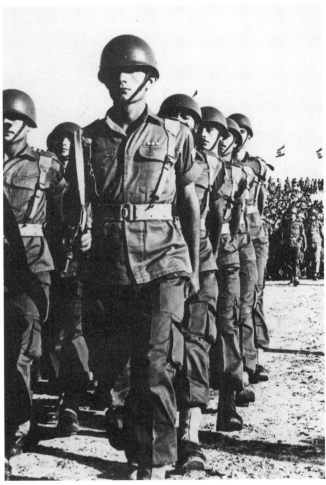

△ Four young women stake out a good viewing spot in Jerusalem at dawn on the day of the I.D.F. parade. Hundreds of thousands of Israelis stream into the city for the event.

▷ Admiration and pride in the I.D.F. is at its height in 1958, only 1½ years after the Sinai Campaign victory.

◁ In 1958, Israel still regards itself as a pioneers' country. Inspired by Ben-Gurion, priority is given to the settlement of the Negev. Here, cattle are raised at Sdeh Boker ("Herdman's Field"), where Ben-Gurion still resides. The milieu of the Negev cowboys is reminiscent of Wild West movies.

 The small town of Eilat booms in 1958 after the opening of the Straits of Tiran following the Sinai Campaign and the development of a port. The oil pipeline from Eilat to the north has been completed, and a new road is built via Mitzpeh Ramon and the Negev highlands linking the city to the north, dubbed the "overland Suez Canal" by Ben-Gurion.

▷ Prime Minister and Defense Minister Ben-Gurion, 72, continues his practice of touring the country extensively. Here, at the excavations of Hatzor, he tunes in to a new invention, the transistor radio.

△ The new campus of the Hebrew University at Giv'at Ram, Jerusalem, is inaugurated during the 10th-anniversary celebrations of the state. The original university campus on Mt. Scopus, part of the Israeli enclave in the Arab-held part of the city, was evacuated in 1948 and classes were conducted in temporary quarters in Jewish Jerusalem thereafter. When a return to Mt. Scopus was seen as unlikely in the foreseeable future, the university embarked on construction of the new campus in the western part of the city.

△ The senior member of the house, MK Mordechai Nurok, reads the dedication.

▷ The cornerstone is laid for the permanent Knesset building. The construction will take 8 years.

THE END OF THE DAYAN ERA IN THE ISRAEL DEFENSE FORCES

Moshe Dayan, who completed a term of over four years as chief of staff of the I.D.F. in late January 1958, was an unusual, charismatic military leader who became a familiar and admired figure both in Israel and abroad.

Dayan became chief of staff at 38, relatively late (his predecessors were 34 and 32). He was not a Haganah or a British Army veteran – groups from which the senior army command stemmed at the time. His career moved fast between 1948 and 1953. On his last day as prime minister and defense minister, Ben-Gurion appointed Dayan chief of staff.

Dayan sought to mold a new type of army, cultivating paratroop units under the command of Ariel Sharon. He soon patterned the entire army along these lines in terms of training, tenacity and morale, continuously pressing the government to respond more aggressively to attacks and infiltration from the surrounding Arab countries.

The surprising success of the I.D.F. during the Sinai Campaign turned the "one-eyed general" into an international hero, his rough and ready personal style and sharp tongue enhancing his public persona all the more. Reaching the conclusion in 1957 that he had exhausted his potential in military life, he submitted his resignation. Ben-Gurion tried to dissuade him, but by early 1958 Dayan was determined to enter the political arena.

1959

January

5 The oil pipeline from Eilat reaches Haifa.

28 Speaker of the Knesset Yosef Sprintzak, who has filled the post since its inception, dies.

February

1 Price controls and rationing of essential commodities end.

Intense politicking in the Knesset over the election of a new speaker results in a successful combined effort by factions on the left and the right to prevent a Mapai ("Israel Labor Party") candidate from attaining the post.

March

2 MK Nahum Nir of Ahdut Ha'avodah ("Unity of Labor") is elected speaker of the Knesset, defeating the Mapai candidate, Berl Locker.

4 Acceding to protests by Arab countries against Jewish immigration to Israel from Eastern European countries, the Soviet Union announces that it will prohibit such migration from its territory.

April

1 The I.D.F. conducts an unannounced practice call-up of reserve units by means of radio announcements. The country is in a state of tension. The Arab states are alarmed.

6 The Knesset defeats a vote of no-confidence over the practice call-up episode.

14 Major Generals Meir Zore'a and Yehoshafat Harkavi are relieved of their duties as a result of the practice call-up and are shifted to other posts.

18 Former French Minister of Defense Pierre Koenig, one of the architects of French-Israeli friendship, visits the country.

19 In a high-ranking I.D.F. reshuffle, Maj. Gen. Itzhak Rabin is named chief of Operations Branch, replacing Meir Zore'a, who becomes head of the Northern Command; Maj. Gen. Hayim Herzog replaces Yehoshafat Harkavi as chief of the Intelligence Branch; and Harkavi takes leave for study.

May

11 A distinguished French guest, former Prime Minister Guy Mollet, participates in the 11th Independence Day celebrations.

21 Relations between Israel and Egypt deteriorate again when Egypt detains a Danish ship bound for Israel, the Inge Toft, and embargoes its Israeli-bound cargo.

July

4 U.N. Secretary-General Dag Hammarskjold, on a visit to Cairo, fails to persuade the Egyptians to allow the passage of Israeli cargo through the Suez Canal.

5 A government crisis develops over the issue of Israeli arms sales to West Germany, with Mapam ("United Workers Party") and Ahdut Ha'avodah ("Unity of Labor") voting against the government. Ben-Gurion submits his resignation. President Ben-Zvi begins a series of talks with representatives of the various political factions to form a new government.

9 Rioting over perceived ethnic discrimination breaks out in the Wadi Salib slum quarter in Haifa, led by immigrants from North Africa. It will be followed by other riots, in other settlements.

15 President Ben-Zvi requests Ben-Gurion to form a new government, but Ben-Gurion informs him that he is unable to do so. The President decides that the outgoing government will function in a transitional capacity until the forthcoming elections for the Fourth Knesset, scheduled for November.

17 A consortium of foreign investors, headed by Baron Rothschild from France, announces a plan to lay a larger oil pipeline from Eilat to Haifa.

24 Ashkenazi Chief Rabbi Itzhak Halevi Herzog dies aged 71.

31 A new wave of riots erupts in Wadi Salib.

August

5 A proposal to abolish military rule over the Arab regions in Israel is defeated by the Knesset.

26 The episode involving the embargo of the Inge Toft cargo is still unresolved despite renewed mediation efforts by U.N. Secretary-General Hammarskjold.

September

13 Former mayor of Tel-Aviv and Minister of the Interior Israel Rokakh dies aged 63.

October

6 The country's first subway, named the Carmelit, is inaugurated in Haifa.

14 West Germany requests Britain to extradite Adolf Eichmann, reportedly in British-controlled Kuwait.

15 The Bank of Israel issues a new series of currency notes ranging from IL 0.50 to IL 50.

21 Israel's soccer team draws with Yugoslavia 2:2.

22 French car manufacturer Renault, yielding to the Arab boycott, ends the assembly of its cars in the Ilin plant in Haifa.

November

3 Elections for the Fourth Knesset result in a large gain for Mapai – 47 seats (up from 40), a slide for the General Zionists – 8 (from 13), a small gain for Herut – 17 (from 15), and the failure of the ethnic tickets.

19 Pierre Mendès-France, France's former prime minister, visits Israel.

30 The Fourth Knesset convenes. A new speaker, Kadish Luz of Kibbutz Deganya Bet (Mapai), is elected unanimously.

December

5 General Gianni from India replaces General Carl von Horn from Sweden as chief U.N. observer in the region.

13 An upset in the Tel-Aviv mayoral elections: Mapai's Mordechai Namir defeats the General Zionists' Hayim Levanon.

15 Jerusalem's new mayor is Mapai's Mordechai Ish-Shalom. Veteran Mapai ("Israel Labor Party") Mayor of Haifa Abba Houshi is reelected.

16 Israel's first submarine, the Tanin ("alligator"), arrives in Haifa port.

17 A new government led by Ben-Gurion is approved by the Knesset by a vote of 78 to 33. New ministers include Moshe Dayan (agriculture), Giora Yoseftal (labor), and Abba Eban (without portfolio).

23 Egyptian President Nasser declares that Israel will not be permitted to use the Suez Canal "until the Palestine problem is resolved."

Israeli-made car, 1959 model.

345

MAPAI AT THE HEIGHT OF ITS POWER

Ben-Gurion and the party he led, Mapai – Israel Labor Party – achieved their greatest electoral support ever in the elections for the Fourth Knesset, held on November 3, 1959, obtaining 47 seats as compared to their record of 46, 45 and 40 seats (in chronological order) in the previous three elections. This success was attributable to the still-palpable aura of the victory in Sinai three years previously; an improved economic situation and the cancellation of rationing; and the promotion by the party, at Ben-Gurion's insistence, of a group of popular young leaders who were allotted realistic places in Mapai's list of candidates for the Knesset.

The Labor bloc, led by Mapai, attained a solid majority of 63 M.K.s (Mapai 47, Mapam – "United Workers Party" – 9, Ahdut Ha'avodah – "Unity of Labor" – 7), and, together with the centrist Progressives, who climbed to 6 seats, constituted a coalition of 69 M.K.s. Although the National Religious Party had left the government during the "Who is a Jew" crisis, it rejoined the new coalition, bringing total government support to a substantial 86 M.K.s. A new generation of three ministers were added to the government: Dayan, minister of agriculture, Yoseftal, minister of labor, and Abba Eban, minister without portfolio. Shim'on Peres was appointed deputy defense minister.

∇ The most outstanding of the young Mapai candidates is unquestionably former chief of staff Moshe Dayan, who ended his army career nearly two years before the elections and pursued university studies thereafter.

A popular figure in Israel and abroad, Dayan adds luster to the party list, although he is in conflict with most of the Mapai veteran leaders. Following the elections, Ben-Gurion names him agriculture minister.

△ Following the death of veteran Knesset Speaker Yoseph Sprintzak in January 1959, Nahum Nir of Ahdut Ha'avodah is elected speaker, shown here upon being informed of his election to the Knesset by two Gadna ("Youth Corps") members.

△ Menahem Begin, leader of the Herut movement, invests all his political talent in the campaign, but, as in the three previous elections for the Knesset, fails to overtake Mapai. He will have to wait for four more elections until he attains victory.

▷ New currency notes issued in 1959 depict various vocations. The evolution of the half-pound note began with a depiction of a male agricultural worker (upper r.), metamorphosing into a female (lower r.) – upon the realization that women had not been represented in the series – and ending up a woman Nahal soldier (below) because of the need to depict the I.D.F., too.

▽ Many of the immigrants of 1959 are from Rumania. Shown, a family arrives from the cold Rumanian climate to the warm Israeli one.

THE WADI SALIB EPISODE

The bitter outburst in 1959 at Wadi Salib against a background of socioeconomic and ethnic factors had a strong impact on the young country.

It was sparked by a minor incident involving the arrest on July 8, 1959, of a resident of the Wadi Salib quarter in Haifa, which housed a depressed immigrant population from North Africa. During the arrest, the inhabitants of the neighborhood began a riot and shots were fired. The next day, some 200 residents of the quarter carrying black flags and a bloodstained Israeli flag demonstrated to protest ethnic discrimination. The demonstration soon turned into a mass riot during which neighborhood stores were damaged, cars were torched, and establishment buildings – mainly Histadrut ("Federation of Labor") and Mapai ("Israel Labor Party") clubhouses – were destroyed. Later that day, several of the young residents of the neighborhood moved on to the nearby affluent Hadar Hacarmel neighborhood, smashing store windows and damaging cars before police stopped them.

Some four months later, a newly created party, Likud North Africa, led by Wadi Salib resident David Ben-Harush, ran in the Knesset elections of November 1959. Despite obtaining 8,199 votes (0.85% of the electorate), the party failed to pass the minimum threshold for a Knesset seat.

The term Wadi Salib became an inseparable part of the consciousness of "the Second Israel" (a name designating Oriental Jews in contrast to "the First Israel," which designates the European Jews). It is beyond doubt that the outburst brought about long-term political consequences and influenced the course of elections in the sixties and the seventies.

△ The Wadi Salib riot in Haifa is depicted on the cover of the weekly *Ha'olam Hazeh* ("This World").

▽ Minister of Commerce and Industry Pinhas Sapir (2nd from l.) ends food rationing in February 1959.

▽ Winner of the Bible Contest for Youth in 1959 is Shim'on Shitrit, 13, later to become a professor of law and a government minister.

△ The Nahal Entertainment Troupe comprises many future stars. From (l.) to (r.): Amiram Spektor, Gavri Banai, Hanan Goldblat, Yoram Gaon. Standing: Israel Poliakov (Poly).

◁ The new subway, Carmelit, is an attraction in Haifa.

▽ Purim festivities in Tel-Aviv feature effigies of Ben-Gurion, Golda Meir, Dayan, and an African figure.

△ Diplomatic relations are cordial even at the height of the Cold War. President Itzhak Ben-Zvi (r.) chats with U.S. Ambassador Ogden Reid (at center) and Soviet Ambassador Mikhail Bodrov (l.) at Israel's 11th anniversary celebrations.

The Seventh Decade: 1960-1969

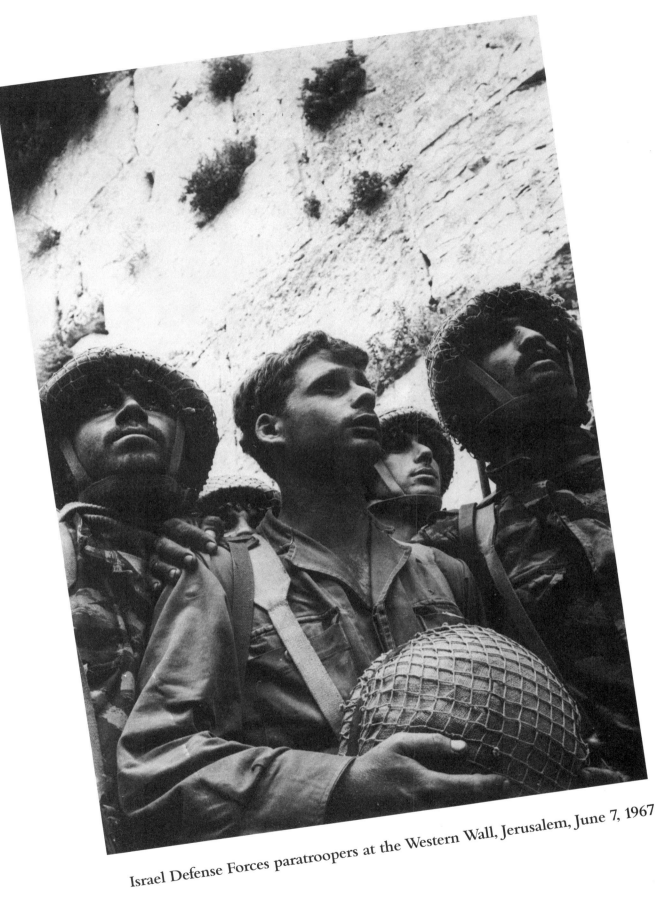

Israel Defense Forces paratroopers at the Western Wall, Jerusalem, June 7, 1967

Although over 15 years had passed since the end of World War II, the trauma of the war, and especially the horrors of the Holocaust, did not cease haunting many of Israel's inhabitants. These feelings were intensified with the capture in Argentina of Nazi war criminal Adolf Eichmann by Israeli Mossad agents, his transfer to Israel, his trial, and his execution. The trial became a focus of national and international attention over a two-year period (1960-62), with Holocaust-related issues remaining on the national agenda thereafter as well.

Immigration in the early 1960s rose once again. The primary countries of origin at this time were Morocco and Romania.

In Morocco, a large number of Jews were prepared to emigrate, but the new independent regime had prohibited their departure since the second half of the fifties, and the Jews who left Morocco during those years did so illegally. In the early sixties, an agreement was reached with the new king, Hassan II, over a legal and orderly exodus of the Jews. Within a few years, Israel received some 80,000 immigrants from Morocco. A large number of immigrants arrived from Romania, too, although intermittently, as the communist regime kept changing its policy, at times allowing the exit of Jews, at other times prohibiting it.

Major development projects were carried out during the first half of the 1960s, headed by the completion of the national water carrier, which was inaugurated in its entirety in 1964. Heightened infrastructure development, ongoing immigration, and continued large-scale housing construction for immigrants led to a rise in the standard of living but to a growing deficit in the country's balance of payments. By mid-decade, the government decided to check this trend by implementing a policy of restraint. Viewed retrospectively, this recessive policy succeeded only too well, and within a year the country was contending with an economic slowdown and unemployment, which produced the side effect of emigration. How this situation would have been resolved is a matter of speculation, for in mid-1967 the Six-Day War broke out.

The decade between the Sinai Campaign (1956) and the Six-Day War of 1967 was one of military calm along the southern border with Egypt and partial calm along the Jordanian border. The situation along the Syrian border, however, was volatile, with ongoing friction in the demilitarized zone, at Lake Kinneret, and for a long while in every development linked with Syrian efforts to divert the sources of the Jordan River. The battle for water constituted a serious threat to Israel, as it involved the main sources of water in the north and the operation of the national water carrier. As a result, the I.D.F. responded aggressively, which prompted Syria to stop its diversion works in 1966.

Incidents along the Syrian border continued into early 1967, alongside terrorist acts by Fatah, which began in 1965. While at first Israel reacted with restraint, by 1967 it responded with a series of retaliatory raids against Palestinian terrorist bases in Jordan and Lebanon. Although successful, the raids did not halt the infiltration of terrorist squads.

By May 1967, the security situation began to deteriorate rapidly. Egypt deployed large numbers of troops in the Sinai and dismissed the U.N. force there. Arab propaganda organs called for the annihilation of Israel, and in a matter of days, in May, the Middle East turned into a powder keg. The Egyptians blockaded the Straits of Tiran, placing Israel in a grave position. Attempts by the government to get the great powers to remove the blockade failed. Domestically, demands were made to broaden the base of the government by including the opposition Gahal and Rafi parties. Late in May, Prime Minister Eshkol yielded to this pressure and brought in Moshe Dayan, of Rafi, as minister of defense. A few days later, the Six-Day War broke out.

Israel's swift and decisive victory in June 1967 astonished the world. Portrayed during the tense waiting period preceding the war as a small country whose leadership was locked in strife and which lacked international backing, Israel defeated the armies of Egypt, Jordan and Syria in a matter of days and took control of the entire Sinai Peninsula, the Gaza Strip, the area on the west bank of the Jordan River controlled by Jordan (the West Bank), and the Golan Heights.

After the war, the anticipation in Israel was for a long period of quiet, since the Arab countries would require years to rehabilitate their armies and overcome their defeat. This was not to happen. The Soviet Union promptly came to Egypt's and Syria's aid, and the Arab countries announced that "what was taken by force will be returned by force," refusing to conduct any peace negotiations with Israel or to recognize it.

Still, the sense of victory in Israel was enduring. The Jewish state was perceived at home and even abroad as a regional power. Moreover, its economic situation improved rapidly following the war, and immigration resumed. By the end of the decade, most Israelis felt more self-confident, and had more confidence in their country than ever before. The Arabs in the occupied territories did not display any particular opposition to Israeli governmental authority, while intermittent terrorist acts in the territories, and even in Israel, were regarded as unavoidable. The Israelis also expected that the war of attrition which the Egyptians initiated along the Suez Canal in the winter of 1969 would end as the preceding war had ended – in the total defeat of the enemy.

In 1969, the boundaries of Israel extended from Mount Hermon in the north to Sharm al-Sheikh in the south, and from the Jordan River to the Suez Canal. Talk of "territories for peace," which was heard shortly after the victory of 1967, receded. Peace appeared far away and Israel was getting accustomed to its hold over the occupied territories.

January

1 The agorah coin replaces the prutah. The Israeli lira now has 100 agorot instead of 1,000 prutot.

16 Holland proposes that the Common Market accept Israel as a member.

31 (until February 1) An I.D.F. unit attacks Hirbet Taufiq on the Golan Heights southeast of Lake Kinneret following Syrian attacks, marking Israel's first large-scale retaliatory operation since 1956.

February

17 The Inge Toft, the Danish ship held by the Egyptians in the Suez Canal for nine months, arrives at Haifa port. The Egyptians do not release its cargo.

Archeologists discover important findings in the Judean Desert from the period of the Bar Kokhva revolt.

Egyptian army forces build up in Sinai toward the end of the month. The southern border is tense. Nasser warns the West against intervening.

March

6 Israel beats Greece at soccer, 2:1.

Prime Minister Ben-Gurion leaves for visits to the United States and Europe. He meets with President Eisenhower, the candidates for the 1960 presidential elections, Chancellor Adenauer (in New York), and British Prime Minister MacMillan.

8 Industrialist Efraim Ilin announces that his factory in Haifa will assemble American cars for the company Studebaker Lark.

April

3 The U.A.R. threatens to declare war against Israel if it diverts water from the Jordan.

10 Israel scores an impressive victory when it beats Yugoslavia at soccer, 2:1.

13 New York stevedores refuse to unload the Egyptian Cleopatra as a protest against Egypt's blocking of Israeli shipping and cargo at the Suez Canal.

May

7 The boycott of the Cleopatra ends when the American government promises to take action to halt the anti-Israel discrimination at the Suez Canal.

8 Gideon Hausner is appointed attorney general.

Letters from the archives of Bar Kokhva are found in the excavations conducted in the Judean Desert.

12 The Yossele Shumacher affair makes headlines when the child's ultra-Orthodox grandfather, Nahman Shtarks, is arrested on suspicion of abducting him from his parents.

Ben-Gurion instigates a public storm by suggesting in a lecture that only 600 Israelites left Egypt during the Exodus, not 600,000.

22 Israel's winning soccer streak continues: The junior Israeli team beats its British counterpart, 4:0.

23 In a dramatic announcement in the Knesset, Ben-Gurion reveals that Adolf Eichmann has been captured in Argentina by Mossad agents.

June

2 A crisis in Israeli-Argentinian relations develops as a result of Eichmann's capture and kidnapping from Argentina.

Ben-Gurion conducts a round of visits in Europe. He meets with President de Gaulle in France, King Baudouin in Belgium, Queen Juliana in the Netherlands, and with other prominent statesmen.

15 A Technion professor, Kurt Sita, is arrested on suspicion of spying for the Soviet Union.

16 Israel's first atomic energy reactor, at Nahal Sorek, becomes operational.

July

6 Israel Aircraft Industries delivers its first domestically assembled jet trainer, the Fouga Magister, to the I.D.F.

17 The government coalition is extended by the joining of two M.K.s from Po'alei Agudat Israel. Binyamin Mintz is appointed minister of the post.

23 Israel's ambassador to Argentina is declared persona non grata in the wake of the Eichmann capture.

28 The World Bank grants Israel a loan of $27.5 million to build a new deep-water port at Ashdod.

31 Abba Eban, until now minister without portfolio, is named minister of education and culture.

August

1 Israel and Argentina resolve their bilateral conflict.

25 The Olympic Games are opened in Rome. Israel is represented by 23 athletes.

September

The Mishap (of 1954) resurfaces with heightened intensity and soon becomes the Lavon Affair. Chief of Staff Hayim Laskov appoints an investigative commission – the Cohen Commission – to hold an inquiry into whether then-Minister of Defense Pinhas Lavon was responsible for the mishandled espionage operation. Ben-Gurion meets with Lavon.

27 Nasser, addressing the U.N. General Assembly, demands that "the situation in Palestine be restored to its former state."

Avraham Shapira, "the oldest shomer" ("Watch-man"), celebrates his 90th birthday in Petah Tikvah.

October

2 The debate over the Lavon Affair intensifies. Ben-Gurion adopts a negative stand against Lavon. The topic occupies the press and the public daily.

16 Deganya, the "mother of the kibbutzim," celebrates 50 years since its founding.

19 An Egyptian Mig 17 overflies the Negev and is brought down by Israeli combat planes.

Mediation efforts are made in Mapai ("Israel Labor Party") between the two camps that have evolved as a result of the Lavon Affair.

30 A ministerial committee, the Committee of Seven, is appointed to investigate the Lavon Affair.

November

27 Maj. Gen. Zvi Zur is designated chief of staff.

December

17 Reports in the United States claim that Israel has a second nuclear reactor in the Negev. Israel responds that its research is for peaceful purposes only.

21 The Committee of Seven concludes unanimously that Lavon "did not give the order in the Affair." Ben-Gurion demurs.

25 The government approves the Committee of Seven conclusion by a majority. Ben-Gurion does not participate in the vote.

27 The 25th Zionist Congress opens in Jerusalem.

A good year for Israel in soccer. With the Jewish Hungarian coach, Gyula Mandi, the All-Star team scores 6 victories, 2 losses, and 1 draw.

1960

The new agorah replaces the prutah.

EICHMANN'S CAPTURE

In a special announcement to the Knesset on May 23, 1960, Prime Minister David Ben-Gurion reported: "It is my duty to inform the Knesset that some time ago, one of the major Nazi criminals, Adolf Eichmann, who, together with the Nazi leaders, is responsible for ... the destruction of six million of the Jews of Europe, was located by the Israeli security services. Adolf Eichmann is now in custody in Israel and will soon stand trial..."

Ben-Gurion's dramatic announcement marked the end of a prolonged chase mounted by the Israeli security services for an elusive war criminal. Eichmann had settled in Argentina under a counterfeit identity, calling himself Ricardo Klement. Once his whereabouts were discovered, a decision was made in Israel to capture him, remove him from Argentina, and try him in Israel. In the spring of 1960, the Israelis stopped Eichmann in the street near his home, pushed him into a car, and brought him to a hiding place where he was held for 10 days. His kidnapping from Argentina was facilitated by the landing then of an Israeli plane that brought a large official mission to Argentina for the 150th anniversary celebrations of its independence. When the mission flew back, Eichmann and his captors secretly went on board. Eichmann's trial, which opened in Jerusalem in May 1961, drew world attention to Israel and the Holocaust.

△ Adolf Eichmann, photographed in Israel in 1960.

▽ Eichmann's capture makes major headlines in Israel and throughout the world. Here, the headline in *Yedi'ot Aharonot* ("Latest News"): "Eichmann is in Israel."

▷ August 1960 marks the opening of the largest medical center in the Middle East, the Hadassah-Hebrew University Medical Center at Ein-Kerem, outside Jerusalem. It is to replace the Hadassah hospital on Mount Scopus, closed down since 1948.

▽ Cracks begin to appear in Mapai, the old ruling Labor party of the Yishuv and the State of Israel since its inception. One aspect of the dissension is the growing struggle between the old and the new generation of politicians, the latter represented most prominently by Moshe Dayan (c.) and Shim'on Peres (l.). Between them is Dayan's assistant, Gad Ya'akobi, later a minister and Israel's ambassador in the U.N.

◁ "What's he really after?" wonders caricaturist Dosh in *Ma'ariv* ("Evening Paper"), referring to Ben-Gurion's tenacious pursuit of the Lavon Affair.

▽ Pinhas Lavon, secretary-general of the Histadrut ("Federation of Labor") in 1960 and formerly (1954-55) minister of defense, is at the vortex of a political storm in the fall of 1960.

THE LAVON AFFAIR

The Lavon Affair, or simply the Affair, preoccupied Israel virtually constantly for a period of five years at least, from September 1960 onward.

Originally dubbed "the Mishap" when it emerged in 1954, the affair involved a failed Israeli espionage operation in Egypt that year. Pinhas Lavon, then minister of defense, was forced to resign over the issue in early 1955, although later that year he was elected secretary-general of the Histadrut ("Federation of Labor") and was a leading light in Mapai ("Israel Labor Party"). During the later 1950s, rumors began to circulate regarding a web of lies and perjuries connected with the affair, aimed at bringing Lavon down. The issue was raised formally in the summer of 1960 when two army officers came under suspicion of suborning witnesses at the time in order to make it appear that the responsibility for the Mishap was Lavon's. Minister of Defense Ben-Gurion then instructed Chief of Staff Hayim Laskov to form an investigative commission on the matter. Lavon demanded that his name be cleared entirely, whereupon Ben-Gurion replied that he could not take such a step, as it

was not he who had disqualified Lavon from holding office at the time (Ben-Gurion was then out of office). Lavon then turned to the Knesset Foreign Affairs and Security Committee and gave his version of the events.

At that stage, Lavon decided to go public with a series of grave accusations against the heads of the defense establishment, arousing opposition on Ben-Gurion's part and a demand by him for a judicial commission of inquiry. The government, however, rejected Ben-Gurion's demand and instead appointed a ministerial investigative committee, the Committee of Seven, headed by Minister of Justice Pinhas Rosen. This committee, submitting its findings at the end of 1960, cleared Lavon, determining that the Mishap operation had been carried out without his knowledge.

Ben-Gurion demurred, however, and decided to take a prolonged leave of absence. Mapai was divided between Ben-Gurion supporters and Lavon supporters, as was the press, while the public remained confused.

The affair dragged on, becoming increasingly tangled, and prompting early elections for the Knesset in 1961.

△ Israel Aircraft Industries assembles its first jet trainer in 1960, the Fouga Magister.

▽ Three Labor movement leaders at Kibbutz Deganya's 50th anniversary celebration (l. to r.): Ya'ari, Tabenkin, and Ben-Gurion.

△ Franco-Israeli relations are at their height, and Prime Minister Ben-Gurion is received warmly by President de Gaulle in 1960. France is viewed as Israel's closest ally. Senior French personalities visit Israel frequently, and France supplies the I.D.F. with most of its armaments. In the course of the year, Ben-Gurion visits the United States, Britain, Belgium, and the Netherlands for talks with their leaders.

▷ A small nuclear reactor at Nahal Sorek near the Mediterranean, west of the town Yavneh, is reported to be operational in mid-1960. It arouses interest in the Arab countries, as well as in other countries. Israel emphasizes that the reactor is experimental and is for peaceful purposes only.

◁ The Ilin firm in Haifa begins assembling the American Studebaker Lark. Within a few years, thousands of Studebaker Larks will be seen in the streets of Israel.

▽ The annual four-day march, a tradition begun in the mid-1950s, grows in popularity and by 1960 draws thousands of participants from both the armed forces and civilian life. It becomes a national tradition that includes a "pilgrimage" to Jerusalem.

▽ Archeologists digging in the Judean Desert unearth important findings from the period of the Bar Kokhva revolt in 132-135 A.D.

△ Two who make an important contribution to Israel's soccer success in the early 1960s are goalie Ya'akov Hodorov (l.), who plays with the All-Star team for over ten years, and Hungarian-born national coach Gyula Mandi.

1961

January

The Lavon Affair continues to occupy both Mapai ("Israel Labor Party") and the press.

1 Zvi Zur replaces Hayim Laskov as chief of staff.

11 The Egoz, a small vessel carrying Jews leaving Morocco illegally, sinks en route to Israel with the loss of 42 lives.

12 The trial of a member of Kibbutz Sha'ar Ha'amakim, Aharon Cohen, accused of spying for the Soviet Union, begins.

31 Prime Minister Ben-Gurion submits his resignation in the wake of the findings of the Committee of Seven. He accuses the government of "appointing itself as a judge."

February

4 The Mapai ("Israel Labor Party") executive decides that Pinhas Lavon cannot continue to serve as secretary-general of the Histadrut ("Federation of Labor").

7 Professor Sita from the Technion, charged with espionage, is sentenced to five years in prison.

9 The Histadrut executive commitee accepts Lavon's resignation.

16 President Ben-Zvi assigns Ben-Gurion the task of forming a new government.

[continued top of column 2]

27 The Histadrut elects a new secretary-general, Aharon Becker.

28 Ben-Gurion informs the president that he sees no possibility of forming a new government.

March

5 A strike of secondary school teachers breaks out and lasts two months.

15 The remains of David Raziel, the commander of Etzel who was killed in Iraq in 1941, are brought to Israel and reinterred in a state ceremony at Mount Herzl.

28 The Fourth Knesset moves to disband in light of the deepening crisis engendered by the Lavon Affair. Elections for the Fifth Knesset are scheduled for August 15, 1961.

April

11 The trial of Adolf Eichmann begins in Jerusalem.

16 A report is released on the arrest in late March of Dr. Israel Bar, a high-ranking I.D.F. reserves officer and an international military analyst, on suspicion of spying for a foreign power (U.S.S.R.). The news causes shock.

25 The General Zionists and the Progressives unite to establish the Liberal Party with 14 members of Knesset.

28 Israeli combat planes shoot down an Egyptian Mig 17 that penetrates Israel's airspace over the Negev.

May

15 Work on the tunnel of Menashe is finished. It is the longest tunnel in Israel (7 km), part of the national water carrier – which is still under construction.

June

6 The Hadassah-Hebrew University Medical Center opens in Ein-Kerem.

7 Israel Shohat, the founder and leader of Hashomer ("The Watchman"), dies at age 75. His wife Mania died three and a half months earlier.

15 The Nigerian prime minister arrives in Israel for a visit. Thereafter, a series of heads of government of other newly established African countries follow suit.

29 Soviet authorities accuse the first secretary of the Israeli embassy in Moscow, Ya'akov Sharett, of spying, and instruct him to leave immediately.

July

1 The Port Authority is established.

5 Israel launches an experimental missile, the Shavit 2.

26 The Haifa Theater opens with *The Taming of the Shrew*.

30 Work on the construction of the port at Ashdod begins.

August

15 Elections for the Fifth Knesset are held. Mapai ("Israel Labor Party") loses seats, the Liberals gain, and most of the other parties remain stable.

29 The sixth Maccabiah opens at Ramat Gan.

September

4 The Fifth Knesset convenes. Mapai's Kadish Luz is elected speaker.

6 President Ben-Zvi, after conferring with representatives of the parties, assigns Ben-Gurion the task of forming the government.

7 Ben-Gurion announces that he is unable to form a government "in the existing circumstances."

14 The president assigns the task of forming the government to Levi Eshkol. Eshkol announces his intention of forming a government led by Ben-Gurion.

23 An international harp competition, named after Pablo Casals, is opened in Jerusalem.

27 Prime Minister Ben-Gurion celebrates his 75th birthday.

30 The U.A.R. disbands. Syria resumes its status as an independent country. It applies for renewed membership in the U.N..

October

4 The International Bible Prize is awarded to Rabbi Yihyeh Alsheikh.

November

2 Ben-Gurion presents his new government, formed by Levi Eshkol. New ministers are Yigal Allon, Zerah Warhaftig, Eliyahu Sasson, and Yosef Almogi. Mapam ("United Workers Party") does not join.

December

4 Prime Minister Ben-Gurion leaves for a visit to Burma.

11 Itzhak Ernst Nebenzahl takes office as state comptroller, replacing Siegfried Moses, who has filled the post since 1949.

14 The Jerusalem District Court sentences Adolf Eichmann to death by hanging.

27 The Cameri theater inaugurates its new building in Dizengoff Street with the play *Kinneret, Kinneret*, written by Natan Alterman.

28 Operation Yakhin – the transfer of the Jews of Morocco to Israel with the permission of the Moroccan government – begins. Some 80,000 Jews are brought to Israel from there by 1964.

Immigration swells in 1961, following a falloff of several years' duration. Over 47,000 newcomers arrive, nearly twice as many as in 1960.

Susita – an Israeli-made fiberglass car – model 1961.

THE EICHMANN TRIAL

The trial that began in Jerusalem on April 11, 1961, was perhaps the trial of the decade, from the point of view both of Israel and the world. Nazi criminal Adolf Eichmann, placed in a bulletproof glass booth, faced a panel of three judges of the Jerusalem District Court – Justices Moshe Landau, Binyamin Halevi, and Itzhak Raveh. The prosecuting attorney in the trial was Attorney-General Gideon Hausner, while the defendant was represented by a German attorney, Robert Servatius. Lasting some nine months, the trial illuminated the Nazi death machine in all its horror.

A long series of witnesses exposed the atrocities of the Nazis in agonizing personal testimonies. Eichmann's defense was that he had merely followed orders.

The court handed down the death sentence on December 15, 1961. Eichmann appealed but the Supreme Court confirmed the death sentence. Eichmann was executed in the night of May 31-June 1, 1962. His body was cremated, and a few hours later, his ashes were cast in the midst of the Mediterranean.

I stand before you in this place, judges of Israel, as prosecutor of Adolf Eichmann, but I do not stand alone. With me at this moment stand six million prosecutors. They cannot stand up on their feet to point an accusing finger at the glass booth and scream at the person seated in it "I accuse!" because their ashes are piled on the hills of Auschwitz and the fields of Treblinka, washed away in the rivers of Poland, their graves scattered through the length and breadth of Europe. Their blood is crying out, but their voices cannot be heard. I shall therefore serve as their mouth, and on their behalf bring the terrible charge."

Gideon Hausner, attorney general of the State of Israel, at the start of the Eichmann trial, April 1961.

△ Poet Abba Kovner, a fighter in the Vilna Ghetto during the war, is one of the prosecution witnesses. His testimony rivets the assembly in the hall, as well as hundreds of thousands of listeners who follow the trial over the radio. Live Kol Israel broadcasts bring the trial into every home and workplace in Israel.

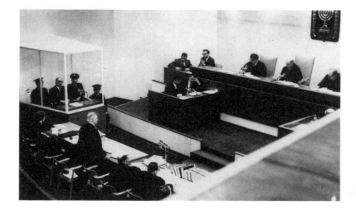

△ Eichmann is kept in a bulletproof glass booth (l.) during of the trial. Officially, the trial is registered as Criminal Record N. 40/61.

▷ Writer K. Zetnick (Yehiel Dinur), whose books on the Holocaust were published in Israel during the 1950s, collapses while testifying against Eichmann.

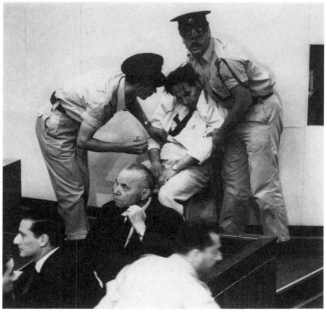

THE FIFTH KNESSET

The Lavon Affair cast a long shadow over Israeli politics, and especially over Mapai ("Israel Labor Party"), with signs at the start of 1961 that the crisis was irremediable. Ben-Gurion was not prepared to head a government most of whose members did not support him on the Affair issue. Mapai, therefore, had to choose between Ben-Gurion and Lavon. It chose Ben-Gurion.

The public was called upon to vote in early elections, held August 15, 1961, and the results showed Mapai to be the primary loser, with 42, as compared to its previous 47, seats. Most of the other parties maintained their positions, while the new Liberal Party (an amalgamation of the General Zionists and the Progressives) grew from 14 to 17 seats. President Ben-Zvi assigned Ben-Gurion the task of forming the government. Ben-Gurion declared that he was unable to do so. The president assigned the task to Levi Eshkol. After several weeks, Eshkol managed to form a government, appointing Ben-Gurion as prime minister.

△ A population census is conducted in 1961, the first since 1948. Forms are distributed to every household, to be collected later.

▽ "A master in arms, but a failure in economics" – the Liberals' campaign poster during the elections points out Dayan's difficulties as minister of agriculture.

△ Lieut. Gen. Zvi Zur becomes chief of staff on January 1, 1961.

▽ The Lavon Affair continues to preoccupy Israel for yet another year.

BEN-GURION RESIGNS OVER GOV'T CONCLUSIONS ON 'LAVON AFFAIR'

Knesset Marks 12th Birthday

The Knesset last night marked its twelfth birthday by holding its traditional Tu B'shvat reception.

Closing yesterday's session of the House, Speaker Kadish Luz said that in its brief history the Knesset had established a reputation for itself among world parliaments.

B-G's Letter

The following is the text of Mr. Ben-Gurion's letter to President Ben-Zvi:

Mr. President,

I hereby have the honour to inform you that I am resigning from my membership in the Government.

I do so with profound regret. It may be that many ci-

Prime Minister David Ben-Gurion last night submitted his resignation, which automatically means the resignation of the Cabinet, to President Itzhak Ben-Zvi. The Premier, in his letter of resignation to the President, said his conscience forbade him to accept responsibility for the Cabinet's decision of December 25 last, which endorses the conclusions of the 7-man Ministerial Committee on the "Lavon Affair." The Prime Minister handed in his resignation to Mr. Ben-Zvi at 8.45 p.m. immediately after a ten-minute extraordinary Cabinet meeting to which he made a brief statement on his decision. It is not ruled out that Mr. Ben-Gurion may accept the leadership of a new Cabinet which is not bound by the decisions of the Ministerial Committee on the Lavon "Affair."

resignation was that the

A YEAR OF DRAMA

A series of dramatic events unfolded in close succession during 1961, each one occupying the public. The Lavon Affair continued to overshadow the functioning of the government, leading finally to its fall and the holding of new elections in the summer. An additional aspect of the fallout from the Affair was the dismissal of Pinhas Lavon as secretary-general of the Histadrut ("Federation of Labor") at the start of the year and his removal from active involvement in Mapai ("Israel Labor Party").

The arrest of Dr. Israel Bar, an intelligence officer in the I.D.F. reserves and a military analyst of international repute, for spying for a foreign power – the U.S.S.R. – was another development that shocked the public. Bar had a close relationship with Ben-Gurion.

The very same week, the Eichmann trial, which was to become a focus of intense public attention for months to come, began in Jerusalem.

A short while before the elections, Israel launched an experimental space missile, the Shavit 2, evoking widespread national pride, although some commentators suggested that the timing of the achievement may have been connected to Mapai's election campaign.

△ Immigration from Morocco rises in 1961, after an agreement with King Hassan II. A family from Morocco arrives at the port of Haifa in December 1961.

▽ Dr. Israel Bar, a military analyst and an intelligence lieutenant colonel in the I.D.F. reserves, is taken into custody.

1962

January

9 Aharon Cohen of Kibbutz Sha'ar Ha'amakim is sentenced to five years in prison for conveying classified information to a foreign (Soviet) agent.

14 Dr. Israel Bar is sentenced to 10 years in prison for spying for the Soviet Union.

February

6 A series of 12 stained glass windows by Marc Chagall is unveiled at the Hadassah Medical Center at Ein-Kerem.

9 The government adopts a new economic policy involving a major devaluation of the Israeli pound to IL3 = $1. Demonstrations are held protesting the attendant price rises and the linkage of mortgages to the dollar.

20 The Knesset rejects a proposal to abolish military rule in the Arab sector.

March

16–17 The I.D.F. mounts a retaliatory operation targeting the Syrian fortification of Nuqeib, east of Lake Kinneret, in the wake of Syrian attacks. Seven I.D.F. soldiers and dozens of Syrians are killed.

22 The Supreme Court begins hearing Eichmann's appeal against his sentence.

April

9 The U.N. Security Council censures Israel for its raid at Nuqeib. The United States and Britain support the censure; France abstains.

10 The Knesset rejects the censure by the U.N. Security Council.

May

6 President Leon M'ba of Gabon, Africa, arrives for a state visit to Israel. In the next weeks, the presidents of the Central African Republic, Liberia, and the Ivory Coast will visit Israel.

9 The Independence Day parade takes place in driving rain, an unusual meteorological occurrence for the season.

10 The rabbi of Moshav Komemiyut in the south, Rabbi Binyamin Mendelson, is arrested on suspicion of aiding in the abduction of Yossele Shumacher, a child concealed from his parents by his ultra-Orthodox grandfather.

29 The Supreme Court confirms the death sentence handed down to Eichmann.

31 Adolf Eichmann is executed by hanging.

June

28 The Soblen affair begins. Dr. Robert Soblen, an American Jew sentenced to life imprisonment in the United States for spying for the Soviet Union, escapes custody, arrives in Israel under a false identity, and is arrested. The United States demands his extradition.

July

1 Dr. Soblen is deported from Israel by order of the minister of interior. He injures himself during the flight and is hospitalized in London. The Israeli public follows the saga with keen interest.

3 The Yossele Shumacher saga ends when Mossad agents discover the child in New York and return him to his parents in Israel.

Jordanian soldiers fire on I.D.F. soldiers in Jerusalem, killing two Israeli soldiers.

10 Rabbi Yehuda Leib Fishman-Maimon, a prominent religious leader and former government minister, dies at age 86.

21 Egypt launches four one-stage missiles. Nasser announces: "We can reach anywhere south of Beirut."

August

20 Israeli combat planes down two Syrian Migs in an aerial skirmish northeast of Lake Kinneret.

September

11 Dr. Soblen dies in

Ben-Gurion (c.), and Yosef Weitz (r.), a Jewish National Fund leader, plan a new settlement bloc in the Galilee.

London (see above, July 1).

The discovery that Egyptian missile production is based essentially on the work of West German scientists there causes agitation in Israel. The government weighs raising the issue with the West German government.

26 A revolution against the monarchy in Yemen splits the Arab world. Egypt supports the republican rebels and sends forces to their aid. Jordan and Saudi Arabia are for the monarchy.

27 The United States announces that it will sell Hawk antiaircraft missiles to Israel.

October

28 In a spinoff of the Yossele Shumacher affair (see May 12, 1960), Britain extradites the child's uncle, Shalom Shtarks, to Israel.

30 Itzhak Ben-Zvi is elected to a third term as president of Israel.

November

21 Settlement begins in the town of Arad in the Judean Desert.

27 Dr. Israel Bar appeals his 10-year sentence for spying. The Supreme Court hands down a judgment lengthening the sentence to 15 years.

30 Attorney General Gideon Hausner resigns over differences of opinion with the minister of justice.

December

Syria continues to attack Israeli settlements and farmers in the north.

The Eichmann appeal at the Supreme Court.

TENSION ON THE SYRIAN BORDER

While Israel's borders with Jordan and Egypt were more or less calm, the Syrians kept their border with Israel in a continuous state of tension. Early in 1962, they stepped up attacks on Israeli fishermen on Lake Kinneret and intermittently opened fire on Israeli coast guard vessels. The situation reached the boiling point in March, prompting the I.D.F. to mount a large-scale retaliatory operation aimed at the Syrian fortification at Nuqeib north of Kibbutz Ein-Gev.

The difficult battle conducted by the Golani Brigade included fighting in Syrian trenches and pill boxes. Heavy shelling by the Syrians elicited Israeli air attacks as well. Following the operation, the situation calmed down, although incidents continued to occur in the demilitarized zone southeast of the Kinneret. Israeli farmers who cultivated the lands were often attacked from the Syrian fortifications, as Syria claimed the lands used to be under her control. At the end of 1962, U.N. observers suggested a compromise, and part of the agricultural work in the region stopped.

▷ Major Zvi Ofer tends a wounded fellow soldier during the I.D.F. operation targeting the Syrian fortifications at Nuqeib, north of Ein-Gev, on the night of March 16-17, 1962.

„אמא! אמא שלי!" – זעק יוסל'ה
לאחר שעה של הסתייגות ומועקה
כתבנו בארה"ב מתאר את הפגישה הדרמטית בקומה ה-14, של בנין ההגירה

„מאמעלע! מאמעלע!' התיפח יוס'לה
בפגישה הדרמטית עם אמו ואחותו
עוד היום יוחזר הילד לרשות האם, כנראה בלי הופעה בבית המשפט
ליחסי משפחה

◁ A prolonged affair that raises a storm in Israel ends in early July 1962 when an abducted child, Yossele Shumacher, is located in New York by Mossad agents and returned to Israel. Two evening papers headline the event, although whether the child called out for his mother in Hebrew, as quoted in *Yedi'ot Aharonot* (above), or Yiddish, as in the *Ma'ariv* version (below), is unclear.

▷ On the way to a new development town, Arad. The town is founded in the Judean Desert following a hiatus of several years in the planning of new development towns. A special staff worked on siting and on infrastructure preparation, including the construction of a road linking the town to the Beersheva-Hebron road. The settlement of the Negev continues to have high national priority.

△ The Soblen affair involves the escape to Israel of Dr. Soblen, an American Jew, who was sentenced to life imprisonment in the U.S., his deportation by Israel, his suicide attempt, and his death in London.

▷ Leisure develops in Israel in the sixties. For those attending Saturday evening entertainment events, midnight trains are provided between Tel-Aviv and Haifa. After a while, the arrangement stops.

◁▽ A major devaluation of the Israeli pound (by 66.6%) in February 1962 causes large-scale shifts in the economy accompanied by the cancellation of subsidies and damage to various economic sectors. Tens of thousands of Israelis discover that loans they hold have ballooned by two-thirds overnight. Thousands take to the streets to protest the policy. Among the slogans: "Not even Hercules can carry the burden of such taxes," "Devaluation for the poor, gain for the rich."

A NEW ECONOMIC POLICY

A new economic policy announced by Minister of Finance Levi Eshkol in a special radio broadcast on February 9, 1962, centered on a major devaluation (by 66.6%) of the Israeli pound from 1.80 to 3.00 to the U.S. dollar, initiating a new economic era in Israel.

The devaluation, the first in a decade, stemmed from several factors: pressure from the International Monetary Fund, a large imbalance of imports over exports, and the failure of the alternative economic solution – subsidies and taxes.

The devaluation was accompanied by the cancellation of the country's various exchange rates and of a large proportion of export subsidies. Prices went up, while dollar-linked loans, including personal loans and mortgages, instantly soared by two-thirds. The result was palpable public discontent, with thousands taking to the streets in protest. The devaluation caused a rise in inflation and the deficit in the balance of payments increased. After some years, it was evident that the new economic policy had not brought about the desired results.

▷ The 1962 I.D.F. Independence Day parade in May drenches thousands of participants and hundreds of thousands of spectators.

△ The United States, which has limited all arms sales to Israel, decides in 1962 to supply it with Hawk antiaircraft missiles.

◁ Charles Marc, a master French vitrage artisan, assists in the installation of the Chagall windows.

△ A series of 12 windows created by Marc Chagall are installed at the Hadassah Medical Center in Ein-Kerem.

1963

January

7 Shalom Shtarks is tried for abducting his nephew, Yossele Shumacher. He is sentenced to three years in prison.

11 Labor leader Itzhak Ben-Aharon publishes an article in *Lamerhav* ("Opening Out") titled *The Courage to Change in the Face of Disaster"* – an appeal for the unification of all the Labor parties.

23 The Herut movement decides to establish its own faction in the Histadrut ("Federation of Labor").

A bribery scandal linked to the construction of a new hospital at Tel-Giborim occupies the public. Suspects include Deputy Director-General of the Ministry of Health Yehuda Shpiegel.

February

3 District Judge Moshe

The year 1962-63 is marked as "the year of the Pioneers." A stamp is issued for the 80th anniversary of the First Aliyah.

Ben-Ze'ev is named attorney-general.

11 A nationwide power failure shuts down the international airport at Lod.

14 The 32-km Beersheva-Arad road is inaugurated.

March

22 In a landmark decision, the Supreme Court instructs the ministry of interior to recognize the marriage of a Jew to a Christian, performed in Cyprus.

2 An Israeli, Yosef Ben-Gal, and an Austrian, Otto Juklik, are arrested in Switzerland on suspicion of committing hostile acts against West German scientists working in Egypt. West Germany demands their extradition.

6 The Knesset approves a government decision to set up an educational television network in Israel.

Reports are published in Israel about the involvement of West German engineers and technicians in missile production in Egypt. The Knesset calls upon West Germany to halt this activity on March 20.

25 Mossad head Isser Harel resigns over differences of opinion with the prime minister regarding the activity of the West German scientists in Egypt.

April

Work begins on the new development town of Carmi'el in the Lower Galilee.

21 The first International Book Fair opens in Jerusalem.

23 Itzhak Ben-Zvi, second president of the State of Israel, dies aged 79.

May

2 Ahdut Ha'avodah ("Unity of Labor") proposes the establishment of an alliance with Mapai ("Israel Labor Party") and Mapam ("United Workers Party").

13 Ben-Gurion and the representatives of Herut face off in a sharp confrontation in the Knesset over the question of relations with West Germany.

21 The Knesset elects Zalman Shazar, a prominent Labor movement personality, past editor of *Davar* ("A Matter"), former government minister, and chairman of the Jewish Agency, as third president of Israel.

27 The arrival of former West German defense minister Franz Josef Strauss

for a visit prompts agitated demonstrations.

Haifa University is inaugurated. Initially, it functions under the sponsorship of the Hebrew University.

June

2 Norwegian General Odd Bull replaces Swedish General Carl von Horn as chief of the U.N. truce observers in the Middle East.

12 Ben-Gal and Juklik (see March 2) are sentenced to two months in prison in Switzerland.

16 Prime Minister and Minister of Defense Ben-Gurion announces his resignation, citing personal reasons. Minister of Finance Levi Eshkol takes his place.

26 A new government, led by Eshkol, is approved by the Knesset. Eshkol presents it as a "government of continuity." He, as did Ben-Gurion, will hold the defense portfolio. Abba Eban is appointed deputy prime minister.

July

4 Nasser, in a conciliatory vein, announces that the "Palestinian problem will not be solved by war."

August

7 The Knesset passes a law establishing the Nature Reserves Authority and the National Parks Authority.

Tension mounts along the Syrian border. Each side accuses the other of responsibility for it.

19 Syrian soldiers kill two I.D.F. soldiers near the settlement of Almagor northwest of Lake Kinneret. Israel demands the convening of the U.N. Security Council.

27 Religious circles are agitated by the decision by Zim, the country's national shipping line, to operate two kitchens – kosher and non-kosher – on the Shalom, its passenger ship.

September

3 The Soviets veto a Western proposal to censure Syria for the murder of the Israeli soldiers at Almagor.

10 Demonstrations are held by religious Jews against Christian missionary activity in Israel.

The Arab League resolves to block the diversion of the Jordan waters by Israel.

19 An impressive achievement for the All-Star basketball team: it beats Yugoslavia – which holds second place in the world – by 66:45.

October

12 The League for the Abolition of Religious Coercion demonstrates against the latest demonstrations by the ultra-Orthodox.

14 The National Defense College is inaugurated.

21 Prime Minister and Minister of Defense Levi Eshkol announces the annulment of some facets of military rule in the Arab sector.

A large-scale archeological dig is begun at Massada under the direction of Prof. Yigael Yadin.

November

24 The new president, Zalman Shazar, leaves for the United States to represent Israel at President John F. Kennedy's funeral.

December

12 A decision is made at a conference of Arab chiefs of staff to jointly divert the Jordan River headwaters to prevent access by Israel.

18 Levi Eshkol announces the shortening of compulsory army service for men by four months.

21 The dispute over the kitchens on the Shalom intensifies. The Chief Rabbinate threatens to rescind kashrut ("kosher") approval for all Zim ships.

Exchange of P.O.W.s between Israel and Syria. Israeli prisoners report torture and humiliation in the Syrian prisons.

Arab threats of war against Israel grow as the national water carrier is about to begin operation.

Immigration continues to rise, originating primarily from Morocco and Romania. Over 61,000 newcomers arrive in 1963.

BEN-GURION'S RESIGNATION

Ben-Gurion resigned more often than any other Israeli politician. Knowing he was irreplaceable, he would resign whenever his mind was set on some controversial matter. Citing "personal reasons," Prime Minister David Ben-Gurion announced his resignation – this one final – in June 1963, a decision that had been known only to his closest aides. His Mapai ("Israel Labor Party") colleagues in the cabinet, informed of his decision shortly before the weekly meeting of the government, attempted to dissuade him, but his mind was made up. Apologizing for causing the resignation of the entire government by his move, he requested that his colleagues preserve the existing coalition.

Ben-Gurion's successor, Minister of Finance Levi Eshkol, formed a "government of continuity," by his own definition, within days, making only a few ministerial changes. Like Ben-Gurion, he became prime minister and defense minister.

Ben-Gurion's final resignation, at the age of 77, marked the end of an era in the history of the State of Israel.

△ Farewell to the I.D.F.: Prime Minister and Minister of Defense David Ben-Gurion salutes soldiers cited as outstanding on Independence Day, 1963. Several weeks later he resigns from his governmental offices.

▽ Eshkol with an eshkol ("cluster of grapes"). Having served as finance minister for 11 years, Levi Eshkol is chosen by his party, Mapai, to succeed Ben-Gurion as prime minister. Here, he visits an immigrant moshav whose foundation he has supported.

△ A collegial handshake. Prime Minister Levi Eshkol congratulates Ben-Gurion on his 77th birthday, a few months after the resignation of the latter. Initially good, their relationship will later deteriorate considerably.

△ The Shalom makes headlines in 1963 when the Zim navigation company plans to install two kitchens in it – kosher and non-kosher.

△ Ben-Zvi is succeeded by Zalman Shazar (Rubashov) as third president of Israel, shown here taking the oath of office in the Knesset. Shazar, a distinguished journalist, editor, poet, and orator, served as minister of education and culture in the past. To his left is Kadish Luz, speaker of the Knesset.

▽ A caricature with antisemitic overtones in 1963 in the Lebanese *al-Anwar* ("The Lights") warns that Israel will meet with a bad end on the water issue. The Arab states threaten war against Israel with the completion of Israel's national water carrier.

▷ President Itzhak Ben-Zvi dies in 1963.

▷ West German leader Franz Josef Strauss visits Israel in May 1963, encountering protest demonstrations but a cordial reception at Israel Military Industries. Uziel Gal (l.) displays his invention: the Uzi machine-gun.

△ The new development
town of Arad is dedicated
in 1963 during the 15th
anniversary celebrations of
the state. Its first residents
live in prefabricated
asbestos huts. Later, these
will be replaced by stone
buildings.

▽ Foreign Minister Golda
Meir, who has been in
office for seven years, is
highly regarded both at
home and abroad. Shown,
her meeting with President
John F. Kennedy in 1963.
Meir also invests much
effort in the relationships
with the new states in Asia
and Africa.

לבחירתך בשנת 1963

מודלים חדישים במחיר: 13.000-6.700 ל"י / מרדכי פאר

גוגומוביל 400

חזקה ומהירה למרות ממי־
דיה הקטנים. בחרים עולה
יפה ביחס לגודלה, ואינה מ־
זללנית הדלק. היושבים ק־
דימה יהנו מהנוחיות ואילו
השניים היושבים מאחור ח־
ייבים להצטופף.

פיאט 500

מודל עממי נפוץ בארץ הר־
דות לתצרוכת הדלק הנמוכה,
יכולת תמרון טובה, וארבעה
מושבים נוחים בהשוואה לנ־
פח המכונית. למרות ממדיה
הקטנים עוברת בקלות את
ה־90 ק"מש. מופיעה גם ב־
צורת סטיישן.

△ Cars are still small in the
sixties, with engines of only
400-800 c.c., as the news-
paper *Barechev* ("The
Vehicle") shows.

1964

January

1 Itzhak Rabin replaces Lieut. Gen. Zvi Zur as chief of staff.

5 Pope Paul VI arrives in Israel on a historic visit.

13 The first Arab summit, convening in Cairo, resolves

Minister of Agriculture Moshe Dayan resigns from the government.

to divert the headwaters of the Jordan River in order to preclude Israeli access to them.

19 An Egyptian pilot, Mahmud Abbas Hilmi, lands in

Israel in a Yak training plane and requests political asylum.

February

19 Deputy Director of the Ministry of Health Yehuda Shpiegel and contractor Yar'oni are sentenced to one year in prison for their involvement in the Tel-Giborim bribery scandal.

March

3 Prime Minister Levi Eshkol, a widower, marries Miriam Zelikowitz, the Knesset librarian.

17 In elections for the Chief Rabbinate, Rabbi Itzhak Nissim is reelected Sephardi Chief Rabbi and Rabbi

New Chief of Staff, Lieut. Gen. Itzhak Rabin.

Yehuda Isser Unterman, then Ashkenazi Chief Rabbi of Tel-Aviv, becomes Ashkenazi Chief Rabbi, a post that has been vacant for five years.

May

6 The first agreement between Israel and the Common Market is signed in Brussels.

June

1 Prime Minister Levi Eshkol is welcomed by President Lyndon Johnson on the first state visit by an Israeli prime minister to the United States.

2 The Palestine Liberation Organization (P.L.O.) is established at a conference in East Jerusalem. It determines that "the partition of Palestine and the establishment of the State of Israel are annulled."

3 Israel beats South Korea in soccer 2:1 and wins the Asia Cup.

10 The national water carrier is fully operational following a running-in period.

16 The Knesset passes a basic law titled The President of the State.

July

9 The remains of Zionist leader Ze'ev Jabotinsky are brought to Israel and reinterred at Mount Herzl in a state ceremony 24 years after his death.

September

11 A second Arab summit reaffirms the diversion by the Arabs of the Jordan River headwaters in order to preclude Israeli access.

October

28 Israel's national soccer team beats Yugoslavia's Olympics team 2:0 in a game played in Jaffa.

29 The development town of Carmi'el is inaugurated.

November

Mapai ("Israel Labor Party") is in a state of internal dissent over rivalry between Ben-Gurion, who continues to serve as an MK and to play an important role in the party, and Levi Eshkol; continued fallout from the Lavon Affair; and pressure by a majority to amalgamate with Ahdut Ha'avodah ("Unity of Labor").

The Syrians begin work on the diversion of the headwaters of the Jordan River to their territory.

2 The 16th World Chess Championship opens in Jerusalem.

3 A shooting incident with the Syrians develops in the Tel-Dan vicinity.

4 The crisis in Mapai deepens. Minister of Agriculture Moshe Dayan, who supports Ben-Gurion, resigns.

7 A group of Mapai activists calling themselves "From the Foundations," identified with Pinhas Lavon, leaves the party.

9 Hayim Gvati is named minister of agriculture.

13 Israel uses air power to silence heavy Syrian artillery

fire along the border.

15 The Mapai executive committee approves an alliance with Ahdut Ha'avodah ("Unity of Labor"). Ben-Gurion is opposed.

16 Employees of the Egyptian embassy in Rome unsuccessfully attempt to smuggle out an Israeli, Mordechai Luk, in a trunk, but he is apprehended by the Italian authorities and extradited to Israel on November 24th. He is accused of spying for Egypt.

December

14 Eshkol announces his resignation as a result of a dispute with Ben-Gurion related to the Lavon Affair. The government resigns as well.

22 A new government is formed by Eshkol.

23 Jordanian soldiers fire at an Israeli police escort accompanying Arab women picking olives in the Israeli enclave on Mt. Scopus, Jerusalem.

30 The 26th Zionist Congress opens in Jerusalem.

Hapo'el Ramat Gan becomes national soccer champion after Hapo'el Petah Tikvah held the championship for five years.

Just married: Miriam and Levi Eshkol.

A HISTORIC VISIT

Although by 1964, Israel, at nearly 16, was no longer awed by diplomatic visits from kings and heads of state, the visit by the Pope was different. It was perceived as an unusual event frought with centuries of convoluted historical associations.

Pope Paul VI arrived from Jordan for a brief visit – 11 hours in all. He entered Israel on January 5, 1964, at 9:45 a.m. from a border point at Megido opened especially for the occasion, where President Shazar and the entire cabinet awaited him. After reviewing an I.D.F. honor guard, the Pope toured the Christian holy sites in Nazareth, Tabha, Capernaum, and the Mount of Beatitudes. He was then taken to Jerusalem, arriving there at 7:55 p.m., and was welcomed at the entrance to the city by Mayor Ish-Shalom with the traditional loaf of bread and salt. Twenty minutes later, the Pope was at the Church of the Dormition and the Hall of the Last Supper on Mount Zion. The party arrived at the Mandelbaum Gate at 8:50 p.m., where, following a brief ceremony in the presence of President Shazar, the Pope recrossed the border into Jordan.

The brevity of the visit did not preclude awkward moments. At his farewell, for instance, the Pope defended his predecessor, Pius XII, who had been criticized for failing to act on behalf of the European Jews during the Holocaust.

△ Pope Paul VI on Mount Zion in Jerusalem, one of the stops in his 11-hour visit to Israel. He visits Nazareth, Capernaum at Lake Kinneret, and Jerusalem.

△ Carmi'el, a new town in the Galilee. Dedicated in 1964; it is the last development town to be established during the period between the founding of the state in 1948 and the Six-Day War in 1967.

THE COMPLETION OF THE NATIONAL WATER CARRIER

Completed in June 1964, the national water carrier project conveyed the waters of the north southward – to the Negev, allowing for the expansion of agriculture and industry in arid areas; to the central part of the country, where water sources were insufficient and/or saline as a result of over-exploitation; and to groundwater sources for the purpose of replenishment.

As originally planned, the water was to flow southward from the Jordan River at the Bnot Ya'akov Bridge area, but military and political factors (Syrian military activity and opposition by the United States and the U.N.) impelled the planners to change the conception in favor of pumping water from Lake Kinneret.

The carrier consisted of a series of components: water was pumped from the Sapir Site on the Kinneret into an open channel, where it flowed to the Eshkol Lakes at the Bet-Netofah basin. From there it was channeled southward into giant concrete pipes of 2.75 m (108 in) in circumference, passing at intervals through two long tunnels (the Shimron and the Menashe). The final station of the carrier was at Rosh Ha'ayin, where it linked up with the Yarkon-Negev pipeline built in the mid-1950s.

The carrier conveyed approximately 300 million cubic meters annually. Upon completion in 1964, achieved despite threats by the Arab states to disable it and to divert the Jordan River headwaters away from Israel, the carrier was viewed as one of the country's major development projects.

1 Zalmon Station
2 Netofah Channel
3 Jordan Channel
4 Shimron Tunnel

△ The national water carrier network from Lake Kinneret to Rosh Ha'ayin. Since 1964, this system conveys approximately 1 million cubic meters of water daily from the north to the center and south of the country for agricultural and industrial use and as drinking water.

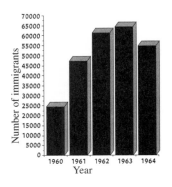

△ The national water carrier on the eve of its operation. Former prime minister David Ben-Gurion is invited to inspect the giant pipeline before it is inaugurated. To his left water specialist Aharon Weiner is explaining.

◁ Prime Minister Eshkol's younger brother, Ben-Zion Shkolnik (57, r.), receives a rare exit permit from the Soviet Union and arrives in Israel in 1964.

▽ Immigration rises again during the first half of the 1960s to about 250,000 newcomers.

▷ Mordechai Luk (2nd from l.), an Israeli spy, shown upon arriving in Egypt in 1963. He is extradited to Israel in 1964 following an abortive attempt by the Egyptian embassy in Rome to smuggle him in a trunk to Cairo.

◁ Prime Minister Levi Eshkol and his wife, Miriam, during the prime minister's official visit to the United States in June 1964.

◁ A surprise landing in Israel is made by an Egyptian pilot seeking political asylum, Mahmud Abbas Hilmi, in January 1964. Air force personnel and journalists are shown examining the Czechoslovakian Yak training plane that he flew.

▽ Two new Chief Rabbis are elected in March 1964: Rabbi Yehuda Isser Unterman (Ashkenazi, l.) – the Ashkenazi Chief Rabbi of Tel-Aviv – and Rabbi Itzhak Nissim (Sephardi).

1965

January

3 A Fatah band attempts to sabotage the national water carrier.

5 Ben-Gurion again demands a judicial investigation of the Lavon Affair, declaring that he "will not rest until justice is done."

February

4 The Ahdut Ha'avodah ("Unity of Labor") executive approves the proposal for an alignment with Mapai ("Israel Labor Party").

16 The 10th Mapai Conference opens under the cloud of the internal crisis over the Lavon Affair and its aftermath. It approves the establishment of the Alignment ("Ma'arakh") on February 19.

28 Fatah attacks Kfar Hess in the Sharon region.

March

3 Incidents occur both in the north and the south. I.D.F. artillery silences Syrian guns pounding the Israelis on the northern border. Israel Air Force planes eject Egyptian Migs from Negev airspace.

6 The Arab world is agitated by an appeal by Tunisian President Habib Bourguiba to solve the "Palestine problem" through coexistence with Israel.

7 The Liberal Party splits; opponents of unification with the Herut movement establish the Independent Liberal Party.

The West German government announces that it is ready to establish diplomatic relations with Israel. The Arab states are outraged.

14 Israel announces that it is willing to establish diplomatic relations with West Germany.

16 The Knesset approves the government's decision about the establishment of

relations with West Germany. A proposal by Herut to hold a referendum on the issue is defeated.

17 In a major incident on the Syrian border, Israeli tanks destroy Syrian equipment being used to divert the Jordan headwaters.

18 Justice Shim'on Agranat succeeds retiring Justice Itzhak Olshan as president of the Supreme Court.

April

5 An atomic molecular accelerator is inaugurated in the Weizmann Institute.

11 Esther, the first Israeli-constructed ship in Haifa, is delivered to the Zim company.

18 The first Hawk missiles are delivered to Israel by the United States.

20 The Shrine of the Book, housing the Dead Sea Scrolls, is dedicated in Jerusalem.

26 A new political bloc – the Herut-Liberal Bloc (Gahal) – is formed with 27 members of Knesset.

May

5 Israel wins the soccer Youth Asia Cup.

11 The Israel Museum in Jerusalem opens.

12 A political storm is raised by Ben-Gurion when he declares that Levi Eshkol "is unfit to serve as prime minister." Tension in Mapai intensifies between a majority around Eshkol and a minority led by Ben-Gurion.

13 Israeli tanks again destroy Syrian water-diversion equipment.

18 Eli Cohen, condemned by the Syrians for spying for Israel, is executed publicly in Damascus by hanging.

19 Mapai ("Israel Labor Party") and Ahdut Ha'avodah ("Unity of Labor") sign an agreement forming the Alignment.

20 Minister of Housing and Development Yosef Almogi and Deputy Minister of Defense Shim'on Peres, leaders of the minority in Mapai who oppose amalgamation with Ahdut Ha'avodah, announce their resignation from government office.

25 An Arab summit in Cairo

works out plans for the diversion of the Jordan headwaters.

27 The I.D.F. raids Fatah bases in Jordan in the wake of a series of terrorist incidents in Israeli territory.

31 Jordanian soldiers open fire in Jerusalem, killing two Israelis and wounding four.

June

3 The crisis in Mapai ("Israel Labor Party") deepens. The party executive elects Eshkol as its candidate for prime minister after the forthcoming elections, rejecting a minority demand to convene a party convention.

8 The Israel Broadcasting Authority is established.

13 Prof. Martin Buber dies aged 87.

29 Mapai splits. Ben-Gurion announces the formation of a new party.

July

7 Moshe Sharett, former prime minister and foreign minister, dies aged 70.

12 The Mapai executive decides to expel all party members who join Ben-Gurion.

21 The Knesset passes the Law of Libel.

22 The Mapai rebels hold a founding convention of Rafi (Reshimat Po'alei Israel – "Israel Labor List").

August

2 Maki, the Israel Communist Party, splits. A rebel faction forms Rakah (Reshimah Komunistit Hadashah – "New Communist List").

12 Heavy Syrian equipment for water diversion is destroyed in another large-scale incident at the northern border.

19 West Germany's first ambassador, Dr. Rolf Pauls, presents his credentials to President Shazar while large-scale protest demonstrations take place.

24 Israel's first ambassador in Bonn, Asher Ben-Natan, presents his credentials.

September

5 The I.D.F. raids waterworks in the Qalqilya area in response to terrorist activity emanating from Jordan.

Moshe Dayan joins Rafi after a period of indecision.

10 Mordechai Luk, the "spy in the trunk," (see 11–16. 1964) is sentenced to 13 years in prison.

19 Elections for the Histadrut ("Federation of Labor") Convention result in the Alignment narrowly preserving its majority – approximately 51% of the seats, Gahal obtaining 15%, Mapam ("United Workers Party") 14.5%, and Rafi 12%.

October

28-29 The I.D.F. raids two Lebanese villages in response to Fatah activity emanating from there.

Due to frequent labour disputes, the operation of the new Ashdod port faces difficulties.

November

2 Elections for the Sixth Knesset are held. Eshkol and the Alignment emerge as winners with 45 seats. Rafi, led by Ben-Gurion, is disappointed with its 10 seats. Gahal ("Herut-Liberal Bloc") obtains 26 seats, the National Religious Party, 11.

16 Israeli press strike in protest against the Law of Libel.

21 The Ashdod port is inaugurated. The first ship to anchor there is Wingland, a Swedish vessel.

30 Teddy Kollek is the newly elected mayor of Jerusalem.

December

10 The ultra-Orthodox demonstrate in Ashdod due to the operation of the port on the Sabbath.

Prime Minister Eshkol's illness delays the formation of a new government.

By the end of 1965, the population in Israel reaches 2.6 million – 2.3 million Jews, and 300,000 non-Jews. Immigration is at a low ebb.

◁ Fatah initiates terrorist operations against Israel in 1965, primarily in the border areas but also in Israel's hinterland. Here, the home of Miriam and David Zalmonovitz has been blown up in an incident at Moshav Giv'at Yesha'yahu on October 17, 1965, near the Jordanian border.

▽ The I.D.F. attacks a series of targets in Jordanian territory in May 1965: Jenin and Qalqilya, west of the Jordan River, and a target near Shuna, east of the Jordan, which is used as a Fatah base. On the night of October 27-28, it raids the home of the mukhtar ("headman") of Kafr Huleh in southern Lebanon, as well as nearby waterworks, in response to terrorist acts. Shown are I.D.F. soldiers returning from the Lebanese operation.

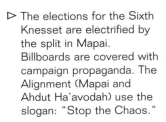

THE SPLIT IN MAPAI

Mapai, the Israel Labor Party, the country's largest party for a period of 35 years, split in 1965, a move headed by the country's, and the party's, veteran leader David Ben-Gurion.

Ben-Gurion resigned from his office as prime minister in mid-1963, announcing his intention to withdraw from public and political activity. But he did not do so. He demanded that the Lavon Affair be reinvestigated by a judicial committee of inquiry, while questioning several of the steps taken by the Eshkol government and going so far as to question Eshkol's suitability as prime minister.

The situation led to a confrontation at the 10th Mapai Convention between the majority within the party, which sided with Eshkol, and the minority, which sided with Ben-Gurion. The crisis deepened further when Ben-Gurion loyalists Dayan, Peres, and Almogi resigned from the Eshkol government. An additional cause of tension between the camps was Eshkol's rapprochement with Ahdut Ha'avodah and the formation of an alignment between the two parties in anticipation of the elections to the Sixth Knesset.

In June 1965, Ben-Gurion announced the establishment of a new party, the Israel Labor List (Rafi), joined by most of the "young" Mapai faction, including Peres and Dayan. Mapai, for its part, ejected the rebels from its ranks. In the Knesset elections on November 2, 1965, marking the climax of the Ben-Gurion-Eshkol power struggle, Eshkol emerged as the victor. His party, the Alignment, won 45 seats in the Knesset, while Rafi obtained only 10.

△ Former prime minister Moshe Sharett attends the 10th Mapai Convention in a wheelchair. He will pass away a few months later.

△ The opening session of the Sixth Knesset is inaugurated, by tradition, by its most senior member, in this case MK David Ben-Gurion, now a member of the opposition.

▷ The elections for the Sixth Knesset are electrified by the split in Mapai. Billboards are covered with campaign propaganda. The Alignment (Mapai and Ahdut Ha'avodah) use the slogan: "Stop the Chaos."

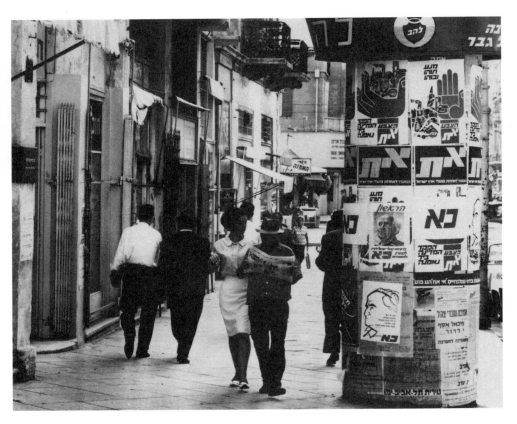

▷ Eli Cohen, condemned to death by the Syrians for spying for Israel, is publicly executed in Damascus by hanging in May 1965. Cohen, 40, assumed the identity of a prominent Syrian, befriended high-ranking government officials and army officers, and acquired important information from them.

THE JERUSALEM POST

WEDNESDAY, MAY 19, 1965 • 17 Iyar, 5725 • 18 Muharam, 1385

ISRAEL'S FAVOURED CIGAR! Bouquet

Syria hangs Eli Cohen in public square, as spy

Sense of shock and outrage in Jerusalem

ISRAELI DENIED DEFENCE

DAMASCUS (Reuter). — Eli Cohen, convicted of heading an Israeli spy ring in Syria, was executed by public hanging before dawn yesterday.

He was the first Israeli citizen to be executed in Syria.

The Foreign Ministry in Jerusalem yesterday expressed "shock and outrage at the fact that an Israeli citizen has been executed in Syria after a travesty of a trial, without any opportunity for legal defence, in defiance of the most elementary precepts of justice and in spite of the appeals by scores of personalities and organisations in enlightened countries asking the Syrian authorities to abide by the customary rules of justice and clemency."

The Ministry's state-

The execution was attended by Lt.-Col. Salah al-Dilli, head of the special military court which sentenced Cohen to death on May 8, members of the court, newsmen and Rabbi Nissim Andeu, religious head of the Jewish community in Syria.

Earlier Cohen was driven in a heavily guarded military car from the Mazza prison down to police headquarters in the very heart of the city. The nearby Marja Square (Martyrs' Square) looked like a battlefield with red-capped military police and troops throwing two parallel cordons around the

sentenced to death in the name of the Arab people in Syria after being found guilty of entering a military place in disguise and of obtaining classified information and passing it to an enemy.

Cohen, who was 40, was arrested early this year. His trial began in February and lasted 40 days.

He came to Syria by way of Beirut in 1962, carrying the passport of a Lebanese emigrant in Argentina and assuming the name of Kamel Amin Thabet.

PRAISED BY FRIENDS

Eli Cohen's friends yesterday highly praised his personality.

The last minutes of Eli Cohen, 40, shown during three moments of his hanging in public in Damascus yesterday. (AP radiophoto)

◁ Eli Cohen operates in Syria for three years. The information he passes on to Israel was to be of great value during the Six-Day War, according to foreign sources.

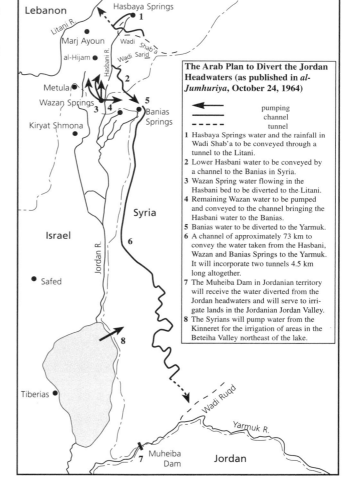

The Arab Plan to Divert the Jordan Headwaters (as published in *al-Jumhuriya*, October 24, 1964)

◀──────── pumping
─────────── channel
- - - - - - - tunnel

1 Hasbaya Springs water and the rainfall in Wadi Shab'a to be conveyed through a tunnel to the Litani.
2 Lower Hasbani water to be conveyed by a channel to the Banias in Syria.
3 Wazan Spring water flowing in the Hasbani bed to be diverted to the Litani.
4 Remaining Wazan water to be pumped and conveyed to the channel bringing the Hasbani water to the Banias.
5 Banias water to be diverted to the Yarmuk.
6 A channel of approximately 73 km to convey the water taken from the Hasbani, Wazan and Banias Springs to the Yarmuk. It will incorporate two tunnels 4.5 km long altogether.
7 The Muheiba Dam in Jordanian territory will receive the water diverted from the Jordan headwaters and will serve to irrigate lands in the Jordanian Jordan Valley.
8 The Syrians will pump water from the Kinneret for the irrigation of areas in the Beteiha Valley northeast of the lake.

THE BATTLE FOR WATER

The Arab states attempted, during the first half of the 1960s, to prevent Israel from conveying water from the Jordan River headwaters southward in the national water carrier. In the summer of 1964, before the national water carrier was in operation, Syria had called for military intervention against it. But the other Arab countries chose a more moderate solution. Led by Egypt, the Arabs resolved to implement this effort by diverting the Jordan headwaters via the Golan Heights to the Jordan Valley in Jordanian territory.

The "battle for water" began in earnest in late 1964, continued through 1965, and came to an end in mid-1966. The Syrians, using heavy earth-moving equipment, cleared terrain for a channel in the Golan Heights of some 40 km in length to convey the diverted water. Israel intervened intermittently, destroying the equipment by tank gunfire and by air attacks. As a result, the Syrians managed to excavate only some 1500 meters of the channel during a period of about a year and a half. On July 14, 1966, an accord ending the Syrian diversion project was signed.

The extent of Syria's work on the project in the Golan Heights was observable close up in the wake of the Six-Day War of 1967.

△ The plan for the diversion of the Jordan headwaters, taking away water vital to Israel, occupies the Arab world for several years. Work on this project goes on in Lebanon, Syria, and Jordan until it is stopped primarily by I.D.F. operations that damage the diversion equipment. The battle for water waged in the northern part of the country during the mid-1960s appears to be heading to the point of full-scale warfare.

▽ The movie *Cast a Giant Shadow*, about the life of David Marcus, is filmed in Israel in 1965. The cast includes Kirk Douglas (l.) and Yul Brynner (r.).

▷ The first German ambassador in Israel, Dr. Rolf Pauls, is greeted by highly charged demonstrations. The sign reads: "Six million times – no!"

◁ The archeological excavations at Massada, conducted in the winters of 1963-64 and 1964-65, led by Prof. Yigael Yadin, continue to reveal important findings. Shown, reconstructed storage rooms of the Herodian period.

▽ After the failed attempt of *Yedi'ot Aharonot* ("Latest News") to publish a satirical supplement, writers Dan Ben-Amotz, Hayim Hefer, Shim'on Zabar, and Amos Keinan publish their own weekly in February 1965. Its first issue foresees Israel unifying the two Germanies.

1966

January

12 Levi Eshkol forms a new government. Changes include the cooption into the coalition of Mapam ("United Workers Party"), and the replacement of Golda Meir by Abba Eban as foreign minister. The Knesset approves the new government by 71 to 41.
18 Louis (Arieh) Pincus is elected chairman of the Jewish Agency, succeeding the deceased Moshe Sharett.
30 American writer and Nobel Prize winner for Literature John Steinbeck is a guest in Israel. Among other places, he visits the American Colony – a neighborhood near Jaffa (today in Tel-Aviv) where his ancestors lived in the 19th century.

February

2 Golda Meir is elected secretary-general of Mapai ("Israel Labor Party").
4 A large fire destroys the Zim navigation company building in Tel-Aviv.
4-13 Ashdod port is closed in the wake of a strike by the port workers.
28 Tel-Aviv restaurateur Abie Natan pilots a light plane to Egypt on a one-man mission for peace. An erroneous report indicates that his plane has exploded.

March

1 Abie Natan is barred from entry into Egypt.
24 The Educational Television Service begins T.V. broadcasts in Israel.

Incidents along the Syrian border heighten tension in

In November 1966, the I.D.F. launches a retaliatory operation in Samu'a, Jordan.

the region.

April

16 Coca-Cola will become available in Israel, the giant American company announces. The Arab boycott will not deter it from opening a bottling operation in Israel, says Coca-Cola.
21 In an unusual move, Soviet writer Konstantine Simonov visits Israel.
25 Israel celebrates its 18th Independence Day. The military parade in Haifa takes place in a hot hamsin wind. For the first time, American Patton tanks are on display.
26 Maj. Gen. Ezer Weizman is named chief of operations at G.H.Q. after serving as Air Force commander for eight years. The new Air Force commander is Mordechai Hod.
29 The I.D.F. raids two villages and two police stations in Jordan in the wake of Fatah terrorist acts in Israeli territory.

May

1 The first signs of a recession are in evidence. Unemployed workers clash with police in Ashdod.
2 A prominent and controversial guest, former chancellor of West Germany Konrad Adenauer, arrives in Israel. He meets with the political leadership, evoking protest demonstrations.
10 A violent incident in the northeastern Negev involving Jordanian soldiers causes two I.D.F. fatalities.
16 Two Jewish National Fund workers are killed when their vehicle triggers a mine near Moshav Almagor north of Lake Kinneret.
18 Prime Minister Eshkol declares that Israel has no nuclear arms and will not be the first to introduce them into the Middle East.
19 Israel is about to obtain Skyhawk fighter planes from the United States.

June

Prime Minister Levi Eshkol leaves for state visits to seven countries in Africa. President Shazar visits three states in South America.
28 MK Menahem Begin announces at the Herut movement convention that he will not present his candidacy for chairman of the movement.
30 A storm erupts in the Herut party when it becomes known that there have been furtive attempts to establish a new leadership without MK Begin.

July

4 The Kennedy Memorial is unveiled in the Jerusalem hills on the occasion of American Independence Day.
13 A series of incidents carried out both by the Syrians and Fatah terrorists heightens tension along the northern borders.
14 In a major incident at the northern border, the I.D.F. destroys Syrian water-diversion equipment and Israeli planes down a Syrian Mig 21. The Syrians end work on the diversion project.

August

2 President Shazar visits the White House in Washington at the invitation of President Johnson.
4 Israel signs an agreement with the American C.B.S. television company for the planning of a general T.V. broadcasting service in Israel.
8 In a prisoner exchange with Syria, four Israelis imprisoned there for years are returned.
15 A major incident develops at Lake Kinneret when the Syrians block the rescue of an Israeli Border Police vessel that has run aground off the Syrian shore. A Syrian plane is downed in an aerial fight and a second one is shot down by gunfire from the ship.
16 An Iraqi fighter pilot, Munin Rufa, lands a Mig 21 in Israel and requests asylum, creating an international sensation.
30 The new Knesset building in Jerusalem is inaugurated. Guests include dozens of foreign heads of parliament as well as leading Jewish personalities from around the world.

Pressure in Israel and abroad is heightened for the emigration of Soviet Jewry.

September

11 The government approves a deflationary economic policy.
22 The U.S.S.R. cancels a planned tour of the Israel Philharmonic Orchestra on account of the "anti-Soviet campaign" taking place in Israel.

Incidents initiated by Syria along the northern border increase. Fatah terrorists infiltrate from Jordan and attack targets at the Dead Sea.

The crisis in the Herut leadership deepens.

The new Knesset building in Jerusalem is inaugurated in August 1966.

Ben-Gurion, his wife Paula, and Shimon Peres (far right) at Ben-Gurion's 80th birthday celebration in Sdeh Boker.

△ Fatah terrorist incidents increase in the second half of 1966. In the picture, an apartment building in the Romema neighborhood in north Jerusalem close to the Jordanian border is sabotaged in October.

▽ The wing of a Syrian fighter plane is extracted from Lake Kinneret in August 1966. The Syrians, attempting to block the rescue of an Israeli vessel that ran aground off the Syrian shore of the lake, lose two planes in the incident that unfolds.

October

2 Thousands of well-wishers arrive at Kibbutz Sdeh Boker in the Negev to congratulate Ben-Gurion on his 80th birthday.
8 Two apartment buildings in the Romema neighborhood of Jerusalem are sabotaged by terrorists who infiltrate from Jordan, injuring five residents.
9 In a serious incident in the north, four border policemen are killed when their jeep triggers a road mine near Kibbutz Sha'ar Hagolan. Israel submits a protest against Syria to the U.N. Security Council. It is defeated by a Soviet veto.
19 A border policeman is killed in an incident at Moshav Dishon in the Galilee. Three terrorists are killed.
27 A freight train triggers a mine near the village of Battir on the Jerusalem line, wounding a railroad worker.

The economic recession is reflected in depressed retail trade.

November

8 Prime Minister and Minister of Defense Eshkol makes two major announcements in the Knesset: The reduction of compulsory military service for men to 26 months is annulled and will revert back to 30 months; and military rule in the Arab sector of Israel will be abolished.
12 An I.D.F. command car runs over a mine in the southern Hebron hills region, killing three soldiers and wounding six.

13 A large-scale I.D.F. retaliatory operation at Samu'a and the vicinity in the southern Hebron hills results in heavy Jordanian losses. The I.D.F. has one fatality. The operation engenders unrest and demonstrations against King Hussein in Jordan's cities.
26 The U.N. Security Council censures Israel for the Samu'a operation.
28 A countrywide university students' strike over a rise in tuition continues until December 7.

Israeli Mirages down two Egyptian Migs 19 that penetrate into Israeli airspace over the Negev.

December

10 The Nobel Prize for Literature is awarded jointly to Israeli author S.Y. Agnon and Jewish author Nelly Sachs, a resident of Sweden.
20 Israel defeats Thailand in the basketball finals in the Asia Games held in Bangkok.

Immigration to Israel is at a low ebb. Only 15,700 newcomers arrive in 1966, the lowest figure since 1953.

GROWING TERRORISM AND TENSION ALONG THE BORDERS

The Eshkol government, which followed a policy of military restraint, was forced to deviate from this line in 1966 in light of heightened tension along the Syrian and Jordanian borders.

The threat emanated both from Syria, which mounted attacks against Israel, and Fatah terrorists who infiltrated from Jordan and Lebanon with increasing frequency. Israel retaliated in Jordanian and Lebanese territory, but not only did the terrorist acts continue, they intensified toward the end of the year, eliciting criticism in Israel that the government was not doing enough to prevent them. Prime Minister and Minister of Defense Eshkol's assurance that "the ledger is open and the hand records [such incidents]" was perceived as unconvincing. Even after Israel mounted a large-scale retaliatory operation against the Jordanians at village Samu'a south of Hebron, terrorist activity continued.

▽ The state of security along the border worsens in the fall of 1966. A grave terrorist incident in October takes the lives of four border policemen when their vehicle sets off a road mine near Kibbutz Sha'ar Hagolan southeast of Lake Kinneret.

◁ In the wake of a series of terrorist acts targeting both Israeli soldiers and civilians, Minister of Defense Levi Eshkol abandons his policy of restraint and orders a large-scale retaliatory operation in Jordan against the village Samu'a in the southern Hebron hills area (shown), whose residents have aided, or have not prevented, Fatah terrorism. The operation prompts demonstrations against the regime in Jordan.

▽ Spoils of the Samu'a raid: a Jordanian Land-Rover.

△ An Iraqi pilot, Munir Rufa, seeking asylum, lands a Mig 21 in Israel in August, 1966. The event arouses attention internationally.

◁ Former chancellor of West Germany (1949-63) Konrad Adenauer (l.), one of the architects of the reparations agreement with Israel, arrives in the country for a visit in May and meets with the political leadership. Like every visitor from Germany so far, he encounters angry demonstrations aimed at him and his country. He is shown receiving an honorary doctorate from the Weizmann Institute of Science. At right, Institute President Meir Weisgal.

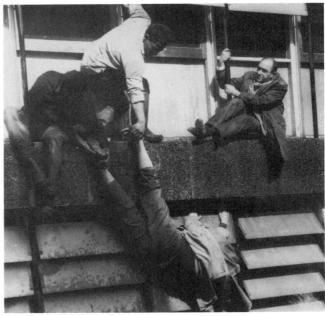

△ The Zim navigation company building on Rothschild Boulevard in Tel-Aviv goes up in flames in February 1966. Complex rescue efforts require the use of helicopters.

◁ Restaurateur Abie Natan creates a drama in 1966 by flying to Egypt with a light plane on a private peace mission. The two headlines in *Ma'ariv* ("Evening Paper") from February 28 and March 1 tell the story of how at first he had been thought to be dead, and how he returned the next day.

△ Educational television broadcasting begins on March 24, 1966. Johanna Frenner conducts a class on T.V., transmitted to the first schools to acquire T.V. sets.

▽ Although T.V. programs from neighboring countries have been received on sets in Israel before 1966, only now does Hebrew appear on the screen.

THE RECESSION

Following years of intensive infrastructure investment, a growing trade deficit, and regular wage increases, Israel's economic planners switched gears in early 1966 and implemented a policy of economic restraint, namely a reduction in government spending, the exposure of domestic manufacture to competition by foreign imports in order to increase efficiency and production, the abolition of subsidies, and the dampening of consumer demand. These steps, the planners thought, would heal the illnesses of the Israeli economy and decrease the deficit in the foreign trade balance.

The policy at first elicited support from the public, with various sectors even announcing wage cuts. This situation, however, soon reversed itself. Reduced government spending resulted in a drastic drop in public construction, and thousands of workers in this and related industries found themselves out of work. Disposable income fell, manufacturing slowed, and the growth in imports led to the closure of local industries.

By the final quarter of 1966, the government, realizing that its policy had succeeded only too well, began reviving construction and development projects. The public mood, however, was distrustful. Emigration increased and immigration was at a low. The recession, and the dejected public mood that it created, was, psychologically, the most difficult crisis the state had faced since its founding. This was reflected in a bitter joke: "Let the last emigrant switch off the light at Lod Airport."

The deflation, although well-intentioned, produced negative results. It persisted into 1967, ending only with the Six-Day War of 1967 and the euphoria that followed.

▷ Reports filtering in from Stockholm in mid-October 1966 indicate that Israeli author S. Y. Agnon, 78, will receive the Nobel Prize for Literature, evoking great excitement in the country. Agnon is shown responding to the hundreds of well-wishers who congratulate him when the news is confirmed.

1967

January

Tank battles with the Syrians take place intermittently during the month on the northern border.

10 Israel submits a complaint over Syrian aggression to the U.N. Security Council.

14 A mine laid by terrorists explodes during a soccer game at Moshav Dishon in the Galilee, resulting in one fatality and two wounded.

15 The Syrians fire at an Israeli Border Police vessel on Lake Kinneret.

A Saudi ship opens fire at an Israeli ship in the Gulf of Eilat.

24 A bank scandal erupts when the managements of the Feuchtwanger Bank and the Elran Bank are taken over by the Bank of Israel due to irregularities.

25 The Israeli ship Hashloshah sinks west of Italy. Twenty of its crew drown.

February

5 The recession deepens and unemployment grows. The government initiates the payment of unemployment compensation.

6 The government founds a coordinating body for the establishment of general television, directed by Maj. Gen. (Res.) El'ad Peled.

15 The Herut faction in the Knesset suspends three of its MKs, led by Shmuel Tamir, for a period of a year, for rebelling against the party leadership under Menahem Begin.

March

14 A highly charged demonstration in Jerusalem by the ulta-Orthodox against permitting autopsies results in the injury of 30 demonstrators and policemen, including the chief of police of Jerusalem.

During a demonstration in Tel-Aviv, the unemployed also clash with the police. Unemployment reaches approximately 100,000 nationally.

21 MK Shmuel Tamir and his colleagues establish a new party, the Free Center, with three MKs.

Arab terrorist acts increase both in the border regions and the hinterland.

"Literary" guests reach Israel in the course of the month: Jean-Paul Sartre and Simone de Beauvoir from France, and Günter Grass from West Germany.

April

7 Israeli combat planes bring down six Syrian Migs 21 in an aerial fight in the north. The Syrians respond by bombing Israeli settlements along the border.

26 The U.S.S.R. warns Israel that its policy toward its Arab neighbors is "perilous" and that, should it act against them, it will do so "at its own risk."

27 Israel's youth soccer team wins the Asia Cup for the fourth time consecutively, beating Indonesia in the finals, 3:0.

May

An all-out confrontation with Syria is anticipated in Israel in light of Syrian provocations along the entire border and terrorist penetration into Israeli territory.

12 Oded Kotler wins the Best Actor Award in the Cannes Film Festival for his leading role in the Israeli film: *Three Days and a Child*.

15 A military parade is held in Jerusalem marking Israel's 19th Independence Day.

The Egyptians begin to deploy large military forces in the Sinai Peninsula.

A song is born – *Jerusalem of Gold*, by Naomi Shemer, performed for the first time on Independence Day. It soon becomes a kind of national anthem.

16 The security situation in the Sinai and along Israel's borders grows more threatening. The pre-Six-Day War waiting period begins in an atmosphere dominated by Egyptian threats to attack Israel and the evacuation of the U.N. forces, at Egypt's demand, from the Gaza Strip and the Sinai (see box).

22 Egypt blocks the Straits of Tiran to Israeli navigation.

Israel makes diplomatic efforts to persuade the great powers to end Egypt's blockade in the Gulf of Eilat.

Heavy pressure is put on Eshkol during the final week of the month to widen the base of the government in light of the state of emergency and to yield the defense portfolio.

28 Eshkol announces in a speech over the radio that the Egyptian blockade constitutes an act of aggression against Israel. The speech, delivered in a hesitant manner, has the effect of heightening the public's apprehension.

June

1 A national unity government is formed, joined by Gahal ("Herut-Liberal Bloc") and Rafi ("Israel Labor List").

Entertainment does not stop. The Nahal ("Fighting Pioneer Youth Corps") Troupe performs in Rafah on June 6, 1967.

Moshe Dayan becomes minister of defense; Menahem Begin and Yosef Sapir are named ministers without portfolio.

5-10 The Six-Day War breaks out. The Israel Air Force attacks Egyptian, Jordanian, Iraqi, and Syrian airfields and destroys most of their aircraft within hours. Thereafter, Israeli Ground Forces achieve victories on all fronts. In the wake of the war, all the Eastern European countries (with the exception of Romania), led by the U.S.S.R., break off diplomatic relations with Israel.

12 The I.D.F. announce that they have lost 679 soldiers in the war. Israel estimates that Egyptian losses are about 10,000. Over 5,000 Egyptian P.O.W.s are held by Israel.

14 (The Shavu'ot holiday) Hundreds of thousands of Israelis arrive at the Western Wall in Jerusalem, which has become accessible to Jews for the first time since 1948.

17 A special session of the U.N. General Assembly opens to discuss the Middle East crisis. The Soviets demand that Israel withdraw from all territory that it conquered and pay compensation to the Arab states.

19 President Lyndon Johnson outlines a five-point peace plan for the Middle East. It does not include Israeli withdrawal.

21 President Charles de Gaulle censures Israel for embarking in the Six-Day War.

27 In a P.O.W. exchange with Jordan, Israel exchanges 428 Jordanian soldiers for two Israeli pilots held by Iraq.

The Knesset passes a law which allows the annexation of territories in Eretz Israel to the State of Israel. First to be annexed is East Jerusalem.

28 The government declares East Jerusalem to be within the municipal boundaries of Jerusalem.

29 Minister of Defense Moshe Dayan declares: "Israel will hold onto the territories until peace agreements are signed."

May

15 Israel marks its 19th Independence Day with a military parade in Jerusalem. Egypt deploys military forces in Sinai.

16 The Egyptians demand the withdrawal of the U.N. Emergency Force in Sinai from the border. Israel declares a state of alert.

17 U.N. Secretary-General U Thant refuses to accede to Egypt's demand, responding that the U.N. force will either remain where it is or evacuate entirely. A state of alert is declared in Jordan, Syria, and Iraq. The I.D.F. calls up reserve units.

19 The U.N. force evacuates from Sinai and the Gaza Strip by order of U Thant. The Egyptians occupy the U.N. stations.

19-20 Israel expands its reserves call-up.

20 An Egyptian paratroop battalion takes control of Sharm al-Sheikh and the Straits of Tiran.
U Thant announces in New York: the situation in the Middle East has not been this dangerous since 1956.

21 Egypt announces the call-up of its reserves. The Jordanian chief of staff visits Cairo to coordinate Arab military moves.

22 Nasser, visiting Sinai, announces that the Straits of Tiran are closed to Israeli navigation: "If the Israelis want war – ahlan-

usahlan [welcome]."
Israel fortifies its combat units in the Negev.

23 Israel reacts to the closure of the straits by ordering the I.D.F. to stand by in a state of readiness. U Thant leaves for a visit to Cairo.

24 Foreign Minister Abba Eban embarks on a series of visits to Western capitals. Egypt reinforces its troops in the Sinai. Intensive diplomatic activity is conducted in foreign capitals and in the U.N. Eban meets with President de Gaulle. The Jordanian army reinforces its troops in the Jordan Valley. Efforts are made in Israel to broaden the base of the government.

25 U Thant fails in his mediation effort in Egypt. Eban meets with Secretary of State Dean Rusk in Washington. Egypt's minister of war visits Moscow. The Mapai leadership is unwilling to broaden the base of the government at the present stage.

26 Nasser warns that should war erupt, Egypt will destroy Israel. Internal pressure heightens in Israel to form a national unity government. Eban meets with President Johnson.

27 The United States calls for restraint by Israel so that a political process can be implemented to open the Straits of Tiran.
Eban returns to Israel. In a cabinet meeting, nine ministers,

including Eban, are for the political process. Nine ministers, including Eshkol, are for an immediate reaction against Egypt's aggression.

28 The Israeli government yields to American pressure and refrains from taking military action. Eshkol delivers an equivocal speech to the nation on the radio, which elicits widespread consternation and frustration. Senior army officers demand that the government issue them the order to act.

29 Nasser continues to threaten Israel. Eshkol tells the Knesset that Israel will test international commitments to the protection of its sovereign rights. The I.D.F. is in a state of alert. The Soviet Union warns Israel against "a military adventure."

30 King Hussein arrives in Cairo and signs a joint defense pact with Egypt. Intensive international diplomatic activity to solve the crisis proves unsuccessful. Internal pressure rises in Israel, including within Mapai, for the formation of a national unity government.

31 Eshkol offers the defense portfolio to Yigal Allon. Dayan is proposed as commander of the southern front. Pro-Israel demonstrations are held in Western capitals.

June

1 An Egyptian general arrives in Amman and is handed the command of the Jordanian army. In Israel, domestic debate over the formation of a national unity government reaches a peak. Eshkol coopts Dayan into the government as minister of defense, leading to the formation of a national unity government. A sense of relief is palpable in the country. The United States reports that it does not intend forming an international naval force to break the Tiran blockade.

2 President de Gaulle warns against the use of force in the Middle East crisis. The Egyptian army completes its combat deployment in the Sinai.

3 Egyptian forces are airlifted to Jordan.

4 Iraq joins the Egyptian-Jordanian military pact. Iraqi forces are deployed in Jordan. The Israeli government approves an I.D.F. operation against the Egyptian army scheduled for June 5.

5 The Six-Day War begins.

July

1-2 The first of a series of incidents occurs at the Suez Canal front when the Egyptians attempt to take control of the northern section of the eastern bank. An I.D.F. unit thwarts them.
8 Another incident at the Suez Canal ends with five I.D.F. soldiers killed and three wounded.
11 Israeli navy vessels sink two Egyptian torpedo boats in a sea battle in the Rumani region southeast of Port Sa'id.
17 Israel exchanges 591 Syrian P.O.W.s for two Israelis held by Syria.

August

7 A protest strike of commerce and services is called in East Jerusalem.

September

1 The Arab summit in Khartoum, Sudan, publishes three "no's" regarding the recent war and its aftermath: no recognition of Israel, no negotiations with Israel, and no peace with Israel.
27 The return begins to Kibbutz Kfar Etzion in the Hebron hills, established in 1943 and captured and destroyed by the Jordanians in 1948.
A series of skirmishes break out along the Suez Canal during the month between the I.D.F. and Egyptian army units.

October

3 Nahal ("Fighting Pioneer Youth Corps") founds the first settlement in the Sinai: Nahal Yam.
The results of a census conducted in the territories occupied by Israel show that

approximately 1 million Arabs live there.
21 An Israeli destroyer, the Eilat, is sunk by Egyptian missiles opposite Port Sa'id, with 47 dead and missing and approximately 100 wounded.
24 The I.D.F. attacks and destroys the Egyptian oil refineries at Suez.
France holds up the delivery of additional Mirage aircraft on order by Israel.
29 Mapai approves the proposal to amalgamate with Ahdut Ha'avodah and Rafi.
30 Chief of Staff Itzhak Rabin awards 51 military citations to heroes of the Six-Day War.
31 The Greater Land of Israel movement is established, with members from all points on the political spectrum.

November

19 The Israeli pound is

devalued from IL 3.00 to IL 3.50 to the dollar.
22 The U.N. Security Council adopts Resolution 242, calling for peace with secure and recognized borders in the Middle East and withdrawal from territories occupied in the Six-Day War. Swedish diplomat Gunnar Jarring is appointed special U.N. representative to mediate between the parties in the Middle East.
26 Bus line N. 9 in Jerusalem renews its route to Mount Scopus after a 19-year hiatus.
27 De Gaulle, irritated by French Jewish support for Israel, calls the Jewish people "elitist, self-confident and domineering."

December

8 A student demonstration in Tel-Aviv protests de Gaulle's anti-Israel policy.

◁ Life goes on as usual during the first part of 1967 despite military tension. The annual Israel Prize is awarded to (l. to r.): artist Marcel Janco, Prof. Aryeh Olitzki (accepted by his daughter), Prof. Binyamin Akzin, Prof. Akiva Ernst Simon, and poet Avraham Shlonsky.

△ Günter Grass, the German writer, a guest in Israel.

▽ Tension rises along the Syrian border in early 1967 and terrorist incidents proliferate. Syria, in response to the downing by Israel of six of its Mig 21s, systematically shells Israeli settlements along the northern border, including Kibbutz Gadot in the Upper Galilee (shown), where houses are destroyed repeatedly. In April 1967, it seems that the main threat is coming from the north.

◁ Two guests from France in 1967 are Jean-Paul Sartre (l.) and Simone de Beauvoir, shown with Israeli poet Avraham Shlonsky.

386

◁ The U.N. observer force – the "Blue Berets" – who have manned posts along the Israeli-Egyptian border since 1957, are ordered by the Egyptians to withdraw from the border area in May 1967, prompting U.N. Secretary-General U Thant to evacuate them from the region entirely. Shown, a group of U.N. observers departing from the Erez checkpoint at the northern border of the Gaza Strip.

△ A caricature in the Lebanese *al-Jarida* ("The Newspaper"), May 31 1967, depicts Israel as having no chance against eight Arab armies.

▽ Thousands of Israeli soldiers are deployed along the country's southern border. The message on the command car bumper reads: "Express to Cairo."

△ Following a period of indecision, a national unity government is formed, adding two Gahal personalities – Menahem Begin (r.) and Yosef Sapir (next to him) – and Moshe Dayan of Rafi (foreground) to the Eshkol government. Begin joins the government after 18 years in the opposition. Dayan's cooption as minister of defense, a portfolio heretofore held by Eshkol himself, is regarded as particularly important. Dayan is considered "soldier No. 1" in Israel. The public believes in his ability to reverse the country's military position, which has been weakened during the waiting period.

△ Before the battle:
An I.D.F. tank at the ready during the three-week wait for the war.

▽ After the battle:
A typical scene in the Sinai, showing a column of Egyptian tanks and armored vehicles destroyed by the I.D.F.

◁ Israeli jeeps fitted with recoilless guns at the Sinai front. So effective was the blow delivered by Israel to the Egyptian army that within four days that army collapsed and retreated in panic across the Suez Canal into Egypt. The Israeli campaign was initiated by its Air Force and completed by its armored divisions, infantry, and the rest of the I.D.F. branches. After four days of combat, Egypt agrees to a cease-fire.

▷ The winning team of senior I.D.F. officers at a briefing at the height of the war includes Southern Command leader Maj. Gen. Yesha'yahu Gavish (far right), to his right, Gorodish, Commander of Brigade 7, and Col. and divisional task force leader Maj. Gen. Israel Tal (crouching, l.).

◁ An I.D.F. officer with a dove after the capture of Rafah.

◁ Principal Israeli advances in Sinai and the Gaza Strip during the four days of combat on the southern front, June 5-8, 1967. Israel attacks Sinai with three army divisions.

▽ Israel Air Force planes destroy 400 enemy aircrafts, most of them on the ground. Shown, damage to an Egyptian airport.

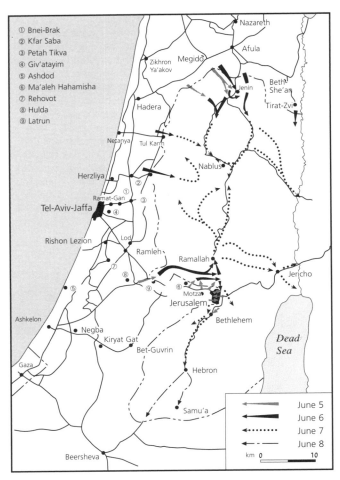

① Bnei-Brak
② Kfar Saba
③ Petah Tikva
④ Giv'atayim
⑤ Ashdod
⑥ Ma'aleh Hahamisha
⑦ Rehovot
⑧ Hulda
⑨ Latrun

June 5
June 6
June 7
June 8
km 0 — 10

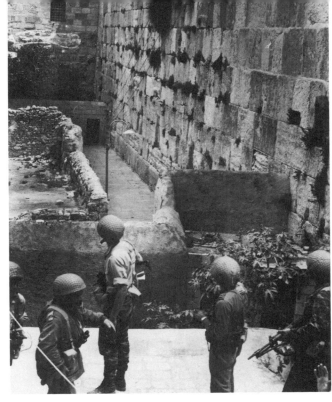

◁ Principal battles and Israeli advances on the Jordanian front, June 5-8, 1967.

△ The Western Wall, a few moments before the entry of the I.D.F. paratroopers into the plaza. In a short while, thousands of people will stream in.

▽ A villager in Samaria surrenders to an I.D.F. force.

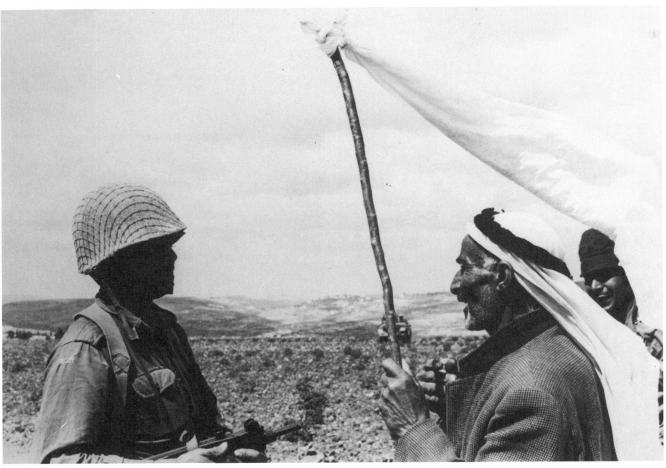

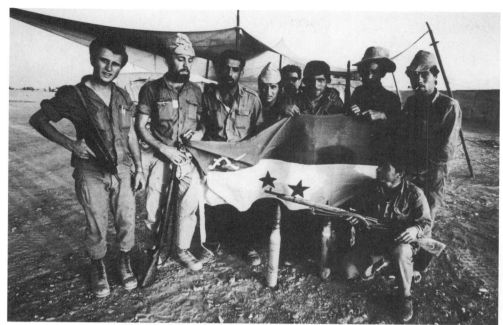

▽ Grave facts are revealed after the fighting ends. For example, the Jordanians removed monuments from the Jewish cemetery on the Mt. of Olives in Jerusalem and used them as stair treads and paving stones in army bases (shown). Egypt planned to capture Eilat and sever the southern Negev from Israel.

△ Israeli soldiers in Quneitra with a Syrian flag, June 11, 1967.

▽ Principal Israeli advances and battles on the Golan Heights front, June 9-10, 1967.

THE VICTORY

For Israelis, the decisive victory in the Six-Day War was magnified all the more by events that had preceded it. The country was in the throes of a recession; the tense waiting period before the outbreak of the war, and the attendant domestic political pressures, heightened uncertainty; and the Arab leaders, especially Egypt's President Nasser, loudly reiterated their determination to "wipe out" Israel. Not a few Israelis feared the impending destruction of the Jewish state and the advent of a new Holocaust. In addition, Israel maintained a policy of silence on the first day of the war, while the Arab media boasted of "the destruction of the Zionist entity" and carried detailed – fabricated – reports of Tel-Aviv and Haifa going up in flames.

The war showed the Israel Defense Forces to be a highly effective military machine, earning accolades both at home and abroad as the "finest army in the world." In the course of a single week, morale in Israel, as well as in Jewish communities throughout the Diaspora, rocketed from the depths of apprehension to immeasurable heights. The conquest of Sinai and of the Golan Heights, and the return, after nearly 20 years, to the Old City of Jerusalem, the Temple Mount and the Western Wall – engendered a sense of euphoria. Within a few months, dozens of books that documented the war and victory appeared.

The territories that Israel occupied (the Golan Heights, the West Bank, the Gaza Strip, and the Sinai Peninsula) were three times as large as its original size. Now Israel possessed "strategic depth."

Its frontiers became much shorter, and waterways, i.e. the Suez Canal and the Jordan River, separated Israel from its enemies.

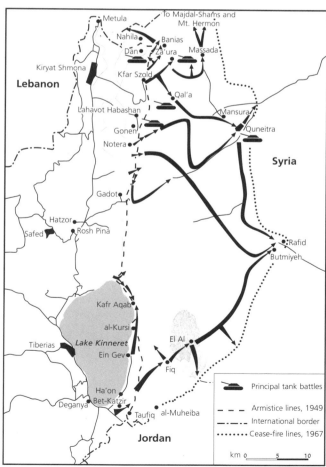

▽ Three victorious major generals add the Six-Day War ribbon to their insignia (l. to r.): Hayim Bar-Lev (later chief of staff), Ezer Weizman (later president of Israel), and Yesha'yahu Gavish.

▷ Chief of Staff Itzhak Rabin addresses an audience at Mt. Scopus, Jerusalem, shortly after the Six-Day War upon receiving an honorary degree from the Hebrew University.

This army, which I have been privileged to lead during this war, comes from the people and returns to the people, a people that rises to the challenge in the hour of need and is capable of overcoming any enemy by virtue of its moral, spiritual, and emotional level at the time of trial..."

Chief of Staff Itzhak Rabin upon receiving an honorary doctorate at Mt. Scopus, Jerusalem, after the Six-Day War, 1967

▽ Thousands of Israeli soldiers in Sinai cheer at the close of the "Victory Order of the Day." Later, the entire country will commemorate the victory in every possible way – in books, photography albums, assemblies, and ceremonies.

THE SHOCK TO THE ARABS

The outcome of the Six-Day War came as a complete shock to the Arab world. Anticipating the rapid destruction of Israel, as trumpeted in the media, the Arabs were forced to confront, instead, conquest and defeat at the hands of the Israelis. Moreover, the defeat was the third one, and this time without any involvement on the Israeli side of any of the great powers (although Egypt tried to assert that American pilots had aided Israel).

A million Arab residents of the territories on the west bank of the Jordan River (which had been part of Jordan) and in the Gaza Strip (which had been part of Egypt) found themselves under Israeli rule. Their shock was twofold: occupation, and the encounter with the Israelis, who for years had been demonized and suddenly appeared in a quite different guise.

The Israelis hoped for two results from the war: military calm for a long period, until the Arab armies recovered from the blow they received, and a peace agreement. Minister of Defense Moshe Dayan was quoted saying that he was "waiting for a telephone call" from the Arab side. Neither hope was realized. With the aid of the Soviet Union, primarily, the Arab armies were soon rehabilitated, while the Arab governments rejected any peace proposal short of total Israeli withdrawal from all occupied territory.

The real beneficiaries of the colossal Arab defeat were the Palestinian terrorist organizations, which continued to harass Israel. Every minor terrorist action was highly valued in the Arab world, which had an existential need to prove that the conflict with Israel was not over.

△ The post-Six-Day War period is one of euphoria in Israel. Tens of thousands of Israelis visit the Old City of Jerusalem and the towns and villages of the West Bank, touring historic sites and discovering the treasures of the oriental markets. Shown, an Israeli shopper examines Hebron glassware. The local merchants hurriedly affix signs in Hebrew. Residents of the West Bank visit Tel-Aviv, too, and it appears that a new quiet period in the region has begun.

◁ U.N. emissary Gunnar Jarring (r.) shuttles back and forth to the Middle East from late 1967 in an effort to move the sides toward an agreement. He is shown here with Israeli foreign ministry official Yosef Tekoa, later Israeli ambassador to the U.N.

△ The recession of 1966-67 is soon forgotten, to be replaced by a continuous economic boom. A Tel-Aviv importer of NSU cars, popular in Israel in the latter 1960s, typically links his advertising pitch to the new situation. It reads: "Now, after the victory – You ought to enjoy life! Buy a good car! Buy NSU."

1968

January

1 Hayim Bar-Lev succeeds Itzhak Rabin and becomes eighth chief of staff of the I.D.F.

10 Compulsory military service for men is lengthened to three years.

21 The Labor Party is founded, amalgamating Mapai ("Israel Labor Party"), Ahdut Ha'avodah ("Unity of Labor"), and Rafi ("Israel Labor List"). Ben-Gurion does not join.

23 Israel and Egypt complete their P.O.W. exchange: 4,500 Egyptians for 10 Israelis, including the Mishap prisoners.

26 The Dakar, an Israeli submarine, disappears en route from England to Israel. A search is mounted but is unproductive.

February

4 The Dakar is declared missing.

20 Itzhak Rabin takes up the post of ambassador to the United States.

Terrorist incidents proliferate along the cease-fire line with Jordan and in the territories.

21 Automatic inter-urban telephone dialing is operational in all parts of the country.

March

18 In a grave incident in the Aravah, a school bus explodes a road mine north of Eilat, resulting in two fatalities and 28 injured.

20 Minister of Defense Moshe Dayan is injured during a cave-in at an archeo-logical dig at Azur and is hospitalized for several weeks.

21 The I.D.F. attacks Pales-tinian terrorist bases in Jordanian territory in Opera-tion Karama, causing heavy losses to the terrorists but a high toll to the I.D.F.: 27 fata-

lities and dozens of wounded.

26 President Zalman Shazar is reelected for a second term unopposed.

28 France decides to renege on Israel's order of Mirage aircraft.

April

Terrorist incidents in the territories and along the Jordanian border continue.

12 A group of Jews celebrates the Seder night (Passover) in Hebron, and announces its decision to settle in the town.

May

2 (Independence Day) Israel T.V. begins operating. Its first broadcast is live coverage of the Independence Day military parade, held for the first time in united Jerusalem.

June

9 The government decides to establish a ministry of immigration, which, instead of the Jewish Agency, will be in charge of the absorption of immigrants.

14 A mortar attack from Lebanese territory targeting Kibbutz Manara marks the start of the deterioration of the security situation along the Lebanese border. Incidents continue along the other borders as well.

22 Prime Minister Eshkol declares: "The Jordan River is the security border for Israel."

July

8 Golda Meir resigns from her office as secretary of the Labor Party.

17 The Palestinian National Council approves the Pales-tinian Covenant, which rejects the existence of Israel and strives for the "liberation of Palestine through armed struggle."

23 Palestinian terrorists hijack an El Al plane flying from Rome to Lod and land it in Algiers.

24 The hijackers of the El Al plane release all non-Israeli passengers.

26 Finance Minister Pinhas Sapir resigns from the government. He is named secretary-general of the

Labor Party. Minister of Trade and Industry Ze'ev Sharf assumes the finance portfolio.

The hijackers of the El Al plane in Algiers release the Israeli women and children.

August

13 The International Pilots Union announces a boycott of flights to Algeria in light of Algeria's assistance to the hijackers of the Israeli plane. The boycott lasts three days.

31 The hijackers release the remaining passengers of the El Al plane.

September

4 Explosives planted by Palestinian terrorists in the Tel-Aviv central bus station kill one person and wound 70.

8 The Egyptians shell I.D.F. forces along the Suez Canal, causing 10 fatalities and 18 wounded.

17 Israel releases Palestin-ian terrorists in return for the release of the hijacked El Al plane and its passengers.

The pursuit of Palestinian terrorists from Jordan who infiltrate the West Bank intensifies. Incidents also occur along the Jordanian border in the Bet-She'an Valley region.

25 Zubin Mehta, the young Indian conductor, becomes musical adviser to the Israel Philharmonic Orchestra.

October

A campaign to draft Moshe Dayan as prime minister is mounted. Dayan is noncom-mittal.

The I.D.F. clashes with the Egyptian army and with Palestinian terrorists during the final week of the month. An I.D.F. force destroys a power station and bridges on the Nile deep in Egyptian territory. Incidents continue along the Jordanian border. Highly charged anti-Israel demonstrations take place in the West Bank.

The Israel soccer team reaches the quarter finals in the Olympics in Mexico, but loses to Brazil, 4:1.

November

A war of attrition is initiated by Palestinian terrorists and

by the Jordanian army against border settlements and the I.D.F. in the Bet-She'an and Jordan Valleys.

2 Eilat is shelled by Katyusha rockets fired from Jordanian territory.

11 Jordanian shelling of Kibbutz Kfar Ruppin in the Bet-She'an Valley causes one fatality and two wounded.

22 A booby-trapped car explodes in Jerusalem's Mahaneh Yehuda market killing 12 and wounding 70.

30 Katyushas from Jordan hit the Dead Sea Works at Sodom but fail to cause damage.

December

1 Israel mounts a retaliatory operation aimed at Jordanian targets south of the Dead Sea.

2-3 Israel Air Force planes bomb Irbid in Jordan in response to shooting at Israeli settlements south of Lake Kinneret.

4 A new Israeli air raid on Jordan, aimed this time at Iraqi troops. One Israeli plane is downed.

5 Surgeon Morris Levy conducts the first heart-transplant surgery in Israel.

11 Ben-Gurion demands the status of an independent faction in the Knesset.

19 The first hearttransplant patient, Itzhak Sulam, dies.

26 Palestinian terrorists attack an El Al plane in Athens airport. One passenger is killed.

27 An I.D.F. force raids the Beirut airport and destroys 13 planes.

The United States announces that it will supply Israel with 50 Phantom fighter planes.

30 A woman soldier is killed when Palestinian terrorists shell the Nahal ("Fighting Pioneer Youth Corps") settlement Tzofar in the Aravah.

31 The U.N. Security Council unanimously censures the I.D.F. incursion into Beirut.

▽ Moshe Dayan, the most prominent personality in Rafi, seems doubtful about the unification move. Is it because Ben-Gurion, his teacher and model, does not join?

◁ Yigal Allon, a leader of Ahdut Ha'avodah, appears pleased by the merger.

▽ Shim'on Peres of Rafi (r.) looks on as Itzhak Tabenkin of Ahdut Ha'avodah signs the charter.

△ The Labor Party is established at the start of 1968. Signatories of the unification charter include Golda Meir (r.) and Prime Minister Levi Eshkol (c.), representing Mapai, and Israel Galili, representing Ahdut Ha'avodah.

THE ESTABLISHMENT OF THE LABOR PARTY

The reunification of the largest Labor party in Israel, a process that was ongoing for nearly a generation, reached its conclusion in January 1968. Mapai ("Israel Labor Party") had split apart in 1944 when its leftist faction, Ahdut Ha'avodah ("Unity of Labor"), broke away. During the first half of the 1960s, a rapprochement between the two was effected, producing the first Alignment during the Knesset electoral campaign of 1965. Then, however, the hawkish faction broke off, under the leadership of Ben-Gurion, Dayan, and Peres, to establish Rafi ("Israel Labor List").

Following the Six-Day War, a new unification process was initiated, during which Mapai and Ahdut Ha'avodah again reached agreement. Elements within Rafi also wanted to return to the mother party. Ben-Gurion, however, was opposed, although he did not thwart the process. Late in 1967, Rafi voted by a narrow margin to join the tripartite amalgamation. Mapai was allocated 57% of the delegates to the unity conference, while the other two parties received 21.5% each.

Ben-Gurion did not join, instead forming a new party, the State List, with several supporters.

The post-Six-Day War euphoria is sustained during 1968, manifested, among other things, by a wave of popularity for the army entertainment troupes which perform songs on the theme of the victory and the country's expanded borders. Shown, the Southern Command Troupe performing in Sinai. At l. is Mati Kaspi, a future popstar.

THE OPEN BRIDGES POLICY

Dayan was perceived in the Arab world as a dedicated Arab-hater in light of the retaliatory military policy he initiated as chief of staff, the Sinai Campaign, and the I.D.F. victory in 1967 when he was defense minister. The Arabs in the occupied territories were therefore surprised to discover, shortly after the war, that Dayan showed a liberal approach in dealing with their daily affairs.

This approach was exemplified by the open bridges policy. Several weeks after the war, a problem flared up over the transport of agricultural produce from the West Bank into Jordan and from there to other Arab countries. I.D.F. soldiers stationed along the river observed loaded trucks from the territories driving across the Jordan River at shallow points, to Jordan. Commanding officer Maj. Gen. Uzi Narkiss, informed of the situation, sanctioned the transport retroactively. In addition, Dayan ordered the repair of the bridges, initiating a flow of goods and people between the occupied territories and Jordan. Later, he granted approval for summer visits by residents of the territories living in Arab countries; allowed local self-government; permitted inhabitants of the territories to work in Israel; and stimulated normalization in relations between Israel and the occupied territories.

Even though local strikes were called from time to time, and Palestinian terrorists continued to carry out acts of violence, Dayan's liberal policy diffused tension. In the view of some observers, this approach deferred a popular uprising in the territories for many years, until late 1987, when the Intifada began.

◁ Palestinian terrorist acts proliferate during 1968. An explosion in Jerusalem's Mahaneh Yehuda market on November 22nd claims 12 lives, with 70 wounded.

△ Border settlements bear the main brunt of Palestinian terrorism originating in Jordan, and of Jordanian army operations, as at Kibbutz Massada, shelled by the Jordanians in March.

△ The war against the Egyptians along the Suez Canal is dubbed the "war on the water." Simultaneously, the Jordan River and the fish-breeding ponds in the vicinity are also under fire.

▷ In a retaliatory operation, I.D.F. forces cross the Jordan River on March 21, 1968, and raid a Fatah base at Karama in Jordanian territory.

◁ The country is in a state of tension for over a month by the hijacking of an El Al passenger plane en route from Rome to Lod which is forced to land in Algiers. The Palestinian terrorists thus open a new front in their war against Israel. At first they release the non-Israeli passengers, and later the Israeli women and children. Only after the intervention of the International Pilots Organization, which imposed a boycott on flights to Algeria, and Israel's agreement to free 12 terrorists that it holds, are the remaining hostages, and the plane, released.

THE RISE IN PALESTINIAN TERROR

Terrorist acts by the Palestinian organizations increased during 1968 in the occupied territories, in Israeli territory, and abroad. Ongoing attempts by terrorist cells to infiltrate into Israel, especially from Jordan, prompted a constant struggle aimed at eliminating them.

The shelling of Israeli settlements by mortar and by Katyusha missiles launched by terrorists based in Jordanian and Lebanese territory also increased during the year. The I.D.F. responded with ground, artillery and air operations.

For the first time, the Palestinians carried out acts of terrorism in the skies. In July, they hijacked an El Al plane to Algiers, and in December they attacked an El Al plane in Athens airport. The I.D.F. retaliated by attacking Beirut airport and destroying several planes.

◁ The waterway separating the I.D.F. from the Egyptian army – the Suez Canal – is relatively quiet in early 1968. After the exchange of P.O.W.s is completed in January, when Israel trades 4,500 Egyptian prisoners for 10 Israelis, including the 1954 Mishap prisoners, the canal front heats up and battles erupt along it intermittently during the year.

◁ The outgoing chief of staff, Itzhak Rabin, shown with his wife Lea, leaves for the United States in early 1968 to serve as ambassador there.

▷ Incoming Chief of Staff Lieut. Gen. Hayim Bar-Lev begins his tour of duty on January 1, 1968. He will initiate the building of fortified observation posts along the Suez Canal, called the Bar-Lev Line.

◁ An Israeli submarine, the Dakar, disappears in late January 1968. Early in 1969 the vessel's buoy (shown) is washed up on the Gaza shore, but the mystery remains unsolved.

△ Agitation in Israel at the Red Army invasion of Prague in 1968 is expressed in anti-U.S.S.R. protests and demonstrations. Signs read: "Germany – '38; Russia – '68" and "Down with Soviet Imperialism."

1968

△ The most famous casualty of 1968 is Minister of Defense Moshe Dayan, injured at an archeological dig. Here, he is visited by David Ben-Gurion.

▽ The annual I.D.F. parade takes place in reunified Jerusalem on Israel's 20th Independence Day, May 2, 1968. Israeli T.V. also begins broadcasting this day.

1969

January
President de Gaulle places an embargo on arms to Israel in the wake of Israel's retaliatory operation in Beirut in December, 1968.

16 A mass demonstration in Tel-Aviv protests the French embargo.

19 The Labor Party and Mapam ("United Workers Party") establish a political alignment, which will last until 1984. The two parties run in a combined list in all elections – Knesset, municipal and Histadrut ("Federation of Labor").

27 The Iraqi authorities publicly execute nine Jews by hanging on charges of spying for Israel. Israel and the Jewish world are outraged.

30 Maccabi Tel-Aviv wins the Asia championship in soccer after it defeats the South Korean team 1:0.

February
9 The Dead Sea Works at Sodom are bombarded by Katyusha rockets launched from Jordanian territory.

14 Terrorists bombard settlements in the Jordan Valley and Mitzpeh Ramon in the Negev with Katyusha rockets.

18 Palestinian terrorists attack an El Al plane at Zurich airport. An apprentice pilot, Yoram Peres, is injured and dies of his wounds. An Israeli security guard, Mordechai Rahamim, shoots and kills one of the terrorists.

24 Tension mounts along the northern border. The Israel Air Force attacks two Fatah bases in the Damascus area. Two Syrian Mig 17 planes are shot down in aerial combat.

26 Levi Eshkol, prime minister since June 1963, dies aged 74.

March
Numerous incidents occur during the month along the borders, in the occupied territories, and in Jerusalem.

6 A terrorist explosion in the cafeteria of the Hebrew University of Jerusalem wounds dozens of people.

8 Egypt initiates what will be called, retrospectively, the War of Attrition, along the Suez Canal. Fighting will go on almost continuously until August 1970.

17 The Knesset ratifies a government headed by Golda Meir, who replaces the late Levi Eshkol as prime minister.

April
Skirmishes aimed at thwarting the infiltration of terrorists from Jordan into the West Bank proliferate.

6 Israel's youth soccer team beats the Soviet team 1:0 in a sensational upset at a tournament in Cannes.

8 Eilat is bombarded by Katyushas. The Israel Air Force attacks Aqaba port.

29 Retaliating for Egyptian attacks at the Suez Canal, Israeli forces blow up bridges on the Nile and a power station deep in Egyptian territory.

May
Incidents continue along the Suez Canal, in the Jordan Plain, and in the Bet-She'an Valley.

19 Palestinian terrorists from Jordan bombard the Musa Alami school near Jericho.

21 Israeli planes bring down three Egyptian Mig 21s in the Suez Canal zone.

28 Katyusha rockets from Jordan bombard Jericho twice.

The fortified Green Island raided by the I.D.F., July 1969.

30 Palestinian terrorists blow up the oil pipeline (T.A.P. line) which passes through the Golan Heights. Thousands of tons of crude oil pollute the river-beds, but are blocked on their way to the Lake Kinneret.

June
1 The Ohel Theater is closed down after 43 years of existence.

26 Israeli planes bring down two Egyptian Mig 21s in an aerial battle over the Suez Canal.

29-30 An I.D.F. unit destroys a high-tension electric line deep in Egyptian territory.

Numerous incidents occur on the Egyptian front and along the Jordanian border during the month.

July
Skirmishes take place on land, on sea, and in the air along all the borders. The I.D.F. raids targets across the borders. Terrorists strike at various points in Israeli territory.

7 Israeli planes bring down two Egyptian Mig 21s in an

aerial battle south of Sharm al-Sheikh.

8 Israeli planes bring down seven Syrian Mig 21s over the Golan Heights.

20 The I.D.F. raids the fortified Green Island south of the Suez Canal.

23 Nasser declares that the cease-fire is dead, the liberation stage has begun, and another war is in the offing.

24 Israeli planes bring down seven Egyptian planes and damage two others in the Suez Canal zone.

28 The eighth Maccabiah opens in Ramat Gan.

August
Skirmishes and incidents continue in all the border zones. I.D.F. units continue to raid targets behind enemy lines.

21 A young Australian tourist, Michael Rohan, sets fire to the al-Aqsa mosque. The Arab world is in an uproar and blames Israel for the act.

26 In an unprecedented move, 18 families from the Soviet Republic of Georgia send a letter to the U.N., to the Israeli government, and to other foreign bodies requesting help to enable them to emigrate to Israel.

29 Palestinian terrorists hijack a T.W.A. passenger plane and land it in Damascus. All passengers are freed except for six Israelis.

September
1 The hijackers of the T.W.A. plane release four Israeli women passengers but continue to hold two Israeli men.

2 Elections to the 11th

Katyushas land in Eilat in April 1969.

△ A demonstration is held in Jerusalem in September demanding the release of the two Israelis held in Damascus since August when the T.W.A. plane they were on was hijacked. The sign reads: "Americans – yes. Israelis – no?" (a reference to the immediate release of the American passengers).

▽ Tension is high in the Labor Party during the election campaign for the Knesset in 1969. The struggle for the leadership is renewed. A draft campaign for Moshe Dayan as prime minister amasses thousands of signatures.

Histadrut ("Federation of Labor") Convention result in a significant loss to the Alignment (including Mapam), which wins 62% of the seats. Gahal wins approximately 17%.

Kiryat Shmona is bombarded by Katyusha rockets. Two residents are killed and five are wounded.

5 The first Phantom combat planes are delivered to Israel by the United States.

9 The I.D.F. mounts a large armored raid into Egypt from the western bank of the Gulf of Suez.

11 Israeli planes bring down 11 Egyptian planes at the Egyptian front. One Israeli plane is hit and its pilot taken prisoner.

23 The Swiss police arrest Alfred Frauknecht, a Swiss engineer, on suspicion of passing on plans for the construction of the French Mirage plane to Israel.

October

Incidents and raids continue along the cease-fire lines and

Prime Minister Levi Eshkol dies in February 1969 and is replaced by Golda Meir.

in enemy territory. The Palestinian terrorists heighten activity in Israel, with explosive devices in public places.

28 Elections are held for the Seventh Knesset. The Alignment wins 55 seats. Gahal wins 26.

November

7 Israeli T.V. is to broadcast on the Sabbath eve despite a government decision to the contrary, the Supreme Court decides. The case, brought up by a private citizen, Adi Kaplan, is argued by attorney Yehuda Ressler, who gains wide publicity.

11 Beersheva University operates as an independent academic institute. Later it will change its name into Ben-Gurion University.

16 Egyptian frogmen from Aqaba sabotage two Israeli ships in the harbor of Eilat.

December

Skirmishes and incidents continue. I.D.F. units continue to raid targets beyond the borders and to seek out Palestinian terrorists.

2 A demonstration is staged on Tel-Aviv's Kings of Israel Square for the "Jews of Silence" in the Soviet Union.

6 The two Israeli passengers of the T.W.A. plane hijacked in August are returned, as are two pilots, in P.O.W. exchanges with Syria and Egypt.

9 The United States propose a plan, named for Secretary of State Rogers, to settle the conflict between Israel and its neighbors based on withdrawal to the pre-Six-Day War borders, with slight adjustments; recognition of Israel's temporary security borders; and the unification of Jerusalem, with the granting of a special status to Jordan in economic, civil and religious matters. The plan is immediately rejected by Israel, Egypt, and Jordan.

15 Golda Meir presents her new government, a national unity government. One of the new Gahal ministers is Ezer Weizman (transportation).

16 Itzhak Ben-Aharon is elected secretary-general of the Histadrut.

22 A Swiss court clears Mordechai Rahamim, the El Al security guard, of any blame for killing one of the terrorists. (see February 18)

25 An airlifted I.D.F. unit penetrates deep into Egyptian territory and removes an advanced Soviet radar installation.

26 Five missile boats built for Israel in France and held back because of the embargo imposed by France are spirited out of Cherbourg harbor and sail for Israel.

Israel's national soccer team competes in the World Cup finals for the first time. It beats Australia 1:0 in Ramat Gan (December 4) and draws with it in Sydney 1:1.

THE BEGINNING OF THE WAR OF ATTRITION

The Egyptians, although badly beaten in the Six-Day War, did not relinquish the military option even after their defeat and attacked the I.D.F. forces stationed along the Suez Canal intermittently. On March 8, 1969, Egypt's President Nasser announced the annulment of the cease-fire that was in force since June 1967, signaling the start of daily skirmishing that was to be referred to as the War of Attrition and that lasted for seventeen months, until August 7, 1970.

Fighting intensified and in the summer of 1969, after lethal artillery attacks and commando raids on I.D.F. troops garrisoned in fortified positions along the Suez Canal, Israel began using air power against Egyptian forces at the canal, resulting in a reduction of Egyptian activity. Ground attacks into Egyptian territory were

also mounted and the Egyptian cities along the Suez Canal were shelled intensively. Particularly daring Israeli initiatives included a commando attack on the fortified Green Island in the northern Gulf of Suez, and the removal from Egyptian territory of a complete Soviet radar installation, together with its operators, in a helicopter operation.

Both sides sustained heavy losses in the fighting. Israeli casualties, occurring nearly daily, caused domestic concern, prompting Minister of Defense Moshe Dayan to state: "When the Creator said to the Jewish people 'Fear not, Jacob, my servant,' He did not mean that He was giving him an insurance policy. The significance of the statement is that we are fated to live in constant struggle, and we dare not fail out of cowardice."

◯ position
△ observation post
⊨ machine-guns
•▪• antiaircraft machine-gun
⤨ antiaircraft weapon
⬭ armored track
⊥⊥ mortar
Ⅱ tanks
⚬⚬⚬⚬ fencing
✱✱✱
•••• mines
▮ bunker

◁ Plan of a fortified position – one of several dozen along the Suez Canal (the Bar-Lev Line). Each position is manned by several dozen soldiers and contains large quantities of arms and ammunition. The Bar-Lev Line is assumed to be uncrossable.

△ The Israeli soldiers stationed in the fortified positions are visited by entertainers and speakers to help ease their service. Here, they watch a performance, November 1969.

▷ Israeli-American relations are close in 1969, at least partly by virtue of the presence of Ambassador Itzhak Rabin (r.), who earns high marks in Washington. Prime Minister Golda Meir appears in high spirits at a meeting in September with Senators J. William Fulbright (far left) and Stuart Symington (c.) on Capitol Hill. The good atmosphere does not keep the U.S. administration from publishing the Rogers Plan a few months later, which will be rejected by all sides.

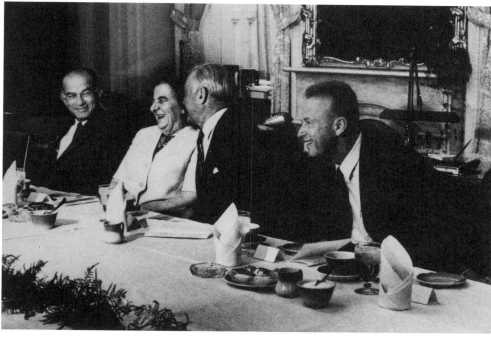

▽ Minister of Defense Moshe Dayan and Minister of Education and Culture Yigal Allon survey the damage to the al-Aqsa mosque after a fire there in August, 1969. The Arab propaganda organs vociferously insist that Israel, and not an unbalanced young Australian tourist, is responsible for setting the fire. Cartoonist Ze'ev has his own opinion (left). The lion is the emblem of Jerusalem.

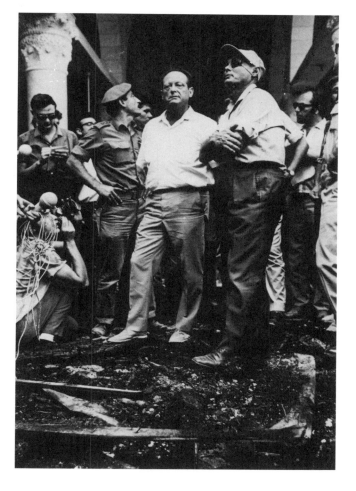

GOLDA MEIR – PRIME MINISTER

The passing in February 1969 of Levi Eshkol, the country's first prime minister to die in office, did not evoke prolonged indecision over a successor. Curiously, although there were several likely candidates, the one who was chosen – Golda Meir – had only shortly beforehand appeared unpromising. The other candidates in the Labor Party leadership were Pinhas Sapir, who refused; Yigal Allon, who was identified with the Ahdut Ha'avodah faction and was thus unacceptable to part of the old-time Mapai leadership; Moshe Dayan, a former Rafi figure who was feared by nearly all the Mapai leaders; and Abba Eban, whose dovish views were an impediment.

Golda Meir, who had been given a low rating in public opinion polls several weeks before Eshkol's death, was nevertheless perceived both within the party and outside it as a good choice, and in a short time gained wide support from the public as well.

Only several months later, Meir faced elections for the Seventh Knesset, which were held in October 1969, and which her party won handsomely.

▽ Terrorist incidents mount sharply during 1969. Minister of Defense Moshe Dayan visits a casualty of an explosion in a Jerusalem supermarket – his brother-in-law, Israel Gefen.

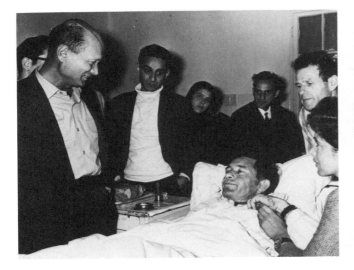

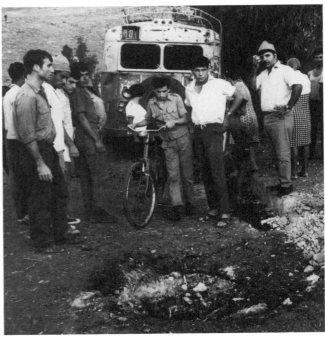

△ A crater is gouged out by a Katyusha rocket that lands in Kiryat Shmona in September 1969.

◁ In an odd twist, an Arab agricultural school north of Jericho headed by Musa Alami, is bombarded by Katyusha rockets launched from Jordan. Arab pupils help sandbag the building.

▽ Newspaper headlines reflect the conflict over T.V. broadcasting on Friday eve: "The Alignment exerts pressure on the ultra-Orthodox: if there is no coalition in Tel-Aviv, there will be television on Sabbath."

המערך לוחץ על המפד"ל: אם אין
קואליציה בת"א – יש טלוויזיה בשבת

צמרת משרד המשפטים דנה הבוקר
בפרשת היתר שידורי הטלוויזיה בשבת

שרי המערך ומפד"ל עושים מאמצים
אחרונים למנוע שידורי טלוויזיה הערב

◁ Business as usual despite the military tension. Hundreds of Arab farmers attend an agriculture fair organized in October by the Israeli authorities in Bethlehem.

▽ Prime Minister Golda Meir and artist Marc Chagall at a dedication ceremony of tapestries that the artist created for, and donated to the Knesset building.

▽ The five "Cherbourg boats" make headlines during the last week of 1969 (shown, three of the boats) when they slip out of France and head for Israel. Israel extracts the vessels after France has imposed an embargo on the export of arms and military equipment to Israel. The ships reach Israel on December 31, 1969.

The Eighth Decade:
1970-1979

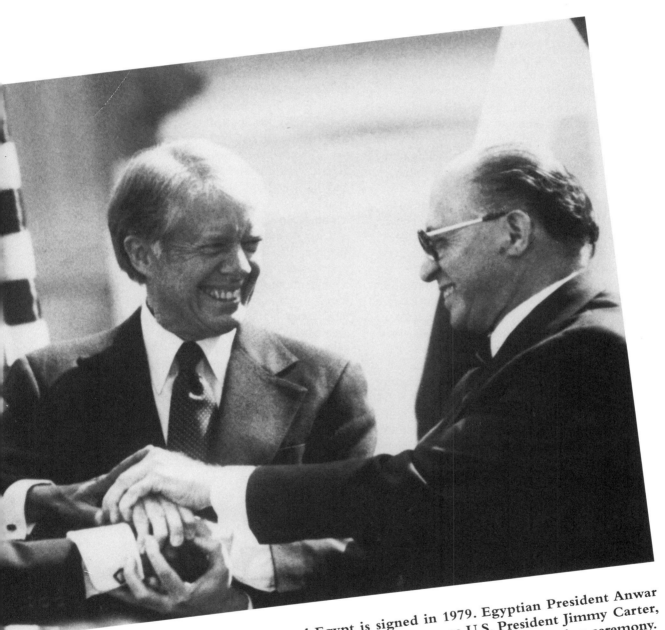

The first peace treaty between Israel and Egypt is signed in 1979. Egyptian President Anwar Sadat and Israeli Prime Minister Menahem Begin look happy as U.S. President Jimmy Carter, the mediator in the peace process, joins them in a triple handshake after the signing ceremony.

The 1970s witnessed wars followed by political upset and a peace agreement, the latter two constituting first-time events for Israel.

The decade began with the continuation of the War of Attrition, fought primarily with Egypt along the Suez Canal. This conflict ended with a cease-fire in the summer of 1970, which, however, already contained the seeds of – the Yom Kippur War, to come three years later. During the years preceding the war, Israel, confident of its military power, rested on its laurels while Egypt and Syria secretly prepared the next blow.

Even though intelligence information pointed out unusual preparations by the Egyptian and Syrian armies, Israel was taken by surprise in October 1973 both by the outbreak of the war and by its extent. Both Arab countries attacked with large numbers of armored and infantry brigades and divisions as well as missile systems that caused serious damage to Israeli tanks and planes at the start of the campaign. Although the tide began to turn in Israel's favor after a few days of fighting, the memory of the surprise, the first disappointing and frustrating days, and the large losses was to be indelible.

The Yom Kippur War marked a severe change in Israel that would affect the country for years to come. The results of the war, the Arab oil boycott, and the economic and social crisis that developed in Israel contributed to both internal and external problems. Immigration, mainly from the Soviet Union, diminished after 1973. This was partly due to the difficulties caused by the Soviet regime and partly because an increasing number of the Soviet emigrants dropped out once they reached the transit camps (in western Europe).

Two elections were held in Israel during the decade – in 1973 and in 1977. The 1973 elections, scheduled for October and postponed because of the war until the last day of December, did not yet reflect the full extent of the cataclysm experienced by the country. The traditional leading party – the Alignment (Labor plus Mapam) – dropped only slightly in the polls and continued as the party in power, although it was forced in 1974 to reshuffle its leadership and allow in new faces, giving rise to the hope that change could come from within: Itzhak Rabin replaced Golda Meir as prime minister, Shim'on Peres replaced Moshe Dayan as defense minister, and Yehoshua Rabinovitz replaced Pinhas Sapir as finance minister.

However, Rabin's government, which lasted three years, ran into trouble. Objective difficulties in the aftermath of the Yom Kippur War, power struggles within the leadership, and the exposure of political corruption led to public discontent with the government and with the political party that stood behind it. Elections on May 17, 1977, signaled the country's first political upset in government, with the main opposition party, the Likud, gaining a large enough increase in support (of only 10%) to turn it into the main political player.

Simultaneously, the Alignment's strength plummeted, with most of its deserters shifting to the new Democratic Movement for Change (Dash), a center party that attracted dissatisfied voters from the right as well. The religious parties, who traditionally were coalition partners with Labor, switched allegiance to the winning team. A new period dawned in Israel, ending some 30 years of sustained governance under the same center-left party.

Menahem Begin, leader of Herut and the Likud, who had failed in the previous eight election campaigns, emerged as the big winner of the 1977 upset. The center-right government that he formed, with the participation of the religious parties and Dash, rapidly implemented an economic upset as well. Moreover, unlike preceding governments, it supported the expansion of Jewish settlement in the occupied territories enthusiastically. Yet, surprisingly, it was Begin, perceived as a radical hawk ideologically, who was to yield the entire Sinai Peninsula to Egypt in the peace treaty signed between the two countries in 1979. However, he made a clear-cut distinction between the Egyptian territories and the West Bank (Judea and Samaria), and the Golan Heights.

The decade, which started with a war with Egypt, ended with a peace agreement. In November 1977, Egyptian President Anwar Sadat, who succeeded Nasser upon his death in 1970, startled the entire world by announcing his wish to come to Jerusalem and address the Knesset. For Israelis, his visit constituted an impossible dream come true. Following prolonged negotiations, a peace agreement was signed in March 1979.

Domestically, developments whose roots lay in the previous decades emerged full blown in the 1970s. One example was the widening gap between the haves and the have-nots, which found expression at the start of the decade in activity and demonstrations mounted by the Black Panthers protest group. In many respects, the political upset of 1977 was a social upheaval as well, with most Israelis of oriental origin, and those in the development towns, casting their ballots for the Likud, thereby removing from power the party that had settled them into Israeli life yet viewed them – in their perception – as second-class citizens. Now they were giving Begin the chance to tear down the barriers to full integration.

Another development was the growing political strength of the ultra-Orthodox community. For decades, the ultra-Orthodox participated in the elections, obtained modest achievements, but kept back from political struggles. This attitude changed after 1977. The Agudat Israel party supported Begin's government, at times constituting the government's decisive parliamentary strength. For its part, the national religious population, represented by the N.R.P., moved increasingly rightward toward the Likud, abandoning its historic alliance with Mapai and the Labor Party.

January

1 A guard in Metula, Shmuel Rosenwasser, is kidnapped by Palestinian terrorists.

The head of Israel's defense ministry mission to France, Maj. Gen. Mordechai Limon, is asked by the French to leave in the wake of the "Cherbourg affair."

Israel Air Force planes attack the Ghor Canal in Jordan.

7 Israeli planes begin attacking targets deep in Egyptian territory.

15 Poet Lea Goldberg dies at the age of 59.

20-21 An armored I.D.F. unit attacks Palestinian terrorist bases in Jordan southeast of the Dead Sea.

22 An I.D.F. unit captures Shadwan Island in the Gulf of Suez. The operation results in a heavy loss of Egyptian lives and over 60 P.O.W.s taken by Israel. The I.D.F. loses three soldiers.

24 In a tragic accident in Eilat, 18 soldiers are killed and 42 wounded when an ammunition truck explodes in the harbor.

The War of Attrition at the Suez front is at its height, involving frequent air battles and Israeli bombing deep inside Egyptian territory and in the Cairo area. Terrorist incidents occur along the length of the Jordan Valley and the Lebanese border. The I.D.F. attacks Lebanon by land and air.

February

1 An economic program is worked out between the treasury, the Histadrut ("Federation of Labor") and the manufacturers.

5 Two Israeli navy boats are sunk by Egyptian frogmen in the harbor of Eilat.

8 The treasury announces a series of increases in indirect taxation.

10 Palestinian terrorists attack El Al passengers at the Munich Airport. One passenger is killed and 11 are wounded, including actress Hanna Meron.

12 Israeli bombing deep inside Egypt continues. Israel announces that a metal factory in Abu Za'abel has been hit accidentally, resulting in the death of dozens of workers.

17 Nobel Prize-winner S. Y. Agnon, one of Israel's greatest authors, dies at the age of 82.

21 A Swissair plane flying from Zurich to Tel-Aviv explodes in midair. The 47 fatalities include 15 Israelis. The perpetrator is the Popular Front for the Liberation of Palestine.

March

The Soviet Union's anti-Israel propaganda campaign intensifies and Soviet Rabbis are forced to censure Israel. Nevertheless, groups of Soviet Jews publicly express support for Israel and declare their wish to immigrate there.

28 Poet, translator, and playwright Natan Alterman dies at the age of 60.

Battles along the ceasefire lines with Egypt, Jordan and Syria continue, including aerial fighting. Israel continues its raids deep in enemy territory.

April

Fighting continues. Egypt, Syria and the Palestinian terrorists incur heavy losses. The I.D.F. sustains many casualties as well.

2 The remodeled Habimah theater building is inaugurated after a long period of renovation.

5 Dr. Nahum Goldmann, president of the Conference of Jewish Organizations, is invited to meet with President Nasser in Cairo. The Israeli government objects.

11 Settlements in the Galilee and the Bet-She'an Valley are fired upon and shelled by Katyusha missiles.

29 Chief of Staff Hayim Bar-Lev reveals that Soviet pilots are taking part in Egyptian operational flights.

May

The staging of the play *Queen of the Bathtub* at the Cameri theater creates a stir, eliciting censure by some as "antipatriotic."

3 An I.D.F. unit kills 21 Palestinian terrorists who have infiltrated into the Jordan Valley.

6 The town of Kiryat Shmona is targeted in a Katyusha missile attack. A father and his daughter are killed.

Terrorist activity along the northern border increases.

9 Actress Hanna Meron, wounded in the terrorist attack at the Munich airport in February, returns to Israel after treatment in Germany.

12 A large I.D.F. force raids Palestinian terrorist bases in southern Lebanon.

14 An Egyptian missile boat sinks an Israeli fishing vessel, the Orit, north of Lake Bardawil.

16 Israel Air Force planes respond by sinking an Egyptian missile boat and a destroyer in the Red Sea.

18 David Ben-Gurion resigns from the Knesset after serving as a member continuously from its inception in 1949.

Israeli planes attack artillery batteries deep in Jordanian territory.

22 Palestinian terrorists attack a school-bus at the Moshav Avivim in the Upper Galilee. Nine children, the driver, and two other adults are killed, and 19 children and adults are wounded.

The situation at the Suez Canal border deteriorates toward the end of the month. An Egyptian attack on the 30th results in 13 Israeli fatalities, 4 wounded and 2 taken prisoner.

June

1-3 Two Katyusha salvos land in the town of Bet-She'an. Kiryat Shmona is similarly attacked on the 3rd. Tiberias also comes under artillery fire by the Jordanians

1970

that day. Israeli planes respond by bombing the city of Irbid and Palestinian terrorist bases in Jordan.

Several Israeli planes are shot down in battles in the Suez Canal arena.

Participating in the World Cup soccer finals for the first time, Israel's national team ties Sweden (1:1) and Italy (0:0), but fails to reach the quarter finals when it loses to Uruguay (2:0).

11 Palestinian terrorists again fire Katyusha missiles at Kiryat Shmona.

Heavy fighting continues on land and in the air along the Egyptian and Syrian borders. The terrorists continue to bombard the northern settlements with Katyushas.

July

6 The Soviets are reportedly operating S.A. 1 and 2 antiaircraft missile launches against Israel.

14 Eighty Jews ask the Supreme Soviet to be allowed to immigrate to their "historic homeland."

17 Moshe Hayim Shapira, a

"Bears as well as forest" – Soviet missiles at the Suez Canal

Darian depicts Soviet missile threat by means of a graphic pun.

minister in Israel's governments since the founding of the state and a leader of the N.R.P. (National Religious Party), dies at age 68.

31 The government votes to accept the American-sponsored proposal for a three-month cease-fire (the second Rogers Plan) based on U.N. Security Council Resolution 242.

August

4 The Knesset approves the American cease-fire initiative. The Gahal ministers resign from the national unity government.

7 The War of Attrition between Egypt and Israel ends.

12 Israel discovers that the Egyptians and the Soviets have moved missiles to the Suez Canal area in violation of the cease-fire agreement.

September

Palestinian terrorists hijack three passenger planes: Pan Am, T.W.A., and Swissair. An attempt to hijack an El Al plane is thwarted.

9 Palestinian terrorists hijack a B.O.A.C. plane and land it in Zarqa, Jordan, beside two other hijacked planes. The Pan Am plane is blown up in Cairo.

12 The terrorists explode the three planes in Zarqa. The hostages are still in their hands.

Black September – Palestinian terrorists in Jordan are dealt a lethal blow by the Jordanian army and are banned from operating against Israel from there. A Syrian force that crosses into Jordan is repulsed. Israel monitors developments closely.

24 Director of the Port Authority Hayim Laskov resigns in the wake of strikes and slow-downs at Ashdod port.

28 President Nasser of Egypt dies.

October

5 Anwar Sadat is elected president of Egypt by the ruling party.

26 Head of Intelligence Maj. Gen. Aharon Yariv reports that the Egyptians have moved up dozens of missile batteries to the Suez Canal in violation of the cease-fire agreement.

November

4 High school teachers begin a strike that will last until December 15th.

30 A T.W.A. cargo plane and an Israel Air Force transport plane collide on the ground of Lod airport, causing two fatalities and two injured. Both planes go up in flames.

December

20 Two Katyusha missiles land in Jerusalem. No injuries are caused.

29 Bet-She'an is again attacked by Katyushas.

30 Rainstorms cause a tragedy at Moshav Ne'ot Hakikar south of the Dead Sea when a massive rock formation collapses on an army mess hall below it, causing the death of 19 soldiers and civilians.

Demonstrations are mounted in Israel and elsewhere throughout the world protesting the repressive attitude of the Soviet Union toward the Jews and the "Leningrad Trial," in which a group of Jews was convicted for attempting to hijack a plane in order to escape from the Soviet Union. Two are sentenced to death and nine to long prison terms.

Inflation in 1970 is 6.1%, the last time a single-digit figure is to be recorded for this index for years to come.

△ A typical picture from the period of the War of Attrition on the Jordanian border. The children of Kibbutz Gesher spend another night in the shelter. The shelling of settlements, their residents, and farmers working the fields continues until the end of 1970 without interruption.

▷ Israel Air Force planes begin bombing targets inside Egyptian territory in January, 1970, in order to dissuade Egyptian action from the Suez Canal front line. The map shows the comprehensive plan of action.

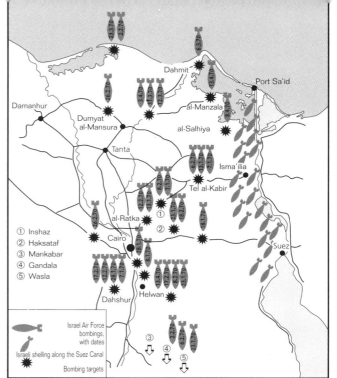

① Inshaz
② Haksataf
③ Mankabar
④ Gandala
⑤ Wasla

Israel Air Force bombings, with dates

Israeli shelling along the Suez Canal

Bombing targets

△ The I.D.F. attacks Egypt's Shadwan Island in the Gulf of Suez in January, 1970.

▷ Gahal (the bloc formed by Herut and the Liberal Party) opposes the Rogers Plan. Cartoon by Ze'ev.

THE WAR OF ATTRITION AND THE CEASE-FIRE

The War of Attrition against Israel, begun in March 1969, continued to be waged in full force during the first half of 1970 along the country's borders, especially at the Egyptian front. In January, 1970, Israel decided to respond to continuous Egyptian firing along the Suez Canal by dispatching I.D.F. planes targeting points deep inside Egyptian territory, prompting Egyptian President Nasser to request aerial protection from the Soviet Union. Soviet involvement mounted during the spring and summer, with Russian pilots taking part in air battles against Israeli planes and Soviet officers and advisors attached to nearly every Egyptian unit.

The I.D.F. scored a series of impressive successes during the first few months of 1970, including the two-day takeover of the fortified island of Shadwan in the Red Sea. The Egyptians, however, responded with com-mando operations against Israeli positions along the Suez Canal, several of which caused heavy casualties.

Efforts by the United States to end the fighting were intensified in July, 1970, with both sides responding to Secretary of State Rogers' initiative. A three-months cease-fire went into effect on August 7th, to be extended several times thereafter. However, the Egyptians violated the agreement on the first night, advancing their antiaircraft missile systems to the Suez Canal line. Israel, debating whether to resume the fighting as a result, decided at that point merely to defer talks with U.N. mediator Gunnar Jarring.

Retrospectively, some observers believe that this was a serious error for which Israel was to pay dearly when the Egyptians scored initial successes in the Yom Kippur War of 1973.

△ Actress Hanna Meron returns to Israel in May 1970 after being wounded in the terrorist attack at Munich airport in February.

▽ Northern Command Maj. Gen. Motta Gur surveys the schoolbus that has been blown up near Moshav Avivim.

CONFRONTATIONS WITH THE TERRORISTS AND WITH JORDAN

Numerous attempts were made by Palestinian terrorists to infiltrate into Israeli territory during the course of the year, while the shelling of Israeli settlements and cities from a distance was ongoing. Katyusha missiles were fired at the town of Bet-She'an and the surrounding settlements, at Kiryat Shmona and the settlements of the Galilee, and even at Jerusalem on one occasion.

Losses from these incidents were painful, as, for example, the terrorist attack on a schoolbus from Moshav Avivim in the Upper Galilee. The I.D.F. response to these attacks was vigorous and included raids across the borders into Jordan and Lebanon. During the first half of the year, the Jordanian army was involved in some of the incidents, using artillery against targets in Israel, including the city of Tiberias. The I.D.F. responded with artillery fire and air attacks.

Terrorism in international air traffic also continued. Terrorists attacked a bus carrying Israeli travelers at the airport of Munich. A Swissair plane flying from Switzerland to Israel was blown up in the air, killing all passengers and the crew. In September, the Palestinians hijacked four planes belonging to different airlines, forced them to land, and blew up one plane in Cairo and three in Zarqa, Jordan. An attempt to hijack an El Al plane was thwarted. The terrorists released the passengers in exchange for the release of comrades imprisoned in Europe.

King Hussein, who opposed the use being made of his kingdom by the Palestinian terrorists, launched a full-scale offensive against them resulting in numerous Palestinians killed and thousands captured in what became known as "Black September." As a consequence, the Palestinians moved their bases to southern Lebanon, which solved the problem for Jordan, but merely shifted the center of tension to the northern border for Israel.

▷ Children in Kiryat Shmona examine a wall hit by shrapnel from Katyusha missiles. The northern town is hit several times during 1970 as are other settlements along the Jordanian and Lebanese border.

◁ A cultural tempest breaks out in the spring when the Cameri theater presents Hanokh Levin's *Queen of the Bathtub*, which questions national values, like self-sacrifice for one's homeland. The play is attacked as antipatriotic and closes shortly after its premiere.

▽ Widespread discontent in Israel in 1970, in cartoonist Dosh's view, aids the Egyptian president.

"The Goldmann affair, Queen of the Bathtub, friction and protest in Israel! Great! They're getting nervous!"

△ Life goes on routinely in the occupied territories. Palestinians attend an agricultural exhibition in al-Bira.

▷ Lea Goldberg, poet, playwright and translator, dies in the winter of 1970 59 years old.

A DARK WINTER FOR LITERATURE

The world of Hebrew letters lost several luminaries during the winter of 1969/70. Yehuda Burla, one of the great story-tellers, whose works focused on the Sephardic communities in Israel and the Middle East, died in November 1969 at the age of 83. Lea Goldberg, poet, playwright and translator, died at the age of 59 in January 1970. S. Y. Agnon, a Nobel Prize-winner for Literature in 1966, died in February 1970 at the age of 82. Natan Alterman, leading poet, translator, and playwright, whose poems appeared for 20 years in the *Seventh Column* in *Davar*, died in March 1970 at the age of 60. Avigdor Hame'iri, poet, writer and satirist, who founded the Kumkum ("Kettle") theater in the twenties, died in April 1970, 83 years old. All five were recipients of the Israel Prize during their lifetimes.

△ For the first time, Israel
takes part in the finals of
the soccer World Cup,

held in Mexico City. The
crowd cheers for Israel in
early playoffs.

▽ A mass rally in Tel-Aviv's
Kings of Israel Square
protests the "Leningrad

Trial" in which a group of
Soviet Jews were convicted
of hijacking an airplane.

January

2 A terrorist attack in Gaza results in the death of two Israeli children and serious injury to their mother.

4 A first Israeli civilian settlement is founded in Pithat Rafiah, in the northern Sinai.

11 The three-millionth citizen of Israel arrives – Natan Zirolnikov, an immi-grant from the Soviet Union.

14-15 An I.D.F. unit attacks two terrorist bases deep in Lebanese territory.

U.N. mediator Gunnar Jarring tours the Middle East and hears the views of all sides regarding the resolution of the conflict.

31 An oil pipeline on the Golan Heights that belongs to the T.A.P. (Trans Arabian Pipeline) line, destroyed by Palestinian terrorists, is made operational again.

February

4 Sadat calls for Israel's withdrawal from the eastern bank of the Suez Canal as a first stage in an overall retreat to the borders of June 4, 1967. He announces his willingness to open the canal to Israeli navigation if Israel agrees to a partial withdrawal.

5 The truce at the Suez Canal is approaching its expiry. Egypt is pre-pared to extend it by a month.

11 Jarring presents his plan: an Israeli withdrawal to the international boundary, a peace agreement, freedom of navigation in the Suez Canal, Egyptian governance of Sinai, and a U.N. force stationed at Sharm al-Sheikh.

14 Israel rejects Jarring's proposal. Egypt accepts it on the 16th, with conditions.

16 A fire breaks out in the Shalom Tower in Tel-Aviv caus-ing damages of IL 1 million.

28 Shmuel Rosenwasser, the guard kidnapped from Metula in January 1970, is returned in exchange for Mahmud Hejazi, a terrorist sentenced by Israel to death and resentenced to 30 years in prison in light of the nonimplementation of the death penalty in Israel.

March

16 U.S. Secretary of State Rogers announces that his country supports an Israeli withdrawal to the boundaries of June 4, 1967. In exchange, the U.S. guarantees Israel's security.

Jews hold protests and de-monstrations in Moscow dur-ing the month demanding per-mission to immigrate to Israel.

April

5 Minister of Defense Moshe Dayan an-nounces at the Labor Party Convention that Israel will not return to the June 4, 1967, lines even if this leads to war.

18 The Maimuna festival, part of the Moroccan Jewish tradition, is celebrated offi-cially in Jerusalem for the first time.

Police arrest five tourists from France for possession of explosives. They are suspected of ties to a Palestinian terror organization.

19 The Tel-Aviv Museum is inaugurated.

Jewish immigration from the Soviet Union increases.

Natan Zirolnikov, an immigrant from the Soviet Union who arrives in 1971, becomes the country's three-millionth citizen.

May

6 Secretary of State Rogers visits Israel on a Middle East trip.

17 Israeli consul in Istanbul Efraim Elrom is kidnapped by a Turkish underground organization. His body is discovered five days later.

18 The Black Panthers organize demonstrations in Jerusalem. Three fire bombs are thrown. The police arrest dozens of demonstrators.

June

1 The newspaper *Davar* ("A Matter") celebrates its 45th anniversary by merging with the daily *Lamerhav* ("Opening Out"), which is closed down.

2 The first El Al jumbo jet is delivered to Israel.

7 Fans of the Bnei-Yehuda soccer team from the Hatikva neighborhood of Tel-Aviv stage a violent protest against perceived discrimi-nation of their team by the

Israel Soccer Association, resulting in injuries, property damage, and arrests. A search of the neighborhood reveals a cache of Molotov cocktails.

11 An oil tanker, the Coral Sea, en route to Eilat, is attacked by bazooka gunfire upon approaching the Red Sea at the Bab al-Mandeb Strait. The ship is lightly damaged.

13 Settlers in Kiryat Arba near Hebron move into the first permanent housing built for them.

21 The reconstituted Jewish Agency holds its founding convention in Jerusalem.

A wave of strikes is held by physicians, hospital administrative personnel, electric company employees, and others.

July

6 Itzhak Tabenkin, Labor movement leader and founder of the Hakibbutz Hame'uhad movement, dies at 84.

7 A Katyusha barrage targeting Petah Tikva, deep in Israeli territory, results in the

Tel-Avivians are promised a new central bus station "in the immediate of future." The station will open only in 1994.

1971

△ An improved economic picture and increased immigration prompt heightened social protest by populations that see themselves as marginalized, most conspicuously by the Black Panthers, young activists of oriental origin from depressed neighborhoods.

▽ The Black Panthers demonstrate in Tel-Aviv, protesting the financial benefits granted to immigrants from the Soviet Union. The banner reads: "When will Abutbul be (treated like) a Feigan?" (Abutbul = Moroccan; Feigin = Russian)

death of three women and one child.

8 An Israel Air Force helicopter explodes over the sea off al-Arish, killing all 10 on board.

15 The Palestinian terrorist cell that launched the Katyushas at Petah Tikva is apprehended.

A portion of the inhabitants of the refugee camps in the Gaza Strip are resettled in permanent housing in al-Arish as part of a government program to thin out the population in the camps.

August

2 The I.D.F. authorities in Gaza call upon the terrorists to turn themselves in, promising them "fair treatment."

4 Three of the younger French nationals who attempted to smuggle explosives into the country with the aim of sabotaging hotels in Israel are sentenced to 17, 12 and 10 years' imprisonment. The remaining two, an elderly couple, are sentenced to eight and four years on the 21st.

8 Sadat reiterates Nasser's slogan: That which was taken by force will be returned by force.

20 In the wake of changes in American fiscal policy, the government devalues the lira from IL 3.50 to IL 4.20 to the dollar.

22 Seventy Jews in the Soviet Union request Israeli citizenship even before they are granted permission to emigrate.

A tripartite meeting between the presidents of Egypt, Syria, and Libya ends with a harsh announcement: No agreement, no negotiations, and no peace with Israel.

23 The Black Panthers stage a violent demonstration in Jerusalem.

September

5-6 A 30-hour strike by Lod airport employees cuts off the country from the outside world.

10 Israel achieves a military feat when a machine-gunner brings down an Egyptian Sukhoi 7 jet that has penetrated Sinai airspace.

17 An Israeli Stratocruiser plane is brought down by a missile ambush laid by the Egyptians in Sinai. Seven on board are killed and one survives.

19 (Rosh Hashanah eve) Israel's population numbers 3,062,000, of whom 2,610,000 are Jews and 452,000 Arabs and others.

29 Egyptian President Sadat announces that 1971 will be a decisive year "in peace or war." He threatens Israel with "heavy blows."

30 Foreign Minister Abba Eban, addressing the U.N., proposes various ways of resolving the crisis in the Middle East, including direct Israeli-Egyptian negotiations.

Demands by Jews in the Soviet Union for permission to immigrate to Israel intensify.

October

1 Egypt rejects Foreign Minister Eban's proposal for direct negotiations.

4 Eban, meeting with Secretary of State Rogers, rejects the American proposal for a temporary Israeli-Egyptian arrangement that would allow the reopening of the Suez Canal.

6 David Ben-Gurion's 85th birthday is celebrated at his home in Kibbutz Sdeh Boker.

9 A hand grenade is thrown near the Western Wall, resulting in 16 wounded.

November

2 The presidents of Nigeria, Senegal, Cameroon, and Zaire arrive for a joint state visit in Israel.

13 News is released for the first time that the surviving ex-prisoners from the Mishap Affair in Egypt are living in Israel.

December

The "Autocars affair" creates a public stir. Irregularities are exposed in an Israeli company producing fiberglass cars. Large discounts have been given to public figures and high-ranking officials.

Sadat repeatedly declares, during the course of the year, that he will sacrifice a million soldiers in order to recapture Sinai.

Inflation in 1971 reaches 12%.

416

ATTEMPTS AT A REGIONAL SOLUTION

The U.N. and the Americans made continuous efforts during 1971-72 to resolve the conflict in the Middle East, with U.N. mediator Gunnar Jarring, Secretary of State William Rogers, and Assistant Secretary of State Joseph Sisco shuttling between the capitals of the region seeking a solution.

Egypt continued to demand total Israeli withdrawal, although Sadat was prepared to accept partial withdrawal as a first step in the process. Israel, for its part, made it clear that it would not withdraw to the June 4, 1967, lines under any circumstances. Prime Minister Golda Meir and Defense Minister Moshe Dayan were explicit that Israel would keep its hold on most of the occupied territories, while on the issue of Sinai it would at most agree to demilitarization. Several announcements made by Dayan implied that war was preferable to a return to the borders of June 4, 1967.

As 1971 drew to a close, Israel became more confident of its position. The War of Attrition along the Suez Canal was subsiding; the country's economic situation had improved rapidly; the U.S. was approaching an election year in 1972, during which pressure on Israel probably would not be applied; and Sadat was perceived as a weak leader more prone to threats than acts.

In the next two years, until the Yom Kippur War, the widespread feeling in Israel was: "We have never had it so good."

△ The I.D.F. toughens its policy in the Gaza Strip following a terrorist incident there in January 1971 in which two Israeli children and their mother are killed. Minister of Defense Moshe Dayan visits a refugee camp in Gaza in May 1971.

▷ Minister of Finance Pinhas Sapir attempts to halt inflation, which reaches 12% in 1971.

△ U.S. Secretary of State William Rogers and Israeli Chief of Staff Hayim Bar-Lev (l.) confer during a flight over southern Sinai. Bar-Lev explains the peninsula's importance for Israel to his guests.

◁ In an unprecedented military development, a salvo of Katyusha missiles is fired at the city of Petah Tikva, not far from Tel-Aviv. The missiles have been smuggled into Samaria from Jordan and launched from an open area. Casualties are three women and a child killed, and many wounded. Property damage is considerable. Shortly afterward, the security forces succeed in tracking down the terrorist cell responsible for the attack.

△ The daily *Lamerhav* ("Opening Out"), issued by the Ahdut Ha'avodah ("Unity of Labor") party, ceases to appear on May 31, 1971. Its last issue announces a merger with *Davar* ("A Matter"). The next day, *Davar* (shown) greets its new readers in the name of *Lamerhav*.

▽ Chairman of the Herut executive committee Ezer Weizman, formerly commander of the air force and minister of transporation, becomes a member of the Histadrut ("Federation of Labor") in early 1971. He is handed the red membership booklet by Secretary-General Itzhak Ben-Aharon.

January

1 David Ela'zar succeeds Hayim Bar-Lev as chief of staff.
2 Ilya Ripps, who in 1969 set himself on fire in Riga, Latvia, to protest Soviet restrictions on immigration to Israel, arrives in the country as a new immigrant.

A new wave of letter bombs reaches Israel.
18 The 28th Zionist Congress opens in Jerusalem.

A cable car is installed at Mt. Hermon on the Golan Heights.

The borders heat up again. Confrontations with Palestinian terrorists occur in the Jordan Valley and the Lebanese border; Katyusha missile attacks target Kiryat Shmona and the northern settlements; and the Israel Air Force attacks terrorist targets in Syria.

February

2 Israel agrees to "close proximity" talks with Egypt with U.S. mediation.
3 Construction of the town of Ofira is begun at Sharm al-Sheikh.
6 The Golden Globe is awarded in the United States to Efraim Kishon's film *Azulai the Policeman*.

Terrorist incidents continue at the northern border. The I.D.F. mounts an operation against terrorist bases in Lebanon on February 26th.

March

1 The Israel Air Force attacks terrorist bases in Syria. The Syrians bomb settlements in the Golan Heights.

Dr. Moshe Sneh, chairman of Maki (Israel Communist Party), dies.
6 Former chief of staff Hayim Bar-Lev is named minister of trade and industry.
30 Ugandan President Idi Amin cuts off diplomatic relations with Israel and expels all Israeli experts and advisors from Uganda.

April

4 Reuven Barkat, speaker of the Knesset, dies at age 67.

Reports state that Israel will be supplied with Hercules planes and Patton tanks by the United States.

May

1 Sadat, at a May 1st ceremony in Alexandria, declares that Egypt is prepared to sacrifice a million soldiers in order to liberate the occupied territories and put an end to "Israeli arrogance" dating back to 1948.
2 Local Arab elections are held in Judea.
8 A Sabena airplane is hijacked by Palestinian terrorists en route from Belgium to Israel. The hijackers demand the release of hundreds of imprisoned terrorists in exchange for the passengers.
9 An I.D.F. force storms the Sabena plane at Lod Airport and takes control of it.

The newly elected speaker of the Knesset is Israel Yesha'yahu of Labor.
14 Secretary-General of the Histadrut ("Federation of Labor") Itzhak Ben-Aharon resigns but retracts his resignation two days later.
15 A nationwide university students strike called to protest a raise in tuition lasts a week.
30 Three Japanese terrorists who arrive at Lod Airport aboard an Air France plane begin shooting indiscriminately, killing 25 and wounding 70. One of the fatalities is internationally noted scientist Aharon Katzir.

June

Terrorist attacks along the Lebanese border continue, including a Katyusha attack on Kiryat Shmona. This time, there are no casualties.

July

11 A bomb laid at Tel-Aviv's central bus station wounds 11 persons.
17 The surviving Japanese terrorist who took part in the massacre at Lod Airport, Kozo Okamoto, is sentenced to life imprisonment.
18 Anwar Sadat orders the expulsion of all Soviet advisors from Egypt.
23 The government decides against the return of the dispossessed Israeli Arabs to their villages, Ikrit and Bir'am in the Galilee.
24 Strike of workers in the chocolate factory Elite lasts two months.

26 Israel links up with international satellite communications upon the inauguration of its satellite ground station in the Elah Valley.

August

9 The Israel Air Force bombs 11 terrorist bases in Lebanon.
14 Two women terrorists are sentenced to life imprisonment for their role in the Sabena hijacking.
16 A booby-trapped record player explodes aboard an El Al flight en route from Rome to Israel. The pilot manages to land the plane safely in Rome. The record player had been given to two British passengers by Arab terrorists before takeoff.
23 The Knesset censures a new practice instituted by the Soviet Union – levying a steep "education ransom" on emigrants to Israel.

September

5 Palestinian terrorists belonging to the Black September organization kill 11 members of the Israeli team at the Olympic Games in Munich.
8 Israeli planes attack terrorist bases in Lebanon intensively.
9 Three Syrian planes are brought down by Israel and a fourth is damaged in an aerial battle.

Kozo Okamoto, at his trial.

16 The I.D.F. carries out a large-scale operation against Palestinian terrorist targets in southern Lebanon.
19 Agricultural Attache to the Israel embassy in London Dr. Ami Shehori is killed by a letter bomb. Similar devices are received in the mail by Israeli legations in other European cities.

1972

October

15 Rabbis Shlomo Goren and Ovadia Yosef are elected Ashkenazi and Sephardi chief rabbis respectively.
30 The Israel Air Force launches a large-scale raid on Palestinian terrorist bases in Syria.

November

5 Meir Lansky, one of the heads of the organized crime in the U.S.A. is expelled from Israel after a long stay.
19 Miriam and Hanokh Langer, formerly declared as "mamzerim" (bastards), are readmitted to the community of Israel by a special court headed by Chief Rabbi Goren.

The military situation on the Golan Heights heats up. Terrorist infiltration and Syrian attacks increase. Israeli planes bring down several Syrian Migs. The Syrians shell Israeli settlements.

December

7 Details of a spy ring in Israel operated from Syria are revealed. Four of the 20 suspects arrested are Israeli Jews with radical leftist views.
16 The U.N. General Assembly announces that all measures adopted by Israel regarding the occupied territories since 1967 are "null and void."
21 Ezer Weizman resigns as chairman of the Herut movement executive committee.

Incidents continue to take place on the Syrian border. Syrian shelling prompts an attack by the Israel Air Force on a military base deep inside Syrian territory.

Immigration from the Soviet Union continues to rise. Newcomers include released Prisoners of Zion.

419

▷ Prime Minister Golda Meir tours the Israeli fortified line (Bar-Lev Line) along the Suez Canal. Egyptian President Anwar Sadat continues to threaten Israel with military steps if it does not withdraw from Sinai, including the "sacrifice of a million soldiers." But his threats are not taken seriously in Israel.

▽ A demonstration demanding the return of dispossessed Israeli Arab residents to the Galilee villages of Ikrit and Bir'am is held in Jerusalem. The government decides against the return to the villages, which were evacuated after the War of 1948.

◁ A new Israeli town, Ofira, is under construction at Sharm al-Sheikh in 1972.

▷ Elections for the Chief Rabbinate in 1972 are won by Rabbis Shlomo Goren (l.) and Ovadia Yosef.

◁ Immigrants are joyful upon arrival in the country in 1972.

IMMIGRATION PEAKS

Immigration to Israel rose steadily in the wake of the Six-Day War of 1967. The newcomers arrived from the east and the west, but mostly from the Soviet Union, at first by the thousands and then, from the early 1970s, more massively. Approximately 56,000 immigrants arrived in 1972, the largest annual figure between 1963 and 1990.

The immigration from the Soviet Union was viewed as a miracle, both because of Soviet efforts to block it or slow it down, and because decades of official suppression of every manifestation of Judaism was thought to have resulted in the extinguishing of Jewish, and certainly Zionist, identity. The Six-Day War, however, revived this consciousness. Israel welcomed this development, yet was also somewhat overwhelmed by the arrival of the rising tide of immigrants. Some Israelis resented the preferential treatment accorded to the newcomers, who were granted housing on special terms and tax-free purchase of cars. Problems of absorption and employment also arose, such as the difficulty of integrating over 3,000 physicians and an even larger number of engineers who arrived from the Soviet Union during the 1970s.

▽ Newly elected speaker of the Knesset Israel Yesha'yahu, of Labor (r.), welcomes visiting French Socialist leader François Mitterand, who will later serve as president of France. Yesha'yahu, the fifth speaker of the Knesset, is a veteran Mapai activist and one of the organizers of Operation Magic Carpet (airlifting of the Yemenite Jews to Israel) in 1949-50. He replaces the deceased

◁ Immigration from the Soviet Union keeps rising. The topic occupies the Israeli public, the media, and the government leadership in light of the obstacles created by the Soviet Union to discourage emigration to Israel. Both new and veteran immigrants mount frequent protests, including hunger strikes, to galvanize world public opinion. Shown, hunger strikers at the Western Wall plaza, spring 1972.

△ May 1972: Immigrants' baggage at Lod airport.

▷ May 1972: Minutes after the terrorist massacre at Lod airport.

THE BLOODY OLYMPICS

A delegation of several dozen Israeli athletes, coaches, and escorts traveled to the Olympic Games in Munich, West Germany, in early September 1972. Not all returned home. Eleven were murdered by the Palestinian terrorist group Black September.

Before dawn on September 5, 1972, eight terrorists entered the Israelis' living quarters with the aim of kidnapping them. Efforts by the Israelis to resist cost two of them their lives. Most managed to escape, but nine were caught by the terrorists, who conducted negotiations with the German authorities for a full day. The Germans proposed a ransom, the exchange of the hostages for German public figures, and other possibilities.

The terrorists insisted on the release of their colleagues imprisoned in Israel. In the evening, the terrorists and the hostages were transported in three helicopters to Fürstenfeldbruck, a military airport 30 km from Munich where a plane stood by, ostensibly to fly them to an Arab state. The German plan, however, was to eliminate the terrorists and rescue the hostages before they boarded. The plan failed and only some of the terrorists were killed. The others blew up the plane with the hostages inside. Apparently, German fire also caused some of the deaths.

The Israeli delegation left the Olympics and returned home. The Games were halted for a single day.

▽ The struggle against terror is waged in the Gaza Strip.

△ Passengers are rescued from the Sabena plane hijacked by Palestinian terrorists at Lod airport in May 1972. Shown in white is the commander of the commando rescue team, Ehud Barak (later chief of staff, foreign minister, and chairman of the Labor Party), disguised as an airplane technician, just after the end of the operation.

◁ Patricia, age 6, traveling by herself on the hijacked Sabena flight, is united with her grandfather at Lod airport.

January

8 The Syrians shell Israeli fortifications and settlements on the Golan Heights. Israel responds with artillery attacks. Six Syrian planes are shot down. Army camps deep in Syrian territory are bombed.

15 In a historic encounter, Golda Meir, the first Israeli prime minister to visit the Vatican, meets with the Pope.

A wave of letter bombs arrives in Israel. A teacher in Kiryat Gat is wounded while opening an envelope.

February

20-21 I.D.F. forces attack seven Palestinian terrorist bases in the Tripoli area in northern Lebanon.

21 Israel Air Force planes bring down a Libyan Boeing that penetrates Sinai airspace and fails to heed warnings. Over 100 are killed and injured.

March

20 The Environmental Protection Service (later, the Environmental Protection Office) begins functioning in the Office of the Prime Minister.

April

3 Simha Dinitz succeeds Itzhak Rabin as Israel's ambassador in Washington.

9 Israel's security services foil a terrorist attempt to hijack an El Al plane and to attack the Israel embassy in Nicosia, Cyprus.

9-10 The I.D.F. carries out daring raids on the main offices of the Palestinian terrorist organizations in Beirut (seven targets) and Sidon (one target).

11 The I.D.F. displays a new rifle, the Galil, produced by the Israel Military Industries.

19 President Nixon reveals that the Soviet Union has suspended the "education ransom" imposed on Jews preparing to immigrate to Israel.

May

7 Israel's 25th Independence Day is celebrated throughout the country and the Jewish world. The I.D.F. holds a large parade in Jerusalem.

18 Avraham Shlonsky, poet, translator and editor, dies at age 73.

Abie Natan opens his Voice of Peace radio station on a ship in the Mediterranean outside Israeli territorial waters.

24 Israel's new president is Professor Efraim Katzir (Katchalski), succeeding Zalman Shazar.

In the second half of May, fears of an Egyptian-Syrian attack are raised. The I.D.F. is on the alert, but nothing happens. Dayan however warns the senior command of a forthcoming war with Syria and Egypt by the end of the summer.

June

3 In a P.O.W. exchange with Syria, three Israeli pilots are released in exchange for 46 Syrian soldiers and officers.

A prolonged physicians' strike takes place during the month.

July

1 Col. Yosef (Joe) Allon, an Israeli air attache in the United States, is shot and killed in Washington by Fatah terrorists.

5 The physicians' strike ends.

15 The I.D.F. plans to shorten the military service for men from 36 to 33 months. The service for women remains 20 months long.

27 Israelis are arrested in Norway on suspicion of murdering a waiter of Morrocan origin, Ahmed Bushiki. Israeli-Norwegian relations are strained.

August

10 Israel forces down a Lebanese passenger plane flying from Lebanon to Iraq on the suspicion that several senior figures in the Popular Front for the Liberation of Palestine are aboard. The plane is released two hours later when a search reveals that the persons in question are not aboard.

15 The U.N. Security Council unanimously censures Israel for the interception of the Lebanese plane.

The I.D.F. spokesman confirms reports that North Korean pilots are flying Mig 21 planes for Egypt.

September

11 The Likud movement is established, made up of the Herut-Liberal bloc (Gahal), the State List, the Free Center Party and activists from the Greater Land of Israel movement.

13 Israel brings down 13 Syrian planes in aerial battles. One Israeli Mirage is shot down but its pilot is rescued.

25 The Civil Rights Movement – Ratz – is established.

Of 22 lists submitted for the elections to the Eighth Knesset, 12 are new.

28 Palestinian terrorists kidnap a group of immigrants from Russia who are in transit to Israel by way of Austria. The terrorists demand that Austria close down the Jewish Agency immigrant transit center at Schoenau. The Austrians comply.

October

6-24 The Yom Kippur War is fought. Egypt and Syria attack Israel.

16 Foreign airlines, with the exception of Air France and Sterling (Denmark), halt flights to and from Israel.

17 The Arab states use the oil weapon as part of their efforts to isolate Israel during the Yom Kippur War.

22 The U.N. Security Council adopts Resolution 338 calling for a cease-fire in the Middle East.

29 The first Egyptian relief convoy, carrying medicine, food and water, is permitted by Israel to link up with Egypt's besieged Third Army.

30 Elections for the Eighth Knesset, scheduled for this day, are postponed until December 31st.

Most of the African states break off diplomatic relations with Israel in the aftermath of the Yom Kippur War.

November

6 The I.D.F. holds some 8,000 Egyptian and Syrian P.O.W.s, 643 of whom are officers.

11 Israel and Egypt sign an agreement stabilizing the cease-fire at Kilometer 101 on the Cairo-Suez highway west of the Suez Canal.

15 P.O.W.s exchanges begin

1973

between Israel and Egypt. Israel returns over 8,000 prisoners and receives 233, including nine who were taken captive during the War of Attrition.

17 Histadrut ("Federation of Labor") Secretary-General Itzhak Ben-Aharon resigns from his post.

18 The government establishes a commission of inquiry headed by Supreme Court President Shim'on Agranat to investigate the events of the Yom Kippur War (the Agranat Commission).

A worldwide oil crisis develops as a result of the Arab oil boycott. Israel, too, faces the problem of fuel supplies.

December

1 David Ben-Gurion dies at age 87.

21 The Geneva Conference – peace conference on the Middle East – opens with the participation of Israel, Egypt, Jordan, the U.S., and the U.S.S.R. It constitutes a framework for the separation of forces agreements between Israel, Egypt, and Syria.

31 Elections to the Eighth Knesset are held. The Alignment is weakened but retains its leading position with 51 seats, followed by Likud 39, N.R.P. (National Religious Party) 10, Agudat Israel and Po'alei Agudat Israel 5, Independent Liberals 4, Communists 4, Civil Rights Movement 3, the Arab lists 3 and Moked (a far left grouping) 1.

Inflation in 1973 spirals to 20%.

ISRAELI COUNTERSTRIKES ABROAD

Israel's struggle against Palestinian terrorism continued unabated after the Six-Day War of 1967, moving out of the country's borders in response to terrorist attacks against Israeli and Jewish targets far from Israel. According to reports in the West, Israel decided, in the wake of the murder of the Israeli athletes in Munich in September 1972, to strike at the terrorist leaders systematically, especially in the Black September group, which was responsible for the murders in Munich.

A number of terrorist leaders were indeed killed during 1973 (and thereafter) in Europe and in the Arab countries in various types of operations. I.D.F. forces attacked deep inside Lebanon, targeting terrorist bases in Tripoli (February 21, 1973) and Black September headquarters in Beirut (April 10), with heavy losses to the Palestinians.

There were also failures, however, such as the Lillehamer affair in Norway in July 1973 when a Moroccan waiter, Ahmed Bushiki, was wrongly identified as Black September leader Hassan Ali Salameh and mistakenly murdered.

The terrorists kept up attacks both in Israel and abroad during all of 1973. Abroad alone, dozens of incidents were reported. Among them, murders of Israelis, letter bombs sent to Israelis and to Jews, attempts to attack Israeli legations and El Al planes, and attempts to kidnap Soviet Jewish emigrants who were on their way to the transit camps.

▽ Moshe Dayan, minister of defense for over six years, warns in May 1973 of the possibility of an imminent Egyptian-Syrian attack.

△ A new president, Prof. Efraim Katzir, is elected in May 1973.

△ State visits by German personalities generally prompt protest demonstrations, as when German Chancellor Willy Brandt arrives in June 1973.

"LOW PROBABILITY OF WAR"

Israel, in the fall of 1973, viewed itself as a power. Its territory stretched from Mount Hermon to Sharm al-Sheikh and from the Jordan River to the Suez Canal; the Israel Defense Forces was large and strong, preserving calm along the Egyptian border for over three years; the Syrian enemy did not appear to constitute a threat; President Sadat of Egypt was not perceived as a charismatic figure in the Arab world; and the Israeli economy had improved.

In contrast to this sanguine atmosphere, a growing number of reports pointed to Egyptian-Syrian intentions to attack Israel. These reports were not given much weight by the country's political and military leadership. The abiding security perception attached low probability to a joint attack of this sort, while the prospect of Egypt or Syria attacking on their own was dismissed.

Although signs of war on the enemy side mounted in early October, the original conception did not change. The chief of Intelligence continued to attach "low probability" to the outbreak of a war, viewing the large-scale army concentrations across the Suez Canal and opposite the Golan Heights as maneuvers only.

In the early morning hours of Yom Kippur, however, it became incontrovertibly plain that Syria and Egypt were about to launch a war that very day. Chief of Staff Ela'zar demanded approval for a preemptive air strike, but the minister of defense and the government demurred, deciding on a call-up of the reserves alone. At 2 p.m. that afternoon, when the Egyptians and the Syrians attacked massively, Israel was not ready.

△ Israel, represented by Golda Meir, simultaneously faces off Egypt, represented by Sadat (l.), and Syria, represented by Assad, in a caricature by Ze'ev (Ya'akov Farcas) at the beginning of the Yom Kippur War.

Citizens of Israel, today, close to 2 p.m., the Egyptian and Syrian armies mounted an attack on Israel. They launched a series of air, armor, and artillery attacks in Sinai and in the Golan Heights. The Israel Defense Forces fought and repulsed the attack. The enemy incurred serious losses... Our enemies hoped to surprise the citizens of Israel on Yom Kippur. Our attackers thought that on Yom Kippur we would not be prepared to fight back. We were not surprised.

Prime Minister Golda Meir on the day of the outbreak of the Yom Kippur War.

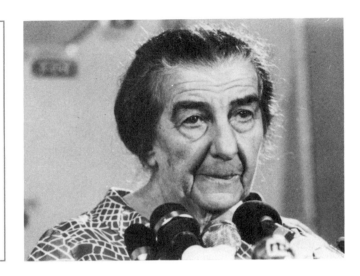

△ Her expression resolute and her glance penetrating, Prime Minister Golda Meir informs the nation and the world of the Egyptian-Syrian attack on October 6, 1973. The first days of the war are extremely hard and painful.

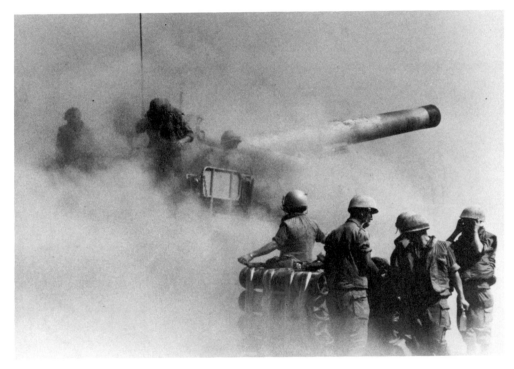

◁ A 203 mm Israeli canon in action on the Golan Heights on the fifth day of the Yom Kippur War. Initially, Syrian armored forces advanced rapidly over the Golan Heights, seemingly unstoppable. The situation along the Suez Canal is no better, where the Egyptians have taken over most of the Bar-Lev Line.

THE YOM KIPPUR WAR

The Yom Kippur War lasted 18 days, from October 6th (Yom Kippur) to the 24th, 1973. Taking the I.D.F. along the Suez Canal and on the Golan Heights by surprise, the Egyptian and Syrian armies attained initial success. Within several days, however, the situation was reversed when the I.D.F. began pushing the Syrians back over the Golan, followed, in the south, by the Israeli crossing of the Suez Canal.

Over 2,500 Israeli soldiers were killed in the war, 7,500 were wounded, 300 were taken prisoner. The blow to Israeli morale was profound both because of the extent of the casualties and because of the element of surprise that undermined the perception of the I.D.F.'s invincibility.

When large Egyptian forces crossed the Suez Canal on October 6th, they faced Israeli fortified positions on the other side manned by several hundred soldiers only.

The number of Israeli tanks on hand was also small, as against thousands deployed by the enemy. The Egyptians quickly laid bridges over the Canal and brought up massive quantities of armor, equipment and soldiers. Israeli armored reserve units that were dispatched to the south failed to block the Egyptian advance and Israeli counterattacks were repulsed, causing large losses. The Syrian campaign on the Golan Heights similarly made impressive gains on the ground during the opening days of the war until the I.D.F. was able to deploy sufficient forces to drive the Syrians back. By the end of the war, Israel, and Egypt were nominally even: each side had crossed the Suez Canal and captured a part of the enemy's territory. On the Syrian front however, the war ended in Israel's favor. After driving the Syrians back over the Golan, the I.D.F. proceeded deep into Syria and stopped only 40 km from Damascus.

▽ The "eyes of the country" – the highest I.D.F. fortified position on Mt. Hermon – falls to the Syrians on the first day of the war. A Golani Brigade force tries to recapture the position on October 8th but fails. The brigade finally retakes it near the end of the war, on October 21st, suffering heavy casualties. At the same time, a paratrooper unit takes control of the "Syrian Hermon," which completes the Israeli conquest of the tall mountain.

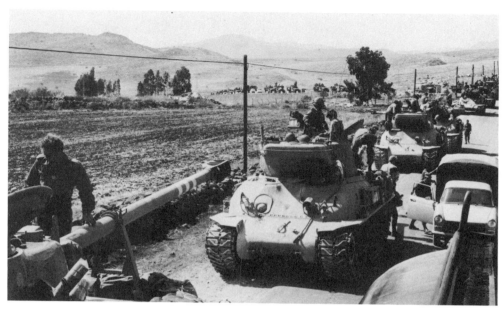

△ A variegated Israeli armored column, not entirely in regimental formation, moves toward the battle arena. Old Sherman tanks take part, too.

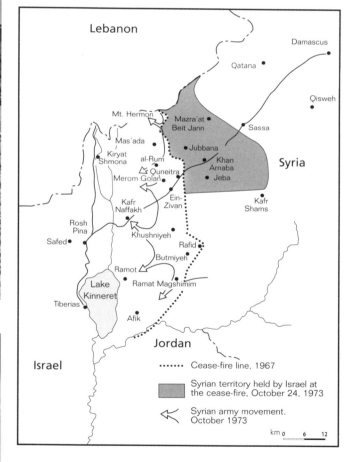

◁ Chief of Staff David Ela'zar ("Dado") addresses a press conference on October 8, 1973.

△ Battle map of the Golan Heights front. Following initial Syrian success, the I.D.F. takes the initiative.

427

△ Sinai scene, October 1973: An improvised I.D.F. position not far from the Suez Canal. The truck at left, a dairy delivery van, is one of many civilian vehicles recruited by the army during the war.

▽ Golan scene, October 1973: Prime Minister Golda Meir, Defense Minister Moshe Dayan, and chief of the Northern Command Major General Itzhak Hofi at an improvised encounter with soldiers at the northern front.

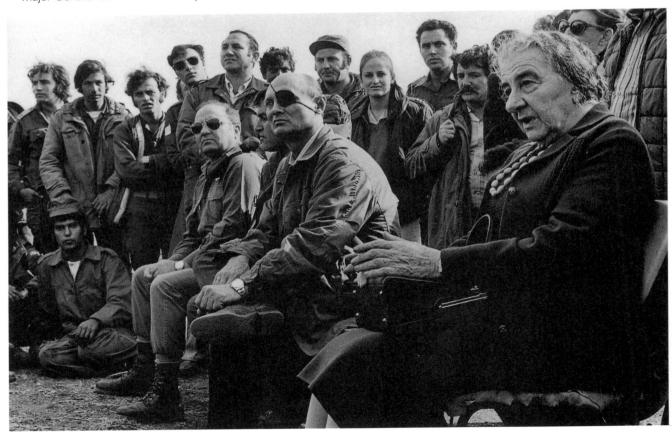

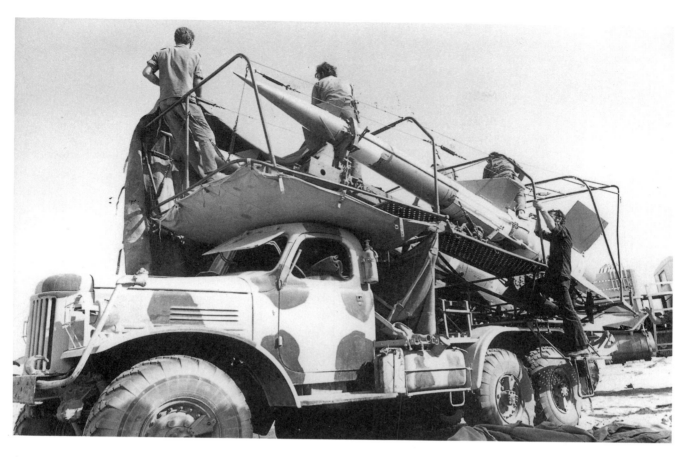

△ A Soviet Sam 3 missile captured by the I.D.F. at the Egyptian front is transported to Israel.

▽ A battle plan is studied at a high-level consultation in the desert involving (l. to r.) Maj. Gen. Avraham Adan ("Bren"), Lieut. Gen.(Res.) Hayim Bar-Lev, Minister of Defense Moshe Dayan and Maj. Gen. Ariel Sharon (bandaged).

▽ A bridge laid over the Suez Canal by the Israelis under heavy fire allows the I.D.F. to cross westward. The first forces to cross over are from Maj. Gen. Ariel Sharon's division.

▷ The Egyptians overpower every Israeli fortified position along the "Bar-Lev Line" save the northernmost one at Port Fuad, and take control of a narrow strip along most of the Suez Canal. A few days later, the I.D.F. manages to push the front to the western side of the Canal, capturing a large area there.

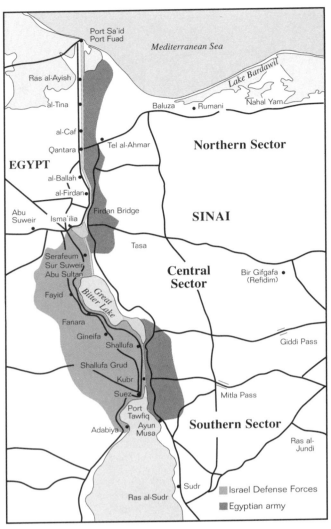

EGYPT

Mediterranean Sea

Lake Bardawil

Port Sa'id
Port Fuad

Ras al-Ayish

al-Tina

Baluza · Rumani

Nahal Yam

al-Caf

Northern Sector

Qantara

Tel al-Ahmar

al-Ballah

al-Firdan

Abu Suweir

Isma'ilia

Firdan Bridge

SINAI

Tasa

Serafeum
Sur Suweir
Abu Sultan

Central Sector

Bir Gifgafa
(Refidim)

Fayid

Great Bitter Lake

Fanara

Gineifa

Shallufa

Giddi Pass

Shallufa Grud

Kubr

Suez

Mitla Pass

Port Tawfiq

Adabiya

Ayun Musa

Southern Sector

Ras al-Jundi

Sudr

Ras al-Sudr

■ Israel Defense Forces

■ Egyptian army

◁ An entire Egyptian army that has crossed the Suez Canal south of the Great Bitter Lake is under siege by the I.D.F. on the eastern bank, a development that serves as a bargaining chip for Israel. Shown: a relief convoy with water supplies for the besieged Third Army.

▽ The Egyptian view of the Yom Kippur War is reflected in a cartoon in the Cairo *Akhbar al-Yaum* ("Today's News") on October 11th: "The victory that swallowed the defeat." (l.) 5 June (1967); (r.) 6 October (1973).

430

△ A bridge over the fresh water canal makes for a scenic landscape in the area captured by the I.D.F. west of the Suez Canal.

▽ As in previous wars, thousands volunteer on the home front. Here, a volunteer paints headlights dark blue, required by blackout regulations.

◁ Military negotiations between the two sides are conducted at the end of the war in a tent set up in the desert at Kilometer 101 on the Cairo-Suez highway – the most forward point reached by the I.D.F. during the war.

▽ Jewish artists from abroad volunteer their services for Israel's war effort. Here, actor Danny Kaye, who arrives to entertain war-wounded soldiers, performs at the Mann Auditorium in Tel-Aviv.

▷ The Arab countries announce an oil boycott in October 1973. Fuel prices rapidly soar. Fuel rationing is instituted in Israel, and car-owners are required to designate one "carless" day weekly, marked on a windshield sticker.

▽ Demonstrators during the country's brief election campaign in late 1973 call for Defense Minister Moshe Dayan to resign because of his failure to anticipate the Yom Kippur War.

▷ Prime Minister Golda Meir votes in the elections for the Eighth Knesset. She is reelected, but will step down several months later.

▽ A wounded soldier at Tel-Hashomer hospital votes in the elections for Knesset held slightly over two months after the end of the Yom Kippur War. The elections do not result in a change in the country's political lineup. The political upheaval will take place in 1977.

Yoram Gaon stars in *Casablan*, the hit musical of the 1960s produced by Giora Godik which deals with the hardships of integration of the oriental community in Israel.

▷ Israel's first sky-
scraper, the Shalom
Tower, is built in
Tel-Aviv on the site
of the abandoned
Gymnasia Herzliya
on Ahad Ha'am
Street.

מגדל שלום מאיר

△ The I.D.F. continues
its tradition of hold-
ing a large parade
on Independence
Day. Painting by
Perry Rosenfeld.

▷ Israeli agriculture is
mechanized inten-
sively during the
1960s, including in
the Bedouin sector
in the Negev.

△ Left: Three leaders
who pass away
during the 1960s are
commemorated on
Israeli currency bills
(top to bot.): Itzhak
Ben-Zvi, Moshe
Sharett, and Levi
Eshkol. Right: David
Ben-Gurion resigns
as prime minister in
1963.

◁ Prime Minister
Eshkol pays a state
visit to the U.S. in
1964. He and his
wife Miriam, are
welcomed by Presi-
dent Johnson (l.) and
Lady Bird (in red).

435

THE SIX-DAY WAR

△ The Six-Day War insignia awarded to all participating soldiers.

▷ The I.D.F. breaks through to the Old City of Jerusalem on June 7, 1967. Shown: The Lions' Gate (St. Stephen's Gate).

△ The price of victory: An improvised monument in Jerusalem erected by soldiers in a paratroop unit in memory of their comrades who fell in battle.

▽ The hero of the Six-Day War is Moshe Dayan, who takes up the position of minister of defense only days before the outbreak of the war, yet overshadows all the I.D.F. commanders and the other political leaders.

◁ One of the best-known photos of the Six-Day War: A young tank officer, Yossi Ben-Hanan (later a major general), holds up an Egyptian Kalatchnikov rifle in the Suez Canal.

▷ The country expands after the Six-Day War. The Central Command Entertainment Troupe is photographed with a view of the Jordan River north of the Dead Sea in the background – territory formerly in Jordanian hands.

▽ The Western Wall plaza is enlarged to accommodate crowds of visitors. Painting by Shmuel Katz.

The Americans make concerted efforts to mediate between Israel and the Arab states following the Six-Day War. Shown is Secretary of State William Rogers (l.) being welcomed by Foreign Minister Abba Eban.

△ Wedding of the year: Ya'el Dayan (2nd from r.), daughter of Defense Minister Moshe Dayan, writer and later a M.K., weds Col. Dov Sion in 1967. At left: Brother Assi Dayan and his wife Aharona.

◁ Israel's 20th anniversary is celebrated extensively in the spring of 1968, focusing especially on the Six-Day War victory less than a year previously. Shown: the official commemorative anniversary poster.

439

The open bridges policy initiated by Minister of Defense Moshe Dayan several weeks after the Six-Day War evokes admiration both at home and abroad. The bridges across the Jordan River are opened to the passage of people and goods between the occupied territories and Jordan (three photos at left and below).

△ The War of Attrition along the Suez Canal ends in August 1970, to be followed by a period of calm that will last over three years. Israeli soldiers feel secure at the shoreline.

▽ The I.D.F. occupies a central place in Israeli life in the late 1960s, reflected even in new year greeting cards.

רק עליהם
אפשר לסמוך

אמת
המערך

△ American Jewish
pianist Arthur
Rubinstein is a local
cultural idol who
comes to Israel fre-
quently to perform.

◁ The election poster
reads: "Only they
can be counted on."
The Alignment
candidates in 1973 are
(clockwise) Golda
Meir, Allon, Ya'ari,
Eban, Sapir, and
Dayan. Prior to the
Yom Kippur War,
the Alignment had
nearly an absolute
majority in the
Knesset.

◁ The last large-scale
I.D.F. parade is held
in Jerusalem in 1973,
marking the coun-
try's 25th anniversary.

441

▷ The early 1970s witness a vast cultural blossoming in Israel. The Israel Philharmonic performs throughout the country, including at Sharm al-Sheikh in 1973.

▽ Famous film stars continue visiting Israel, such as Elizabeth Taylor, who arrives as a guest of Variety to aid disabled children.

THE YOM KIPPUR WAR

△ The Yom Kippur War insignia.

◁ A burnt tree on the Golan Heights – the Israeli flag waves again after the grim battles.

▽ Blood, fire, and columns of smoke in Sinai, October 1973.

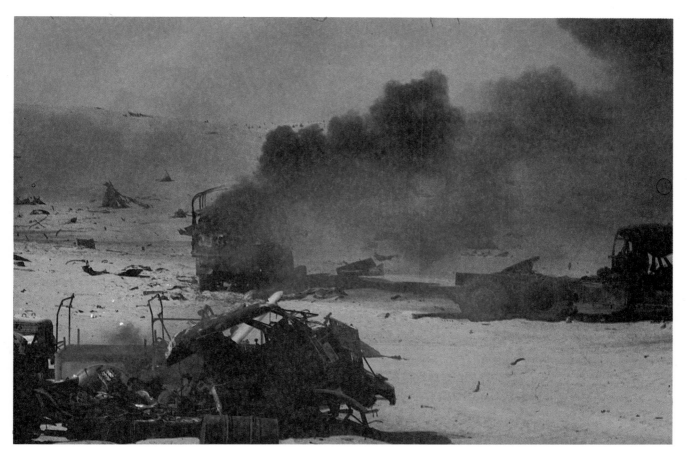

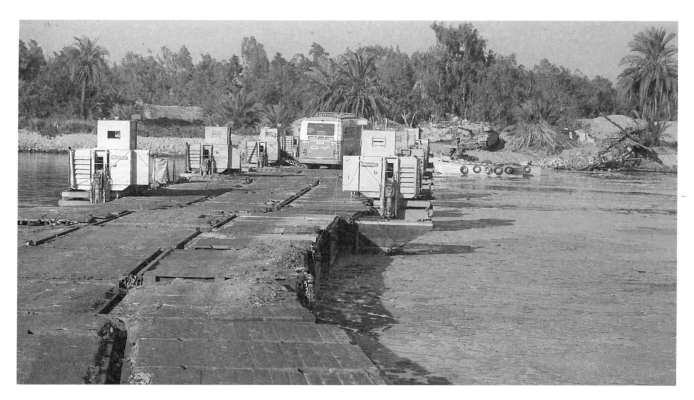

△ Bridge over the canal. Laid under heavy fire, the Israeli bridge over the Suez Canal enables the passage of troops to the west bank in an area that becomes known as the "Land of Goshen."

▽ Some of the approximately 8,000 Egyptian P.O.W.s taken by the I.D.F. during the Yom Kippur War are shown in this picture taken in Sinai shortly after the war has ended.

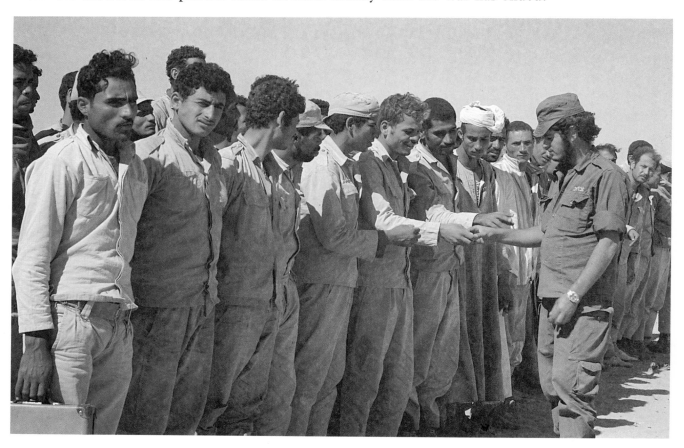

△ The Israelis (l.) face the Egyptians (r.), with the U.N. delegation at the center, in the separation-of-forces negotiations that take place in a tent at Kilometer 101 west of the Suez Canal. The talks are conducted in a surprisingly congenial atmosphere.

▽ The toll of the war is heavy – over 2,500 Israeli dead and thousands wounded. Talk of failure to perform during the first days of the war is widespread after the fighting ends, and the Agranat Commission is appointed to inquire into the events of the war.

▷ Itzhak Rabin, the first sabra (native-born Israeli) to become prime minister, is elected eight months after the Yom Kippur War. Yigal Allon (r.) serves as foreign minister.

△ Noted artists continue to arrive in Israel during and after the Yom Kippur War. Singer Enrico Macias is a frequent visitor.

▷ A poster with the message "Am Israel Hai" (The People of Israel Live) by Paul Kor is distributed in 1974.

we are all in the same boat

GIVE NOW TO THE JOINT ISRAEL APPEAL

446

△ Begin (l.) and Sadat (c.) emerge as a surprising pair of Middle Eastern leaders during the latter 1970s and are awarded the Nobel Prize for Peace in 1978.

▽ Richard Nixon is the first American president to visit Israel while in office, in June 1974. He is shown (standing) at a reception in the Knesset.

▷ Artist Tartakover, asked to design a poster for the country's 30th anniversary in 1978, uses the word "shalom" (peace) and highlights the letter *lamed*, which signifies 30. A month later, Sadat arrives in Israel, leading to the erroneous assumption that it was the visit that inspired the prescient artist.

▽ An envelope bearing the first-day issue of a stamp commemorating the peace agreement with Egypt in March 1979 is sent to several dozen Israeli artists with the request that they sketch their impression of peace. Shown: artist Streichman's drawing.

שלום

שנת השלושים לעצמאות ישראל

...WHO SPREADETH THE TABERNACLE OF PEACE OVER US AND OVER ALL HIS PEOPLE ISRAEL AND OVER JERUSALEM.

448

January

2 An Israeli Hawk missile mistakenly hits Israeli oil refineries at Abu Rudeis in Sinai, causing a massive fire.

11 Secretary of State Henry Kissinger begins shuttle talks with Israel and Egypt aimed at attaining a separation of forces.

14 Fuel prices in Israel soar by 40%-100%.

18 The Israeli and Egyptian chiefs of staff sign a separation of forces agreement. Despite the existing ceasefire, incidents between the two armies had proliferated. Following the separation of forces agreement, the I.D.F. begins evacuating its positions in the "Land of Goshen" west of the Suez Canal and the Egyptians thin out their forces east of the Canal.

21 President Katzir assigns the task of forming a new government to Golda Meir.

February

10 A grass roots protest movement targets the political and military establishment in the wake of the events of the Yom Kippur War. One of its dominant figures is Moti Ashkenazi, the commander of the fortification at the north of the Suez Canal, the only fortification that did not fall to the Egyptians.

25 The I.D.F. completes its evacuation of the territory it captured west of the Suez Canal.

Gush Emunim, a religious Zionist settlement movement, is formed, aimed at intensified settlement of all territories of Eretz Israel, especially in the West Bank and the Gaza Strip.

March

10 A new government comprising the Alignment, the N.R.P. (National Religious Party) and the Independent Liberals is approved by the Knesset.

The number of Israeli military fatalities during the Yom Kippur War is 2,522. Of these, 609 were officers.

Protest rallies are held throughout the country demanding the resignation of Prime Minister Golda Meir and Defense Minister Moshe Dayan for their role in the Yom Kippur War.

April

1 The Agranat Commission issues a partial report recommending the termination of service of Chief of Staff David Ela'zar and the transfer from their posts of Intelligence Chief Eli Ze'ira and several other officers. The chief of staff announces his resignation. He is temporarily replaced by Maj. Gen. Itzhak Hofi.

6 The I.D.F. repulses a Syrian attempt to wrest control of the Mt. Hermon peak from Israel, in control of the area since the Yom Kippur War.

11 Prime Minister Golda Meir tenders her resignation and the resignation of her government to President Katzir in the wake of the implications of the Agranat Commission report.

A major terrorist attack on Kiryat Shmona results in 18 fatalities, consisting of 8 children, 8 adults, and 2 soldiers. Israel responds on April 12th with a raid on six villages in southern Lebanon known to harbor Palestinian terrorists.

14 The new chief of staff is Lieut. Gen. Mordechai ("Motta") Gur.

26 President Katzir assigns Itzhak Rabin, outgoing minister of labor, the task of forming a new government.

Syrian forces confront the I.D.F. during the entire month on the ground, in artillery duels, and in the "Syrian enclave" east of the Golan Heights, taken by Israel during the Yom Kippur War.

May

15 Palestinian terrorists take control of a school in the town of Ma'alot, causing the death of 21 pupils and 3 adults, with dozens wounded.

16 In retaliation for the Ma'alot attack, the Israel air and navy forces shell Palestinian terrorist targets in Lebanon.

31 Israel and Syria sign a separation of forces agreement in Geneva. Israel evacuates from the "Syrian enclave" and from Quneitra.

June

1 A P.O.W. exchange with Syria begins: 65 Israeli soldiers are returned in exchange for 408 Syrians.

3 Itzhak Rabin's government is ratified by the Knesset by 61 to 51 with 5 abstentions. New faces include ministers Shim'on Peres – defense, and Yehoshua Rabinovitz – finance.

12-24 United States President Richard Nixon visits the Middle East, including Israel.

Terrorist attacks in Israeli territory continue. Among them: infiltration into Kibbutz Shamir and murder of 3 women (6.13); infiltration into a residence in Nahariya and murder of a mother and her two children (6.24).

25 The separation of forces on the Syrian front is completed.

July

8-9 The Israeli navy carries out a large-scale operation against terrorist naval bases along the Lebanese coast.

10 The Agranat Commission submits a second interim report.

25 Several hundred Jewish settlers arrive at Sebastia in the West Bank with the intention of erecting living quarters without the approval of the government. A confrontation develops with I.D.F. soldiers. The incident ends on July 29th with the forcible evacuation of the settlers by the army.

August

Confrontations with Palestinian terrorists continue on the Lebanese border and in "Fatah-land," an area of southern Lebanon controlled by Fatah.

18 The head of the Greek Catholic Church in Jerusalem, Archbishop Hilarion Capucci, is arrested on suspicion of smuggling arms and ammunition hidden in his car to Fatah.

September

Terrorist incidents continue in Israel. The I.D.F. responds with attacks in southern Lebanon.

October

5 Zalman Shazar, Israel's third president, dies at age 85.

1974

14 In a measure passed by a large majority, the U.N. General Assembly invites the P.L.O. to join it, with observer status.

November

8 The Israeli lira is devalued from IL 4.20 to IL 6.00 to the dollar. The government cancels subsidies on basic commodities and temporarily bans car imports. Protests are mounted throughout the country.

13 Yasser Arafat delivers an anti-Israel diatribe at the U.N. General Assembly, asserting that the Jews are not a nation and have no right to a state of their own.

Katyusha missile salvos are fired at Kiryat Shmona, Safed, and Moshav Dovev.

19 Palestinian terrorists infiltrate into the town of Bet-She'an, killing 4 residents and wounding 20.

22 The U.N. General Assembly recognizes the Palestinians' right to self-determination and grants the P.L.O. the status of permanent observer in all bodies of the organization.

December

9 Archbishop Capucci is sentenced to 12 years in prison for smuggling arms.

10 The P.L.O. headquarters in Beirut are hit by missiles fired from passing cars. The terrorists blame Israel for the act.

11 A terrorist throws a hand grenade into the Chen cinema in Tel-Aviv during the screening of a film, causing 2 fatalities and approximately 60 wounded.

Inflation doubles in 1974, from 20% to 39.7%.

THE AGRANAT COMMISSION

Responding to the pressure of public opinion in the wake of the Yom Kippur War, the government formed a state commission of inquiry to investigate the reasons for Israel's "mehdal" (failure due to oversight) regarding the war. The commission, headed by Supreme Court President Shim'on Agranat, included Supreme Court Justice Moshe Landau, State Comptroller Itzhak Nebenzahl, and two former chiefs of staff, Lieut. Generals (Res.) Yigael Yadin and Hayim Laskov. Its mandate was to investigate two issues: The information available during the period preceding the war as to the enemy's moves and intentions, and the evaluations by the military leaders concerned; and the preparedness of the I.D.F. before the war and its functioning during the first two days of the fighting.

In an interim report issued on April 1, 1974, the commission found that the I.D.F. had received appropriate information regarding Egyptian and Syrian preparations but it was not interpreted correctly because of the adher-

ence to a mistaken conception, namely that Egypt would not attempt a war without a strong air force, which was not achievable in late 1973. Additionally, the senior echelons of the I.D.F. assumed there would be sufficient advance warning to preclude any surprise. The commission also criticized the army's state of alertness before the war. It recommended terminating Chief of Staff Ela'zar's term of office and transferring Intelligence Chief Ze'ira, Chief of the Southern Command Maj. Gen. Gonen (Gorodish), and several senior intelligence officers from their posts.

However, the commission did not deal with the ministerial responsibility, considering it a political issue. This became the subject of bitter public debate, with criticism voiced at the forced resignation of the chief of staff while the minister of defense Moshe Dayan retained his position. However, when Rabin formed a new government in July 1974, Dayan was excluded.

▷ The five-member Agranat Commission (l. to r.): Lieut. Gen. (Res.). Yigael Yadin, Supreme Court Justice Moshe Landau, President of the Supreme Court Justice Shim'on Agranat, State Comptroller Itzhak Nebenzahl and Lieut. Gen. (Res.). Hayim Laskov. The commission, convening nearly daily during most of 1974, hears hundreds of witnesses and experts. After 2 interim reports, it issues its final report on 30 January 1975. Most of the collected material is classified.

◁ Noted "refusenik" Sylva Zalmanson of the U.S.S.R. arrives in Israel after a long ordeal.

△ Settlers confront the I.D.F. in Sebastia over unsanctioned settlement activity in the West Bank.

△ A traumatic photo in 1974: An Israeli soldier who has participated in the effort to overpower terrorists holding dozens of pupils hostage in the northern town of Ma'alot carries out one of the wounded survivors – his own sister. 21 pupils and 3 adults are killed in the course of the rescue operation.

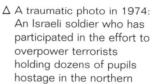

△ Minister of Defense Dayan vacates his post in June 1974, following Prime Minister Meir's resignation in the wake of the Agranat Commission report.

▷ Archbishop Hilarion Capucci is arrested while attempting to smuggle weapons and ammunition hidden in his car intended for Fatah terrorists.

451

THE SECOND GOVERNMENT IN 80 DAYS

Prime Minister Golda Meir's government, ratified by the Knesset on March 10, 1974, was in office only a month when, in the wake of the first interim report published by the Agranat Commission, the prime minister tendered her resignation. New efforts to form another government focused on the central issue of who would fill the office of prime minister. Golda Meir had left the stage. Moshe Dayan was no longer a candidate as a consequence of the Yom Kippur War. Finance Minister Pinhas Sapir refused, as did Yigal Allon. The Labor Party had to choose between two new candidates – Itzhak Rabin and Shim'on Peres.

Rabin, backed by the veteran leadership, won out over Peres by a small margin and began the task of coalition-building. But the N.R.P. (National Religious Party), whose coalition was necessary to reach a majority, refused to join. Discord followed in the Labor Party on the question of admitting the new Civil Rights Movement – founded by Shulamit Aloni – to the government. Golda Meir, who still enjoyed wide influence within the party, was against it. Nevertheless, Rabin coopted the Civil Rights Movement in early June 1974, giving him a bare majority of 61 M.K.s.

The new government had many new faces. Most of the ministers had not served in the government that had been in office during the Yom Kippur War. For the first time, the prime minister of Israel was a sabra – a native-born Israeli. The defense portfolio was given to Shim'on Peres, who from then on played a central role in the party leadership.

▽ "They don't care," the placard reads in a demonstration against Golda Meir's government.

△ The primary target of popular resentment after the Yom Kippur War is Defense Minister Moshe Dayan. Thousands take to the streets to demonstrate. One placard reads: "Dayan go to the Likud."

▷ U.S. Secretary of State Henry Kissinger (2nd. from r.) shuttles between the capitals of the region during 1974. Here he shares a light moment with Foreign Minister Abba Eban (far r.) on a visit to Israel in January.

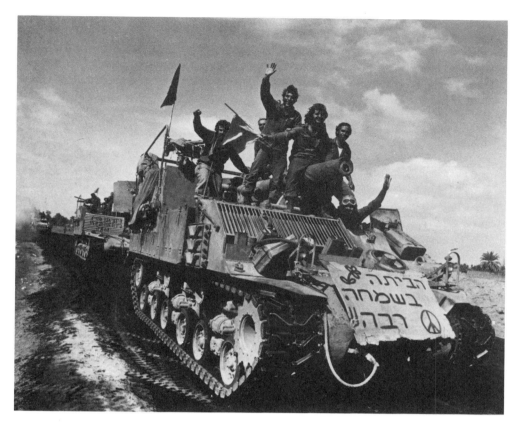

△ The minister of finance in the new government of June 1974 is Yehoshua Rabinovitz.

◁ Returning to Israel from the "Land of Goshen" winter 1974. The sign reads: "Glad to go home!"

▽ Returning to Israel from the "Syrian enclave" summer 1974.

A WAR OF ATTRITION IN THE SOUTH AND THE NORTH

Although the Yom Kippur War had ended, neither Egypt nor Syria stopped firing completely, while at the same time the Arabs kept up the oil boycott against the west. Israel responded to ongoing attacks against its forces in kind and battles broke out periodically, especially in the enclaves held by Israel deep in Egyptian and Syrian territory.

This war of attrition continued for approximately three months on the Egyptian front, until January 18, 1974, when the Israeli and Egyptian chiefs of staff signed a separation of forces agreement and Israel committed itself to evacuating the territory it held west of the Suez Canal. All fighting then ceased.

The fighting went on longer, however, on the northern front. At first limited to incidents – sometimes on a daily basis – the confrontations developed into all-out warfare in mid-March 1974 when the Syrians began massive shelling and attacks by armored, infantry, and commando units. The I.D.F. responded aggressively, using air support, causing the Syrians heavy losses. This war, carried out in the Golan Heights, Mt. Hermon, and the enclave in Syrian territory captured by Israel during the Yom Kippur War, continued until the end of May 1974 when Israel and Syria signed a separation of forces agreement. A U.N. observer force was deployed between the two sides in the Golan Heights and on the Mt. Hermon peak. Israel withdrew from the "Syrian enclave" and from the city of Quneitra (included in the buffer zone) and from some land by the Rafid crossroads.

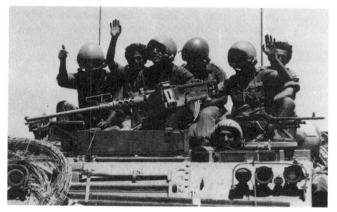

▽ The devaluation of the Israeli lira by 42% in November 1974 results in steep increases in prices of basic commodities and prompts anti-government demonstrations. Signs read: "Peace! Bread! Work!"

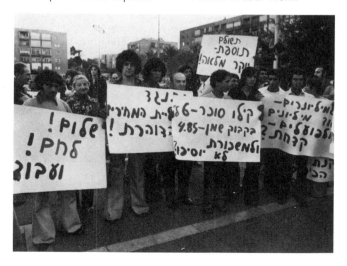

1975

January

7 The 100,000th immigrant from the U.S.S.R. arrives. However, a growing number of immigrants from the Soviet Union ostensibly bound for Israel drop out en route. Over a third such emigrants drop out in Vienna during January.

Palestinian terrorists make two unsuccessful attempts to attack El Al planes in Paris, on January 13th and 19th.

23 An agreement between Israel and the Common Market provides for the abolishment of import taxes on Israeli products in the Market countries from 1977 and vice-versa from 1989.

30 The Agranat Commission submits the final report of its findings to the government. The report will be classified for 30 years.

Israeli-produced Kfir fighter plane.

February

U.S. Secretary of State Kissinger shuttles between the Middle East states in anticipation of negotiations taking place between the sides.

17 Prime Minister Rabin, visiting the Golan Heights, states that the settlements there were not established in order to be evacuated one day.

March

5 Eight Palestinian terrorists reach Tel-Aviv by sea and take control of a seaside hotel, the Savoy. Seven are killed by I.D.F. soldiers and the eighth is captured. Three Israeli soldiers are killed.

5-6 An attempt by a Gush Emunim group to establish an unauthorized settlement, Elon Moreh, in the West Bank, is thwarted by the I.D.F.

9 Kissinger arrives for a new round of shuttle diplomacy.

23 Kissinger suspends his talks in Israel and Egypt because of an impasse.

24 The United States announces a reassessment of its Middle East policy in light of the failure of Kissinger's efforts. Deliberations on the supply of additional weapons to Israel are deferred.

April

4 Egypt returns the bodies of 39 soldiers missing since the Yom Kippur War. In return, Israel releases "security prisoners."

14 Israel unveils its domestically produced Kfir fighter plane to coincide with upcoming 27th anniversary Independence Day celebrations.

May

8 The I.D.F. awards decorations for bravery in the Yom Kippur War.

26 Terrorists resume firing Katyusha missiles at Safed, Moshav Avivim, and Nahariya after a long hiatus.

June

2 Prime Minister Rabin announces that Israel will thin out its forces west of the Suez Canal by half upon the opening of the canal.

5 The Suez Canal is opened to traffic after a closure of eight years. Sadat announces that Egypt will demolish the results of "Zionist aggression" in the Golan Heights, Sinai, and Palestine and is determined to restore "stolen Arab rights."

15 A terrorist attack on Kfar Yuval, near the Lebanese border, prompts the Israel air force and artillery to fire at Palestinian targets in Lebanon.

17 The ministry of finance announces a policy of "creeping devaluation" at intervals of 2%. The first such step establishes the lira at IL 6.12 to the dollar.

26 The remains of the two Lehi activists, Eliyahu Hakim and Eliyahu Bet-Zuri, who were executed in Egypt in 1945 for the assassination of Lord Moyne in Cairo, are transferred to Israel for burial.

July

4 A booby-trapped refrigerator placed by terrorists in Zion Square in the center of Jerusalem explodes, killing 13 and wounding 60.

7 Palestinian terrorists fire Katyusha salvos from southern Lebanon to the Galilee.

16 A conference of foreign ministers of Muslim states calls for the expulsion of Israel from the U.N.

29 The Knesset passes a law for direct elections of municipal mayors and heads of local councils by a large majority.

August

12 Pinhas Sapir, chairman of the Zionist Executive, Labor leader, and former minister of finance, dies at age 68.

21 Kissinger initiates another round of shuttle diplomacy in the Middle East.

September

1 Kissinger's efforts prompt Israel and Egypt to initial an interim agreement providing for an Israeli withdrawal east of the Giddi and Mitla Passes and evacuation from the Abu Rudeis area.

3 The Knesset approves the withdrawal agreement by 70 to 43, with 7 abstentions.

4 A ceremonial signing of the Israeli-Egyptian agreement takes place in Geneva.

24 The new town of Ma'aleh Adumim is established in the West Bank.

27 A relatively large devaluation of the Israeli lira is implemented, putting the exchange rate at IL 7 to the dollar. Simultaneously, the government imposes a freeze on prices.

October

21 The Hadassah Hospital on Mt. Scopus, completely rebuilt following the Six-Day War, is reopened after a closure of 27 years.

November

2 In the wake of the interim agreement with Egypt, the first ship bound for Israel – carrying a cargo of cement – passes through the Suez Canal.

10 The U.N. General Assembly passes a resolution by a large majority labeling Zionism "a form of racism and racial discrimination."

13 A terrorist explosion on Jaffa Road in Jerusalem causes 6 fatalities and 46 wounded. The P.L.O. claims responsibility.

20 Palestinian terrorists infiltrate from Syria into the settlement of Ramat Magshimim on the Golan Heights, killing three yeshiva students and wounding two.

25 In a tragic air force accident in Sinai, an Israeli Hercules plane crashes into Mt. Halal, killing all 20 crew and passengers.

30 Israel hands over the oil fields at Abu Rudeis to intermediaries – the U.N. observer force and an Italian oil company – for return to Egypt.

A group of settlers establish the settlement of Elon Moreh in the West Bank without government authorization.

December

1 The Elon Moreh affair continues. The government decides to evacuate the settlers. They refuse to evacuate voluntarily.

5 In a compromise, the Elon Moreh settlers evacuate to a nearby army camp.

6 The U.N. General Assembly reaches a decision by 84 to 17 with 27 abstentions to demand that Israel return the territories it occupied in the Six-Day War. If not, sanctions will be applied against it.

Inflation in 1975 remains at 39.3%, unchanged since 1974.

▷ I.D.F. soldiers burst into the Savoy Hotel in Tel-Aviv during a terrorist attack in March 1975.

▽ A hostage in the Savoy Hotel, Kokhava Levy, conducts the negotiations with the terrorists.

△ A terrorist explosion caused by a booby-trapped refrigerator in the center of Jerusalem kills 13 and wounds 60.

▷ Prime Minister Rabin and Minister of Defense Peres view the maiden flight of the Israeli-produced Kfir fighter in April 1975. Their relations are strained.

455

A "REASSESSMENT" AND AN INTERIM AGREEMENT WITH EGYPT

Israeli-American relations fluctuated during 1975, reaching a low point when the Washington Administration announced a reassessment of its policy toward Israel in late March. Earlier, Secretary of State Henry Kissinger had intensified his efforts to achieve an interim agreement between Israel and Egypt. Shuttling between the two countries, he failed, however, to bridge the gaps between them. Egypt demanded a deeper withdrawal from Sinai than Israel was willing to agree to, while Israel insisted on a declaration of nonbelligerency by Egypt. The U.S. Administration, blaming Israeli intransigence for the failure of the diplomatic effort, announced a reassessment of its policy toward Israel. In practice, this meant witholding approval for new supplies of weapons to Israel, and improving relations with the P.L.O.

American coolness lasted approximately half a year. In August 1975, Kissinger resumed his shuttle diplomacy in the Middle East, persuading both sides to sign an agreement by which Israel would withdraw east of the Mitla and Giddi Passes, and from a strip along the Red Sea which included the Abu Rudeis oil region, to be returned to Egyptian civilian control.

Israel conditioned its agreement on a series of American commitments: oil supply by the U.S. if necessary; no American acknowledgement of the P.L.O. and no negotiations with it; no deviation by the U.S. from U.N. resolutions 242 and 338; the U.S. was to supply modern arms and fighter planes to Israel.

▷ Pro: The first Israeli-Egyptian interim agreement, signed on September 1, 1975, elicits tension in the political establishment and in the public at large. Shown, a pro-agreement rally in Tel-Aviv by the leftist Mapam.

▽ Con: The rightist Gush Emunim movement holds a heated demonstration in Jerusalem in protest against the agreement.

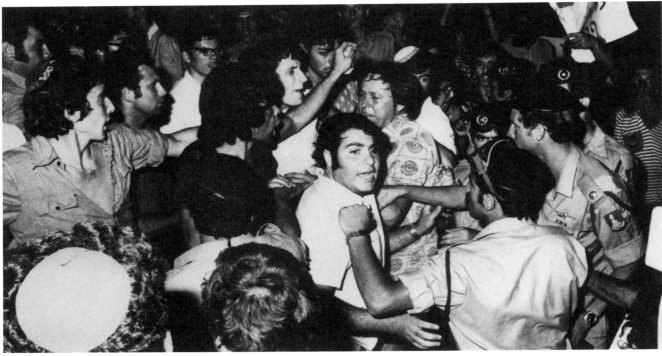

▷ Chief of Staff Mordechai Gur signs the interim agreement with Egypt on September 1, 1975. Israel agrees to withdraw from part of Sinai and to evacuate the oil field region.

◁ New signs in three languages appear in Sinai in the fall of 1975 with the evacuation of the I.D.F. and the deployment of U.N. forces.

◁ The last Israelis to leave the Abu Rudeis oil fields on November 30, 1975. Employees of the oil company "Netivei Neft" sign their names on the Israeli flag taken down from the mast.

▽ A confrontation develops in late 1975 between Gush Emunim settlers, who attempt to establish an unauthorized settlement at Elon Moreh in the West Bank, and the government, which opposes the settlement campaign. The settlers, agreeing to be evacuated to a nearby army camp, view the episode as a victory. Shown, r., Hanan Porat, l. Rabbi Levinger.

1976

January
6 The new chairman of the Zionist Executive is Yosef Almogi, formerly a cabinet member and mayor of Haifa.
12 Katyusha salvos are fired by Palestinian terrorists at northern settlements. The I.D.F. responds with artillery barrages.
28 Prime Minister Rabin addresses both Houses of Congress in Washington.

The civil war in Lebanon intensifies. Israel opens its northern border to Christian fugitives.

February
16 The government introduces a 15% tax on the import of services, including travel abroad.
20 The I.D.F. completes its withdrawal from the Giddi and Mitla Passes in compliance with the interim agreement.

March
Protests and violent demonstrations are mounted in the West Bank during the month. Most of the mayors and heads of local councils resign.
14 New economic measures are instituted raising the prices of basic commodities by 25% and abolishing subsidies. The "creeping" devaluation brings the exchange rate to IL 7.52 to the dollar.
21 The prime minister's security advisor, Ariel Sharon, resigns.
30 Land Day, a protest against land appropriation, is marked by the Arabs in Israel. Clashes with the police result in the death of 6 Arabs and the wounding of 12 security officers.

April
7 The Shalom Bridge is inaugurated in Tel-Aviv – the first of a series of bridges planned by the Netivei Ayalon Company.
15 David Ela'zar, chief of staff during the Yom Kippur War, dies at age 51.
28 A terrorist explosion in the center of Jerusalem results in the death of two police officers, with four persons wounded.

May
3 Yet another terrorist explosion in the center of Jerusalem wounds 33 persons. One woman later dies of her injuries.
9 The government decides on a policy supporting the right of Jewish settlement on

Miss Universe Rina Mor.

both sides of the Green Line (Israel's borders before the Six-Day War of 1967) but only within the context of approved plans.
25 A booby-trapped suitcase explodes at Ben-Gurion Airport, killing a woman security officer and the owner of the suitcase, a young German leftist radical.

June
18 Two Israeli navy missile ships set out for New York to participate in the U.S. bicentennial celebrations.
23 The Knesset rejects by a majority of 31 to 18 a law recognizing civil marriage in Israel.
27 The Entebbe drama begins. Palestinian terrorists hijack an Air France plane en route from Tel-Aviv to Paris via Athens, land it in Benghazi, Libya, and fly it from there to Entebbe, Uganda (see next page).

July
1 A value added tax of 8% is introduced.
3-4 Operation Yonatan: I.D.F. forces take control of the Entebbe Airport and free over 100 Israelis kidnapped by Palestinian terrorists.
4 The U.S. celebrates the bicentennial of its founding. Israel's operation in Entebbe steals the limelight, to a large extent, in the world media.
11 Israeli beauty Rina Mor is chosen as Miss Universe for 1976.
18 The Israeli lira is linked to a currency basket of U.S., German, Dutch, French, and British currencies.
25 Brazil beats Israel in soccer, 4:1, at the Olympic Games in Montreal, thereby eliminating Israel. Previously, Israel played in three tied games. Runner Esther Roth-Shahamorov and weightlifters Edward Weitz and Rami Meron achieve good results.

August
5 Asher Yadlin is designated by the government to succeed Moshe Zanbar as governor of the Bank of Israel.
11 Terrorists attack an El Al plane at the Istanbul Airport, killing four and wounding 21.
16 Grocers strike for three days in protest against the value added tax.
31 Registration for apartments in a new town in the Golan, Katzrin, opens.

September
1 Moshe Dayan publishes a newspaper, *Hayom Hazeh* ("This Day"). It will last a few months.
25 A large-scale terrorist incident scheduled for Rosh Hashanah is prevented when five Palestinian terrorists are caught landing a boat on the Tel-Aviv shore.

October
3 Incited Arab crowds burst into the Makhpelah cave in Hebron on Yom Kippur eve, destroy the synagogue there, and deface Torah scrolls.
18 The police arrest Asher Yadlin, governor-designate of the Bank of Israel, on suspicion of receipt of bribes and illegal transactions while in public office.
24 The new governor-designate of the Bank of Israel is Director-General of the Ministry of Finance Arnon Gafni.

November
Two significant political developments occur during the month: the establishment of the Democratic Movement for Change (Dash) – a new party headed by Prof. Yigael Yadin – and the decision by Ariel Sharon to leave the Likud and run for the next Knesset elections on an independent list.

December
Demonstrations are held in the West Bank in protest against the value added tax.
11 The first F-15 fighters arrive from the United States, landing just after the start of the Sabbath. The religious parties are angered.
14 The Torah Front party calls for a vote of no confidence in the government because of the violation of the Sabbath on December 11th. The proposal is supported by other parties, led by the Likud, but is defeated. The N.R.P. (National Religious Party), which is in the coalition, abstains.
19 Prime Minister Rabin demands the resignation of the N.R.P. ministers from the government in light of their abstention. When they refuse, Rabin submits his resignation to the president. Labor and Mapam call for early elections.

The "good fence" policy at the northern border is initiated in 1976, featuring Israeli aid to the Christians in southern Lebanon.

Minister of Finance Yehoshua Rabinovitz manages to reduce inflation to 31.3% in 1976.

OPERATION YONATAN

On June 27, 1976, a group of Palestinian terrorists hijacked an Air France plane in flight from Tel-Aviv to Paris and forced it to land in Entebbe, Uganda. On board were 268 passengers, of whom 104 were Israelis, and 12 crew members.

The hijackers, backed by Uganda's ruler Idi Amin, demanded the release of 53 terrorists, 40 of whom were imprisoned in Israel, threatening to harm the hostages if their demands were unmet. In view of the distance from Israel – some 4,000 km – the Israeli government was at first doubtful about the feasibility of an I.D.F. rescue operation and resigned itself to the prospect of negotiating with the hijackers as the only alternative. Two days later, on June 29th, the situation became graver as the hijackers separated the Israeli passengers from all the rest. When the I.D.F. formulated a daring military rescue operation, the government was hesitant because of the high risk of dispatching an airborne force so far away. Nevertheless, on July 3rd, a Saturday, the government approved the operation and briefed the opposition about it.

The Israeli force set out in six planes. They flew paratroopers, Golani soldiers, and soldiers from a special combat unit. Several vehicles were also taken along, among which, as the story goes, a black Mercedes, similar to Idi Amin's. One of the planes served as hovering headquarters, and another as a field hospital. The latter landed in Nairobi airport and waited.

The force landed in Entebbe and within minutes took control of the airport and the terminal where the hostages were being held, eliminating the terrorists along with dozens of Ugandan soldiers who intervened. The Israeli force incurred one fatality – the commanding officer, Lieut. Col. Yonatan Netanyahu – and one soldier wounded. Three hostages were killed and six were wounded. The audacious operation astounded the world and evoked international admiration of the kind Israel had not experienced in years.

▷ The terminal at Entebbe Airport in Uganda where the drama of the night of July 3-4, 1976, takes place. I.D.F. soldiers rescue the Israeli hostages in an operation that astounds the world.

▽ The returning hostages are welcomed emotionally in Israel on the morning of July 4, 1976.

I believe that life, in its essence, does not consist of the sum of hours and days between one's birth and one's death, but of the meaning we ascribe to it. The stronger expression of existence is not the mere flow of time in a man's life, but rather the marks he leaves, owing to his deeds and personality, on those surrounding him. Some people are granted long life, but in this respect they practically do not live. And some live a short life, learning, loving, going into battle, educating others in battle, grappling with the deeper problems of life – yet remaining sensitive and open to a smile, a hike, a flower, a poem.... If there is any consolation for a life that has been cut off at age thirty – this is that consolation.

Ehud Barak, from a eulogy at the grave of Yoni Netanyahu, 1976

THE "GOOD FENCE"

The Israeli-Lebanese border, peaceful for many years, became inflamed following the Six-Day War of 1967 as a result of Arab terrorist activity, with infiltration into northern Israel increasing year by year. In response, Israel set up a defense system along the entire length of this border, from the Mediterranean to Mt. Hermon. In 1976, however, the security fence was breached at several points – surprisingly, by Israel itself. This development, dubbed the "good fence," reflected Israel's desire to aid the Christians of southern Lebanon, who were viewed as potential allies against a common enemy – the Palestinian terrorists.

In June, 1976, a mobile I.D.F. field clinic was set up close to the border near Metula to serve nearby Lebanese Christian villages. Thereafter, additional clinics were set up at other points and joint activity between Israel and the Lebanese Christians expanded. Lebanese workers crossed into Israel for jobs, while Israel assisted the Christians in agricultural modernization, road paving, the laying of water lines, and other areas, eventually granting military aid to the militias in the Christian enclave.

△ Two relatives, from Israel and southern Lebanon, have an emotional reunion at the "good fence."

▷ The "good fence" at Metula, opened in 1976, becomes a popular tourist site.

▽ Thousands of Israelis and foreign tourists travel south to Ofira at Sharm al-Sheikh. The "Kennedy Statue" (r.), a natural wonder, is one of the attractions.

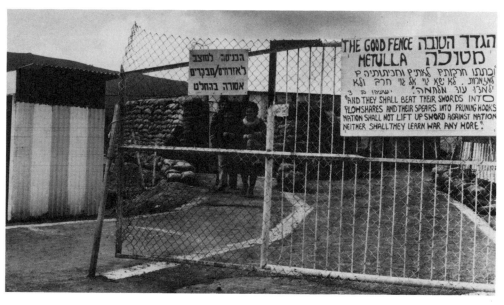

The Netivei Ayalon Company, established to ease traffic congestion in the Tel-Aviv area, inaugurates the Shalom Bridge, the first of a planned series, in April 1976. Tel-Aviv Mayor Shlomo Lahat delivers greetings. To his right, Gad Ya'akobi, minister of transportation.

▽ The plane that causes a political crisis, an F-15 fighter delivered by the U.S. to the Israeli air force, lands on Sabbath eve, December 11, 1976, as the sun sets – to the discontent of the ultra-Orthodox parties. Prime Minister Rabin briefly tours the cockpit (left).

▽ A table published in early 1976 shows that the Israeli lira has dropped to 1/29th of its original value.

▷ Subaru cars reach Israel in the late sixties to become "the car of the year" in the seventies and through the eighties.

1977

January

3 Minister of Housing Avraham Ofer commits suicide following accusations of corruption.

5 The Knesset votes to hold elections on May 17, 1977.

Dash ("The Democratic Movement for Change"), headed by Yigael Yadin, gains support. Two M.K.s from the Free Center party, as well as various public service and business figures previously identified with Labor, join the movement.

February

17 Maccabi Tel-Aviv scores an impressive basketball victory against Moscow C.S.K.A. 91:79.

22 Asher Yadlin, who had been designated governor of the Bank of Israel, is sentenced to five years in prison for taking bribes while holding public office.

23 Itzhak Rabin tops Shim'on Peres by a slim margin – 1,445:1,4404 – at the Labor Party runoff for the candidacy for the office of prime minister.

March

15 Dash elects its list of candidates for the elections: Yigael Yadin, former dean of Tel-Aviv University Law School Amnon Rubinstein, former chief of Intelligence Meir Amit, M.K. Shmuel Tamir, and Meir Zore'a.

18 Sheli, a new left-wing party, is founded.

April

3 Dayan announces that he has been approached by other parties, but that he will not abandon the Labor.

7 In an address broadcast in the evening on the electronic media, Prime Minister Rabin announces his withdrawal from the race for prime minister, and his resignation as head of his party, because of an unauthorized account held by his wife in a U.S. bank.

Maccabi Tel-Aviv beats Italy's Mobilgirgi Varese 78:77 to become Europe's champion basketball team.

10 Shim'on Peres is chosen by Labor as its candidate for prime minister.

17 Lea Rabin is fined IL 250,000 for holding an account in the United States illegally.

May

15 The first American-style T.V. election debate takes place between candidates Shim'on Peres and Menahem Begin.

17 The elections for the Ninth Knesset result in a political upset: the Likud, together with Ariel Sharon's Shlomzion party, attains 45 seats, the Alignment drops to 32, and Dash achieves 15.

25 In a surprising move, Prime Minister-designate Menahem Begin offers the foreign affairs portfolio to Moshe Dayan of Labor. Dayan accepts.

June

7 The president assigns Begin the task of forming a new government.

13 Itzhak Shamir, Likud, is elected speaker of the Ninth Knesset.

21 Begin presents his government to the Knesset. It is made up of the Likud, the National Religious Party, and Agudat Israel.

22 Histadrut ("Federation of Labor") elections do not reflect the political upset. Labor obtains 56% of the seats, while the Likud receives 28%.

28 Prime Minister Begin announces that Israel is prepared to take part in peace talks in a convention to take place in Geneva.

July

1 The Labor Party elects Shim'on Peres as its chairman.

An agreement between Israel and the Common Market is reached concerning a free trade policy and the abolishment of taxes on Israel's export products.

The government introduces a new policy: All Jewish settlements already established in the occupied territories are recognized as legal.

August

16 The "creeping" devaluations of the Israeli lira bring the rate of exchange to IL 10.14 to the dollar.

17 The Ministerial Committee on Settlement decides on the establishment of three new settlements in the West Bank.

31 Agriculture Minister Ariel Sharon drafts a broad settlement plan for the occupied territories envisioning 2 million inhabitants within 20 years.

September

21 Barrages of Katyusha missiles are launched at Safed and Kiryat Shmona following a long hiatus.

A dispute breaks out between Gush Emunim and the government during the month over the establishment of new settlements in the West Bank. The settlers want to establish 12 new settlements. The government proposes that they use the facilities of six army camps temporarily. The American Administration censures Jewish settlement in the West Bank.

29 The Ministry of Housing plans to expand Yamit, in northeastern Sinai, into a city of 100,000.

October

1 An American-Soviet declaration states that every Israeli-Arab peace agreement ought to secure "the legitimate rights of the Palestinian people."

10 Egyptian President Sadat warns that if peace efforts fail, Egypt and Saudi Arabia will go to war against Israel.

20 Dash decides by a majority of some 60% to join the government coalition.

31 The government, introducing a major economic shift, abolishes control of foreign currency. In a separate move, value added tax is raised to 12%.

November

3 Demonstrations protesting the new economic policy are mounted in Tel-Aviv.

6 Responding to a request by the Pope, Israel releases Archbishop Hilarion Capucci, imprisoned for smuggling arms for Fatah.

8 A Katyusha attack is launched at Nahariya. One woman is killed and five residents are wounded. The I.D.F. responds with artillery and air attacks.

10 Sadat announces in the Egyptian parliament that he is prepared to come to Israel in order to search for a peace arrangement.

12 Prime Minister Begin invites Sadat for a visit to Jerusalem. The official invitation is issued on November 15th.

19 In a historic development, President of Egypt Anwar Sadat arrives in Israel for a three-day visit.

21 Sadat is received enthusiastically upon his return from Jerusalem to Cairo.

December

13 The first El Al plane to land in Cairo brings an Israeli delegation to the Cairo Conference in which Israel, Egypt, the United States, and the U.N. participate.

22 Prime Minister Begin presents the autonomy plan for the West Bank.

Gush Emunim and the Greater Land of Israel movement oppose the government's peace plans. Residents of the settlements in the West Bank, the Gaza Strip, and the Pithat Rafiah region are apprehensive.

25 Begin leaves for a summit meeting with Sadat in Isma'ilia.

The Knesset approves the government's peace plan by 64 to 8 votes, with 40 abstentions. Two of the opposing votes are cast by Likud M.K.s Ge'ula Cohen and Moshe Shamir.

Inflation for 1977 is 34.6%.

▷ "Hurrah Maccabi Tel-Aviv" reads the giant lighted sign in Tel-Aviv marking the basketball team's attainment of the European championship in April 1977.

▽ That same evening, on April 7, 1977, Itzhak Rabin announces the withdrawal of his candidacy in the forthcoming elections. The picture is two months old, taken at a meeting with the movement Citizens for Rabin. At left, Uri Zohar.

▽ Yigael Yadin, a new figure in the political arena.

△ Avraham Ofer, minister of housing, commits suicide in early 1977.

THE POLITICAL UPSET

The Labor Party, successor to Mapai, which had been the ruling party since the establishment of the state in 1948, was in poor shape in early 1977. Its image, and that of its leadership, was tarnished by constant bickering at the top between Prime Minister Rabin and Defense Minister Peres; the trial and imprisonment of the governor-designate of the Bank of Israel, Asher Yadlin; the suicide of Minister of Housing Avraham Ofer following unproven allegations of financial wrongdoing; and endless strikes and work slowdowns. The perception of an absence of leadership was prevalent.

Early in April 1977, the *Ha'aretz* ("The Land") correspondent in Washington, Dan Margalit, revealed that the wife of the prime minister, Lea Rabin, had a bank account in the United States, which was against Israeli law. The prime minister, taking responsibility, announced his resignation and withdrawal from the election race. In fact, he could not technically resign, as his government was already functioning as a transitional government. The prime minister took a leave of absence, with Defense Minister Shim'on Peres filling in for him until the elections.

The Alignment (Labor plus Mapam) thus approached the elections for the Ninth Knesset in a weakened state. The Likud, its main rival, mounted a focused campaign led by Ezer Weizman while party leader Menahem Begin convalesced from a heart attack. A third party that attracted considerable attention and support was the Democratic Movement for Change (Dash), led by Yigael Yadin, founded in 1976 by a group of prominent personalities, most of whom had become disillusioned with Labor.

The Alignemnt placed Shim'on Peres at the head of its list. Begin recovered and headed the Likud list. On May 17, 1977, the Israeli electorate showed at the polls that it wanted a change. The Alignment was defeated, sinking from 51 to 32 seats in the Knesset. The Likud rose from 39 to 43. Dash attained 15 seats, most if not all at the expense of the Alignment. Ariel Sharon, heading a party called Shlomzion, obtained only 2 seats and promptly teamed up with the Likud, creating a coalition of 45 seats. The religious parties also came in, allowing Begin to form a new government within a short time. Several months later, the Democratic Movement for Change joined Begin's government as well.

▷ The big winner in the 1977 elections is Menahem Begin, shown casting his vote on May 17th with his wife, Aliza. Having run unsuccessfully in eight elections, Begin is victorious in the ninth.

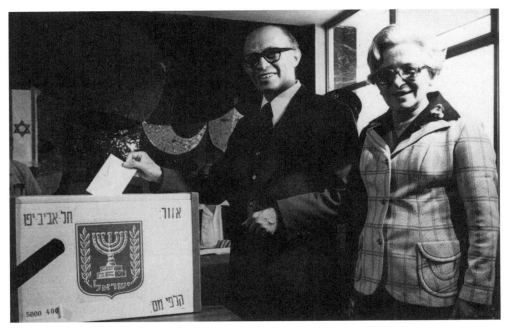

▽ Who is he voting for? Moshe Dayan, stressing prior to the elections that he is a member of the Labor Party and will not abandon it, becomes foreign minister in Begin's government following the elections.

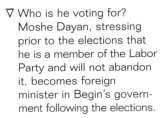

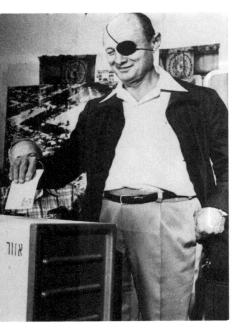

▽ Although still prime minister, Itzhak Rabin stands in line at the polls like everyone else on May 17, 1977. In actuality, Rabin cannot resign, as his government is already functioning in a transitional capacity until the elections, and resignation is not permissible. However, government meetings are led by Defense Minister Shim'on Peres, the Labor candidate for prime minister. Both Rabin and his government come in for criticism by the public during this period.

סוף

המסך יורד

סוף מערכת הבחירות — מאי 1977.
האם יהיה זה סוף שהוא סוף?
סוף להרבה דברים יפים וחשובים,
מובנים מאליהם, (כאילו),
שנוצרו בארץ הזאת בהרבה יזמה ומאמץ,
או שיהיה זה סוף שהוא התחלה?
התחלה של תקופה חדשה, השוטפת את פגמי העבר ועיוותיו, אך השואבת
ממנו את כוחה והשראתה.

בידך, היום, לקבוע.

בידך, היום, לאפשר לנו — למערך, לסכם
ולהתחיל, לחדש ולהמשיך.

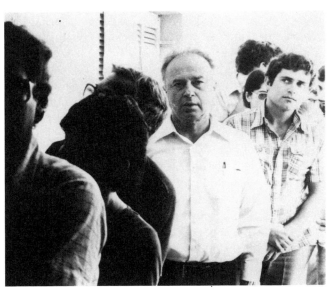

△ An odd advertisement published by the Labor Party on election day highlights the word "End," followed by "The curtain falls." Eulogizing the party's achievements of the past, Labor is asking for a new chance.

▷ Menahem Begin delivers his victory announcement from Likud headquarters in Tel-Aviv early on May 18, 1977, having waited until the election results are conclusive. T.V. reporter Elimelekh Ram (with microphone) transmits the speech live. In the course of his speech, Begin thanks his wife, Aliza, "who has walked with me through the desert, in a land sown with mines."

△ Outgoing Labor speaker of the Knesset Israel Yesha'yahu (l.) hands over his gavel to incoming Likud Speaker Itzhak Shamir.

▽ Likud campaign headquarters are joyful after the upset of May 17, 1977, is confirmed. Some Israelis have waited for this moment for decades.

SADAT'S VISIT TO JERUSALEM

The year 1977 will be remembered in Israel for two compelling events: the political upset and the visit by Egyptian President Sadat to Jerusalem.

Begin included a surprisingly flexible foreign-policy message in his victory speech the day after his election, calling for peace with the Arab states. His subsequent appointment of Moshe Dayan (late of Labor) as foreign minister also hinted at a moderate approach.

During the summer and fall of 1977, a peace plan forged discretely by Israel and Egypt began to take shape. It began with secret meetings between Foreign Minister Dayan and Egyptian Deputy Prime Minister Hassan al-Tuhmi, in Rabat, Morocco. In November, Sadat surprised the world by announcing his desire to come to Jerusalem to address the Knesset. Begin took up the challenge and issued an official invitation, although some in Israel suspected Egypt of planning a large military operation behind a smokescreen of political dialogue. Following the Sabbath on November 19, 1977, Sadat alighted from a special plane that brought him to Ben-Gurion Airport and began the historic visit of the first Arab head of state to Israel.

Events followed at a dizzying pace. Within a month, the first Israeli governmental delegation traveled to Cairo to initiate peace negotiations between both countries. Relations and negotiations with Egypt were to undergo many ups and downs during the sixteen months that followed, but the first step had been taken and a peace treaty between Israel and Egypt was signed on March 26, 1979.

▷ The event of the year 1977, after the political upset in Israel, is the dramatic visit by Egyptian President Anwar Sadat to Jerusalem. Arriving at Ben-Gurion Airport after the Sabbath on November 19, 1977, he is received there by President Efraim Katzir (r.) and Prime Minister Menahem Begin (l.). Preparations for the trip are completed within only two days, yet ceremonies and events are carried out smoothly.

◁ "Sadat Fashion." After Sadat's visit, many shops are named after him.

△ Sadat meets with opposition leaders Golda Meir and Shim'on Peres.

January

8 Prime Minister Begin warns that Egyptian non-agreement to the retention by Israel of its settlements in Sinai could lead Israel to withdraw its offer to return the penninsula to Egypt. The government decides to expand these settlements.

17 The Israel-Egypt-U.S.A. commission confers in Jerusalem.

18 Dissent mounts in the course of the conference. Sadat calls his delegation back to Cairo. On the next day, it returns to Jerusalem.

23 The city of Katzrin is inaugurated on the Golan Heights.

February

Poisoned citrus exports from Israel are discovered in West European markets during the month – the work of an Arab terrorist group.

11 Sadat meets with Labor Party Chairman Shim'on Peres in Salzburg.

19 The Shimron Commission confirms the existence of organized crime in Israel.

20 The 29th Zionist Congress opens in Jerusalem.

22 Aryeh Dulzin is elected chairman of the Zionist Executive.

Mordechai Makleff, Israel's third chief of staff, dies at age 58.

March

11 In a grave incident on the Coastal Road outside Tel-Aviv, Palestinian terrorists seize a bus, killing 35 men, women and children and wounding many others.

15 The I.D.F. mounts Operation Litani, aimed at routing the terrorists from southern Lebanon.

17 The terrorists respond with Katyusha attacks on the Western Galilee, resulting in two fatalities and two wounded.

22 The first U.N.I.F.I.L. (United Nations Interim Force in Lebanon) force is stationed in southern Lebanon.

April

The Peace Now movement begins to coalesce.

10 The Wolf Prize for achievement worldwide in the sciences and the arts, awarded in Israel, is inaugurated.

16 Lieut. Gen. Rafael Eitan succeeds Lieut. Gen. Mordechai Gur as chief of staff.

19 Israel's new president is Itzhak Navon, who wins the Knesset vote over the Likud candidate, Prof. Itzhak Shaveh. He succeeds outgoing president Efraim Katzir.

22 Izhar Cohen wins the first prize in the Eurovision contest held in Paris with the song *Abanibbi*. Next year, the contest will be held in Jerusalem.

May

3 Pinhas Rosen, chairman of the Independant Liberals and minister of justice for many years, dies at age 91.

11 Israel marks 30 years since its establishment.

15 The Diaspora Museum, devoted to the history of the Jewish people in all its dispersions, opens in Tel-Aviv.

June

2 A terrorist bomb blows up in a bus in Jerusalem, causing 6 fatalities and 19 wounded.

13 The I.D.F. completes its evacuation from southern Lebanon, ending Operation Litani. The evacuated area is handed over to the Christian militias, thereby creating a contiguous security zone.

26 The U.S. makes efforts to renew talks between Israel and Egypt.

28 Abie Natan ends a hunger strike of $1^1/2$ months which he held to protest what he views as the government's blocking of peace efforts.

July

11 The Ben-Gurion Airport-Sha'ar Hagai link of the new highway between Tel-Aviv and Jerusalem is opened.

13 Minister of Defense Ezer Weizman meets with Sadat in Austria in order to prod the peace process.

18 The Israeli and Egyptian foreign ministers and the U.S. secretary of state meet in England to advance the peace process.

23 Prof. Itzhak Zamir is named attorney general, succeeding Prof. Aharon Barak, who is appointed justice of the Supreme Court. The

transfer becomes effective at the beginning of September.

August

3 A terrorist bomb explodes at the Carmel market in Tel-Aviv, causing one fatality and approximately 50 wounded.

20 Palestinian terrorists attack El Al crew members in the airport at London, killing an El Al stewardess and wounding eight.

23 The Democratic Movement for Change splits. One faction is headed by Yadin, the other by Rubinstein.

September

18 The Camp David conference concludes with a historic accord reached after 13 days of talks. Prime Minister Begin and President Sadat sign a "framework for conclusion of a peace treaty between Egypt and Israel," according to which Israel will evacuate Sinai and both countries will establish full peace and diplomatic ties.

The dropout rate in Vienna among Soviet Jewish emigrants ostensibly bound for Israel climbs to over 60%.

27 The Knesset ratifies the Camp David accords by 84 to 19, with 17 abstentions. Twenty-seven M.K.s who oppose or abstain are members of the government coalition.

October

Talks between Israeli and Egyptian representatives on the wording of the peace agreement are held in Washington. The Israeli government approves the draft agreement on the 25th, deciding at the same time to enlarge the settlements in the West Bank. The Americans are outraged.

27 Reports claim that Begin and Sadat will receive the Nobel Prize for Peace in 1978.

November

5 The Islamic revolution in Iran reveals anti-Israeli features. A mob runs riot and smashes the windows of the El Al office in Teheran.

7 Municipal elections in which the vote for mayor is separate from the vote for

the local council are conducted for the first time. Mayors Teddy Kollek of Jerusalem, Shlomo Lahat of Tel-Aviv, and Aryeh Gurel of Haifa are reelected by expanded majorities.

12 A strike of intermediary school teachers breaks out. It will last until 12.25.

15 Three M.K.s opposed to the government's peace policy – Moshe Shamir, Rabbi Hayim Druckman, and Ge'ula Cohen – stage an unprecedented demonstration in the Knesset plenum, displaying a sign that reads: "The government of Israel is on the brink of an abyss – stop!"

The Israeli-Egyptian peace talks falter when Egypt demands linking the peace agreement to the future status of the West Bank and Gaza.

December

8 Golda Meir, prime minister during 1969-74, dies at age 80.

10 The Nobel Prize for Peace is awarded jointly to Israeli Prime Minister Begin and Egyptian President Sadat.

21 A Katyusha attack aimed at Kiryat Shmona kills one resident and wounds 10.

The Israeli-Egyptian peace talks remain on hold. A breakthrough develops, however, toward the end of the month.

Inflation in 1978 spirals to 48.1%.

1978

▽ The bus blown up by terrorists on the Coastal Road north of Tel-Aviv in March 1978. One of the gravest of the terrorist incidents of the 1970s, resulting in 35 fatalities, it elicits a resolute response by Menahem Begin's government: Operation Litani.

OPERATION LITANI

On March 11, 1978, a band of Palestinian terrorists landed on the Mediterranean shore and took control of a bus carrying day-trippers on the Coastal Road between Haifa and Tel-Aviv. Forcing the driver to head south at high speed, the terrorists fired in all directions at cars that pursued them and at the passengers in the bus. The bus traveled some 50 km until it was stopped at a road-block set up at the Glilot junction north of Tel-Aviv. In a confrontation there with an anti-terrorism police unit, nine of the terrorists were killed and the remaining two captured, although not before they managed to blow up the bus. The toll was 35 Israeli fatalities and over 70 wounded.

On March 15, Israel responded with all its force, deploying a force of several thousand soldiers, along with planes and ships, to southern Lebanon in an attack against the Palestinian terrorist bases established there. Operation Litani, as it became known, destroyed the terrorists' infrastructure and killed hundreds of terrorists within days, with most of the rest fleeing to the north. Only after the U.N.I.F.I.L. (United Nations Interim Force in Lebanon) was stationed in southern Lebanon, did the I.D.F. units return to Israel, in June 1978.

The blow dealt to the terrorists was severe, but once the I.D.F. withdrew, they returned to southern Lebanon.

▷ I.D.F. soldiers are accorded a friendly reception by the Christian population of southern Lebanon during Operation Litani. In center foreground, a Lebanese Christian Phalangist.

△ Commander of the Christian forces in southern Lebanon, Major Sa'ad Haddad.

▷ Israeli armored vehicles in southern Lebanon during Operation Litani. The operation lasts three months.

▷ On the country's 30th anniversary the Israeli-produced Merkava tank is displayed side by side with the Hotchkiss used in the War of 1948.

▽ A series of stamps issued for the 30th anniversary commemorates Golomb, Sneh, Sadeh, Stern, and Raziel (shown).

▷ The new chief of staff, Rafael Eitan, is awarded his insignia as lieutenant general by Prime Minister Begin (r.) and Minister of Defense Weizman in the spring of 1978.

▽ The country's fifth president – Itzhak Navon, also takes office in the spring, shown with his wife Ofira and two children.

△ Because of the rapidly rising inflation rates, coins with higher values are issued.

THE CAMP DAVID CONFERENCE

President Sadat's visit to Jerusalem in November 1977 prompted Israel and Egypt to initiate peace negotiations along various tracks. Yet as time passed, the gulf beween the sides seemed to widen and by the summer of 1978 the talks had reached an impasse. Taking the initiative, U.S. President Jimmy Carter invited the Israeli and Egyptian heads of state, Begin and Sadat, with their ministers and senior aides, to confer at Camp David outside Washington. There, the leaders conducted direct talks for 13 days under the auspices of the American president.

These negotiations, too, were far from smooth, and it appeared, more than once, that they reached a dead-end. But President Carter was determined, and on September 18, 1978, Begin and Sadat signed two accords: the "framework for the conclusion of a peace treaty between Egypt and Israel," and the "framework for peace in the Middle East." Both sides expressed willingness to institute a peace treaty between them. Israel would withdraw from Sinai, while Israeli ships would be permitted to pass through the Suez Canal. Israeli withdrawal arrangements were fixed, as were the conditions for the deployment of Egyptian military forces in Sinai and other matters. The second agreement dealt with the issue of the West Bank and the Gaza Strip. Begin agreed to "full autonomy for the inhabitants" and to a self-governing authority that would replace Israel's military government and civilian administration following a transitional period of five years. Various other issues that could not be resolved at that stage were summarized in appendixes attached to the accords. In the agreement with Egypt, for instance, there was no mention of the evacuation of the Israeli settlements from Sinai. Although Sadat demanded it, Begin insisted he required the approval of the Knesset for the matter.

The Knesset ratified the Camp David accords by a large majority of 84 to 19, with 27 abstentions.

Both sides were prodded to make concessions. Indisputably, however, Israel's were greater.

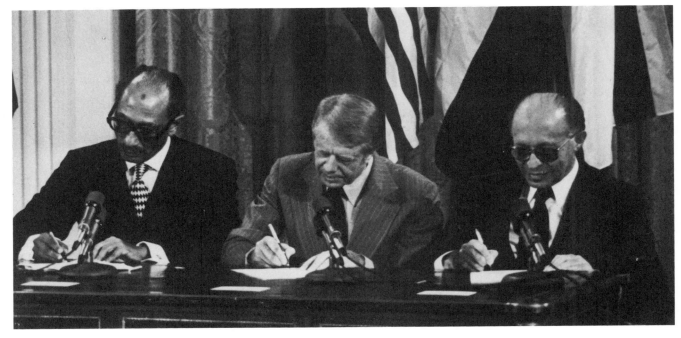

△ Egyptian President Anwar Sadat, U.S. President Jimmy Carter, and Israeli Prime Minister Menahem Begin sign the agreements known as the Camp David accords.

▷ Israeli Minister of Defense Ezer Weizman, on a bicycle, encounters Egyptian President Sadat on a path at Camp David.

◁ The gate to Camp David, where the agreement is achieved.

470

1979

January
7 The government of Israel permits a second group of 100 Vietnamese refugees to enter the country, in addition to a previous, larger group that arrived in 1977.

February
21 A new stage in the Israeli-Egyptian peace talks opens in Washington with the participation of Israeli Foreign Minister Dayan and Egyptian Prime Minister Mustafa Khalil.

March
7 President Carter travels to the Middle East in order to advance the peace process.
10-12 President Carter visits Israel and addresses the Knesset.
13 Carter announces that Israel and Egypt are close to the point of signing a peace agreement.
14 Israel releases 76 Palestinian terrorists in return for the soldier Avraham Amram.
19 The peace agreement is approved in a meeting of the Israeli government by 15 to 2.
22 The Knesset ratifies the peace agreement by a large majority of 95 to 18.
26 The Israeli-Egyptian peace agreement is signed in Washington by the heads of state of Israel, Egypt, and the United States.
31 Eighteen member states of the Arab League, and the P.L.O., decide to impose sanctions against Egypt for signing the peace agreement with Israel.

The song *Halleluyah,* sung by Gali Attari, wins first prize in the Eurovision song contest held in Jerusalem.

April
2 Prime Minister Begin confers in Cairo with President Sadat over autonomy in the West Bank.
10 The Hebrew University of Jerusalem returns to its pre-1948 campus – completely rebuilt since 1967 – on Mt. Scopus.
22 A terrorist attack in Nahariya ends with the death of a father, his two daughters, and a policeman.
25 The Israeli-Egyptian peace treaty takes effect.
30 In the wake of the peace treaty, the first Israeli ship, the Ashdod, passes through the Suez Canal.

May
23 A confrontation erupts between I.D.F. soldiers and members of Moshav Ne'ot Sinai during a protest against the scheduled evacuation of Sinai.

A terrorist bomb explodes at a bus stop in Petah Tikva, killing three women.
25 Talks between Israel and Egypt on the autonomy plan begin in Beersheva.
27 The Israeli-Egyptian border is opened. President Sadat arrives for a visit in Beersheva.

June
6 M.K. Ge'ula Cohen leaves the Likud because of the peace agreement.
20 Israel's basketball team

attains second place in the European championship games. It is beaten in the finals by the U.S.S.R., 98:76.
23 The United Kibbutz Movement ("Takam") is established, merging two kibbutz federations – Hakibbutz Hame'uhad ("The United Kibbutz") and the United Groups and Kibbutzim.
27 Israel Air Force planes on a bombing mission aimed at Palestinian terrorist targets bring down five Syrian planes over south Lebanon.

July
10-12 Begin and Sadat meet in Alexandria.
25 The I.D.F. completes an additional stage in the withdrawal from Sinai.

August
5 The autonomy talks between Israel and Egypt

Publication of the United Kibbutz Movement: *Yahad* ("Together").

Chief of Staff Rafael Eitan and Jerusalem Mayor Teddy Kollek do not look excited by President Carter's speech at the Knesset, March 1979.

resume in Haifa.
21 The first Israeli tourists leave for Egypt.

September
4 President Sadat arrives for another visit in Israel, in

Haifa.
16 The government revokes the prohibition on the purchase of land by Jews in the West Bank.
24 The Israel Air Force brings down four Syrian planes in an air battle.

October
21 Foreign Minister Moshe Dayan resigns over differences of opinion with Begin on the autonomy talks. Begin takes over the foreign affairs portfolio.

The Tehiya movement is established by loyalists to the principle of retaining all the land of Greater Israel.

November
7 Yigal Hurwitz replaces Simha Ehrlich as minister of finance.

The I.D.F. withdrawal from Sinai continues. The Santa Katherina area is handed over to Egypt on November 15th and the

Alma oil field on the 25th.

Inflation continues to soar, reaching 78.3% in 1979.

Incoming: Yigal Hurwitz.

Outgoing: Simha Ehrlich.

THE SIGNING OF THE PEACE AGREEMENT

Observers who may have thought that Sadat's visit to Jerusalem would lead to the rapid evolution of a peace treaty between Israel and Egypt were in for a disappointment. Long months of halting negotiations, as well as sustained American pressure, were required until the sides signed first a "framework agreement" at Camp David (in September 1978) and, six months later, the peace agreement itself.

Following the signing of the accords at Camp David, a series of talks were held but they failed to bring about the anticipated breakthrough. In March 1979, U.S. President Jimmy Carter again took the initiative, traveling to the Middle East with the intention of bridging the remaining gaps. Visiting both Israel and Egypt, he exerted intense pressure on both sides, paving the way for the signing of a peace agreement. In Israel, the Knesset approved the agreement by a majority of 95 to 18. Begin and Sadat eventually traveled to Washington to sign the peace treaty in a ceremonial setting on the White House lawn on March 26, 1979. Anwar Sadat signed first and Menahem Begin signed next, with Jimmy Carter the last signatory, in the role of patron of the Egyptian-Israeli peace. All three then joined in a triple handshake.

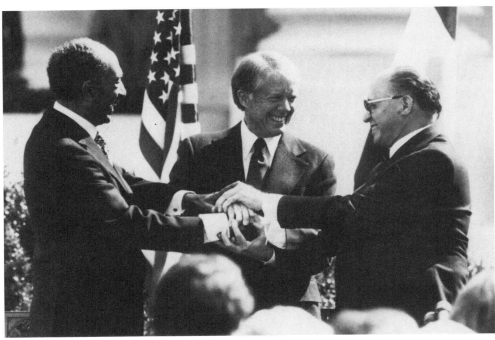

◁ Sixteen months after Sadat's historic visit to Jerusalem, the first peace agreement between Israel and an Arab state is concluded. The ceremony takes place in Washington on March 26, 1979, on the White House lawn. The three parties to the agreement are Israeli Prime Minister Menahem Begin, Egyptian President Anwar Sadat, and U.S. President Jimmy Carter. It was President Carter who pushed Egypt and Israel to resume talks whenever they reached a dead-end.

△ The logo "peace" (designed by Ben-Hador) in three languages – Hebrew, English and Arabic – comprises the giant headline in the daily *Ma'ariv ("Evening Paper")* on March 26, 1979.

▷ Carter and Begin embrace upon the arrival of the American president in Israel. Carter travels to the Middle East in March 1979 to break the impasse in the peace negotiations.

▽ Drama in the Knesset: Likud M.K. Ge'ula Cohen tears up a copy of the Israeli-Egyptian peace agreement. In a few months, she will leave the Likud.

▷ Immigration from the Soviet Union continues. Newcomers, and especially "refuseniks" (Jews arbitrarily denied an exit permit and harassed for long periods), are welcomed emotionally.

▽ Jewish construction in the West Bank expands significantly under the Likud government. In 1977, Begin promised the construction of many settlements. Here, the start of the Elon Moreh settlement in Samaria.

▽ The fruits of peace: Captain
Mendelovitz (r.), of the
Ashdod, the first Israeli ship
to pass through the Suez
Canal after the signing of

the peace agreement, is given
a warm welcome by the
Egyptian Canal Authority
navigator. In a few months,
the first Israeli tourist groups
will travel to Egypt.

▽ Tel-Aviv undergoes a face-
lift: Dizengoff Square be-
comes a two-tiered
structure to facilitate the
flow of traffic.

▷ Moshe Dayan in his garden
in Zahala shortly after re-
signing as minister of foreign
affairs, October 1979.

▽ Gali Attari and the Milk and Honey vocal group perform *Halleluyah* at the Eurovision song contest, held in Jerusalem in March 1979. Israel wins first place for the second year in a row.

△ A deep friendship develops between Egyptian President Sadat and Minister of Defense Ezer Weizman.

▷ A second group of Vietnamese refugees is allowed into Israel in 1979.

The Ninth Decade
1980-1989

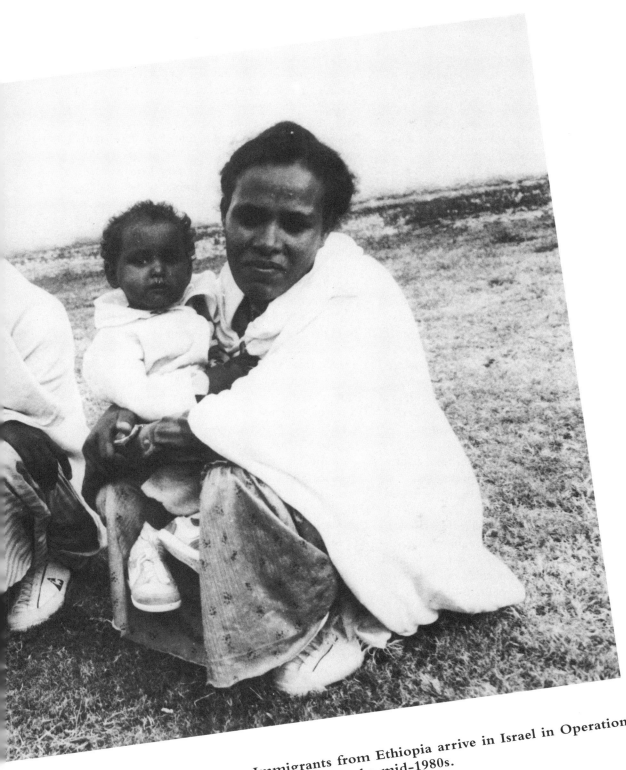

Immigrants from Ethiopia arrive in Israel in Operation Moshe during the mid-1980s.

The decade of the 1980s was turbulent in nearly every area.

A new, unprecedented pattern emerged in the country's domestic politics: a nearly equal balance between the two main blocs – Likud and Alignment (Labor from 1984 onwards, following the departure of Mapam). In the early eighties, the rightist bloc had the advantage, albeit a small one, but the tied elections in 1984 forced both major parties to join forces and form a national unity government, with the office of prime minister rotating between the respective leaders of Labor and Likud. Another significant development was the voluntary resignation from political life, for reasons he did not make public, of Prime Minister Menahem Begin, who led the Likud government from 1977 until 1983 . Some related his withdrawal to emotional distress caused by the extensive casualties in the war in Lebanon, a war which he had initiated in 1982 but did not end as planned.

The first unity government lasted until the 1988 elections, followed by the establishment of a new unity government, this time without prime ministerial rotation. Both governments, especially the second, were fraught with tension and crises. Critics of the unity government concept charged that it engendered political paralysis, while advocates insisted that it was the least of all evils and faithfully reflected the will of the electorate.

In the area of foreign affairs, relations with the United States were close despite several crises when the Americans pressed Israel to soften its positions, especially regarding the Palestinians. Relations with the Soviet Union began to thaw, a process that gained momentum alongside the growing changes in, and disbandment of, the Communist empire. The same was true of the rest of the East European countries. Israeli ties with many of the African states improved as well. By contrast, the Common Market countries continued censuring Israel for its ongoing control of the occupied territories, and the U.N. continued passing anti-Israel resolutions.

The first half of the decade was dominated by the war in Lebanon. Responding to escalating attacks by the Palestinian terrorist organizations based in Lebanon, the Israeli government, led by Menahem Begin, with strong advocacy by Minister of Defense Ariel Sharon, decided on a military operation aimed at knocking out the terrorists' infrastructure in all parts of southern Lebanon.

The invasion by the I.D.F. of southern Lebanon (Operation Peace for Galilee) in June 1982 was at first widely supported by the Israeli public, but this backing began to shrink once it became clear that the Sharon-Begin goal was to achieve a "new order" in Lebanon in addition to weakening the Palestinian terrorists. The I.D.F. rapidly advanced to the outskirts of Beirut, but once there began to sink into the "Lebanese mire." The number of Israeli casualties grew, evoking severe criticism. A prolonged period of sharp political debate ensued between the Left (which called for a withdrawal from Lebanon) and the Right (which justified Israel's

presence there), ending with the formation of a new government which evacuated the I.D.F. in mid-1985.

A new stage in Israel's relationship with the Palestinians in the West Bank and Gaza Strip began in late 1987 with the outbreak of the Intifada. This grass roots insurrection continued for years, forcing the I.D.F. to intensify its presence and activity there, with only partially successful results.

Economically, the period can be divided into two. The first half of the decade witnessed galloping inflation that reached its peak in 1984 – 400%. At times, the Likud finance ministers appeared to be losing control of the economy, which more than ever before was harnessed to political ends. This was graphically reflected in the 1981 election campaign, which highlighted Finance Minister Yoram Aridor's policy of "correct economics." Soaring to unprecedented heights, the stock market then crashed in late 1983, causing a serious psychological as well as financial jolt to the country. The national unity government formed in the summer of 1984 addressed itself to the task of halting inflation, managing in a relatively short time to rein it in to 20% annually, although this did not solve the country's economic ills, which persisted until the end of the decade.

Immigration was scanty, a result, among other things, of difficulties in absorption, a restrictive emigration policy in the Soviet Union, and mounting "dropping out" to other destinations by those Jewish emigrants from the U.S.S.R. who did obtain exit permits to Israel. At mid-decade, a large group of Jewish immigrants arrived from Ethiopia (Operation Moshe), while at the end of the decade the changes taking place in the Soviet Union began to affect emigration to Israel, heralding the wave of hundreds of thousands of immigrants from the former Soviet Union who would reach the country in the early 1990s.

Political, ethnic and religious tensions typified the decade. Political-ethnic tension was at its peak in the elections of 1981, when massive abuse was directed at the Alignment candidate, Shim'on Peres. After 1982, the Left-Right political struggle centered on the evacuation of Sinai, the presence of the I.D.F. in Lebanon, and the Jewish settlements in the West Bank. The formation of a unity government in 1984 reduced the confrontations between the two camps to a large extent. Relations between the ultra-Orthodox and the secular sectors deteriorated, with conflicts surfacing periodically and remaining unresolved. Another growing focus of tension involved the Jewish settlers in the West Bank and Gaza Strip, who charged that the government was not doing enough to expand Jewish settlement there and that it displayed weakness in the face of Palestinian terror. An underground Jewish organization established against this background in the occupied territories carried out several acts of revenge against Arabs. The perpetrators were apprehended and sentenced to prison, although in most cases their sentences were later reduced.

January

2 Herzl Shafir is named the new inspector general of the police.

7-10 Begin and Sadat meet for talks in Aswan.

23 The fifth stage of Israel's withdrawal from Sinai is completed. One of the sites returned is the Refidim air base.

Strikes break out by teachers and air and sea portworkers.

February

2 Hanna Rovina, the grand dame of the Israeli stage, dies at age 90.

18 An Israeli embassy is opened in Cairo.

24 The Israeli lira is replaced by the shekel: 1 shekel=10 liras.

26 Full diplomatic relations come into effect between Israel and Egypt.

27 Talks between Israel, Egypt, and the United States on the future of the autonomy in the West Bank and Gaza Strip are begun in Holland.

29 Yigal Allon, one of the first commanding officers of the Israel Defense Forces, a government minister, and deputy prime minister, dies aged 62.

March

1 The U.S. supports a U.N. Security Council resolution calling for the disbandment of all Jewish settlements in the West Bank and the Gaza Strip. Israel is distressed.

3 El Al, Israel's national carrier, inaugurates a regular line to Cairo.

4 President Carter terms the U.N. Security Council vote a "misunderstanding."

10 Itzhak Shamir is appointed foreign minister.

27 The Maccabi Tel-Aviv basketball team loses in the Europe finals cup to Real Madrid, 89:85.

April

7 A terrorist attack on Kibbutz Misgav Am at the northern border results in 3 Israelis killed and 16 wounded. I.D.F. troops respond by entering Lebanese territory on April 9 and carrying out anti-terrorist operations there until the 13.

May

1 A May 1 rally in Tel-Aviv attracts 150,000 marchers displaying anti-government slogans.

2 Palestinian terrorists attack Jews returning from Sabbath eve prayers in Hebron, killing six.

3 Israel responds to the murder of the six in Hebron by deporting three prominent Arab public figures to Jordan: the Mayor and the Kadi of Hebron, and the Mayor of Halhul. Their expulsion is suspended until a decision is reached by the Supreme Court.

8 The autonomy talks are suspended at Egypt's initiative.

16 The I.D.F. takes action against Palestinian terrorists in Lebanese territory. The terrorists retaliate by bombing settlements in the Upper Galilee panhandle.

22 The Israeli Olympics Committee decides against participation in the forthcoming games in Moscow, joining most Western countries in a protest against Soviet intervention in Afghanistan.

25 Minister of Defense Ezer Weizman resigns over disagreements with government policy on autonomy. Prime Minister Begin takes over the defense portfolio.

June

2 Nablus Mayor Bassam Shak'a and Ramallah Mayor Karim Khalaf are seriously wounded by explosives planted in their cars.

13 The European Community adopts an anti-Israel resolution – the Venice declaration, which, while affirming Israel's right to exist, calls on it to enter into negotiations with the P.L.O., provided that the latter ceases terrorist activity, and demands that Israel end its occupation of the West Bank and Gaza Strip.

A kidnapping and murder episode creates shock waves in Israel: Zvi Gur kidnaps Oron Yarden, a boy of 10 from Savyon, on June 8. He demands a ransom and receives it. On the 30th, the body of the child is found. The kidnapper is captured.

July

The first F-16 fighter planes arrive in Israel from the U.S.

13 The Israeli-Egyptian autonomy talks resume in Cairo.

20 An explosion at Israel Military Industries causes 6 fatalities.

29 Another sharp anti-Israel resolution is passed in the U.N.

30 The Knesset passes the Jerusalem Law, confirming that city as the capital of Israel, by a vote of 65 to 15. Various countries protest. Countries that have embassies in Jerusalem transfer them to Tel-Aviv.

August

2 Sadat suspends the autonomy talks in protest against the passage of the Jerusalem Law.

3 Minister of Justice Shmuel Tamir resigns. He is replaced by Moshe Nissim.

19 Large Israeli forces attack terrorist bases in southern Lebanon. Katyusha rocket attacks on Israel's northern settlements follow.

21 The U.N. Security Council calls on the countries of the world not to recognize the Jerusalem Law.

Reports in the press announce that the minister of religious affairs, Aharon Abu Hatzira (National Religious Party), will be interrogated on account of theft and fraud and under suspicion of having transferred funds from state institutions to his faction.

September

14 An I.D.F. Skyhawk crashes in the village of Yokne'am. One woman is injured and later dies. Two people suffer heart attacks. The pilot is extricated unhurt.

October

5 A bomb planted in a package explodes in a post office in Giv'atayim, killing 3 and wounding 7.

17 Israeli forces attack terrorist bases in southern Lebanon.

21 A series of price rises is announced.

26-30 The first visit to Egypt by an Israeli president – Itzhak Navon – takes place.

November

5 The cost of gasoline rises by 25%.

6 A Katyusha missile attack on Kiryat Shmona wounds several residents.

7 I.D.F. planes respond to the attack on Kiryat Shmona by attacking terrorist bases in Lebanon.

23 The Herut movement cancels Ezer Weizman's membership after he supports a vote of no-confidence in the government.

28 Painter and author of children's books, Nahum Gutman, dies aged 82.

30 Zvi Gur, who kidnapped and murdered the child Oron Yarden, is sentenced to life imprisonment and 34 additional years.

December

3 Young men from the depressed Hatikva neighborhood lock the Mayor of Tel-Aviv-Jaffa, Shlomo Lahat, in his office. He is released, one hour later, by the police, the fire department, and the Border Police.

5 The military government deports the Mayors of Hebron and Halhul – Fahad Kawasma and Muhammad Milhem – to Lebanon despite a recommendation by the Supreme Court that the government reconsider this decision.

18 Shim'on Peres beats Itzhak Rabin as the Labor Party's candidate for the post of prime minister at the party's third convention.

In the course of the month, several demonstrations are held by the ultra-Orthodox in Jerusalem.

Inflation soars to 131% during the year.

1980

479

▽ With the Israeli-Egyptian peace agreement signed (March 1979), full diplomatic relations come into effect in February 1980, and El Al planes begin flying to Cairo.

▷ The first ladies of Egypt and Israel, Jehan Sadat (l.) and Ofira Navon, meet in Cairo in the fall of 1980.

△ Egypt's first ambassador to Israel, Sa'ad Murtada, arrives in February 1980. The cloud of smoke is not symbolic; relations are cordial. The ambassador is received very warmly in Israel and is invited to public events and to private homes.

▷ Itzhak Navon meets with Anwar Sadat during the historic first trip by an Israeli president to Egypt. Sadat, too, gives a warm reception to Israeli leaders and public figures.

▽ Cairo, capital of Egypt, has never before witnessed a sight such as this: the Israeli flag flying from a building rented to house the Israeli Embassay. Egyptians come to stare at the unusual sight. Israel's first ambassador is Eliyahu Ben-Elysar, Director General of the Prime Minister's Office since 1977.

▷ The fifth stage of the I.D.F. withdrawal from Sinai is completed in January 1980, including evacuation from the large army base and airfield at Refidim. The sign left by the soldiers reads: "We did not withdraw – we conceded for the sake of peace."

A DIFFICULT YEAR

Opening a new decade, the year 1980 did not augur well for the State of Israel, its government, or its inhabitants, and ended even less promisingly. The government functioned poorly, with Prime Minister Begin himself referring to "impairments" in it. These consisted essentially of interministerial frictions as well as ongoing leaks from cabinet meetings.

Relations between Prime Minister Begin and Defense Minister Ezer Weizman deteriorated during the first half of the year, culminating in Weizman's resignation early in the summer over differences in opinion with Begin regarding the pace of progress in implementing the Camp David accords in the West Bank and Gaza.

The economic situation was in a state of decline. Despite appeals by Finance Minister Yigal Hurwitz for economic restraint, inflation continued to spiral. The lira was replaced by a new currency unit, the shekel, at a rate of 1 shekel to 10 liras, but this did not brake rising prices, and the year ended with an unprecedented rate of inflation: 131%.

The adoption by the Knesset in July of the Jerusalem Law affirming Jerusalem as the capital of Israel elicited censure on all sides, and the country's standing in Europe, the U.S., and the U.N., in decline even beforehand, deteriorated further. Countries that maintained their embassies in Jerusalem moved them to Tel-Aviv.

Friction between the Arab and Jewish residents of the West Bank intensified. The mayors of Nablus and Ramallah were injured by terrorist devices planted in their cars by Jews.

Toward the end of the year, the Begin government appeared to be nearing the end of its ability to function, although almost a whole year remained until the next scheduled elections.

▷ A Palestinian terrorist band infiltrates into Kibbutz Misgav Am at the northern border and takes control of the children's residence. Three Israelis are killed in the ensuing battle – a member of the kibbutz, a child, and a soldier – and 16 are injured, while all the terrorists are killed. Numerous other incidents occur along the northern border during the year.

△ The deportation of three prominent Arab figures from the region of Hebron preoccupies the Israeli justice system, the press, and the I.D.F. during most of the year.

▽ Histadrut ("Federation of Labor") Secretary-General Yeruham Meshel, addressing tens of thousands at a May 1 rally in Tel Aviv, attacks the Likud government's policies.

482

קיימים / חדשים

△ The Israeli lira (l.), in use since the founding of the state, is replaced in early 1980 by a new monetary unit, the shekel (r.), at the rate of 10 liras=1 shekel, in the hope of catching up with the galloping inflation of 131% in 1980.

▷ A new police inspector general, Maj. Gen. (Res.) Herzl Shafir, formerly head of Operations Branch at G.H.Q., is appointed in January 1980. He is shown (l.) with Prime Minister Begin (r.) and Minister of the Interior and of the Police Yosef Burg.

◁ Minister of Religious Affairs Aharon Abu Hatzira (c.), a National Religous Party leader, is in the eye of a storm in the fall of 1980 when he is accused of fraud and the transfer of funds and allocations from religious institutions to the N.R.P. faction that he heads. He is requested by the attorney general to resign, but refuses.

△ A stamp issued by the Jewish National Fund commemorating Zionist leader Gruenbaum bears a shekel denomination before the change-over is announced.

△ A post office in Giv'atayim is blown up by a terrorist bomb planted in a package. The toll is three killed and seven wounded.

▽ Yigal Allon, an I.D.F. major general, member of Knesset, and government minister, dies in 1980 at age 62.

△ Shim'on Peres (top) beats Itzhak Rabin in 1980 in a new round in their ongoing rivalry.

△ Changes in the government during 1980 include the resignation in May of Defense Minister Ezer Weizman (picture) and in August of Justice Minister Shmuel Tamir. Weizman has been dissatisfied with the government's position on the autonomy talks. Prime Minister Begin takes over the defense portfolio until the elections in 1981.

1981

January

11 Minister of Finance Hurwitz resigns, claiming he can no longer function in light of the government's adoption of the Etzioni Commission report recommending the raising of teachers' salaries.

Prime Minister Begin proposes advancing the elections from November to June.

13 Minister of Communications, Yoram Aridor, announces that T.V. programs will be broadcast in color.

21 Yoram Aridor is named new finance minister.

22 The one-shekel coin is put into use. The public is irritated by its tiny size.

28 Burglary at Ha'aretz Museum in Tel-Aviv. Art objects valued at millions are stolen.

February

1 The treasury announces tax reductions on cars and electrical appliances, a move viewed by some as "election economics" being applied by Finance Minister Aridor.

2-3 The Tel-Aviv Stock Exchange crashes. Stocks drop by an average of 15%.

18 Prisoner of Zion Yosef Mendelovitz arrives in Israel from the Soviet Union.

22 University lecturers strike. The entire educational system strikes on February 24 and 25.

The ultra-Orthodox demonstrate in Jerusalem over the opening of a major traffic artery – the Ramot road – adjoining one of their neighborhoods. Thousands demonstrate on the Sabbath of March 14 at the Ramot road. Passing cars are stoned.

6-7 A Palestinian terrorist using a windsurfer infiltrates into the Acre area and takes a hostage. After a dramatic nightlong search, he is apprehended asleep in an Arab village in the Galilee while the hostage has escaped.

8 University studies resume.

The Israeli freighter Massada sinks in the vicinity of the Bermuda Triangle with a loss of 24 crew members.

26 Maccabi Tel-Aviv wins the European basketball cup for the second time, beating Sinudyne Bologna 80:79.

April

7 The Alignment gains 63% in elections to the Histadrut ("Federation of Labor") while the Likud attains 26%.

10 An Israeli force overruns a terrorist arms depot near Nabatiyeh in Lebanon.

16 A hot-air balloon operated by Palestinian terrorists is brought down near Kibbutz Manara in the Galilee. The terrorists are killed.

20–21 Intensive skirmishes

panhandle is bombarded by Katyushas.

28 Israeli planes bring down two Syrian helicopters over Lebanese territory.

29 Syria positions S.A.6 antiaircraft missiles in Lebanese territory.

May

9 Poet Uri Zvi Greenberg dies aged 84.

11 M.K. Flatto-Sharon, convicted of bribing voters in the 1977 elections, is sentenced to three years in prison, nine months of it in practice.

19 U.S. envoy Philip Habib presents a proposal for the solution of the Lebanese problem and the Syrian missile crisis.

21 Two families renew the Jewish presence in the ancient Jewish quarter of Hebron.

24 Abu Hatzira is cleared on the first indictment because of insufficient evidence. He decides to run for the Knesset on an independent party – Tami.

26 The forthcoming elections for the Tenth Knesset encompass 36 tickets, 24 of them new.

28 Israeli planes destroy Libyan antiaircraft missile positions on the outskirts of Beirut.

31 Five Druze leaders in the Golan Heights are arrested on suspicion of incitement against Israel.

June

3 The Golan Druze declare a general strike in response to the arrest of their leaders.

4 Begin and Sadat meet at Ofira at the southern tip of Sinai.

7 Israeli planes destroy Iraq's nuclear reactor.

10 President Reagan registers his displeasure over the Israeli operation in Iraq by holding up the delivery of F-15 fighter planes to Israel.

19 The U.N. Security Council censures Israel's destruction of the Iraqi reactor.

25 Begin debates Peres on television.

30 The elections result in 48 seats for the Likud and 47 for the Alignment. Begin will be able to form a new government.

July

10 Responding to I.D.F. attacks on their bases in Lebanon, Palestinian terrorists bombard Kiryat Shmona with Katyushas, wounding 14 inhabitants.

The terrorists continue to bombard Kiryat Shmona, along with Nahariya, for several days. Israeli planes carry out bombing missions in Lebanon. The terrorists respond with further Katyusha attacks. An Israeli force attacks a terrorist base near the mouth of the Zaharani River. The toll in Israel after a week of confrontation is five civilians killed and some 50 wounded.

24 American mediation between Israel and the P.L.O. in Lebanon achieves a ceasefire.

August

3 A flare-up occurs between archeologists digging in the City of David area south of the Western Wall and the ultra-Orthodox, who claim

Election economics, 1981: unloading televisions in Tel-Aviv.

March

Doctors, teachers, university lecturers, engineers, and other sectors hold strikes during the course of the month.

take place between Israeli forces and Palestinian terrorists in southern Lebanon. Israeli planes attack terrorist bases. The Upper Galilee

The Americanization of the 1981 elections: Begin kisses a child in Migdal Ha'emek.

that an ancient Jewish cemetery, which may not be disturbed, lies at the site.

485

△ Archeological digs result in confrontation with the ultra-Orthodox. The satiric sign laid in the rubble reads: "Thou shalt not dig/Thou shalt not engage in research/Thou shalt not know…"

▽ Hapo'el Tel-Aviv soccer stars Shabtai Levy (c.) and Moshe Sinai (r.) are guided in putting on ritual phylacteries in Tel-Aviv. This may have helped their team win the National League championship in 1981.

Confrontations and demonstrations on the issue take place during the month in the Me'ah She'arim neighborhood and elsewhere in Jerusalem.

5 Begin forms a new government consisting of the Likud, the National Religious Party, and Tami, with external support from Agudat Israel, totaling 61 M.K.s (of 120). David Levy is deputy prime minister. Ariel Sharon is defense minister.

24 A new power station at Hadera links up with the national grid.

25 Begin and Sadat meet in Alexandria and decide to renew the autonomy talks.

26 Fighter planes held back from delivery by President Reagan arrive in Israel.

A ruling by the Chief Rabbinate to halt archeological digging at the City of David prompts Education Minister Hammer to shift jurisdiction on the issue to the attorney general.

September

Tension over the archeological digging at the City of David continues. The issue reaches the Supreme Court after Education Minister Hammer signs an order halting the digging for two weeks. The Supreme Court rules that the dig may continue.

20 Attorney General Zamir expresses the opinion that the Rabbinic Court does not have the authority to determine whether a cemetery existed in the City of David area and that the issue is one for experts to decide.

22 Talks on the autonomy of the West Bank and Gaza Strip resume between Israel and Egypt.

24-26 An Israeli missile boat runs aground off the Saudi coast. It is extricated after contact is made with the Saudis through the Americans.

October

6 President Anwar Sadat of Egypt is assassinated during a rally marking eight years since the Yom Kippur War. A high-ranking Israeli delegation led by Prime Minister Begin attends his funeral. Husni Mubarak

succeeds Sadat.

16 Moshe Dayan dies aged 66.

27 An Israeli-Egyptian agreement on the completion of Israel's withdrawal from Sinai is signed.

November

A wave of work sanctions disrupts public services.

1 The Hebrew University of Jerusalem begins the academic year in its campus on Mt. Scopus after a hiatus of over three decades.

5-18 El Al strikes. The strike ends following the resignation of the chairman of the board, Buma Shavit.

8 A new military airfield in the Negev, Uvdah, is inaugurated.

20 The first Israeli woman undergoes in vitro fertilization.

December

1 The U.S. and Israel sign a Memorandum of Strategic Understanding. Defense Minister Ariel Sharon signs for Israel.

The settlers of Yamit in northern Sinai barricade themselves in their settlement in protest against the scheduled evacuation.

7 The barricade is removed at Yamit. Defense Minister Sharon visits the settlement and promises to act on the issue of compensation.

14 The Golan Law is passed in the Knesset in a streamlined one-day procedure, establishing Israeli sovereignty on the Golan Heights. The move elicits world protest.

18 The U.S. suspends the Memorandum of Strategic Understanding in response to the passage of the Golan Law.

23 A slash in subsidies of basic commodities results in cost hikes of 20%-25%.

24-25 Talks between the Yamit settlers and the minister of finance on the issue of compensation break down.

Inflation in 1981 is 116.8%.

THE BOMBING OF THE NUCLEAR REACTOR IN IRAQ

Led by its president, Saddam Hussein, Iraq systematically upgraded its military capabilities during the late 1970s and early 1980s, including the construction of a French-made nuclear reactor (named "July 17," the day the Ba'ath came to power).

Israel feared that the reactor was nearing attainment of the capability to produce nuclear bombs. In June, 1981, after an intelligence report determined that the reactor would be "hot" within a month, after which its destruction would engender radioactive fallout, Israel decided to act. Eight Israel Air Force planes took off for Iraq, overflying Jordan and Saudi Arabia without being detected by the radar systems of either country or of Iraq. The planes deposited 16 tons of explosives on the target within two minutes and flew back safely.

Iraq's nuclear dream was shattered. The Israeli public welcomed the news, while the Arab states raged and censure was registered in the West. The *New York Times* wrote that "the surprise attack on the reactor was an unforgivable and shortsighted aggressive act," while the *Washington Post* called the Israeli act "grave."

A decade later, however, in light of the Gulf War, most experts and observers were in agreement that Israel had been justified in crippling Iraq's nuclear potential so drastically and that it had thus probably prevented a nuclear threat to the Middle East for many years.

△ The Iraqi nuclear reactor blown up by the Israel Air Force on June 7, 1981, is destroyed in less than two minutes. The operation evokes criticism but also admiration in Israel and elsewhere. A *Yedi'ot Aharonot* ("Latest News") headline (below) refers to it as "Operation Entebbe Two."

▽ Prime Minister and Defense Minister Menahem Begin visits the air squadron that carried out the bombing of the Iraqi nuclear reactor. Critics link the operation to the approaching Knesset elections, a charge that Begin rejects out of hand.

△ Posters in the ultra-Ortho-
dox Me'ah She'arim neigh-
borhood state: "We are
not taking part in the elec-
tions," a reflection of the
ideological gulf between
this community and the
"Zionist" government.
Nevertheless, most of the
ultra-Orthodox do vote,
and become a distinct
political force.

▷ Running for the Knesset
for the last time, Moshe
Dayan, who resigned from
the Begin government in
1979, campaigns in April
1981 at the head of a
new party and wins two
seats. A few months later,
however, he dies.

THE ELECTIONS FOR THE TENTH KNESSET

Elections for the Tenth Knesset were held at the end of
June 1981. Begin, whose personal popularity, like that
of his government, had been at a low ebb only months
before, turned the situation around, with polls indicating
that he could win. Factors working in his favor included
the "correct economics" policy introduced by the new
finance minister, Yoram Aridor, which was well received
by the public and prompted a sense of well-being even
though objectively the economic situation was poor and
inflation was out of control. A violent campaign that
vilified Alignment candidate Peres succeeded in retriev-
ing large sectors of the Likud electorate and reviving
confidence in the government's viability. Additionally,
the bombing of the Iraqi nuclear reactor three weeks
earlier elicited widespread public support, although its
timing was perceived by some observers both at home
and abroad as a domestic political move. Lastly, the
ongoing rivalry between Peres and Rabin weakened the
Alignment's chances.

A T.V. exit poll screened just after the polls closed
pointed to a close race with a slight edge for the Align-
ment, prompting Peres aides to declare him the new
prime minister. They were soon proved wrong, how-
ever. Although the Alignment showed an impressive
gain in Knesset seats (from 33 to 47), the Likud's gain
(from 45 to 48) proved decisive. Moreover, the
Alignment lacked coalition allies, as the left and center
parties had disappeared or been weakened. Begin co-
opted three small religious parties – the N.R.P. (6 seats),
Agudat Israel (4), and Tami (3) – thereby forming a
minimalist coalition of 61 M.K.s. Ariel Sharon joined
the government as defense minister.

▷ The election campaign for the Tenth Knesset is stormy, featuring mudslinging and abuse, with Alignment candidate Shim'on Peres the chief target. His speeches at campaign appearances are systematically heckled by Likud stalwarts, as in the photo of a rally in Petah Tikva in June 1981. At this rally, a fist fight starts and many people are injured.

△ The first reports on the election results, predicting victory for the Alignment, evoke apprehension in the Likud leadership (l.), but

the picture later changes (r.), as reflected in the optimistic faces of David Levy (l.) and Yoram Aridor.

▽ The process is reversed in the Alignment camp. Joy (l.) turns to sorrow (r.) when it becomes clear that

despite the party's gains, the Likud has triumphed. (Left to right: Rabin, Peleg, Peres.)

◁ A photograph released for publication only years later shows a Jewish boy from Ethiopia en route to Israel. The Israeli navy, along with various other parties, play a role in this immigration operation in March 1981. The Ethiopian Jews are picked up by the navy from the shores of Sudan and taken to Israel.

△ Palestinian terrorists bomb the settlements in the north repeatedly during July 1981. Shown, a building in Kiryat Shmona hit by a Katyusha rocket.

▷ Former N.R.P. leader Aharon Abu Hatzira decides to form a new, ethnic-based religious party, Tami, in 1981.

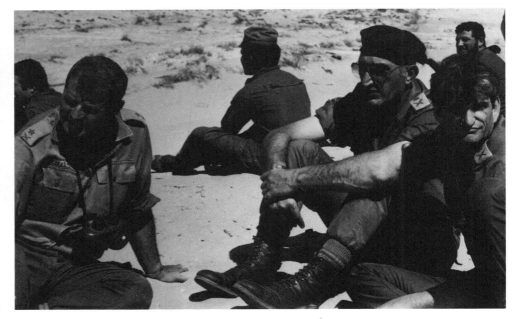

▷ I.D.F. generals review the worrisome situation at the northern border, July 1981. In foreground, l. to r: Amir Drori, Moshe Levy and Avigdor Ben-Gal ("Yanush").

January

1 The last stage of the evacuation from Sinai begins.

6 A new state comptroller, Itzhak Tunik, replaces outgoing comptroller Nebenzahl.

19 An agreement is signed by Israel and Egypt to complete the evacuation from Sinai and normalize relations.

February

Tension between the Druze of the Golan and the Israeli government comes to the fore during the month. The Druze hold strikes and demonstrations to show their identification with Syria.

6 The U.N. General Assembly calls for an international boycott of Israel. The vote is 86 countries for, 21 against, and 34 abstentions.

9 All government-controlled products and services are adjusted upward in price as a result of inflation.

16 Israel's new ambassador to the U.S. is Moshe Arens.

21 Prof. Gershom Scholem, eminent scholar of the Kabbalah and of Jewish history, dies aged 84.

March

3 French President François Mitterand arrives in Israel for a visit.

The settlements at the Pithat Rafiah region of Sinai are disbanded during the first week of the month. Opponents of the evacuation attempt to block it.

12 Minister of Planning Ya'akov Meridor unveils an electricity-saving invention on T.V., which evokes derision as being scientifically unsound.

14 The government decides to appoint a commission of inquiry on the controversial unsolved case of the murder of Hayim Arlozoroff in 1933.

23 A Knesset vote of confidence in the government results in a tie, 58 to 58. The government does not resign.

Violent incidents occur in the West Bank. A contributing factor is the closure of Bir Zeit University near Ramallah.

The military government dismisses the mayors of Ramallah, al-Bira, and Nablus for noncooperation.

April

1 The Yamit region in Sinai is declared a closed military area.

Tension continues in the Druze community of the Golan Heights. Many Druze who opted for Israeli citizenship demonstratively turn in their identity cards.

11 In a violent incident on the Temple Mount, an Israeli soldier who immigrated from the U.S., Eliot Goodman, opens fire indiscriminately, killing 2 Arabs and wounding 12. The incident prompts demonstrations and riots in the Arab world.

19 A week of troubling confrontation begins at Yamit between the I.D.F. and the

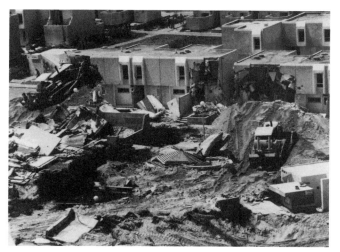

Bulldozers tear down Yamit, April 1982.

last of the settlers there, along with supporters from the Movement to Halt the Withdrawal, who barricade themselves in the settlement.

21 The anti-evacuation protesters in Yamit bombard I.D.F. soldiers with stones, bottles, and other objects.

23 M.K. Aharon Abu Hatzira is convicted of theft, fraud and breach of trust by a public servant and manager of a public fund. He receives a suspended prison sentence.

25 The relinquishing of the Sinai Peninsula to Egypt is completed according to the terms of the peace accords. The inhabitants of Yamit who refuse to leave, together with their supporters, are evacuated by force. Bulldozers raze the town.

May

2 Implementing one aspect of the coalition agreement with the religious parties, the government announces that El Al will cease flying on the Sabbath.

9 Responding to attacks by Israeli planes on Palestinian terrorist bases in Lebanon, the terrorists bombard the Galilee with Katyusha missiles.

18 The Likud faction in the Knesset is trimmed by the crossover to the Alignment of two of its M.K.s., Amnon Lin and Itzhak Peretz.

19 The government wins a vote of confidence in the Knesset by a slim majority of 58 to 57 with 3 abstentions.

25 Israel Air Force planes down two Syrian planes over Lebanese territory.

June

3 A Palestinian terrorist shoots Israel's ambassador in Britain, Shlomo Argov, wounding him seriously.

4-5 Israel responds to the assassination attempt in Britain by attacking terrorist bases in Lebanon. The terrorists launch Katyushas into the Galilee.

6 Operation Peace for Galilee begins (see box).

8 The U.S. vetoes a U.N. Security Council proposal to censure Israel and impose sanctions on it because of its refusal to withdraw from Lebanon. A special U.S. ambassador to deal with the crisis in Lebanon, Philip Habib, arrives in the region.

15 Israel's value added tax is raised from 12% to 15%.

Prime Minister Begin leaves for the U.S.

18 The prices of basic commodities are raised by 19%.

27 Israel demands that the Palestinian terrorists evacuate from Beirut as a condition of starting negotiations between the sides over the future of Lebanon.

Israel is censured in Europe and the U.S. over the fighting in Lebanon.

July

3 A Peace Now rally in Tel-Aviv protesting against the war in Lebanon attracts 100,000 participants.

8 Bir Zeit University near Ramallah is closed once again, for three months.

17 A large demonstration is

Prime Minister Begin and President Reagan confer in Washington shortly after the start of the Lebanon War.

The Lebanon War (Operation Peace for Galilee) Principal Events during 1982

June

6 Israeli forces enter Lebanon along three routes – eastern, central and western, encountering only moderate opposition. They conquer "Fatah Land", in the heart of the region. The Beaufort fortification is seized in the morning of 6.7.

7-9 The Israeli forces advance toward Beirut. The Syrians join the battle and engage the Israelis. Damur falls. The I.D.F. reaches Khaldeh, south of Beirut. Battles with the Syrians in Ein Zahleta.

9 Israel Air Force planes attack Syrian missile launches in Lebanon and destroy most of them. Dozens of Syrian planes are downed in aerial battles, with no Israeli losses.

11 Armored battles with the Syrians take place in the eastern sector. Israel announces a cease-fire. Israeli forces dig in south and east of Beirut. The I.D.F. captures large quantities of weapons and equipment held by the Palestinian terrorists.

15 At the end of 10 days of fighting, the I.D.F. has captured 5,000 terrorists, including citizens of Syria, Jordan, Kuwait, Iraq, Pakistan, and other countries, as well as 149 Syrian soldiers. Israeli losses are 214 killed, 23 missing, 1 soldier captured and 1,114 wounded.

23-25 Battles between the Palestinian I.D.F. and the Syrians take place in the Bahamdun-Aleh-Zofar region. A new cease-fire is implemented.

27 Israel demands that the Palestinian terrorists evacuate Beirut and leave Lebanon, a condition supported by the Knesset in a vote on June 29th.

July

4 The I.D.F. tightens its encirclement of southern Beirut.

21-24 Terrorists attack Israeli forces in the eastern sector and near Tyre. The I.D.F. engages the terrorists and the Syrians in fighting.

August

1-4 The I.D.F. tightens its siege on the terrorist strongholds in Beirut and takes control of the international airport in the outskirts of the city.

4 President Reagan, in a strongly worded letter, demands of Prime Minister Begin to halt the I.D.F. bombing of Beirut.

21 The evacuation of the terrorists from Beirut begins under the supervision of a multi-national force. One of the conditions of the evacuation is the return of two Israeli prisoners.

23 Bashir Jumayil is elected president of Lebanon.

31 The last of the Syrian troops leaves Beirut.

September

1 The evacuation of some 15,000 Palestinian terrorists from Beirut ends.

4 Terrorists kidnap eight I.D.F. soldiers in the Bahamdun area of central Lebanon.

13 A prolonged violation of the cease-fire prompts Israeli planes to attack terrorist and Syrian targets, as well as a Libyan force in Lebanon.

14 Lebanese President-elect Bashir Jumayil is murdered.

15 Israeli armored and infantry forces enter western Beirut.

17-18 Palestinians are massacred by Christian Phalangists in the Sabra and Shatila refugee camps in Beirut.

21 Amin Jumayil, Bashir's brother, is elected president of Lebanon.

27 French and Italian paratroop forces take up positions in Lebanon.

29 The I.D.F. evacuates from Beirut Airport.

October-December

The terrorists in Lebanon periodically attack I.D.F. forces. On 10.3., a bus driving soldiers back from their home leave is attacked in the area of Aleh. Six soldiers are killed and 22 injured. Several incidents are caused by mines. Confrontations also occur between Druze and Christians in Lebanon, mostly in the Israeli occupied zone. Israeli soldiers, often reluctantly, get involved in such confrontations.

Israeli casualties from the start of the fighting on June 6 until the end of the year are 454 soldiers killed, 2,435 wounded, 11 taken prisoner by the Syrians and the terrorists, and 5 missing.

held in Tel-Aviv by the Right in support of the government and the war in Lebanon.

25 Begin widens the coalition, coopting the right-wing Tehiya party.

U.S. envoy Philip Habib continues mediation efforts on the Lebanese question.

August

5 The prices of basic commodities rise once again, by 15%-40%.

12 El Al workers at Ben-Gurion Airport strike over the plan to halt flights on the Sabbath.

22 The government announces the discontinuation of El Al flights on the Sabbath and religious holidays from September 1st.

29 Nahum Goldmann, president of the World Zionist Organization, dies aged 87.

September

1 Prime Minister Begin meets with Lebanese President Bashir Jumayil in Nahariya.

17-18 Lebanese Christian Phalangists massacre Palestinians in the Sabra and Shatila refugee camps in Beirut. Israel, whose forces control the area, is held accountable by the world.

25 The largest-ever demonstration held in Israel takes place at the Kings of Israel Square in Tel-Aviv with 400,000 participants. The rally calls for the establishment of a commission of inquiry regarding Sabra and Shatila, withdrawal from Lebanon, and the resignation of the government.

28 The government decides to establish a commission of inquiry on the Sabra and Shatila issue.

October

1 The Cahan Commission is formed to examine the events surrounding the Sabra and Shatila incident. It is headed by Supreme Court President Itzhak Cahan and composed of Supreme Court Justice Aharon Barak and Maj. Gen. (Res.) Yona Efrat.

19 El Al personnel continue strikes and work stoppages. The airline's board of direc-

tors decides to close the company, a step approved by the government (10.24). The employees shut down Ben-Gurion Airport for a full day (10.27).

November

11 A tragedy in Tyre, southern Lebanon, occurs when a gas leak in the Israeli military government building causes an explosion that takes the lives of 75 Israeli soldiers and security personnel and 15 local workers, and wounds dozens of others.

14 Aliza Begin, wife of the prime minister, dies. The prime minister leaves the U.S., where he is on a state visit, to return home.

24 The Cahan Commission notifies a series of high-ranking figures, including the prime minister, the defense minister, and the chief of staff, that they are liable to incriminate themselves under questioning.

December

1 A new currency note of 500 shekels is issued, evidence of the galloping inflation in the economy.

5 El Al goes into receivership.

7-17 The 30th Zionist Congress convenes in Jerusalem.

23 Rioting erupts in the depressed Tel-Aviv neighborhood of Kfar Shalem when an illegally constructed building is razed. A young resident pulls out and shoots a revolver and is killed by a policeman.

27 An agreement is signed between the El Al receiver and the Histadrut ("Federation of Labor") over the operation of the company. The pilots initially oppose the agreement but accede to it on December 30th.

28 Talks begin between Israel and Lebanon at Khaldeh in Lebanon and at Kiryat Shmona.

Many strikes are held in the public sector during the month of December.

Inflation in 1982: 120.3%.

THE FINAL EVACUATION FROM SINAI

The I.D.F. evacuation of the Sinai Peninsula and the transfer of its control to the Egyptians was completed in April 1982 as stipulated in the peace agreement.

Although the redeployment of the I.D.F. northward to Israeli territory was completed without incident, thousands of civilians in the Yamit region, including a large number of settlers and supporters who came to buttress the local residents, announced that they would resist evacuation. The arena for the final struggle was the town of Yamit. Opponents of the withdrawal barricaded themselves in homes, on roofs, and in basements, some chaining themselves to their homes and several threatening to blow up fuel tanks around themselves and the soldiers in charge of the evacuation. Thousands of men and women soldiers (the latter assigned to deal with the women and children) were assigned to the operation. Locked in a wrenching confrontation with the resisters, they used water and foam hoses, barraged meanwhile by volleys of heavy objects, their ladders pushed back from the rooftops repeatedly.

The I.D.F. won this sad war, too. Defense Minister Ariel Sharon, with characteristic determination, ordered the razing of Yamit. Bulldozers carried out the order over a period of several days. According to Sharon, the Egyptians had demanded the demolition, although this was denied by them.

▽ I.D.F. soldiers equipped with water and foam hoses and ladders confront Yamit settlers who barricade themselves on the roofs of their homes and throw on the soldiers whatever their hands can reach.

△ Bitter pictures of the evacuation of Yamit, April 1982. A weeping soldier evacuates a child from a house about to be demolished, while the parents of the child, together with their friends, are still barricaded in it.

493

THE BUILDUP TO THE LEBANON WAR

Following a period of violent incidents along Israel's northern border in July, 1981, the region quietened down and the Palestinian terrorists in southern Lebanon refrained from attacks on Israeli territory, although the situation remained volatile. When Defense Minister Sharon assumed his post in the summer of 1981, he pressed for a comprehensive move against the terrorists in Lebanon.

The I.D.F. drew up two separate plans for action in Lebanon – small-scale and large-scale. The former envisioned taking control of southern Lebanon, while the latter anticipated an advance beyond the Beirut-Damascus road to take control of central Lebanon as well. Sharon was in contact with the leaders of the Phalangists (the Christian forces) in Lebanon and hoped to conduct most of the fighting with their aid. The Phalangists, however, thought differently, namely that it was the Israelis who should do the work.

The Israeli government, presented with the large-scale plan, did not authorize it, whereupon Sharon, with Begin, decided to implement the smaller plan and see how it worked out.

Early in June, 1982, Israel's ambassador to Britain, Shlomo Argov, was shot and seriously wounded. The Israeli government, in response, ordered the air force to bomb terrorist bases in the Beirut area. This prompted an intensive Katyusha missile bombardment by the terrorists aimed at the settlements in the Galilee. The Israeli reaction was Operation Peace for the Galilee, initiated on June 6, 1982. At first, a limited operation of only 40 km in depth was discussed, but within a few days the campaign widened out and the I.D.F. reached the outskirts of Beirut, where battles with the Syrians began.

Fighters, you who today are deployed in positions stretching from the Lebanese Beqa'a to the outskirts of Beirut serve as a shining example of the successful implementation and completion of the assignment given to the I.D.F. by the government of Israel. Your fighting has destroyed the P.L.O. terrorist infrastructure down to the ground – its thousands of terrorists, its hundreds of artillery nests, and its mountains of weapons concentrated in Lebanon with the aim of sowing death and destruction in Israel. But your heroism has swept away the murderers from the peak of the Beaufort.

From an order of the day by Minister of Defense Ariel Sharon, June, 1982

△ A column of I.D.F. and Christian Phalangist troops moves northward at the start of the war. Seated in the lead vehicle, c., is Major Sa'ad Haddad, commander of the Christian forces.

▷ A famous photo at the start of the Lebanon War shows Prime Minister Menahem Begin (r.) and Defense Minister Ariel Sharon at the Beaufort ruins in southern Lebanon, a point dubbed "the eyes of the terrorists." The site is captured on the first night of the war, removing the threat to Israel's northern settlements – only a few kilometers to the south.

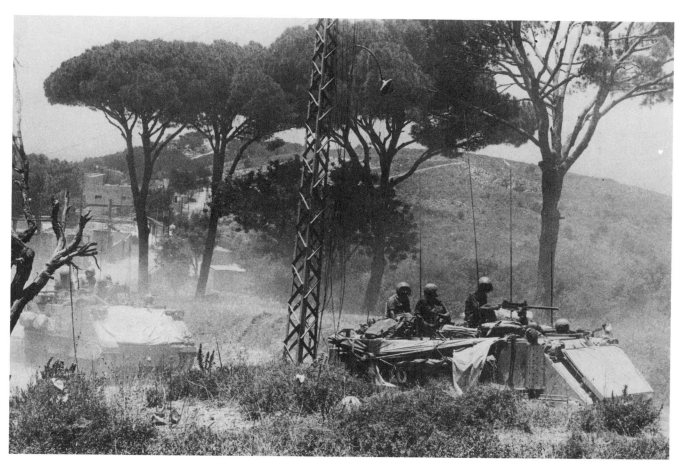

◁ The I.D.F. soldiers are at first welcomed in Lebanon. Local children befriend them, and rice is thrown on their tanks.

△ A typical Lebanese landscape, which is to become familiar to the Israeli forces during the following three years. At first much taken by the breathtaking scenery, the soldiers later come to view it as part of the "Lebanese mire" into which the army seems to be sinking.

▷ Is Beirut burning? The city indeed burns as a result of I.D.F. bombing missions in the summer of 1982, especially the western part of the city, which serves as the base for Palestinian terrorists and various Muslim militias and forces. The bombing lasts for a long period and arouses criticism at home and abroad.

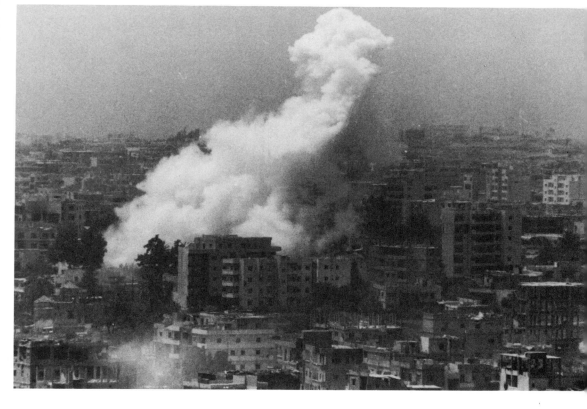

▷ One of Israel's main de-
mands in the Lebanon War
is the evacuation of the
thousands of Palestinian
terrorists based in Beirut
and their departure from
Lebanon. In late August,
1982, some 2¹/₂ months
after the start of the
fighting, the evacuation of
the terrorists from Beirut to
various Arab countries
begins, supervised by a
multi-national force. The
evacuees attempt to show
that they are the victors,
and adorn their vehicles
with pictures of Arafat,
Assad, and Guevara.

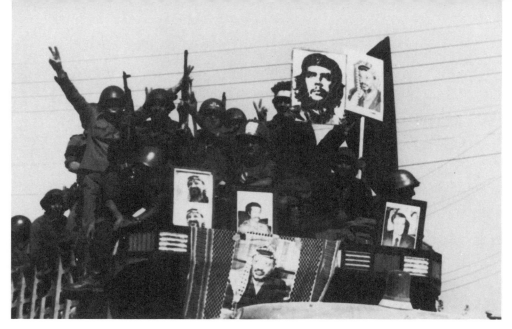

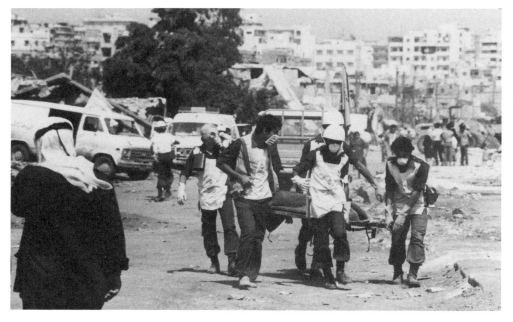

◁ The massacre perpetrated
by the Christian
Phalangists in the Sabra
and Shatila refugee camps
in south Beirut on
September 17,18, 1982,
shocks Israel and the
world. Shown, the removal
of a body from Sabra.

▽ A week after the massacre,
the largest-yet demonstra-
tion in Israel takes place in
the Kings of Israel Square,
Tel-Aviv. Hundreds of
thousands demand with-
drawal from Lebanon, the
resignation of the govern-
ment, and the establishment
of a commission of inquiry
to investigate Israel's
connection to the events
at Sabra and Shatila.

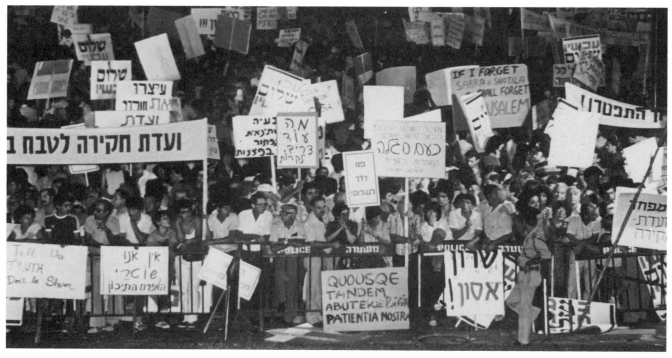

496

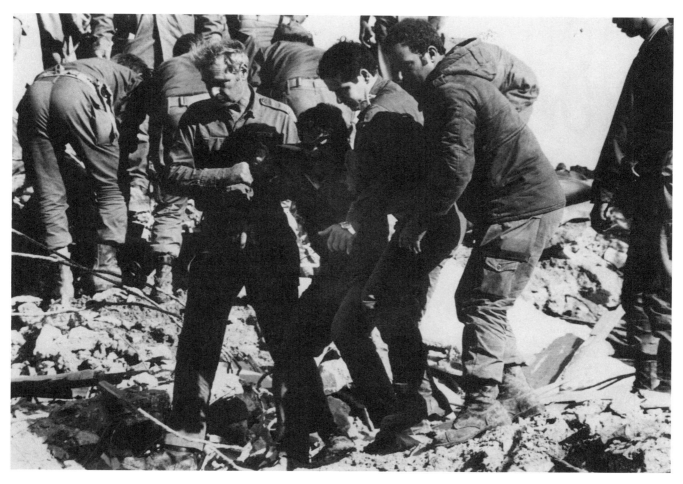

△ Israeli casualties mount as the Lebanon War drags on. The situation is exacerbated by accidents, especially a powerful explosion at Israel's military headquarters in Tyre in November, 1982, as a result of a gas leak. The building collapses, crushing 75 Israelis and 15 local employees to death.

◁ Prime Minister Begin, injured after he slipped in his bathtub, welcomes newly elected French President François Mitterand in a wheelchair during his visit to Israel in March, 1982.

△ The government's decision to halt El Al flights on the Sabbath and religious holidays prompts the company's workers to strike, demonstrate and burn tires on the runways. The company closes down for several months.

1983

January

8 Palestinian terrorists throw hand grenades at a bus en route from Tel-Aviv to Rehovot, resulting in 11 passengers wounded.

12 El Al renews flights after a shutdown of four months.

24 The Tel-Aviv Stock Market plummets. Investors lose a total of billions of dollars as 300 stocks drop by as much as 60%.

February

8 The Cahan Commission publishes its findings on the Sabra and Shatila incident. Several figures are singled out for criticism, especially Defense Minister Sharon.

10 A Peace Now activist, Emil Greenzweig, is killed by a hand grenade thrown at demonstrators in Jerusalem protesting the Lebanon War. Ten other demonstrators are wounded.

The government adopts the Cahan Commission findings.

14 Defense Minister Ariel Sharon resigns in light of the Cahan Commission findings. He is replaced by Moshe Arens (2.27). Sharon remains in the cabinet as a minister without portfolio.

Terrorist attacks on the I.D.F. in Lebanon continue despite the evacuation of the terrorists from Beirut.

March

1 A physicians' labor dispute with the health funds and the government erupts.

2 The physicians declare a general strike. The government issues restraining orders for some 3,500 physicians. The physicians disobey the orders and open alternative treatment sites outside health clinic premises.

15 An international confer-

ence for Soviet Jewry opens in Jerusalem.

Two new chief rabbis are named: Avraham Shapira (Ashkenazi) and Mordechai Eliyahu (Sephardi).

22 Hayim Herzog, the Labor nominee, is elected sixth president of the State of Israel by a majority of 61 M.K.s. His opponent, Supreme Court Justice Menahem Elon, receives 57 votes. Two blank votes are cast.

April

Palestinian terrorists and Lebanese militias continue attacks on the I.D.F. in Lebanon.

The Satmer Rebbe in Israel, June 1983.

6-7 Military decorations are awarded to fighters in the Lebanon War.

19 Chief of Staff Rafael Eitan completes his term of office and is replaced by Moshe Levy.

27 U.S. Secretary of State George Shultz arrives in Israel to advance negotiations with Lebanon.

May

A public storm erupts at the start of the month over the intention of the Hevra Kadisha (religious burial society) to exhume the grave of Tirza Engelovitz, discovered to have been a Christian, and reinter her outside the cemetery premises.

5 Hayim Herzog is inaugurated as president.

16 An agreement with Lebanon ending the state of war is approved by the Knesset by a large majority (57 to 6), with 45 abstentions.

17 The Israeli-Lebanese agreement is signed at Kiryat Shmona and at Khaldeh. It will take effect following the withdrawal of the Syrians from Lebanon and the return of the P.O.W.s and M.I.A.s.

22 The country's physicians, still on strike, take an "organized vacation," followed by a resumption of the strike.

26 Violence in Lebanon continues. A remote control explosive charge targets a busload of I.D.F. soldiers, killing one and wounding 14.

June

4 A mass demonstration in Tel-Aviv by Peace Now calls on the government to leave Lebanon.

7 The Satmer Rebbe arrives from the U.S. for a visit. Thousands of Hasidim welcome him.

10 Three I.D.F. soldiers are killed in an ambush at Tyre. The number of Israeli fatalities since the start of the Lebanon War a year previously reaches 500.

14 The Lebanese parliament approves the agreement with Israel by a vote of 75 to 2.

The striking physicians announce a hunger strike.

19 Deputy Prime Minister and Minister of Agriculture Simha Ehrlich, formerly minister of finance, dies aged 68.

27 The physicians' strike ends after nearly four months, following arbitration with the government.

A group of reserve officers demonstrate opposite Begin's residence for several weeks, calling for withdrawal from Lebanon.

July

5 Sara Doron of the Liberal Party is named minister without portfolio.

7 The military government in the West Bank removes Hebron Mayor Mustafa Natsheh following a series of violent incidents between Arabs and Jews in the city, culminating in the murder of a yeshiva student, Aharon Gross.

11 The ultra-Orthodox

demonstrate in Jerusalem again to protest archeological excavations.

20 Israel decides to withdraw from Beirut to a line to the south along the Awali River.

26 An attack on the Islamic College in Hebron results in three fatalities and dozens of wounded. It is apparently perpetrated by Jewish extremists in retaliation for the murder of the yeshiva student Gross.

August

16 Defense Minister Moshe Arens holds a series of talks in Beirut with Lebanese governmental leaders.

28 Prime Minister Begin announces his intention to resign, causing a jolt in the country's political arena.

September

Efforts are made during the month to form a new government under Foreign Minister Itzhak Shamir, who beats Deputy Prime Minister David Levy as the Herut nominee for the post in internal party elections, 59% to 41%.

4 Israeli forces withdraw from Aleh and the Shuf Mts. to a line along the Awali River.

15 Begin's letter of resignation is conveyed to the president 19 days after the prime minister has announced his intention to retire. Secluded in his home, Begin dispatches the letter with the cabinet secretary.

21 President Herzog assigns the task of forming a new government to Itzhak Shamir.

24 American singers Simon and Garfunkel perform at the Ramat Gan Stadium before a crowd of 50,000.

October

3 A "dollar panic" develops following reports of a large devaluation. The Tel-Aviv Stock Exchange crashes, with 295 stocks dropping and 111 listed as sellers only.

4 Finance Minister Yoram Aridor denies reports of an impending devaluation. Panic continues, however.

5 Bank stocks register strong offerings.

6 The demand for dollars

mounts.

9 The economic crisis continues. The banks cease regulating their stocks. Bank shareholders incur serious losses. The stock exchange shuts down until further notice.

10 Shamir's government is ratified by the Knesset by a vote of 60 to 53.

11 The public goes on a buying spree of unprecedented proportions, perceiving an imminent rise in prices. The government announces a devaluation of 23%. The dollar is now worth 80 shekels.

12 The government promises bank shareholders that it will preserve the present value of the shares, redeemable in five years' time.

13 Finance Minister Yoram Aridor resigns following

reports that he instigated the dollarization of the economy. He is replaced by Yigal Cohen-Orgad (10.18).

20 The bank-share arrangement is signed.

The stock exchange reopens after a hiatus of 11 days.

25 Municipal elections are held. Mayors Teddy Kollek of Jerusalem, Shlomo Lahat of Tel-Aviv, and Aryeh Gurel of Haifa are reelected.

30 Former chief of staff Rafael Eitan forms a new movement, Tzomet, which he defines as nonpolitical.

November

4 In a second disaster at Tyre, terrorists slip a booby-trapped truck into the courtyard of I.D.F. headquarters there and detonate it. The toll

is 28 Israelis and 32 local detainees killed and dozens wounded.

14 Prices of basic commodities soar by 75% in one month.

15 The unprecedentedly high inflation of 21.1% is announced for the month of October.

17 Inflation continues to climb, reflected by the introduction of a 1,000 shekel currency note.

23 All Arab prisoners in the Ansar prison camp in Lebanon, and an additional 99 held in Israel, making a total of 4,600, are exchanged for 6 Israeli P.O.W.s. Dissatisfaction is widespread in Israel over the disproportionate exchange and the fact that not all the Israeli P.O.W.s were returned.

27 The new chief justice of the Supreme Court is Meir Shamgar, who replaces outgoing Justice Itzhak Cahan.

December

Violent incidents targeting the I.D.F. in Lebanon increase, involving remote-controlled explosive devices, ambushes, and artillery attacks. Israeli planes and **6** ips pound terrorist bases.

A bomb explodes in a Jerusalem bus, wounding nearly every passenger. Six are killed and 50 are wounded. The P.L.O. claims respon- **9** bility.

Basic commodities rise in price once again.

Inflation rises to a record 145.7%.

In a grave terrorist incident in December 1983, explosives planted on a bus in Jerusalem cause 6 deaths and the wounding of 50. The P.L.O. claims responsibility for it. Shown, the bus after the explosion.

THE END OF THE BEGIN ERA

Menahem Begin, who served as prime minister from June 1977, encountered problems both of a personal and political nature that prompted him to resign from the political arena in 1983. The death of his wife, Aliza; the state of his own health; and the country's prolonged entanglement in Lebanon, with the large number of casualties incurred, apparently led him to the conclusion that he could no longer function as prime minister.

His announcement in late August of his intention to resign, however, took his friends, his rivals, and even his closest aides by surprise. Furthermore, he did not hurry to implement the decision, secluding himself in his home for several weeks. Meanwhile, the Herut party elected Foreign Minister Itzhak Shamir over Deputy Prime Minister David Levy as the Likud nominee to take over the post of prime minister.

An odd problem arose when Begin held back from presenting his resignation to the president and was solved unconventionally when the cabinet secretary delivered Begin's letter of resignation to the president.

Begin withdrew inside his home for nine years, until his death in 1992.

▷ Prime Minister Menahem Begin in the cabinet tier of the Knesset, June, 1983. Aides and close associates discern a deterioration of his state over a long period. In late August he announces his intention to resign. Although party colleagues attempt to dissuade him, he is resolute. His party begins choosing his successor among three candidates: Shamir, Levy, and Sharon.

△ The contest for the position of prime minister following Begin's resignation is ultimately between David Levy (l.) and Itzhak Shamir. The Herut party chooses Shamir.

▷ Itzhak Shamir, 68, until then foreign minister, becomes Israel's seventh prime minister in the fall of 1983.

500

△ The country's physicians strike for four months in 1983. At various intervals during the strike, the physicians leave their workplaces; announce a vacation; and conduct a hunger strike. Shown, a physician wearing a tag stating "On a Hunger Strike," treats a patient.

▷ The Cahan Commission hears testimony from Defense Minister Ariel Sharon (l.). The commission recommends that Sharon draw personal conclusions in light of the flaws found in the fulfillment of his duties.

THE CAHAN COMMISSION AND ITS FINDINGS

The Cahan Commission – headed by Supreme Court President Itzhak Cahan – was appointed in October, 1982, to examine the events surrounding the massacre at the Sabra and Shatila refugee camps in Lebanon in September 1982. In a report published on February 8, 1983, the commission stated that neither Israel nor Israelis had any involvement in the brutal acts perpetrated by the Phalangists, yet it did ascribe political and military responsibility to those who were supposed to have known about the intentions of the perpetrators or who could have taken steps to prevent such acts.

The main weight of the blame was laid on Defense Minister Ariel Sharon, who was advised to draw personal conclusions from the flaws found in the fulfillment of his duties. "If necessary," the commission recommended, "the prime minister should see fit to use his authority according to the Basic Law: The Government, which allows him to relieve a minister of office." Grave findings were also reached regarding the chief of Intelligence, Maj. Gen. Yehoshua Sagi, whom the commission recommended should be transferred from his post. Chief of Staff Rafael Eitan also came in for criticism, although the commission did not suggest that he draw conclusions, as he was about to end his tour of duty.

Sharon refused to resign from the cabinet and remained as minister without portfolio.

THE BANK SHARES CRISIS

Investors in the Tel-Aviv Stock Exchange had reason to celebrate in 1983, as their stocks rose month by month. The fastest-rising stocks of all were shares in the major banks, systematically regulated upward by the banks themselves. However, late in September, the public, fearing the approach of a large devaluation, began buying dollars as a hedge, to the extent that the treasury had to fly in additional foreign currency. Market shares were sold off in order to finance the purchase of dollars and the banks were filled with nervous, apprehensive customers.

By early October, the situation reached crisis proportions. The bank shares plummeted and the purchase of dollars and of imported goods (another hedge) reached fever pitch. The banks ceased regulating their shares,

and it was feared that hundreds of thousands of citizens would be ruined by the collapse of the shares. The government closed down the stock exchange and the public awaited a large devaluation. This indeed occurred, at a rate of 23%. At the same time, the government announced a "bank-share arrangement": anyone retaining the shares for five years would be able to redeem them at their full value, linked to the dollar. This arrangement was to cost the state treasury billions of dollars.

Finance Minister Yoram Aridor, who instigated the "dollarization" of the economy, was forced to resign, and was replaced by Yigal Cohen-Orgad. The crisis, however, continued once the stock exchange was reopened. Stocks sank further and inflation continued to gallop.

△ "The Treasury Intends to Link the Entire Economy to the Dollar," trumpets the *Yedi'ot Aharonot* ("Latest News") headline on October 13, 1983, heralding the "dollarization" of Israel – said to be instigated by Finance Minister Aridor. Consequently, Aridor resigns.

▽ Presidential shift: Itzhak Navon (l.), who served as fifth president (shown with his wife Ofira and their two children), makes way for Hayim Herzog on May 5, 1983.

△ M.K. Avraham Shapira, chairman of the Knesset Finance Committee, plays a prominent role in devising the "bank-share arrangement" in 1983.

502

◁ The country is shocked when a grenade thrown into a Peace Now demonstration in Jerusalem in February, 1983, kills one of the participants, Emil Greenzweig. Shown, evacuation of a wounded demonstrator.

▽ There are also happy times. Some 50,000 Israelis crowd the Ramat Gan Stadium to hear American pop stars Simon and Garfunkel in concert in September, 1983.

▽ Terrorist acts targeting the I.D.F. in Lebanon continue in 1983, climaxing with a second disaster in Tyre, in November, 1983, when a booby-trapped truck ex-

plodes in the courtyard of I.D.F. headquarters there. The toll is 28 Israelis killed and approximately 30 wounded, as well as dozens of local detainees killed and wounded.

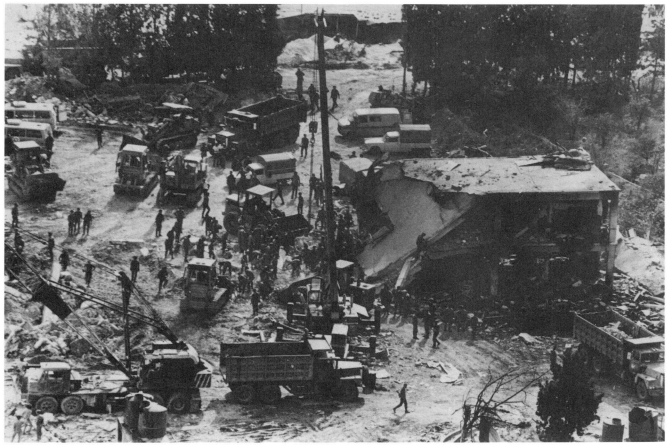

1984

January

The Levinson affair emerges during the month when a sum of $400,000 is discovered to have been withdrawn fraudulently from the Hapo'alim Bank in Israel and in its branches abroad, possibly by the former chairman of its board, Ya'akov Levinson.

14 Major Sa'ad Haddad, commander of the Christian forces in southern Lebanon dies of an illness.

16 A series of price rises is

A sign of runaway inflation: a new 10,000 shekel currency note.

approved by the government and restrictions imposed on acquiring foreign currency.

27 An attempt by Jews to perpetrate violence at the Temple Mount is thwarted by the police.

February

1 Bezek, a telecommunications company, begins operations, taking over management of the country's telephone system from the government.

A law banning smoking in public places takes effect.

23 Ya'akov Levinson, former chairman of the board of the Hapo'alim Bank, commits suicide while under investigation.

March

4 A third national daily

afternoon newspaper starts up – *Hadashot* ("News").

Fifteen I.D.F. soldiers are wounded in two terrorist incidents in Lebanon.

5 Lebanon, under Syrian pressure, annuls the agreement with Israel signed in May 1983.

22 The Knesset votes to advance elections, 61 to 58. A single M.K. does not arrive for the vote – Begin.

Attacks on the I.D.F. in Lebanon continue.

April

2 Palestinian terrorists fire indiscriminantly at pedestrians in central Jerusalem, killing one and wounding approximately 60.

4 A new commander takes over in the South Lebanese Army – Gen. Antoine Lahad.

12-13 Palestinian terrorists hijack a bus on the 300 line from Tel-Aviv to Ashkelon. During the rescue operation, a woman soldier who is a passenger is killed. The incident creates a stir in Israel when it is learned that two terrorists captured alive died soon thereafter.

Prime Minister Shamir leads the race in the Likud camp as the candidate for the post of prime minister in the next elections, topping Sharon by a vote of 56% to 42% in internal party elections. David Levy does not run.

29 The military censor shuts down *Hadashot* ("News") for four days for publishing an unauthorized report on the formation of a commission of inquiry into the circumstances surrounding the death of two of the bus hijackers in the incident earlier in the month.

A storm erupts over the opening of the Heikhal cinema in Petah Tikva on Sabbath eve. The ultra-Orthodox demonstrate. Secular groups counter-demonstrate.

May

Details are released on the existence of a Jewish anti-Arab terror organization in the territories. Dozens of its members, some of them reserve officers, are arrested.

1 Three members of the Israeli-Lebanese Liaison Commission in Beirut are kidnapped by Syrians while traveling south of Tripoli.

3 An internal vote in the Likud for the party lineup in the next Knesset results in Moshe Arens in first place and David Levy in second, with Ariel Sharon in ninth.

15 The new secretary-general of the Histadrut ("Federation of Labor") is Israel Kessar, who replaces Yeruham Meshel.

16 The Alignment announces its election lineup. Shim'on Peres, Itzhak Navon, and Itzhak Rabin.

23 The Jewish underground is charged, among other things, with murder, attempted murder, membership in a terror organization, acts of violence against Arab mayors, and planting explosives in Arab buses.

28 The commission of inquiry investigating the Bus 300 hijack affair – the Zore'a Commission – finds that the two terrorists captured alive were beaten to death thereafter.

June

Strikes and work sanctions break out, symptomatic of the election season.

17 The Central Elections Commission disqualifies Rabbi Meir Kahane's party (Kach) for racial incitement, and the Progressive List for Peace for undermining the basic tenets of the State of Israel.

The trial of 27 members of the Jewish underground begins.

28 The Supreme Court allows Kahane's party and the Progressive List for Peace to participate in the elections.

A storm erupts over the opening of the Heikhal cinema in Petah Tikva on Sabbath eve. The ultra-Orthodox demonstrate. Secular groups counter-demonstrate.

In a P.O.W. exchange with Syria, over 300 Syrian prisoners are exchanged for 3 Israeli soldiers, 3 civilians and 2 bodies of Israeli officers killed in the Lebanon War.

July

23 Climaxing a tumultuous campaign, the elections for the Eleventh Knesset give the Alignment the lead with 44 seats, followed by the Likud with 41. Tehiya obtains 5; the N.R.P. (religious), Hadash (Communist), and Shas (religious Sephardi party) 4 each; Democratic Movement for Change, Civil Rights, and Yahad (Ezer Weizman's party) 3 each; Progressive List for Peace, Agudat Israel, and Morashah (religious) 2 each; and Tami, Ometz (center-right), and Kach (Kahane's party) 1 each.

August

4 The four major banks – Leumi, Hapo'alim, Discount and United Mizrahi – and their directors are charged with violating the law of restricted business trade practice by regulating their stocks.

9 A new currency note of 5,000 shekels is issued. It bears the likeness of former prime minister Levi Eshkol.

12 The popular Kaveret ("Beehive") rock group reunites and performs at Tel-Aviv's Yarkon Park for a mass audience of hundreds of thousands.

13 The Eleventh Knesset is sworn in and adjourns for the summer recess.

September

5 The Eleventh Knesset convenes, chaired temporarily by the oldest member of the house, Abba Eban.

4-6 The Likud and the Alignment work out differences over the formation of a unity government.

9 A split in the Alignment occurs when Mapam, opposed to a unity government, breaks away after 15 years of partnership. M.K. Yossi Sarid leaves for the same reason and joins the Civil Rights Movement. Ezer Weizman and the Yahad movement that he heads join the Alignment.

13 A national unity government is formed. The prime minister for the first two years is Shim'on Peres. Deputy prime minister and foreign minister is Itzhak Shamir. The two will switch roles two years hence. The Knesset approves the government by a vote of 89 to 19.

16 Binyamin Netanyahu is named ambassador to the U.N.

17 Addressing the country's economic problems, the new government announces a devaluation of 9% as its first measure.

October

2 Tight restrictions are placed on the import of luxury goods such as high-priced cars and large refrigerators.

21 Attacks on the I.D.F. continue in Lebanon. Israel's 600th fatality of the Lebanese War, Allon Tzur, is brought home for burial.

22 Two Israeli students, a man and a woman, are murdered by an Arab terrorist near the Cremisan monastery in the Bethlehem area.

28 The government approves an evacuation from Lebanon, on condition that the I.D.F. will have freedom of movement in a narrow strip north of the international Lebanese-Israeli border.

An Israeli soldier on leave fires a Lau missile at an Arab bus in East Jerusalem, killing one passenger and wounding 10.

Immigration from the Soviet Union has almost completely ceased as a result of restrictions imposed by the Soviets.

November

2 The government, the Histadrut ("Federation of Labor"), and the manufacturers sign a three-month package deal aimed at braking inflation and stabilizing the economy. Prices are frozen.

8 Israel and Lebanon hold talks on the military level in Nakura regarding an I.D.F. withdrawal from Lebanon.

13 Ariel Sharon's libel suit against *Time* magazine, which accused him of being responsible for the massacre at Sabra and Shatila by encouraging the Jumayil family to take revenge against the Palestinians after the murder of Bashir Jumayil, comes up for trial in New York.

27 Introduction of a new currency bill of 10,000 shekels. It bears the likeness of former prime minister Golda Meir.

December

25 The Knesset decides to restrict the freedom of movement of M.K. Meir Kahane to preclude anti-Arab incitement by him.

The rise in the cost of living for 1984 is the highest in Israel's history: 373.8%

△ Minister of Finance Itzhak Moda'i (r.) and Prime Minister Shim'on Peres mount a war against inflation.

△ Inflation necessitates the updating of prices on a weekly basis. Newspapers carry the latest listings.

◁ In May 1984, Israel Kessar (r.) replaces Yeruham Meshel as secretary-general of the Histadrut.

▷ Ya'akov Levinson, former chairman of the board of the Hapo'alim Bank.

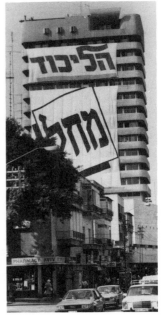

△ The 1984 elections take place while large Israeli forces are still deployed in Lebanon. Soldiers arrive in armored vehicles at field polling booths.

△ Elections '84: Huge banners reading "The Likud" and "Mahal" cover the facade of the Likud headquarters in Tel-Aviv.

◁ Prime Minister Peres (r.) and Deputy Prime Minister Shamir, September 1984.

▷ A cartoon in a Jewish newspaper in the U.S. following the formation of the rotation government in Israel.

THE NATIONAL UNITY GOVERNMENT AND THE ROTATION ARRANGEMENT

The results of the elections held on July 23, 1984, came as a pleasant surprise for the Likud, which despite runaway inflation approaching 400%, and the high casualties of the Lebanon War, including some 600 fatalities, was not dealt a knockout blow. The elections also proved once again that the two main political blocs – the Likud and the Alignment – were equally balanced in strength, with each capable of rallying support from approximately half the members of Knesset.

Both the Likud (which dropped from 48 to 41 M.K.s) and the Alignment (which dropped from 47 to 44) began making coalition overtures to the small parties, but after weeks of fruitless negotiations both parties consented to the option of a national unity government under the joint leadership of the Likud and the Alignment.

Mapam, however, opposed the unity government and broke away from Labor, after 15 years of partnership.

An original method of filling the office of prime minister was adopted – rotation. Shim'on Peres of the Alignment would hold the office during the first two years of the term, with Itzhak Shamir of the Likud serving as deputy prime minister and foreign minister, and the two would switch during the final two years. All the other ministers, including Defense Minister Rabin, would hold their posts for the entire four years.

In order to preclude undue influence by the smaller parties in the equally balanced political setup, a cabinet of ten – five ministers from each of the two large parties – was formed to deal with major issues unresolved by the government. Despite the difficulties involved in this cumbersome arrangement, the unity government lasted for the full four years and the rotation between Peres and Shamir was implemented.

THE EXPOSURE OF THE JEWISH UNDERGROUND

Most of the Israeli public was dismayed to learn, in the spring of 1984, of the existence of a Jewish anti-Arab underground operating in the West Bank and the Golan Heights. This group, it was later discovered, had been responsible for anti-Arab terror acts since the early 1980s, and their plan was to expand their activity to include planting explosives in Arab buses and staging attacks on the mosques at the Temple Mount.

Weapons and explosive devices were found in their possession, and 27 were arrested. The three principal defendants – Menahem Livni, Yehuda Etzion and Shaul Nir – were accused of intent to damage the Temple Mount mosques, attacks on Arab mayors in the occupied territories in 1980, the attack on the Islamic College in Hebron in 1983, planting explosives in Arab buses, and other crimes.

The trial of the detainees took place in the summer of 1984. Several were sentenced to long prison terms. Most, however, were pardoned and freed before their sentences were completed.

▽ A Jewish underground detainee, No'am Yinon, is led to prison. The detainees are settlers of the West Bank and the Golan Heights. Most of their prison terms will be shortened by a presidential pardon.

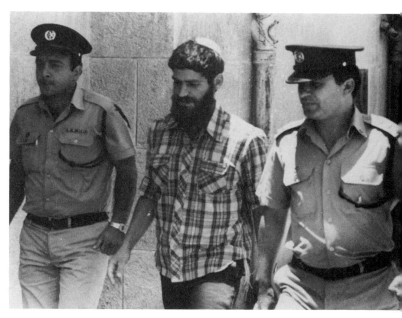

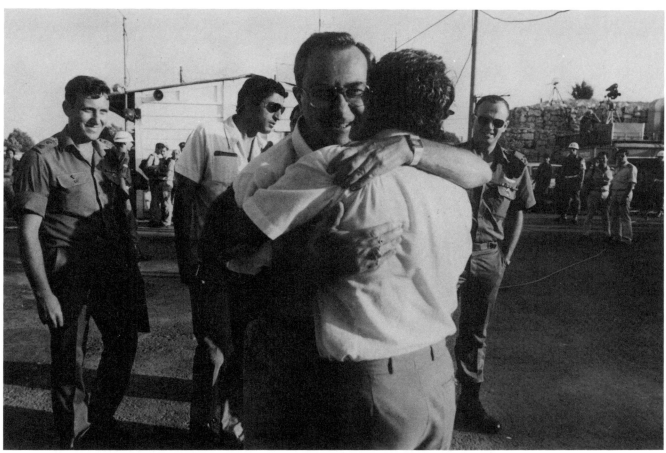

△ Defense Minister Moshe Arens embraces an Israeli P.O.W. released by Syria in June, 1984.

Israel returns 300 Syrian P.O.W.s in exchange for 3 Israeli soldiers, 3 civilians, and 2 bodies of I.D.F.

officers killed in the Lebanon War. The exchange involved difficult negotiations with the Syrians. Attempts to retrieve

the remains of Eli Cohen, Israel's spy hanged in Damascus in 1965, were to no avail.

△ A serious incident occurs in April 1984 when a group of Palestinian terrorists takes control of a bus on line 300 en route from Tel-Aviv to Ashkelon. During the rescue effort, a woman soldier who is a passenger on the bus is killed. Two of the terrorists are captured alive (one is shown, c.), but are subsequently beaten to death. The affair elicits a commission of inquiry – the Zore'a Commission; grave accusations involving the security services; and the replacement of key figures.

▷ The Kaveret ("Beehive") rock group, reuniting for a series of performances, attracts a crowd of hundreds of thousands at a concert at the Yarkon Park in Tel-Aviv, in August, 1984.

January

Information is released that thousands of Jewish immigrants from Ethiopia have arrived in Israel during the preceding weeks in Operation Moshe.

2 Israel Aircraft Industries displays the prototype of its Lavi fighter plane.

13 Yona Avrushmi is sentenced to life imprisonment for the murder of Emil Greenzweig at a Peace Now demonstration in February, 1983.

14 The I.D.F. draws up plans to implement a government order to withdraw from Lebanon in three stages.

24 A second package deal is signed by the key components of Israel's economy with the aim of restoring stability. Finance Minister Itzhak Moda'i announces that heavy taxes will be imposed on imports and travel abroad.

A jury in the New York trial of *Time* magazine initiated by Ariel Sharon clears the magazine of libel charges.

27 Israeli-Egyptian talks on the future status of Taba, the small area of Sinai territory adjacent to Eilat, begin in Beersheva.

Numerous attacks on Israeli forces in Lebanon are carried out during the month.

February

3 In a daring bank robbery in Jerusalem, foreign currency, jewelry, and millions of dollars in cash are stolen from safe deposit boxes in a branch of the Hapo'alim Bank.

5 Price rises, an increase in the travel tax, and a 3% tax on car imports are announced

Michael Albin leaps to his death while under police investigation.

by the government.

16 The I.D.F. completes the first stage of the withdrawal from Lebanon.

18 Two I.D.F. officers, a colonel and a major, are killed in terrorist ambushes in Lebanon. Attacks on the Israeli forces are a daily occurrence.

22 The prices of subsidized basic commodities are raised by an average of 25%.

28 The Ata textile company, one of the largest manufacturers in Israel, dismisses 400 workers.

March

10 In a serious incident in southern Lebanon not far from Metula at Israel's northern border, a suicide terrorist explodes a booby-trapped car near a truck transporting I.D.F. soldiers, killing 12 and wounding 14.

April

2 The Ansar prison camp in Lebanon is closed down. Most of the prisoners – Palestinian terrorists captured in Lebanon – are transferred to Israel. The rest are released.

11 The I.D.F. completes the second stage of the withdrawal from Lebanon. The Nabatiyeh triangle region is evacuated.

17 The soldier who fired a missile at an Arab bus in Jerusalem while on leave (see October 28, 1984), David Ben-Shimol, is sentenced to life imprisonment.

22 A free trade agreement is signed with the U.S., effective as of July.

24 Justice Itzhak Cahan, former chief justice of the Supreme Court, dies aged 72.

May

13 Elections to the Histadrut ("Federation of Labor") convention result in a gain for the Alignment (66.7% of the seats) and a drop for the Likud (21.4%).

15 The cost of living for the month of April is 19.4%. The government implements further economic measures. The value added tax is raised on May 19 to 17%, the tax on travel abroad is raised to $300 shekels, and the maximum purchase of foreign

currency permitted for travel abroad is set at $800 per person.

20 Israel releases 1,150 Palestinian prisoners in exchange for 3 Israeli soldiers held by Ahmed Jibril's Popular Front for the Liberation of Palestine. The move is criticized in Israel. Hundreds demonstrate outside Prime Minister Peres' residence. Shamir demands that the Jewish underground prisoners be pardoned.

27 Workers at the Ata textile concern, which is on the verge of closing down, barricade themselves in the plant.

28 The prices of subsidized basic commodities are again raised.

June

4 The commission of inquiry formed in 1983 to investigate the murder of Hayim Arlozoroff in 1933 finds that the three suspects at the time, Stavski, Ahimeir, and Rosenblatt, were not connected with the murder. It is unable, however, to determine who the murderers were.

10 The I.D.F. completes its withdrawal from Lebanon. A small force remains in the security zone north of the Israeli border.

Prime Minister Peres announces in the Knesset that Israel is prepared to begin talks with a joint Palestinian-Jordanian delegation on condition that the Palestinian delegates are not members of the P.L.O.

11 In a shocking tragedy at a junction near Moshav Habonim, a train and a school bus collide, killing 19 children and 3 adults and injuring 16.

20 Finance Minister Itzhak Moda'i presents an economic recovery program to Prime Minister Peres, who approves it. Prices of foodstuffs and electrical appliances rise within days.

25 The Knesset calls on the government to prevent the closing of Ata.

28 The treasury announces emergency measures, including imminent layoffs in government-owned enterprises and governmental offices.

29 A concert given by the Israel Philharmonic together

with the New York Philharmonic Orchestras conducted by Zubin Mehta draws an audience of hundreds of thousands to the Yarkon Park in Tel-Aviv.

July

1 The new economic program is announced. The shekel is devalued by 20%. The prices of all commodities and services rise. Thousands of layoffs will be implemented in the public sector. The measures prompt a wave of strikes.

3 Israel releases 300 Lebanese prisoners held in Israeli territory.

14 Some 11,500 layoffs in public service are anticipated in light of the new economic measures.

14-16 A dysentery epidemic breaks out in the Krayot area outside Haifa as a result of water pollution. Thousands take ill.

16-18 A demand by the Chief Rabbinate that the immigrants from Ethiopia undergo conversion to Judaism causes a furor.

22 Three of the Jewish underground detainees are sentenced to life imprisonment for the murder at the Islamic College in Hebron. Twelve others are sentenced to prison terms ranging from 1 1/2 to 7 years.

Opposition to the dismissal of thousands of workers in the public sector intensifies.

Terrorist incidents in Israeli territory continue. They include the murder of two teachers from Afula and the stabbing of five children in the center of Jerusalem.

August

3 Prominent businessman Michael Albin, under investigation for fraud, commits

△ Headlines from 1985: "20% Devaluation", "Travel Tax Raised to $200," "Prices Rise by 25%."

▽ A monument memorializes the 19 children and 3 adults from Petah Tikva killed in a collision between a train and a school bus in June 1985, near Moshav Habonim.

suicide by jumping from a window at police headquarters in Jaffa.

9 Rabbi Ya'akov Israel Kaneivsky, a leader of the ultra-Orthodox community and considered the halakhic authority of the generation, dies.

15 The rise in the cost of living published for the month of July – 27.5% – causes shock waves. It is the highest-ever monthly figure in the country's history.

16 A chilling crime is committed in the Negev when a driver rapes a woman soldier hitchhiker, shoots her, and abandons her, paralyzed. She is saved by Bedouin.

20 A terrorist attack on the Israeli embassy in Cairo results in the death of the administrative attache, Albert Atrakzi, and the wounding of his wife and a woman staff member.

24 The Israeli-American trade agreement goes into effect.

Public attention is focused on Brig. Gen. Itzhak Mordechai, who is cleared by the commission of inquiry of the charge of killing the Palestinian terrorists in the Bus 300 incident in 1984, but is brought to trial by the army's judge advocate general. He is cleared once again.

September

4 The new Israeli shekel replaces the old shekel at the rate of 1,000 old shekels=1 N.I.S.

8 Sextuplets are born at Sheba Hospital near Tel Aviv. One baby subsequently dies.

18 Tension rises within the government coalition on the issue of Taba. Labor supports a compromise agreement with the Egyptians. The Likud is opposed.

22 A crowd of several thousand heckles a rally by Rabbi Kahane in Giv'atayim.

25 Palestinian terrorists kill three Israelis who are anchoring their yacht at the port of Larnaca in Cyprus.

29 Poet Yona Wollach dies aged 41.

The government approves the establishment of a second T.V. channel.

October

1 In a long-range operation, Israel Air Force planes bomb P.L.O. headquarters in Tunisia some 2,500 km away in retaliation for the murder of the Israelis at Larnaca. Egypt suspends the Taba talks.

5 An Egyptian soldier opens fire on a group of Israeli tourists at the Ras Burka shore in Sinai. The toll is 7 killed (including 4 children) and 3 wounded (all children).

13 The student body at the Technion goes on strike at the start of the academic year, demanding the lowering of tuition fees. All the rest of the students in the country join the strike on October 20th. It lasts until November 1st.

21 Prime Minister Peres, addressing the U.N. General Assembly, calls for peace with Jordan and an end to hostilities with the Palestinians.

November

Unemployment rapidly rises.

1 Eilat becomes a duty-free zone.

19 I.D.F. planes down two Syrian planes over Lebanon.

21 Jonathan Pollard, a U.S. Navy employee, is arrested on suspicion of spying for Israel. Israel, "shocked and dismayed," recalls three diplomats from Washington several days later.

December

The ultra-Orthodox set fire to bus stops that display advertisements viewed by the community as immodest.

A new affair occupies the politicians and the public: land purchases by Jews in the West Bank. M.K. Michael Dekel, formerly deputy minister of agriculture, is one of the figures involved.

The rise in the cost of living falls off drastically toward the end of the year. In October it is less than 0.5%, and in November 1.3%. The annual total, however, is 304.6% Immigration in 1985 is at a low ebb: 12,410, only slightly over a thousand newcomers per month.

510

THE WITHDRAWAL FROM LEBANON

The national unity government led by Shim'on Peres decided, against the wishes of most of its Likud members but with the support of David Levy, to end the I.D.F.'s involvement in Lebanon. Cooperation between the prime minister and the defense minister – Itzhak Rabin – was essential for this step, and despite past rivalry between the two, they acted in union. By mid-1985, the I.D.F. completed its withdrawal to the security zone, leaving a limited force in this buffer strip between the region to the north, controlled by the terrorists and the Lebanese militias, and Israel to the south. The Israelis were aided by the South Lebanon Army (S.L.A.) in the zone.

The I.D.F. withdrawal from the "Lebanon mire" was greeted by the Israeli public with relief. One consequence of the war was that Syria effectively took control of Lebanon. Israel's northern border, which was supposed to have been made safe by the war, was still volatile after the withdrawal.

△ The large Ansar prison camp in Lebanon empties out in preparation for the I.D.F. withdrawal from Lebanon. Most of its inmates are terrorists captured in Lebanon, who are transferred to Israeli territory.

◁ The final months for the I.D.F. in Lebanon are filled with terrorist incidents and attacks. Shown, an I.D.F. jeep hit by a road mine. Withdrawal is completed on June 10, 1985, three years and four days after the outbreak of the war.

▷ Coming home. Yosef Groff, one of three Israeli soldiers returned on May 20, 1985, by Ahmed Jibril's terror organization in exchange for 1,150 terrorists, is welcomed emotionally by his family. The other two soldiers are Hezi Shai and Nissim Salem. The three were flown home via Geneva, while the released terrorists were flown to Libya in Red Cross planes. Criticism is voiced in Israel over the high price that was paid. Hundreds demonstrate in front of Prime Minister Peres' residence.

REINING IN INFLATION

The national unity government, under the leadership of Prime Minister Shim'on Peres and Finance Minister Itzhak Moda'i, declared war on the runaway inflation that was the legacy of the Likud government, which by late 1984 and during the first half of 1985 was well over 20% monthly.

The immediate measures applied by the government to deal with the problem – devaluations, raising the prices of basic commodities, and imposing various taxes and restrictions – did not appear to be effective. The cost of living (C.O.L.) continued climbing. This prompted the announcement of a new, stiffer economic policy in July 1985, even before the record-breaking rise in the C.O.L. index of 27.5% for that month was known. The new measures included a large devaluation; the freezing of prices, wages, and the dollar exchange rate; and close price supervision. The government also announced a significant tightening up in the public sector. This translated into thousands of layoffs, causing unrest, strikes and demonstrations. An additional measure was the switch to the new shekel, which dropped three zeroes from the extant currency. The new shekel restored astronomic prices back to normality – the evening paper for instance, costing 34 agorot instead of 340 shekels.

By the end of the year, the new policy showed evidence of success. The rise in the C.O.L. for the month of November had shrunk to 1.3%. Inflation, which had come to be perceived as an uncontrollable act of nature, had been curbed at last. This was borne out in 1986, when the annual rise in the C.O.L. rate fell to 50% from the meteoric rate of over 300% in 1985, dropping further in 1987 to 19.9% – still high, but minimal in comparison with 1984 and 1985.

◁ Three currency notes illustrate the braking of inflation: A whopping 50,000 (old) shekel note is printed but is not put into use, as the new shekel currency is introduced soon after. Beneath it, an (old) shekel note of 1,000 drops three zeroes in its new shekel version (below).

▷ By the summer of 1985, the country's economic condition is poor, with inflation soaring to 27% monthly. Strikes erupt daily, such as that by the Tel-Aviv sanitation workers, the results of which are evident in this photo of Dizengoff Street at the height of the strike.

◁ Information about the immigration from Ethiopia to Israel in late 1984 is released only in January 1985. Shown, a leader of the community in traditional dress.

▽ Immigrants from Ethiopia arrive at an absorption center outside Jerusalem in January, 1985. They have reached Israel by a roundabout route to preclude publicity of the operation.

△ The immigrants from Ethiopia encounter various kinds of problems upon their arrival in Israel, but the one that most agitates them is the demand by the Chief Rabbinate that they be formally converted because of doubts about the authenticity of their Jewishness. The immigrants demonstrate repeatedly against this demand.

OPERATION MOSHE

Only in early January 1985 were reports released regarding the immigration to Israel in late 1984 of thousands of Jews from Ethiopia, members of the Beta Israel community.

Israel began aiding the Jews of Ethiopia in their efforts to leave their country and settle in Israel in the early 1980s. With the knowledge of the Sudanese government, some 2,000 Jews from Ethiopia were brought to Israel via Sudan in 1981. Later, a mass flight of Ethiopians began toward Sudan, which included many Jews. By the winter of 1984, some 10,000 Jews were living in camps there. Toward the end of the year, Operation Moshe airlifted approximately 7,000 immigrants from Khartoum, capital of Sudan, to Europe, and from there to Israel.

Their absorption into Israeli life was not easy. In addition to problems of housing and employment, the conversion to Judaism, insisted upon by the Chief Rabbinate to erase any doubt about their Jewishness, was a bitter pill for the community, which had been persecuted in Ethiopia for centuries because of its Jewish faith. The issue prompted them to demonstrate and led to friction inside the community as well.

▽ While according to the rotation agreement of 1984 Shim'on Peres will serve as prime minister for two years only, after which he will switch with Itzhak Shamir, Itzhak Rabin (shown, playing tennis with his wife, Lea) is named defense minister for the full four-year term.

△ Yona Avrushmi, a metalworker from Jerusalem convicted of murdering Emil Greenzweig during a Peace Now demonstration in early 1983, is sentenced to life imprisonment in January 1985.

▽ Lake Kinneret, the source of a large proportion of Israel's drinking water, drops to its lowest level in decades during the rainless winter of 1985-86.

January

1 The validity of the old shekel expires. The new Israeli shekel (N.I.S.) is the sole legal tender.

1-2 Katyusha missiles land in Kiryat Shmona, with no casualties.

21 Hundreds of workers at Israel Shipyards take over the plant on being notified that they must take an unlimited leave of absence.

29 Screening for A.I.D.S. is initiated for all blood donations.

A Jordanian soldier opens fire at an I.D.F. patrol along the border. Two Israeli soldiers are killed and another two are wounded.

February

4 A Libyan executive airplane is forced down by Israel Air Force planes in Israeli airspace en route to Damascus. According to Israeli information, Palestinian terrorist leaders are on board. The information proves erroneous and the plane is released.

8 Israel Galili, a Haganah founder, M.K., and government minister, dies aged 76.

11 Prisoner of Zion Natan (Anatoly) Sharansky arrives in Israel and receives a state reception.

15 A surprising negative cost of living index of −1.3% is registered for the month of January, spurring price reductions.

17 Terrorists kidnap two I.D.F. soldiers in southern Lebanon. Israeli forces in the security zone move northward in an attempt to locate them.

27 John Demjanjuk, accused in the U.S. of the murder of Jews during World War II, is extradited to Israel for trial.

Palestinian terrorists plant explosives in various locations throughout the country: Ramat Gan, Haifa, Afula, Benei-Brak, and Bet-She'an.

March

11 Violence erupts during the Herut convention. Ministers Ariel Sharon and David Levy form an alliance precluding M.K. Benny Begin's membership in the election committee. Sharon is elected chairman of the committee.

19 The wife of an Israeli embassy attaché is shot to death while driving in Cairo and three other Israelis are wounded.

27 A Katyusha missile attack on Kiryat Shmona wounds four persons. The I.D.F. retaliates with an air and ground attack on terrorist targets in southern Lebanon.

Attacks continue against Israeli forces in southern Lebanon and soldiers and civilians in the occupied territories.

April

13 The unity government survives a crisis that erupts when Finance Minister Moda'i calls Peres a "flying prime minister" – a reference to his numerous trips abroad – prompting Peres to seek to dismiss him. A solution is found whereby Moda'i switches portfolios with Justice Minister Moshe Nissim.

17 An El Al security officer prevents a disaster aboard a jumbo plane when he discovers an explosive device on the person of an Irish woman passenger.

20 The Bejski Commission, formed to investigate the 1983 collapse of the bank stocks, publishes findings sharply critical of the directors of the major banks and of the governor of the Bank of Israel and recommends that they resign or be dismissed within 30 days.

The duration of daylight saving time is to be reduced as a result of pressure by the religious sector (early sunrise inconveniences morning worshippers). The general public is angered.

May

11 Bank Leumi Chairman Ernst Yafet resigns after 16 years in office. Industrialist Eli Hurwitz is appointed in his place.

18 Director-General of the Mizrahi Bank Aharon Meir resigns.

24 Britain's prime minister, Margret Thatcher, arrives for a three day visit to Israel.

25 Attorney General Itzhak Zamir indicts the head of the Shabak (General Security Service) for covering up the killing of two terrorists captured alive during the Bus No. 300 incident in 1984. The move mars relations between Zamir and several government ministers.

28 The Shabak affair intensifies. Justice Minister Itzhak Moda'i appoints attorney Amnon Goldenberg as his special counsel, a step designed to circumvent the attorney general.

June

1 Attorney General Itzhak Zamir resigns. He is replaced by Yosef Harish.

Bank Hapo'alim Chairman Giora Gazit resigns. He is replaced by Amiram Sivan.

2 Governor of the Bank of Israel Moshe Mandelbaum resigns. He is replaced by Prof. Michael Bruno.

23 The nurses announce a strike and leave the hospitals.

26 An El Al security officer in Madrid thwarts an attempt to plant a booby-trapped suitcase on a plane. The suitcase explodes on the airfield, slightly wounding 13, including the security officer.

The Shabak affair contin-

ues. The head of the Shabak is pardoned by the president for all acts related to the Bus No. 300 incident. The head of the Shabak submits his resignation.

July

2 U.S. envoy Abraham Sofer arrives in Israel to mediate the Taba issue.

10 An I.D.F. sea patrol vessel encounters a terrorist-manned boat off Rosh Hanikra at Israel's northern border. All four terrorists aboard are killed in an exchange of fire. The I.D.F. incurs two fatalities and nine wounded. The terrorists were bound for Nahariya on a kidnapping mission.

14 Bank Discount Board Chairman Rafael Recanati belatedly resigns.

15 The city of Tel-Aviv-Jaffa dedicates Ya'akov Agam's kinetic sculpture *Fire and Water* at Dizengoff Square.

21 The Israeli-made Lavi fighter plane is unveiled by Israel Aircraft Industries at Lod. Justice Minister Moda'i resigns. He is replaced by Avraham Sharir.

22 Prime Minister Peres meets with King Hassan II in Morocco. Peres subsequently announces that he will agree to negotiate with Arab states and peace-seeking Palestinians.

27 U.S. Vice President Bush, visiting Israel, calls upon his countrymen to do likewise.

29 The Knesset ratifies a law introducing cable T.V. in Israel.

August

5 After numerous delays, the Knesset ratifies a law prohibiting racial incitement.

10 The Lake Kinneret water level drops to a 50-year low of 212.89 m. below sea level.

Prototype No. 1 of the Lavi fighter plane is unveiled in 1986.

1986

△ The recipient of the 1986 Israel Prize for "life's labor" is Yona Sa'id (l.) of Israel Aircraft Industries, shown shaking hands with prize committee chairman Dr. Moshe Gilbo'a.

▽ Alleged Nazi war criminal John Demjanjuk (r.) is extradited from the U.S. in 1986 to stand trial in Israel. The trial will take several years.

21 Israel's first in vitro babies – quadruplets – are born in the Sharon Hospital in Petah Tikva.

24 President Herzog pardons seven Shabak operatives connected with the Bus No. 300 incident.

Prime Minister Peres visits Cameroon, after the renewal of diplomatic relations between the two countries.

September _____

A government crisis erupts early in the month over criticism voiced by Minister of Trade and Industry Ariel Sharon of the government's response to a terrorist attack on a synagogue in Istanbul. Demands for Sharon's dismissal prompt him to apologize to Peres.

28 The Vanunu affair emerges in the British press. Mordechai Vanunu, a former employee at Israel's nuclear reactor in Dimona, reveals classified information to the press.

The national water carrier shuts down for the first time since its inauguration in 1964 as a result of the low water level in the Kinneret.

29 John Demjanjuk is charged in the Jerusalem district court as a Nazi war criminal.

Numerous attacks against Israeli forces occur in the security zone in southern Lebanon during the month.

The nurses' strike, begun in June, continues.

October _____

An agreement is signed for the amalgamation of the Labor Party and Yahad.

15 A terrorist band hurls hand grenades at an induction ceremony of Giv'ati Brigade conscripts at the Western Wall, resulting in one fatality and 69 wounded.

16 An Israeli plane is downed over southern Lebanon. The pilot is rescued but the navigator, Captain Ron Arad, is captured by terrorists, marking the beginning of a dogged quest by Israel to bring him home.

20 The agreed-upon prime ministerial rotation is implemented. Itzhak Shamir switches positions with Shim'on Peres.

21 The first liver transplant in Israel is performed at Rambam Hospital in Haifa.

31 The prolonged nurses' strike ends.

November _____

9 Israel announces that Mordechai Vanunu is in Israeli territory awaiting charges against him. Foreign newspapers report that he has been abducted to Israel.

11 A debt of $90 million plunges the Bet-Shemesh Engines plant into a state of crisis.

15 A yeshiva student, Eliyahu Amadi, is stabbed to death in the Old City of Jerusalem. Disturbances by Jews subsequently erupt there.

Reports appear at the end of the month regarding Israeli involvement in arms supplies to Iran. Israel denies knowledge that payment for the arms reached the Contras in Nicaragua.

December _____

2 The Supreme Court rules, in an appeal by a convert to Judaism, Shoshana Miller, that the minister of interior does not have the authority to include the term "convert" in her identity card. The president of the court, Justice Meir Shamgar, points out that Jewish nationality in Israel cannot be categorized – i.e., Jews and converted Jews.

4-9 Arab rioting erupts in the West Bank and Gaza Strip, resulting in the death and wounding of Palestinians.

8 Arbitration talks begin between Israel and Egypt regarding Taba.

31 Minister of Interior Rabbi Peretz resigns in light of the Supreme Court decision preventing the identification of convert Shoshana Miller as such on her identity card.

Heavy rains in December elicit optimism by the country's farmers and hydrologists.

The cost of living rise for 1986 is the lowest in eight years: 48.1%.

Immigration in 1986 is at its lowest ebb in over 40 years: less than 11,000. Of these, only 209 arrive from the Soviet Union.

IMMIGRATION REACHES A LOW

Immigration to Israel had fluctuated between 12,000 and 22,000 annually during 1980-85, originating mostly from the Soviet Union. The flow from that country, however, diminished steadily, both because of obstacles designed by the Soviet authorities and a reluctance on the part of Jewish emigrants to settle in Israel. The latter factor was reflected in a high "drop-out" rate by Soviet Jews en route to Israel, primarily at the transit point in Vienna, where 65% to 90% of them switched their destination to the U.S. or Canada.

Immigration to Israel dropped to a low of under 11,000 in 1986, unprecedented in 43 years. Of approximately 1,000 Jewish emigrants permitted to leave the Soviet Union, only 209 arrived in Israel.

▽ The immigrant of the year is indisputably Anatoly (Natan) Sharansky (r.), the Prisoner of Zion who was held by the Soviets for nine years while his wife Avital fought for his release. Freed in February 1986, he is given a state reception by Prime Minister Peres upon his arrival in Israel. U.S. President Reagan is one of the first to congratulate him on his release.

▷ The Israeli-Egyptian dispute over Taba continues during 1986. Deliberations by various delegations take place, with the U.S. providing its good offices. Tension rises within the government too as Labor supports a compromise while the Likud is opposed to it. Shown, a joint Israeli-Egyptian delegation in the disputed area in July 1986.

THE ROTATION OF PRIME MINISTERS

Implementing the rotation agreement that underlay the formation of the national unity government in September, 1984, Shim'on Peres stepped down as prime minister midway in the four-year term and switched roles with Itzhak Shamir, until then deputy prime minister and foreign minister.

The ability of Peres' government to complete even its two-year term had appeared questionable, inasmuch as its two components, Labor and Likud, were frequently in confrontation, especially over the issue of an international conference devoted to peace in the Middle East,

an idea rejected out of hand by the Likud. Reports in the press described negotiations being conducted between Labor leaders and the religious parties aimed at forming a narrow-based government without the Likud.

Additionally, although Peres had established high credibility as prime minister, speculation was rife that, as an old and experienced "political fox," he would find a way to sidestep the rotation agreement. But Peres kept to the agreement and turned over the leadership to Shamir, at the appointed time on October 19, 1986.

▷ Prime Minister Shim'on Peres (l.) switches roles with Deputy Prime Minister and Foreign Minister Itzhak Shamir in October 1986, precisely as stipulated by the rotation agreement.

▽ Social unrest in 1986 includes a strike at Haifa Port of workers at Israel Shipyards because of the government's intention to close down the works.

January

The first few days of the year witness public indignation over the inflated retirement benefits accorded to Bank Leumi chief Ernst Yafet, who was forced to resign as a result of the bank-share regulation scandal.

9 Bank Leumi workers strike all branches. Senior management resigns.

13 The shekel is devalued by 10%. Price increases follow.

15 Two women, Hava Ya'ari and Aviva Granot, convicted of murdering an American tourist, Mela Malevsky, as part of a fraud scam, are sentenced to life imprisonment in a case that is the focus of widespread popular interest.

23 Dr. Meir Het, a noted economist, is named new chairman of the board of the Bank Leumi.

February

3 District Court Justice Ya'akov Melz is named state comptroller.

6 The navy apprehends a terrorist vessel manned by 50 men bound for the Israeli shore.

8 The chief executive officer of the Leumi Bank, Mordechai Einhorn, resigns. He is replaced by Zadik Bino.

14 Druze in the villages of the Golan Heights hold protest demonstrations on the fifth anniversary of the Golan Law annexing the region to Israel.

16 The trial of alleged Nazi war criminal John Demjanjuk begins in Jerusalem.

21 Mapam ("United Workers Party") leader and Hakibbutz Ha'artzi founder Meir Ya'ari dies aged 90.

22 A hand grenade thrown by a Palestinian terrorist in East Jerusalem wounds 17 persons – 12 border policemen and 5 Arabs.

23 The management staff in state hospitals strike for ten days.

March

4 U.S. Navy employee Jonathan Pollard is sentenced to life imprisonment for spying for Israel. The Americans subpoena Israelis who were involved. A crisis in U.S.-Israel relations ensues.

11 University students stage stormy protests in Jerusalem against tuition hikes.

26 Former U.S. president Jimmy Carter visits Israel.

29 David Levy is elected deputy chairman of the Herut party by a narrow margin.

30 The second prototype of the Israeli-produced Lavi fighter plane makes its maiden flight of 51 minutes.

31 Reports are published that the Soviet Union will open its gates to large-scale emigration of Jews directly to Israel.

April

2 The Maccabi Tel-Aviv basketball team loses the final playoff for the European Cup to Tracer Milano, 71:69.

5 Mounted police use batons to subdue an agitated protest by university students in Jerusalem against the raising of tuition costs. Three students are injured and 17 arrested.

6 President Hayim Herzog visits Germany – the first visit there by an Israeli president.

9 Bank Leumi demands a refund of severance monies received by former board chairman Ernst Yafet and appeals to the courts to set "fair" severance terms for him.

10 Israel and the U.S. sign an agreement to set up a Voice of America transmitting station in the Aravah region. The step evokes criticism in Israel by environmentalists.

11 A terrorist attack on an Israeli car near Qalqilya results in the death by burning of an Israeli woman, Ofra Moses, and serious burns to members of her family.

16 The Shabak (General Security Service) is again the subject of controversy when Izat Nafso, a Circassian I.D.F. officer, is sentenced to 18 years in prison for spying. His lawyer claims that the senior interrogator in the case falsified evidence against Nafso.

19 Lieut. Gen. Dan Shomron replaces Moshe Levy as I.D.F. chief of staff.

Confrontations and incidents continue in the security zone in southern Lebanon and in the occupied territories.

Reports published at the end of the month indicate that of 717 Jews who emigrated from the Soviet Union in April, only 168 came to Israel.

May

7-10 Violent confrontations occur between Jewish settlers and Arab residents in Qalqilya and Nablus.

11 Efforts by Foreign Minister Peres to facilitate an international conference on the Middle East generate opposition by the Likud. The Alignment tries to consolidate a majority in the Knesset in favor of early elections.

17 A move by the universities to charge two separate tuition rates – for I.D.F. veterans and for non-veterans, who would pay more – evokes protest.

Minister of Communications Amnon Rubinstein resigns and the party he leads, Shinu'i ("Change"), leaves the government.

20 Minister of the Interior Rabbi Itzhak Peretz, having resigned from the government in December 1986, resumes his post following a commitment by the Likud to approve a law in the Knesset amending the present procedure for the registration of converts to Judaism.

21 Eight-year-old Rami Haba of Elon Moreh in the West Bank is murdered by terrorists at the outskirts of the settlement.

23 Rioting by Arabs erupts in East Jerusalem.

24 The Supreme Court orders the release of Izat Nafso, the army officer convicted of spying, and criticizes the Shabak (General Security Service) interrogators.

June

1 The government requests the president of the Supreme Court to appoint a commission of inquiry into interrogation norms in the Shabak (General Security Service) in the wake of the Nafso case. The commission is to be headed by the retired Chief justice of the Supreme Court, Moshe Landau.

6 The 20th anniversary of the Six-Day War is marked by rioting by Arabs in the occupied territories.

8 M.K. Meir Kahane's parliamentary immunity is removed following his refusal to take the oath of allegiance to the Knesset and the laws of the state.

Terrorist acts and attempted acts occur in Israel proper, in the occupied territories, and in southern Lebanon.

The pros and cons of manufacturing the Lavi fighter plane are debated.

Labor disputes proliferate in the economy.

July

6 Druze residents of the Galilee village of Beit Jan riot over their demand to develop land near their village designated as a nature reserve, resulting in 31 injured, including policemen and nature reserve inspectors.

11 A crowd of several hundred thousand attends a public concert in Tel-Aviv's Yarkon Park given by violinist Itzhak Perlman and opera singer Placido Domingo.

12 The entire public sector goes on strike for a day.

August

7 The Jerusalem police disperse a demonstration by thousands of ultra-Orthodox protesting the opening of cinemas on the Sabbath eve.

10 Katyusha attacks target the Galilee once again. No casualties are recorded.

17 Actor and entertainer Shaikeh Ofir dies aged 58.

23 Violent confrontations occur between striking workers and management at the Soltam factory at Yokne'am, part of the Koor conglomerate. The workers detain the management by force for 40 hours.

26 Head of the Institute for Palestinian Research in

Jerusalem, Faisal Husseini, is arrested on suspicion of committing a hostile act and inciting residents of East Jerusalem to disorderly conduct.

30 The government decides to discontinue the Lavi project by a vote of 12 to 11. Agitated Israel Aircraft Industries workers stage protest demonstrations.

The trial of accused spy Mordechai Vanunu begins in Jerusalem.

September _____

5 Israel Air Force planes launch a large strike against terrorist bases in Lebanese territory.

16 Three Israeli soldiers are killed and four are wounded in an encounter in southern Lebanon with a band of 12 terrorists heading toward Israel to carry out an attack.

24 Palestinian terrorists kill an Israeli reserve soldier at the Megido junction.

October _____

7 The Israel Broadcasting Authority radio and T.V.

journalists announce a strike for an indefinite period, demanding pay equal to that of the print journalists. Radio and TV broadcasting close down for some two months.

7-12 The Gaza Strip is the scene of rioting and a general strike, spreading to East Jerusalem and Ramallah. Fatalities and injuries occur.

15 Ida Nudel, the well-known Prisoner of Zion in the Soviet Union, is permitted to leave and arrives in Israel.

18 A wave of strikes engulfs the country's health services, involving physicians, nurses, pharmacists, and lab technicians.

24 The ultra-Orthodox renew demonstrations in Jerusalem over the issue of film screenings on Sabbath eve.

30 The Landau Commission submits its findings on Shabak (General Security Service) interrogation norms.

November _____

1 The oldest immigrant ever, Zalman Efterman, aged 100, arrives in Israel from the

Soviet Union.

6 Singer Zohar Argov hangs himself in his cell at the police station at Rishon Lezion.

16 M.K. Rafael Eitan leaves the Tehiya party and forms a new one-man party based on similar nationalist principles.

25 A terrorist hang-glider from Lebanon infiltrates an I.D.F. Nahal ("Fighting Pioneer Youth Corps") base outside Kiryat Shmona, killing six soldiers and wounding seven before being shot and killed.

December _____

2 The commander of the Nahal Brigade is relieved of his post following the terrorist hang-glider incident.

7 A new chairman of the Jewish Agency is named – Simha Dinitz.

9 Rioting erupts in the Gaza Strip following the death of several Arab residents in an accident caused by an Israeli car. The incident marks the start of the Intifada.

15 Minister of Industry and Trade Ariel Sharon marks the

completion of his new house in the Muslim Quarter of the Old City of Jerusalem.

21 The deterioration of the situation in the West Bank and Gaza Strip causes concern both in Israel and in the outside world. The Arabs of Israel hold demonstrations of identification with the residents of the occupied territories. The U.N. Security Council censures Israel's policy in the occupied territories on December 23rd, a move that is not vetoed by the U.S.

28-29 Eight letter bombs are discovered in Israeli post offices. One, in Or Yehuda, explodes, wounding two people.

Many of the longtime Prisoners of Zion are released in the Soviet Union. Some arrive in Israel. The immigration figure for 1987 is nearly 14,000.

The cost of living rise drops to 19.9%, the first time in the 1980s that it registers below 20%.

As is customary, the public visits I.D.F. bases on Israel's 39th Independence Day in 1987, viewing defense innovations and taking pride in the country's achievements.

THE START OF THE INTIFADA

Palestinian terrorism against both Israeli soldiers and civilians in the West Bank and Gaza Strip as well as in Israel intensified in the mid-1980s. Even so, the widely held perception in Israel in June, 1987, which marked 20 years of Israeli rule in the occupied territories, was that the Palestinian population, although dissatisfied with the situation, had grown accustomed to it.

This assessment was to be proven wrong from December, 1987, onward. Widespread rioting erupted first in the Gaza Strip and later in the West Bank in the form of rock-throwing, fire-bombing, the burning of tires, and mass demonstrations. Despite loss of life, the Palestinians continued to confront the I.D.F. and persisted in staging demonstrations and protests, calling this new approach intifada – awakening, or rejuvenation. The development garnered widespread coverage in the media, while Israel had difficulty curbing both the Palestinian violence and the sympathy gained for the Palestinians throughout the world.

The government, the defense establishment, and the army believed at first that the situation would calm down, but the Intifada continued for years.

▽ An I.D.F. soldier in Nablus orders bystanders to disperse. The army and the defense establishment view the unrest in the West Bank and Gaza Strip as a temporary development.

▽ Early Intifada scene, December 1987. From the start, the Intifada is a focus of attention in Israel, in the occupied territories, and in the world media.

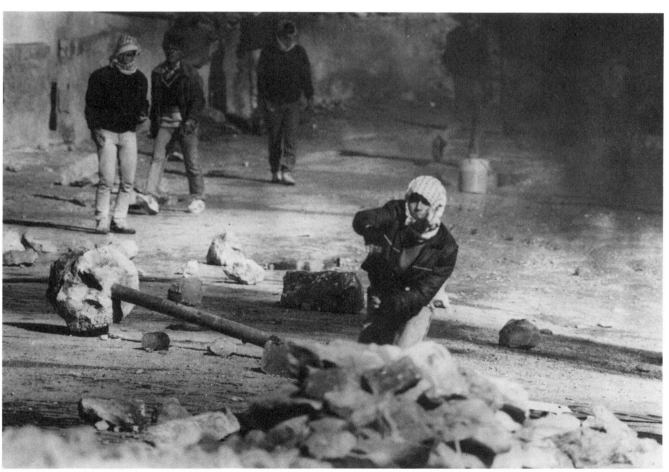

▽ The Ethiopian immigrants who arrive in Israel from the start of the decade integrate into Israeli society. Shown: Hanna Elias, the first woman of Ethiopian origin to complete the I.D.F. officers' training course, September, 1987.

△ Although immigration from the Soviet Union in 1987 is limited, it has several high points, including the arrival of Zalman Efterman, aged 100.

▽ A more famous immigrant is veteran "refusenik" Ida Nudel, who is welcomed at the airport by Prime Minister Shamir, Foreign Minister Peres, former Prisoner of Zion Natan Sharansky, and actress Jane Fonda, along with thousands of Israelis.

△ The Demjanjuk trial opens in Jerusalem in February, 1987, and becomes a focus of intense interest in Israel and elsewhere, evoking comparisons with the Eichmann trial 25 years earlier.

◁ A recurring problem for the Jerusalem police is unauthorized demonstrations by the ultra-Orthdox, sometimes consisting of thousands of persons, necessitating the allocation of large police forces.

▽ The future of the Lavi aircraft project occupies the public for months. Workers at Israel Aircraft Industries burn tires in protest against the government's decision in August 1987 to abort the project.

◁ A volatile convention of the Herut movement in March elects David Levy as deputy chairman by a narrow majority.

▽ A criminal case that preoccupies the country concludes with the conviction of Hava Ya'ari (l., with her attorney, Edna Kaplan) and Aviva Granot for the murder of an American tourist, Mela Malevsky, and their sentence to life imprisonment.

△ Chief of Staff Dan Shomron awards military ranks to operatives who were imprisoned in Egypt for the Mishap in the 1950s (also referred to as the Lavon Affair) in a belated gesture of recognition for their bravery. Marcelle Ninio, shown, receives the rank of lieutenant colonel.

523

1988

January

Mass rioting by the Arabs of the West Bank and Gaza; terrorist attempts in Israel; and incidents in the security zone in Lebanon continue.

2 Israeli planes bomb terrorist headquarters in Lebanon.

10 The arrest on December 23, 1987, of businessman Shabtai Kalmanovitz for spying for the Soviet Union is announced.

14 The editor of the East Jerusalem daily al-Fajr, ("Dawn"), Hanna Siniora, is arrested prior to a press conference at which he planned to announce the start of a civil resistance movement in the West Bank and Gaza.

16 Katyusha missiles are fired at the Galilee. Israel retaliates by bombing terrorist targets in Lebanon.

18 The U.S. vetoes a U.N. Security Council decision to censure Israel for its activity in Lebanon.

20 Prisoner of Zion Yosef Begun arrives in Israel.

February

Rioting in the West Bank and Gaza Strip continues.

1 The Americans again veto a U.N. Security Council proposal, this one calling for Israel to implement the Geneva Convention in the occupied territories.

25 U.S. Secretary of State George Shultz arrives in Israel.

Katyusha missiles land in the Galilee again.

26-27 Intense rioting in the West Bank and Gaza Strip results in 7 Arab fatalities.

Pictures taken by Moshe Alpert, an Israeli photograher who works for C.B.S., are published. In one of them, Israeli soldiers are seen beating up and maltreating an Arab. It evokes a national and international storm.

March

3 A Katyusha missile wounds 5 residents of the Galilee.

4 The "Shultz initiative" is presented to Prime Minister Shamir, Foreign Minister Peres, and King Hussein. It engenders Likud-Labor tension in the government.

7 Terrorists who infiltrate into Israel from Egypt attack a bus in the Negev carrying workers to the nuclear reactor in Dimona, killing three. An Israeli anti-terrorist unit kills the three attackers. The bus becomes known as the "bus of the mothers" because of the large number of women aboard.

9 Israeli forces in the West Bank and Gaza Strip use "gravel mortar" to disperse demonstrators.

Three months since the outbreak of the Intifada are marked in the West Bank and Gaza by a "Day of Rage."

12 A mass Peace Now demonstration in Tel-Aviv calls on Prime Minister Shamir to "say yes to Shultz."

19 The Shabiba youth movement sponsored by Fatah is declared illegal by Israel.

The U.S.S.R. permits an El Al plane to fly over its territory for the first time.

24 Shim'on Peres is unanimously elected chairman of the Labor Party.

27 Mordechai Vanunu is convicted of espionage and treason and sentenced to 18 years in prison.

30 The Arabs of Israel mark their traditional Land Day by a demonstration of identification with the Arabs in the occupied territories.

April

6 In a grave incident in the West Bank, a group of Jewish pupils hiking from Elon Moreh are attacked at the Arab village of Beita. One girl is killed by the fire of the group's armed escort. Fifteen other pupils are wounded in the attack.

11 Eight Arab residents of the West Bank and Gaza Strip, including six who took part in the Beita incident, are deported to Lebanon.

16 In a daring nighttime attack in Tunis, commandos kill Yassir Arafat's second-in-command, Abu Jihad, in his home. The P.L.O. accuses Israel of perpetrating the act.

Violent protest demonstrations in the West Bank and Gaza Strip following the killing of Abu Jihad result in 14 Arab fatalities.

18 Two new ministers without portfolio join the government: Moshe Arens (Likud) and Mordechai Gur (Labor).

John Demjanjuk is convicted by the Jerusalem district court for crimes against the Jewish people.

21 Israel celebrates its 40th Independence Day.

25 Demjanjuk is sentenced to death by hanging. He appeals the conviction in the Supreme Court.

Violence continues in the West Bank and Gaza. Infiltration attempts by terrorists from Lebanon increase.

May

3 A terrorist attack on an Israeli force in the village of Maidoun in Lebanon results in 3 soldiers killed and 17 wounded.

Staff members of the pro-P.L.O. Hebrew-language periodical Derekh Hanitzotz ("Path of the Spark") are arrested for links with Na'if Hawatma's terrorist organization. Four of them – all Israeli Jews – are charged at the end of the month with cooperating with the enemy.

9 Prices of subsidized commodities are raised for the first time since January, 1987.

20 President Herzog reduces the sentences of three imprisoned members of the Jewish underground, bringing to 13 the number of sentences of members of this group that he has lightened, out of a total of 27 members convicted.

23 Marking another step in the thawing of Soviet-Israeli relations, the Soviets permit the establishment of an Israeli consular mission in Moscow.

25 The I.D.F. attacks the Hizbollah in Lebanon, causing several dozen fatalities.

A large number of forest fires break out during the month, some of them acts of Palestinian nationalist terrorism.

June

7 An attempt is made on the life of the mayor of al-Bira. The Israeli Civil Administration attempts to convince Palestinian public figures not to resign from their posts.

9 A general strike is called in the West Bank and Gaza Strip to mark six months since the start of the Intifada.

Shim'on Peres announces in the Labor Party central committee that Itzhak Rabin is second on the party list and Itzhak Navon third.

11 Large fires break out in the Judean Hills and on the Carmel range, apparently set deliberately as part of the Intifada.

14 The new state comptroller is retired Supreme Court Justice Miriam Ben-Porat.

An Israeli court concludes the case of Brona-Caroline, a baby from Brazil adopted by an Israeli family, ruling that she must be returned to her biological parents.

30 A magistrates court in Ramleh sentences four leftist activists who met with P.L.O. representatives in Romania to 1/2-year prison terms for violating the prohibition against meetings with the P.L.O.

Stabbings of Jews by Palestinians increase, as do stone-throwing and drive-by shootings at Israeli cars in the West Bank and Gaza.

July

6 The internal Likud elections for the septuple groupings are heated. David Levy emerges in first place, Ariel Sharon in second, and Moshe Arens – who is allied with Shamir – in only third place.

26 The Knesset decides to separate the Knesset elections from the local elections.

The U.S. and Israel sign an agreement for the joint development of the Arrow anti-missile missile.

The Israel consular mission to the U.S.S.R. sets out for Moscow.

British Jewish press magnate Robert Maxwell acquires ownership of one of Israel's three leading dailies, Ma'ariv ("Evening Paper").

31 King Hussein announces that Jordan will disengage from the West Bank in order

to assist the Palestinians to establish their own independent state.

Tension in southern Lebanon continues.

The wave of forest fires continues.

August

9 Israeli planes attack and silence a P.L.O. broadcasting station in Lebanon.

15 Two Israel Air Force F-15s collide in midair. Both pilots are killed.

20 A terrorist explosion in the Nordau pedestrian mall in Haifa wounds 25 people, 2 of them seriously.

September

A Polio epidemic spreads in Hadera, Ramleh, and Lod. The I.D.F. inoculates all the soldiers.

2 The school year opens a day late as a result of a teachers' strike.

11 The population of Israel reaches 4,455,000, of whom 3,650,000 Jews (82%).

14 Prime Minister Shamir leaves for an official visit to Hungary, the first visit to a Communist Bloc country since relations with them were cut off in 1967.

19 Israel launches a research space satellite, Ofek 1.

29 Arbitration between Israel and Egypt over the Taba border is concluded. It upholds the Egyptian claim to Taba.

Cases of murders of Arabs by Arabs in the West Bank and Gaza Strip increase. The victims are accused of collaboration with Israel.

October

All Israeli citizens up to the age of 40 are inoculated against polio.

5 The Central Elections Commission disqualifies the ultra-right Kach party from participation in the Knesset elections.

19 Terrorists explode a booby-trapped car near the Lebanese-Israeli "Good Fence," killing 8 Israeli soldiers and wounding 7.

26 Likud M.K. Micha Reisser is critically injured in a car accident near Latrun. He dies the following day.

30 Terrorists fire-bomb an

Israeli bus in Jericho. A mother and her three children are killed in the attack.

November

1 Elections for the 12th Knesset are held. The Likud attains first place with 40 seats and Labor second place with 39. Shas obtains 6 seats; Ratz (Civil Rights Movement) and the National Religious Party, 5 each; Hadash (Communists), 4; Mapam and Tehiya, 3 each; and 6 other parties receive 1-2 seats each.

14 The president assigns Itzhak Shamir of the Likud the task of forming a new government.

21 The 12th Knesset convenes. The Likud's Dov Shilansky is elected speaker.

23 The first representative of China's Tourism Office arrives in Israel.

Terrorist incidents continue in the West Bank and Gaza Strip and in southern Lebanon.

December

8-9 Israeli forces move deep into Lebanese territory, attack Hizbollah bases, and withdraw. A Golani battalion commander is killed in the operation.

15 Two Shi'ite leaders in Lebanon are kidnapped by the I.D.F. to provide negotiating leverage for the retrieval of captured and missing Israeli soldiers.

22 Shamir presents his government to the Knesset. It is a national unity government but without rotation for the office of prime minister. The Knesset approves it by a vote of 84 to 19 with 3 abstentions.

24 Kenya resumes diplomatic relations with Israel, cut off since 1973. The two countries have maintained close de facto links all along.

27 The shekel is devalued by 5% following the acquisition by the public of large quantities of foreign currency which threatened to deplete state reserves.

The cost of living rise for 1988 is 16.3%, the lowest in years.

△ The Intifada in the West Bank and Gaza Strip, which erupted in December 1987, gathers momentum during 1988. Shown, a violent demonstration at Bir Zeit University near Ramallah.

▽ Ya'el Meir, a victim of terrorism in August, 1988, is wounded together with her husband, parents, and three children in an explosion in the Nordau pedestrian mall in Haifa.

ELECTIONS: A SWING TO THE RIGHT

The national unity government formed in September, 1984, under Peres (until October, 1986) and Shamir (thereafter) lasted a full term, with elections held as scheduled in November, 1988. This campaign was less heated than usual, a result of the experience of governance together – despite frictions – by the country's two main political blocs, the Likud and Labor.

The elections produced no major changes, with the Likud slipping slightly to 40 M.K.s and Labor reaching 39. The one significant development was a pull to the Right and the strengthening of the ultra-Orthodox component of the religious camp. An attempt by Labor to form a coalition with the religious parties failed largely because only 5 of the 18 religious M.K.s were affiliated with the moderate National Religious Party, while the remaining 13 represented the three ultra-Orthodox parties. Additionally, three small parties to the right of the

Likud received a total of 8 seats. In the leftist camp, three parties left of Labor attained a total of 10 seats, with the Communists and the Arab parties obtaining 5 more.

On paper, the Likud could have formed a stable government with the rightist and the religious parties for a total of 65 seats, whereas the Labor bloc and the Left had only 55 seats. The Likud, however, held back because of the numerous demands of the religious parties. After prolonged negotiations, a new national unity government emerged, comprised of the Likud, Labor, and several small parties, with one basic difference as compared to the previous government: the prime minister – Itzhak Shamir of the Likud – was elected for the full term this time, with no rotation. The government did not survive for its full term, but collapsed in the spring of 1990.

עץ
תחת
עץ

TREE FOR TREE

△ One tactic of the Intifada is to set forest fires, prompting the Jewish National Fund to mount a tree planting campaign.

△ The newly elected government in 1988 attends a reception given by President Hayim Herzog. Shown (l. to r.): Deputy Prime Minister David Levy, Prime Minister Itzhak Shamir, the president, Finance Minister Shim'on Peres and Deputy Prime Minister Itzhak Navon.

מישה ארנס
לעולם לא תצעד לבדך

◁ The Likud elects its candidates to the Knesset at a convention in Herzliya blanketed by campaign banners. The one at the top reads: "Misha [Moshe] Arens - You'll Never Walk Alone."

526

▽ Mock-up of the Arrow missile that will be developed jointly by Israel and the U.S. as agreed in 1988.

▽ Israeli soldiers outfitted with flak jackets, helmets, and shields confront stone-throwing Palestinian young-

sters in Gaza. Rioting in the occupied territories, especially in the Gaza Strip, continues throughout the year.

△ I.D.F. soldiers in action in Lebanon. Terrorist activity by Palestinians and Shi'ites continues all year long.

THE 40TH ANNIVERSARY OF THE STATE

Israel faced several significant developments as it marked its 40th anniversary in the spring of 1988. The Intifada – the Palestinian uprising in the West Bank and Gaza Strip – had been going on for half a year. Moreover, Palestinian aggression spread to Israel in various forms: stone-throwing at buses, stabbings, and forest-burning. Katyusha barrages launched by terrorists in Lebanon targeted the Galilee periodically.

In the realm of foreign affairs, Israel's claim to the disputed location of Taba adjacent to Eilat was rejected in arbitration and the area was assigned to Egypt. In another region, however, relations with the Soviet Union warmed perceptibly, and Israel opened a consulate in Moscow after a hiatus of over 20 years. Relations with China also thawed somewhat, and Israeli tourists began traveling there openly instead of under the aegis of foreign groups.

Immigration remained meager. Conjecture about the Soviets allowing free emigration for Jews was voiced from time to time, but the prospect appeared dim in 1988.

◁ The severe earthquake in Armenia in December, 1988 prompts Israel to send an I.D.F. aid mission there comprising 50 officers and men trained in rescue work, as well as a dog trained to detect survivors.

△ The "bus of the mothers": the bus transporting workers to the Dimona reactor in the Negev is abducted by terrorists who infiltrate from Egypt in March, 1988, and kill three passengers before they themselves are killed.

▷ A new state comptroller is elected by the Knesset (a vote of 67 to 16, with 13 abstentions) in June, 1988 – retired Supreme Court Justice Miriam Ben-Porat, who was a district court judge for 18 years prior to serving on the Supreme Court for 11 years.

1989

January

4 The marking of the border along Taba is completed.

5 A new economic plan is presented by Finance Minister Shim'on Peres that includes budget cutbacks and various new taxes. Prices of controlled consumer products are raised by 10% on January 10.

16 A countrywide power failure occurs due to a cold wave.

25 The head of the Immigration Department of the Jewish Agency, Uri Gordon, foresees the immigration of hundreds of thousands from the Soviet Union.

Terrorist attacks and incidents continue in the West Bank and Gaza Strip, in Israel, and in southern Lebanon.

30 The Egyptian flag is raised at Taba alongside the Israeli flag.

31 Prime Minister Shamir presents a two-stage peace plan.

February

4 The police arrest several activists from a radical rightist organization, Keshet.

15 The cost of living index for January is a high, 4.7%, attributable to the rise in the cost of subsidized goods and services.

16 An I.D.F. soldier, Avi Sasportas, is kidnapped while hitchhiking at the Hodayah Junction in the south.

Labor and Shinui ("Change") party leaders meet with Palestinian leader Faisal Husseini for the first time.

26 Taba is returned to Egypt. The issue of compensation for the hotel and vacation village there is settled.

28 Local elections are held throughout the country.

March

Terrorist activity continues along the borders as well as within the country.

5 The Israel Opera opens in the Noga theater in Jaffa.

27 A further sign of the warming of Eastern Europe toward Israel is the inauguration by El Al of two new air routes, to Poland and to Hungary.

April

8 Writer Dan Ben-Amotz, who is suffering from cancer, gives a farewell party attended by 300 friends.

May

3 A Palestinian terrorist stabs and kills two civilians and wounds three others near Zion Square in Jerusalem.

Hamas terrorists kidnap and kill a soldier, Ilan Sa'adon.

6 Intense rioting in the occupied territories results in four Arabs killed and some 150 wounded in confrontations with the security forces.

7 The body of missing Israeli soldier Avi Sasportas is found. He was kidnapped and murdered by Hamas terrorists.

28 Terrorists in Lebanon barrage the village of Metula with Katyusha missiles.

31 Israeli planes attack terrorist headquarters in Lebanon.

June

Terrorist attacks on Israeli soldiers and civilians in the occupied territories and in Israel continue.

5 President Herzog reduces the sentences of three Jewish underground prisoners. They will be released in 14 months, after having served a reduced prison term (by a third) of 10 years instead of the original sentence of life imprisonment. It is the third reduction in sentence that the president has granted to the three prisoners.

6 State Comptroller Miriam Ben-Porat publishes a list of contributors to the major political parties, causing a furor.

18 A resident of Ariel in the West Bank is stabbed to death by an Arab.

21 Jewish settlers in the occupied territories attack Arabs at Geha Junction near Tel-Aviv in retaliation for the stabbing in Ariel.

22 Prof. Menahem Stern, an eminent Israeli historian and recipient of the Israel Prize, is stabbed to death by a Palestinian terrorist while walking through the Valley of the Cross in Jerusalem.

The shekel is devalued by 4.4%.

27 A group of 63 injured victims of the earthquake in Armenia arrive in Israel on El Al's first flight from the Soviet Union in order to be treated in Israeli hospitals.

29 Eight Intifada leaders in the West Bank and Gaza Strip are deported to Lebanon.

July

6 A Palestinian terrorist forces a bus over a cliff along the Tel-Aviv-Jerusalem road, killing 14 passengers and wounding many others. Two of the wounded later die of their injuries.

7-8 Jewish settlers in the occupied territories riot in reaction to the bus attack.

23 The government ratifies a policy initiative by Prime Minister Shamir permitting local elections for the Arabs in the West Bank and Gaza Strip, rejecting the hard-line principles espoused by Likud ministers Sharon, Levy, and

In a poll conducted by the newspaper *Hadashot* ("News") in 1989, 1200 Israelis are asked:"Who is the most patriotic Israeli since the foundation of the state?" Ben-Gurion (shown) gets the first place, 42.8%; Begin obtains 25.4%; Sharon, 4.9%; Rafael Eitan, 3.2%; Luba Eliav, 2.6%; Abie Natan, 2.3%, Rabin, 2%; Meir Har-Zion, 1.6%; Dayan, 1.5%; Eli Cohen, 1.5%.

Soldiers comb undergrowth in the Ashkelon area in June 1989 for clues to the whereabouts of kidnapped soldier Ilan Sa'adon.

The disputed Taba region returns to Egyptian sovereignty in early 1989 following agreement on a compensation settlement for the Sonesta Hotel and a vacation village built there.

Moda'i.

28 An Israeli force kidnaps one of the leaders of Hizballah in Lebanon, Sheikh Obeid, for leverage in future prisoner exchanges.

Violent incidents continue to occur in the West Bank and Gaza, including the execution by Arabs of Arab collaborators with Israel.

August

A steep rise in unemployment is reported midway in the month. The unemployment figure reaches 150,000.

Shootings and stabbings of Israelis continue in the occupied territories, in southern Lebanon, and inside Israeli territory. Katyushas continue to land in the Galilee. The Arab population of the West Bank and Gaza begins a "tax rebellion."

September

18 Israeli-Hungarian relations are reinstated, 22 years after they were severed by Hungary.
19 A major fire destroys large forested areas of the Carmel Park.

27 Peace activist Abie Natan is convicted of contact with the P.L.O. and sentenced to six months in prison.
28 The Hamas organization is declared illegal.

October

4 The Shalom Department Store in Tel-Aviv closes due to cash flow difficulties.
11 A Syrian pilot flies a Mig 23 over Israeli airspace for seven minutes, lands at the Megido airstrip, and seeks asylum. The circumstances of the incident elicit criticism of the Israel Air Force.
16 Extensive rioting by Arabs takes place in East Jerusalem.
20 Writer and bohemian celebrity Dan Ben-Amotz dies at age 66.
30 A Lebanese fishing boat, apparently booby-trapped, explodes near an Israeli navy vessel off Rosh Hanikra.

November

3 Israel and Ethiopia resume diplomatic relations.
9 Katyusha barrages from Lebanon target northern Israeli settlements. No

casualties are recorded.
13 Elections at the Histadrut ("Federation of Labor") convention result in over 50% of votes for Labor.
13-15 Prime Minister Shamir visits the U.S. and meets with President Bush.
19 The number of yeshiva students not serving in the I.D.F. is reported to have been 18,300 in 1988, four times the figure 20 years previously.

France resumes the sale of military equipment to Israel after a 21-year hiatus.

Three women are elected to the Tel-Aviv Religious Council – a first in the country.
21 The issue of suicides in the I.D.F. evokes public concern. A platoon commander in the Giv'ati Brigade is demoted following the suicide of one of his men.
23 Israeli planes attack terrorist targets in Lebanon, repeated on November 25th.

December

1 Israeli security forces wipe out a cell of the Arab

terrorist Black Panther movement in Nablus.
30 Felafel (chickpea-based street snack) poisoned by an Arab worker causes the hospitalization of two Jerusalem residents.

A large Peace Now rally in Jerusalem ends with dozens of participants injured when police break it up. Fifty demonstrators are arrested.
31 Prime Minister Shamir dismisses Minister of Science Ezer Weizman in light of his links with P.L.O. personalities.

The torching of cars in Jerusalem – an Intifada tactic – increases, as does the stoning of cars in various places in the country.

A record 4,000 immigrants arrive during the month of December.

Some 25,000 immigrants arrive in 1989, a 50% increase over the preceding year and the highest figure of the 1980s.

The cost of living index for 1989 is 20.2%.

A RISE IN PALESTINIAN TERROR

Anti-Israel Palestinian terror took on a new guise in 1989, agitating the Israeli public by the kidnapping and murder of soldiers by Hamas terrorists; the forcing of a bus off the steep road en route from Tel-Aviv to Jerusalem, which resulted in the death of 16 passengers and the wounding of many others; and numerous stabbings of civilians.

The murder of noted historian Prof. Menahem Stern in June 1989 epitomized the random cruelty of the terrorists' operations. As was his habit every morning, the professor set out on foot from his home in Jerusalem to the National Library, passing through the garden surrounding the Monastery of the Cross which was on the way. There he was attacked by a terrorist and stabbed to death. Only when he failed to return home at the end of the day was a search mounted and his body discovered.

During the course of the year, terrorists based in Lebanon attacked the settlements of northern Israel systematically, primarily by means of Katyusha missiles. These terrorists were, in the main, members of the Shi'ite Hizbollah organization who linked up with the Palestinian terrorists.

▽ Palestinian terror increases during 1989 both in the West Bank and Gaza Strip – as part of the Intifada – and in Israel proper. Jewish settlers in the occupied territories set up a protest tent opposite the office of Prime Minister Shamir in Jerusalem, displaying the weaponry used by the terrorists against Israelis: axes, knives, spears, and "ninja nails."

▽ Soldiers and civilians comb the southern part of the country in a search for Avi Sasportas, the soldier kidnapped by Hamas terrorists from Gaza in February 1989.

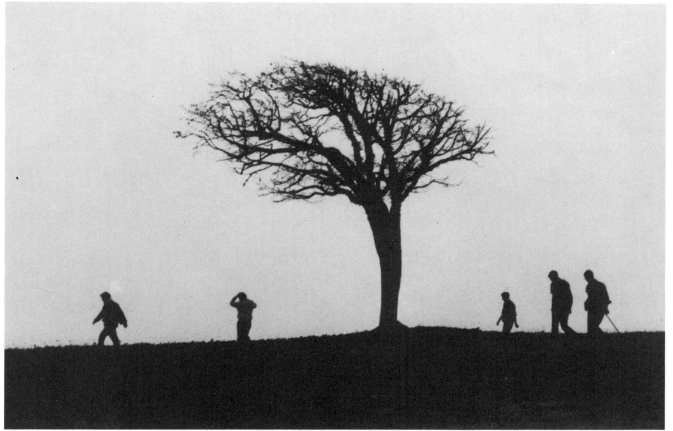

△ Likud Ministers (l. to r.) David Levy (deputy prime minister), Ariel Sharon (industry and trade), and Itzhak Moda'i (justice) adopt a hard line on the possibility of a compromise arrangement in the occupied territories. They are dubbed the "ringmasters," encircling and constraining Shamir's policy.

▽ Former prime minister Menahem Begin, retired from politics since 1983, emerges from his self-imposed confinement to his home in Jerusalem to visit the cemetery and take part in the annual remembrance ceremony for his late wife, Aliza, who died in 1982. To his l., his son, M.K. Benny Begin.

▽ A Purim costume in 1989 portrays Italian actress and stripper Cicciolina, who has visited Israel and obviously impressed the Israelis.

▷ Palestinian leader Faisal Husseini of Jerusalem stands out in 1989 because of his links with Israelis. Shown, in an evening of public discussions in Tel-Aviv.

▷ The traditional post-Passover Mimouna feast celebrated by Jews of Moroccan origin becomes increasingly integral to Israel's cultural as well as political scene in the 1980s. Every self-respecting political figure makes the rounds of visits to the homes and gathering points of the celebrants, especially during election years. Shown, Finance Minister Shim'on Peres (l.) samples Mimouna culinary special-ties.

◁ Israel continues aiding Armenia after the 1988 earthquake there. Over 60 injured Armenians arrive in Israel for medical treatment in June 1989, received at Ben-Gurion Airport by Minister of Health Ya'akov Tzur (l.) and Armenian priests from Jerusalem. Israeli ties with other East European countries are reestablished as well, as exemplified by new El Al air links with Poland and Hungary.

The Tenth Decade
1990-1997

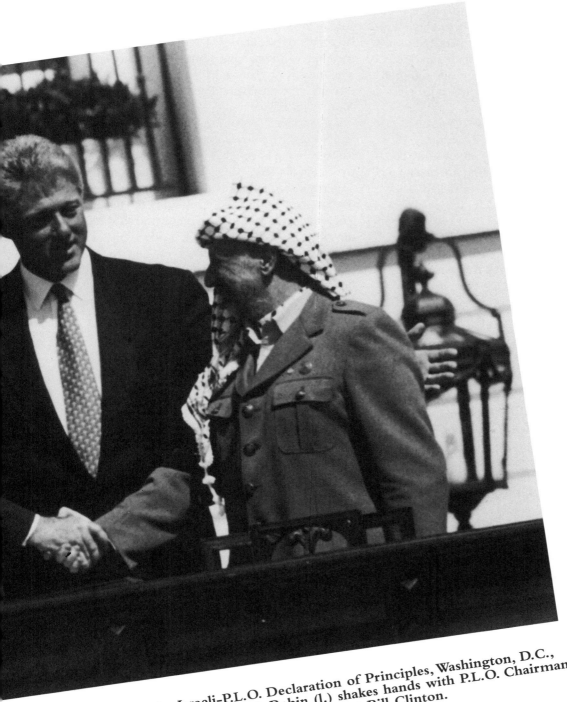

e signing ceremony of the Israeli–P.L.O. Declaration of Principles, Washington, D.C., ptember 13, 1993. Prime Minister Itzhak Rabin (l.) shakes hands with P.L.O. Chairman sser Arafat under the benevolent gaze of U.S. President Bill Clinton.

The first eight years of the 1990s (1990-97) witnessed a series of major events and developments: the resumption of large-scale immigration, the Gulf War, the political upset of 1992, the agreements signed by Israel with the Palestinians and with Jordan, the assassination of Prime Minister Itzhak Rabin on November 4, 1995, and another political upset in 1996.

The breakup of the Soviet Union prompted a mighty wave of immigration to Israel unparalleled since the early 1950s. Some 200,000 newcomers arrived in 1990 after a decade of sparse immigration, ushering in a new era. By 1996, over half a million newcomers had joined Israel's population, pushing the total population figure past the 5 million mark, and creating new and old problems of absorption, housing, employment, and social integration.

The Gulf War of 1991 thrust Israel into a position of military paralysis for the first time in its history. Targeted by Iraqi Scud missiles for a period of weeks, enduring heavy damage, and undergoing a weakening of national morale, Israel nevertheless refrained from responding at the insistence of the U.S., leader of the military coalition against Iraq.

Fifteen years after the political upset of 1977, when the Labor Party lost its supremacy for the first time in Israeli history, it rebounded and took first place in the elections of 1992, although the leftist bloc, based on Labor and Meretz, obtained no more votes than the factionalized and divided rightist bloc. In fact, it was the cooperation between the two Labor leaders, Peres and Rabin, which played a decisive role in the success of the party. The government that was formed in the summer of 1992 under the leadership of Itzhak Rabin was a coalition of Labor, Meretz, and Shas, with the support of the Democratic Front for Peace and Equality and the Arab Democratic Party outside the coalition. The withdrawal of Shas later on reduced the coalition base to 56 seats, enhancing its dependence on the largely Arab "blocking bloc."

The 1992 reversal jolted the Likud, which dropped from 41 to 32 seats, and catapulted a new figure, Binyamin Netanyahu, to the leadership of the party.

The new government addressed the country's pressing problems, both domestic and external, with vigor. Within a short time, large-scale investment was earmarked for infrastructure needs, especially the upgrading of the country's long-neglected highway network, and for the economy.

The major focus of governmental attention, however, was the quest for a breakthrough in the Arab-Israeli conflict. Secret talks held in 1993 under the patronage of Norway led to the signing that fall of a Declaration of Principles with the P.L.O. on the transfer of administrative authority in the Gaza Strip and the Jericho region to the Palestinians as a prelude to a broader agreement on the West Bank territories. This surprising development was received positively by most Israelis, although rightist elements and the settlers in the West Bank and Gaza opposed it vehemently. With the passage of time, continued Palestinian terrorist acts caused a drop in support for the agreement in Israeli public opinion polls. However, the handing over of the Gaza Strip to the Palestinians, including the arrival of Arafat in Gaza to the cheering of the masses, was accepted by most Israelis.

Yet another agreement, which evoked much wider support in Israel, was the full peace treaty signed with Jordan in October, 1994, which opened the border between the two countries. Thousands of Israelis began traveling to Jordan, and embassies were opened by both countries in Amman and Tel-Aviv. Relations were also established with several Persian Gulf countries and with Morocco and Tunisia.

By contrast, news of the peace talks between Israel and Syria elicited tension and suspicion in Israel. Reports in the Israeli and foreign media and statements by Rabin and Peres suggested that they aimed, with American mediation, at attaining full peace with the Syrians even at the cost of returning the Golan Heights. The settlers on the Golan, along with broad sectors of the political establishment and of the public at large, opposed this option vigorously.

The country's economy was on an upswing: the Arab boycott was all but dissipated, and the standard of living rose. Exports increased but so did imports, resulting in a widening of the gap in the country's balance of payments despite efforts to reduce it.

Most Israelis viewed the agreements reached with the Palestinians and with Jordan as promising, but Palestinian terror in 1995, perpetrated by the Hamas and Islamic Jihad organizations despite efforts by the P.L.O. under Arafat's leadership to halt it, hung like a dark cloud over the region.

During 1995, the rightist parties intensified their opposition to the Rabin government and to the agreements signed with the Palestinians. The far Right blocked roads, attempted to set up illegal settlements, and provoked confrontations with the army and the police. The use of invective against Rabin, Peres, and the government mounted, and tension rose by the week. However, neither the government nor the police took any significant action against the inciters, under the assumption that the leaders of the state were not in any physical danger, inasmuch as "a Jew would never harm a Jew." This assumption was to prove shockingly unfounded on November 4, 1995, when a young Jewish Israeli shot and killed Prime Minister Rabin.

Yet another political reversal occurred in the elections of 1996 when the Likud, led by Binyamin Netanyahu, beat Labor's Shim'on Peres and returned to the government leadership. Netanyahu continued the peace process but at a more cautious pace, engendering conflict with the Palestinians.

January

1-6 A wave of letter bombs reaches Israel from Cyprus and Greece. No casualties are caused.

2 A government crisis that has erupted over contacts by Minister of Science Ezer Weizman with the P.L.O. ends with a compromise between Labor and the Likud.

4 The Habimah theater performs the play *The Sunset* by Isaac Babel in Moscow to acclaim.

8 A Czechoslovakian delegation arrives to discusss the renewal of diplomatic relations.

30 The Knesset passes the Second Channel T.V. law.

February

4 An explosion takes place in a bus of Israeli tourists in Egypt resulting in 10 fatalities, including an Egyptian security guard, and 16 wounded.

26 The first legal cable T.V. broadcasting station begins operations in Rishon Lezion.

27 Israel and Poland resume diplomatic relations.

March

The flow of immigrants from the Soviet Union intensifies.

1 U.S. Secretary of State Baker links aid to Israel to a halt in Jewish settlement in the occupied territories and demands of Israel to speed up the peace process.

11 A government crisis develops over demands by the U.S. regarding the composition of the Palestinian delegation to the peace talks.

13 The cable station M.T.V. begins broadcasting in Israel.

15 The government falls in a vote of no-confidence – a first in Israel's history. The vote (60:55) results from the absence of most of the Shas M.K.s. The issue is Prime Minister Shamir's opposition to the U.S. demand to hold peace talks with Palestinians from the West Bank and Gaza.

28 Two reserve officers, Avi Kadosh and Shahar Ben-Meir, hold a hunger strike to underscore demands to change the electoral system from a proportional basis to a majority basis.

April

3 The Ofek 2 Israeli space research satellite is launched.

7 Tens of thousands participate in a demonstration in Tel-Aviv advocating changing the country's system of governance.

22 Two I.D.F. helicopters crash in midair over the Jordan Valley, resulting in seven fatalities.

25 Czechoslovakian President Vaclav Havel arrives in Israel on a state visit.

Immigration from the Soviet Union increases. Over 10,000 arrive during the month of April.

May

3 Diplomatic relations between Israel and Bulgaria are resumed.

16 The Israeli and Soviet soccer teams face each other for the first time after a break of 34 years. Israel wins in a game in Ramat Gan, 3:2.

20 A young Israeli from Rishon Lezion, Ami Popper, shoots and kills seven Palestinian workers. Agitated demonstrations take place in the Gaza Strip and in Nazareth.

28 An explosive device planted in the Mahaneh Yehuda market in Jerusalem causes 1 fatality and 9 wounded.

30 The navy foils a major terrorist attempt when it detects the approach to the Israeli shore of two boats carrying 16 terrorists. Four of the terrorists are killed and the rest captured in a battle at the Nitzanim shore.

June

11 A new government is formed consisting of rightist and religious parties.

12 The 50,000th immigrant of the year arrives.

13 U.S. Secretary of State Baker, pressing Israel once again, declares: "When you're serious about peace, call me," giving his telephone number.

20 The Habimah theater, performing in East Germany for the first time, presents *Else* by Motti Lerner, a play about German-Jewish poet Else Lasker-Schüler.

July

1 Israel announces that it will free 416 Palestinian security prisoners as a goodwill gesture in honor of the Muslim holiday of Id al-Fitr.

1-21 All health services strike.

6-9 Israeli planes attack Hizbollah targets in Lebanon. The U.S. censures the act.

8-18 The rise in immigration, with attendant governmental measures to provide housing for the newcomers, prompts protest by native-born homeless families who demonstrate by setting up tent camps in the centers of various cities.

17 An artillery accident during an I.D.F. training exercise near the Tze'elim camp causes the death of 5 soldiers and the wounding of 10.

20 Tension mounts in the Persian Gulf region. Iraq threatens Kuwait. Defense Minister Moshe Arens leaves for Washington.

22 Shim'on Peres beats Itzhak Rabin in the Labor Party nominations for prime minister in the next elections.

28 An explosive device planted on the Tel-Aviv beach kills a tourist from Canada.

The Arrow anti-missile missile.

Over 17,000 immigrants arrive during the month of July.

August

2 Iraq invades Kuwait and takes control of it, evoking international tension. Israel is on full alert.

3 Approximately 200 Jewish children from Chernobyl, Ukraine, site of the nuclear reactor explosion in 1986, are brought to Israel under the patronage of the Habad Hasidic movement.

4 Palestinian terrorists kidnap two teenage boys on the Ramot road in Jerusalem. Their bodies are found on August 6th. Several Jews attack Arabs in Jerusalem in response.

8 Iraq annexes Kuwait.

9 The first test launch of the Israeli Arrow anti-missile missile is carried out. The missile self-destructs seconds after the launching.

12 Saddam Hussein links the termination of the Gulf crisis to a withdrawal by Israel from the territories it captured in 1967.

20 A commission of inquiry on the country's health system, headed by Justice Shoshana Netanyahu, publishes its findings. It recommends the passing of a state health law and the disbanding of the various health funds.

30 Iraq threatens to attack Israel. Shamir warns: Whoever attacks Israel will regret it.

September

5 The publication of a book in the U.S. about Israel's Mosad by a former Mosad operative, Victor Ostrovsky, causes a tempest in Israel.

11 The 100,000th immigrant of the year arrives.

18 The escalation of tension in the Persian Gulf prompts the U.S. to promise Israel

△ Immigrants young and old stream in all year long. Families, children, and even elderly newcomers arrive, as shown in this picture. While at first tens of thousands are anticipated, by the summer it is clear that the figure will be hundreds of thousands.

▽ A major tragedy is averted during the Shavu'ot holiday when 16 terrorists heading for the Israeli shore in two boats are apprehended by the navy. A battle at the Nitzanim beach in the south ends with the death of four of the terrorists and the capture of the rest, including one shown in the photo.

that it will upgrade Israel's defense capability. Among other things, it promises to deploy two Patriot anti-missile missile launchers in Israel.

20 A reserve soldier, Amnon Pomerantz, loses his way in the al-Bureij refugee camp in the Gaza Strip while driving to his post and is brutally murdered by a crowd.

22 Saddam Hussein warns that if a war breaks out, it will be "the mother of all wars."

October _____

1 The government adopts a decision to distribute gas masks to the entire population for protection against chemical warfare.

7 A trial distribution of gas masks is carried out in Yokne'am, Ofakim, and Kfar Yona. Nationwide distribution is scheduled for October 15.

8 Frenzied rioting breaks out at the Temple Mount in Jerusalem. Stoning by Arabs of Jews praying at the Western Wall below, and the torching of a police station on the mount, prompt police to fire live ammunition. Casualties are dozens of Arabs killed and over 200 wounded, and 26 Jews wounded.

13 The U.N. Security Council censures Israel for the events at the Temple Mount. The U.S. joins the condemnation.

21 A Palestinian stabs and kills a woman soldier, a policeman, and a civilian in Jerusalem.

28 Brig.Gen. Rami Dotan of the air force is arrested for accepting bribes.

30 The first trailer camp to house new immigrants and native homeless families is set up in Bat Yam.

November _____

1 U.N. Secretary-General Javiar Perez de Cuiellar censures Israel for the Temple Mount events in a published report.

2-4 Violent confrontations occur between Palestinians in the Gaza Strip and the I.D.F. According to Palestinian sources, over 150 are wounded.

5 Rabbi Meir Kahane is shot and killed in New York by an Egyptian national.

6 The U.S. demands that

Iraq evacuate from Kuwait within two weeks. Hundreds of thousands of American and other soldiers are concentrated in Saudi Arabia.

12 A Palestinian terrorist from Jordan infiltrates into an I.D.F. outpost in the Jordan Valley and kills the commanding officer.

25 In a grave incident on the western border road north of Eilat, an Egyptian soldier shoots at passing Israeli military and civilian vehicles, killing four passengers and wounding 26.

26 The U.N. warns Iraq that if it fails to withdraw by January, war will break out.

27 Five Giv'ati Brigade soldiers are killed in an encounter with terrorists at Mt. Dov on the Lebanese border.

29 The U.N. Security Council presents Iraq with an ultimatum: withdrawal from Kuwait by January 15, 1991, or a military confrontation.

December _____

2 Three Hamas terrorists stab and kill one passenger and wound three others on a bus traveling from Petah Tikva to Tel-Aviv.

13 A crash of a light I.D.F. plane flying over the Negev results in the death of four I.D.F. pilots and a woman officer aboard.

14 Two Hamas terrorists from Gaza kill two men and one woman employed in a metalworks in Jaffa.

24 Threats by Iraq against Israel continue. Defense Minister Arens warns that if Israel is attacked, it will respond with force.

26 Israel and the Soviet Union establish consular relations after a hiatus of 23 years.

29 At the end of a turbulent day in the Gaza Strip, the Palestinians report 5 dead and 250 wounded in clashes with I.D.F. forces.

Eleven Jewish families from Albania immigrate to Israel, the first such immigration in decades.

Over 200,000 immigrants arrive in Israel in 1990. Inflation for 1990 drops to 17.6%.

AN IMMIGRATION BOOM

Immigration to Israel had long been modest, falling off in the late 1980s to its lowest ebb since Mandate times: 11,000-14,000 annually. However, the picture changed at the end of the decade, and in 1990 a complete reversal occurred with the arrival of 200,000 newcomers – the second largest annual immigration since the start of the Zionist enterprise (the record was set in 1949 when 239,000 newcomers arrived).

A convergence of factors accounted for this dramatic development: the policies of Perestroika and Glasnost implemented by Gorbachev included a more positive attitude by the Soviet authorities toward emigration to Israel; the worsening economic situation in the disintegrating Soviet empire, along with political and ethnic strife, induced more Jews to leave; and the opening of an Israeli consulate in Moscow facilitated visa processing, until then handled by the Dutch embassy. Perhaps the most important factor of all was that in late 1989 an agreement had been concluded between Washington and Moscow requiring emigrants to the U.S. to acquire visas while still in the Soviet Union. This ended the "dropout" phenomenon, generally at the Vienna transit stop, which had reduced immigration to Israel significantly. The U.S. set an annual quota of 40,000 Jewish immigrants from the Soviet Union to its territory. Thereafter, hundreds of thousands of Jews anxious to leave the Soviet Union made their way – whether enthusiastically or from lack of choice – to Israel.

At first, thousands arrived monthly, but the stream turned into a flood and by the end of 1990 Israel was absorbing 10,000-20,000 newcomers a month. The enormous effort invested in the absorption elicited resentment among some Israelis. They claimed that the immigrants were not Zionists, that many among them were not even Jews, and that priority should be given to the employment and housing of the native-born residents of depressed neighborhoods and development towns.

▽ A "tent movement" springs up during 1990 at the instigation of native-born young couples and residents of depressed neighborhoods who perceive themselves as shunted aside in favor of the new immigrants. They pitch tents in town squares and parks.

▽ From the Soviet cold to the Israeli sunshine: An immigrant family arrives at Ben-Gurion Airport dressed in "old country" style. The immigrants arrive from various parts of the Soviet Union.

◁ The Philatelic Service pitches in to the immigrant absorption effort with the issue of a stamp on the topic.

The large immigration streaming into Israel is wonderful. I walk though the streets and encounter these immigrants and feel as though I am being revived with milk and honey after a long period of national hunger and thirst. The State of Israel is awash with something whose immensity, I believe, it does not yet comprehend. We, veterans and new immigrants alike, are still immersed in a dream.

Author A. B. Yehoshua, 1990.

IS A NEW WAR APPROACHING?

Iraqi President Saddam Hussein created an international furor when in early August, 1990, his army invaded neighboring Kuwait, conquered it in a lightening operation, and annexed it to his country. War fever spread through the Middle East, mounting in the months that followed. A coalition of countries formed under the leadership of the U.S. and Great Britain, including such Arab countries as Saudi Arabia, Egypt, and Syria, warned Saddam to withdraw from Kuwait or face war. At the same time, a large international military force – primarily American – coalesced in Saudi Arabia.

Meanwhile, the Iraqi ruler excoriated Israel repeatedly, linking his withdrawal from Kuwait to the withdrawal of Israel from the territories it had captured in 1967 and threatening to attack it relentlessly. Prime Minister Itzhak Shamir responded by declaring that whoever attacks Israel would regret it. Preparations were made in Israel for Iraqi attacks by Scud missiles armed with chemical warheads. Gas masks were distributed to the entire population. The government reiterated that Israel would respond to any attack by Iraq.

On November 29, 1991, after all attempts to remove Saddam from Kuwait had failed, the U.N. Security Council approved an American initiative to eject the Iraqis by force. Saddam adopted a tough stance, reiterating that should war be declared against his country, it would be "the mother of all wars." The I.D.F., for its part, was prepared for every kind of reaction. The crucial question was if Israel was to intervene at all. The American answer was: no.

△ Iraqi threats prompt Israel to distribute gas masks to the entire population. Some recipients record the event photographically.

▽ The I.D.F. is assigned the task of distributing and fitting the masks at specially organized centers throughout the country.

△ A Syrian cartoon in 1990. The Iraqi invasion of Kuwait causes a rift in the Arab world. Old rivalries are renewed, tying the Arabs' hands while Israel is free to act.

◁ A grass roots movement emerges in the first half of 1990 advocating change in the country's system of governance and efficient management in government service. Protests and demonstrations are staged throughout the country. One, held on June 7th, features a horse to highlight "horse-trading" practices in the government.

▽ Relations between Labor Party leaders Itzhak Rabin and Shim'on Peres are at a low ebb in 1990, reflected in their body language during a session of Knesset. Rabin labels Peres' failed effort at forming a government under Labor leadership "the stinking exercise."

△ A welcome guest to Israel in 1990 is British business magnate Robert Maxwell, shown (l.) meeting with Prime Minister Shamir.

▷ Following the fall of the national unity government in March, 1990, in a vote of no-confidence led by Shim'on Peres, and the subsequent failed effort by Peres to form a Labor government, Itzhak Shamir (2nd from r.) forms a rightist-religious government whose stars are Shas' Aryeh Der'i (l., with black beard), the Likud's Moshe Nissim (c., reading document), and David Levy (r.).

1991

January

Tension rises with the approach of the U.N. deadline of January 15, 1991, for Iraq to evacuate from Kuwait. Some Israelis fly out of the country. Observers predict that in the event of war, Iraq will not dare attack Israel.

3 Two Patriot anti-missile missile launchers are delivered to Israel by the U.S.

10 The Civil Defense organization begins instructing the public on the use of anti-chemical protective equipment.

12 The U.S. Congress grants approval for initiating the war against Iraq.

14 The Civil Defense organization issues instructions for sealing rooms in all homes and offices for protection against chemical warfare.

17 The U.S. starts the war against Iraq. Baghdad is bombed intensively. A sense of imminent victory is felt worldwide and in Israel. School is closed in Israel.

18 A barrage of eight Scud missiles is launched by Iraq at the Tel-Aviv and Haifa areas.

19 American Patriot missile-launcher personnel arrive in Israel and install the equipment.

21 The economy is nearly at a standstill in anticipation of further Scud attacks.

22 The defense establishment orders the resumption of normal civilian activity.

Scud missile attacks are launched against Israel at intervals during the final 10 days of the month. Israel, acceding to American demands, does not retaliate.

The American bombing of Iraq continues.

February

The missile barrages from Iraq continue.

Anger is registered in Israel at reports that the Palestinians in the West Bank and Gaza "danced on the rooftops" when the missiles fell in Israel.

2 German planes deliver protective equipment against chemical warfare to Israel.

5 M.K. Rehav'am Ze'evi of the rightist Moledet party joins the government as a minister without portfolio.

9 According to a report, the Patriot missiles have failed to intercept the Scuds.

11 Isreali forces detain hundreds of Hamas activists in the West Bank and Gaza.

14 The police advise prosecuting Shas ministers Aryeh Der'i and Aryeh Pinhasi on suspicion of breach of trust, diverting monies to Shas associates through local government budgets, and fradulent registration of documents.

16 The number of Scuds fired at Israel decreases and targeting is flawed. Mistargeted missiles land in the southern and northern hinterlands and in the West Bank.

24 The Allied land attack against Iraq begins. Allied forces capture Kuwait and penetrate into Iraqi territory in days.

25 The last Scud lands in the South. A total of 39 Scud missiles have been launched.

28 President George Bush announces the termination of the war.

March

10 A Palestinian murders four Jewish women in the Kiryat Yovel neighborhood of Jerusalem.

11 Two I.D.F. soldiers are killed and two are wounded in a hit-and-run attack in the Gaza Strip.

25 The second trial launching of the Israeli-made Arrow missile fails.

Incidents in the Jordan Valley involving Palestinian terrorist infiltration from Jordan increase during the month.

April

1 Lieut. Gen. Ehud Barak takes over from Dan Shomron as chief of staff.

16-18 A series of terrorist incidents take place in the Jordan Valley region from Kibbutz Neveh Ur in the north to the Allenby Bridge to the south.

24 Four Israelis are arrested in Cyprus for attempting to plant telephone taps in the Iranian embassy. They are released on May 9 after paying a fine.

May

16 Maccabi Tel-Aviv wins the national basketball cup for the 22nd consecutive time.

20 Polish President Lech Walesa arrives for a visit to Israel.

25 Operation Shlomo is completed: 14,500 Jews from Ethiopia have been airlifted to Israel in a total of 36 El Al and I.D.F. planes.

June

4 Israeli planes attack terrorist bases in the Sidon region.

9 M.K. Ya'ir Levy of Shas is questioned by the police on suspicion of fraud, forgery, and theft. He reserves the right to remain silent.

22 The Maccabi Haifa soccer team attains the coveted "double," winning both the state championship and the cup (achieved on June 4).

23 The king of the Zulu nation visits Israel.

July

14 Peace activist Abie Natan, having met with Yasser Arafat abroad, is questioned by the police upon his return home for contact with repre-

sentatives of a terror organization.

August

Two African foreign ministers visit Israel – Nigeria's (August 4) and the Congo's (August 21) – apparently in anticipation of the resumption of diplomatic relations with Israel.

6 The publicly owned Bezek telecommunications company strikes over projected plans for privatization. The publicly owned electric company strikes as well.

14 John Demjanjuk's appeal against his conviction as a Nazi war criminal is postponed to December. The prosecutor travels to the Soviet Union to gather new evidence.

August draft figures for the I.D.F. are the highest ever in Israel's history.

September

12 President George Bush criticizes Prime Minister Shamir and expresses doubt about the country's genuine desire for peace in light of the establishment of new Jewish settlements in the West Bank.

15 A new national traffic police force begins operations.

16 Secretary of State James Baker arrives for a one-day visit to advance the prospect of a peace conference.

18 Abie Natan is convicted of meeting with representatives of the P.L.O. and is sentenced to 18 months' prison and an 18-month suspended sentence.

Unemployment grows, immigrant absorption runs

ללא צער ובשמחה רבה, אנו מודיעים
על הסתלקותו של אויבנו, שונאנו
בן נעוות המרדות

סדאם חוסיין

ההלויה הייתה צריכה לצאת מזמן
מבית החולים לחולי נפש "הבוקר הבגדדי".
הוא ישרף אייה היום אפרו יפוזר לכל הרוחות.

לא יושבים שבעה משמחת העמים

A "death notice" for Saddam Hussein plastered on walls as a response to the Iraqi Scuds.

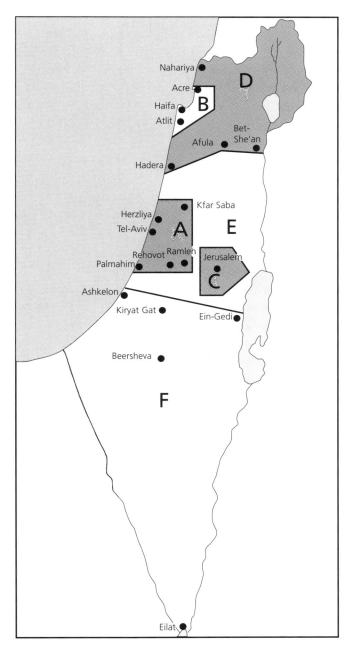

Naharia
Acre
Haifa
Atlit
Afula
Bet-She'an
Hadera
Herzliya
Kfar Saba
Tel-Aviv
Rehovot Ramleh
Palmahim
Jerusalem
Ashkelon
Kiryat Gat
Ein-Gedi
Beersheva
Eilat

D
B
A
E
C
F

△ The country is divided into six zones which are used as reference points in Civil Defense announcements concerning missile landings.

▽ Mazal Tov! A mother gives birth on January 23, 1991, her gas mask by her side.

into difficulties, and immigrants stage demonstrations.

October

7 The first direct flight from the Soviet Union to Israel arrives carrying 150 immigrants.

9 The attorney general requests the Knesset speaker to remove Shas M.K. Ya'ir Levy's parliamentary immunity on the basis of over 100 counts of fraud and forgery.

11 A hit-and-run attack is perpetrated by a Palestinian terrorist from the village of Kibiya who drives into a group of soldiers waiting at the Tel-Hashomer junction, killing 2 and wounding 11.

30 The Madrid Peace Conference opens with the participation of Israel, Egypt, Syria, Jordan, Lebanon, and the Palestinians under the patronage of the U.S. and the U.S.S.R.

A third trial launch of the Israeli-made Arrow missile fails.

31 Prime Minister Shamir declares at Madrid: Israel is committed to the talks until peace is attained. At the same time, Palestinian terrorist acts in Israel increase.

November

4 The Madrid Peace Conference ends without an explicit follow-up schedule of dates and sites.

10 British Jewish press magnate Robert Maxwell, who drowned in mysterious circumstances, is laid to rest in the cemetery on the Mt. of Olives, Jerusalem.

South African President F. W. de Klerk visits Israel.

December

16 The U.N. General Assembly votes by 111 to 25 that Zionism is not racism, thereby reversing the resolution of November 10, 1975.

Eleven fatal stabbings of Israelis are perpetrated by Palestinian terrorists during the course of the year.

The immigration figure for 1991 is 168,000.

Inflation for 1991 is 18%.

The 39 Scuds that hit Israel

January

18 The first barrage consists of 8 missiles: 6 landing in the greater Tel-Aviv area and 2 in Haifa. Approximately 70 persons are wounded and some 750 homes are damaged.

19 Five missiles land in the Tel-Aviv area, wounding some 50 persons and damaging some 1,500 homes.

22 One missile lands in the Tel-Aviv area, wounding some 100 persons.

23 One missile lands in Haifa, causing no injuries but damaging some 900 homes.

25 Seven missiles land in Tel-Aviv, Ramat Gan, and Haifa. The outcome in Ramat Gan is particularly grave: one person killed, 19 wounded and some 3,000 homes damaged. In Tel-Aviv, 25 persons are wounded and some 1,200 homes are damaged. In Haifa, hundreds of homes and workplaces are damaged.

February

Jan. 26 to Feb. 3 Five attacks of a total of 8 missiles target the center of the country, but no casualties or damage are caused.

9 An attack of a single missile in the Tel-Aviv area results in 27 wounded and 1,100 homes damaged.

11 A single missile lands in the Tel-Aviv area, but no casualties or damage are caused.

12 A single missile lands in the Tel-Aviv area resulting in 7 wounded and some 800 homes damaged.

16 Two missiles land, one in the north, the other in the south. No casualties or damage are caused.

19-25 Three attacks of one missile each occur, the first two targeting the center of the country and the last the south. No casualties or damage are caused.

The Scud attacks caused the death of one person directly, while three others died of heart attacks. Some 300 persons were wounded. Over 9,000 homes and workplaces were damaged.

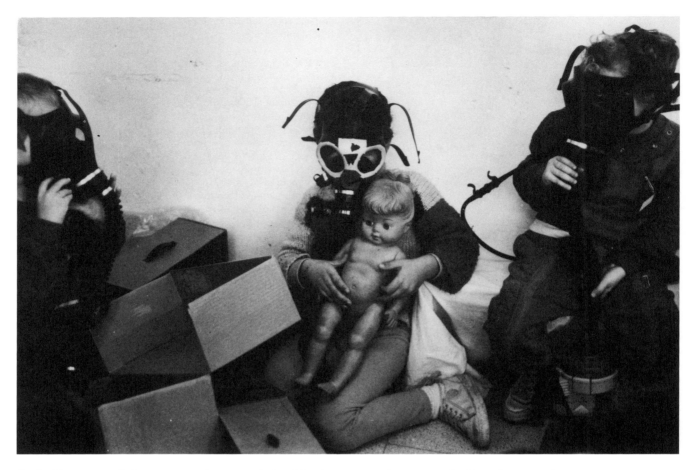

△ Children in a sealed room, January 1991. The entire country spends approximately six weeks in such rooms, with windows and doors taped shut. Morale drops, as Israel is constrained from responding to the attacks, its population protected by gas masks and masking tape only. Alerts for impending attacks, all-clear signals, and other vital information are conveyed by radio and T.V. The army spokesman in wartime, Nahman Shai, turns into the "national pacifier," thanks to his explanations and his calm manner of speech.

THE GULF WAR

The Gulf War was undoubtedly the strangest that Israel had experienced since its founding. Although Israel did not play an active role in it, the country was nevertheless on the receiving end of 39 surface-to-surface Scud missiles launched by Iraq over a six-week period. Many of these struck population centers, causing several deaths, hundreds of wounded, and heavy property damage (see preceding page).

Most observers had believed that Saddam Hussein would not dare launch a missile attack against Israel, but they were proved wrong. Missiles landed in Tel-Aviv, Ramat Gan, Haifa, and other locations in Israel. Fearing the arming of the missiles with chemical warheads, the government instructed the entire population to shut themselves in sealed rooms and to put on gas masks during alerts. The designated rooms which filled with whole families wearing masks, took on a frightening, surrealistic air. Ten thousand residents of the Tel-Aviv area soon evacuated their homes and moved to safer zones, prompting a public debate over whether they were "deserters" or whether their decision was justifiable.

The government, under pressure from the U.S., kept the I.D.F. from intervening in the war, a decision that was uncomfortable and enfeebling for the national psyche, although retrospectively it was the correct policy. Israeli involvement would have probably caused the disbanding of the coalition fighting against Iraq. Shamir was aware that after the fighting ended, Washington would turn its attention to the Israeli-Arab conflict and increase pressure on Israel, and he wanted to maintain the best relations possible with Washington.

Due to the missile attack, the Israeli economy was at a standstill for a few days and the educational system for a longer period. By the end of the Gulf War, in late February 1991, the Iraqi army was beaten and Saddam Hussein appeared destined to be deposed. Israel felt a sense of relief, although by no means a sense of victory.

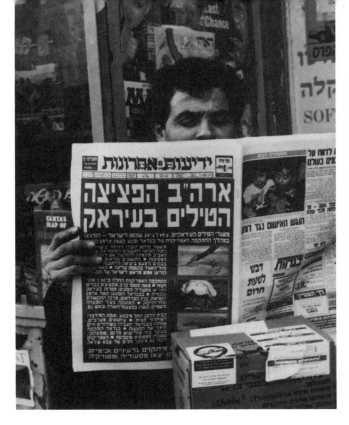

△ A headline in *Yedi'ot Aharonot* ("Latest News") reflects the promising start of the war: "The U.S. Bombs the Missiles in Iraq." According to the paper, they include those aimed at Israel as well. Later, this news will turn out to be inaccurate. At that point, the perception is that American air strength will prove decisive within a short time. Events, however, are to develop differently.

◁ A controversial front page of the Tel-Aviv newspaper *Ha'ir* ("The City") on January 25, 1991, shows a mock-road sign pointing to destinations where the local population is seeking shelter, including: Ima'le (Mommy). The exodus from Tel-Aviv and other cities in the region due to fear of the Scud missiles arouses a public debate. Tel-Aviv-Jaffa Mayor Shlomo ("Chich") Lahat labels the escapees "deserters."

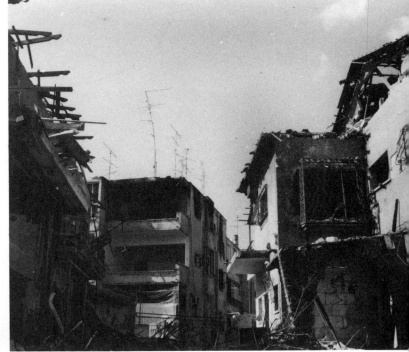

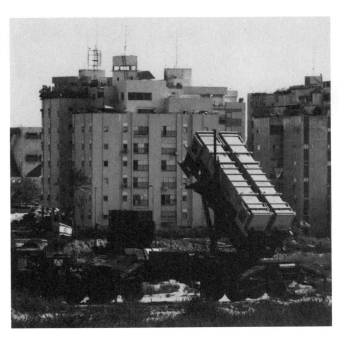

◁ An American Patriot missile launcher in Tel-Aviv, January 1991. The installation of the missiles in Israel at the start of the Gulf War is perceived as a solution to the problem of the Scud missiles. In practice, however, the Patriot missiles fail to prevent the landing of the Scuds and only a small number hit the Iraqi missiles at all.

△ A destroyed street in Ramat Gan. The Tel-Aviv-Ramat Gan area is the worst-hit in the country as a result of a series of missiles that destroy houses and segments of streets. Haifa and several other locations are also hit. By the end of February, the missile attacks dwindle.

OPERATION SHLOMO

The immigration to Israel of Jews from Ethiopia – the Beta Israel community, as they called themselves – continued on a small scale even after the major Operation Moshe airlift in 1984. In the early 1990s, the goal of bringing the remainder of these Jews to Israel became more urgent with the intensification of the civil war in Ethiopia.

By early 1991, thousands of Jews from remote villages had converged in Addis Ababa in the hope of rapid emigration to Israel. Representatives of the Immigration Department of the Jewish Agency for Israel, in cooperation with various other Israeli bodies, worked intensely to register and prepare them for such a move. In May, when Ethiopian opposition forces were closing in on the capital and its airport, the Israeli government decided to implement a second large-scale airlift – Operation Shlomo – with the participation of El Al and I.D.F. aircraft which in 36 hours evacuated over 14,000 Jews from Addis Ababa. During the course of the airlift, the Addis Ababa airport was put in the hands of Israeli personnel who coordinated a total of 36 flights by Israeli aircraft and one by an Ethiopian plane. Remarkably, seven more immigrants arrived in Israel than had boarded the planes in Ethiopia – the result of six births (including one set of twins) en route.

IMMIGRANT ABSORPTION DIFFICULTIES

Despite the Gulf War of early 1991, immigration continued to stream into the country at nearly the same high rate as in 1990. By the end of 1991, some 170,000 newcomers had arrived, mostly from the disbanded Soviet Union – by then the Commonwealth of Independent States.

Absorption difficulties, noticeable in 1990, became even more pronounced in 1991. The thousands of immigrants pouring in monthly faced a major problem in finding work and in desperation held public demonstrations. Many were housed in improvised trailer camps consisting of mobile homes imported by the government.

These difficulties had the effect of reducing immigration during the years that followed, although not to the low level of the 1980s. The post-1991 immigration rate leveled out to 60,000 - 70,000 annually.

▽ Early 1991 – the Gulf War period – does not seem a promising time for the absorption of new immigrants, yet they continue to stream in. Problems mainly involve housing and employment. Here, a group of immigrants in Tel-Aviv are employed as street sweepers.

△ The Israel embassy compound in Addis Ababa, capital of Ethiopia, is converted into an assembly point for thousands of Beta Israel Jews anxious to get to Israel during the early months of 1991. They set up tents in every possible space, and in May are airlifted to Israel in Operation Shlomo.

▷ Lieut. Gen. Ehud Barak replaces Lieut. Gen. Dan Shomron as chief of staff on April 1, 1991, a month after the end of the Gulf War. His insignia are pinned on by Defense Minister Moshe Arens (l.) and Prime Minister Itzhak Shamir.

∇ The Madrid Conference opens in the fall of 1991 with the participation of Israel, Egypt, Syria, Lebanon, and a Palestinian-Jordanian delegation. Shown, U.S. President Bush (l.) addressing the conference. Seated in front row: Netanyahu (2nd from l.), Ben-Elissar (to his l.) and Prime Minister Shamir (2nd from r.).

THE MADRID CONFERENCE

The idea of an international conference to solve the conflict in the Middle East was supported by Labor when it was part of the national unity coalition government until late 1990, but was opposed by the Likud. Ultimately, the conference became a reality, held in Madrid, Spain, in late 1991 with the participation of an Israeli delegation led by Prime Minister Shamir who, under American pressure, was compelled to take part in it. He did so reluctantly, and tried to pose obstacles along the way, such as opposition to the participation of Palestinians in a joint delegation with Jordan.

Shamir went to Madrid fortified by a delegation that contained a number of hard-liners from his party. Significantly absent was dovish Foreign Minister David Levy. Other participants in the conference were Egypt, Syria, Lebanon, and a Palestinian-Jordanian delegation. The hosts were the Spanish prime minister and a representative of the European Community, while the American secretary of state and the Soviet foreign minister acted as sponsors of the event, joined by the heads of the two leading powers, U.S. President George Bush and Soviet President Mikhail Gorbachev. In addition, observers were present from the U.N., the Gulf states, and the North African states. Shamir delivered a relatively moderate speech, while the Arab delegates were extremist, demanding that Israel withdraw from the occupied territories, implement the anti-Israel resolutions adopted by the U.N., and take in millions of Palestinian refugees. The conference ended with an agreement to continue holding bilateral talks.

1992

January
The start of the month witnesses unusually turbulent weather, with flooding and snowstorms in many parts of the country.

5 An Israeli delegation leaves for peace talks in Washington, a continuation of the Madrid Conference.

6 A report by the National Insurance Institute on poverty in the country creates a stir. It discloses that over 500,000 persons live below the poverty line.

15 The extreme rightist Tehiya and Moledet parties drop out of the government on account of the peace talks.

24 Foreign Minister David Levy visits China. Full diplomatic relations are established.

29 The two major political parties agree to hold new elections on June 23, 1992.

February
2-15 Another wave of unusual snowstorms and flooding hits the country.

3 M.K. Ezer Weizman announces his retirement from political life.

The trial of Shas M.K. Ya'ir Levy for fraud and theft begins.

14 In a grave terrorist incident, Israeli Arabs attack an I.D.F. camp near Kibbutz Gal'ed in the Nahal Iron area and axe three soldiers to death, wounding a fourth.

16 An Israeli force attacks and kills the secretary-general of Hizbollah in Lebanon, Sheikh Abbas Musawi.

18-22 Katyusha barrages target the Galilee, after a long hiatus.

19 Itzhak Rabin is nominated as Labor's candidate for prime minister.

March
9 Former prime minister Menahem Begin dies aged 79.

17 The Israel embassy in Buenos Aires is destroyed by the explosion of a booby-trapped car, with 20 fatalities, over 200 wounded, and dozens of persons missing. The Islamic Jihad takes responsibility for the act.

A Palestinian terrorist murders two Jews and wounds 18 in Jaffa.

18 The Knesset passes a law changing the electoral system to direct personal election of the prime minister instead of election by party, by a vote of 55 to 32.

30 Peace activist Abie Natan is released from prison following a reduction of his sentence by the president to six month.

April
6 A convoy of I.D.F. vehicles in southern Lebanon is ambushed. Two soldiers are killed and 5 are wounded.

21 Latvia opens a consulate in Tel-Aviv.

22 Israel and Armenia initiate diplomatic relations.

May
Unemployment reaches a record high of 144,000.

24 A terrorist from Gaza stabs and kills 15-year-old Helena Rapp in Bat Yam. Residents of Bat Yam rampage and attack Palestinians over a period of several days.

30 Two Palestinian terrorists murder a resident of Eilat.

June
Shortly before the Knesset elections, a wave of strikes engulfs the country.

14 Former president of the Soviet Union Mikhail Gorbachev visits Israel.

21 An accidental explosion in an Israel Military Industries plant in the center of the country causes the death of 2 workers and the wounding of 7.

23 Labor beats the Likud in an electoral upset. Itzhak Rabin begins talks toward forming a new government.

25 Palestinian terrorists murder two Israelis in the Gaza Strip.

July
12 The terrorist who murdered 15-year-old Helena Rapp is sentenced to life imprisonment.

A new government is formed by Labor together with Meretz and Shas under the leadership of Itzhak Rabin.

26 The 32nd Zionist Congress opens in Jerusalem.

30 An accidental explosion at an Israel Military Industries plant in Nof Yam kills 2 workers and injures 46.

Israel's women's judo champion Ya'el Arad makes Israeli history by taking a silver medal at the Olympic Games in Barcelona. Oren Smadja wins a bronze in men's judo.

August
Unemployment drops for the first time since the end of 1990.

30 New tension develops in northern Iraq. The Rear Command in Israel publishes new instructions in case of a missile attack.

31 Israel releases 182 Palestinian prisoners.

September
8 A disturbed young man shoots and kills 4 employees at a mental health center in Jerusalem and wounds 2 others. He flees to the roof of the building, where he is shot and killed by the police.

16 China's foreign minister arrives for a visit.

23 A fourth trial launch of the Israeli-made Arrow missile succeeds.

24 Another round of peace talks is concluded in Washington.

October
4 An El Al Boeing 747 cargo plane explodes in the air over a residential area in Holland, causing heavy casualties. The plane's three Israeli crew members and an Israeli passenger are killed.

14 Search activity for the Dakar submarine that sank mysteriously in the Mediterranean in 1969 is resumed in light of new findings.

22 A group of 40 Jews rescued from embattled Sarajevo arrive in Israel.

25 A road mine explodes in southern Lebanon killing 6 I.D.F. soldiers and wounding 4.

27 Katyusha missiles land in Kiryat Shmona, killing a 14-year-old and wounding his father and sister.

November
3 The acquittal for lack of conclusive evidence of a group of teenage boys accused of raping a minor in Kibbutz Shomrat arouses public protest.

3 In a second grave accident at the Tze'elim army base, 5 soldiers are killed and 6 are wounded by a mistargeted missile fired during an exercise.

8-11 Katyusha barrages from Lebanon target northern settlements in Israel. The I.D.F. retaliates with an artillery attack in southern Lebanon.

10 The new Supreme Court building in Jerusalem is inaugurated.

December
Terror attacks against Israeli forces increase. Palestinian terrorists kill three soldiers in the Gaza Strip on December 7th. A border policeman is kidnapped by Hamas in the Jerusalem area on December 13th. His body is discovered two days later.

14 The remains of a group of immigrants from Morocco clandestinely bound for Israel aboard the Egoz in 1961, which sank off the coast of Morocco, are brought to Israel by permission of Morocco's King Hassan and are interred at Mt. Herzl in a state ceremony.

17 The increase of terrorist acts by Palestinians prompts the government to deport over 450 Hamas and Islamic Jihad activists. The decision evokes a public debate and judicial proceedings in Israel, and negative reactions abroad.

Over 71,000 immigrants arrive in Israel in 1992.

The cost of living index drops below 10% (9.4%) for the first time in years.

△ "Prepare for the Coming of the Messiah," reads the banner, reflecting heightened activity by the Hasidic Habad movement in 1992. Large signs cover walls, bridges, and cars throughout the country. Many Habad followers regard the Lubavitcher Rebbe, Rabbi Menachem Mendel Shneerson, as the Messiah.

A battle is waged between the country's two largest dailies, *Ma'ariv* ("Evening Paper") and *Yedi'ot Aharonot* ("Latest News"). Above: "*Ma'ariv* is Afraid of Admitting the Truth. A Survey by the Advertising Union Shows: Only 16.9 % Read *Ma'ariv*." Below: "*Yedi'ot* Realizes at Last that People are Shifting to *Ma'ariv*."

◁ Meretz organizes bus service on Saturdays.

▽ Slogans of the 1992 election campaign: "Likud is the right way"; "The Mafdal (National Religious Party) is right behind you"; "Israel is safe with Tzomet"; "Israel is waiting for Rabin."

THE SECOND ELECTORAL REVERSAL

In a high voter turnout, 2.64 million out of an electorate of 3.40 million (78%), went to the polls on June 23, 1992, to vote for the 13th Knesset. The stability of the rightist government under Itzhak Shamir appeared doubtful in light of internecine friction among the Likud leadership. Whereas most of the Left rallied behind either Labor or Meretz ("Civil Rights Movement + Mapam + Change"), the Right was factionalized. An electoral upset was in the air.

The two primary candidates were Prime Minister Itzhak Shamir and Labor's Itzhak Rabin, the latter emerging as his party's leader over Shim'on Peres in light of the perception that only he could attract voters from the center and even from the Likud.

A T.V. election poll broadcast just after the voting places closed pointed to a second reversal in Israeli electoral history, namely the victory of Rabin and the Labor Party, a forecast that was borne out during the course of the night when Labor emerged with 44 seats to the Likud's 32. Together with Meretz, Labor's natural ally, which obtained 12 seats, Labor marshalled 56 seats, and, backed by the "blocking bloc" consisting of the Democratic Front for Peace and Equality (Hadash), and the Arab Democratic Party, could control 61 (of the Knesset's 120) seats. The factionalization of the Right and the proliferation of a series of tiny new lists prevented Tehiya from passing the electoral threshold. A surprise in the rightist camp was Rafael Eitan's Tzomet party, which entered the Knesset with 8 M.K.s.

The 17-member government led by Rabin (13 Labor, 3 Meretz, 1 Shas) was approved by the Knesset on July 13, 1992.

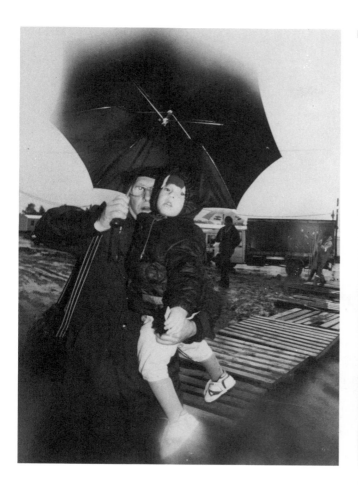

▷ Rightist demonstrations proliferate before the elections of 1992. Shown, rightist activist Avishai Raviv at a demonstration at Tel-Aviv University. He is later expelled from the university.

△
▷ Exceptionally plentiful rainfall in early 1992 results in widespread flooding. The ground water level is raised for years to come.
Above: the Ayalon roadway in the Tel-Aviv area is flooded.
Above l.: hundreds of residents of trailer camps are evacuated.

▽ Despite his advanced age (over 90), Rabbi Eliezer Schach, leader of the Lithuanian ultra-Orthodox community, appears at rallies and castigates secular Jewish society. Thousands attend his rallies.

△ In 1992, the inflation drops below 10% – for the first time in many years.

Bar chart values by year:
- 82: 131.5%
- 83: 190.7%
- 84: 444.9%
- 85: 185.2%
- 86: 19.7%
- 87: 16.1%
- 88: 16.4%
- 89: 20.7%
- 90: 17.6%
- 91: 18.0%
- 92: 9.4%

△ The position of the Supreme Court gains strength in the first half of the 90s. The new Supreme Court building in Jerusalem is inaugurated, commemorated by a specially issued stamp.

◁ Palestinian terrorist incidents proliferate in 1992 in the occupied territories, in Israel, and throughout the world. Shown, Jews seeking to attack Palestinians in Bat Yam in the wake of the stabbing by a terrorist of 15-year-old Helena Rapp. They are restrained by the police.

▽ A new leader comes to the fore in the Likud party – Binyamin ("Bibi") Netanyahu, formerly Israel's ambassador to the U.N.

△ An apartment building in Herzliya is damaged in July 1992 by an accidental explosion in an Israel Military Industries plant at Nof Yam, in which two workers are killed and dozens are wounded. Demands to relocate such plants away from population centers are reiterated.

January

3 A General Security Service (Shabak) operative, Hayim Nahmani, is murdered in an apartment in Jerusalem by the Arab agent under his control.

11 The annual State Comptroller's report severely criticizes the Labor Party in the realm of party financing, accusing it of "purchasing control of the government." A public and political furor results.

14 Ezer Weizman is put forward as the Labor candidate for president of the state.

The "sizzling cassette" affair emerges. Likud M.K. Binyamin ("Bibi") Netanyahu announces on T.V. that he is being blackmailed as a consequence of an affair. He implies that David Levy's camp is responsible for the blackmail. The affair creates a public stir and tension in the Likud.

17 The controversial Prof. Yesha'yahu Leibowitz is designated a recipient of the Israel Prize, eliciting public criticism over granting the prize to an advocate of conscientious objection to military service in the occupied territories. Ultimately, Leibowitz relinquishes the prize.

19 The Knesset annuls the law prohibiting meetings with the P.L.O.

21 Tel-Aviv District Court Judge Aryeh Segalson ignores an agreed-upon plea bargain and sentences M.K. Ya'ir Levy to 5 years' imprisonment for fraud, forgery and theft.

23 A road mine explosion in Lebanon causes the death of two I.D.F. soldiers.

28 The Supreme Court rules that the deportation of the Hamas and Islamic Jihad activists in December 1992 was illegal, yet the deportees are not allowed to return.

30 Two I.D.F. soldiers are killed in an ambush set by Hamas in the Gaza Strip.

31 The Lubavitcher Rebbe is declared the Messiah in Brooklyn, N.Y.

February

1 As a result of an agreement with the U.S., Israel will accept back 100 of the Islamist deportees in Lebanon immediately and the rest in a year.

9 A comment by the governor of the Bank of Israel that "the (Israeli) stock market is a bubble (ready to burst)" plunges the market into a free fall.

17 France beats Israel in a soccer match in the Ramat Gan Stadium, 4:0.

21 Two new chief rabbis are elected: Eliyahu Bakshi-Doron (Sephardi) and Israel Meir Lau (Ashkenazi).

March

A spate of terrorist acts throughout the country includes stabbings in the Aliyah Market in Tel-Aviv, stabbings and stonings of Jews in the Gaza Strip, the stabbing of pupils by a terrorist who bursts into a school in Jerusalem, and the murder of two policemen outside Hadera. The public is tense. Critics call upon Rabin, functioning both as prime minister and defense minister, to resign.

2 A new immigrant from Russia, Yana Hodriker, 20, is chosen as Miss Israel.

10 Shabtai Kalmanovitz, sentenced to 9 years' imprisonment as a spy for the U.S.S.R., is released after 5 years and 3 months and leaves for Russia.

16 Prime Minister Rabin cuts short a visit to the U.S. and returns home in light of the proliferation of terrorist incidents.

24 The Knesset elects Ezer Weizman president of the state by a vote of 66 vs. 53 for the Likud's Dov Shilansky.

31 A total closure is imposed on the West Bank and Gaza in the wake of the proliferation of terrorist acts.

A new police inspector-general is named – Rafi Peled.

April

13 Three I.D.F. soldiers are killed in southern Lebanon by a road mine explosion.

19 Prime Minister Rabin addresses a national memorial ceremony in Poland commemorating the 50th anniversary of the Warsaw Ghetto uprising.

21 Katyusha barrages land in the Galilee.

27 The country's teachers call a strike which continues until May 10.

May

2 A government crisis erupts over remarks attributed to Meretz Minister Shulamit Aloni that are viewed by Shas as insulting. Shas threatens to leave the coalition.

11 The country's nurses declare a strike which lasts a week.

13 Ezer Weizman takes office as Israel's seventh president.

16 Fatah and Hamas terrorists kill two Israeli fruit-and-vegetable wholesalers in Gaza.

19 The Meretz-Shas crisis continues. Rabin temporarily takes over the interior (Der'i's) and education and culture (Aloni's) portfolios.

22 The Guns 'n Roses rock group draws an audience of 50,000 at a performance in Tel-Aviv's Yarkon Park.

24 In a tragedy in Lebanon, two I.D.F. paratroop units fire on each other, resulting in 4 fatalities and 3 wounded.

28 A yeshiva student is murdered in Hebron on his way to prayers in the Makhpelah Cave.

30 The government crisis is resolved by means of a rotation of portfolios. Shulamit Aloni becomes minister of communications, science, and technology; Shim'on Shetreet – economy and planning; Amnon Rubinstein – education and culture; and Moshe Shahal – energy, in addition to police, which he already holds.

June

2 Jerusalem Mayor Teddy Kollek, aged 82, announces that he will run for another term despite a previous commitment to retire.

15-16 Pop star Elton John arrives in Israel and performs for an audience of tens of thousands in Tel-Aviv's Yarkon Park.

20 Minister of Interior Aryeh Der'i is charged with breach of trust and fraud.

28 Katyusha missiles land in Kiryat Shmona, wounding 6 persons.

In an attempt to halt the free fall of the stock market, Finance Minister Avraham Shohat announces stock market profits will not be taxed. The market revives.

July

1 Hamas terrorists kill two women in Jerusalem and wound one man.

7-21 The public sector strikes over a demand to raise salaries.

8-10 The security situation in the north deteriorates. Five I.D.F. soldiers are killed and 8 are wounded in two attacks from Lebanon.

20-25 Tension continues in the north. Katyusha barrages target the Galilee, resulting in fatalities and injuries, while the I.D.F. is attacked unremittingly in southern Lebanon.

25-30 Operation Accountability is launched by the I.D.F. in southern Lebanon. Hizbollah concentrations are bombed intensively. Many residents of Kiryat Shmona leave for the south. The operation evokes criticism from some quarters, including U.S. President Clinton. The Americans mediate a cease-fire on July 30.

29 The Supreme Court acquits John Demjanjuk of crimes against the Jews during World War II on the basis of plausible doubt, and rules that he be deported.

August

Terrorist incidents targeting both civilians and soldiers continue.

17 The new central bus station in Tel-Aviv is inaugurated.

19 The I.D.F. suffers a heavy loss of 9 fatalities in a series of incidents in southern Lebanon.

30 The government approves the Gaza and Jericho First agreement (later known as the Oslo Accords) attained

1993

with the P.L.O. in secret talks in Oslo that come as a surprise to the public. The Right demonstrates against the agreement.

September _____

2 An I.D.F. intelligence colonel (res.), Shim'on Levinzon, is convicted of spying for the Soviet Union and is sentenced to 12 years in prison.

8 Minister of Interior Aryeh Der'i resigns.

9 A group of 181 of the Islamist deportees in Lebanon are permitted to return to their homes in the West Bank and Gaza.

12 A wave of terrorism deluges Israel, obviously timed to precede the signing of the Declaration of Principles agreement with the P.L.O.

13 The Israeli-P.L.O. Declaration of Principles is signed in Washington, D.C. Foreign Minister Shim'on Peres signs on behalf of Israel. Mahmud Abbas (Abu Mazin) signs for the P.L.O. Rabin and Arafat shake hands.

19 American pop star Michael Jackson performs in Tel-Aviv's Yarkon Park for an enthusiastic audience of 70,000.

21 John Demjanjuk is deported from Israel after a series of petitions to the court to prevent his release is rejected.

October _____

Terrorist acts increase. Two hikers are murdered in Wadi Kelt east of Jerusalem on October 10; Palestinian terrorists kidnap and murder two reserve soldiers in the Gaza Strip on October 24; and a resident of Bet-El B is murdered on October 29.

1 Peace activist Abie Natan closes his Voice of Peace radio station, declaring: "The goal has been achieved."

4 A terrorist-driven booby-trapped car rams a bus carrying I.D.F. soldiers near Bet-El, wounding 29 and killing the terrorist.

5 Rock star Madonna performs in Tel-Aviv's Yarkon Park for an audience of 50,000.

13 Talks on the implementation of the Gaza and Jericho First agreement begin in Taba.

14 Another trial launching of the Israeli-made Arrow missile results in what experts call "80%-90% success."

23 Dr. David Alexander is appointed director general of the Habimah theater, and Gari Bilu, artistic director.

November _____

2 Local elections are held throughout the country. Ehud Olmert defeats veteran Mayor Teddy Kollek in Jerusalem; Ronni Milo beats Avigdor Kahalani in Tel-Aviv; Maj. Gen. (res.) Amram Mitzna of Labor is Haifa's new mayor.

4 Israeli television's commercial Second Channel begins operations.

7 Noted yeshiva head Rabbi Hayim Druckman is wounded and his driver is killed by shots fired by terrorists near Hebron. Settlers riot in the wake of the incident.

8 King Juan Carlos of Spain visits Israel.

28 Abie Natan scuttles the Voice of Peace ship for lack of funds to maintain it.

29 The evening daily *Hada-shot* ("News") closes after nearly 10 years of publication.

December _____

Terrorist attacks continue in Israel and the occupied territories. The public is concerned.

5 President Weizman calls for the formation of a national unity government in the wake of the critical situation.

9 The Supreme Court revokes the acquittal of four of the accused teenage rapists in the Kibbutz Shomrat case of 1992 and convicts them.

15 Israel permits approximately 200 of the Islamist deportees to return from southern Lebanon to the West Bank and Gaza.

30 Israel and the Vatican agree to establish diplomatic relations.

The number of immigrants in 1993 is 77,000, of whom 86% arrive from the C.I.S.

The number of terrorist confrontations with I.D.F. soldiers in 1993 is 330, as compared to 172 in 1992.

Inflation in 1993 is 11.2%.

A light moment following the signing of the Declaration of Principles by Israel and the P.L.O. on the White House lawn, Washington, D.C.

△ The historic handshake on the White House lawn, September 13, 1993: Rabin (l.), Arafat (r.), and Clinton. Rabin's reserve does not escape the millions of spectators who follow the ceremony on T.V. The attainment of the Declaration of Principles agreement evokes surprise in the Middle East and throughout the world.

Jews and Palestinians lived in this land in dreams for decades. There were Palestinians who dreamed that the State of Israel would be destroyed, and they would realize the dream of the return to Jaffa and Acre. On the other side, there were Jews who dreamed that it was possible to transfer the Palestinians, or at least continue to rule them... For decades, Jews and Palestinians denied each other's existence and denied the reality in which they lived... Peace is not a dream that has come true. On the contrary. Setting out on the road to peace begins with the awakening from foolish dreams whose essence is the denial of the existence of the other.

Yehoshua Sobol, *Hadashot* ("News"), September 14, 1993

A HISTORIC AGREEMENT BETWEEN ISRAEL AND THE P.L.O.

The year 1993 witnessed one of the most dramatic events in Middle Eastern history. Israel and the P.L.O., enemies for decades, signed a Declaration of Principles which signified the end of fighting and the transfer of most of the Gaza Strip and the Jericho region to Palestinian control.

The agreement was reached in secret talks known to a few persons only, conducted mainly in Oslo, Norway. Simultaneously, bilateral talks between Israel and the P.L.O. proceeded for over a year in Washington, yet they were unproductive. By contrast, substantial progress was made in the secret talks under Norwegian patronage. The talks were initiated by Israel's Deputy Foreign Minister Yossi Beilin, who reported on them to Foreign Minister Shim'on Peres. Prime Minister Itzhak Rabin was informed of the talks at a relatively late stage and gave his approval.

The Oslo Accords, signed on August 20, 1993, came as a great surprise in Israel, in the occupied territories, in the Arab world, and beyond. Most Israelis welcomed the agreement, with the exception of the rightist camp and the settlers of the West Bank and Gaza Strip. Within the Palestinian population, more people approved it than opposed it.

In signing the Declaration of Principles on September 13, 1993, in a ceremony on the White House lawn in Washington, Israel recognized the P.L.O., and the P.L.O. committed itself to peace and to deleting the points in its covenant calling for the elimination of Israel. The climax of the ceremony was a handshake between Prime Minister Itzhak Rabin and Chairman Yasser Arafat, with President Bill Clinton on hand to ensure that nothing went wrong at the last moment.

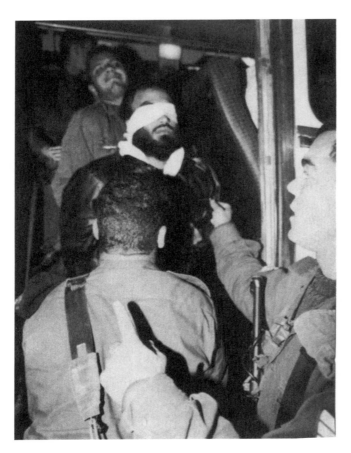

THE HEIGHTENING OF PALESTINIAN TERROR

While Palestinian terror had been applied against Israel for years, especially following the outbreak of the Intifada in late 1987, many Israelis became concerned by its intensification in early 1993. By March, the government and the I.D.F. seemed to be losing control of the security situation. Within a period of weeks, acts of terrorist violence multiplied frighteningly throughout the country, including stabbings on the streets of the main cities. Jews were stoned in the Gaza Strip, while attacks against the I.D.F. in southern Lebanon continued unremittingly. In late March, the government decided to impose a total closure on the West Bank and Gaza in order to separate its inhabitants from the Israeli population. This step calmed the situation from a security point of view but caused problems of a different sort in light of the absence of tens of thousands of Palestinian workers from the territories who filled vital jobs in Israel. The closure was lifted in a few weeks but was reimposed later on when Palestinian terror resumed.

◁ The issue of the Islamist deportees in southern Lebanon occupies public opinion all year long. Shown, a deportee being put on a bus bound for Lebanon.

▽ The Knesset turns into an ongoing wrestling arena between the Labor-Meretz coalition and the rightist opposition. Shown, Foreign Minister Shim'on Peres in one of many confrontations.

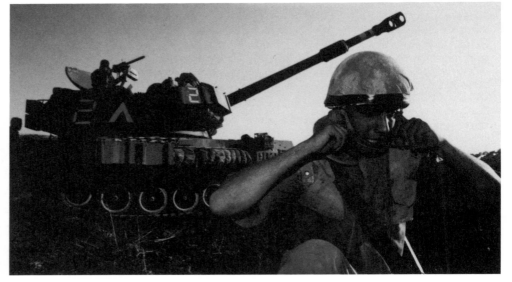

▷ A storm erupts over the designation of Prof. Leibowitz as a recipient of the Israel Prize. Among the dissenters is Prime Minister Rabin. Shown, caricature by Ze'ev. Ultimately, Leibowitz relinquishes the prize.

△ Operation Accountability is mounted by the I.D.F. in southern Lebanon in the summer of 1993. It is a five-day massive artillery response to Hizbollah in the wake of repeated Katyusha missile attacks aimed at the Galilee. A cease-fire is reached through the mediation of the U.S. In a few months, the bombing of the Galilee will resume.

▽ Three T.V. production companies win programming tenders for Israeli television's new commercial Second Channel: Reshet, Keshet, and Tel'ad. Public

Educational T.V. is guaranteed broadcasting time as well. Shown (l. to r.): Chairman of the Second Channel board Yossi Peled, Director of Educational T.V.

Ya'akov. Loverboim, actor Avi Kushnir, Second Channel Director Nahman Shai and actor Moni Moshonov. The channel begins operations in November 1993.

▽ Finding plausible doubt, the Supreme Court on July 29, 1993, acquits John Demjanjuk of crimes against the Jewish people during World War II and orders that he be deported. The deportation takes place on September 21, thus ending a prolonged, highly charged judicial proceeding.

◁ Ashkenazi Chief Rabbi Israel Meir Lau is carried on the shoulders of his supporters upon his election to the post in February 1993.

▷ The "sizzling cassette" affair involving Likud Party Chairman Binyamin Netanyahu creates a public stir in 1993. In a dramatic announcement on T.V., Netanyahu describes an attempt to blackmail him by means of a video portraying a romantic

affair he had, accusing "elements in the Likud" (hinting at David Levy's camp) of perpetrating the blackmail scheme. The affair creates tension in the Likud. Shown, Netanyahu and his wife Sarah in early 1993.

▷ A popular new cultural icon in 1993 is rock singer Aviv Gefen, son of lyricist and journalist Yonatan Gefen. His performances draw thousands of youngsters. The lyrics of his songs are often crude and elicit public protest, for instance, those of the song "We're A Fucked Up Generation."

▽ Hadashot ("News"), an evening daily that began publishing in 1984 closes in November, 1993. The head of the Schocken Group, Amos Schocken, explains the reasons for the closure in a letter to the staff (r.). At l. editor Yoel Esteron appears pensive at the paper's farewell party.

29 בנובמבר 1993

אל: עובדי "חדשות"

מאת: עמוס שוקן

לצערי עלי להודיע לכם על הפסקת הופעתו של "חדשות".

"חדשות" יצא לאור מתוך השאר כי חשבנו שאפשר יהיה לתת לקורא עיתון שונה מ"ידיעות אחרונות" ושונה מ"מעריב", שתהיה לו שפה אחרת ויחס אחר כלפי מי שהוא כותב עליו. חשבנו שאפשר יהיה גם להצליח בכך מבחינה מסחרית, ולחזק את עמדת הקבוצה בתחרות.

"חדשות" הביא אמנם חידושים ושינויים רבים, וגם הכניס לעיתונות היומית אנשים צעירים ומוכשרים. הוא אף יצר לעצמו חוג קוראים נאמן, אבל לא מספיק גדול כדי לקיימו מבחינה כלכלית. הגענו למסקנה שקיומו של "חדשות" מחליש את עמדתנו בתחרות במקום לחזקה.

בעתון יש צוות עובדים מוכשר ובעל יכולת בתחומים רבים אבל לצערי לא הצלחנו לגרום לכך שהשוק ישדיר את הצוות הזה כיכולתו. הנסיון שלנו מראשית השנה להגדיל את העתון לא הביא בסופו של דבר להגדלה משמעותית בתפוצתו אבל גרם להגדלה משמעותית בהוצאות.

איני רואה טעם בתכנית צמצומים חדשה - גם תוכניות כאלה כבר היו לנו די והותר. נראה לי עדיף להציע לעובדים מ"חדשות" להצטרף לעתונים אחרים בקבוצה שמעודרם מבוסס. לפי בדיקה שערכתי נוכל להציע לעובדים לא מעטים מהם המשך תעסוקה כזאת.

הפסקת הופעתו של "חדשות" היא בשבילי צעד כואב. אנשים רבים בעתון עשו מאמץ גדול במשך תקופה ארוכה לקיים את העתון בתנאים לא קלים, ואני אסיר תודה לכולכם.

היום בשעה 12:00 נקיים מפגש עם כל העובדים במלון דן פנורמה ברחוב קויפמן 10 תל-אביב.

שלכם,

הסחיר 1.90 ש"ח (באילת: 1.60 ש"ח) יום שישי 12.12.1993, ט"ז בכסלו ה

January

9 Lecturers at all the universities begin a general strike and demand a doubling of their salary.

Two Jewish 15-year-old boys shoot and kill a taxi driver, Derek Roth, in Herzliya, for no apparent motive. Shock is registered in the public and in the educational system.

13 Chief of the Central Command Maj. Gen. Nehemiah Tamari, his aide-de-camp, and two pilots are killed in a helicopter crash.

February

Stocks in the Tel-Aviv Stock Exchange fall sharply following reports of stock manipulation by bank officials and others. Investors incur heavy losses.

2 The rightist Tzomet party splits. Three of its M.K.s form a new movement, Ye'ud ("Vocation"), with a similar ideology.

6 Minister of Health Hayim Ramon resigns in protest against the government's rejection of the national health law that he has proposed.

7 A Hizbollah ambush in southern Lebanon causes 4 I.D.F. fatalities and 5 wounded.

10-13 A series of violent terrorist acts include the murder of a citrus grower in Rehovot by his Palestinian worker; the murder by Islamic Jihad terrorists of a taxi driver; and the murder of Shabak operative No'am Cohen by a Hamas terrorist in Ramallah.

14 Jewish Agency Chairman Simha Dinitz is indicted for fraud, breach of trust, and other charges.

16 The Jerusalem district court delivers its verdict in the Bankers' Trial (the bank-share manipulation of 1983): 14 senior bank executives are convicted and 2 are acquitted.

25 A settler from Kiryat Arba near Hebron, Dr. Barukh Goldstein, fires indiscriminately at Palestinians praying at the Makhpelah Cave, killing 29 and wounding many others. Shock is registered in Israel. The Arabs of the territories of Israel, and in the Arab world are incensed. Arab riots break out in Jaffa, the Galilee, and the Negev.

The peace talks with the P.L.O. and with Syria are in crisis.

27 The government announces the formation of a commission of inquiry into the massacre at Hebron.

March

4-5 A weekend of unrest in the occupied territories passes in the wake of the massacre in Hebron.

8 The commission of inquiry on the Hebron incident convenes, headed by Supreme Court Chief Justice Meir Shamgar and composed of Supreme Court Justice Eliezer Goldberg, former chief of staff Moshe Levy, District Court Judge Abd al-Rahman Zu'abi, and President of the Open University Prof. Menahem Ya'ari.

17 Prime Minister Rabin has an audience with the Pope in the Vatican.

18 The U.N. Security Council censures the massacre in Hebron. In a separate resolution, it defines East Jerusalem as occupied territory.

23-25 The Rabbi Uzi Meshulam affair begins. A group of religious extremists of Yemenite extraction barricade themselves in a house in the town of Yehud and shoot at anyone who approaches. They demand the establishment of a commission of inquiry into the disappearance of Yemenite Jewish children in the early days of the state.

April

3 The university lecturers' strike ends. Students at several universities refuse to resume studies unless academic requirements for the semester are eased in light of the three-month strike.

6 A booby-trapped car explodes near a bus in Afula, killing 8 passengers and wounding many others. The government decides to implement a prolonged closure of the West Bank and Gaza.

The I.D.F. hands over an installation to Palestinian control in Gaza, marking the start of a gradual evacuation.

11 M.K. Hayim Ramon of Labor announces the formation of an independent ticket under his leadership in the forthcoming Histadrut ("Federation of Labor") elections. The party also includes M.K.s Amir Peretz and Shmuel Avital.

13 A suicide bomber explodes a device in a bus in Hadera, killing 5 passengers and wounding 30.

24 Prime Minister Rabin arrives in Moscow and is received with a full military ceremony.

26 The dollar breaks through the 3-shekel mark.

29 Three rabbis regarded as eminent halakhic authorities in the religious Zionist camp rule that I.D.F. soldiers must disobey orders to evacuate Jews from Hebron should such orders be issued.

1994

May

A new scandal breaks involving suspected phone taps in the offices of the evening newspapers and in various political and economic bodies.

4 Israel and the P.L.O. sign an agreement in Cairo implementing Palestinian self-administration in the Gaza Strip and Jericho. At the last moment, Arafat refuses to initial a series of maps included in the agreement, creating a diplomatic incident. He later consents to sign.

7 Hayim Bar-Lev, former Chief of staff, government minister, and ambassador to Moscow, dies aged 70.

10 The Histadrut elections result in an impressive victory of nearly 50% of votes for Hayim Ramon and his Hayim Hadashim ("New Life") ticket. Labor, headed by Secretary-General Hayim Haberfeld, loses badly.

The police trap and capture Rabbi Uzi Meshulam. His followers surrender the next day after a gunfight. A large store of weapons is discovered in the group's home base in Yehud.

13 Jericho is turned over to Palestinian control.

16 The evacuation of the I.D.F. from the Gaza Strip is completed.

21 An Israeli force in Lebanon kidnaps a leader of the Shi'ite Amal movement, Mustafa Dirani, responsible for handing over Israeli navigator Ron Arad to the Iranians.

The Tel-Aviv Stock Exchange continues to fall.

June

1 The Knesset ratifies the appointment of Dr. Efraim Sneh as minister of health. He begins addressing the problematic situation of the

Is Jaffa burning? Palestinians in Jaffa set fires in the wake of the massacre at the Makhpelah Cave in Hebron perpetrated by Barukh Goldstein.

largest of the country's health funds, Kupat Holim Klalit, which is close to bankruptcy.

2 Israeli planes attack Hizbollah bases in Lebanon. The terrorists respond by firing Katyusha missiles at the Galilee.

4 Maccabi Haifa wins the country's soccer championship. It has won 39 games consecutively.

12 The Lubavitcher Rebbe, Rabbi Menahem Shneerson, dies aged 92. The Hasidic Habad community is in shock. Many refuse to believe that he has died. Some claim he will reappear as the Messiah.

The Israeli-made Arrow missile successfully destroys a surface-to-surface missile.

26 The Shamgar Commission investigating the massacre at the Makhpelah Cave in February publishes its findings: Barukh Goldstein acted alone, and, moreover, his actions could not have been predicted. The commission recommends separating Jewish from Arab worshippers at the cave.

July

1 Chairman of the Palestinian Authority Yasser Arafat arrives in Gaza for his first visit.

5 Hayim Ramon is elected the 11th secretary-general of the Histadrut ("Federation of Labor").

Arafat arrives in Jericho.

M.K. Taufiq Ziad of Hadash is killed in a car crash on his way back from the reception for Arafat in Jericho.

The I.D.F. and the South Lebanon Army (S.L.A.) are attacked repeatedly in southern Lebanon.

7 In two terrorist incidents, the body of a soldier, Aryeh Frankenthal, who had been kidnapped and murdered, is discovered, and a young girl is shot and killed near Kiryat Arba.

12 Arafat, his wife, and high-ranking P.L.O. leaders relocate to Gaza from Tunis.

17 Mass rioting erupts among Palestinian workers at the Erez checkpoint at the entrance to the Gaza Strip as a result of the long waiting time to pass into Israel, necessitated by rigorous searches for terrorists. Two Palestinians are killed and some 100 are

wounded; one Israeli is killed and some 20 are wounded; 150 buses are torched. Israeli and Palestinian forces exchange fire.

25 A summit meeting at the White House in Washington is attended by President Clinton, Prime Minister Rabin, and King Hussein of Jordan. The state of belligerency between Israel and Jordan is ended.

26 A booby-trapped car explodes near the Israel embassy in London, wounding 13 persons. All Israeli embassies are placed on alert.

August

3 King Hussein flies over Israel escorted by three Israel Air Force fighter planes in an aerial salute.

5 A barrage of some 20 Katyusha missiles lands in the Western Galilee, resulting in three persons wounded and heavy damage.

8 The first border-crossing point between Israel and Jordan is inaugurated in the Arava region north of Eilat.

14 Ron Sobel, 18, is killed and 7 other Israelis are wounded in a terrorist attack at the Kisufim junction near the Gaza Strip.

16 The government and the Bank of Israel announce that stock market profits will be taxed. The move elicits harsh criticism for its timing, with the market at a low point.

18 Prof. Yesha'yahu Leibowitz, one of the country's most eminent thinkers, dies aged 91.

24 An agreement is signed in Cairo handing over authority for health, education, culture, as well as other areas to the Palestinians in the West Bank and Gaza.

26 Hamas terrorists employed at a construction site in Ramleh without a work permit murder two young Israeli coworkers.

September

Terrorist incidents in southern Lebanon continue.

10-20 Golan settlement leaders hold a hunger strike in Gamla to protest the government's intention to return the Golan to Syria if a peace treaty is concluded with that country.

29 Prime Minister Rabin and King Hussein of Jordan meet in the king's palace in Aqaba to discuss security, border, and water issues. Present are Chief of Staff Ehud Barak, Jordanian Prime Minister Abd al-Salam al-Majali, and high-ranking governmental figures from both sides.

30 Miss Israel, Lilakh Ben-Simon of Ashdod, is crowned Miss Europe, 1994.

October

9 Two Palestinian terrorists shoot at pedestrians indiscriminately in the Nahlat Shiv'ah quarter in Jerusalem, killing two – a woman soldier

Rabin talks to King Hussein by phone while the Jordanian leader flies over Israel in August 1994.

and an Arab resident of East Jerusalem – and wounding 12. Israeli forces kill the two terrorists and capture a third.

A soldier, Nahshon Wachsman, is kidnapped by Hamas terrorists and held as a hostage. A video is received in Israel on October 11 demanding the release of terrorist leaders held by Israel. The deadline given is October 14 at 9 p.m.

14 An attempt to rescue Nahshon Wachsman, who is held in a village near Ramallah, fails. The kidnappers kill him at the start of a gunfight, during which an Israeli commando officer, Nir Poraz, is also killed.

14 A disaster occurs in Tel-Aviv when a suicide bomber blows himself up on a No. 5 Dan bus near Dizengoff Square, causing 24 fatalities and the wounding of dozens of other persons.

26 The Israeli-Jordanian peace agreement is signed in

a ceremony at Ein-Evrona along the border north of Eilat in the presence of U.S. President Bill Clinton.

27-28 President and Mrs. Clinton visit in Israel.

29 A Hizbollah force attacks and penetrates an I.D.F. fortification in southern Lebanon, killing one Israeli soldier and wounding two.

November

3 Turkish Prime Minister Tansu Ciller visits Israel.

7 The Makhpelah Cave reopens to worshippers for the first time since the massacre in late February. Security arrangements are extensive.

10 King Hussein pays his first public visit to Israel.

11 An attack by an Islamic Jihad suicide bomber at the Netzarim junction in the Gaza Strip results in the death of three reserve officers.

27 The rabbi of the settlement of Otniel, Amram Olami, is killed in his car in a drive-by shooting by terrorists.

The weather during November is unusually rainy and stormy.

December

10 The Nobel Peace Prizes for 1994 are awarded in Oslo to Prime Minister Rabin, Chairman Arafat, and Foreign Minister Peres.

11 Israel and Jordan open embassies in Amman and Tel-Aviv, respectively.

14 An I.D.F. reserve soldier loses his way in Ramallah, becomes entangled in a Palestinian street parade, and narrowly escapes being lynched. The fact that he avoided using his weapon elicits mixed reactions in Israel.

19-23 A series of terrorist incidents in southern Lebanon claim the lives of 4 I.D.F. soldiers, with 11 wounded.

25 A suicide bomber blows himself up alongside a bus carrying Israeli soldiers in Jerusalem, resulting in 13 wounded.

Over 80,000 immigrants arrive in Israel in 1994, mostly from the C.I.S.

Inflation in 1994 is higher than during the preceding two years: 14.5%.

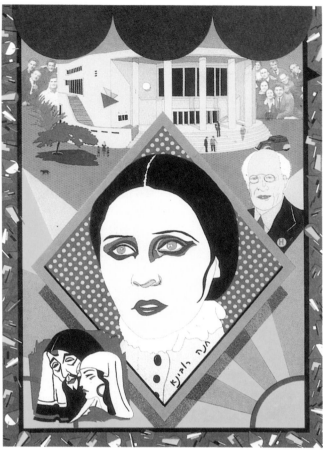

△ Actress Hanna Rovina, the grande dame of
Israeli theater, dies in 1980 aged 91. Artist
David Tartakover memorializes her uniquely.

△ Israel's 40th anniversary is celebrated in
1988 in the tumultuous atmosphere of im-
pending elections and the ongoing Intifada.

▽ Knesset debates reach every home with the introduction of television coverage.

△ The Operation Peace for Galilee (the Lebanon War) insignia.

◁ Chief of Staff Rafael Eitan ("Raful") (l.) views the remains of the Israeli administration building in Tyre, November 1982, following an explosion caused by a gas leak.

▽ Israeli soldiers in the Lebanese snow. The I.D.F. is deployed in Lebanon for three years (June 1982– June 1985).

▷ An arena for confrontation between ultra-Orthodox and secular Israelis: outdoor advertising. When the ultra-Orthodox consider it inappropiate, they paint it out or deface it. The scrawled message reads: "An end to abominations! Shame!"

▽ An arena for confrontation between Jews and Arabs: the Makhpelah Cave in Hebron.

Protest in Israel increasingly moves into the streets. Positions become more entrenched and slogans more extreme. Above: "Leftists – Traitors!" and "Peace Now is a Knife in the Back." Below: "Occupation Corrupts!" and "Bring the Soldiers Home."

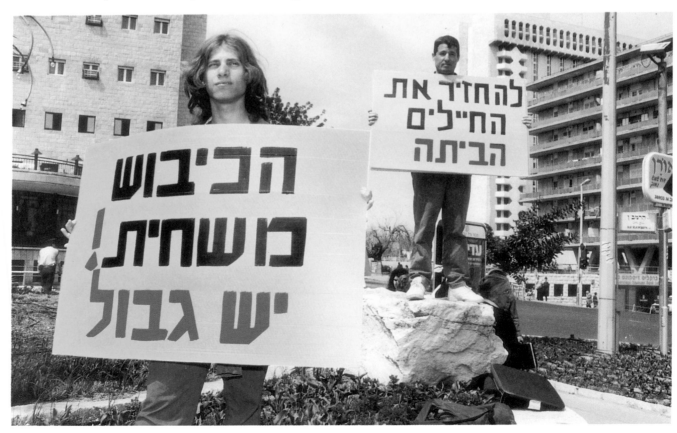

▷ The police are required to devote more and more resources to crowd control in the demonstrations that proliferate during the 1980s and '90s, sometimes performing their task with a heavy hand. The young religious demonstrator seems to be asking: "What did I do? What do you want from me?"

▽ Demonstrations by the ultra-Orthodox, primarily in Jerusalem, become increasingly massive. Among other things, they protest the violation of the Sabbath, the establishment of secular institutions near ultra-Orthodox neighborhoods, and archeological excavations.

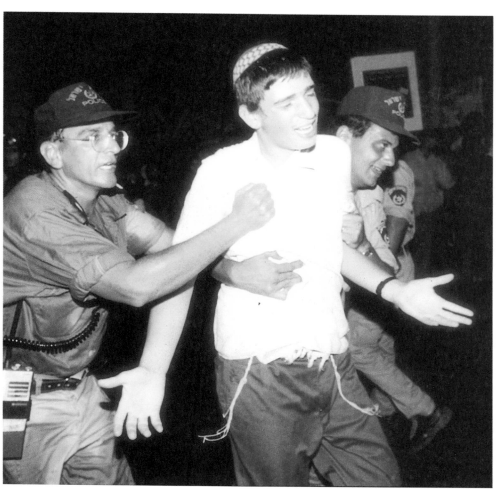

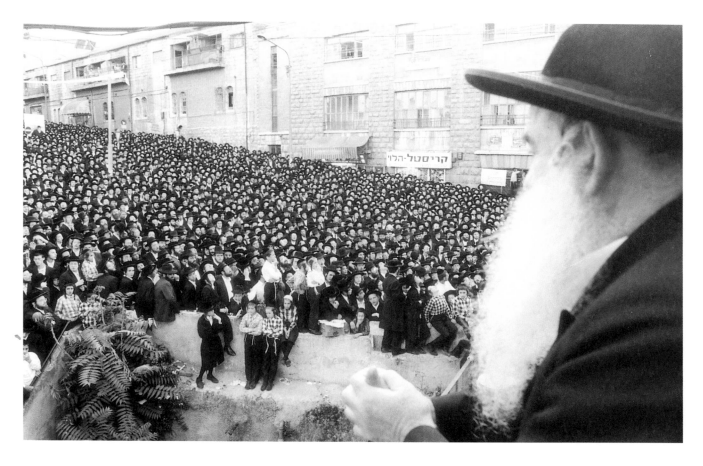

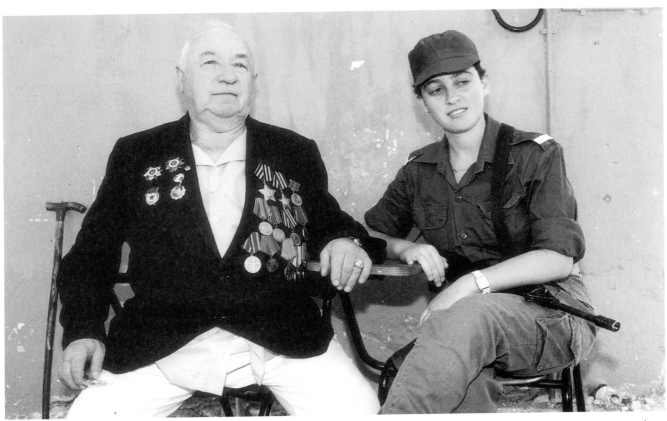

Sights from the 1950s seem to be reappearing 40 years later with the inflow of thousands, and later tens of thousands, of immigrants monthly from early 1990 onward, most of them from the Soviet Union. As in the earlier period, the I.D.F. plays an active role in absorbing the new-comers. Above: a soldier poses with a bemedaled immigrant, September 1990, in the Tzrifin army base, which houses thousands of new immigrants. Below: a trailer camp in the Negev town of Sderot – a modern version of the ma'abara (old-time immigrant transit camp).

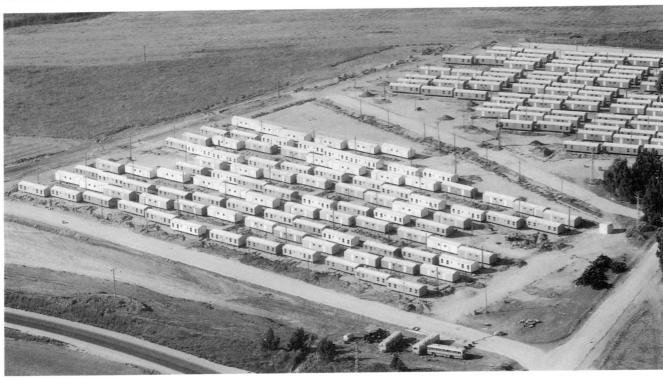

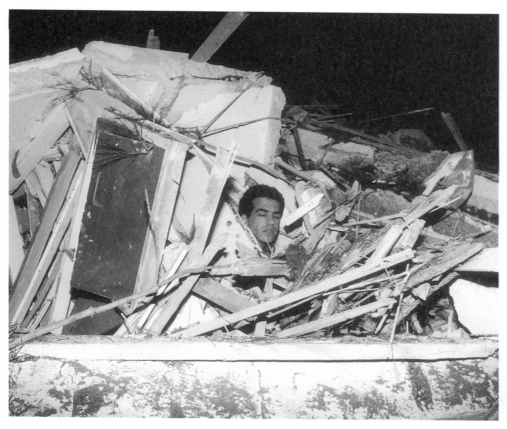

◁ Moments after a Scud missile hits the prosperous suburb of Savyon outside Tel–Aviv, before the arrival of rescue units.

▽ American Patriot anti-missile missiles are launched to intercept Iraqi Scud missiles over Tel-Aviv, February 1991. The effective-ness of the Patriots is to prove minimal.

◁ Communication satellite dishes are set up rapidly, bringing the war to the whole world. Israelis learn close up about the capability and efficiency of the American C.N.N. news network.

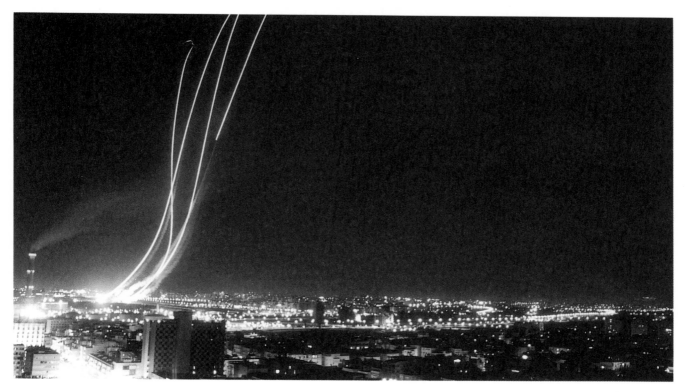

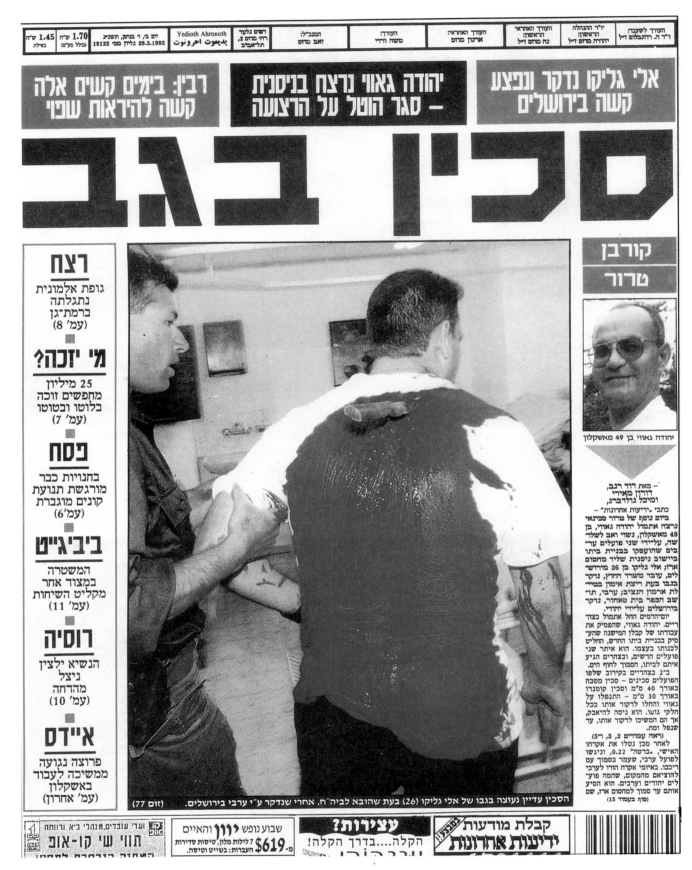

Stabbings by Palestinian terrorists increase in the spring of 1993. The front page of
Yedi'ot Aharonot ("Latest News") on March 29: "A Knife in the Back."

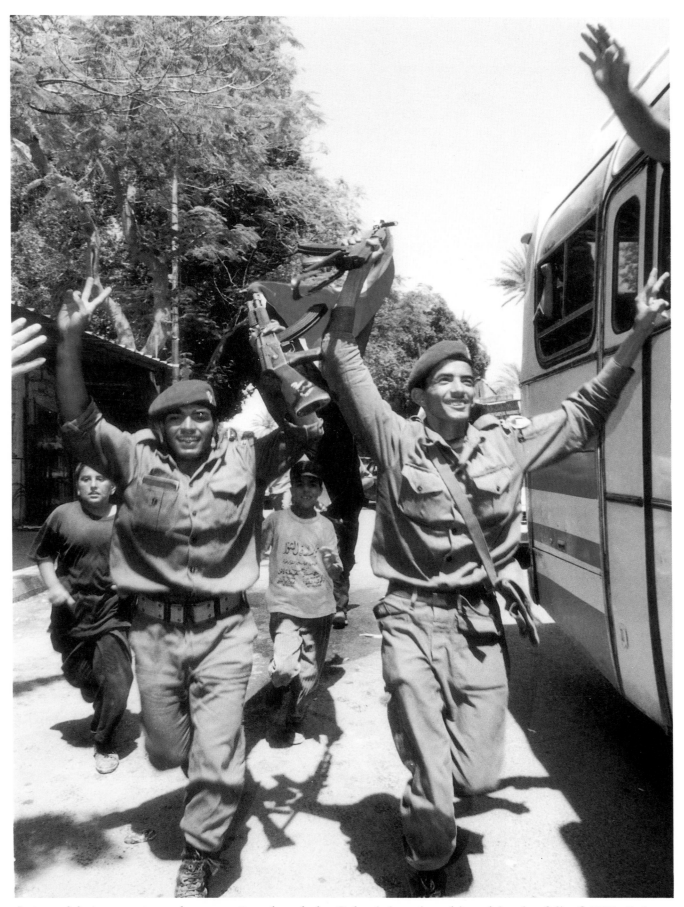

A surprising agreement between Israel and the Palestinians is achieved in the fall of 1993. It is to be first implemented with the evacuation of the I.D.F. from most of the Gaza Strip and the Jericho area. Gaza celebrates the evacuation in 1994, while the Israelis, too, have few regrets.

THE FLOODS OF 1992

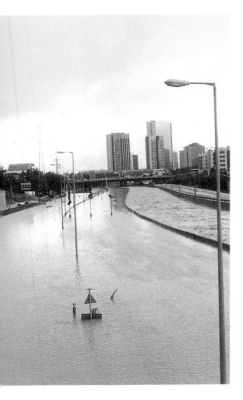

△ The Ayalon highway network, the country's most modern urban traffic system, floods repeatedly during the heavy rains of 1992.

▷ Rivers rise and flooding hampers transportation during the rainy winter of 1992. The Yarkon, a river that has nearly dried out, overflows its banks several times, as shown in this view of the outskirts of Tel-Aviv.

POLITICIANS, OLD AND NEW

▷ Prime Minister Rabin, elected in 1992, pushes hard during 1993-94 to attain agreements with the Palestinians, Jordan, and Syria, frequently facing protests against his position. The placards read: "Rabin has no Mandate for Concessions on the Golan."

▽ Chief of Staff Ehud Barak – shown on a tour of the Gaza Strip toward the end of his term of office – retires from the army at the end of 1994 and enters political life.

△ A view of peace by an Israeli child from Tiv'on, from an exhibition of children's drawings on the theme of peace at the Jewish–Arab Institute in Bet–Berl College, Kfar Saba.

▽ King Hussein and Foreign Minister Peres minutes before the signing of the Israeli–Jordanian peace agreement in the Arava, October, 1994. Looking on are Prime Minister Rabin and Jordan's Queen Noor.

Pages 574–575:
**Itzhak Rabin Square
(formerly Kings of
Israel Square), Tel-
Aviv, November,
1995. Young people
mourn the murder
of Prime Minister
Rabin.**

◁ **Operation Shlomo
in 1991 constitutes a
unique chapter in
the annals of immi-
gration to Israel in
the 1990s. Some
14,000 Jews from
Ethiopia are airlifted
to Israel within 36
hours. In one case,
over 1,000 are flown
in a single jumbo
plane.**

▽ **Israel in the mid-
1990s: Morning traf-
fic jams the Tel-Aviv
region highways.**

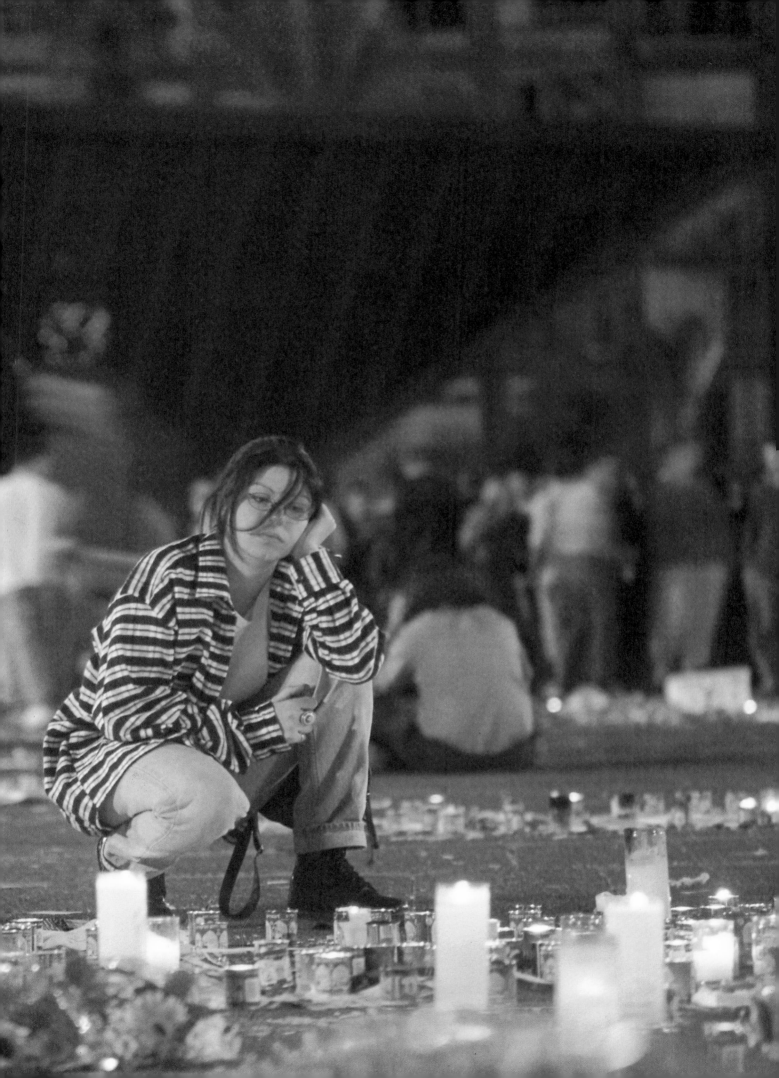

Rear window messages: Israelis increasingly express their views through stickers fixed on the rear windows of their cars. Until the assassination of Prime Minister Rabin, many stickers conveyed attacks on, and even vilification of, the Labor government and its leader. Thereafter, most of the abusive stickers are scraped off, and "Shalom, haver" (Goodbye, friend) – taken from President Bill Clinton's moving eulogy – appear on thousands of cars. Later, stickers of all kinds reappear.

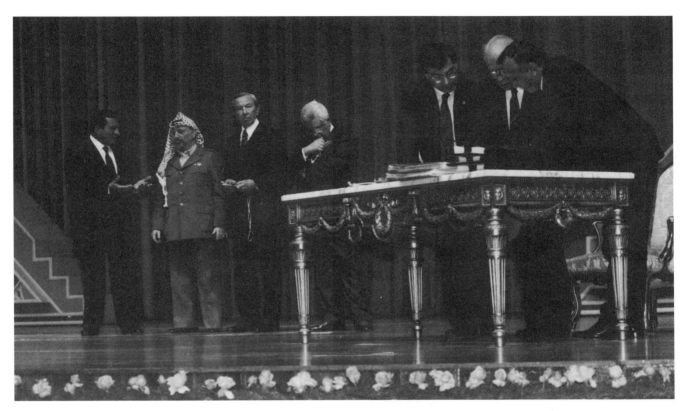

△ Drama in Cairo. Dignitaries
▷ who assemble in Cairo on May 4, 1994, for the signing of the Gaza-Jericho agreement, including U.S. Secretary of State Christopher (3rd. from l.), Egyptian President Mubarak (far l.), Prime Minister Rabin (c. behind the table), and Foreign Minister Peres, are discomfitted when P.L.O. Chairman Arafat (2nd. from l.), at first refuses to sign. Right, from l. to r.: Peres, Arafat, Rabin.

△ M.K. Hayim Ramon (r.) sets out to wrest control of the Histadrut ("Federation of Labor") from the Labor Party against all odds, together with M.K.s Amir Peretz (shown with him) and Shmuel Avital. He wins by a large margin in the Histadrut elections on May 10, 1994, and becomes its secretary-general.

▷ The Lubavitcher Rebbe, Rabbi Menahem Mendel Shneerson, who heads the Hasidic Habad movement, dies in his home in Brooklyn, N.Y., on June 12, 1994. Shown, an exact replica of his house, built in Kfar Habad in Israel.

△ A shocking tragedy takes place in central Tel-Aviv near Dizengoff Square when a suicide bomber blows himself up on a bus filled with passengers on the Dan No. 5 line, climaxing attempts by Palestinian opponents of the agreement with Israel to hinder the peace process. The explosion kills 24 passengers, and dozens of persons are wounded. The attack places the government, which is in the process of concluding a peace agreement with the P.L.O. in a difficult position. Arafat condemns the act and promises to take steps to halt Palestinian terror.

△ A burning tire in East Jerusalem in 1994. Although the Intifada has died down following the attainment of an agreement between Israel and the P.L.O., rioting and violent demonstrations erupt intermittently.

▷ Despite ongoing improvement in Israel's economic situation, symptoms of deprivation are observable, for example the problem of the homeless, especially in Tel-Aviv, an issue that gains attention in 1994.

GAZA – THE FINALE

Twenty-seven years after the I.D.F. had first entered the Gaza Strip in June 1967, it evacuated the region, turning over control of most of it to the Palestinian Authority in June 1994 as part of the Israeli-Palestinian agreement of September 1993. Few Israelis regretted this move. Since the outbreak of the Intifada in late 1987, and even before, Israeli rule in Gaza had constituted a heavy burden, involving violent confrontations, stone-throwing and shootings at I.D.F. soldiers. On the very last day of Israeli rule, stones were thrown at Israeli soldiers, although there were calmer farewell encounters as well. The I.D.F. evacuated the city of Gaza and most of the strip with the exception of the territory where Jewish settlements had been established. Procedures were worked out between Israel and the Palestinian Authority for maintaining order and solving problems, which proliferated during the first few months.

Arafat was greeted with enthusiasum in Gaza, but Hamas and Islamic Jihad extremists rejected his conciliatory line and continued their terrorist attacks on Israel.

▽ An Israeli soldier says farewell to a group of Palestinians in Gaza. Not all the partings are amiable, and violent confrontations take place even on the last day of Israeli rule.

△ The house near Ramallah where kidnapped Israeli soldier Nahshon Wachsman is murdered in October 1994. Terror by radical Palestinians increases during the course of the year.

A DISAPPOINTING YEAR FOR STOCK MARKET INVESTORS

While the early 1990s were good years for investors in the Tel-Aviv Stock Exchange, showing high returns, the trend reversed itself in 1994. Various factors were at play: the peace process, which had acted as a market stimulus in 1993, became bogged down in early 1994; the extent of the manipulation of stocks by interested parties, especially bankers, surfaced, and several bank executives were arrested; and the rise of the leading-securities index to a record of nearly 259 points in February 1994 appeared to the experts to be inflated. When the governor of the Bank of Israel, Prof. Ya'akov Frankel, termed the stock market a "bubble," the inevitable burst followed.

The rupture caused considerable fallout. The market plunged by several dozen percentiles, with the leading-securities index sinking to a low of 148 points (a drop of approximately 75% as compared to the start of the year). Reviving thereafter, it became unstable, standing at 175 points at the end of the year. Tens of thousands of small investors, who in the halcyon days were offered generous loans from the banks to acquire stocks, found themselves deeply in debt.

Side by side with the instability of the stock market, however, the economy registered growth of 7%, unemployment went down steadily, and the standard of living rose by an estimated 10%. With this, a worrisome rise in the trade deficit was recorded, while inflation, which the government had promised would drop to single figures, climbed to 14.5%.

△ Worried expressions at the stock market, summer 1994. Israeli investors are sorely disappointed by the performance of the Tel-Aviv Stock Market in 1994, which falls almost steadily, in contrast to the preceding years, which have been profitable. Most small investors decide to get out of the market.

▽ The house in Yehud where Rabbi Uzi Meshulam and his followers barricade themselves, threatening to blow themselves up and attack anyone who approaches. Meshulam, captured eventually by the police, demands an investigation into the disappearance of children from Yemen in the early years of the state. Thereafter, the government establishes a commission of inquiry on the issue.

THE PEACE AGREEMENT WITH JORDAN

Israeli leaders had carried on clandestine talks with Jordan's King Hussein for decades, although he would not agree to open talks. A turning point came in 1994 when Prime Minister Itzhak Rabin and Foreign Minister Shim'on Peres informed the king that once an agreement was signed with the P.L.O., Jordan might find itself "out of the game." Hussein consulted with Egyptian President Mubarak, who encouraged him to enter into peace talks, and with Syrian President Hafiz al-Asad, who, surprisingly, also advised him to talk with the Israelis, although not to sign a peace treaty.

The Clinton Administration, in need of a political achievement in the Middle East, pressed the king to get on the peace bandwagon, promising, among other things, to write off Jordan's growing debt to the U.S. Talks between Israel and Jordan were begun during the summer of 1994 and were soon made public. The main sticking point was a border area of some 400 sq. km. in the Arava region, which the Jordanians claimed had been illegally annexed by Israel over the years. Jordan agreed to lease the territory to Israel in exchange for a commitment by Israel to provide Jordan with millions of cubic meters of water from the northern Jordan Valley.

The signing of the Israeli-Jordanian peace agreement was held on October 26, 1994, at the new border crossing north of Eilat, with U.S. President Bill Clinton the guest of honor. Prime Ministers Rabin and Majali signed the agreement. King Hussein, Israeli President Weizman, Foreign Minister Peres, and Clinton shook hands all around. The ceremony ended with the release of thousands of balloons into the sky.

Israeli public opinion was overwhelmingly favorable toward the agreement. Egypt gave its blessing to it, while Syria ignored it. The Hizbollah terrorists in southern Lebanon expressed their opinion by shelling the Upper Galilee panhandle 20 minutes prior to the signing of the treaty. Israeli residents there, rushing to their shelters, took along portable T.V.s so that they wouldn't miss the peace ceremony.

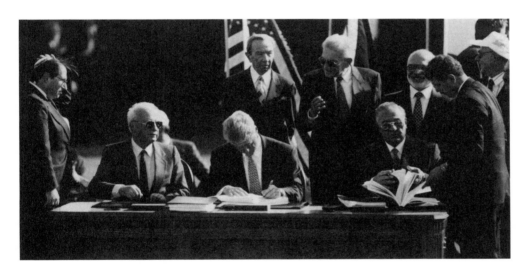

◁ The signing of the Israeli-Jordanian peace agreement, October 1994. Seated, l. to r.: Prime Minister Rabin, President Clinton, and Jordanian Prime Minister Majali. Standing behind them: Secretary of State Christopher, Israeli President Weizman, and King Hussein.

▽ Waiting for the ceremony to begin: Rabin (l.), Hussein, and the empty chair for Clinton.

△ President Clinton (l.) and Prime Minister Rabin in discussion during Clinton's visit in Israel following the signing of the peace agreement with Jordan.

1995

January

1 Lieut. Gen. Amnon Lipkin-Shahak replaces outgoing Chief of Staff Ehud Barak.

A tax on stock market profits is announced, evoking widespread criticism.

6 A Palestinian terrorist kills a young woman, Ofra Feliks, on the road to Elon Moreh in the West Bank.

8 The government decides to establish a commission of inquiry into recurring charges that children from Yemen disappeared under mysterious circumstances in the early years of the state.

19 Rabin and Arafat meet for talks. Israel commits itself to freezing construction in the occupied territories.

22 Two shocking suicide-bomber incidents at the Bet-Lid junction near Netanya result in the death of 21 Israelis, most of them soldiers.

30 Prime Minister Rabin annuls the stock market tax, overriding the opinion of the minister of finance. The market soars.

February

Terrorist incidents by Hamas and the Islamic Jihad continue, as do attacks in Lebanon.

2 A four-way summit takes place in Cairo between Rabin, Hussein, Mubarak, and Arafat to discuss implementation of the Israeli-Palestinian agreement.

13 The Palestinians promise, in talks in Washington, to fight terror in their midst.

27 The Tel-Aviv Stock Exchange sinks again, reaching a low of 146.8 points.

March

5 U.S. Secretary of State Warren Christopher shuttles between Jerusalem and Damascus to advance the peace talks between Israel and Syria.

19 Terrorists shoot at an Israeli bus near Hebron, killing two passengers.

31 The Mapam daily *Al Hamishmar* ("On Guard") closes after 52 years of publication.

April

5 The Israeli Ofek 3 research satellite is launched successfully.

9 Two explosions of booby-trapped cars near Kfar Darom in the Gaza Strip result in the death of 6 I.D.F. soldiers.

16 Israeli forces kill 3 Hamas terrorists in Hebron who murdered 8 Israelis.

18 Remarks by Foreign Minister Peres referring to an Israeli withdrawal from the Golan Heights up to the international boundary arouse indignation in the public.

26 An announcement by Prime Minister Rabin about the impending evacuation by the I.D.F. of three bases in the West Bank evokes criticism.

May

8 A crisis develops in relations between Israel and the Arab states in the wake of an announcement by Israeli authorities regarding land expropriation in East Jerusalem.

11 Poet David Avidan dies aged 60.

14 The government announces that no more land will be expropriated in East Jerusalem.

20 Former chief of staff Ehud Barak announces his decision to enter political life.

22 A political storm erupts following a motion for a vote of no-confidence in the government proposed by the Arab parties over the issue of land expropriation in Jerusalem. The Likud supports the motion.

An I.D.F. soldier opens fire in a church in Jaffa, engendering rioting by Arabs in the city.

Demonstrations are mounted by settlers in the Golan Heights against government plans for withdrawal from the region.

June

The I.D.F. begins redeploying in the West Bank. The Right and the settlers in the West Bank are agitated.

15 Katyusha missiles fired at the Galilee wound 8 inhabitants.

18 M.K. David Levy leaves the Likud party after confrontations with party leader Binyamin Netanyahu and begins to organize a new political party.

Prime Minister Rabin denies the existence of plans to uproot settlements in the occupied territories.

22 An Israeli cargo ship, Mineral Dempier, sinks in the China Sea. Nine of the 27 missing crew members are Israelis.

23 Katyusha missiles are fired at the north of the country, killing one resident and wounding 9.

A wave of bank holdups takes place in Tel-Aviv and elsewhere in the country during the month.

July

2 A massive forest fire breaks out in the Jerusalem Corridor, causing extensive damage.

3 Incidents occur one after another in southern Lebanon, taking a toll of two I.D.F. fatalities.

6 I.D.F. soldiers serving in the Hesder program (combined military service and yeshiva study) request their rabbis to rule on the proper response to orders that negate their principles. The I.D.F. fears disobedience by religious soldiers regarding orders to evacuate army bases in the occupied territories.

10 The Council of Settlements in the West Bank and Gaza threatens to declare a civil rebellion.

12 Fifteen rabbis rule that any order to evacuate I.D.F. bases in Judea and Samaria must be disobeyed. Reactions in the country are turbulent.

15 The Israeli-Syrian talks in Washington are at a crisis.

16 Deputy Defense Minister Mordechai Gur takes his own life by gunshot after a prolonged battle with cancer.

18 Two new ministers join the government: Ehud Barak (interior) and Yossi Beilin (economy and planning).

A tragedy occurs at the annual pop music festival in Arad when a crowd of tens of thousands trample three teenagers to death, with over 100 others injured.

Two hikers are murdered in Wadi Kelt east of Jerusalem. The perpetrators flee to Jericho. Arafat orders their arrest and trial.

24 A suicide bomber blows himself up on a bus in Ramat Gan, causing the death of 5 passengers and a large number of wounded. A closure is imposed on the occupied territories. Thousands of Israelis demonstrate at the site of the incident. Prime Minister Rabin and Chief of Staff Lipkin-Shahak, who arrive at the site, are derided by the crowd.

August

6 A headline in the daily *Ma'ariv* ("Evening Paper") reads: "Security Around Rabin is Heightened. The Shabak Fears an Assassination Attempt by Radical Jews."

10 Two I.D.F. pilots are killed in a plane crash caused by the blockage of the engine by birds.

11 The Israeli-Palestinian Oslo 2 accords are initialed. Arafat commits himself to altering the Palestinian Charter, which calls for the destruction of Israel.

13 The new president of the Supreme Court is Justice Aharon Barak, who replaces retiring Justice Meir Shamgar.

21 A suicide bomber blows himself up in a bus in Jerusalem which damages a second bus as well. Five passengers are killed and over 100 are wounded. Agitated anti-government demonstrations are held in Jerusalem and elsewhere throughout the country.

29 Government ministers receive threats by right-wing extremists. Likud Chairman Binyamin Netanyahu denounces them.

September

Regional radio stations begin operating throughout the country.

1 Schools fail to open as scheduled in protest against inadequate anti-terror security measures. They open the following day.

4 The trimillennial celebration year for the city of Jerusalem begins. The U.S. ambassador is absent from the ceremony.

5 A terrorist murders a settler in Ma'aleh Mikhmash in the West Bank and seriously wounds his pregnant wife.

19 A steward hijacks a plane in Iran and lands it at the Uvdah airport north of Eilat. Israel returns the plane and the passengers to Iran and detains the steward for trial in Israel.

27 Israeli composer Alexander (Sasha) Argov dies at age 81.

28 The Israeli-Palestinian Oslo 2 accord is signed in Washington after a series of delays and crises. Among other things, the I.D.F. will withdraw from the major cities of the West Bank, and 1,200 Palestinian prisoners will be freed. The Right holds turbulent demonstrations protesting the accord as "traitorous." Rabin is excoriated in print, orally, and at rallies where he appears.

October

5 The Knesset ratifies the Oslo 2 accord by a narrow majority.

Rightist demonstrators attack Prime Minister Rabin's and Housing Minister Binyamin Ben-Eliezer's cars.

10 A new phase of the I.D.F. evacuation from the West Bank begins. The first point to be evacuated is the town of Salfit.

11 The Shabak is reported to have heightened security for government ministers and senior officials in light of threats of violence.

12 An ambush by Hizbollah of a Golani Brigade convoy in southern Lebanon results in 3 soldiers killed and 6 wounded. An ambush on October 15 kills 6 more soldiers from the same battalion.

22 The Israeli and Jordanian air forces hold a joint "peace flypast."

24 The U.S. Congress votes by a large majority to transfer the U.S. embassy in Israel to Jerusalem. The U.S. Administration is opposed. A compromise is worked out whereby the transfer is deferred to 1999.

25 The leader of the Islamic Jihad, Fathi Shkaki, is shot and killed in Malta. Foreign sources claim he was eliminated by the Mosad.

November

4 Prime Minister Itzhak Rabin is murdered by Yigal Amir, a radical rightist, while leaving a mass rally at Kings of Israel Square in Tel-Aviv. The country is in shock.

6 The funeral of Itzhak Rabin is held at Mt. Herzl, Jerusalem, in the presence of world dignitaries, including U.S. President Bill Clinton, King Hussein of Jordan, Egyptian President Mubarak, Prime Minister Major of Great Britain, and Chancellor Kohl of Germany.

8 The government decides to establish a commission of inquiry into the circumstances of the assassination, headed by former Chief Justice of the Supreme Court Meir Shamgar. The public is shocked by the security oversights that facilitated the act.

9 One of the many condolence visitors who arrive at the Rabin home in Tel-Aviv is Yasser Arafat.

12 A massive memorial rally is held at Kings of Israel Square in Tel-Aviv, which is to be renamed Itzhak Rabin Square. The police detain several persons suspected of aiding the assassin, including his brother, Hagai Amir. Secretary-General of the Histadrut ("Federation of Labor") Hayim Ramon returns to the Labor Party.

15 President Weizman assigns Shim'on Peres the task of forming a new government.

19 The Shamgar Commission begins its investigation of the circumstances of the assassination. The public is shocked to learn that the head of the radical rightist Eyal organization, Avishai Raviv, is a Shabak undercover agent.

22 The government formed by Peres is approved by the Knesset. Peres is prime minister and defense minister; Ehud Barak – foreign affairs; Hayim Ramon – interior; Moshe Shahal – internal security; Rabbi Yehuda Amital – minister without portfolio. The rest of the previous cabinet remains as it was.

An earthquake in Israel and neighboring countries measures 6.2 on the Richter scale, causing large-scale damage in Eilat.

26 Two rabbis are questioned on suspicion of granting religious sanction to the murder of Rabin.

28 An intensive Katyusha missile barrage targets the north of the country, wounding dozens of residents.

An I.D.F. evacuation from additional cities in the West Bank – starting with Jenin – begins toward the end of the month.

December

Strict security measures are adopted during the month to guard Prime Minister Shim'on Peres.

The Americans apply pressure on Israel and Syria at the start of the month to begin serious peace talks.

1 Peres states: "Israel must pay Syria the full price for a full peace."

7 M.K. David Magen of the Likud announces that he is shifting to David Levy's new list.

10 The I.D.F. evacuates from Tul Karm.

11 The I.D.F. evacuates from Nablus in haste a day before schedule in an atmosphere of tension and public hostility.

19 The trial of Rabin's assassin, Yigal Amir, begins in the Tel-Aviv district court. The judge reads out the charges while the suspect smiles. The trial is scheduled to resume on January 1, 1996.

A video of the assassination filmed by an amateur photographer, Roni Kempler, is broadcast on T.V. The public is shocked by the ease of access that the murderer had and by the security gaps.

21 The I.D.F. evacuates from Bethlehem.

The representive rate of the dollar to the shekel climbs rapidly. It reaches 3.17 shekels during approximately one month, a rise of 5%.

24 The Uman knitwear plant in Ofakim closes and its 230 workers are dismissed. The town is in an uproar.

27 High-ranking Israeli and Syrian delegates begin peace talks in the U.S.

29-30 Two Katyusha barrages targeting Kiryat Shmona cause heavy damage.

Some 77,000 immigrants arrive in Israel in 1995, 85% of them from the C.I.S. countries.

Inflation in 1995 is the lowest in 26 years: 8.1%.

Shim'on Peres and Lea Rabin at Itzhak Rabin's funeral at Mt. Herzl.

▽ Itzhak Rabin – the last year. The year 1995 is crowded with events in which Rabin plays an active role. Shown, the inauguration of an overpass at the Kfar Shmaryahu junction, dubbed until then the "bottleneck of the state." Later, it becomes known that Amir attempted to assassinate Rabin at this ceremony.

▷ Difficult tasks are addressed as well during the first 10 months of 1995. Here, Rabin views the site of two suicide bombings at the Bet-Lid junction shortly after they are perpetrated on January 22, 1995, in which 21 Israelis – most of them soldiers – are killed.

▽ The signing of the Oslo 2 accord prompts protest demonstrations in Israel. Shown, demonstrations in Hebron depicting Rabin and Arafat as "blood brothers" and accusing Rabin of "crimes against the Jewish people."

OSLO 2

Two years after the signing of the Israeli-P.L.O. Declaration of Principles (the Oslo Accords), a second agreement was concluded widening out Palestinian control in the West Bank – Oslo 2. It provided for the transfer of some 2,000 sq. km. of territory to the Palestinians, with the retention by Israel of some 3,900 sq. km.

Negotiations were prolonged and interrupted by crises. The signing of the agreement, deferred repeatedly, took place at last on September 28, 1995, at the White House in Washington. Rabin declared at that time: "We are not withdrawing. We are conceding for the sake of peace." The Israeli public in the immediate aftermath of the agreement was divided, with only a small majority supporting it: 51% to 47%. The Right and the settlers protested vehemently, staging demonstrations that featured vociferous attacks against the government, against Peres, and especially against Rabin.

By the end of the year, the I.D.F., in adherence to the agreement, had evacuated from all the large Palestinian cities (Area A) except for Hebron, with only minor incidents. Thousand of Palestinian prisoners were released. The withdrawal from Area B – Palestinian towns, villages, and refugee camps – was to be completed in the spring of 1996. Area C – the settlements, I.D.F. bases, and the Jordan Valley – was to remain in Israeli hands.

◁ Rabin's last appearance at the U.N., at the commemoration of the organization's 50th anniversary.

▽ On the way to Oslo 2: (l. to r.) Hussein, Rabin, Clinton, Arafat, and Mubarak.

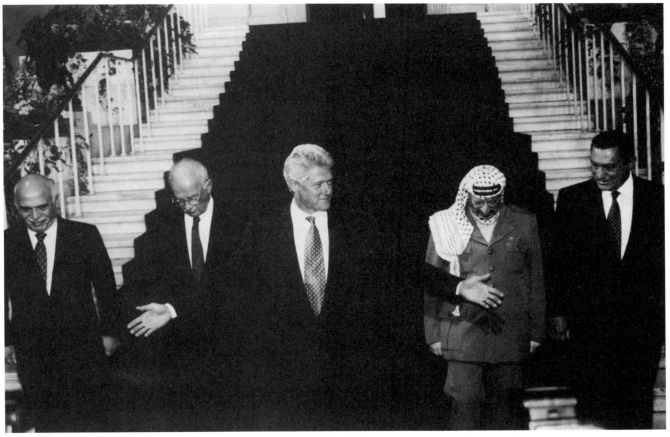

△ A new chief of staff takes office on January 1, 1995: Lieut. Gen. Amnon Lipkin-Shahak.

△ M.K. David Levy announces his exit from the Likud party in mid-1995 at a tumultuous meeting of his supporters.

▽ The police periodically raid illegally established gambling casinos that proliferate in Israel in 1995.

△ The two major newspapers in the country, *Yedi'ot Aharonot* ("Latest News") and *Ma'ariv* ("Evening Paper"), report in detail on problems experienced by the other paper, especially on the questioning of both editors in chief by the police in connection with illegal wiretapping. Chairman of the Board of *Ma'ariv* Ofer Nimrodi is shown arriving at police headquarters for questioning.

▷ *Yedi'ot Aharonot* Editor in Chief Moshe Vardi on his way to questioning by the police.

△ The new chairman of the Jewish Agency and the World Zionist Organization is former M.K. Avraham Burg. He begins initiating changes in the two veteran bodies.

▷ An earthquake measuring 6.2 on the Richter scale occurs in Sinai on November 22, 1995, causing heavy damage in Eilat and cracks in the earth's surface in many areas.

◁ A Shalom, haver ("Goodbye [also: Peace], friend") sticker turns up in an unexpected place: a restaurant door in Madaba, Jordan, December 1995.

▽ Hasidic yeshiva students stage a violent confrontation with police in Jaffa, demanding a halt to construction at a building site because of the discovery of an ancient Jewish cemetery.

◁ The last song. Itzhak Rabin, guest of honor at a pro-peace rally, holds a sheet with the words of the *Peace Song*. Moments later he is shot by Yigal Amir.

▽ The message read out by Eitan Haber, director of the Prime Minister's office, announcing the government's shock, regret and deep sorrow following the assassination of Itzhak Rabin on the night of Nov. 4, 1995.

"SHALOM, HAVER" – ITZHAK RABIN, 1922–1995

The period following November 4, 1995, was one of the most terrible for the State of Israel since its founding. A political leader had been assassinated for the first time – Prime Minister Itzhak Rabin. Rabin had served as minister of defense as well, with Shimon Peres as foreign minister. Surprisingly – perhaps even to the two men themselves – they had effected a rapprochement, and cooperation between them grew. Rabin and Peres led the country to a historic agreement with the P.L.O. and thereafter to a peace treaty with Jordan. On the horizon, there was even the possibility of a treaty with Syria.

Rabin was a prime minister involved in social and economic issues and in immigrant absorption. He met frequently with intellectuals. He toured the country. He appeared to be more conciliatory than in the past despite continuous attacks against him for his "submission" to the P.L.O. and his concession of parts of the Land of Israel. Rabbis, too, denigrated him. The radical Right depicted him in a Nazi uniform in their demonstrations. These attacks and threats intensified during the summer and fall of 1995, but Rabin did not take them seriously. From time to time he responded sharply to the leaders of the Right, but he was confident that most of the public was with him, encouraged by surveys showing that, following a slip downward, he had rebounded and was rated as the country's most popular leader.

In an attempt to demonstrate broad public support for peace, a mass rally was scheduled for November 4, 1995, at the termination of the Sabbath, at Kings of Israel Square in Tel Aviv. The theme was: Yes to Peace – No to Violence. Prime Minister Rabin, the guest of honor, was openly pleased by the turnout of hundreds of thousands in support of his policy. "The people of Israel want peace and support peace," he declared to the wildly cheering crowd. At the end of the program, he joined singer Miri Aloni in the *Peace Song*. Following the *Hatikvah* anthem, he made his way toward his car, exchanging greetings with people he recognized and cheered on by hundreds of young people who awaited him in the parking area, shouting "Peace, peace" and "We're with you." Close to his car, a slim young man pulled out a pistol and shot him three times at point blank range. Two of the bullets struck Rabin and the third hit his bodyguard. The prime minister was rushed to nearby Ikhilov Hospital, but died shortly thereafter.

The country was plunged into deep mourning. Many other countries throughout the world declared a period of mourning, too, and lowered their flags to half-mast. U.S. President Bill Clinton, eulogizing Rabin emotionally, said that the world had lost "one of its great men – a fighter for the freedom of his people and for peace," ending his remarks with a sentence in Hebrew: "Shalom, haver, shalom lekha yedidi" ("Goodbye, friend, goodbye to you my friend").

△ The mass crowd at the
Kings of Israel Square,
Tel-Aviv, at the peace rally
of November 4, 1995.

Some of the signs read: "The
people have decided: Peace,"
"Students for the peace
process," and "Givatayim

(a city adjacent to Tel-Aviv)
youth want peace."
Moments after the end of the
rally, Rabin is shot to death.

△ Yigal Amir, Rabin's
assassin, is a third-year
law student at Bar-Ilan
University. Shown, during
the reconstruction of the
murder.

◁ Shim'on Peres eulogizes
Itzhak Rabin at the end of
the traditional seven-day
mourning period.

1996

January

5 Palestinian archterrorist Yihyeh Ayash ("The Engineer"), responsible for the murder of 67 Israelis and the wounding of 390, is killed by an explosive connected to his cellular phone. The Palestinians accuse Israel of the act.

7 General Security Service (Shabak) head Carmi Gillon announces his resignation.

9 Some 800 Palestinian security prisoners, including 400 members of Hamas, are released from prisons in Israel as part of the Oslo 2 agreement.

10 King Hussein of Jordan visits Israel and tours Tel-Aviv and the Lake Kinneret shore.

14-16 President Ezer Weizman visits Germany and delivers a historic speech in Hebrew at the German Bundestag, declaring, among other things: "I do not forgive and I do not forget."

16 A terrorist shooting on the Jerusalem-Hebron road kills an Israeli army doctor and a medic.

22 Israel Eldad, Lehi leader, ideologist and translator, dies at age 85.

28 Following a report that all blood donations from immigrants of Ethiopian origin are systematically discarded because of the danger of AIDS contamination, some 10,000 Ethiopian immigrants take part in a turbulent demonstration in Jerusalem that results in 61 persons injured, including 41 policemen.

30 An I.D.F. soldier is stabbed to death by a Hamas activist who infiltrates into an army camp.

February

9 The family of a Palestinian who has been killed in an accident donates his organs for transplants in Israel.

11 Prime Minister Shim'on Peres announces early elections.

16 Hizbollah shells 20 I.D.F. and S.L.A. positions simultaneously.

18 An Israeli-Turkish agreement is signed in the area of defense cooperation.

23 George Habash's Popular Front for the Liberation of Palestine announces the halt of violence in Palestinian Authority territory.

25 Two Hamas suicide bombers explode themselves on a No. 18 bus in Jerusalem and at the Ashkelon junction, respectively, causing a total of 27 fatalities and 80 wounded.

26 A car driven by a Palestinian with American citizenship rams and kills an Israeli woman and wounds 23 in Jerusalem.

A total closure is imposed on the occupied territories in light of terrorist acts.

27 Yigal Amir is convicted by the Tel-Aviv District Court for the murder of Prime Minister Itzhak Rabin.

29 The Shamgar Commission examining the circumstances of the assassination publishes the finding that Rabin's murder was a security failure.

March

3 A Hamas suicide bomber explodes himself on yet another No. 18 bus in Jerusalem, killing 18 passengers and wounding 70. Many Purim festivities are canceled throughout the country. Arafat announces that quasi-military Palestinian organizations will be declared illegal.

4 A suicide bomber explodes himself near Dizengoff Center in Tel-Aviv, causing 13 fatalities and some 100 wounded. The perpetrator is a member of Hamas from Khan Yunis who was smuggled into Israel by an Israeli Arab.

13 The Sharm al-Sheikh Summit opens with the participation of leaders from 22 countries who censure terror and call for the establishment of a framework for joint international cooperation to combat it. Participants include Israeli Prime Minister Peres, Egyptian President

Jerusalem celebrates. The commemoration of the 3,000th anniversary of the city concludes with a dazzling display of lights and fireworks over the Old City walls.

Mubarak, and U.S. President Clinton.

14 Clinton visits in Israel following the summit, meeting with youth in Tel-Aviv and Jerusalem.

31 An unexplained explosion of an I.D.F. helicopter over the Judean Desert takes the lives of 7 members of the crew.

April

2 An Israeli-Qatari agreement is concluded for the establishment of commercial legations in both countries.

7 An Israeli-Jordanian air line is inaugurated.

9-27 Operation Grapes of Wrath is mounted by the I.D.F. in Lebanon in retaliation for the shelling of Israel's northern settlements. The I.D.F. attacks terrorist bases by artillery and by air. Enemy fatalities in Lebanon total 126, including Syrian soldiers, at least 50 terrorists, and a large number of civilians in a mistargeted bombing of the village of Kana. The I.D.F. has no casualties. The northern region of Israel incurs losses to property, industry, and agriculture as a result of the flight of residents southward. A cease-fire is announced following the attainment of an understanding between Israel and Hizbollah.

18 The state basketball cup is won by Hapo'el Jerusalem, which beats Maccabi Tel-Aviv.

29 The first cemetery in the country under nonreligious auspices is established in Beersheva.

May

Hizbollah attacks against the I.D.F. in southern Lebanon continue. The I.D.F. responds with artillery and air attacks.

2 Emil Habibi, Arab author, Israel Prize recipient, former M.K., and noted leader of the Arab population in Israel, dies.

8 A violent confrontation takes place between Palestinian Authority police and I.D.F. soldiers at the Netzarim junction in the Gaza Strip.

18 Israel launches its Amos communications satellite.

The elections campaign for the 14th Knesset heats up. A serious incident occurs when a Likud activist shoots a Labor Party worker who is pasting up campaign posters.

19 The financial daily *Telegraph* closes after three years of publication.

25 Fires rage out of control in the Galilee and Golan Heights. Heavy damage is caused to flora, natural forests, and pasture. The Bnot Ya'akov Bridge is closed for several hours because of dense smoke.

29 Elections for the 14th Knesset and the premiership are held, the first time the two elements are split. Likud candidate Binyamin Netanyahu tops Labor candidate Shim'on Peres by a narrow margin. Both major parties lose strength in the polls. Forty new M.K.s enter the Knesset.

30 Two road mines explode in Marj Ayun in southern Lebanon, killing 4 I.D.F. soldiers and wounding 7.

June

2 The new head of the Mosad is former General Danny Yotam, who replaces Shabtai Shavit.

6 The Hizbollah violates the understanding drawn up with Israel and fires on northern Israel in several separate incidents.

8 The I.D.F. announces for the first time that the motivation among new recruits to serve in combat units has dropped.

9 A young husband and wife are killed in a terrorist drive-by shooting in the Bet-Shemesh area.

10 Terrorist firing in the security zone in Lebanon kills 5 I.D.F. soldiers.

17 The 14th Knesset convenes under the temporary chairmanship of the eldest member, Shim'on Peres.

18 Binyamin Netanyahu's government is sworn in by the Knesset. The coalition consists of a merger of the Likud, Tzomet and Gesher (David Levy's list); Shas; the National Religious Party; Yahadut Hatorah (an ultra-religious party); Israel Be'aliyah (Russian immigrants' party); and the Third Way (a Greater Land of Israel party). Several portfolios are not yet assigned.

26 A terrorist ambush in the Jordan Valley claims the lives of 3 I.D.F. soldiers.

July

1 The Histadrut ("Federation of Labor") declares an hour-long strike by some 400,000 public service workers in protest against economic privatization measures that fail to protect workers' rights.

6 Thousands of ultra-Orthodox demonstrate on the Sabbath at Bar-Ilan Street in Jerusalem, demanding to close the street, which passes through an ultra-Orthodox neighborhood, to traffic on the Sabbath. Many more such demonstrations, some of them violent, are to follow in the coming months.

9 Prime Minister Netanyahu visits the U.S. Differences in opinion regarding the peace process emerge in his meeting with President Clinton.

17 Most of the public sector strikes in protest against the government's economic plan, which features privatization and budget-cutting.

18 Prime Minister Netanyahu visits Egypt. President Mubarak expresses optimism regarding the chances for peace.

21 The remains of I.D.F. soldiers Rahamim Alsheikh and Yosef Fink, who were captured in Lebanon in 1986 by terrorists, are returned to Israel in exchange for the release of Lebanese prisoners and the transfer of the remains of terrorists to the Hizbollah.

26 Another drive-by shooting by terrorists in the Bet-Shemesh area results in the death of three members of a single family.

29 Israeli windsurfer Gal Friedman wins a bronze medal in the Olympic Games in Atlanta.

30 The remains are found of a missing soldier, Ilan Sa'adon, who was kidnapped and murdered by Hamas in May 1989.

August

6 A terrorist attack on the I.D.F. in southern Lebanon results in the death of a soldier. I.D.F. planes attack Hizbollah bases in response.

8 Justice Minister Ya'akov Ne'eman resigns after he is charged with disruption of due process in the trial of M.K. Aryeh Deri.

14 Sessions of the Israeli-Palestinian Joint Supreme Civil Council resume after a prolonged break in the wake of the terrorist acts earlier in the year.

15 The Supreme Court, ruling on the Bar-Ilan Street issue, orders that the street remain open on the Sabbath but recommends that a public council be formed to consider the issue, including the question of closing streets on the Sabbath.

18 Three forest fires in the Jerusalem hills result in the destruction of some 300 dunams (75 acres) of forested area.

20 Friendly fire in Lebanon causes the death of a soldier in the Giv'ati Brigade and the serious wounding of another.

21 A criminal investigation is initiated against M.K. Dedi Zucker (Meretz) in connection with his involvement in the nonprofit body sponsoring the Camera Obscura school of photography.

25 A campaign is mounted in the ultra-Orthodox press against Supreme Court Chief Justice Aharon Barak in the wake of the court's decision on the Bar-Ilan Street issue (see August 15). Threats are made on the judge's life, prompting the stationing of guards to protect him.

Fighting by Hizbollah against the I.D.F. and the S.L.A. is continuous.

Problems related to foreign workers in Israel, estimated at 250,000 persons, worsen.

Traffic accidents in the month of August cause the death of 61 persons.

September

3 A tunnel road shortening the travel distance between Jerusalem and the Gush Etzion and Hebron regions is inaugurated.

5 Binyamin Netanyahu and Yasser Arafat hold their first meeting.

6 A fire in the Jerusalem Corridor injures 13 persons and damages 40 homes.

9 M.K. Ehud Barak announces his intention to contend for the chairmanship of the Labor Party.

An I.D.F. soldier, Sharon Edri, is missing. Kidnapping is suspected. Extensive searches in the central part of the country, where he was last seen, reveal nothing.

18 A midair crash of two I.D.F. helicopters off the Nahariya coast results in the death of the two pilots and an officer.

19 M.K. Shim'on Peres announces that he will not contend for the chairmanship of the Labor Party.

20 An intense skirmish between I.D.F. and Hizbollah forces results in 2 Israeli fatalities and 8 wounded.

24-30 The Tunnel Affair in Jerusalem begins. The Ministry of Religious Affairs, with the approval of the prime minister, opens a connecting tunnel from the ancient Hasmonean passageway under the Western Wall to the Muslim Quarter of the city. Arabs in Jerusalem and the occupied territories riot. Confrontations between Palestinians and the I.D.F. result in 69 Palestinian fatalities and the death of 11 Israeli soldiers. Protests are held in the Arab world. The head of the General Security Service (Shabak), Ami Ayalon,

A promising start for the year: Israel, just emerging from the trauma of the assassination of Prime Minister Itzhak Rabin on November 4, 1995, warmly welcomes the evolving peace with Jordan. King Hussein arrives on his first visit to Tel-Aviv in January.

The boundary between Israel and the areas under Palestinian control ignites in the wake of the opening of the "Western Wall tunnel" in Jerusalem's Old City by the Ministry of Religious Affairs with the approval of Prime Minister Netanyahu. Both sides incur numerous fatalities and wounded before a cessation of hostilities is achieved. Israel's forces near the main Arab cities in the occupied territories are put on alert. Shown, Israeli tanks facing Nablus.

admits: "The Shabak erred in its assessment of the results of the opening of the tunnel." Relations between Israel and the Palestinian Authority are at a low ebb.

October _____

9 President Ezer Weizman and Chairman Yasser Arafat meet in Caesarea in an effort to calm the atmosphere in the wake of the tunnel affair.

10 An earthquake measuring 6 on the Richter scale occurs in Israel and the region.

13 Joint patrols in Hebron by Israeli and Palestinian security forces are resumed.

16 Members of the Palestinian Council visit the Knesset for the first time. Three M.K.s protest vehemently and are expelled from the house.

21 The opposition outnumbers the coalition in a vote of no-confidence, but the government does not fall because of the Direct Elections Law which requires a majority of over 60 M.K.s in such a vote.

22 A right-wing extremist flings boiling tea at M.K. Ya'el Dayan (Labor) during a parliamentary tour in Hebron. The man had previously been convicted of murdering an Arab.

French President Jacques Chirac, on a visit to Israel, is outspokenly critical of Israeli policy and procedure.

23 An attack on the I.D.F. in southern Lebanon results in the death of 2 soldiers and the wounding of 5.

November _____

A report at the beginning of the month indicates that the number of ultra-Orthodox not recruited into the I.D.F. is rising.

2 A mass memorial rally marking a year since Rabin's assassination is held in Rabin Square in Tel-Aviv. The crowd stands for a moment of silence at 9:45 p.m., the time of the murder.

9 A missile fired at an I.D.F. tank in southern Lebanon results in the death of one soldier and the wounding of 3.

11 A Druze citizen of Israel from the Galilee, Azam Azam, is arrested in Egypt on suspicion of spying for Israel.

18 Video footage showing two Israeli Border Guard police beating apparently helpless Palestinian workers arouses indignation in Israel and abroad.

December _____

3 Attorney General Michael Ben-Ya'ir announces his resignation.

7 A road mine in Lebanon kills an I.D.F. soldier in the Golani Brigade.

11 A band of three terrorists shoots and kills an Israeli mother and her son near Bet-El in the West Bank. The Palestinian Authority arrests two suspects.

14 Katyusha missiles land in the western Galilee.

An I.D.F. convoy is attacked in southern Lebanon.

30 A Palestinian who attempts to attack two settlers in Kfar Darom in the Gaza Strip is shot and killed.

Some 70,000 immigrants arrive in Israel in 1996, mostly from the C.I.S.

Inflation in 1996 is 10.6%.

Mass terrorist acts by Hamas and the Islamic Jihad occur in February and March 1996. Three separate incidents – two in Jerusalem and one in Tel-Aviv – claim a toll of 60 Israeli fatalities and hundreds of wounded. Shown, the aftermath of the incident that targeted a No. 18 bus in Jerusalem on February 25, 1996. Not only do the terrorist acts weaken relations between Israel and the Palestinians, they are a contributing factor to the defeat of the Labor government in the elections.

Fighting along the Lebanese border takes place nearly daily in 1996, climaxing in April with Operation Grapes of Wrath, Israel's response to intensive Katyusha missile attacks against its northern settlements. Shown, I.D.F. soldiers on a combat mission against Hizbollah in southern Lebanon.

Probably the photo of the year: Israel's new prime minister, Binyamin Netanyahu, meets Palestinian Authority head Yasser Arafat for the first time in September 1996. Before the elections, which took place on May 29, 1996, this eventuality seemed impossible.

Shim'on Peres, leading in the surveys, is confident of victory in the winter of 1996. Visiting Great Britain in February, he meets with Labor candidate Tony Blair, then leader of the opposition. Peres will lose, while Blair will win in the British elections of 1997.

ANOTHER ELECTORAL REVERSAL, 1996

In the wake of its defeat in 1992, the Likud party reorganized under the leadership of a new political figure, Binyamin Netanyahu, 44. The campaign that he launched in 1996 was at a distinct disadvantage, as the rival Labor Party candidate, Prime Minister and Minister of Defense Shim'on Peres, led the opinion polls by a wide margin and appeared to be the obvious winner in the first direct elections for the premiership to be held in Israel.

The gap between the two, however, narrowed steadily as Election Day, scheduled for May 29, 1996, drew near. Three days beforehand, the traditional television debate between the candidates showed a worried-looking and unfocused Peres vis-a-vis a young prize fighter-like Netanyahu relishing the fight. Public opinion had it that Netanyahu was the winner in the T.V. duel.

During the few days that remained before the elections, thousands of Habad hasidim came out in support of Netanyahu, papering the country with the slogan: "Netanyahu is good for the Jews."

Critics censured the Likud, and Netanyahu, for using such a crude slogan, but the Election Day results showed that this last-minute push brought Netanyahu victory.

The count was close. During election night, Peres still seemed to be the victor. Polls by both T.V. channels, and even early returns, gave him a small edge. The upset, however, emerged during the small hours of the morning, leading to the final result of Netanyahu's victory by a narrow margin of 30,000 votes (less than 1% of the vote).

Retrospectively, it appeared that Peres and Labor had lost as a result of overconfidence as well as a failure to exploit the widespread sympathy for Labor and the hostility toward the Right following the assassination of Itzhak Rabin.

△ Election Day, May 29, 1996. Prime Minister Shim'on Peres (l.) and Likud contender Binyamin Netanyahu, with wife Sarah at his side, cast their votes at the polls.

1997

January

1 An Israeli soldier, Noam Friedman, opens fire on Palestinian passersby in Hebron, wounding seven people. An I.D.F. officer overpowers him and thus prevents a serious tragedy.

12 The new attorney general, Roni Bar'on, appointed on January 10th, resigns in the wake of wide-spread criticism in the media and by the public of his lack of qualification for the post.

15 The government approves the Hebron agreement worked out between Prime Minister Netanyahu and Palestinian Authority Chairman Yasser Arafat, which involves the I.D.F.'s withdrawal from parts of the city. Eleven ministers vote in favor of it and seven are opposed. Science Minister Benny Begin, an opponent, announces his resignation from the government.

20 The Hebron-Bar'on affair becomes public. Reporter Ayala Hasson's exposé of a political deal involving the appointment of Bar'on as attorney general in exchange for support by the Shas party for the Hebron agreement is broadcasted by Israeli T.V.'s Channel One. The report evokes a public uproar.

25 The government transfers the investigation of the attorney general's appointment to the police. Public figures, M.K.s, and government ministers, including the prime minister, are questioned during the weeks that follow.

29 The government unanimously approves the appointment of Jerusalem's District Court Judge Elyakim Rubinstein as the new attorney general.

February

4 A grim air disaster takes the lives of 73 Israeli soldiers when two I.D.F. helicopters collide over the Upper Galilee while en route to relieve Israeli forces in southern Lebanon.

A reform in foreign currency regulations in the country allows Israelis to invest in foreign stock markets as well as to exchange Israeli currency for up to $7,000 without having to show proof of a flight ticket abroad, as previously.

16 Israeli-Palestinian delegations start discussions on the implementation of the Hebron agreement.

March

The police investigation of the Hebron-Bar'on affair continues. Lawyers and political figures are questioned. Tension mounts as the investigation continu. The questioning of ministers and M.K.s sometimes takes 10 hours or more. Prime Minister Netanyahu, who is also questioned, frequently attacks the media, and especially Channel One, for its role in the affair.

7 In a close vote, the government decides on the extent of the territory to be handed over to the Palestinians during the first phase of the withdrawal from the West Bank.

13 In a shocking incident at the Israeli-Jordanian border, a Jordanian soldier opens fire at a group of Israeli schoolgirls who are on a tour of the Naharayim region south of the Yarmuk River, killing seven of the girls. A Jordanian police officer is assigned to the investigation team set up to examine the circumstances of the incident.

14 The government announces its decision to build a large new neighborhood in southern Jerusalem at Har Homah on land which belonged to the Jordanian sector of the city until 1967. Vociferous opposition is voiced by the Arab population in the West Bank and by the Arab states. Under stepped-up security

An Arab youngster hoists a Palestinian flag over the headquarters in Hebron, January 1997.

conditions, work on the infrastructure is begun by the end of the month.

16 King Hussein of Jordan arrives in Israel to pay condolence visits to the families of the murdered schoolgirls from the town of Bet-Shemesh.

21 A Palestinian suicide bomber from a village in the Hebron area blows himself up at the Apropo Cafe in Tel-Aviv, causing the death of three young women and dozens of injured. A closure is imposed on the Palestinian territories.

27 Israeli tycoon Shaul Eisenberg, whose business interests spanned the world, dies aged 76.

April

The ongoing closure and the deterioration in relations between Israel and the Palestinians evoke demonstrations and incidents in Bethlehem, Hebron, Jenin, the Gaza Strip, and elsewhere.

10 Israeli security forces arrest a Hamas cell responsible for the murder of eleven Israelis in the preceding months. The Palestinian Authority assists in efforts to apprehend them. Among the detainees are the terrorists reponsible for planning the Apropo Cafe incident.

16 The high-ranking police team investigating the Hebron-Bar'on affair submits its findings. It recommends indicting Prime Minister

Netanyahu, Justice Minister Tzahi Hanegbi, Director of the Prime Minister's Office Avigdor Lieberman, and M.K. Aryeh Deri for fraud and breach of trust. The political establishment and the public are in turmoil.

17 Hayim Herzog, I.D.F. general, member of Knesset, and sixth President of the State of Israel, dies at the age of 79.

20 Attorney General Elyakim Rubinstein and State Attorney Edna Arbel reject the police recommendation to indict Prime Minister Netanyahu and Justice Minister Hanegbi but declare that a grave attempt was made to exert control over the state prosecutor's office and that "persons under criminal indictment banded together to determine the appointee to the post of government attorney general." Sufficient evidence is found to indict M.K. Deri. The two legal officials commend the media for filling an important role in the "exposure of a difficult and painful subject."

24 Egypt's state prosecutor demands a sentence of life imprisonment for Israeli Druze citizen Azam Azam, arrested in Egypt in 1996 on charges of spying.

May

3 A mass demonstration takes place in front of the Prime Minister's Office in Jerusalem demanding the establishment of a commission

of inquiry into the attorney general affair.

8 A Palestinian land dealer is murdered by Palestinians on suspicion of selling land to Israelis. Other such murders follow.

12 Businessman Zvi Ben-Ari (Gregory Lerner), suspected of belonging to the "Russian Mafia" in Israel, is arrested for large-scale fraud and for attempted murder in Russia.

18 Transportation Minister Itzhak Levy decides that Bar-Ilan Street in Jerusalem, the subject of violent contention, will be closed on the Sabbath and holidays during prayer time.

June

3 M.K. Ehud Barak, former chief of staff and foreign minister, is elected the new leader of the Labor Party, defeating M.K.s Yossi Beilin, Shlomo Ben-Ami, and Efraim Sneh.

17 The government contends with a new crisis when Finance Minister Dan Meridor resigns over deep-seated differences of opinion with Prime Minister Netanyahu. Other ministers consider resigning as well.

24 The Knesset defeats a motion of no confidence in the government by a vote of 55 to 50 in the wake of Meridor's resignation.

28 Thousands demonstrate at Rabin Square in Tel-Aviv calling for early elections to the Knesset.

Signs of a recession and growing unemployment are evident by the end of the month.

July

14 The 15th Maccabiah Games open. A tragedy occurs on the opening night when a temporary bridge put up over the Yarkon River for access to the stadium collapses, resulting in the death of four members of the Australian contingent and the injury of dozens of others. Sharp criticism is levelled against the planners, the builders, and the Maccabiah authorities.

30 Explosions by Hamas suicide bombers in the Mahaneh Yehuda market in Jerusalem cause 16 deaths and over 150 wounded.

August

9 In an insurrection in Military Jail No. 6, 16 prisoners overpower their guards and hold them hostage. Following a day of negotiations, an agreement is reached in which the I.D.F. promises to investigate the prisoners' demands for improved conditions and not bring them to trial. This agreement is later breached.

31 Azam Azam is convicted in Egypt of spying for Israel and is sentenced to 15 years imprisonment with hard labor.

Incidents in southern Lebanon continue throughout the month. On August 28, four I.D.F. soldiers are burned to death in a brush fire that breaks out in the wake of Israeli artillery fire. Katyusha rockets hit Galilee settlements.

September

4 In yet another terrorist attack in Jerusalem, three suicide bombers set off explosives in the Ben-Yehuda pedestrian mall, causing the death of four persons and injuries to some 200.

5 A failed Israeli naval commando operation in southern Lebanon results in 11 I.D.F. fatalities and one soldier missing.

In the largest privatization transaction in Israel yet, 43% of Bank Hapo'alim stock is acquired by an investment group headed by business magnate Ted Arison.

10-11 U.S. Secretary of State Madeleine Albright, visiting the region for the first time in her new capacity, expresses disappointment over her discussions with both Israeli and Palestinian leaders.

14-18 The Ras al-Amud Affair breaks out in the wake of the entry by three families of Jewish settlers into a complex of houses in an Arab neighborhood in East Jerusalem acquired by an American, Irving Moskowitz. The act elicits tension in Israel and in the Palestinian Authority and is widely criticized. The Israeli government, led by Binyamin Netanyahu, is not anxious for a new confrontation, and after prolonged negotiations, the three families are evacuated, to be replaced by 10

yeshiva students delineated as guards and maintenance personnel.

22 A shooting incident in Jordan results in the wounding of two Israeli embassy guards in Amman.

25 Labor Party Chairman Ehud Barak, speaking in the name of his party, asks forgiveness retroactively from Israelis who had immigrated from the Arab states during the 1950s and 1960s for the condescending attitude displayed to them by Labor's predecessor, Mapai, the party in power then.

The Mash'al Affair begins. Mossad agents fail at an attempt to eliminate a senior Hamas figure in Jordan, Halid Mash'al. Two operatives are caught and 4 others are sheltered in the Israeli embassy in Amman. King Hussein is furious. Mash'al, who has been poisoned, is saved by an Israeli physician. Netanyahu rushes with a high-ranking delegation to Jordan in an effort to salvage relations with it. An agreement is reached in which the agents are returned to Israel in return for the release of radical Hamas founder Sheikh Yassin, held by Israel.

28 The Histadrut (Federation of Labor) holds a one-day nationwide strike to protest the government's refusal to adhere to pension agreements signed by the previous government, as well as privatization steps taken without consultation with workers.

Oktober

6 The two Mossad agents arrested by the Jordanians in connection with the Mash'al incident are returned to Israel. In exchange, Israel frees Sheikh Yassin along with several dozen Palestinian prisoners.

8 A roadside explosive device laid by Hizbollah in southern Lebanon causes the death of 2 I.D.F. soldiers, with 6 wounded.

11 Jordan announces the freezing of security cooperation with Israel.

26 Morocco freezes relations with Israel.

November

4 Memorial ceremonies and protest assemblies are held

throughout Israel, marking the second anniversary of Rabin's assassination.

19 A shooting in the Old City of Jerusalem causes the death of one yeshiva student and the wounding of another.

Itzhak Moda'i, Chairman of the Association for the State's 50th Anniversary, proposes a large-scale amnesty to mark the event. The issue prompts public as well as political debate.

23 The all-powerful director of the Prime Minister's Office, Avigdor Lieberman, announces his resignation.

30 A strike of the governmental administrative sector is declared, gradually expanding to the rest of the economy, at the instigation of Histadrut Chairman Amir Peretz. It lasts over a week.

December

1-7 Work disputes continue. A statement by Finance Minister Ya'akov Ne'eman that Israeli workers are "self-destructing bombs" prompts the Histadrut to announce a general strike.

15 In a surprise development, the rise in the cost-of-living is only 0.3% for the month of November, the lowest figure since May 1992. Unemployment figures, however, are worrisome: 151,600 are jobless.

16 Agitated demonstrations take place in Ofakim, which has the highest unemployment rate in the country – some 15%. Attempts are made thereafter to aid the town, including a visit by Prime Minister Netanyahu, who presents a list of workplaces prepared to employ the jobless.

23 The 33rd Zionist Congress opens in Jerusalem in the midst of a heated debate over the various currents in Judaism.

The coalition is divided over approval of the 1998 budget. It suffers a series of defeats in the Knesset when coalition ministers and M.K.s vote against it.

Immigration to Israel in 1997 is 66,000.

The annual inflation rate is 7%, the lowest figure in 29 years.

Ezer Weizman, President of the State of Israel, and Madeleine Albright, U.S. Secretary of State, visit two wounded Jerusalemites after the explosion in the city center caused by Hamas in September 1997.

Two Israeli soldiers at the site of Har Homah, Jerusalem, March 1997.

King Hussein of Jordan visits the families of the young victims of the Naharayim shootings, Bet-Shemesh, March 1997.

Attorney General Elyakim Rubinstein (r.) and State Attorney Edna Arbel (l.), report on the Bar'on Affair, April 1997.

Index

608

467 479 486 490 492 498
515 548 553 583
Kiryat Shmuel 204
Kiryat Yam 295
Kiryat Ye'arim 311
Kisch, Frederick 123 124 128
163 169 170 232
Kishinev, pogrom 10 22 24 25 28
Kishon, Ephraim, writer 419
Kissinger, Henry 449 452 454
456
Kisufim, kibbutz 322
Kitruni, Rabbi 142
Klausner, Joseph 88
Kleinbaum, Moshe – see Sneh,
Yosef
Klement, Ricardo – see Eich-
mann, Adolf
Klerk, F. W. de 543
Kluger, Zoltan 188
Knesset – the parliament of
Israel
Knesset, permanent building
341 344 405 441 447 561
Knesset, First 267 268 270 280
293 294 297 299 300 303 346
Knesset, Second 300 303 306
307-309 310-312 317 322
346
Knesset, Third 319 322 325 327
328 336 337 341 344-346
Knesset, Fourth 329 330 345
346 348 354 358
Knesset, Fifth 358 360 362 366
368 370 374
Knesset, Sixth 374 376 379
380 384 385 394 400
Knesset, Seventh 401 403 408
409 410 419 421 423
Knesset, Eighth 423 432 449
452 454 458 461 462
Knesset, Ninth 462 463 467
470-473 479 481 485
Knesset, Tenth 485 487-489
491 492 498 499 502 504
Knesset, Eleventh 504-506 509
515 516 524 528
Knesset, Twelfth 524-526 528
537 542 548
Knesset, Thirteenth 548 550
553 556 560 583 587
Knesset, Fourteenth 590 591
592 597
Koenig, Pierre 345
Kofer Hayishuv 204 244
Kohl, Chancellor Helmut 583
Kol Koreh – see under Vitkin,
Yosef
Kol Israel, Haganah underground
radio station 217 242 359
Kol Zion Lagolah ("Voice of
Zion for the Diaspora"), radio
station 293
Kollek, Teddy 374 467 471 499
553 554
Komemiyut, moshav 362
Konigshoffer, Yona – see Begin,
Menahem
Kook, Rabbi Avraham Itzhak
Hacohen 26 27 56 62 64
86 114 134 154 183 187
192

Koor, conglomerate 236 520
Kor, Paul 446
Korean War 299
Koslowsky, Pinhas – see Sapir
Kosygin, Alexei 428
Kotler, Oded, actor 384
Kovner, Abba, poet 359
Kraus, Ahuva 317
Krikorian, Gerard, photographer
34
Krinitzi, Avraham 251
Krinitzi-Goralsky, carpentry
workshop 123
Kristallnacht 204
Ktuvim ("Hagiograph"),
newspaper 138 143
Kubovy, Aryeh 307
Kumkum, theater 144 146 149
413
Kunteres, newspaper 86 94
Kupat Am Bank 189
Kupat Holim (Klalit) ("General
Sick Fund" or "The Sick
Fund") 50 54 61 163 173 560
Kurdistan 302
Kushnir, Avi 557
Kutai, Ari 128
Kuwait 345 537 538 540 542

L

Labor Legion – see Gedud
Ha'avodah
Labor Organization of Palestine
(Yishuv) 11
Labor Party 394 395 400 401
403 408 415 419-421 452
454 458 462-464 466 467
478 479 481 536 537 541
547 548 550 553 554 556
559 577 583 589 590 591
593 595 597
Lachish Region 322 323 326
Lachower, F. 154
Lagerlof, Selma, writer 11
Lahad, Antoine 504
Lahat, Shlomo 461 467 474 479
499 545
Lahrs, Dr. Yosef 199
Lamerhav ("Opening Out"),
newspaper 318 337 366 415
418
Lancet, Batia 137
Lancet, Irina 137
Lancet, Moshe 137
Land Day 458
Land of Goshen 444 449 453
Landau Commission 519 520
Landau, Moshe 359 450 519 520
Landoberg, Itzhak – see Sadeh,
Itzhak
Langer, Miriam and Hanokh 419
Language War 62
Lansky, Meir 419
Laskov, Hayim 243 341 353 358
410 450
Latrun 232 246 247 259
Latvia 419 548
Lau, Rabbi Israel Meir 553 557
Lausanne Conference 267 268
Lavi, Israeli aircraft 509 515 519
520 523

Lavon Affair (The Mishap or the
Affair) 317-320 322 353 355
358 360 361 370 374 376
394 398 416 523
Committee of Seven 353 355
358
Cohen Commission 353
Lavon, Pinhas 297 299 306 309
317 319 320 322 353 355
358 360 361 370
Lawrence, Col. T. E. 114 118
Layehudim ("For the Jews"),
newspaper 61
Le'asirenu, association 249
League for the Abolition of
Religious Coercion 366
League V 226 234
League of Nations Council 119
155
Learning Youth movement 163
Lebanon 82 89 94 190 204-206
215 217 218 222 223 225
258 259 262 265 267 269
311 312 323 341 352 368
374 375 377 381 387 394
397 409 410 412 415 419
423 424 449 454 458 460
467 468 471 478 479 482
485 486 491 492 494-499
503-506 509-511 515 516
519 520 524 525 527-531
537 543 547 548 553 554
556 559 560 562 581-583
590 591 593 596 597
Lebanon War (Operation Peace
for Galilee) 478 491 492 494-
498 500 504-507 511 519
525 562
Lehi (acronym for Lohamei
Herut Israel – Israel Freedom
Fighters) 143 216 217 226
229 232 236 239 241 242
246-249 251-253 258 259
454 590
Lehmann, Dr. Siegfried 217
Leibowitz, David 258
Leibowitz, Dov 66
Leibowitz, Yesha'yahu,
philosopher 237 553 556 560
Leicester, Sir 177
Lemel, school 22
Leningrad Trial 414
Lerner, Motti 537
Levanon, Hayim 323 345
Levant Fair 173-175 182 193
Lev, Kokhava 455
Levi, Rabbi Moshe 32 36
Levi, Shaul 123 128
Levin, Hanokh, playwright 413
Levin, Rabbi Itzhak Meir 306
Levinger, Rabbi 457 557
Levinson, Ya'akov 504 505
Levinzon, Shim'on 554
Levison, Rahel 296
Levitov, Zohara 263
Levontin, Zalman David 22 25
30
Levy, David 486 489 498 500
504 511 515 519 523 524
526 530 532 536 541 547
548 553 557 582 583 586
591

Levy, Itzhak 597
Levy, Morris 394
Levy, Moshe 490 498 519 559
Levy, N. and Partners, printers
39
Levy, Shabtai 486
Levy, Ya'ir 542 543 548 553
Levy, Yosef 23
Liberal Party 358 360 374 411
423 449 467 498 525
Liberia 362
Libya 217 218 222 223 226 232
416 423 424 458 485 511
Lie, Trygve 299
Lieberman, Avigdor 596
Likud, party 408 423 458 462
463 465 471 473 478 482
485 486 488 489 491 498
500 504-506 509-512 517-
519 524-526 532 536 537
547 548 550 552 553 557
582 586 590 591 597
Li-La-Lo Theater 303
Lilien, Ephraim Moses 18 32
Lillehammer affair 424
Limon, Mordechai 409
Lin, Amnon 491
Lipkin-Shahak, Amnon 555 582
586
Lishansky, Batya 203
Lishansky, Yosef 74 77 81
Livni, Menahem 507
Locker, Berl 345
Locusts 70 71 74 306
Lod (Lydda) 19 144 145 194
197 209 242 252 259 312
383 394 397 410 416 525
Lod airport 419 421 422
London 363 364 419
London Conference 93
Loverboim, Dr. 557
Lower Gvat 183
Lubavitcher Rebbe – see
Shneerson, Rabbi Menahem
Mendel
Lubin, Aryeh 106
Luk, Mordechai 370 373 374
Luke, Harry 149 154
Luxemburg 310
Luz, Kadish 345 358 368
Lydda – see Lod

M

Ma'abarot (immigrant transit
camps) 281 282 291-295 299-
302 304-307 318 456 566
Ma'agan, kibbutz 317
Ma'aleh Adumim 454
Ma'aleh Akrabim 317 320 467
Ma'aleh Hahamisha, kibbutz 199
Ma'aleh Michmash 583
Ma'alot 449 451
Ma'ariv ("Evening Paper"),
newspaper 258 317 327 355
363 382 425 472 524 541
549 559 582 583 586
Ma'ayan Harod 114 115
Maccabi, sports association 58
149
Maccabi Hagibor, soccer team
144

611

Illustration Sources

Photographs and Documents

Ahad Ha'am Library, Bet Ariella, Tel Aviv ● Albatross ● American Colony, Jerusalem ● Archive of the History of Jewish Education, Tel Aviv University ● Ashuah, Yigal ● Avrahami, Reli ● *Bamahaneh* Archive ● Bank of Israel ● Ben-Dov, Ya'akov ● Ben-Ezer (Raab) Family Collection ● Ben-Zvi Institute Archive, Jerusalem ● British War Museum, London ● Cameron, Denis ● Carmi, Boris ● Central Zionist Archive, Jerusalem ● Davar Archive, Tel Aviv ● Dinar, Lazar ● Eitan, Moshe ● Finn, Hans ● Freidin, Itzhak ● Friedman, Moshe ● Gal, Alex ● Dr. Menuha Gilboa Collection, Tel Aviv ● Government Press Office, Jerusalem ● Haganah Archive, Tel Aviv ● Harley, Frank ● Historical Archive, Tel Aviv-Jaffa ● Ya'akov Hodorov Collection, Rishon Lezion ● I.D.F. Spokesman ● Institute for Research of the Jewish Press, Tel Aviv University, Danny Rosenblum Collection; Sraya Shapira Collection ● Information Center, Jerusalem ● Israel Aircraft Industries ● Israel Defense Forces Archive, Giv'atayim ● Israel Philatelic Service ● Israel Philharmonic Orchestra Archive ● Israel Sun, Tel Aviv ● Jewish National Fund Archive, Jerusalem ● Kahana, Vardi ● Keren Hayesod Archive, Jerusalem ● Kluger, Zoltan ● Korbman, Shim'on ● Kot, Joe ● Krikorian, Gerard ● Lavon Institute, Tel Aviv ● Libek, Alex ● *Life* Archive ● Maritime Museum, Haifa ● Ministry of Defense Publishing House, Tel Aviv ● Museum of Eretz Israel, Tel Aviv ● Naor, Dr. Mordecai ● Newsphot, Tel Aviv ● Oppenheim, Naftali ● Rafaelowitz, Yeshayahu ● Rappel, Yoel ● Schiller, Eli – *Ariel* Publishers, Jerusalem ● Schlezinger, Kurt ● Schweig, Yosef ● Soskin, Avraham ● Tartakover, David, Tel Aviv ● Vered, Avraham ● Wisenstein, S., Pri Or Photography Studio ● Ziv, Kfir

Illustrations, Drawings, Paintings, and Caricatures

Alouil, Aryeh ● Baurenfeind, Gustav ● Bergner, Yossl ● Bezem, Naftali ● Blum, Ludwig ● Brandstaetter, Yehoshua ● Dalí, Salvador ● Dosh ● Adari, Yehoshua ● Elhanani, Aryeh ● Fnichel, Abba ● Frankel, Itzhak ● Gutman, Nahum ● Janco, Marcel ● Jérôme, Jean Louis ● Katz, Shmuel ● Kor, Paul ● Kraus, Franz ● Lehman, A. ● Lilien, Ephraim Moses ● Litvinovsky, Pinhas ● Lubin, Aryeh ● Navon, Aryeh ● Ovadyahu, Mordechai ● Peretz ● Raban, Ze'ev ● Rosenfeld, Perry ● Rubin, Reuven ● Schick, Artur ● Shamir Brothers ● Sigard, Eliyahu ● Streichman, Yehezkel ● Tagger, Ziona ● Tartakover, David ● Ze'ev ● Zipper, Moshe

Press

Anfang, Der ● Barechev ● Davar ● Davar Hashavu'a ● Dror ● Eshnav ● Ha'ahdut ● Ha'aretz ● Haboker ● Hadashot ● Hadashot Ha'aretz ● Hadorban ● Haherut ● Ha'ir ● Hamashkif ● Hamar-Gamal ● Ha'olam Hazeh ● Ha'omer ● Hapo'el Hatza'ir ● Hashkafah ● Hayom ● Hazvi ● Jerusalem Post ● Ketuvim ● Kol Ha'am ● Kunteres ● Lahayal ● Layehudim ● Ma'ariv ● Mishmar ● Palestine Post ● Radio (Warsaw) ● Tsipor Hanefesh ● Welt, Die ● Yediot Aharonot ● Zemanim

The publisher wishes to acknowledge all sources of graphics that appear in this book but remain unidentified.